qlv3

artWorks

For as long as there has been art, there has been discussion about art. Over the past two centuries, as ideas and movements have succeeded each other with dizzying speed and the debate between various aesthetics has turned increasingly vivid, art criticism and theory have taken on an unprecedented relevance to the development of art itself.

ARTWORKS restores to print the most significant writings about art — whether letters and essays by the artists themselves, memoirs and polemics by those who lived with them in the thick of creation, or illuminating studies by some of our most prominent scholars and critics. Many of these works have long been unavailable in English, but they merit republication because the truths they convey remain valid and important. The list is eclectic because art is eclectic; taken as a whole, these titles reflect the history of art in all its color and variation, but they are bound together by a concern for their importance as primary documents.

These are writings that address art as being of both the eye and the mind, that recognize and celebrate the constant flux in which creation has occurred. And as such, they are crucial to any understanding or criticism of art today.

Eugène Delacroix

SELECTED LETTERS
1813-1863

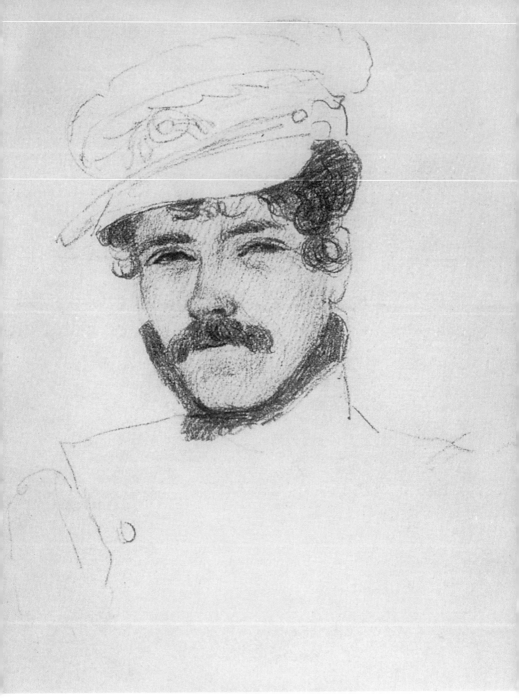

Self-portrait in travelling dress, 1832

Eugène Delacroix
SELECTED LETTERS
1813-1863

selected and translated by
JEAN STEWART

with an introduction by
JOHN RUSSELL

artWorks

MFA PUBLICATIONS
a division of the
Museum of Fine Arts, Boston

MFA Publications
a division of the Museum of Fine Arts, Boston
295 Huntington Avenue
Boston, Massachusetts 02115

For a complete listing of MFA Publications, please contact the publisher at the above address, or call 617 369 4367.

This volume contains translated extracts from the *Correspondance générale d'Eugene Delacroix*, ed. André Joubin, published by Librairie Plon, Paris, in 1935–38, and from Eugène Delacroix, *Lettres intimes, correspondance inédite*, ed. Alfred Dupont, published by Editions Gallimard, Paris, in 1954. This translation was originally published in 1971 by St. Martin's Press, New York. The present edition is published by arrangement with Editions Gallimard. John Russell's introduction is republished by permission of the author.

ISBN 0-87846-632-0
Library of Congress Catalogue Card Number: 70-150246

Available through D.A.P. / Distributed Art Publishers
155 Sixth Avenue, 2nd floor
New York, New York 10013
Tel.: 212 627 1999 · Fax: 212 627 9484

FIRST ARTWORKS EDITION, 2001
Printed and bound in the United States of America

CONTENTS

ILLUSTRATIONS · vii

TRANSLATOR'S NOTE · xiii

INTRODUCTION BY JOHN RUSSELL · 1

PART I Early Letters (1813-24) · 31

PART II Journeys to England and Morocco (1825-32) · 121

PART III Maturity (1833-53) · 201

PART IV Last Years (1854-63) · 321

APPENDIX

Select bibliography · 391

Index of correspondents · 395

General index · 399

ILLUSTRATIONS

Self-portrait in travelling dress, 1832 *frontispiece*
Cabinet des Dessins, Louvre (Archives Photographiques)

between pages 16 *and* 17

1 *a* Portrait of Elizabeth Salter, *c.* 1817
 Private Collection (Photographie Giraudon)
 b Draft of letter to Elizabeth Salter, *c.* 1817
 Bibliothèque d'Art et d'Archéologie, Paris
2 *a* Félix Guillemardet, *c.* 1827
 Musée du Louvre (Archives Photographiques)
 b Delacroix and his friends on New Year's Eve, 1817
 Cabinet des Dessins, Louvre (Archives Photographiques)
3 *a* Léon Riesener, 1834
 Musée du Louvre (Photographie Giraudon)
 b Frédéric Villot, *c.* 1832
 Prague National Museum
4 *a* Pierret in Turkish costume, 1825
 Private Collection (Archives Photographiques)
 b Madame Pierret, *c.* 1830-5
 Private Collection (Thames & Hudson Ltd)

between pages 32 *and* 33

5 Portrait of Delacroix by Géricault, *c.* 1818
 Musée des Beaux-Arts, Rouen (Thames & Hudson Ltd)
6 Dante and Virgil in the Inferno, 1822
 Musée du Louvre (Archives Photographiques)
7 The Massacre at Chios, 1824 (detail)
 Musée du Louvre (Archives Photographiques)
8 The Death of Sardanapalus, 1827 (detail)
 Musée du Louvre (Photographie Giraudon)

between pages 80 *and* 81

9 *a* Tasso in the Madhouse, 1824
 National Gallery of Switzerland (Dr Oskar Reinhart Collection)

 b Faust and Mephisto
 *Moreau-Nélaton Collection (Archives Photo-
 graphiques)*
10 *a* Tam o' Shanter. Drawing
 Fitzwilliam Museum, Cambridge
 b The Giaour. Drawing
 *Lord Clark of Saltwood (from Arts Council
 Catalogue, 1964)*
11 *a* Landscape near London, from English sketchbook,
 1825
 *Cabinet des Dessins, Louvre (Direction des Musées
 de France)*
 b English landscape, from English sketchbook
 *Cabinet des Dessins, Louvre (Direction des Musées
 de France)*
12 *a* Brighton Beach, from English sketchbook
 *Cabinet des Dessins, Louvre (Direction des Musées
 de France)*
 b Aimée Dalton, 1831
 Private Collection (Direction des Musées de France)

 between pages 96 and 97
13 *a* Young Tiger playing with its Mother *and*
 b Lion
 *Cabinet des Dessins, Louvre (Direction des Musées
 de France)*
14 Woman with a Parrot, 1827
 Musée des Beaux-Arts, Lyon
15 *a, b* Studies for Liberty leading the People, 1830
 *Cabinet des Dessins, Louvre (Direction des Musées
 de France)*
16 Liberty leading the People, 1830
 Musée du Louvre (Archives Photographiques)

 between pages 144 and 145
 Morocco 1832
17 The Comte de Mornay
 *Cabinet des Dessins, Louvre (Archives Photo-
 graphiques)*
18 *a* View of Gibraltar
 *Cabinet des Dessins, Louvre (Archives Photo-
 graphiques)*

b Environs of Tangier
 Cabinet des Dessins, Louvre (Archives Photographiques)

19 *a* Tangier
 Cabinet des Dessins, Louvre (Archives Photographiques)

b Arab lying on mat
 Cabinet des Dessins, Louvre (Archives Photographiques)

20 *a* Page from Moroccan sketchbook. Arab musicians
 Cabinet des Dessins, Louvre (Archives Photographiques)

b Page from Moroccan sketchbook. Ruined gateway
 Cabinet des Dessins, Louvre (Archives Photographiques)

between pages 160 *and* 161

21 *a* Amin-Bias
 Cabinet des Dessins, Louvre (Direction des Musées de France)

b Women of Algiers (study)
 Cabinet des Dessins, Louvre (Direction des Musées de France)

22 Women of Algiers, 1834
 Cabinet des Dessins, Louvre (Archives Photographiques)

23 *a* Encampment at Alcazar
 Cabinet des Dessins, Louvre (Direction des Musées de France)

b Fantasia before the gates of Meknes
 Cabinet des Dessins, Louvre (Direction des Musées de France)

24 *a* Arab horses fighting in a stable, 1860
 Cabinet des Dessins, Louvre (Direction des Musées de France)

b Tiger and wild horse
 Cabinet des Dessins, Louvre (Direction des Musées de France)

between pages 208 *and* 209

25 Baron Schwiter, *c.* 1827
 National Gallery, London

26 Self-portrait, 1835-7
 Musée du Louvre (Archives Photographiques)

27 Joséphine de Forget, medallion by David d'Angers, 1847
 (*Photo: Thames & Hudson Ltd*)

28 *a* Frédéric Chopin, 1838
 Musée du Louvre (*Direction des Musées de France*)

 b Chopin as Dante
 Cabinet des Dessins, Louvre (*Archives Photographiques*)

between pages 224 and 225

29 George Sand, 1834
 Private Collection (*Photographie Giraudon*)

30 Mother and Child, 1842
 Mme D. David-Weill Collection, Paris

31 Study for the Pietà in the church of Saint-Denis du Saint-Sacrement, Paris, 1844
 Formerly collection of Mme Lauwick (*née Riesener*)
 (*Direction des Musées de France*)

32 George Sand's garden at Nohant, 1842
 Metropolitan Museum of Art, New York (*Wolfe Fund, 1922*)

between pages 272 and 273

33 Peonies
 National Gallery, Oslo (*Thames & Hudson Ltd*)

34 *a* Caricature of the Institut
 Cabinet des Dessins, Louvre (*Archives Photographiques*)

 b Sketches of Iowa Indians, 1845
 Cabinet des Dessins, Louvre (*Direction des Musées de France*)

 c Sketches of cats
 Cabinets des Dessins, Louvre (*Direction des Musées de France*)

35 *a* Interior of Eugène Delacroix's studio
 (*Archives Photographiques*)

 b Eugène Delacroix's studio in the rue Furstenberg
 (*Private photograph*)

36 *a* View of Paris
 (Archives Photographiques)

 b Landscape in the Pyrenees, 1845
 Cabinet des Dessins, Louvre (*Archives Photographiques*)

between pages 288 *and* 289

37 *a* View near Champrosay
 Cabinet des Dessins, Louvre (Direction des Musées de France)

 b Garden at twilight
 Cabinet des Dessins, Louvre (Direction des Musées de France)

38 Grounds of Valmont Abbey, *c.* 1843. Study for *Death of Ophelia*
 Private Collection (Thames & Hudson Ltd)

39 *a* Sea at Dieppe. Watercolour, *c.* 1855
 Dr Peter Nathan, Zürich

 b Augerville, 1846
 Cabinet des Dessins, Louvre (Direction des Musées de France)

40 Dieppe, quai Duquesne, 1854
 Cabinet des Dessins, Louvre (Archives Photographiques)

between pages 336 *and* 337

41 Jenny Leguillou, 1840
 Musée du Louvre (Archives Photographiques)

42 Delacroix at a musical soirée (with Musset, Mérimée, Auber, Gounod) by Eugène Lami, 1850
 Formerly Jean-Louis Vaudoyer Collection (Thames & Hudson Ltd)

43 The Education of Achilles: Palais Bourbon, 1838-47
 (éditions du Temps)

44 Cincinnatus: Palais du Luxembourg, 1838-47
 (éditions du Temps)

between pages 352 *and* 353

45 Apollo, detail: Galerie d'Apollon in Louvre, 1850-1
 (Musée du Louvre)

46 Study for Apollo ceiling, 1850-1
 Musée Royal des Beaux-Arts, Brussels (éditions du Temps)

47 Christ on the Lake of Genesareth, 1853
 Dr Peter Nathan, Zürich (Photographie Giraudon)

48 Study for Jacob and the Angel in St Sulpice, 1856-61
 Fogg Art Museum, Harvard University (Gift of Philip Hofer)

ACKNOWLEDGEMENTS

Thanks are due to trustees of museums and art galleries for kind permission to reproduce pictures in their possession, especially to the Cabinet des Dessins of the Musée du Louvre, Paris; Musée des Beaux-Arts, Rouen; Prague National Museum; Fitzwilliam Museum, Cambridge; Musée des Beaux-Arts, Lyon; National Gallery, London; Metropolitan Museum of Art, New York (Wolfe Fund, 1922); National Gallery, Oslo; Musée Royal des Beaux-Arts, Brussels; and to the Fogg Art Museum, Harvard University (gift of Philip Hofer). Also to owners or trustees of private collections, especially to John Russell, Esq.; National Gallery of Switzerland (Dr Oskar Reinhart Collection); the Moreau-Nélaton Collection, Paris; Lord Clark of Saltwood; Mme D. David-Weill, Paris; and to Dr Peter Nathan, Zürich. For the use of copyright photographs acknowledgements are made to those concerned and especially to Archives Photographiques, Paris; Photographie Giraudon, Paris; Thames & Hudson Ltd, London; the Arts Council of Great Britain; Direction des Musées de France; and to Éditions du Temps, Paris.

TRANSLATOR'S NOTE

The first systematic attempt to collect and publish the letters of Delacroix was made by Philippe Burty, *Lettres d'Eugène Delacroix*, some fifteen years after the painter's death. A first edition in 1878 contained just over 300 letters and Burty managed to secure some 60 more for the second edition (2 vols, 1880). The interest of this collection stimulated other enthusiasts and art critics (Charles de Lacombe, 1885; Alfred Robaut; Étienne Moreau-Nélaton, 1916; Raymond Escholier, 1926-9); and by 1935 André Joubin was able to publish his five-volume *Correspondance générale*, comprising over 1,500 letters. It is from this that the bulk of the present selection has been made.

Inevitably Joubin's collection is far from complete: for instance, all Delacroix's letters to Mérimée were lost in a fire, those to Mme de Forget during the first ten years of their liaison were destroyed by her executors, and those to Stendhal and to Chopin, except for a few insignificant notes, are missing. However, a welcome supplement to Joubin's book appeared in 1954; *Lettres intimes, correspondance inédite*, edited by Alfred Dupont – some fifty hitherto unpublished letters to the painter's personal friends, Piron, Guillemardet and Soulier, and to his brother Charles, many of considerable interest.

Choice has been difficult, but I have tried to ensure that all the varied aspects of Delacroix's personality should be represented, however inadequately. Exigencies of space have necessitated the ruthless pruning of trivia, repetitions, formal or affectionate openings and endings of letters. The presence of four dots at the end of a sentence usually indicates an omission before the next new sentence. Three dots . . . in the middle of a sentence indicates a cut of words, except where the punctuation is equal to a pause in the original French. The dating of the letters involved Joubin in a certain amount of guesswork, which I have followed. Delacroix did not always date his letters and the postmark is not always available. Footnotes in the text are chiefly based on those in Joubin's edition.

The pictures and drawings reproduced have been chosen as far as possible with reference to people, places, works or incidents referred to in the text.

I should like to express my grateful thanks for advice on general or specific problems to M. Maurice Sérullaz, Conservateur des Dessins,

Musée du Louvre, Dr Lee Johnson, Dr R. W. Ratcliffe and Mr John Russell; and particularly to the Witt Library in the Courtauld Institute of Art of the University of London. For facilities of translation from printed texts thanks are tendered, respectively, to Librairie Plon for extracts from *Correspondance générale d'Eugène Delacroix*, ed. André Joubin, 5 vols (1935-8); and to Éditions Gallimard for extracts from *Lettres intimes, correspondance inédite*, ed. Alfred Dupont (1954).

Cambridge, 1971 JEAN STEWART

Eugène Delacroix

SELECTED LETTERS
1813-1863

INTRODUCTION

Delacroix in his *Journal* is one of the most cogent of arguments for the human race. That we are in the company of a great man is never in doubt. But whereas not every great man gains by proximity, or can usefully be studied in isolation from his work, Delacroix the diarist begins with our respect and ends, just on half a million words later, with our unbounded affection. Incomplete as they are, his diaries rank among the *fragmenta aurea* of European civilisation. They are passionate but not scabrous, worldly but not heartless, intimate but not indiscreet, animated but not rackety, profound but not ponderous, discursive but not self-indulgent. Above all, they are truthful and direct. Delacroix never forces the note, never writes for effect, never adjusts with an eye to posterity. Beside him, Amiel is a cry-baby, Gide an evasive old humbug, Crabb Robinson an unselective chatterbox, Edmond de Goncourt a fount of ill nature and Boswell a self-advertising cad.

The *Journal* is full of surprises for those who think of Delacroix primarily as an adventurer of the imagination, a disorderly, intermittently inspired and largely demoniac story-teller. Anyone who looks to the *Journal* as a work of revolutionary inspiration will be dismayed to find that once the brief transports of youth are over the Delacroix who comes uppermost is Delacroix the conservative, the classicist, the solitary, the bookman and the valetudinarian. He may happen to tell us about Meyerbeer's big feet, or about the gaps between Balzac's teeth, or about the black hangings which turned Alberthe de Rubempré's apartment into a sorcerer's den; but as a practising diarist he preferred things to people. What we get from the *Journal*, and what makes it so uniquely valuable, is the quintessence of a great nature that has valued above all things the 'exquisite mixture of peace and excitement that physical passion can never give'. This particular kind of purposeful concentration is something that no novelist has contrived to render: in Delacroix's *Journal* it comes to us complete and immediate.

But the *Journal* is only a fragment. We have it for 1822 to 1824, for the African journey of 1832, for 1847, and for 1849 to 1863. (The notebook for 1848 was lost by Delacroix himself.) As Delacroix was born in 1798, this means that there is no diary for the years of adolescence and early youth. There is a gap, also, of nearly twenty-five years

1

at a time when he was in full evolution. The diaries do not, for instance, cover the crucial journey to Morocco in 1832. The hardly less crucial visit to England in 1825 likewise goes unrecorded. Landmarks in his career such as *The Death of Sardanapalus* (1827), *The Battle of Taillebourg* (1837), *The Justice of Trajan* (1840), *The Fall of Constantinople* (1841), and the huge decorations in the Palais Bourbon and the Palais du Luxembourg fall outside the scope of the *Journal*. Much in his private life appears briefly or not at all: when one thinks of the importance of Baudelaire to Delacroix's reputation it is frustrating, to say the least, to find that the *Journal* refers to him merely as a young visitor whose views 'seem exceedingly modern and progressive'. Faced with such entries, we have the feeling that a great master of the art of behaviour is putting us politely in our places.

At these moments it may occur to us that more might be forthcoming from our second great source of information about Delacroix: his letters. The Joubin *Correspondance Générale* runs to five volumes, as against the *Journal's* three, and although there is a minority of chalky official letters and brief notes of the order of 'M. Delacroix regrets . . .' the bulk of those five volumes is of an unbroken fascination for the enthusiast. For the young Delacroix, and for Delacroix in his thirties and forties, the letters are our only substantial source of first-hand information. And even during the years of the *Journal* there are ensembles of letters – those, for instance, to Mme de Forget, to George Sand, and to more than one man friend of long standing – which are as direct and as eloquent as anything in the *Journal*. The letter to Mme de Forget of 16 August 1855, the letter (drafted, but not sent) to Balzac on the subject of 'Louis Lambert', the letters of 1844 to his assistant Louis de Planet, the solitary surviving letter to his servant Jenny Leguillou, and the irresistible, open-hearted letters of the early 1820s – all these and a hundred others are quite simply indispensable to our knowledge of Delacroix. Long before the diaries were begun, Delacroix was committing himself to paper in his letters. Certain things needed, even, an audience other than himself: the eulogy of painting, for instance, in the letter to Soulier of 30 April 1821. And certain people never lost the power to stir him to action: in the last weeks of his life, when the *Journal* was laid aside, the habit of letter-writing remained with him.

Delacroix was a natural writer who at one time might have turned professional. (The manuscripts of a play, a short historical novel, and a romance set in Switzerland have all passed through the Parisian book-market since the war.) He needed to write. Orphaned by the time he was fifteen, left with the slenderest possible financial prospects and cared for – if that is the word – by an older sister, he needed to

establish relations of security with somebody, somewhere: his men friends helped towards this and he remained grateful to them for the rest of his life, but he was enough in need of female assurance to undertake the most desperate and implausible of manœuvres. I know of few relics more moving, in their kind, than the drafts of the letters which he hacked out in English when his sister's housemaid, Elizabeth Salter, was the object of his affections. From his letters to his sister we know, also, of the shifts and devices to which he was put at this stage in his life. Letters to her were dated from his friends' houses, when he could not afford a fire at home. He was often at the local pawn-shop. Duns and tax-collectors had to be avoided on every hand. His only black suit split in two places and could no longer be repaired. Locksmith and decorator should have been paid, but could not be; Delacroix himself lunched unvaryingly on bread and cheese, lost weight in consequence and kept running an unaccountable fever. . . .

A boy born to poverty might have survived this sort of thing quite well. But Delacroix was not born to poverty: quite the reverse. His father had been Foreign Secretary – for a brief moment, admittedly – and at the time of his death in 1805 he was Prefect of the Gironde. Delacroix's older brother Charles was a colonel in the French cavalry and had been aide-de-camp to Prince Eugène. It was whispered that Talleyrand himself had been keenly interested in Mme Delacroix not long before Delacroix was born. On the face of it, one might expect him to have enjoyed a stylish childhood at a time when French fortunes were at their very highest. But his father died when he was seven; his mother's qualities did not include a good head for money; and when she died in 1814 it was found that the family was completely ruined. His sister had inherited her mother's frailty in more than one department of life, and by 1819 she and her husband left Paris in the hope of turning their estate near Angoulême to good account. Delacroix was left, meanwhile, to find some desirable tenants for the family house in Paris; it is from the letters, and not from the *Journal*, that we know of his life from day to day at this time.

Genteel penury was not the whole of that life. The estate near Angoulême was well over three thousand acres, and Delacroix did not at all mind telling his friends that the single-storeyed white house which went with it was as comfortable, and as elegant, as many a great town-house in Paris. Another family property, the Abbaye de Valmont, near Fécamp, is a country house on the grand scale; and even if he was barely more than the caretaker of his sister's house in Paris, that house was in the middle of the Faubourg Saint-Germain. The look of grandeur in all this was deceptive; but, as a look, it could hardly have been bettered.

It was mainly in the country that Delacroix wrote the long and revelatory letters which make up the first section of this book. In Paris, he had less time and less reason to write. (There are no letters, for instance, to Géricault, of whom Delacroix saw a great deal between 1819 and 1824.) The country letters are revelatory not only for the circumstances of Delacroix's life but for the climate of feeling within which he lived. This was predominantly one of thoughtful loneliness: he liked, for instance, to compare himself, by implication, with Virgil's Gallus who, in the tenth Eclogue, retires to the forest to seek consolation for the loss of his mistress. So far was he from the conventional effusions of Romanticism that he chose Horace, in those difficult days, as the best of guides. With no opportunity, as yet, of arriving at a profound and articulate contact with a woman of his own quality, he staked everything on friendship. Through the letters to Pierret, for instance, there stalks the phantom of an ideal affection, a meeting and mingling of lofty and gifted minds, an intuitive sympathy freed from all sexual alloy. Letters, he wrote, would be the true test of such an attachment; for in letters a man stands revealed, and those who seem cold and withdrawn in everyday life may turn out to be the warmest, most impulsive, most out-going and giving of men.

Delacroix had a sharp eye for reality from the very beginning, and he must have known that his earlier friends, Pierret and Soulier and the Guillemardet brothers, were not men of genius and were unlikely to cut anything but a modest figure in life. But it was not in his nature to drop them on that account. When he was staying with his brother-in-law's family near Souillac, and the four-hour meals were larded with recollections of the nursery, Delacroix waited for Pierret's letters as eagerly as he would have waited, in later life, for one from Chopin or from Mme de Forget. For his own part he gave himself, entire, in his letters, and he was determined that a friend, once made, should be kept for ever. Looking around him, he realised that it was rare for a man of forty to have even one friend on whom he could rely. His father had died at sixty-six with two or three old friends whom he loved whole-heartedly: his mother, likewise. But society as a whole was not rich in such affections: and it was because Delacroix at this stage in his life was short of affections of any sort that he steam-heated the tone of his letters to a temperature well above that of everyday.

Perhaps it was already clear to him that work alone would yield him lasting happiness. Already in 1820 he had a very clear idea of what it meant to be a great artist: a man, in other words, who could conceive a grand design and carry it through to a conclusion. 'How great the great men are!' he wrote to Pierret on 20 October: and to Soulier, in April 1821, 'Painting is life itself!' To find out what Dela-

4

croix thought about the actual business of painting, we have to go mainly to the *Journal*: the letters of his maturity relate rather to the painter's public existence. But in the letters of early youth vital decisions are talked over: whether or not to go to Italy, for instance. The history of painting might have taken a different turn if Delacroix had won the Prix de Rome, or had gone to live and work in Italy on his own, or had even made the classic Italian tour. In the event, he never went there, even in the years when he could afford it. The great artist is the one who knows, by inmost instinct, what is best for him; and when Delacroix went abroad, as he did to England in 1825, to North Africa in 1852, and to Belgium and Holland in 1858, it was because there was something in those countries that he could not do without.

Meanwhile, he went nowhere. His friend Soulier was in Italy, but Soulier was too interested in food and drink and ephemeral 'conquests' to get anywhere as a painter. Delacroix felt, quite rightly, that it was more to the point to know Géricault than to post off to Elba in search of compliant peasant girls. He was still tempted by Italy, and even in April 1822 he talked of going there as soon as he could. But fundamentally he was a quiet, reserved and variable man who thrived in a quiet, reserved and variable climate. The Dordogne (or, later, George Sand's house at Nohant) was as far south as he ever cared to go. He sometimes grumbled about Paris, but Paris was where he had to be: all the more so, in fact, after 24 April 1822, the day on which for the first time he showed a major painting in public.

This painting was *Dante and Virgil*. It was a picture which Delacroix had painted with a specific object in mind: that of making a stir at the Salon. Art-life in the 1820s was very different from what it is today, and for practical purposes there was only one way to make a name for oneself. The big painters were the people who made big pictures for the big exhibition. In planning his big picture, Delacroix thought of Michelangelo for one of the figures, and of Rubens for another. But fundamentally the master he had in mind was his friend Géricault. He had himself posed, in 1819, for one of the figures in Géricault's *Radeau de la Méduse*; the memory of that great painting, with its unearthly lighting, its all but naked figures half in and half out of the sea, and the Michelangelesque eloquence with which Géricault had covered up for the hideous facts – all this came flooding back to him when he got down to work. What he did not get from Géricault, but from himself, was the free and expressive use of colour which, already in 1822, looked forward to the adventures of sixty and seventy years later.

There was no lack of ambitious young painters in the Salon and

Delacroix made his mark with what has seemed to some people an almost suspicious rapidity. On 11 May he was singled out by Adolphe Thiers, in an article in the *Constitutionnel*, as a man of true genius. And on 30 May he was sounded by the Surintendant des Beaux-Arts as to the price he would put on *Dante and Virgil*. The State beat him down from 2,400 francs to 2,000, but it was bought, all the same, and since 1874 it has been in the Louvre.

Because it was unusual for a young painter to be honoured in this way at his début, and because Thiers later had a brilliant political career, it has been inferred that Delacroix at this stage in his life had a protector behind the scenes. This ignores two relevant facts: first, that Forbin, the Surintendant des Beaux-Arts, had been a patron of Géricault and in 1820, whether wittingly or not, had allowed Géricault to pass on to Delacroix a commission for a *Virgin of the Sacred Heart* which is now in Ajaccio Cathedral; and second, that Thiers at the time was a young man of twenty-four whom Delacroix might well have known personally, since both of them frequented the salon of Baron Gérard. It is therefore perfectly probable that Delacroix's success was owed to his own efforts and that no august figure was active on his behalf.

The rumour does, however, allow us to consider a related question as to which stronger evidence exists. Was Delacroix the son of Talleyrand? In this matter, very few things are clear. But one is incontrovertible: seven months before the birth of Eugène Delacroix, Charles Delacroix underwent a serious operation. During the months which preceded this operation (of which a detailed account was published in December 1797) he was absolutely incapable of engendering a child. Only two possibilities exist, therefore: either Eugène Delacroix was illegitimate, or he was born prematurely. The fact that he revered Charles Delacroix, and that Charles Delacroix showed him the greatest kindness, would seem to favour the second interpretation. Delacroix had the published account of his father's operation in his library. If he had had any doubts on the subject of his paternity it seems implausible that he would not have confided them, even obliquely, to his diaries. But not only does he speak tenderly of his father: he speaks of Talleyrand, and of the Duc de Morny (who on the alternative interpretation would be his nephew) with the same detached curiosity that he bestowed on every other conspicuous man of his time.

On the other side there can be adduced a striking physical likeness between Delacroix and Talleyrand. And although Delacroix quite lacked Talleyrand's mastery of manœuvres advantageous to himself, he was distinguished in everyday life by a fastidious aloofness which was widely remarked. Much as he liked his elder brother, he had

6

nothing in common with him, either in looks or in character: it would have been quite unlike Eugène Delacroix to settle for a wife who was an embarrassment to him every time he had to go into society. There is, finally, the fact that Talleyrand was closely connected with Charles Delacroix, succeeded him as Foreign Secretary, and had him packed off to Holland at the time of Mme Delacroix's pregnancy. It is probable, also, that Talleyrand took a covert interest in Delacroix's career, though the practical results of that interest have never been brought into the open.

Altogether, this is a problem which can be solved only by the disclosure of papers hitherto kept private. Delacroix in his writings never gave the slightest hint of whatever beliefs he may have had on the subject: nor do we know that any of his friends held opinions about it which might have come from him. He was close, in all private matters – we can scour the *Journal* from end to end and not come up with a piece of scandal – and in this matter he was close absolutely.

Delacroix was not a man to have his head turned by early success and he had hardly got *Dante and Virgil* out of the way before he began looking about for a subject that would allow of even grander treatment. The example of Géricault had suggested that current or recent events, even if properly handled, could be the point of departure for a great painting. Gros, with his *Bonaparte Visiting the Victims of the Plague at Jaffa* (1799), was even nearer to Delacroix's own preoccupations. From the very beginnings of his career – from the time, that is to say, when he began to draw in his schoolbooks – Delacroix had been fascinated by the Near and Middle East. In this he was helped by the mysterious figure of Jules-Robert Auguste, whom he had known as a near neighbour of Géricault's. 'Monsieur Auguste', as he was commonly known, was only nine years older than Delacroix, but he had a way of imposing himself as a man of extensive cosmopolitan experience. This was no more than the truth: in his early twenties Monsieur Auguste had travelled in Greece, Turkey, Syria and Egypt. He was a natural accumulator and had made haste to acquire a large collection of costumes, jewellery, arms and armour in the countries that he visited. When these got back to Paris, and he was able to instal them in his apartment in the rue des Martyrs, together with his own copies from the Old Masters (and from Constable), they formed what René Huyghe has rightly called 'a Pandora's box, whose lid Delacroix lifted with bewitched delight'. Monsieur Auguste's own work had, moreover, a marked stylistic influence on Delacroix.

This being so, Delacroix cast round for a subject with an eastward orientation. In September 1821, in a letter to Soulier, he had mooted the idea of a subject from the Greek War of Independence. In April

7

1822 there occurred one of the most famous and horrific episodes in that war: the massacres perpetrated by the Turks on the island of Chios. All Europe rang, before long, with the story of how twenty thousand Greeks had been killed and nearly all the remaining inhabitants of the island had been carried off into slavery. In 1829 Victor Hugo was to publish an elegy for the fallen in his *Orientales*, but already in May 1823 Delacroix had decided that his next major painting should be on the same subject. By November he had completed a first draft for the composition, by December the huge canvas (164 × 139 inches) was in the studio, and on 12 January 1824 Delacroix had an interview with a French officer who had served with the Greeks and could give him first-hand information: it was from that day that he dated the beginnings of real work on the picture. From then until the opening of the Salon on 25 August, 1824, he was in full activity. The *Massacre* is one of the paintings most fully documented in the *Journal*. If his letters have relatively little to offer, it is because Delacroix was in Paris throughout: his friends came to see him, or he went to see them, and there was little time and less reason for him to write letters. Delacroix had the freedom at this time of a new group of friends whom he had met either with Baron Gérard, or with Monsieur Auguste; and now that he was himself a Parisian figure there was no call for the lengthy and detailed effusions with which he had whiled away his solitary days in the country.

Scenes from the Massacre at Chios is counted today as one of the quintessential documents of the Romantic movement. Its author stands with Berlioz, and with Victor Hugo, as one of France's three great contributors to that movement; and it would be natural to suppose that, like Berlioz and Hugo, he was a man of outsize passions. When we read of Hugo breaking stones between his teeth, and of Berlioz conducting with a drawn sword, we might well conceive of Delacroix as in some way comparable. In his thirtieth year he designed costumes for Hugo's *Amy Robsart* at the Odéon, and when the English actors came to the same theatre in 1827 he admired Miss Harriet Smithson almost as much as did Berlioz, who gave her no peace until in 1833 she married him. It would have been the right thing, from the scenarist's point of view, if the three big men had been as united as Porthos, Aramis and d'Artagnan.

In point of fact Delacroix never took to Berlioz's music: 'an appalling row, a kind of heroic mish-mash', he wrote after one concert. Of Victor Hugo the writer he said in later life that he 'never came within a hundred miles of truth and simplicity', and whatever enthusiasm he had once had for Hugo the man was quick to cool. The truth is that when Berlioz and Hugo were pushing every emotion to its extremest

8

point Delacroix, in March 1824, with the *Massacre* half done in the studio, was writing in his diary that 'I must try to live austerely, as Plato did. . . . I need to live a more solitary life. . . . Valuable ideas beyond number miscarry because I have no continuity in my thoughts . . .' He was tormented by what he took to be his pallid, weedy appearance. If he took advantage of some sexual opportunity, he reproached himself for wasting time when it turned out well and was tortured by the fear of impotence when it did not. ('I could do nothing,' he noted in April 1824: 'Can I be going the same way as my brother?')

These are curious, contradictory states of mind for one who, in the general opinion, was a paragon of aggressivity. But the truth is that like many diarists Delacroix turned to his notebooks primarily in moments of uncertainty, or when nothing more urgent presented itself. What he set down on paper were the times when everything went wrong: 'I must not eat much in the evening, and I must work alone. . . . The things which we experience for ourselves when we are on our own are stronger by far, and fresher. . . . The future is all blackness . . . I must try to free myself from the ties that dull my mind and endanger my health . . .'. And all this at a time when, as we know from those same diaries, he was working on the *Massacre* with what looks like an admirable persistence. The evidence, as assembled in the *Memorial de l'Exposition organisée à l'occasion du Centenaire de l'Artiste*, allows us to follow the progress of the great painting from day to day: but it also allows us to eavesdrop on a Delacroix who spoke of himself as 'vegetating like a fungus on a rotten trunk' at precisely the same time. What looks paradoxical is, in reality, one of the most penetrating of our insights into the creative life.

In April 1824 Delacroix was haunted by the idea of going to Egypt, and of learning Arabic by way of preparation. In the end, he never did either: instead, he followed the unfailing inner compass which every true artist possesses and set his course for England. Ever since he had seen the copy after Constable's *View of the Stour near Dedham* which Monsieur Auguste had made in London in 1822, he had known that Constable had a great deal to teach him; the *Massacre* had been retouched, to an extent which is still matter for controversy, under the influence of the paintings which Constable had sent to the Salon of 1824; and Delacroix had been friendly with more than one English painter in Paris. English ways attracted him as much as English literature; and the pull of London was stronger in the end than the pull of Egypt or Italy. In May 1825 he set off on an adventure which was to mark him for life.

Of that adventure, the letters afford our only first-hand account. Delacroix had discontinued his diary in the autumn of 1824 and did

9

not start up again – North African travel notes excepted – until January 1847. In England he noted down what interested him in his sketchbooks, and very telling some of those pages are: but for the written word we rely on his letters to Pierret and Soulier, since none of his English friends kept a record of the visit. Nor did any of the English notabilities whom he got to see think the encounter worth describing. (Before we scold them, we should remember that when J. M. W. Turner called on Delacroix in Paris, Delacroix was not especially impressed, and likened him to 'an English farmer, with his rough black coat and heavy boots and his cold, hard expression'.)

Delacroix was not, as he said himself, either a keen or a consistent sightseer. He would no more have gone to a picture gallery, in the way of duty, than he would have gone to one of the public hangings which were held regularly every Monday and Friday during his visit. Nor was he one to gush: the English theatre was very fine, and so were the courtesy of Sir Thomas Lawrence and the beauty of the rowing-boats, each one like an Amati violin, on the Thames. But the pettiness of the people! Their ugliness! And their rapacity! He was amazed that Shakespeare should have been born an Englishman. The Old Masters were all very well, but pictures were pictures the world over. As for the opera, it was unspeakable.

He was not, for that matter, the only member of his circle to return from England with mixed feelings. Stendhal, for one, had moments of supreme discomfiture in our capital. But, as happens with every intelligent traveller, what remained with Delacroix were those elements in the experience which he could put to good use. Thanks to Monsieur Auguste, he had lodged with a horse-trainer off the Edgware Road: whence the freedom and assurance, not less remarkable than Géricault's, with which thereafter he handled the motif of the horse. He saw Kean at his best. He was in Byron's native land at a time when all Europe was still in mourning for him. He learned from Wilkie's sketches, and from Etty, as well as from the fugacity and transparency of our water-colourists. Much as he disliked many of the Englishmen he met, and although he found English women in general dirty and ill-kempt, he never budged from his delight in English friendships: Bonington, had he lived, would surely have remained one of those closest to him. There were also other, seemingly more trivial ways in which he gained a lot from England. He learned, for instance, to mask his self-consciousness about his looks and bearing with a look of English sang-froid. Baudelaire remarked on the fact that Delacroix's politeness remained constant through a gamut of nuances that ranged from full-hearted affability to a perfectly judged insolence: 'He had at least twenty different ways of saying "Mon cher monsieur", and to

a practised ear each one of them stood for a different step in the scale of feeling'. At a time when young painters liked to call attention to themselves by extravagance in their dress, Delacroix kept to what Max Beerbohm called 'certain congruities of dark cloth and a rigid perfection of linen'. These were things that stayed with him for life and were often remarked upon when he was a famous man whose every move was matter for awed attention: we can mark them up to the credit of his English adventure, just as we can point to the influence of Bonington on his *Marino Faliero*, of Etty on his *Christ on the Lake of Genesareth*, and of Lawrence on the portrait of *Baron Schwiter* in the National Gallery in London. Two particularly English subjects appear, also, among the pictures which date from shortly after his English journey: *Milton and his Daughters* and *Cromwell at Windsor Castle*.

Neither Milton nor Cromwell can be fitted into the Romantic movement; and Delacroix's general bearing on his return from England was as un-Byronic as it could possibly be. To his friends he wrote that he was more and more of a stay-at-home, that he lived to an increasing degree in the past, and that death had claimed all too many of those who had been dear to him. Had he been seventy-eight and not twenty-eight, all this might have seemed timely: as it is, we can only attribute it to a powerful injection of *le phlegme anglais*. We are also entitled to remember that a letter-writer is not on oath, and that at this same period Delacroix was painting, or working up to paint, a series of masterpieces large and small which stand out in the canon of European painting for the intensity of their erotic feeling. 1827 was the great year, in this respect. From the little *Woman with a Parrot* (see plate 14), now in Lyons, to the gigantic *Death of Sardanapalus* Delacroix maintained the note of an immense and fulfilled sensuality. A great part was played in this by one of his favourite models, a girl whose beauty had tormented him for several years already: 'It's an amazing thing,' he noted in his diary in April 1824, 'but although I wanted to make love to Laure all the time she was posing for me, I lost all heart for it from the moment she began to leave . . .'. Possibly there was in his relations with Laure an unfulfilled element which gave an additional poignancy to his portrayals of her: it is certain, in any case, that neither Milton nor Cromwell had anything to do with the delicious *Woman with a Parrot* or its companion-piece, the *Woman with White Stockings* in the Louvre. These were pictures such as his friends Stendhal and Mérimée would have painted, had they been able, as records of an untroubled libertinage. It would seem likely, however, that in Delacroix's case the act of painting served to steady and concentrate and intensify feelings which, in life, went beyond his control. He himself was far too circumspect to give any indication of

11

this, but a surviving letter from Mérimée to Stendhal puts the matter in a different perspective. Delacroix at one time used to dine once a week or more with Stendhal and Mérimée, and very often they were joined by other friends: among them Alfred de Musset, the diarist Horace de Viel-Castel, and Sutton Sharpe the libidinous English lawyer. On this occasion:

> Musset was all affectation till the champagne arrived, when he became natural and amusing again. He suggested that he should treat us to the spectacle of himself making love to a girl by the light of twenty-five candles. The idea was greeted with enthusiasm and we at once got up from the table to put it into execution. There had been rioting earlier in the day and it was all that we could do to make our way through the massed Gardes Nationales. When we got to Leriche's, our romantic poet began to bleed at the nose and tried to put us off with a lot of Ifs and Buts, and so on. To cut a long story short, he simply couldn't bring it off, although two quite pretty girls brought all their energy and all their skill to the task. Then we sent for more girls and had six of them run through some gymnastic exercises in *puris naturalibus*. The idea was that each of us should take charge of one of them. B. was unmoved, as a faithful lover should be. Horace displayed an astounding gift for crapulous eloquence. But our friend Delacroix was beside himself – puffing and blowing as if he wanted to take on the whole six of them at once. If it were not for the respect we owe to pen and paper I should have some very funny things to tell you about his appetites in this regard. . . .

So it would not quite do to take Delacroix at his word when he writes to old friends about his longing for a modest, withdrawn, slippered existence. The discrepancy arose partly, no doubt, from the fact that he had still to find a woman friend, let alone a lover, of anything like his own calibre. 'A wife who is one's equal', he had noted in 1823, 'is the greatest of all blessings': but he had gone none of the way towards finding such a person. He accepted, on the contrary, a way of life in which random affections waxed and waned; and when his friends married he would send them a congratulatory note which, though invariably well put, lacked altogether the note of envy.

He did, all the same, nurture an exalted idea – an abstract idea, almost – of womanhood. This came about progressively: in the *Massacre at Chios* women were seen as loyal but essentially passive. In *The Death of Sardanapalus* they were *machines à plaisir*: well-chosen, physically of extreme splendour, full of proud and generous impulses, but once again fundamentally passive. It was in *Greece Expiring on the Ruins of Missolonghi*, and even more in *Liberty*

Leading the People (1831), that Delacroix turned towards the idea that humanity could be quintessentialised in the form of a superior woman: a woman who could add the masculine attributes of leadership and direction to the physical magnificence with which he had consistently endowed her. In the *Greece Expiring*, these attributes were latent: history had denied them fulfilment. In the *Liberty*, they were in full command, just as Liberty herself was in the front rank of her operatic rabble.

The *Liberty* is altogether a very curious and important and mysterious episode in Delacroix's career. The letters have almost nothing to tell us about it: at most, one could infer from a massive order for colours, dated September 1830, that Delacroix had already something substantial in mind; M. Sérullaz quotes from an unpublished letter to Delacroix's brother, dated 18 October 1830, to the effect that 'I have started work on a modern subject, a scene on the barricades. . . . I may not have fought for my country but at least I shall have painted for her . . .'. And it would seem from a letter to Soulier, dated 6 December 1830, that he had put on a turn of speed and by then had more or less completed the painting. A bare two months, on this reading, sufficed for this huge and elaborate painting, which was not a romantic 'evocation' but a carefully studied historical record in which only the figure of Liberty departs from circumstantial truth.

When we, today, come upon this great painting in the Louvre, we see it through a haze of unfocussed glory. To be led into a cloudless future by a beautiful half-naked woman is a dream that never fails of its effect, and the visitor is rare who stops to wonder what has happened since 1830 to that untrammelled Liberty. In the painting, she is present as vividly as ever, and seems as likely as she was in 1831 to jump right out of the picture and directly down among us. As a call to action, the *Liberty* is unexcelled: nothing in 1789, nothing in 1848, nothing in 1917 came or has come within a mile of it. It looks like a manifesto of the purest idealism, a gesture of identification not easily reconciled with Delacroix's sceptical attitude to public events.

The *Liberty* is, in fact, all the more remarkable if we consider that Delacroix in general saw the crowd, and in particular the revolutionary crowd, as an instrument of blind and destructive passions. Paintings like *Boissy d'Anglas* and *The Murder of the Bishop of Liège*, both contemporary with the *Liberty*, are eloquent of this. Nor was he a natural democrat: his own inclination was towards a hierarchical society. But he had reached the stage in life at which people like to feel beneath their feet the firm arch of a career. Possibly, also, he remembered from his first childhood how very agreeable it can be to be surrounded by the comforts of position: his father had been Prefect

13

of the Gironde and a Prefect is, even today, a little local monarch, with powers that not many an authentic crowned head has at his disposal. The established painter was a great figure in the France of Delacroix's youth and early manhood: Delacroix had been decorated very early in the new regime, at a time when he was still working on the gigantic *Battle of Nancy*, which had been commissioned from him under the reign of Charles X. He was willing in 1831 to run in competition with thirty-one other painters for the honour of painting an historical subject for the salle des séances in the Palais-Bourbon. He put on the uniform of the Garde Nationale (displaying, by the way, an English concern with refinements of tailoring). That he was willing to come forward as a spokesman for art and for artists we see from his letters of 1 March 1831 and 27 June 1831 and from the draft which he made in July of that year for the members of the Société Libre de Peinture et de Sculpture. Distinctly, therefore, he was getting ready to be one of the leaders, if not the outright leader, of his profession; and he saw in the new regime a whole gamut of possibilities which he had not seen, or had not hoped to realise, under Charles X.

Not all his friends had aspirations of this sort. They made fun, for instance, of his decoration: 'Delacroix is delighted with his cross,' Mérimée wrote to Stendhal in March 1831, 'but he has not yet begun to fart when he walks into a drawing-room. . . .' (Mérimée's sense of comedy was well employed, too, in describing the ambitions of the new regime in matters of art.) But Delacroix certainly seems to have believed that life under the Citizen King might turn out well: probably he was influenced by the fact that his champion Adolphe Thiers had played a substantial part in getting Louis-Philippe on to the throne. For a long time it was believed that he had identified himself with the risings to the point of including in the *Liberty* a self-portrait in the top-hatted figure in the foreground on the left. It would, however, have been quite unlike Delacroix to claim for himself a role more heroic than the one which he had actually played: that of a sympathetic spectator. There seems no reason to doubt the amendment offered by Lee Johnson: that the man in question was Etienne Arago, the director of the Théâtre du Vaudeville, who was a heartfelt Republican and supplied the rebels with muskets from his own property-room. Mr Johnson also suggests that the pose of Liberty herself is a free adaptation of that assumed by the Aphrodite of Melos, which had been on view in the Louvre since 1821: this would accord with Delacroix's universalising turn of mind and innate respect for antiquity.

By the late summer of 1831 Delacroix had had enough of his new

role in Parisian life and was very glad to get away to the Abbaye de Valmont. As we see from his letter of 30 September to Pierret, he had even lost his appetite for work. Something was needed to regalvanise him: and that something was forthcoming very soon, in the form of an invitation from the Comte de Mornay to accompany him on the mission to Morocco with which he had been charged by the new government. (It is one of the happy accidents of art history that Isabey, who had been first choice in this matter, did not want to go.) Delacroix owed the invitation above all to his passion for the theatre, in that it was Duponchel, the director of the Opéra, and Mlle Mars, one of the great ladies of the French stage, who between them put forward his name. It was essential to have someone who was not only a gifted artist but also an agreeable companion, and Mlle Mars reported after a New Year's Eve meeting with Delacroix that he had 'talent, wit, and the social graces, and is apparently of an excellent character: not a thing to be sneezed at when people have to spend four or five months together'.

If Delacroix was an ideal choice, in personal terms, he was also all that could have been dreamed of as a fastidious recorder. No mission in diplomatic history has been as well served: if it were not for their small dimensions and physical fragility, the sketchbooks in the Louvre would have long been recognised as a body of work as delicious as anything in French art. As it is, only a Stendhalian 'happy few' can work through them page by page; but Delacroix drew upon the données of the African journey for the rest of his career. (The last painting in the Centenary Exhibition was, in fact, an Arab scene dating from the year 1863.) Delacroix was changed for life – no other phrase will do – by what he saw between 25 January, when the party disembarked at Tangier, and 28 June, when they left Algiers for Toulon. Luckily for us, the letters give a remarkably full and characteristically lively account of his journey.

I shall not anticipate or foreshorten the effect of that account, beyond making one general point: that almost all great artists need a complete change of environment some time between the age of twenty and the age of thirty-five. It need not be a long one, in terms of time: Klee was only in Tunisia for a week or two. What is needed is the experience of a completely different scale of light. In Delacroix's case, this was combined with a different gamut of colour and – what mattered a great deal to him – a different gamut of human bearing. He was very sensitive to the way people carried themselves, both physically and morally. He had always loved exotic costume, but from the moment he landed in Tangier he savoured that costume in relation to a way of life which was quite outside European experience. He had

15

always thought of young women as playthings, or as toys to be dressed and undressed as the fancy took him: in North Africa he found that his fancy had been established as a principle of life, and that whereas in France it was only a rare enthusiast like his friend the singer Baroilhet who would masquerade in Turkish costume during the daytime, in Morocco life was one long spontaneous pageant.

He was sensitive, equally, to the nuances of landscape and architecture, to the deep 'fig-like blue-green' of the sea, to the sight of Arab horses fighting on the shore, and to the uninhibited excitements of the *fantasia*, in which armed horsemen by the hundred would come tearing at a gallop across the sanded ground. One after another, the fantasies on which his imagination had battened came to realisation: the women, the horses, the withdrawn, stately, white-robed men, and the landscape a-riot with colour. We know from Mornay that when Delacroix was admitted to a harem in Algiers he was so excited that he had to be calmed down with sorbets; and excitements no less intense, though more convenient in the mode of their expression, are recorded on page after page of the sketchbooks.

Delacroix found in North Africa that nature did not merely confirm, but actually ran far ahead of, the intimations which he had formed for himself in Europe. The revelation came at a particularly good moment, in that in the previous year or two his colour had become less adventurous: either an enveloping indoor darkness had dominated the scene, as in *The Murder of the Bishop of Liège*, or there had been a backward glance towards Géricault, as in *Liberty leading the People*. Now, in North Africa, he reverted instinctively to English water-colour techniques in an attempt to render the freshness, the intensity and the unmixed purity of his impressions. (At the end of the journey, when he gave M. de Mornay a present in souvenir of their joint travels, he chose not an oil-painting, as might have seemed appropriate, but a series of eighteen worked-up water-colours which he had done while in quarantine in Toulon.)

Had he been in any doubt as to the gulf which separated the North African world from that of his native country, the experience of quarantine would have convinced him: the stinking, louse-ridden lazaret was in supreme contrast to the sunlit cities in which Antiquity was reborn and even the humblest passer-by had stepped straight out of the Panathenaic procession. Those who on the evidence of *Liberty leading the People* see Delacroix as a thorough-going democrat should look up the letter of 7 July 1832 to Félix Feuillet, in which Delacroix pictures to himself Paris laid waste by civil strife and the arts reduced to 'the worst of occupations for those who practise them, and a feeble pastime for the others . . .'. Even in Paris he found it difficult to re-

16

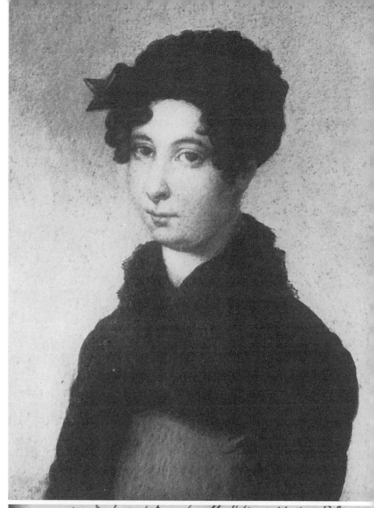

1a Portrait of
Elizabeth
Salter, c.1817

1b Draft of letter
to Elizabeth
Salter, c.1817

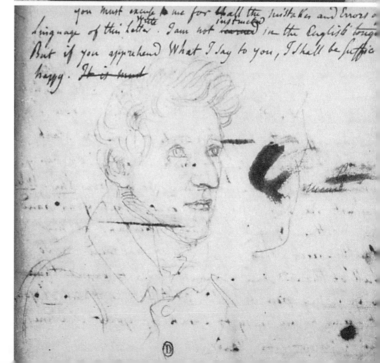

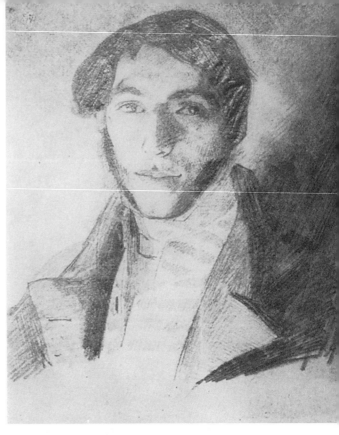

2a Félix Guille-
 mardet, c.1827

2b Delacroix and his
 friends on New
 Year's Eve, 1817

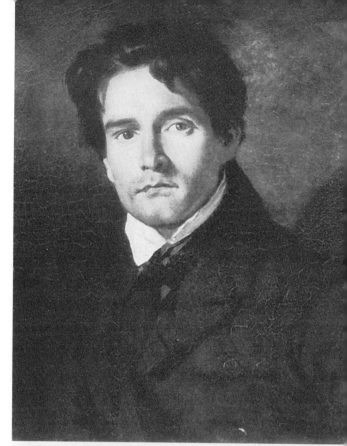

3a Léon Riesener, 1834

3b Frédéric Villot, c.1832

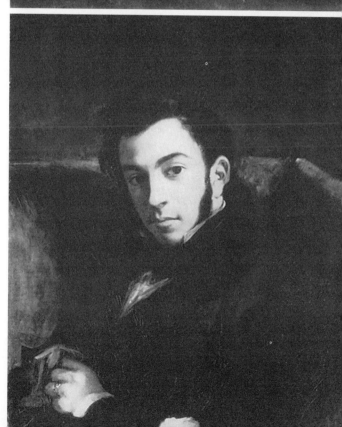

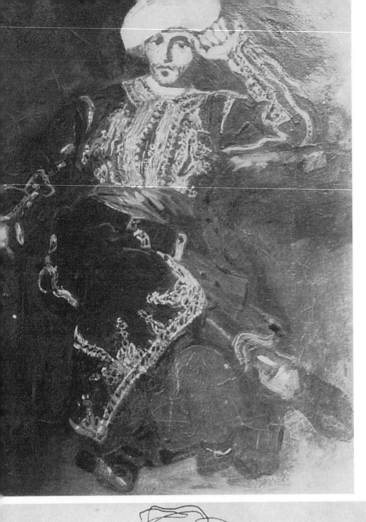

4a Pierret in
 Turkish costume,
 1825

4b Madame Pierret,
 c.1830

adjust: writing to Balzac to thank him for the gift of *Louis Lambert*, he could not help saying that a great book, like a great painting, could never be anything but a compromise between the quality and intensity of the germinal idea and the mitigated responses of the public. The artist was doomed never to realise himself fully: and this fatality weighed upon him all the more heavily at times when the whole current of life was against the tranquil enjoyment of great art.

Delacroix was obsessed, in short, by the feeling of paralysis and inanition which often follows an entirely successful journey. He was there, and yet not there: vividly awake, and yet anaesthetised. Over-stimulation of the kind which he had enjoyed for six months and more ends by throwing the system out of action. Back within his own walls, the traveller feels like a sick bear, cannot muster two ideas to rub together, looks out with horror on the familiar scene, and is convinced that he will wander for ever in an infertile *Zwischenwelt*. He once had methods of work, but cannot now return to them; as for the innumerable insights which elsewhere had flooded in on every hand, they turn out not to be transferable. This was Delacroix's situation in the last weeks of 1832, and the letters bring it painfully home to us. We know, but he must then have found it impossible to believe, that in the next fifteen years he would get through a prodigious amount of work; meanwhile his nature was not to be hurried, and he had to live through the period as best he could.

Where his work was concerned, any number of subjects cried out for enlargement: but how to effect that enlargement without losing the delicious transparency, the authentic lightness and the unforced animation of the sketchbook notes? He also had a new notion of the underlying purpose of art. Antiquity, to the artists of his generation, had been a matter of patient recreation from plaster casts. Delacroix himself, in his *Death of Cato* (1824), had shanghaied a formula from Rubens to give some kind of authority to what was, by his own standards, stiff and un-felt. But now, since his North African journey, he knew that it was possible to find Antiquity in everyday life. The lesson of the ancients, for Delacroix, was that they combined two qualities he admired: Responsibility, and Style. His Moroccans had Style without Responsibility; the rulers of France had Responsibility without Style. Delacroix saw it as one of his duties to prove that the two could still be combined; and he was to do it as much, over the next thirty years, in his life as in his work.

But he still had to get restarted. What he needed was a call to coordinated effort: a natural encyclopaedist, he had never had the chance to set down the full sweep of his ideas. His reputation had been made above all with paintings like *The Death of Sardanapalus*, in

which individualism is portrayed as having got completely out of hand, and there is no doubt that such pictures relate to fantasies which he was fortunately too timorous to act out in life. But his early career is also marked by subjects of a graver sort: the elaborate study, for instance, of Justinian the law-giver, which he painted in 1826 for the *Conseil d'État*. From the aptness of the historical parallel, and from the intense care which Delacroix took in all matters of historical detail, we realise that he saw himself as not only a painter but a moral preceptor: a man born to show others the right way.

He could have excelled as historian, statesman, preacher, judge, or far-famed headmaster. But as destiny had made him a painter, he would at least be, in his public capacity, a painter-moralist. If the State made calls on his work, he would show the State how states should be run. In private, at the easel, he could live out the fantasies with which his name is still most often associated; but if he were asked to serve as public orator, he would objectify those fantasies and turn them to universal intent.

All this might have remained in the sphere of hypothesis, with the Abbaye de Valmont as the only building that he ever had the chance to decorate. That it did not do so was owed to Adolphe Thiers. Thiers had backed Louis-Philippe from the start, and after the Revolution of 1830 he became one of the most important men in France: in 1832 he was made Minister of the Interior, and as such could commission works of art on the epic scale. Delacroix was at the top of his list, and in the spring of 1833 the period of inanition was ended once and for all by the offer of the Salon du Roi in the Palais-Bourbon. Thereafter, and until he was too ill to undertake anything more, Delacroix never lacked for a commission of this sort. If Thiers had had his way, Delacroix in 1837 would have been handed the entire Chambre des Députés to decorate as he pleased; but, even as it was, he went on from the Salon du Roi to decorate the library of the Palais-Bourbon, the library of the Palais du Luxembourg, the ceiling of the Galerie d'Apollon in the Louvre, and the Salon de la Paix in the Hôtel de Ville. This last was destroyed in the troubles of 1871, but the other four constitute a body of work which it would be difficult to equal, in any one city and by any one man, since the Renaissance. Delacroix also executed two church commissions: the *Pietà* for Saint-Denis du Saint-Sacrement, hard by the Musée Carnavalet, and the Chapelle des Anges in Saint-Sulpice, which was the last of his major works.

The big tasks suited him. Even in the last years of his life he would get up at dawn and go out, as soon as the light allowed, with an unbounded appetite for work. He was fascinated by the sheer physical task of covering a huge area; it stimulated him to cope with archi-

18

tectural environments which were often anything but ideal; little as he cared for politicians, it undoubtedly pleased him to think that his decorations would preside in perpetuity over the private moments of Deputy and Senator; above all, he saw it as a sacred responsibility to base his decorations on a valid philosophical scheme.

In undertaking his big decorative schemes, Delacroix from the very first condemned some of his finest inspirations to virtual invisibility. It was only with great difficulty, after the Salon du Roi was completed, that he secured permission for the public to be admitted to see the decorations in October and November 1836. Since then, and with the exception of a week or two in 1963, his centenary year, the paint might as well be on the moon for all that visitors to Paris can see them: and the same could be said of the two great libraries. Saint-Sulpice is open to everyone, but it is not every visitor who distinguishes the contribution of Delacroix from the contributions of Heim, Lafon, and Soldtz. The Galerie d'Apollon is one of the most splendid rooms in Europe, but our generation has lost the habit of looking up, and many people get more pleasure from the large working-sketch, which is now in Brussels, than they do from peering upwards at the final result. One of the greatest admirers of the Galerie d'Apollon was Henry James, who at the age of seventy described how he had been taken to see it as a child: 'the wondrous Galerie d'Apollon', as he remembered it, constituted a

> bridge over to Style, drawn out for me as a long but assured initiation and seeming to form, with its supreme coved ceiling and inordinately shining parquet, a prodigious tube or tunnel through which I inhaled little by little, that is again and again, a general sense of *glory*. The glory meant ever so many things at once, not only beauty and art and supreme design, but history and fame and power, the world in fine raised to the richest and noblest expression.

Delacroix would have been quite pleased, I think, with the terms of this; but he would certainly have wished his admirers to take more exact note of the scenarios. The decorations were meant to be *read*, not gaped at. It should not be taken for granted that, as in the Apollo ceiling, light would conquer darkness: the point was that it might not have done so, and that the serpent Python was an adversary to be reckoned with. That civilisation was a fragile thing and in constant danger: this was the message, and it was conveyed with the help of what Odilon Redon called 'moral colour'. Redon saw that Delacroix was using colour not so much to make an agreeable effect as to create zones of feeling: 'it becomes almost pointless to give each god his attribute when colour has taken over the task of saying everything . . .'. (Andrieu, who worked with Delacroix on the ceiling, remarked of his

19

palette at the time that 'nothing could be intense enough or brilliant enough'.)

In the Galerie d'Apollon he was set to complete an ensemble in which most of the other elements had been in place for nearly two hundred years. The 'general sense of *glory*' which so impressed Henry James had been initiated by Le Vau and Le Brun, and Delacroix's task was, in a plain sense, to go one better. In his other major secular commissions he himself set the pictorial pace, and he did so with the systematic gravity which was growing ever more predominant in his nature. He was a man who liked to know everything. But he was also a man who liked to establish a hierarchy among items of knowledge. He was an orderer and organiser of ideas. When, for instance, an astronomer called Borzebilocoquantius discovered a new star with his telescope, Delacroix noted merely that 'no telescope has been invented, as yet, to show the relations between objects'.

He never mentions Auguste Comte, either in his diary or in his surviving letters; but it is unlikely that a man as sensitive as he to the movement of ideas would not have known that Comte had in hand, between 1830 and 1842, a systematic review of man's relations with the universe. In his scenario for the library of the Palais-Bourbon, Delacroix ran parallel with Comte's Law of the Three States, in so far as he followed Comte's division of human ideas into the Theological, the Metaphysical, and the Positive. He also put on the wall a pictorial counterpart of Comte's 'Positivist Calendar': a choice, that is to say, among the great men of the past who had contributed to civilisation. The parallel was not exact: Delacroix envisaged five states instead of three, and in his choice of secular saints he did not venture even on to the threshold of the modern world. Where Comte, for instance, advanced both Gutenberg and Shakespeare to the front rank, Delacroix's Deputies were left meditating on the suicide of Seneca.

It was a sombre world-picture which he bequeathed to today's legislators. He was not the man to fob them off with vapid generalities. In the hemicycles which bring the decorations to a close he set out the alternatives before us: on the one hand, Orpheus; on the other, Attila. Civilisation could change the condition, and change the very nature, of mankind; but it could also be overrun at any time and from any quarter. Delacroix knew that he was living at a time when history hung on the hinge and could swing one way or the other. He was privileged to set up a warning-system in the sanctums of power; and to the best of his ability he did so. When Pliny the Elder turns in terror towards Vesuvius, the implication is that calamity can strike when we least expect it; and when Herodotus stands before the Wise

20

Men the scene has an awesome quality which does not derive only from its echoes of Masaccio.

Delacroix began these commissions at a stage in his life when he was already a master of easel-painting. But just as he never hesitated to pester his friends for exact historical information, so he tried continually to gather new strength from the art of the past. Borrowings or adaptations preoccupied him constantly as his fancy ranged from the frescoes at Fontainebleau to the metopes of the Parthenon, and from the Masaccio frescoes in S. Maria di Carmine to Pompeian painting and Goujon's Fontaine des Innocents. He lost no time, also, in joining the Société Française de la Photographie. He was without prejudices of any kind, where his range of expression was concerned.

He was not, of course, alone in feeling that it was a social duty, as much as a challenge to his invention, to give the public a synoptic view of history. Painters shared the general view that humanity had arrived at a high plateau, from which its previous activities could be estimated at their true value. Ingres in 1827 had given the lead with his *Apotheosis of Homer*, which was commissioned by the Comte de Forbin for a ceiling in the Louvre. Braque in the 1950s saw no reason to depart from his private imaginings in response to such a commission; but Ingres saw it as his duty to rattle through the annals of art and literature and pick a First Eleven (and a Second Eleven too, as it turned out). The grandeur of one or two of the individual portraits – Poussin and Molière, for instance – battles in vain, in the *Apotheosis*, against the august fatuity of the general idea. Delaroche in the École des Beaux-Arts and Chassériau in the Cour des Comptes foundered, alike as painters and as thinkers; and although Delacroix's friend Chenavard was a veritable geyser of good ideas he never managed to bring them to fulfilment. Delacroix alone could tackle such things and not be diminished.

It is in this context that we should follow the evolution of his correspondence. For there is a great difference in this context, between the effusions of first youth and the spare, considered letters of middle life, where there is rarely a word too many or a word that fails to tell. The Delacroix of the 1820s was a spontaneous, headlong communicator: a man who put in everything. By the mid-1830s the letters have quite another tone. Delacroix the diplomat and Delacroix the public figure join hands with Delacroix the man who had learned not to waste his time. He had also, meanwhile, acquired a new set of friends; and although he was not at all a man to condescend to his old friends on that account the correspondence takes on a new weight and a new variety with the arrival of George Sand, and Frédéric Villot, and Joséphine de Forget, among those to whom he disburdened

21

himself. In Villot, who later became Curator of Paintings in the Louvre, he found someone who knew the history of art ideally well: Delacroix could write to him quite freely, and with no kindly adjustments, when the problems of painting were on his mind. George Sand and Mme de Forget were the most enduring of his women friends, and in his letters to them we can sense both the inventive tenderness and the horror of any binding obligation which distinguished Delacroix throughout his life. Where the fleeting animal contacts of the 1820s survive only in pictorial form, the attachments of middle life have their memorial in the letters.

One of the rewards of reading the letters is, to my mind, the re-mystification of George Sand which results from a careful perusal of Delacroix's relations with her. George Sand wrote so much, and was so much talked about, and in general weighed so heavily on the awareness of her own time that later generations have never cared to dig away at the dead matter which surrounds her and see if there is something of real interest within. She has suffered, also, from the fact that every subsequent age has had a George Sand of its own. We none of us have to search very far before we hit on a gifted writer who thinks like a man, argues like a man, claims a man's privileges in her professional life and yet exacts, in the alcove, the homage owed to a beautiful woman. The name varies from generation to generation, but the basic elements remain the same: and they were apotheosised in the first instance by George Sand. Most of what she wrote is unreadable; her looks mean nothing to a later age; the emancipation which she fought for is now taken for granted; and although we know it for a historical fact that someone like Matthew Arnold went to Nohant with his heart in his mouth we cannot picture it to ourselves as we can picture, for instance, a call upon Colette. But when we read Delacroix's letters to her we notice at once his change of tone: it is as if, today, we came into the room during a telephone conversation and knew that someone quite special was at the other end of the line.

His feelings were returned.

Our relationship has no history [she wrote in her memoirs]. Two words are enough to describe it: an unclouded friendship. His character may have its imperfections. But I have lived with him in the depths of the country, day after day and week after week. We saw one another constantly. I could never fault him in even the smallest degree. And yet no one could have been less aloof, or more spontaneous. No one ever gave himself more completely in friendship. He was such a delightful companion that when one was with him one felt that one's own shortcomings no longer existed. To Delacroix

22

I owe what were beyond question the happiest hours that I ever spent with a fellow-artist. I have known other men of great intelligence, and on occasion they have talked to me, in the light of a shared ideal, about things that they had discovered or things that they had intensely enjoyed. But I have never met anyone comparable to Delacroix, or anyone so easy to understand when he set out to fire one's imagination. The masterpieces that we read, or look at, or listen to, come to us with redoubled force when we have at our side a man of genius who is willing to share his impressions with us. Delacroix gave of himself as freely and as authoritatively when music and poetry were being discussed as he did when painting was the topic of the moment, and there was never anything self-conscious about the spell which he exerted.

Delacroix first came to know George Sand in the winter of 1834-5, at the time when she was suffering intensely from the break in her relations with Alfred de Musset. Buloz, the editor of the *Revue des Deux Mondes*, had asked Delacroix to paint her portrait; and he at once endeared himself to her not merely by his gifts, and by his extreme sensibility, but by a fastidious discretion which was not often met with among her followers. People sponged on her without scruple – in the country, she often came down to find as many as twelve people sitting, uninvited, at her table – and she liked, in later years, to contrast the behaviour of Delacroix, who lived as frugally as was humanly possible and would never have dreamed of intruding himself. Delacroix was already a friend of Chopin at the time (December 1836) when Chopin met George Sand; and when Chopin and George Sand were living together in a pavilion at the bottom of the garden at No. 16, rue Pigalle, Delacroix developed the double friendship which was one of the richest, and where Chopin was concerned one of the most poignant, of his entire life. He was probably the only human being who meant as much to the one as to the other. Where Heine or Balzac came to the house primarily for George Sand, and Adam Mickiewicz or Marcelline Czartoryska came primarily for Chopin, Delacroix was prized by both of them equally. Perhaps he was never more completely happy than during the summers of 1842 and 1843, when he went to stay at Nohant and he, Chopin and George Sand were alone together; something of this happiness comes out in the letters.

George Sand's was an open and a confiding nature, and she was too practised a writer to muff, as we have seen, the chance of leaving a portrait of Delacroix that was as telling as his portraits of her. Altogether different was the character of Joséphine de Forget, who came into Delacroix's life in 1830 or thereabouts and remained in it, as an intimate friend, until the day of his death. Mme de Forget was

born Joséphine de Lavalette: her father had been Directeur des Postes under the Empire, and her mother, Joséphine de Beauharnais, was a niece of the Empress Joséphine. Delacroix was a distant relation of the Lavalettes. Mme de Forget would have been a figure of interest to him in any case – partly because of her links with the great days of the Empire, partly because she had conducted herself with superb courage and presence of mind when in 1815, as a girl of thirteen, she helped her father to escape from the Conciergerie. *Fidelio* itself has hardly a more thrilling *dénouement* than the scene in which Lavalette, dressed in his wife's clothes and feigning to weep into his wife's handkerchief, was guided out of the condemned cell by his little daughter. This is the kind of beginning which might make the rest of life seem flat; certainly her marriage in 1817 to the Baron de Forget was not a great success, although Forget had quite a distinguished career and was Préfet de l'Aude at the time of his accidental death in 1836. We know from David d'Angers' medallion of her that even in 1847 Mme de Forget was a strikingly beautiful woman. It was a composed, finely drawn, imperious kind of beauty: a very different thing from the animal good-nature of the models with whom Delacroix had once amused himself. In the 1830s, when she was living apart from her husband in all but an outward sense, Mme de Forget formed an attachment with Alfred-Auguste Cuvillier-Fleury, a friend of Delacroix who was acting as tutor to the Duc d'Aumale. Her self-command was to be tested when, after a year or two, she found herself to be pregnant; and it became matter for legend that on the very day in 1833 on which she gave birth to a baby girl she presided at an official dinner as if nothing had happened.

It would seem, from René Huyghe's biography,[1] that Delacroix 'was already paying court to *la bonne cousine* by May 1, 1830'. The fact that she instructed her executors to destroy the letters which she received from Delacroix between the years 1834 and 1844 is generally taken to mean that she was Delacroix's mistress during that time: as she was presumably occupied with Cuvillier-Fleury until 1833, and as she is believed to have taken another lover in the middle or late 1840s, this is a plausible hypothesis. It is, in any case, a misfortune for the rest of us that her instructions were carried out in full. Mme de Forget was a woman who kept her secrets to the last: in this, Delacroix had met his equal.

In other respects, also, Mme de Forget would have made him, in the world's terms, an ideal wife. She had the looks, the loyalty, the sense of style in all things; and she understood Delacroix completely. M. Huyghe quotes two letters which she wrote to him in 1844: their

[1] *Delacroix*, trans. Jonathan Griffin (Thames & Hudson, 1963)

24

ten-years' intimacy had not staled, but she had come to terms with the fact that he would never put her first. 'You devote yourself entirely to your painting,' she wrote: 'It is your strongest passion, your ruling one, and nothing and no one can replace it.' Delacroix's biographers have made her out to be a spoilt, worldly kind of person who preferred the amusements of Paris to life with Delacroix in the poky little suburban house which he had bought for himself at Champrosay. This seems to me an injustice: the truth is, rather, that Mme de Forget had a powerful streak of French realism. She knew that she would never get Delacroix to be her husband. This being so, and after having tried in every honourable way to make him change his mind, she saw no reason to abandon her own manner of life. 'I have come to realise,' she wrote, 'that you have no need of the comforts and solaces which serve for so many people; I have gone about it in a thousand ways and have not succeeded.' Anyone who believed, as she did, that 'a good understanding is the main constituent of happiness' was quite justified in making up her mind to go on as before, rather than to pine away to no purpose. Delacroix prized this side of her, and he would certainly not have written to her as he did on 16 August 1855 if he had not counted absolutely on her 'good understanding'. Their relationship may have been inconclusive, in a matrimonial sense, but it was a relationship of equals.

The 1830s were for Delacroix a period of change and evolution in many departments of life: and not least in his attitude to the Establishment. For a major painter of our own day to aspire to membership of the Institut would be unthinkable: but readers of the letters will have many a painful reminder of the fact that for twenty years (1837-57) Delacroix took time off from more rewarding activities to advance his candidature for the Institut. From the very first – Schnetz was the successful candidate in 1837 – he had to do with people vastly inferior to himself. The elaborate pantomime by which candidates had to canvass each member of the Institut in turn was as repugnant to him as to any other man of spirit. Yet he went applying, year by year, in the belief that a thing once begun must be carried through to a conclusion. One should remember, also, that throughout his life he was treated as a person of no account by precisely the kind of people who barred his way to the Institut. It became an obsession with him to beat them on their ground; and although the victory of 1857 occurred too late for him to profit by it he never regretted the long struggle.

The campaign for the Institut was only one of the ways in which Delacroix came to terms with the Establishment. He complained a great deal about the boredom and the inconvenience of official life;

but he went to the dinners, all the same, and he had the uniforms made with the utmost care and expense, and he wrote the letters and sat on the committees and paid the formal visits which were necessary. He was the last great French painter to think these things worth while; but he did them, as he did everything else, with a sovereign distinction. One of the duties of the painter-moralist was, as he saw it, to leave the world a better place: richer in works of art, to begin with, but also better organised and more equitable, with its ideas properly worked out and tabulated. It was in the interest of these adjustments that Delacroix lived a parallel life from the mid-1830s onwards: the private and the public self ran side by side, within signalling distance, but did not overlap.

Delacroix during the period of the major decorations might well have had no time or no energy for easel-painting. Complex and tedious organisational problems were involved in the great ceilings. It was a novel experience, and not always a happy one, for Delacroix to have to do with assistants. But in his ability to spread his energies without loss of quality he was nearer to Rubens, or to Tintoretto, or to G. B. Tiepolo, than to the short-winded masters of our own century. During the years in question he produced a continual stream of easel-paintings of the first order. Some of these are paintings that everyone knows: the *Women of Algiers*, for instance, in the Louvre. Others no less fine are in places where few seek them out: the *Christ on the Cross* of 1835, for example, which has been in Vannes ever since it left the Salon. There are cabinet-pictures which were made for a domestic setting and are still in private hands, like the *Odalisque* of 1847 in the David-Weill collection. There are late pictures like the *Amadis de Gaule delivering a young girl from the Château de Galpan* of 1860 which relate to romances of chivalry which Don Quixote himself would have thought outmoded; and there are paintings from the motif which could not be surpassed for their simplicity. When Théophile Silvestre writes to Bruyas, for example, that he looked at Delacroix's *Cliffs at Etretat* (1849) in the company of Corot, we can imagine that not even Corot could fault Delacroix in the matter of tonal control. Delacroix in his fifties and sixties could do anything; and he *did* do anything, much to the discomfiture of his biographers, who incline to trace his development stage by stage up till 1835 or thereabouts, and thereafter to fall back on eulogies of a general sort.

This is a very complicated question. In his life time Delacroix would never let any of his sketches or preliminary drawings out of the studio; but our present idea of his achievement is based, to an extent which would have dismayed him, on the hundreds and hundreds of such things which figured in the Vente Delacroix of 1864. The spontaneous,

26

impulsive, arrowy side of his nature is the one which comes up most often at the dealers' and in the sale-room; and now that the great exhibitions of the centenary-period are over we are unlikely for a long time to see the other, complementary side of his nature at full stretch anywhere but in the Louvre. Short of going to the museum in Toledo, Ohio, for instance, it is difficult to realise how very closely in his *Return of Christopher Columbus* (1839) Delacroix followed Titian's lead. And we should have to go to Tokyo to see, in the *Education of the Virgin* (1853), the finest of all Delacroix's landscape-backgrounds: the one, that is to say, in which he was able to direct the scene, as he wished, without losing the spontaneity of the thing actually experienced. The Louvre is stronger in Delacroix than in any other of the great French painters; but there are lacunae, even so, which can only be filled up in far places.

There is the difficulty, also, that Delacroix was not a painter who took an idea, got it out of his system, and went on to another. With Van Gogh we can point to the Nuenen period, the Arles period and the period at Auvers-sur-Oise, and it is very unlikely that one could be mistaken for either of the others. Few people would confuse a Cézanne painted at Pontoise with a Cézanne painted near Aix. A Seurat done in the Ile-de-France is a very different thing from a Seurat done at Gravelines. But Delacroix was by turns the last of the baroque decorators and an annexe of the English water-colour school. He was a pioneer of the impulsive oil-sketch, considered by us as a presentable, displayable work of art; but he was also a man who would carry an idea in his head for twenty years before setting it down. His genius was both public and private, direct and allusive, spontaneous and considered, epigrammatic and epical. He was the complete professional, who would repeat a painting to order twenty-four years after the first version was completed; he was also the man fifty years ahead of his time, who could paint the great *Lion Hunt* sketch in the spring of 1854 and leave it, untouched and unshown, in his studio. And he was all these people at one and the same time, or in an order which no one could predict.

It would be a great advertisement for this book if we could say that in the letters all these things sort themselves out. Certain subjects are missing from them, just as the list of correspondents is not, and never can be, ideally complete: Delacroix's letters to Mérimée were lost in a fire in 1871; the letters to Stendhal and Chenavard have vanished; and although we have a few brief notes from Delacroix to Chopin they do not convey anything like the depth and power and poignancy of the relationship. If Delacroix ever wrote to his English friends, the letters have not been recovered: we miss particularly, in this context,

an example of how he would have addressed himself to Bonington. And we cannot help wishing that Delacroix had kept up a correspondence with Baudelaire. But it is pointless to harbour such regrets: the point is, rather, that the letters of Delacroix as they exist today form a book that we can go back and back to for ever.

Delacroix in middle life did not make new and close friends easily, and the list of his correspondents does not vary very much after the 1830s. Even his colour-man, M. Haro, was a permanency. What he liked above all things was to get down to Champrosay, eat one meal a day, let his beard grow, undergo a voluntary *cure de silence* and turn his back on the rest of the world. (He had nothing but scorn for people who went to the country and felt bound to amuse themselves.) This was tiresome for those who would have liked to get them to their hideous dinner-parties, and even more tiresome for the ladies who would have liked to share his solitude, but it was providential for ourselves. For Delacroix revealed himself as freely in letters to his old friends as he did in the diaries. In those letters, as equally in oils on canvas, he was one of the great masters of tone: and of tone considered not as a matter of outward form but as the heart's inmost expression. In writing to his friends he had the feeling that he was saving something, and something intact and unflawed, from the wreckage of a life in which fundamentally we are all of us losers. '*Inexplicable vie*,' he wrote to Soulier in June 1843, '*abîme de tristesse et d'ennui quand on regarde par-dessus le bord*.' No sooner did he envisage a colony of tried friends who would live near to one another and see each other constantly, 'just as they do in Madame de Scudéry's novels', than he foresaw the disappointments to which such a venture would give rise. Letters were the thing – and, at certain times in his life, the only thing – that made human intercourse bearable.

So that, if we love the letters, it is for the privilege of intimacy which they confer upon us. Indispensable as they are to the biographer for the date on which Paul Huet made Delacroix a present of one of his etchings, or the fact, unrecorded elsewhere, that Flaubert once sent him a book, the letters have above all a conversational fascination. Now that both the man who wrote them and the people to whom they are addressed are dead, it is today's reader who has his name on the envelope: a great man speaks to us, directly and simply, and such is the spell of his personality that we involve ourselves in each letter, almost as completely as did the original recipient. We bless the turn of mind, and the physical predispositions, which led Delacroix to spend so much time on his own; for it is with us, after so many years, that he turns out to be spending it.

1970 JOHN RUSSELL

28

PART 1

Early Letters
1813 - 1824

ଙ୍ TO FÉLIX GUILLEMARDET[1]

[*Valmont*][2] 28 *September* 1813

... I have so much to tell you that I should never finish if I wanted to give you a detailed account of all that I've seen, all that I've done and all that I intend to do. But I must tell you about Valmont, for I have talked about nothing but the sea and that becomes very boring in the long run. I am sleeping in a room which is close to the old abbey church, for Valmont was once a Benedictine abbey. There are huge interminable passages. At the end of one of them, *right at the very end,* there is my room. Beside my door there is a little winding stair ... (beware, this is becoming like a novel) you go down that winding stair ... (I can see you trembling) and you find a little, very low door. You open the little door and you find yourself ... inside the church, which is partly ruined. In the middle of the church there is a crypt! In the crypt there is a staircase and all about there are ... monks buried in coffins of new lead. I hope that's enough to make your flesh creep. But there's more to come. In the neighbourhood there is ... no, I won't tell you, you wouldn't be able to sleep ... there is ... I am itching to tell you. ... If you're willing to sacrifice your sleep, I'll tell you that there is ... a lady who comes back at midnight and rushes wildly about the place. I'll tell you her story. I must admit that she hasn't yet come to tweak my feet but I am expecting her any minute. That is not all: there's a certain wood. ... Goodbye, my dear friend, that is enough for today. If you deign to answer me I'll give you further details. ...

<div align="right">Your friend,
Eugène</div>

ଙ୍ TO FÉLIX LOUVET[3]

10 *January* 1814

... Apart from the delight of seeing the sea – a very real one for me and one which I had not enjoyed for a long time – my hermitage at Valmont provided a host of pleasures which made up for those I thought I was missing when I left Paris. Moreover, I visited several towns which I did not yet know. Rouen, for instance, is a very large town, but it is poor in famous monuments. It is true that some of its churches, particularly the cathedral, by the boldness of their fine Gothic vaults

[1] Félix and his brother Louis Guillemardet were Delacroix's cousins. Their father Ferdinand Guillemardet was ambassador to Spain. See plate 2*a*.
[2] Delacroix, aged fifteen, was spending his holidays at the abbey of Valmont, owned by his cousin Augustin Bataille. He was not to return there until sixteen years later. See letter to Guillemardet, 2 November 1829, p. 157.
[3] Son of J.-B. Louvet de Couvrai (president of the Convention); a schoolfellow of Eugène's at the Lycée Impérial (Louis-le-Grand).

and the prodigious height of their towers, loaded outside and inside with a mass of those ornaments and arabesques which our forebears delighted to lavish, but which are not to be compared with the noble simplicity of Greek and Roman architecture, aroused a certain wonder in me. But a monument more worthy of attracting the attention of curious visitors is the humble cottage where the great Corneille was born. The inhabitants of Rouen are proud of it: I mean those who are somewhat above the common run, for the common people pass by this house without bothering their heads as to the meaning of the inscription engraved there in gold letters; and some day, some ignorant owner will have it pulled down, with equal unconcern. But still, I saw it, and this gave me real pleasure. . . .

We were at one of my cousin's, in a delightful estate. He had laid out his garden himself. The house is a former Benedictine abbey which, as you may well imagine, was in no small degree romantic. Great passages, so long that you could scarcely see to the end of them; narrow staircases where two could not go abreast, and above all the ancient church, half in ruins, in which were tombs, great Gothic windows with dim glass, and vaults in which stood the foundations of the abbey, all these things aroused in me a host of highly romantic ideas. At night the wind whistled through the ill-fitting casements and we were woken by owls which had found their way in through the church. But all these things, which many people might find disagreeable, were full of delight for me. I loved to walk by myself, day-dreaming, through the ruins of this silent church, whose walls echoed the very sound of my footsteps. I don't believe, however, that I should have found the same delight there by night, for not being very brave by nature, even though there was no danger to be feared, I should have felt little inclined to go there and meditate. But indeed I had company every evening; in a word, I was the happiest of men. . . .

৶ TO ACHILLE PIRON[1]

Paris [postmark 20 August 1815]

What a lot I should have to tell you, my dear fellow, if I had not lost my head, but unfortunately my old madness has come over me again, and you can easily guess why. What a moment that is when you see

[1] Achille Piron, one of Delacroix's oldest and most faithful friends, became his residuary legatee and wrote an important memoir of him, *Eugène Delacroix, sa vie et ses œuvres* (1865). He became an official in the Post Office and Eugène frequently made use of his services in sending letters to his friends.

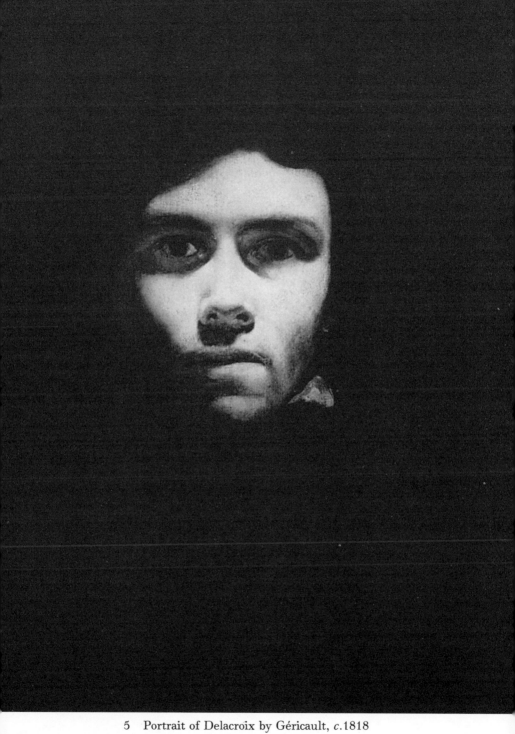

5 Portrait of Delacroix by Géricault, *c.*1818

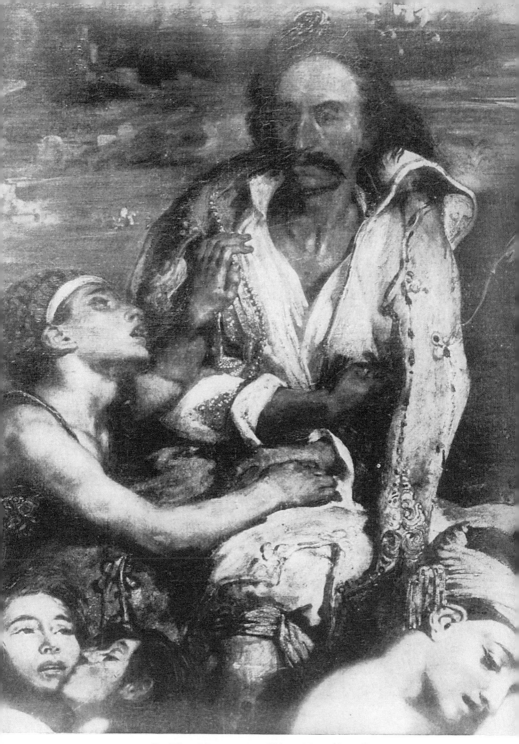

7 The Massacre at Chios, 1824 (detail)

once again, after centuries, somebody you thought you had loved[1] and who had almost completely vanished from your heart! In the midst of it all I am amazed when I think of my self-control yesterday, during that delicious and terrible moment when for a brief while I stood beside the one whom I had been base enough to forget. It often happens to me that a mental experience, of whatever sort, only affects me after the event, and when I am by myself or withdrawn into the seclusion of my own mind I feel the effect renewed all the more powerfully because the cause is removed. That is when my imagination gets to work and, unlike sight, it makes things seem larger the further away they are. I reproach myself for not having fully enjoyed the moment that chance had granted me; I build fantastic castles in the air, and go off roaming and wandering on the 'boundless and shoreless sea of illusions'. And so I became just as foolish as I had ever been. At the first moment my heart beat so wildly. . . . My head was reeling so that I was afraid of doing something crazy; I could not take a step without being aware that I was beside her, that our eyes were looking at the same objects and we were breathing the same air; when I had spoken to her and you dragged me off into the other room I think I could have beaten you, and yet I was not sorry, on the other hand, to leave her side, but I think that hell and all its demons could not have forced me to leave that blessed house while I knew my Julie was there. And then those black clothes, that pale, wan head, the vague chill that overcame me, the presence of death everywhere, those youthful charms and radiant beauty, that light lively foot stepping over the cold relics of a thousand generations and the dust of a few tyrants – so many feelings, so many things – a stronger head than mine could not have resisted, and, after all, why uproot from one's soul an emotion that fills it so perfectly and is so much in tune with my thoughts?

Little by little my senses settled down: we talked, we made a few jokes, this calmed me, but as soon as I had left you my mind and heart were entirely given up to the Petits-Augustins. Well, what do you expect? I am the craziest of fools; I don't care, I've got to see her, I'd give the devil to win her. You know more or less on what terms I am with her, yesterday she looked at me with a certain attentiveness and a frequency which convinced my vanity that she is not wholly indifferent to me, while from another point of view I interpret it as mere curiosity. You must give me your advice about it all as soon as possible, you must explain it all. I implore you, by all my affection for you, think of something, do your utmost, rack your brains as hard

[1] Another letter in similar vein headed, 'Tuesday, 21 August, 11 o'clock at night', bears a note by Piron: '1815. Eugène in love with Mlle de Villemessant. A childish love affair.'

as you can so as to find some way for me to see her, to speak to her, to write to her. Fine things I am saying, crazy nonsense. What should I say in a year's time, in a month's maybe if I were to see a wretched letter like this! But I am young and – no, I'm not in love yet; but it's for you to decide whether I am to be so or not. . . .

ꙮ TO ACHILLE PIRON

[Paris, postmark 11 November 1815]
Friday evening

I haven't seen you for centuries, my dear friend, I'm pining away so far from you and cursing the capricious fate which has stuck you in a remote district unfrequented by my noble self for the last few days, which accounts for my not having been to pay my respects to you. I dare hope you will deign to honour me with your visit on Sunday, particularly as it's important that we should consult together about the next day's expedition. My dear friend Monsieur —— is to come with me, and I should be heartbroken if Pantaloon weren't there. You know you are the faithful companion, the *fidus, fidissimus* Achates of my eminence, and that's why I should be deeply grieved if I had to do without my dear aide-de-camp on one of Talma's days.[1] I'm talking nonsense as usual, but that's a habit of mine. And then from time to time these crazy moods take possession of me, like drifts of smoke that fill your head and yet leave it empty. When I think of happiness, I foam at the mouth like all maniacs from those of the Old and New Testaments down to the possessed of Saint-Médard and their like.

Talent, talent, and a lot more things that are worth our talking about. I'm writing to you with a vile pen and an even worse head, for I'm seeing double and I'm mad enough for ten. I have projects; I should like to do something and . . . I see nothing clearly enough as yet. It is all a chaos, a glory-hole, a dunghill on which perhaps a few pearls may grow. Pray heaven that I may be a great man, and may heaven do the same to you. I wish you that with all my heart, and a good night into the bargain. Ortis, Talma, Poussin . . . ingots of pure genius, such men, my friends.

I love you with all my heart,

E. Delacroix

I shall be at home all morning, till three o'clock at least. I expect you.

[1] The actor.

✑ TO J.-B. PIERRET[1]

Wednesday evening, 11 *December*

[*postmark* 1817]

Come and see me, dear friend; you would give me great pleasure. It is a great pity that your evenings are taken up at Baour's:[2] but if you could spare me a brief one it would be very kind of you. I am in a very odd state. I do not know how it happens: I always seem to be on the staircase, and all day long I keep going down into the courtyard, then up again, then down again.[3] The sound of a certain door (you know which I mean) is constantly echoing in my ears and I often hear it when there is no sound at all. I open my door and go forth with a casual air, and then a bonneted face[4] emerges from that damned door that teases my ear-drums so. I hear the sound again. I dash forward like a madman; and I halt with my hand on the latch. I hesitate; I listen through the cracks and then open the door; I stick my nose out; I hear a rustle like a fairy's skirts; the upstairs door shuts again, and I've seen nothing. However, perseverance is a fine thing and it's not entirely fruitless. What an odd business it all is!

I don't want to make myself out an interesting case, implying that I've only one single idea in my head. I have others, but they always bring me back to the one that colours them all and that keeps me in a tenderly melting mood, now glowing, now shivering. I run through my days as if I were letting out a rope, grasping the knots one after the other. I seem to be waiting for something that never comes. When I read, the letters grow blurred. I put down my book and take hold of my head, closing my eyes, with my feet in the chimney corner; well, that is still not what I need; I get up and walk about, and take down my guitar, and there I am on the staircase with a guitar in my hand. And do you know, in the midst of it all I still do not admit myself vanquished. It's like drifting smoke which fascinates me for a moment; but I can see that all things considered, to be honest, it will last only as long as my excitement does. And anyhow, let's take a chance and snatch what we can! Frankly, too, it's worth it! Such pretty eyes! Limpid as fine pearls and soft as velvet. Forgive the simile, which is a

[1] Jean-Baptiste Pierret, Eugène's schoolfellow. See plate 4*a*.

[2] Baour-Lormian (1770-1854), Academician and second-rate poet. Pierret was his secretary.

[3] To meet Elizabeth Salter, his sister's English maid. See plate 1*a*.

[4] His sister Henriette de Verninac, with whom he was then living at 100 rue de l'Université.

silly one; but it's for lack of anything better. Her nose is a rather uncommon one; the nostrils are proudly curved, and dilate from time to time as her pupils widen and contract. Her mouth has a charming delicacy, but the chief glory of that head lies in its contour. The cheek, the little double chin, the way the whole thing is set on the neck is something to be worshipped. Oh, what a singular little woman it is! I do not know what to think. Come along, you old initiate, come and enlighten me about these mysteries. I had thought when I began that I should write a longer letter; but I'm cooling off, and in any case you'll probably lose nothing by waiting. Come tomorrow or the day after, that would be very nice of you. We'll have a delightful evening. You were to have written to me, you rascal, and you have done nothing of the sort. Oh, good heavens, I have no more room and I want to say a whole heap of things: above all, hide this; if my sister were to find and read this letter I don't know what I might not do. I will be expecting you, goodbye.

<div align="right">Your friend</div>

⤳ TO J.-B. PIERRET

Tuesday evening [*end December* 1817]

Oh! my dear friend, I've absolutely got to talk to you tonight, because I am full of news; so full that everything is in confusion within me and that I don't know what to say or where to begin. This evening, with the help of my dictionary, I made up a wretched letter[1] which will say things as best it can. I don't understand it too well myself and Heaven

[1] See plate 1b. Drafts of Eugène's letters in English to Elizabeth Salter have been published by John Russell, *Portfolio and Art News Annual*, No. 6 (1962), 74ff. Huyghe (pl. 67) reproduces a draft which, being written in the winter of 1817, might well be the letter referred to here (quoted in Catalogue to Arts Council, Delacroix Exhibition, 1964): 'I conceive you are wearied to see me in stairs to the face of the whole house, and I confess it not please me much. . . . Often when I go near the kitchen I hear your fits of laughing, and I laugh in no wise . . . I frame many purposes to see you easily but needless. . . . Oh my lips are arid, since had been cooled so deliciously. If my mouth could be so nimble to pronounce your linguage, as to savour so great sweetness, I not should be so wearied when I endeavour to speak or to write you. . . . You will not omit, you will tell me Sunday a thing which interest me. I am sure you laugh at it and you prepare to amuse me with trifflings. You are a cruel person which play afflicting the anothers. Nevertheless not be angry at it; I am a pitiful Englishman and I bet I have told in this write a multitude of impertinence. It must therefore pardon me in consideration of my good intentions. Thought of me.
'I will go out this evening. Prithee come a few. I hope God will remove our enemies. I beg him for that. My whisker not sting more.' (Louvre sketchbook, RF 9146, fol. 22-3.)

knows if somebody else will understand it; my soul was in suspense, torn between listening and the wish to say something that made sense. At nine o'clock I heard my signal, and in four bounds I was upstairs. There I found you know who, waiting faithfully as her delightful custom is. Today my blood was on fire more than usual, and she seemed to me ten times more desirable. A moment later my Argus[1] in a greasy apron decided to go out in search of some forcemeat or sausage meat for the *daube* she was stuffing. A matter of moment for her; a fine opportunity for us. Click! I bolted the door and there we were by ourselves, at night, on one chair, with our knees touching and soon with our knees interlocked. O God: I had never felt my heart throb so violently. Yorick bent his head on Eliza's bosom, Yorick seized Eliza by her slender waist and drew her close to his lips. God, why didn't I write to you immediately after that: where has my ardour gone, where is my indignation? But one moment! Stop, what are you imagining? Perhaps I have let you suppose that I had attained my goal. Alas, in the midst of my physical and moral tension, just as shameless desires were raising their heads and giving my soul the courage of a demi-god, there was a knock on the door . . . to hell with the knocker! and I kissed her other cheek: the knocking was renewed . . . I stopped, we listened to one another, and both, panting and breathless, listened to the silence, as the poet says, and I could hear nothing but the throbbing of my own heart. Protector of virtue! it was my sister. . . . The latch was lifted, and my discomfited beauty was veiled with blushes. Coldly irritated, my sister made her entrance, looking cross enough to have frightened away the small boys in the street; she was interested only in her *daube*, and had come in search of her cook. She was annoyed, and perhaps she had good reason to be. For indeed, one feels pretty foolish waiting behind the closed door of a room where people are making love: but devil take it, love-making must go on in spite of spoilsports. What else can I tell you? I was furious, and I'd have blasted the house if I'd had a thunderbolt at my disposal. Fortunately, the flood has subsided, and I shall now subside too, into my own bed, somewhat calmer than I was an hour ago. Now, while my head is full of my encounter and my feelings are still warm, I am going to make a fair copy of my uncouth, distraught letter. Goodbye then and goodnight, love your Fanchette well and love your friend. It's all over: till Friday then, thine for life, amen, amen.

<div align="right">Yorick</div>

[1] Henriette.

The Foresters' Lodge, Forest of Boixe[1]
September 1818

I'm writing to you, my dear fellow, with my backside still aching from a journey on horseback which I made yesterday to Angoulême, with the wind blowing full gale against me all the way there and a downpour of rain all the way back. This morning, as the weather is still bad, there is no shooting or walking, and what is to be done while one is sheltering? I have decided to write to you, not because the rain forces me to do so, but because I simply must write to you or else you'll think I'm dead, and it's not easy to keep that sort of promise here. I've settled down to it a score of times without being able to bring myself to begin. Don't imagine I am forgetting you, my dear Félix, but I have so many distractions here myself that I'm good for nothing. I spend part of my time game-shooting; a few exploits in this field have gone to my head. I've also done some pistol-shooting, in short if I stay here much longer I shall probably become an insolent swashbuckler whom you would insult at your peril. I think I remember your saying that you planned to go to riding school during these holidays. That's all to the good, too: we shall be preparing for our holidays at Ermenonville and Montmorency, which are still a long way off. It seems to me, since leaving Paris, that nobody ought to go on living there: that's what makes me ask you how you're getting on there at this moment. Just as usual, probably. But I find things so different here! Living in a house built in the middle of an enormous forest, hearing very little noise by day and none at all by night; with horses, goats, chickens and dogs, hares, partridges, thrushes and fledgling birds; wolves howling at one end of the forest and answering one another with long-drawn-out lamentable howls from the other; going for walks of over a league without leaving one's home ground, these are things you rarely find in Paris. The forest is as green as if the leaves had just grown, for the oaks (*les cheignes* as they call them here) retain their green leaves throughout the winter, right until the new ones come to oust them. Incidentally, not much painting here. For one thing our trunks, which were to have come in ten days, have still not arrived, and for another I'm too lazy to do much, in spite of the lovely views I find hereabouts. I hope that when I begin to find life

[1] A family property near Mansle (Charente), where Eugène spent his holidays until 1820. Originally bought by his mother as guarantee for a debt of her late husband's, it remained unsold and heavily mortgaged on her death; in 1818 her son-in-law, Raymond de Verninac, took it over. He died in 1823 and the property was eventually sold at a loss, after ruinous lawsuits and much family bitterness.

monotonous here, which is liable to happen everywhere, I shall then envisage with some pleasure the prospect of returning to Paris. In any case, there is one thing that one always feels the lack of when one leaves it behind anywhere, and that is friendship. I feel as if it were a year since I last saw you. We've often been a long time without seeing one another; you yourself, in Paris, may have gone weeks without seeing Pierret, but since you're breathing the same air, it's almost as if you were seeing him. You feel close to your friends because you know that by walking a few steps you can be together. Now, on the contrary, I'm trying to recall your features. Yesterday evening while the rain was beating down on me and I was trotting drearily along the high road, I said to myself in a fit of reverie: Where are they now? Perhaps at table, perhaps queuing for the theatre and talking of their absent friend. For a few moments there was a magnificent sky which I admired with delight, and I thought perhaps you were doing the same thing. The time will soon come when we can gaze at it together. But truly, I cannot think without a pang of the long years I shall spend in Italy,[1] far from all those who may take an interest in me. It's a cruel thing that in this sad world one cannot enjoy any happiness without, by contrast, experiencing some painful feeling. In this way one spends the whole of one's life possessing nothing completely, and in perpetual pursuit of a stability which is beyond man's reach. I think the happiest man is he whose soul is well filled and whose mind is occupied. The soul indeed is forever reaching out, unsatisfied, longing for objects as boundless as itself: but its enjoyments are all the sweeter. . . .

Your friend for life,
Eugène Delacroix

&3 TO J.-B. PIERRET

The Foresters' Lodge, Forest of Boixe
18 *September* 1818

There's nothing easier, my dear friend, than to promise to write, and there's nothing more difficult than to write. I have been living a life of idleness since I came here a fortnight ago, and yet I've not found a moment to send you news of myself or to ask for news of you. I seem to be living here in a land unknown to the rest of the earth, where there are neither calendars nor clocks, and where I forget my own existence. You can imagine the sort of life I lead from the house

[1] He was planning to compete for the *Prix de Rome*. All his life he dreamed of visiting Italy but, for various reasons, never went there.

and its situation. Here I am, practically in the middle of a forest 4,400 *journaux*[1] wide, at the intersection of two avenues about thirty feet broad, one of which runs straight for a couple of leagues or more, as we should reckon them around Paris. It's in this spot, which is known locally as *La Croisée*, that you discover, when you're right on top of it, a white house with green shutters, lacking an upper storey, so that it consists only of a ground floor. From outside, it is less impressive than certain houses in the region, but inside it is as comfortably and even as elegantly fitted out as a Paris house, which again distinguishes it from the dwellings of the rich folk hereabouts. These are no better than huge hen-houses, with wallpaper fit for taverns on the drawing-room walls and none on any other walls, great lopsided beams in the ceilings and broken-down floorboards under your feet; which makes our house an object of envy for all our neighbours, that's to say the people who live two or three leagues away. I rise very early; sometimes with the sun. I go out sometimes by myself, sometimes with a companion: but always with a dog and a good gun which I'm hardly ever without. I walk for three or four hours without stopping, burning plenty of gunpowder and tearing my clothes as I pursue my quarry through thickets and along green glades. I enjoy game-shooting immensely. When I hear the dog bark, my heart throbs violently and I run after my timid prey, with the ardour of a warrior storming palisades and rushing to the slaughter. I am not dissatisfied with my efforts, and I should never have believed myself capable of brilliant prowess in the chase; I have already shot two fine partridges on the wing, not to mention smaller birds; and you must know that it is very difficult to shoot a bird on the wing, particularly for a novice. The gamekeepers praise what they call my fine shots, and say I show great promise. If you have never yet shot any partridge, let me tell you that's one of the pleasures of life you still have to experience. At the mere sight of a small bird falling one has the same sense of excitement and triumph as a man who has just discovered that his mistress loves him.

At the moment of writing this I can't help feeling a reaction which brings me back to other ideas which often fill my heart. And it brings me back to talking to you not about all the things I'm doing here, which are not likely to interest you: but about yourself, and the friendship between us, and the feelings which each of us has, independent of our friendship, but which mutual trust has made common to us both. Whatever pleasure may be found in a new and active way of life, it cannot blot out the memory of the bonds of affection formed elsewhere in earlier days. We retain throughout life only the remembrance of

[1] A *journal* is as much land as can be ploughed in a day.

feelings that have touched us deeply; everything else is even less than what is past, for nothing colours it in one's imagination. With what joy do I remember those precious conversations in which we poured out our hearts to one another; with what delight shall I embrace you when I return, you, my good friend, who have listened to the tale of all my follies. And how frigid the beginning of this letter will seem to you. In the midst of the activities that distract me, when I remember a few lines of poetry, when I recall some sublime painting, my spirit is roused to indignation and spurns the vain sustenance of the common herd. And in the same way, when I think of those I love, my soul clings eagerly to the elusive trace of these cherished ideas. Yes, I am sure of it, great friendship is like great genius, and the remembrance of a great and enduring friendship is like that of great works of genius. . . . What a life would be that of two great poets who loved each other as we do! That would be too great for human kind. Do you remember a certain conversation we had a few days before I left? I told you that either friend must feel aware of his rightful share in his friend's affection. I tell you so again, and I am very anxious that you should feel sure of yours. . . . May the winter evenings come quickly, when we can forget our cares by a warm fireside, and that New Year's Eve when each year we renew our brotherly vows.[1] Goodbye, my dearest friend, I'm leaving you to go to dinner; that's very wrong of me no doubt, but as one cannot live without dining and cannot love without living, I'm going to dinner.

ᥱ TO J.-B. PIERRET

At the Foresters' Lodge
23 *October* 1818

I only received your letter yesterday evening. It was a long time since any messenger had been sent to Mansle to fetch mail, and I, being conscious only of your silence, felt that this letter was taking a very long time to come. What a selfish friend I was! I was forgetting how long you had had to wait for a paltry letter from myself, full of insipid details, and in my eager impatience I had begun another to request an answer from you. Now I have it. When the messenger came back from the post I was told I had four letters, and I immediately glanced over the addresses. But I did not see your writing. Put yourself in my place for a moment and imagine my feelings. I unsealed them all

[1] The friends celebrated New Year's Eve, the feast of Saint-Sylvestre, at one another's house in turn, and commemorated the occasion by drawing in an album which is preserved in the Louvre. See plate 2*b*.

and when I came to yours, I felt my heart give a mighty leap. I stared at it before beginning, like a young cat playing with its prey. I gazed with rapture at that beloved handwriting, which grew more and more close-packed as it went on, like all letters between people who are fond of one another. As I read I kept glancing at what was still left for me to enjoy, and I had to go back to the beginning of each paragraph, for my eyes were blurred every time I began something and my mind could make out nothing of what still remained to be read. What a crazy fellow you are! Your heart, which always speaks louder than your intelligence, misleads that simple sound intelligence. Your letter is an eloquent one, for as Jesus Christ says, out of the fullness of the heart the mouth speaks; and your heart was full, I'm sure of it, as mine is when I write to you. But beware of letting that heart deceive you. On reading certain lines in your letter I could not help feeling an affectionate indignation; and there's only enough of that left to give you an affectionate scolding: my poor friend, you don't know me better than you know yourself, or else I am far from knowing myself completely. Between us two, surely, there can be no room for any sort of pretence about those promptings of vanity to which, as you well remember, I have often been subject, but which have never lasted long. This is not to say that I don't believe myself capable of something, and what I am writing to you here, I don't want to tell anyone else; but it is so confused a mystery that you are as yet the only one to have an inkling of it, I am sure, and that because I have sometimes been vain enough to talk to you about myself. But it's a far cry from childish dreams to that golden bough which only Nature's favourites are privileged to pluck; and even as I write these lines I seem to myself so ridiculous that I want to destroy them and forget them and even to forget all those passages in your letter that arouse such ideas in my mind.

Imagine your letter being found by somebody I know,[1] what shouts of pitying laughter there'd be! But, my friend, I'm distressing you now, without a doubt; for since I am convinced you love me, the mere idea of your friend being laughed at must shock you, as it would me; to such good friends as we are, what does genius matter? If we have it, we'll be lucky if we remain ignorant of it until others' envy makes us conscious of it. For a man who is sensitive to nature, happiness consists in expressing nature. How infinitely happy, then, is the man who reflects nature like a mirror without being aware of it, who does the thing for love of it and not from any pretensions to take first place. This noble unselfconsciousness is what we find in all truly great men, in the founders of the arts. I picture the great Poussin, in his

[1] Henriette de Verninac.

42

retreat, delighting in the study of the human heart, surrounded by masterpieces of Classical art and caring little about Richelieu's academies and pensions.[1] I picture Raphael in the arms of his mistress, turning from La Fornarina to paint his Saint Cecilia, creating his sublime pictures and compositions as others breathe and speak, moved by an easy, effortless inspiration. O my friend, when I think of these great models I am only too well aware that I am far not only from their divine spirit, but even from their modest simplicity. Teach me to stifle ambitious impulses, and when I have the joy of seeing you once more, keep me on the firm and humble path I have traced out for myself. I cannot think about seeing you again without delight. We'll tell one another many infinitely precious secrets. The whole of your letter was not like the items I mentioned earlier. Oh, what a good letter it was! How well you know how to arouse my interest! I think of her[2] constantly. A year has passed since I knew her. I think of her almost every night. In this very bitterness there is so much sweetness that I delight in tormenting myself by turning over her image in my mind in a thousand different ways. What should I be without those long winter evenings when I braved the cold so happily for hours for the sake of one or two minutes' happiness! What can be compared with that delicious anticipation in the dark night, with that furtive encounter that vanishes in an instant, leaving one mutely straining to gaze after what can no longer be seen? And yet what is one to believe? How unfathomable are those charming hearts! When I went home after spending a pleasant evening with you, I was already making my plans, calculating all possibilities, summing up all the chances I should have of saying two or three words that evening, always the same words, and often nothing at all; for as often as not I could think of nothing to say except to keep on asking for what I always had to take. You're right, the pain of losing such joys is too sharp. When I think of that last letter, that last farewell she bade me, and at the same time of that last interview so lingeringly sealed, and the days that followed our parting, I toss about in bed like a man in a fever, not knowing on what side to sleep. And yet even as I write this I begin to wonder if I do, in fact, think about her. I believe this feeling is an illusion, like the dreams I often have. I don't want it to be, however: for I love my dreams, but where will they lead me? This winter we must see a great deal of one another and read some good books. I'm quite surprised to find myself weeping over Latin. Reading the classics renews one's strength and moves one's feelings; they are

[1] Cardinal Richelieu founded the French Academy in 1635.
[2] Elizabeth Salter.

43

so true, so pure, so close to one's own thoughts![1] . . . Every evening and every morning I re-read your letter and I think of such affectionate things to say in reply, so full of gratitude for all your kind thoughts. Unfortunately when I come to write I forget them all. Whatever people say, when one is full of a feeling one is ill fitted to express it, to convey it vividly; at least as far as feelings of friendship or love are concerned. When I want to talk to you about these two I can think of nothing but everlasting commonplaces. On reading over again the third page of my letter I said to myself: How can you possibly speak so foolishly and so coldly about a thing that stirs you so strongly when you look into your heart? Moreover I believe that this emotion is so strong that the most eloquent man on earth has never said all that he felt; that this emotion holds treasures of private delight for the man who experiences it, which he will never be able to reflect in the minds of other people. I know that I have read in Rousseau the description of a love superior to all others, and I also know that at the same time I, who lack Rousseau's fire and fervour, I who had not at that time felt the passion of Saint-Preux,[2] I found within myself something more potent than all those ardent lines. Perhaps such things are incompatible with the labour of a writer, who files and polishes his period for the printer. Try, you who are a man of feeling, to express the emotions you have most powerfully experienced, you will either think you are expressing the feelings of someone other than yourself, or you will lose, in your heart's memory, even the fugitive traces of your own feeling. . . .

ᴄᴊ ᴛᴏ Fᴇ́ʟɪx Gᴜɪʟʟᴇᴍᴀʀᴅᴇᴛ

[*Forest of Boixe*] 23 *October* 1818

. . . The time for our departure is drawing near. And yet as this is only talked about vaguely, our stay may well be prolonged for some little time more, and but for the vision of that relentless sickleman who never lets go of his prey, and of business at the law courts awaiting my brother-in-law, we should be enjoying the last fine days of the year. Apart from a few wet days the weather has been delightful and too fine, I confess to my shame, for I ought to have taken advantage of it not to let those wretched paints dry up completely, which I brought somewhat uselessly from Paris. There are still some fine beeches with all their greenery, sturdy oaks in their full summer dress, wooded irregular hillsides, clear springs rising among grasses and plants of every sort and shape: all this pricks my conscience painfully,

[1] He translates and discusses a passage from Virgil, *Eclogue* X.
[2] Hero of Rousseau's *Nouvelle Héloïse*.

coming to life in order to reproach me for my idleness; laurels and heath speak to me, as in an eclogue, and despite all these marvels my palette dries up, my paint brushes are like drum-sticks and my oil has turned to gelatine. So if you ask me what I'm doing: I'm doing nothing. I come and go, and then come back. The day goes by so fast, one's rising is so naturally followed by breakfast, which leads inevitably and just as swiftly to dinner, like the leaves of the forest, like the waves of the sea. What's to do after dinner? A little stroll, as before, and then to bed. And then invitations to shooting-parties and dinner-parties. And what dinners! Twelve side dishes, as many *hors-d'œuvres*, two great tureens of thick soup, jugs of water, five or six roasts, a typically provincial profusion: hares, pikes as long as a table, and a table to seat twelve at which twenty-five are crowded, and covered with dishes. This gives a rough picture of the way dinner is served in these parts; and if you add the presence of the curé who, in order to keep up the conversation, is obliged to cut up and devour his food like an ogre, you may get some slight idea of it.

If only I could transport Paris to within ten leagues of the Forest of Boixe, I should have nothing left to wish for. What an inconstant creature man is. I think of the Louvre in Paris and I picture my delight at going back there, at going there with you, at asking for news of what has been done in painting and literature during my absence. I think of our nice, delicious winter evenings when we talk nonsense by the fireside, over a glass of Dantzig anisette. That's the time when each of us grows expansive and pours out his heart to his friend, revealing his secret griefs and hopes. I left you fancy-free and clear-headed. Shall I find, on my return, that some sweet change has taken place? Ah, beware of that sweet poison, turn away from that potion, sooner or later it means swallowing bitterness: sooner or later come vain regrets and even vainer hopes that torment and enfeeble you. How much better to have no other concern than chatting with one's friends; reading Horace by the fireside and enjoying one's duties and occupations. Horace, by the way, is in my opinion the soul's finest doctor, the one who best helps you to recover, who makes you fondest of life in certain circumstances and best teaches you, in others, how to despise it. I have been doing some Latin during this vacation and although I told you earlier that I was just an idler, I must at least claim an exception in this respect. I'm indulging in the notion that we might study some together sometimes this winter. I can't vouch for it though, for far from carrying out all the plans I've made, such as this one, I should find it hard even to draw up a list of them. I am expecting from you and Monsieur a learned description of the paintings you tell me you have seen. He also promises me in his letter to tell

me about the annual meeting of the *Beaux-Arts*, which is always interesting: I am eager to know if I shall have to discuss some other speech by some other amphibious creature, one I mean who is both painter, poet, logician and orator. . . .

↵ TO ACHILLE PIRON

The Foresters' Lodge
23 *October* 1818

. . . The time is drawing near for my return to Paris. No more shooting-parties, no more guns then. But to make up for that I shall see my friends again, of whom you are one of the dearest. I always remember with pleasure our swimming parties and our music. I imagine you won't have neglected the latter during my absence and that I shall enjoy the progress you'll have made. Why can't I play the cello or the piano: not that I have taken a dislike to my beloved guitar, but it is inadequate to accompany the flute. Its good qualities make no impression and only the bad ones are felt. As time goes on I hope to acquire some greater proficiency in music and then what a concert we shall have, what an upheaval we shall cause among the cats in the rue de l'Université or the rue Simon-le-Franc. . . .

↵ TO J.-B. PIERRET

6 *November* 1818

You sent me so short a letter that I could not believe it was from you, and this time you really are, as you say yourself, my insolvent debtor, or rather in arrears: but unfortunately you will not be able to repay me with those letters of yours which give me so much pleasure: for my departure is very close. I cannot fix a date: but I hope before long to make up, by the sight of you, for the share of joy you have withheld from me by writing so little. . . .

What pleasures do you imagine I have come here to enjoy? What do you suppose I do when I want to spend delicious moments? I withdraw into myself; I forget all that surrounds me, I think of you, of all that I still hold dear on the earth. Tears spring to my eyes when I think of my loneliness, and on the other hand of all those who have shown some fondness for me. I am only happy, completely happy when I am with a friend. The hours I spend with my friend are my treasure: they are the only hours that endure in my memory; they are my red-letter days and my true wealth. This is not an illusion; this is no

exaggeration; all is empty around me without the presence of the one I love, and I tell you in all sincerity, I think myself all the happier while I enjoy that presence for deeming myself unworthy to inspire affectionate interest. Why do you love me? Why do you involve yourself with my fate? You must have felt, as I have, that any man who has a soul needs to fill it with something other than all the things that charm the common herd of men, and which are of less worth than the faintest shadow of a feeling. I have never loved the crowd, nor all that the crowd feeds on, and I think I shall love you the more for that, you who have chosen me. Our friendship is no ordinary friendship: it is true and lively. It did not begin with fine words or with ridiculous and splendid projects based on something other than itself. We never made one another those protestations which prove nothing but the desire to show off, and which show nothing at all. I have never said to you: my friend to all eternity! And yet every time we have seen one another something has told us that it could not be otherwise: we had to be true friends. That's how things are between us. It happens too that in my daydreams I think of a time which I certainly long for: the time of my visit to Rome.[1] I say to myself then: I have been unable to endure my dear friend's absence for a couple of months without distress, and how many years shall I have to spend longing for a sight of him, satisfying myself with his letters and the mere remembrance of him? Ah, I shall feel then, when I am in that city, that treasure-house of delights, far from all those I love, as I often feel in the shooting-parties which I sometimes take part in here. I am assigned my post: I am told, the hare is going to run past you, keep on your guard: and then I forget all about my hare: my gun, a cumbersome burden for a daydreamer, slips down and I lean nonchalantly on it, my mind very far away, I promise you, from the wretched hare, whom I see them all pursuing with somewhat ridiculous seriousness. So I shall not have you by my side to admire the *Loggie*[2] and all the rest of lovely Rome: where will you be? Oh, let's talk of something different. It would make me feel too anxious, too remorseful: we shall have plenty of opportunities to talk of it. . . .

I'm already thinking of the pleasure I shall have in fulfilling my annual debt in your album:[3] you, perhaps, are thinking only of the prodigious time I kept you waiting for it last year. If it can give you the slightest pleasure for me to scribble something in it, choose me beforehand – I insist on this – a good number of subjects, from which

[1] Evidently Eugène was thinking of the *Prix de Rome*.
[2] Raphael's *Loggie* in the Vatican.
[3] The New Year's Eve album.

we can pick out something together: but the sort of subjects I like: come on, rack your brains: you must do it, I beseech you to.

Adiou, adiou, adiou [sic]. I end with these words, which I still love.

Eugène

I see from the *Minerve*[1] that your friend Baour's[2] work is about to appear. I'm longing to know whether he's going to let you enjoy part of his glory and his profit in the form of a shower of solid gold napoleons. You've surely earned that, with your copy of the book into the bargain, and I mean an illustrated copy, on glossy paper. I'm looking forward, too, to making the acquaintance of that new embryo they call *Le Conservateur*,[3] which so far exists only in a prospectus and possibly one or two issues. We'll have a look at all this.

I should be very glad, too – how I run on! – if this year we could once again attend the opening of Cousin's[4] course, which I imagine has not yet begun.

✠ TO CHARLES SOULIER[5]

Place Vendôme, Paris [in English]
10 *December* 1818

Dear Friend,

I am very displeased to cannot to go Saturday to pass the night in your pleasant company; for I have promised another person to see her

[1] *La Minerve française* (1818-20), a short-lived periodical of advanced Liberal views, edited by Constant and others, suppressed when the censorship was re-established following the assassination of the duc de Berry.

[2] As Baour-Lormian's secretary Pierret helped with the revised version of his translation of Tasso's *Gerusalemme Liberata*, which appeared in 1819.

[3] *Le Conservateur*, an ultra (right-wing) periodical produced in opposition to *La Minerve*, but equally short-lived.

[4] Victor Cousin (1792-1867) taught modern philosophy at the Sorbonne from 1815 to 1820.

[5] Charles Soulier was brought up in England, where his father was an *émigré*. He taught Eugène English and introduced him to English painting, and to water-colour. Soulier copied out the seventy-two letters written to him by Delacroix between 1818 and 1862; this, the first, is accompanied by the following note. 'This letter must be the first written me by Delacroix. We first met in 1816; I was painting in water-colour, and he was very anxious to learn this art, which at the time was hardly practised in France; and I was fresh from the hands of my friend Copley Fielding, who later distinguished himself in this branch of art, in which he was almost unrivalled. I had already travelled and drawn a great deal and I gave English lessons to M. Andrieux, of the Académie Française . . . two or three evenings a week. . . . My other evenings were devoted to entertaining a few young men in my humble attic in the Place Vendôme, at the Hôtel du Domaine Extraordinaire where I was . . . secretary to the Intendant, the Marquis de la Maisonfort. Horace Raisson was in the same office and it was he who brought along Eugène Delacroix,

48

that day; it is not, as you shall imagine as M. Horace[1] also, without a great disappointment. But I hope it will not be the last time, we shall have the opportunity of come together. I thank you at your Italian-english-french and grateful letter. I conjure you to excuse my bad english language. I dare a little time past with your obligeant lessons, I will better speak and write in that fair tongue, in which I am so desiderous to be readily instructed. Should M. Raisson have the complaisance to go on Saturday in the morning at M. Guérin's house,[2] or Sunday Morning at my own, likewise in the morning, we could together so resolve in what day we can to begin our undertaking of *colorage*, which I wish to see quickly termined.

Your sincere friend and thankful disciple,

Eugène Delacroix

ᴊ TO J.-B. PIERRET

Monday, 6 September
[*postmark Mansle, 10 September* 1819]

My dear friend,

We arrived here on Sunday morning, very weary after the worst journey imaginable. When we left, the sky was grey and lowering: I was in a bad humour. I had rushed headlong into the carriage, having scarcely had time to arrange my things and pack what I wanted to take; and besides I saw the tears rising in a certain pair of eyes, poor eyes that I shall probably never see again. The poor girl[3] was going hither and thither, packing everything wrong, then stopping in the

who was then studying at Guérin's studio. . . . We quickly became fond of one another and our friendship, despite repeated separations, never altered; after all our journeys and amidst our cruellest sorrows, we always came together again, and this lasted as long as my dear, my dearest friend lived, and it will last forever.

'The allusion to colouring refers to an invention of Raisson's to earn us a few pence; and we ended by making drawings of machines to be patented. I drew the outlines and Eugène put on the colours. . . . It all looked rather impressive. But if anyone had tried to carry out our plans, the machines would certainly not have worked; too many gears were missing!

'When I took Eugène his share of the money we'd earned I would find him in the Grand Salon of the Louvre, perched at the top of an immense ladder, copying heads from Paolo Veronese's *Marriage of Cana*. I think this was the first money he earned by his brush, imitating wood and iron and washing it all over in water-colour. We were delighted to have earned twelve louis while enjoying ourselves in my little room and pitying the poor people who would have to work from our drawings.'

[1] Horace Raisson, writer and journalist, who later collaborated with Balzac, was at school with Eugène.
[2] Eugène had entered Guérin's studio in October 1815.
[3] Caroline, his sister's maid, who had been his mistress. The Pierret family took her in.

midst of her work with her hand under her chin, sobbing silently. I hated myself for leaving her without having done what I'd have liked to for her, and still more for having accepted all her sacrifices, and for taking away some of her love without being worthy of it; and meanwhile I hated leaving her, not from sensual desire I assure you, but because I felt sorry for her. I thanked heaven for providing her, through the kindness of your family, with the help that is so necessary in her position. You must tell me how she gets on and if she's of some use to you.

To get back to our journey, the weather turned very bad soon after nightfall. The carriage had been badly arranged inside, and the parcels, which had been too hurriedly put in, were terribly in our way. The wind and the fine rain which was falling fast joined in and were exceedingly unpleasant. About four in the morning, nine or ten stages away from Orléans, the postilion told us as he changed the horses that the front trunk had come loose and was about to fall off; I saw to my distress that not only had it come adrift but it had shed its contents, without exception, along the road for some six leagues back; a succession of jolts had tossed everything out. It happened that all our shoes were lost; we had had several pairs made before we left home, and so my nephew and I are here with only the shoes we had on our feet. My sister had several more important things than shoes in this trunk, which were irretrievably lost, although as soon as we noticed the accident a postilion hastily rode back along the road we had just travelled, without, however, bringing anything back. This incident and the urgent repairs that had to be done kept us waiting three or four hours at least. This delay upset our whole plan; we hoped nonetheless that by pressing forward without stopping at Tours as we had intended we might make up for lost time, but a number of other things stopped us on Saturday night. One of the back springs broke: we were overcharged for mending it, which did not prevent it from breaking again right in the middle of the road, leaving us stranded two or three leagues from the nearest human dwellings. We had to do this distance on foot, in spite of the help of three Gascon peasants who happened to pass by, as they trudged along to seek their fortunes in Paris with sticks on their backs and water-bottles by their side, and who offered us their services. At last, after a dreadful night, we reached our goal on Sunday morning and forgot all our weariness. . . .

Goodbye, my kind friend; my fondest love to you. And write to me as fast as you can, with news of Félix and his departure. Tell him I wish him a luckier journey than we had.

Eugène

ᴄᎫ TO ACHILLE PIRON

Paris, Thursday, 16 *September* 1819

My dear friend,

Here I am once again in that verdant forest which I left last year so yellow and dying at the approach of winter's winds and snows. I find it unchanged, save for some large-scale cutting which gives scope to my skill by providing a multitude of game. Unfortunately I myself have not changed for the better, as regards my sporting proficiency. It's great fun shooting when one hits one's quarry, or at least when one fires at it. But when one simply resigns oneself to seeing the creature run between one's legs, or watching it fly past in the air, one must also resign oneself to not seeing it cooked on the spot. This is the great disadvantage of shooting, in my opinion, and this is what makes its delights singularly insipid most of the time. One has to keep one's attention fixed for hours at a time on a single object, which is to catch the moment when chance, having forty paths to choose from, will bring the hare along that path in which I am standing. I wait patiently, I listen to the game-dog's voice, which is pleasant enough, by the way. The sound has something warlike and exciting which stimulates one's imagination. But after having waited for a long time with one's eyes endlessly fixed on six feet of ground, the gun, that awkward and useless instrument, gently slips from my hands. I lay it down without noticing it. . . . The movement and the rustle of the branches delight me. The clouds float past and I lift my head to follow their flight, or think about some madrigal, when a slight sound, which has been going on for a little while, rouses me slowly from my dream; at last I turn my head and see, to my grief, a little white scut just disappearing into the thicket. I have even, sometimes, caught sight through the bushes, for the twentieth part of a second, of two long ears alertly cocked, taking advantage of my absent-mindedness. That is the story of my shooting adventures. Every day I grumble at my carelessness and every day I chase fresh hares. Really I'm very sorry for the poor dogs, who are tied up all the time they are not out on the chase, and who are only allowed a meagre pittance in order to increase their ardour, and whose efforts are thus wasted. Each time I have been shooting I've seen at least one or two hares, not to speak of partridges. I have seen only one quail so far and that I killed, for I am not to be considered entirely hopeless.

I imagine that your own life goes on much as usual. You haven't even the consolation of shooting larks. But on the other hand you can listen to M. Buissonneau's arguments about the marvellous effects of gunpowder. You can hear him talk about music and best of all, for

51

eight or ten hours a day you can enjoy the sight of his funny little face, which delights and interests me every time I think of it. I'm counting on your showing me, when I get back, your achievements in the way of nicely filled Italian exercise books and good translations of every sort of author. Then our conversations shall be entirely in the ultramontane language. You'll be able to recite Petrarch's or Tasso's sonnets to your mistresses. We shall read these delicious authors together. It will all be delightful. I am very happy to find that you've become fond of that lovely language: I think a knowledge of languages should be the first of one's acquirements. It is so delightful to enjoy writing of every sort and of every country. One enjoys the beauties of one's own language better by comparing it with a foreign language. Translate, translate a great deal: learn dialogues, such as you can find at the end of Veneroni's book, and if you could, on top of it all, dig out some obliging Italian with whom you could talk and get used to the pronunziazione, *questo per te sarebbe una grande utilita et per me un dilettevole piacere.* I have brought along with me several cantos of Dante, which I had once copied out of an Italian edition I had been lent, and from time to time I amuse myself by translating certain passages of it.[1] Wait till you're advanced enough to understand that sublime poet; that's when you will bless the hour when it occurred to you to study his language. What vigour, what imagination, what sweetness and tender melancholy in other passages. You will see Ugolino wringing his arms and biting them with rage. You will hear the touching lamentations of his poor children, consigned with him, despite their innocence, to the most horrible of tortures. You will shed tears over the bitter-sweet regrets of Francesca d'Arimini [*sic*] seen by the poet in the whirling vortex of unhappy lovers, when she remembers and describes her tender love for Paolo, the simple and enchanting way in which their hearts had understood one another and the cruel death that sent them both at once to lament for ever amongst the shades. Whenever I think of these noble conceptions, my soul catches fire and I need to pour out my feelings to a friend. I don't know if you feel as I do, but it seems to me that the more one's mind and heart delight in those pure joys that art purveys, the greater the indifference with which one views the so-called pleasures in which most men revel, being unacquainted with nobler delights or too cold, too poorly endowed by nature to appreciate their savour. I can't remember, speaking of emotional experiences, whether before leaving Paris I urged you to go and see *Agnese*;[2] if I did not, I hasten to do so now. It is a very fine opera, although the music does not really appeal

[1] See letter to Guillemardet, 2 November 1819.
[2] By Ferdinand Paer, an Italian composer.

to me except, of course, for some numbers which I thought truly enchanting. But there are not many of these, and I think the composer's skill is to be admired more in the gay and lively passages than in the expression of passion. But that Pellegrini is quite terrifying in the role of a madman; his eyes are astonishing and his gestures and voice are to match. . . .

❧ TO J.-B. PIERRET

rue du Four-Saint-Germain, No. 50
Paris [postmark 22 September 1819]

Since I don't know, my dear friend, whether I shall receive an answer to the non-letter I wrote you, I've decided at any rate to put down here whatever comes into my head, just as if I were talking to you. It didn't take me long to become aware that I hadn't got you with me: and I don't know on whom to unload all that I have to say: not that I really have anything to say, or that I propose to say anything at all. But you know that when we're together we look at one another and that's enough: it's as good as talking to each other. And so a letter is somewhat embarrassing: for although I'm firmly convinced that I'm talking to you, I cannot imagine that I am seeing you. What have you been doing lately? Nothing, I suppose. It seems to me that since I saw you you've had time to learn hundreds of things, that you must have grown, goodness knows what else. You may perhaps have envied my lot when you saw me leave for the country. Unfortunately, boredom pursues one everywhere. I am really happy here only when I'm scribbling to you, for instance, or to Félix: when I try my hand at various things or when I read. It was certainly not worth travelling a hundred and twenty leagues to enjoy such pleasures. It is true that, willy-nilly, I'm breathing an air that is pure and keen – too keen perhaps, for I don't feel as relaxed as I had hoped. Decidedly, shooting is a pastime that doesn't suit me. When I kill something, I'm delighted and feel enthusiastic for a few moments; the weariness of several hours vanishes and is forgotten. But otherwise, when you have to creep along carrying a heavy, cumbersome weapon through brambles and briars, through the branches that sting your face and the ploughed soil that gets into your shoes and sticks to your soles like layers of lead, through vines whose interlaced boughs entangle you and trip you up, all that can rightly be called tiresome. And the worst thing about it, in my opinion and experience, is this: you have to keep your mind fixed for interminable hours on a single aim: to catch sight of your quarry. The slightest carelessness, the least inattention make you waste the

fruit of an age of patient watchfulness; and the quarry, quick to take advantage of the sportsman's negligence, leaves him with his eyes dull and dazed with boredom, his jaws agape, discomfited at having missed his chance. Of course there are compensations for all this, as I've already said: chances not missed, the rising sun, and the delight of seeing trees, flowers and smiling pastures instead of filthy city pavements. If I had somebody like you with me, it would all be very different: instead of pursuing my quarry all alone, I should pursue it in your company. We would console ourselves for the hares we let slip by talking about beautiful things or by creating them, for as you know we make no bones about promising ourselves immortality.

Would you believe it, I've had the effrontery to write some verse,[1] and moreover I've been clever enough to discover that it was not only great fun, but greater fun than anything else. Artists are the happiest of men: I've often told you this and today I'm more convinced of it than ever. This is what I mean when I speak of their happiness: they are the men who above all others are able, to some extent, to fill the horrible emptiness of man's soul, which I consider bears the same relation to happiness as darkness does to sunlight. There is something in the human heart that's continually active, a cancer which seeks only to devour, a vampire that sucks it and is never satisfied. I feel like reading, and I read; I can only endure the page in front of me by anticipating the next; I reach the longed-for conclusion, and then wish the whole work were to begin again. I long for the country; when from my narrow street I see the blue sky only in the gap between housetops, I imagine with rapture the pure, free horizon, dawn with its gates, the golden fiery sun shining on rivers without quays, on forests, unpruned trees, meadows and fields; when I am in the midst of all this, something is lacking to my enjoyment of it, or else this enjoyment is not enough for me; I grow restless and long for a change. But if I know how to paint, and above all to paint with words, oh, all these riches will be mine, my mind will contain them all; I shall call forth the delicious memories of the past: I shall connect, in my thoughts, my loves and my friendships with my enjoyments: I shall have delightful companions in my solitude: in the midst of bores, I shall withdraw into a temple whose walls will keep out all that is vulgar and second-rate. Whenever I retreat into that sanctuary I shall do so with delight; unlike the common herd of men, who find in their innermost being only tacit reproaches for their laziness of mind. And by this means it becomes possible to endure the idea of a long unhappy life and also to resign oneself to an early death. For in the midst of such wholly

[1] André Joubin published some of these poetic efforts (*Gazette des Beaux-Arts*, 1927, I, 149), which, he comments, add nothing to Delacroix's glory.

immaterial happiness, the heart cannot believe in the soul's mortality. Total death cannot exist for such men of genius, afire with a living flame which they communicate to whatever they touch. Think of André Chénier, shamefully cut down in the flower of his youth, before he had unlocked the treasure-house of his imagination or borne his fruits: can he have died completely, can the base knife that severed his head have scattered to the winds his fertile imagination and his fiery soul? Think of Tasso: can Providence, which provides so carefully for frogs and ravens, have treated Tasso thus? He was doomed, for all his genius, to a life of poverty and suffering. This tortured existence was made bearable only through the love of glory and the prospect of earthly fame; and at the close of his career, Tasso's hand dropped nerveless as he grasped his bays, and his forehead grew ice-cold before feeling the wreath. And do you, who are so good, believe that there is no compensation for all this? It is for the rich, for puffed-up fools, for paunchy gluttons that life ends in corruption, or rather it's for them that hell exists, if there is any justice, and for Tasso there is a delicious Paradise, where miseries crumble away and delicious passions remain, and where the soul is at last satisfied, fulfilled, intoxicated; in such a paradise we shall feed on Poetry and nourish our whole being with it, whereas here we are only allowed to nourish our minds with it. I realise that this is a singular idea, and one which may not be very easy to understand. If you cannot follow, and if I have not made myself clear, I will explain to you what, in my opinion, this strange ambrosia would be. What do you think of my philippic? Might one not suppose, to hear me speak so warmly on the poets' behalf, that I am one of them already and that I have claims to the aforesaid most uncatholic paradise? Among other things that I'm looking forward to in Paris, I long to read your and Baour's *Gerusalemme*. I am not so eager as I'd have expected to revisit the Salon: it has been my misfortune to get so heartily exhausted whenever I've risked my life there, that I can wait quite calmly for the time when I see it again, if that time should come. Be kind and tell me about it, and whether it is to be extended, and until when. And above all, be very kind and pack your lines even closer than I have done and tell me, tell me, tell me a whole world of things about your heart, your general condition and your health. . . . One point which I'd have been very glad to discuss with you is that of the new problems which a certain big belly[1] must have set you. Tell me what has happened, if anything has happened: how godmother has taken the whole thing and what father says. It must be very obvious now, and you're due for an anxious time.

How tremendously interesting the life of Tasso is! What misfortunes

[1] Pierret's mistress was pregnant.

that man endured! How indignant one feels with those shameful patrons who oppressed him under pretext of protecting him against his enemies, and who deprived him of his beloved manuscripts! What tears of rage and indignation he must have shed on seeing that in order to make sure of keeping them from him, his patrons declared him mad and incapable of creating! How many times must he have struck his head against those shameful iron bars, thinking of the baseness of men and blaming for her lack of affection the woman he has immortalised through his love! What a slow fever was to consume him! How his days must have dragged by, with the added pain of seeing them wasted in a lunatic's cell![1] One weeps for him; one moves restlessly in one's chair while reading his story; one's eyes gleam threateningly, one clenches one's teeth involuntarily. One of my regrets is not having been able to read Lord Byron's fine elegy;[2] I call it fine, because he has so ardent a soul and the subject fits him so well that he cannot have failed to express it admirably. I could only gain a partial impression of it. Tell me what you think of it, and how it struck you.

Goodbye, my dear good friend. I embrace you fondly,

Eugène Delacroix

↵ TO FÉLIX GUILLEMARDET

The Foresters' Lodge
23 September 1819

. . . I don't know whether he [Pierret] received my dispatch in time to tell you about our unfortunate journey, in the course of which several most disagreeable accidents delayed and vexed us. One of the front trunks, of which the screws and nuts were broken, came open so that all its contents fell out. These included all our stock of shoes and a number of fairly important things. After having waited on the high road, under a fine penetrating rain and the most uncomfortable wind, for the return of a postilion whom we had sent riding back along the road to look for the things we had lost, we were obliged to continue our journey with only the shoes we had on our feet, having failed to retrieve anything but an old book, tattered and covered in mud, over which the wheels of a carrier's cart had passed and which the postilion brought back in triumph on the pommel of his saddle. A little further on we discovered that a wretched jar of pickled tunny-fish, which we had only brought out of pity, had repaid our care by smashing itself in the case, so that a number of things were covered with oil, including

[1] Delacroix treated this subject in paintings in 1824 and 1825. See plate 9a.
[2] 'Tasso's Lamentation' (1817).

56

a volume of Horace which I had brought as well as a small dictionary which I treasured greatly. Add to this the despair of Minette on finding herself tossed about and jolted in a carriage; far from worrying about travelling post-haste, she kept up an incessant mewing for her beloved staircase, her beloved cellar and her beloved garret, the haunt of her beloved tom.

At Montbazon, just before Poitiers, she succeeded in outwitting our watchfulness. She escaped while the horses were being changed, and there we were in the streets, at one o'clock in the morning, calling Minette under every gateway. Just as we were about to get back into the carriage, a postilion who was peering through the cracks in a door thought he caught sight of her in the courtyard of a house. So then I glued my eyes to the cracks and I did in fact see something black walking calmly about in the shadows. I immediately rang the bell, gently at first for fear of waking people up. At last a man appeared in his shirt, with his hair in a pigtail, and joined us in pursuit of the fugitive, who, calmly jumping from the henhouse to the pigsty roof, proceeded to lick herself with great deliberation while waiting for the success of our efforts. You can imagine how embarrassing these proved, in a house where our ignorance of the various nooks and corners was constantly involving us in some unfortunate mistake. Finally Minette was caught by the man in the shirt, who had climbed up a ladder, and we thanked him profusely. After Poitiers, one of the springs broke and involved us in further trouble and endless delays. However, here we are, and here we have been for some time, which makes me ashamed when I think that all this time I haven't yet asked you for news of yourself. . . . I read as much as I can and I am amusing myself by translating an English tragedy I brought with me from Paris. I had let it lie dormant at first because I'd been warned of the frightful difficulties. Gradually I got used to it and I understand almost all the interesting parts. I find great delight in this, first because it's really very fine, and secondly because it's something quite new for me. If I'm not in too much of a hurry for the post I'll send you at the end, by way of a change from my chatter, a little scrap of translation, taken at random from this tragedy.

And are you enjoying Virgil or Horace as a change from your rural pleasures? I doubt it, for in your part of the world, where everyone is related to you, they must be fighting for possession of you. Besides, I have discovered something among my varied studies here. The idler one is, the lazier one becomes. Although I get the greatest pleasure from my English, discovering such beautiful and astonishing ideas in pages of print which to begin with looked merely like unfamiliar words and combinations of letters, I find it a torture looking up words in a

dictionary. But when one has had the strength of mind to overcome this reluctance, what a pleasure it is to conquer all these ideas one after the other and leave them behind one like enemies of whom one is no longer afraid. Sometimes in the middle of my shooting expeditions, when my zeal for the chase diminishes, I remember Ugolino, which I had the presence of mind to bring with me, and I'm very glad of it. The book has occupied me agreeably during tedious hours of travel and sometimes, too, in my idle hours. It forms a kind of eddy in my mind, whirling round incessantly with words of every sort that I summon to my aid, rhymes rushing into place which I restrain and put on one side to use more profitably elsewhere. Not that it all makes much progress. It's harsh and crude and reflects my lack of inspiration.

I am most impatient for news of Pierret's health and the latest developments in his situation; what worries this will cause him this winter, and how our precious evenings are going to suffer from it. What difficulties he will meet with from his own family and from that of the poor girl, whom I pity. It seems to me that what with his father's illness, the outcries of his own relatives and the endless commitments he has incurred in another direction, he cannot have a single moment untroubled by some distressing thought. As for myself, I shall definitely remain a bachelor, and as such I may perhaps be more helpful to him in various ways, particularly since I shall be living close to the house he has settled on.

You'll have noticed from the different ink that I have begun this letter twice over, and you'll notice the same thing from the long interval between its date and the time when you receive it. The fact is that I have not been left in peace for some time now, owing to the endless very tedious parties to which I've been dragged. Now I have some leisure and I cannot make better use of it. The whole neighbourhood is out in the vineyards, and the vintage is the answer and excuse for everything. On account of the vintage, people do without shepherds, builders and carpenters. And it's on this account, too, that we have to eat cow, piously described as beef. I imagine it must be the same in your part of the world, where wine is an equally important matter. The disadvantages however must be less serious, if you are near a town where supplies are more plentiful.

I am increasingly disgusted with the Turks and with the Amyntases as well as the Philisses of these parts. These peasants, whose frankness and simplicity are praised by everyone who doesn't know them, are the most cunning, false and perverse of creatures; and yet, needless to say, the stupidest, which puts the finishing touch to a detestable whole. I think, honestly, that if they were better educated they would be better than townsfolk, because there is really more simplicity about

58

their ways. But I'm afraid that the new schools will have a great deal to do, particularly in this region. Just think, my dear fellow, how easy it is to deceive oneself on the strength of the best authorities. Wouldn't you believe, to read Jean-Jacques, Bernardin [de] Saint-Pierre[1] and so forth, with all their satirical invective against civilised men and particularly against city-dwellers, that innocence dwelt exclusively under a thatched roof? Virgil tells us the same story, declaring that Justice, before leaving the world of men, lingered for a while among the peasantry; and this is just one of his poetic licences. For there's nothing easier than to imagine such things, and to make other people believe them. And Jean-Jacques, for all his bitter resentment against the corruption of cities, for all the wretchedness and persecution he endured there, never took the obvious course of becoming a ploughboy. It's always the same with whatever men write, they seem to write from the heart, and their actions give them the lie. Everything I read arouses my indignation. For either I'm very wrongheaded, or they are horribly dishonest. That's why I respect poets far more than any purveyors of morality. I take an infinite delight in reading stories that reveal the human heart, or adventures pure and simple.

Just lately I have been devouring with passionate interest the story of the unhappy love affair between Don Carlos, prince of Spain, and his mother-in-law, who had been his intended bride until the king chose to marry her. The fine character of this unfortunate prince and that of the queen transport one and incite one to virtue far more than the most powerful exhortation. One abhors and despises the weakness and cruelty of such a father, capable of causing the death of so accomplished a son, so worthy of the throne. This is one of the stories I must recommend to you, if you don't already know it. The situation of the characters is most impressive, and nothing could be more truly noble than the picture of this great passion, the prince's ardent, but sombre and respectful love and the queen's so desperate, subdued and silent. Don Carlos opened his veins in a bath and died with his eyes fixed on a miniature of the queen. She herself was poisoned a few months later by her husband, who came, in deep mourning, bringing her a potion which he besought her tenderly to drink, although she was not sick. I once read a tragedy by Schiller on this subject, which moved me greatly. But Saint-Réal's story, so simply told, which provided the theme for the play, impressed me even more. I also discovered the *Conspiracy of the Spaniards against Venice*, which I had not yet read, and it so happens that among the books I have brought is Otway's *Venice Preserved*, which is taken from it and which

[1] Bernardin de Saint-Pierre (1737-1814), author of *Paul et Virginie*, idealised the noble savage and the pastoral life.

is one of the most highly admired of all English plays. Saint-Réal's style is all the more magically effective for being simple, really and truly simple. None of those inflated words, deliberately introduced to convey images; he paints effortlessly and with few words; you really know his people: when a catastrophe occurs, it creeps on you unnoticed, without exclamation-marks of emphasis; and indeed on the day when a conspiracy is unmasked, when five or six hundred men are stabbed or drowned, the weather is none the gloomier for that, and the sun runs his course as usual. It seems on the contrary with writers like Chateaubriand that words have to be bigger than things, and that things being too vulgar in themselves for such refined imaginations, the subtlety and inflation of the language have to give them more savour for the poor reader – after all, great efforts must be made to enable him to appreciate nature. I remember I had hoped to send you something out of an English play, but I'm giving that up, in view of the fault I have just criticised, and which I should undoubtedly incur. For in the English language expressions are so forceful, not to say exaggerated, that what we call inflation in French is no more than whipped cream to them. Thinking it over, I've surely bored you enough with my stupid reflections. I've decided to translate a little piece for you literally, just to amuse you: imagine that you're reading ideas in a language that is not French. . . . [Here follows Delacroix's translation of *Richard III*, Act I, sc. 2:

 'Set down, set down your honourable load,
 . . . While I lament King Henry's corse.']

 ◦◦§ TO FÉLIX GUILLEMARDET

[Forest of Boixe] 16 *October* [1819]

. . . When they brought me your letter I had just come back from a little party where they had made me tipsy with new wine. I was a bit dizzy, and my head was swimming as I read. I took a quarter of an hour breaking the seal and I thought I should never finish the first page, because the lines kept dancing about before my eyes. I read it, nevertheless, and it helped considerably to restore me to reason. Please don't believe, however, that I go reeling about the place every day. It happens to me very rarely, and whatever people may say, provided of course it doesn't go beyond certain limits, you feel a sort of well-being, of contentment which makes you gayer and better. You laugh all the time and at everything, and all the sorrows of the world seem remote. When New Year's Eve comes, in Paris, we shall be able to enjoy this delightful condition, which is just what you need in

order to make up for your daily labours. You worry too much, I feel, over your future, which seems to you wholly black. You remind me that I shall be returning to occupations that I enjoy. That's true: they are delightful, compared with those of a clerk, but for that very reason their charm loses its keenness, and one becomes insensitive to it. The thing is a recreation in itself; you see what I'm trying to say. I don't deny that it is very boring to be concerned, as you say, with writs, notifications and injunctions. But unfortunately it's the lot of the vast majority of men to devote their lives to things that mean nothing to them and that have nothing in common with their hearts and minds. . . . You remember [Pierret] was unwell when we left Paris. He is distraught by countless problems. That poor girl, and his father, and his sister, it's all driving him crazy. Loneliness, into the bargain, for I don't think he has any friends besides us two; I am terrified lest he should have fallen ill. If that were the case, and I pray heaven it's not, I should do everything in my power to leave at once and go to comfort him, if possible. I beg you, if you have had any news from him, write and let me know. . . . Tell me, too, when you think the Salon will close down. Enjoy yourself, take all the recreation you can to make up for the time you'll have to spend in your office: ride horseback, climb mountains, sail on the Saône and go to Geneva if you can. . . . I know, unfortunately, what those visits you describe are like. How very odd these worthy people are! It is amazing that human beings should get so little benefit from their faculties. With peasants one could understand it, but well-to-do people, big landlords, merchants, whose names are known and talked about throughout the Department! Well, all these people have never noticed that they had a soul, needing something beyond bread and business matters. One doesn't expect to meet a learned doctor among such gentlemen, and I hate doctors and dreamers. But if you merely talk about the elections to them they reply that they have made eight hundred hogsheads of wine. Provided this can be said of them, and their houses are whitewashed outside, they'll live inside on beans and coarse wine, in squalid rooms whose walls aren't always even roughcast. . . .

You simply must take your various projects in hand. There's no pleasanter way of spending the time: one goes to sleep with one's heroes and they keep you company wherever you go. You'll tell me that you haven't time. . . . Surely one can always manage to steal a few little quarters of an hour even in the strictest lawyers' office, and for one thing one always works better and with more zest when one is stealing the time than when the whole day is at one's disposal. That's when you fall asleep over your work. The more opportunity you have for working, the less you achieve. You begin a hundred things which

you never finish. So think over your project all the way to Paris, in the coach particularly, for it's the best thing you can do there. It will encourage me, meanwhile, to investigate enthusiastically a number of ideas which have come to me. . . .

✺ TO J.-B. PIERRET

Mansle, 29 *October* 1819

If only I could hold back the wretched letter[1] I have just let go! I gave it yesterday to be sent by the post; why did I not wait until today? I've been scolding you, accusing you of neglecting me, you poor orphan! telling you what I suffered at having no letters from you, while you, my dear friend, were enduring the cruellest pain known to mankind! You were laying your father in his coffin while I, in the midst of my amusements, wondered occasionally at your delay. Ought I to have suppressed those horrible words I wrote? No, at the risk of reopening such raw wounds still further, I want to punish myself for my exactingness, my harshness, by your grief itself. And what words can distress your heart more than reality has done? If I were to seek a hundred ways of expressing images of deep despair, what should I have to tell you? So you have kept vigil over your dead father's body. That night, my poor beloved friend, will endure forever in your memory. What that night witnessed, what that room witnessed, is engraved in your mind's eye; that bed, those lights, that midnight silence by your father's corpse will live forever in your imagination. And yet, if I really know your heart well, that death-agony and the sight of that death contain within themselves a sort of consolation. Is it indeed true that the heart finds a secret joy in dwelling on the sight of our dear ones even as we are losing them? Yes, we gaze intently on those features as they fail and fade. We cherish whatever reminds us of our grief; and it does us good to hear it spoken of. I, too, have seen what you saw. My mother left us in the same way.[2] A week before her death we were at a festive party with her, and after that week the earth had closed over her grave and everything had resumed its normal course. My own despair, as I remember, was mechanical. Everyone was weeping around me and I wept too, and when I had no more tears I wondered whether I was unfeeling. The thought of her death, which had so often made me shudder when she was still with us, seemed to me a dream when it had actually happened. It did not haunt me like some disastrous thing that poisons the amuse-

[1] A reproachful letter dated 26 October.
[2] She died on 3 September 1814.

ments and occupations of ordinary life: it obsessed me like an illusion that is bound to cease. The whole scene, all that I had witnessed could not alter me. My sister had come to wake me up and had said, bursting into tears, "Eugène, come, come quickly, we are about to lose our mother!" I had dressed in great distress, sobbing. My mother had endured horrible agonies in the night. Poultices and cauterisations had made her utter dreadful shrieks, which had failed to waken me. Now she was lying motionless, her face flushed with pain and her eyes half shut, as though the light hurt them. Her bedroom door was open, and the room was full of people. When the doctor had been and gone, coldly recommending us to be brave, and all the rest had collapsed into armchairs, I went into my mother's room and found myself alone with her. I went to give her a kiss: it was the last she received; she did not feel it; her face was cold, though it seemed still alive, and her eyes remained fixed on mine. My friend, tears prevent me from seeing what I'm writing. After that she belonged to me no longer, I was not allowed to touch her again, but I saw her once more. The room was full of people again, and all was in confusion. My sister flung herself prostrate on the bed, my brother was sobbing: our cousins and all our friends were there. I was at the foot of the bed and I wanted to see everything. Suddenly, although no movement was noticeable, and her eyes remained wide open, her colours faded like a curtain gently rising and pallor spread from lips to forehead. It was all over! I think you will weep as you read this letter: yours reminded me of my mother, and I am grateful to you for the tears you made me shed. You'll feel the better for those that you have wept yourself, and will yet weep. And then what happened? I still could not imagine all I had lost. Every day, for a far slighter grief, the commonest of men go about sunk in gloom; the very thought of a misfortune haunts one like remorse: but this misfortune cast no gloom over my activities, because my mind could not take it in. What weak creatures we are! Trifles fill us with bitterness and resentment every day of our lives, yet we cannot weep under real afflictions. Ah, you will weep though, because you watched him suffering for so long before you lost him: your pain will be sweetened by the thought of his deliverance, and of what you have done for him. I, even now, cannot grasp the fact of my loneliness: I look around me in search of that which vanished so swiftly, and I lost my mother without repaying her for what she suffered on my behalf and for her kind love for me. If she had died now, or in a few years' time, my grief would have been keener and deeper: but I should have got true joy out of her life. For I was too young to show her, at every moment, how much I loved her! It's an incredible thing! I cannot understand the cult of tombs, the way men love to revisit the sad resting-place of

63

those they have loved. The sight of death has, for all its horror, something reassuring: one has not yet lost quite everything, for one still sees the beloved features, the lifeless mouth that once kissed us, the dear hands that we pressed and that pressed our own! And though all of this is dead, you say to yourself it's the same flesh, it is still my mother. But the thought: I'm trampling on her dust! She is there and I cannot see her, she is shut up close to me, with a stone between us . . . that's what brings forth floods of tears, but they are tears of despair. But what am I trying to tell you? If anyone else saw what I'm writing to you, he would say: what a way to comfort a son who has lost his father! And yet you won't be vexed with me for it, I am sure. I had to write all this to you. I have experienced the same sorrow: you may find some comfort in this further link between us. Conventional condolences are jejune. They make one weep to find men so incapable of feeling what one needs, and of replacing the beloved friends who have gone. Those for whom one is mourning would have mourned for one, and not been content with formal respects. What must comfort you is that you can still make your mother happy. This consolation you will owe only to yourself and your own virtues: what may comfort you further is having a few friends who can weep with you and who grieve for your grief. I should dearly have loved to be with you; now that it's all over, I am glad that my letter has gone before me. One can say so many things in writing that something or other prevents one from speaking. Friends meet again, embrace each other, choking with emotion, and the feelings that are not poured forth sink back into the heart and make it ache. It must be a relief, too, in your position, not to have witnessed your sister's grief. I expect poor Caroline will have been a help to you in these sad moments. You yourself will have reaped the fruit of your filial tenderness. You held your father's head to the last moment and his last glance fell on you. You shared all his sufferings and made all your sacrifices. In such circumstances, and in view of your mother's position, you may surely be released from any other sort of engagement[1] and you can be in no doubt as to your choice. Your duty is to her, and you will still be working for her sake, when you decide to consider the project we had formed. We shall have much to discuss together about all this. I earnestly hope that you will fulfil your intention of writing to me several times more, as you promised in the first part of your letter, provided you can find leisure to do so amid all your troubles. I expect to leave between 5 and 7 November, or 8th at latest. Charles's[2] illness, as I think I told you, has kept me here.

Goodbye, take great care of yourself; during the first moments of a

[1] The problem of his marriage.
[2] Eugène's nephew Charles de Verninac.

great misfortune, one's spirit finds strength to sustain and stimulate it; gradually this fades away, leaving one weaker and more irritable than a sick man.

I embrace you,
Eugène

⌐ꞁ TO FÉLIX GUILLEMARDET

[*Forest of Boixe*] 2 *November* 1819

[The first part deals with Pierret's bereavement and problems.]

The thought of what he must have suffered has embittered almost all my leisure, and for several days I could think of nothing else. And so I shall have no regrets when I leave these parts in order to see him again; winter makes the countryside melancholy; rain is falling incessantly and frosts have yellowed all the leaves, and will soon make them fall; and there is nothing drearier than being in the country when you have to stay by your fireside. Pierret tells me in his letter that the Salon was to close down on 1 November and that a number of new pictures had been shown, among them one by Hersent[1] and one by Hérin, both of which he found very striking. I presume that, as you lead me to hope, in view of the opening of the chambers the closing day may be postponed. I should be very sorry to find the Salon closed when I get back; I have seen nothing, made no comparison. It seems to me now that I should get infinite pleasure from this, although on leaving Paris I felt but little regret for all these things, which I had seen too much of because I had not studied any one of them. The picture of the *Shipwrecked Sailors*[2] has been hung lower and can be seen, so to speak, on the level. So that you already feel as if you had one foot in the water. You need to see it fairly close to appreciate all its merits. You ask me to send you what I've been doing.[3] It would be ungracious of me to refuse, for two, even three, reasons. The first is that since you ask for it you'll be pleased to see it. The second is that the bad weather which keeps me at home leaves me no excuse for refusing. The third is that vanity, which is all on edge for fear of making a bad impression, is yearning to find a reader at all costs. There's no point in making so many excuses. My heart is unchanged. But don't feel obliged to praise; I'm only too glad to find a willing reader. Here vanity obliges me to sharpen my pen. You saw what was almost a beginning in Paris. As the whole thing has to be rewritten, I'm

[1] Hersent (Louis), painter and lithographer (1777-1860).
[2] Géricault's *Raft of the Medusa*.
[3] Translating a passage from Dante's *Inferno*: the episode of Ugolino.

suppressing it, because it no longer fits in with the rest, which should also be rewritten if I weren't showing it to the most indulgent of friends. What oratorical precautions! But you can recognise the man through it all. [Here follows the passage.]

This is all that I have done, you can see my innumerable mistakes. The piece is incredibly difficult. There's something sublimely prosaic about the original that makes one shiver. The style drags, as though to make you live through those six dreadful days with Ugolino. And so, as I was aiming at a somewhat excessive accuracy rather than at elegance, the lines are harsh and the expression nonetheless weak. Still, here they are. Keep working at your projects. We shall get infinite pleasure from that this winter. . . .

∽ TO HENRIETTE DE VERNINAC[1]

Paris,[2] 13 *November* 1819

My dear sister,

We could not write to you before today. Yesterday there was no post out, otherwise we should have written. We arrived on Thursday evening, which we scarcely expected to do, thanks to the confounded carriage we travelled in. Nothing untoward resulted, however, except the anxiety you doubtless felt at getting no news of us, and the considerable inroads into our finances made by a whole day's wait at Tours; for, as well as the cost of carrying our baggage, which was higher than we had expected, the additional food, although we usually ate only one meal a day, etc. . . . absorbed practically the whole of our reserve fund of twenty-five francs. You know we had not got the coachman with us, but a groom who had been recruited at the last minute, who did not know how to drive and who was stupid and brainless to the last degree. The evening of our departure, as we were changing horses at Les Minières, some practical joker took it into his head to pull down the rear prop, that's to say the pole that supports the carriage, which as you know has only two wheels. The result of this was to bring us tumbling down backwards, but we were unhurt and took it as a joke. But what proved no joke was that during this

[1] The Verninacs, having lost their money, had had to leave Paris and settle in their country home, La Boixe near Angoulême. Delacroix had returned to Paris with his nephew Charles, a schoolboy.

[2] 114 rue de l'Université. The Verninacs had left the house in August 1819 and were trying to sublet it. Eugène kept his room there. We find him thus, at the outset of his artistic career, saddled with the responsibility not only of his nephew's health and schooling, but of the care, upkeep and letting of the house, and a variety of domestic, legal and financial problems – and perpetually short of money. During this period (1819-22) he wrote some fifty letters to his sister describing his daily life and its problems.

operation the body of the carriage had slipped along the braces and was tipping backwards. We only noticed the accident when we were some distance from the stage and exactly at the same place where, two months previously, we had found ourselves in a similar situation. It happened that the horses could no longer draw the carriage, but were pulled up into the air by it. We had to get out into the mud, in pitch darkness and a bitter wind, to push from behind, set our shoulders to the wheel, all to no avail. We were a good league or so from Vivonne. Some of the party left the carriage in the rut and went off to Vivonne on foot. I climbed back into the gig, with another stout-hearted fellow, and we began to encourage the driver and the horses. The poor man had lost his head. He tangled up in his reins and shafts; he had lost his sense of direction, and was making frantic efforts without producing any results. At last he decided to lead his poor nags by their bridle. We fellows in the gig shouted gee-up, at random, so that the poor creatures went left when they should have gone right; and since the rain had left enormous puddles along the sides of the road, the man plunged deeper and deeper into the mud and was going quite crazy. Finally the horses stubbornly refused to budge, and at this point I decided to follow the example of those who had gone ahead of us, and Charles and I set off for Vivonne. As for Frédéric, while we were yelling and shoving the wheels and cursing away in the mud, he had stayed in the carriage, perfectly calm and warmly wrapped up. To make a long story short, some horses were sent from Vivonne, where we had to stop at an inn, and the carriage was brought back in a dilapidated state. We ate a poor supper there at great expense. We had to pay the wretched driver between us, to restore him and his horses, all of which came out of our slender funds. Leaving late, we had endless further delays on the road to Poitiers, and had to do part of the journey on foot in the middle of the night; Frédéric, of course, never turned a hair; he was doubtless devoting himself to guarding our possessions. The carriage we found at Tours was quite another matter; we left on Wednesday evening and came like the wind as far as Paris. Here we are at last. We went to see M. Chaussier[1] this morning, I gave him a lengthy account of Charles's illness, of what had preceded and followed it. He said it was not measles, and was nothing serious: there was no need to follow any regimen, and he gave Charles his blessing. I leave you to imagine your son's radiant happiness. The weather has turned frightful and prevents us from getting to the Lycée.[2] We shall have to treat ourselves to a cab. It is a mixture of frozen sleet and snow. I am

[1] The family doctor.
[2] The Lycée Louis-le-Grand, where Charles was at school.

telling you all this because you asked to be kept informed of everything. . . .

↫ TO HENRIETTE DE VERNINAC

Paris, 12 *February* 1820

You are quite right, my dear sister, to say that I'm a great lazybones. I haven't much excuse for it. My laziness is not the only reason, nor perhaps the strongest: for I can readily overcome it to write to you: but a hundred other things. In the first place, I stop at home as little as possible. As soon as I stay by myself for a few hours an unbearable melancholy overcomes me. I feel as if I were all alone in the world, and I need to find new life among people I know. So that as often as I can I get my friends to come and keep me company. We have spent some very pleasant evenings together; but as soon as they've all gone away and I am alone again, I relapse into depression. I have made a purchase which may help me in this respect. It is an old harpsichord, which is in not too bad condition. I had a few ha'pence set aside (which shows you by the way what a steady young man I am) and I gave forty francs for it; you must admit that's not a bad bargain, for that price you could hardly get a wretched pocket-sized fiddle, whereas I am now possessor of a huge, noble instrument which casts a shadow seven and a half feet long in my room. If I had it chopped up for firewood I'd more than get my money back. Enough nonsense. I must tell you that the assessment men came round and assumed a threatening attitude; the portress was in tears, but I did not see them: I stood firm. . . .

Goodbye, with all my love,
Eugène

I got M. Boilheau[1] to extract the death certificate[2] and I've sent it to Sainte-Menehould.

↫ TO HENRIETTE DE VERNINAG

Monday, 1 *May* 1820

Are you cross with me, dear sister? I have heard nothing from you or from my brother-in-law; do you bear me some resentment for yet another crime that I may have committed unwittingly? Mme Lamey, who is luckier than I am, tells me she has had a letter. Every time I

[1] The family lawyer.
[2] For the settlement of their mother's inheritance.

come back I ask the portress if there is anything for me and there never is anything. I think, in any case, that you must be finding more enjoyment in that lovely forest now that it is green and blossoming than when it was leafless. I can picture its beauty. The garden that lies under my windows gives me some idea of it. Since I've been alone, I have become more attentive about a number of things. I have sown flower seeds in all the pots in the house; I even go so far as to water them. Every morning when I get up I look to see if some young hopeful is sprouting through the soil. You write to Mme Lamey that I don't give you any details about my life. I will give you some. You'll have seen from my previous letters that I was not very happy at being always alone. Lately I have grown accustomed to this state, which has its advantages too. I rise fairly early, I practise my harpsichord a little or read. Then I eat a frugal luncheon. As I can never think of anything to vary this modest meal, the portress almost always buys me the same thing: cheese and bread, bread and cheese. After this I go to work either at the museum[1] or at M. Guérin's. I am in fairly good form at the moment, and I don't waste my time. When dinner time comes and I am by myself, I go to a modest restaurant, where for thirty sous or so, depending on my appetite, I eat my solitary meal. There are several inexpensive places to which I go regularly. They are in different districts, so that I always have one of my favourite places within reach. Sometimes I dine with another young man[2] who lives alone like myself, his parents being at Saint-Germain. In that case we go to a better-class eating house and by asking for a single helping of each dish we manage to get a very good dinner which costs us scarcely more than my usual fare. When I am in pocket I treat myself to the theatre. When funds are low, I abstain; and this is usually the case; for since I am obliged to set aside twelve francs every month for my fencing master, I have little to spare. I go to the fencing school three times a week, which takes up a good part of my evenings; I often see Pierret and Félix, and sometimes have dinner at their homes. I also go to my uncle's and my cousin's, but I only dine there when Charles is on leave from school. This is a rough sketch of the life I lead; and one might be worse off. I wish I need only write to you about things like this, or things that interest you. All these obtrusive business matters give a depressing tone to our correspondence. I am constantly having to tell you about the grumblings of workmen who haven't been paid, and the apartment which we've failed to let. Plenty of people come to see it, but they invariably raise the same objection: if there were one or two more principal rooms it would suit them nicely. The two rooms on the second floor tempt everyone that

[1] The Louvre. [2] Soulier.

has seen them. It is very provoking. The locksmith and the wallpaper merchant, who often call at my uncle's, made a most unpleasant scene there not long ago, and the joiner, whom I had tried to pacify by promising him his money very shortly, came and made a great to-do in the portress's lodge. I am really at a loss what to tell them. My uncle, whom they dun more frequently than me, never fails – with his usual tact – to enlarge on all he has to endure from the complaints and threats of these people. I saw Mme de Brancas's servant about the shutters of your bedroom and the cellar door, which had been left behind by his masters. He told me that my brother-in-law had had these articles valued, and that a price of thirty-five or forty francs had been agreed on; when I told him that the cost of various repairs we have been obliged to make might well offset this expense, he pointed out that all the repairs, even down to the flooring-tiles, had been paid to Mme Cazenave, and he showed me all the accounts.

Goodbye, my dear sister. I am very sorry to depress you with all this business. Your Charles had an exeat yesterday. The headmaster seems pleased with him, and he is in excellent health; I urged him to write to you very often. He seems to be kept very busy. He told me our poor Rambeau had died; Rambeau had his faults, but he was, I maintain, an honourable animal, and I'm truly sorry for his loss; take good care of the dog you have left.

Goodbye, with fondest love to yourself and my brother-in-law,

Eugène

ॐ TO HENRIETTE DE VERNINAC

30 *May* [1820]

My dear sister,

Once again, it's quite a long time since I had the pleasure of writing to you. You'll wonder at it less when you hear what has prevented me. About a month ago I undertook a job which will bring me in a little money. It consists in making drawings of machines, which I copy with a young man I know.[1] We are obliged to work without respite, because our copies have to be deposited at certain offices as soon as possible. With such a timetable I literally haven't a moment to do anything else. As I have stopped going to M. Guérin's and given up my fencing master, I have taken a piano teacher with whom I study in the mornings; then I go to the museum, which I don't like to miss because I am paying for an expensive scaffolding; the rest of my time is entirely

[1] Soulier.

devoted to my machines, and it's so fully occupied that I have scarcely time to practise my harpsichord when my teacher isn't there. I am writing to you, however, to prove to you that I am not dead. Time passes very quickly; just a few months more and you'll see your son once more, grown into a great gawk five or six inches taller, and another fellow as brown and lean and bearded as ever. It is going to seem strange to me not to have to worry about my dinner, or the laundress, or the portress, or the workmen, or any of these tiresome people. And yet I'm beginning to get wonderfully accustomed to this independent way of life. I live like a frog, without knowing what time of day it is. That reminds me by the way that my watch is in my drawer and that I haven't yet paid M. Laborie. As soon as I have been given some money for my machines I'll pay the good fellow. I had hoped to spend part of the money I shall have left, after getting a few little things I need, on having at least half a coat made for myself: that's becoming highly necessary, for my coat is a mere rag. But in that case I don't know how I shall pay M. Oudot. I shall also have to think about a hat, for the silk hat I bought when I came back from the Forest was a shoddy thing that has worn very badly and now looks like a tramp's hat. But I might perhaps be able to afford that out of my savings, if I knew a little better how things stood. I was absolutely horrified to read in your letter that you couldn't make head or tail of my accounts. I had spent a long time over them and I thought I was sending you the clearest and most precise summary; to tell you the truth, the fear of having to do them all over again may perhaps have contributed to make me postpone the answer I owed you. I'll try again, however, but I can't promise to be much more enlightening than the first time.

Cousin Lamey was to leave for Altkirch on the 31st; she has put off her journey, I believe, until the 12th. I don't know whether she has told you about this. On the subject of purses, padlocks, etc., I hope I shall have no difficulty in making her see reason about such inopportune scruples. Uncle Pascot will thus be left alone here. You can imagine that if I seldom went to see them both, I shall find it even harder to visit one of them alone. One thing is certain, I don't like going there, and I don't know why, as soon as I'm there my feet are itching to leave. And yet they're very worthy people. But our natures are incompatible.

When you come back to Paris you won't recognise ladies' shapes, their waists grow longer every day. They're now wearing a kind of basque over their skirts that comes down very low, rather like men's in the time of Louis XIV. And they also wear broad sashes below the waist, no doubt as a step towards dropping it still lower. . . .

71

Goodbye, my dear sister, all my love to you and to my brother-in-law. My nephew is being very good, he was recently awarded a 'blue exemption' by the headmaster; that's very distinguished. (By the way what about the money for the Lycée; they're pressing me for his fees.) Let me know, too, how you want me to advertise the apartment in the *Petites Affiches*; Uncle has mislaid your note. People have been to look at it several times, but they haven't come back.

<div align="right">E. Delacroix</div>

I received the money order for a hundred francs. I'll go and cash it today, the other sum has also been spent on paying the workmen.

↬ TO HENRIETTE DE VERNINAC

8 *July* 1820

. . . I received, by the stage coach, the 136 francs for myself and for Charles's boarding fees. I had hoped to find the money for the rent too. Mme Cazenave sent to my uncle's at the beginning of the month to remind him of what was owing her. Please don't put this off any longer than you can help. It's urgent.

I succeeded by the sweat of my brow in procuring a magnificent piece of cloth to get a coat made for myself. It was a bargain, and I took advantage of it. This expense has restricted my means. I should like, if it can be managed, to have enough money to have the coat made up, at least. Otherwise I shall be hard put to it to reach the end of the month.

I must confess that I myself find my accounts very confusing. I hope that between us, by comparing those you have kept with mine, we can disentangle the whole thing. Otherwise it'll be quite impossible.

Mme de Brancas's servant keeps asking me if I've had the money for the shutters. I wish I hadn't always to be telling you about such horrid things, and that any letter I write to you wasn't a statement of accounts like a tradesman's letter. We still haven't let this wretched apartment; it must be because everyone is in the country: for the *Petites Affiches* don't bring in any more people. Actually some English-women came to look at it recently, but they only wanted to pay 1,200 francs.

Goodbye, my dear sister, my love to you and my brother-in-law. Charles is working well and being good. I have just read some verses of his which are very good.

<div align="right">E. Delacroix</div>

M. Riesener[1] has come back from Russia. Apparently he has made a great deal of money, as well as bringing back diamonds, cashmere shawls and fine furs for his wife. He had earned about 110,000 roubles. He thinks it would be to my advantage to go and study with M. David in Brussels; I have often considered this, but I must think it over still further.

ℰ TO HENRIETTE DE VERNINAC

28 *July* 1820

. . . I have just received a commission[2] which may bring me in some money. It's a picture for the bishop of Nantes. I don't know what the sum will be, but it will be well paid. This may prevent me from leaving with Charles as soon as I'd have liked; because it is necessary, not of course to have painted the picture between now and then, but to have done some painted sketches and rough drafts of it to show the said bishop. However I think I can get these done in time. Another thing I wanted to tell you is that I should like to go and see my brother[3] on my way through Tours. You must realise that I cannot pass so close to his home without doing so. If you don't want Charles to come with me, it would be more than unkind of me to leave him at the inn while I went to see my brother. I am very grieved at the way these deplorable business matters divide families. I can understand your reasons for not wanting Charles to go there. I should be very sorry, moreover, not to travel with him. In any case he is a man now and can go in a stage coach by himself just as well as his uncle the painter. He gives the impression of a responsible person, far more than I do myself. You decide what you want to do about it. What might delay me some time in Paris is that the pictures have to be sent to Nantes for the approval of the person who has ordered them. However, we've not reached that point yet, and we shall have left before then.

I have been obliged to spend a good deal on replenishing my wardrobe a bit. Moreover, I'm badly in need of money to pay my

[1] Henri Riesener (1767-1828), Delacroix's uncle (his mother's half-brother), a portrait painter, had gone to Russia in 1816 and stayed there seven years, painting Tsar Alexander and other Russian notables.

[2] 'The Triumph of Religion', or *Virgin of the Sacred Heart*, passed on to Delacroix by Géricault, who knew of his straitened circumstances.

[3] General Charles Delacroix (b. 1779), who had a small estate at Louroux (Indre-et-Loire). He and Henriette had quarrelled over their mother's inheritance and the various lawsuits over the estate. He had further incurred family disapproval by marrying an innkeeper's daughter.

tailor. I bought myself a hat: all this has put me in considerable straits.

Goodbye, my dear sister, all my love to yourself and my brother-in-law.

৶ TO HENRIETTE DE VERNINAC

Louroux, 1 September 1820

My dear sister,

I got here two or three days ago. It is time to tell you what has been happening to me. Since my brother is anxious to keep me for a few days longer, I shall not be able to set off until about the 5th or 7th and as unfortunately I'm afraid I haven't quite enough money to do the rest of my journey by stage coach, I've decided for economy's sake to do at least part of it on foot. This will be a clear saving of money and a beginning to my apprenticeship as a wanderer. Thus I shall be at the Forest by about the 10th or 12th at latest: I'll send my baggage by coach in the meantime, to await collection at Mansle. . . .

৶ TO CHARLES SOULIER
[in English]

[Forest of Boixe, September 1820]

Dear friend,

You must not wonder at my slowness in writing you. From Paris, I gone first to Tours to meet a little with my brother I have not seen long since. I lived here about fifteen days, and not was possible to write any thing in English for I wanted English books or dictionaries. Moreover and to tell the truth, I should be equally diverted from my purpose by the continual fests and entertainments. I left him at last. But during the journey to my dear forest, I was seized suddenly by a devilish fever, which takes away all my pleasure in country. I live tristly long days, without any stomach. I see with impatience from my window the murmuring trees and singing birds. But nor the barking dogs in sonorous groves, nor the raising sun with all its splendor refresh my senses or rejoice them. I am a slave confined in a house; when I attempt to read or write anything, my head is so full of tediousness, so feeble and heavy on my shoulders, that I am very soon forced to forsake all business. You shall discern without difficulty how much is hard and pitiful my english linguage. Nevertheless I find a mere pleasure in writing you. I hope you shall excuse the mistakes and errors; I am so

idle et disconforted, when I must search a word in the dictionary that there is no doubt I put impudently a great deal of improper words. Through my lucid moments, I take my faithful Richard III who was not, I believe, so sweet and delightful to his brothers, nephews and attendants, that to my mind and in my hands. I know not for what reason this tragedy is not placed in number of the betters of Shakespeare. I own there are some long things and needless, but there is always to be felt the tallent of author in the living painting and investigation of secret motions of human heart.

ஃ TO J.-B. PIERRET

Mansle, 2 or 3 October 1820
[*postmark* 8 *October* 1820]

You cure my sickness by writing to me, and I am answering immediately so that you may do the same again and cure me even more completely. How your promptness delighted me! You were the first to take your letter to the post and it was the longest letter. Félix wrote me one as short as my own. He said he had no time. All right! But when I saw yours, so thick and well filled, I am quite sure my fever foresaw its end. So you were able to find time, amidst all your duties at the office and the problems that beset you? You found a way to send the sick man a good soothing draught that will bring strength first to his fingers and to his head, so that he may write the longest reply that he can, and then to his whole body, I'm sure of it, so that he may recover his health and walk about thinking of his friend, under the trees and in the fresh air! The fresh air! The trees! I enjoy them for a few wretched minutes every day, since my legs are too weak to carry me for longer. However, my illness is not serious. It is a lingering fever, not at all dangerous, but liable to last for some little time longer: so there's no cause for anxiety. I am bored, that's all. I am trying to be a practical philosopher, although profuse sweats make me as thin as a matchstick and as feeble as a piece of touchwood. Enough about my fever. You seem dissatisfied with your visit to Dieppe. Can it be that the sea is no longer what it was? The breaking waves, and all that vastness, the sea itself? Oh, we shall have to talk about it all. Kind winter, which others dread, kind winter, what delights you hold in store for us! Yes, it is indeed your turn to give the New Year's Eve party. If it hadn't been yours, I should have liked it to be mine. What a delightful evening! Aren't drinking and feasting a pleasant part of life? There, in the soft candlelight, we shall settle down with our elbows on the table and eat and drink a great deal, till we're aglow

and our merry wit flows freely! That's gaiety indeed. And ours is true gaiety, time well spent! Oh, I pity potentates and great statesmen who have no such New Year's Eve parties. And I believe that at all stages in our lives we shall be able to enjoy that happy evening with the same simple delight.[1] We are not tradesmen. We shall not bury our youthful hearts, at twenty-five or thirty, in the depths of a safe. Passionate hearts, and above all those that are filled with the love of one or other of those arts that are the soul's sustenance, souls such as these do not grow old and desiccated. As for you, even if you were a haberdasher, a charcoal-seller from Auvergne or an ironmonger, or like so many others with brains and feelings and all whose faculties are concerned only with money, you'd still be different from such people. But you see what I'm driving at. You're going to be a painter, my friend: we shall go forward together. O heavenly painting, what happy moments you will give us! Did you not feel a pang of shame when you were asked if you were a painter? It must have touched you to the quick, I am sure. This brings us, by a natural transition, to an issue that is unfortunately of acute interest and delicacy. [Eleven lines deleted.]

I'm resuming my letter, and finishing it more hastily than I could have wished. Night has fallen, the letter will be collected at eight o'clock tomorrow morning, and sick men are not up at that hour. That long interruption, and that disgusting scribble, were in fact some lengthy reflections I had begun on the subject you know.[2] I chose instead to keep them to myself and give you only my conclusion. Yes, I have thought it over, I promise you, and you have made the right decision. I feel as if a dazzling light had at last, and for the first time, made things clear to me. You are afraid of tying yourself down; you're mistaken, for you are already tied down. That freedom you talk about is a mere word. The tie that binds you is your child, not his mother. Your bondage began on the day your child was conceived. Your uncertainties and your distress date from that day. I asked myself in some surprise why this notion, which now seems to me so plain from every angle, had not hitherto struck my mind so clearly, nor yours either. As long as the child existed only in its mother's womb, it was obvious that you did not wish to marry a mere womb; when you saw a red, screaming infant born into the light of day, he was still not

[1] But Delacroix's feelings were rarely simple: on 1 January 1824 he wrote, 'As always, if I remember rightly, I brought nothing but a mood of blackest melancholy away from the splendid New Year's party which Pierret gave for us. These serenades to the New Year and, above all, the horns and trumpets make one feel sad about the passing of time, instead of preparing one to greet the future joyfully. . . .' (*Journal*, Phaidon edn, pp. 19-20.)

[2] Still the question of Pierret's marriage to his mistress, who had had a son.

your son, he had not smiled at you, he looked scarcely human. And I assure you, too, that this child seems to me today, and did the last time I saw him, quite a different creature from the one who, for two or three months, required your care and your concern without ever repaying you with a caress. But when you saw that weak and tender gaze fixed on your own, and that little mouth which owes its breath to you break into a smile, when your hands caressed him, when you discovered that a mind was dawning in that tiny body, you became his father. Try and remember; did not such thoughts as these, vague and ill-defined perhaps, pass through your mind? I am almost sure of it. You are unquestionably doing right. Could you think of parting from that son who is your flesh and blood and who will become a man, and wherever he may be, will not your whole soul yearn towards him? I have considered many objections: you must have raised thousands; well, they count for nothing. I have not yet mentioned a certain other person. What balm of happiness will flow into that heart! And the unhoped-for felicity of a new-forged destiny will bring calm to all those troubled feelings; and you will love her, and you do love her. Habit has bound you with ties that seem onerous; but love and uncertainty on her side have contributed to make them heavy: and could you, however acute the division between you, and even if your child remained by your side, envisage prolonged separation from the woman who has given you so many happy moments? Oh, your heart would then fly back to those happy days which are at present under a cloud: nay rather, it would fly back towards her, to be reunited with her! Can you ever feel indifferent towards her? It is not possible. And even were this love to fade irretrievably, you would still be able to accept her as part of your lot, as you accept your mother, your sister and all your family with whom you live. Consider the thousands of young men who have married at an even earlier age than yourself. They live out their lives like other people. But you, as each new day dawns, will be acquiring a talent which will bring you fame and fortune, and bring happiness to your wife; and your son will be growing up by your side, and you will have found stability, amidst which you will work with a zeal inspired by necessity. That word sounds harsh at first. But consider it well. It has a gentler sound when you see its inevitable fruits. Have I said enough? At any rate, this is neither advice nor argument. My mind chose to pour out part of its thoughts about your situation. This letter, I hope, will find you duly regimented. And let Mother Church play her part; it may be, as I greatly fear, that her oil and holy water and paternosters will prove but feeble instruments. But who knows, as the good folks say as they sit by the fire, and old wives spinning their thread! What nonsense I keep on talking, whereas I had a

77

thousand wise things to say to you. Alas, though, it's late, and a wretched bowl of soup I've just eaten has broken the whole thread of my ideas, and I see that I may not be able to fill up all the blank space. I am tired. I'm making you pay the postage of this letter. Friend Piron, who has had to go away, told me he would be unable to help us for some little time. I thought I should have time to write to Guillemardet, but I was taken unawares. Your letter was the only one I had started when I discovered that time was short. Since I shall pay the postage on your reply, I expect an enormous one from you, a real folio volume, and the quicker the better. And then just fancy getting a letter from my dear good Soulier in Florence! My dear fellow, I shed tears as I opened it, and its contents justified my emotion. We will read it together. Soulier is an excellent fellow, and I love him dearly. But there's no point in saying this over and over again a hundred times. Goodnight then, you husband, yes, you happy husband! My next letter, I hope, will be more copious, because I hope that my state of mind will have somewhat improved. A long, enormous letter, please.

Your friend for life,
Eugène Delacroix

ⳗ TO GENERAL CHARLES DELACROIX[1]

Forest of Boixe, 4 October 1820

. . . I started off cheerfully from Saint-Maur. I covered a long stretch satisfactorily, but the heat of the day grew too intense and I stopped to rest in a tavern: I was foolish enough to catch a chill which almost immediately turned into a slight fever. I was ill by the time I reached Châtellerault; and to crown my misfortune I had to stay for several long days in this unfamiliar town, waiting in an inn for a stage coach or a mail coach to bring me here. I don't advise M. le curé of Louroux to rely on those carriages of which he promised me such an abundance, as he sat comfortably at your dinner table. It's easy to say all this. The one certain fact is that I reached here at last with a definite fever, which I still have and which makes me as thin as a matchstick and as feeble as a piece of touchwood. Only in the last couple of days have I regained a little strength and become slightly more clear-headed. It was a slow fever, recurring daily: no appetite, continual depression and nausea, and such weakness that I felt dizzy whenever I got out of my

[1] This letter, written after the visit referred to in the letter of 28 July 1820 to his sister Henriette, begins with a long discussion of the financial difficulties of the family. It was published by Dupont in its entirety; the concluding paragraph, published by Joubin, and here translated, was wrongly dated 20 September.

armchair. I am at last beginning to recover, thanks to quinine. The fever has begun to abate, the rest will follow.

ও TO FÉLIX GUILLEMARDET[1]

[*Forest of Boixe*] *October* 1820

. . . I should like to leave right at the end of October. I must be in Paris for my picture[2] and I am eager to be finished with it. I didn't tell you that I had a letter from Soulier,[3] a letter from Italy, from Florence. I was very glad, as you can imagine. He is delighted with the country, and Florence, where he is living, is a charming place to stay in. The mountains through which he passed cannot, he says, be painted in words. I hope he will send us a few sketches. All this must seem very new to him. It is an entirely different kind of natural scene from the north. He has passed through Turin, Milan, Bologna, etc. He says he saw, in Bologna, Raphael's painting of St Cecilia, which he says (and I have never known him enthusiastic about Raphael) is the finest thing he has ever seen. In fact, such a picture, seen in isolation, must make a tremendous impression. . . .

ও TO FÉLIX GUILLEMARDET

Souillac,[4] 20 *October* 1820

. . . Unfortunately I think we are pursued by bad luck on our travels, you people in Normandy and myself in my trips to the south. The weather, which had been wonderful till the day before we set off, changed suddenly. The previous evening it had begun to rain. It rained incessantly next day and the days that followed, and thanks to some springs breaking on the bad roads we were much delayed and forced to stop off at inns. That's why I am only answering you now. I am housebound the entire day. It rains continually, and it is impossible to enjoy the splendid views which are to be seen on every side. I sympathise all the more from my own experience with the disappointment and regrets you must have endured on your brief trip to Dieppe. The sea loses almost all its charms in grey rainy weather. It is monotonous, and the water looks dirty. The waves become blurred,

[1] The bulk of this letter deals with Pierret's marriage and reproduces the ideas expressed in the letter of 2 or 3 October to Pierret.
[2] *The Virgin of the Sacred Heart.*
[3] Soulier was a secretary at the French Legation in Florence. See below, p. 86, n. 1.
[4] He was staying in a country house belonging to his brother-in-law de Verninac, a native of Souillac in the Périgord.

79

and you lose that variety of shades and hues that the sea takes on in bright sunlight, reflecting a blue sky. Tempests and storms are another matter, not like the continuous rain which I gather you had. Still, it's something to have seen the sea, whatever it was like, and I am chiefly glad for Pierret's sake, since he had no conception of it. For I imagine you had retained some recollection of it. That is certainly a trip that we should enjoy doing all three together, in fine weather. That is the prime condition of enjoyment in excursions of that sort.

From the lofty detachment with which you speak of documents and deeds I assume that you are on holiday. I did not know: this somewhat reconciles me to solicitors' offices. It's something to allow the poor orphan a couple of months' breathing space, free from stamped papers. Now you are guzzling the fruit of your pillage, and feasting in your eyrie on your bloodstained booty. Poor Pierret won't be taking any holidays. He must now be the most married of men. He has done the right thing. I had sometimes noticed, from certain little incidents, a slight deterioration in his character. But what you told me almost terrifies me. It was like something out of another world. Unquestionably, such a position, if prolonged, would have plunged him into incalculable suffering, and now his peace of mind will be restored. What I long for is to see him work hard at his painting. He would succeed at it, and it would be a powerful standby against all sorts of misfortunes and anxieties.

You are not the only ones, Messieurs, to have seen unfamiliar and beautiful sights. On my way here I came through a great part of the Limousin, which is a splendid region. I saw some most unusual mountains there. And even so, they tell me, we went through the least picturesque part of that region. The finest part is towards the Auvergne. The fact is that I was truly enchanted with what I saw, and yet it was always accompanied by that unending rain. Most of the distances were unfortunately hidden by mist and by a tiresome fine drizzle. It is a vast region, grooved in some parts by broad valleys as far as the eye can reach; more frequently, the valleys are narrow and closed in between immensely tall mountains. The surprising thing is that meadows run from the foot of the mountains right up to their summit, and these are thronged with cattle, feasting on the fresh grass and the clear streams that flow over these beautiful steep hills. The whole thing is intersected by granite rocks of every colour, thrusting through the green here and there or towering overhead alongside the road. Often after travelling for a long while through chestnut woods you suddenly find yourself at a great height, from which your eye can range over a whole chain of small valleys and a little river winding through them and tumbling in a waterfall far

9*a* Tasso in the
 Madhouse, 1824

9*b* Faust and Mephisto

10*a* Tam o' Shanter

10*b* The Giaour

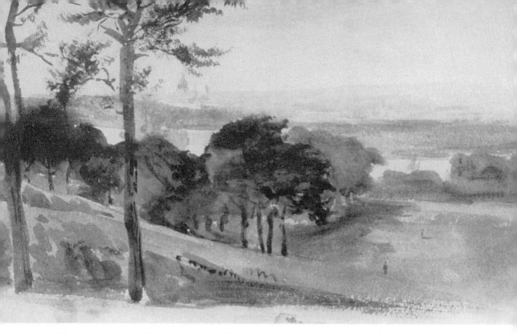

11*a* Landscape near London, from English sketchbook, 1825

11*b* English landscape, from English sketchbook, 1825

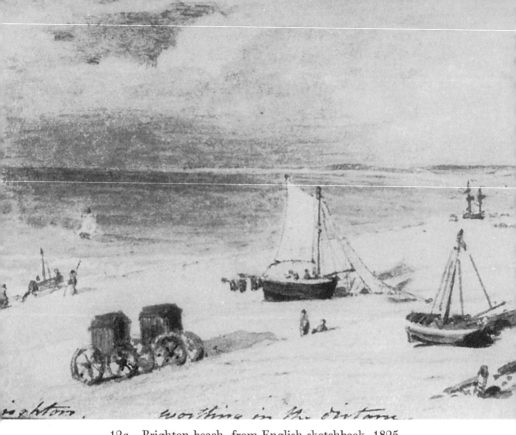

12a Brighton beach, from English sketchbook, 1825

12b Aimée Dalton, 1831

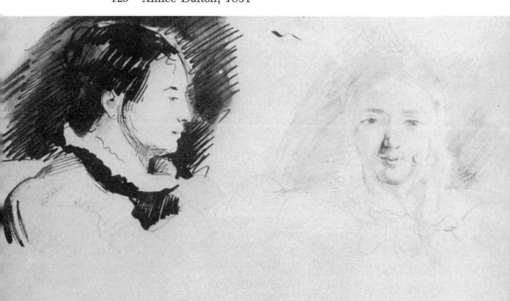

below you, over which you cross on narrow bridges spanning the abyss. It's a great pity, too, that there are so many splendid sights that you don't know which way to turn. The scene changes at every moment. The mountains seem to be playing hide and seek, and the postilion, whose sole object is to get to the next stage as fast as possible, carries you on relentlessly. You have to resign yourself to seeing all these beautiful things slip confusedly before your eyes, and your memory can retain no detail of them. It's true that not everything is lost; one retains a certain recollection of the broad masses which at a pinch could, I am convinced, bring back a great many partly or wholly forgotten things when one takes up the pencil at leisure, especially when one is used to that sort of thing.

I shall soon be taking the coach homewards to see you, my dear friend. The prospect of being together is somewhat spoilt by the thought of your confounded office, to which you'll have to return. But I hope we shall make such good use of the moments when we enjoy each other's company that the boredom of the rest of the time will seem less hard to bear. Let's have a few good evenings when we devote ourselves to serious and profitable things. We have said this a hundred times, I'm sure, and this hundred-and-first will no doubt be as ineffectual as the rest. If at least we each tried to write some sort of essays from the notes we made, my dear cousins, we might show them to one another from time to time. We should thus turn to good account those valuable lessons, from which I confess I have reaped little benefit. I feel more and more the need to exert myself in those strenuous occupations which are so necessary for a man who seeks to be as much of a man as he's got it in him to be. We are living in tempestuous times, when thunderbolts are liable to strike anyone, and even if this storm-tossed passage were all of life that we had to endure, we should find continual support in a steadfast philosophy. I must tell you that I had left my page to dry when I reached the bottom of it, and then being distracted by the pleasant news of dinner, I went downstairs without turning over the page. I might have found some fine things to say to you about the philosophy of the last century, but now I'm starting again immediately on leaving the table, where I behaved like a man who had never studied under anyone but the famous Grimod de la Reynière.[1] I can tell you, I'm fairly eating myself to death. The meals we ate in the Charente are nothing compared with these. In spite of the most strenuous resolution one slips unawares from *hors d'œuvres* to *entrées*, from *entrées* to roasts and endless side dishes that tempt one's miserable belly, which yawns the wider the fuller it gets. I don't deserve to be talked to about philosophy. I'm a slave to my senses. As a result of my

[1] Author of *Almanach des Gourmands*.

fever, which made all food distasteful to me, I now have the most inordinate appetite I've ever seen in anybody. . . .

cᴣ TO J.-B. PIERRET

Souillac, 20 October 1820

. . . When I open your letter I am like a man into whose eyes the cold air brings tears that blur his sight as he gazes at a fine landscape. My mind cannot scan the lines calmly. I hurry on, then I go back; I begin again: since I feel quite sure of my treasure, since it is in the pocket of my waistcoat and never leaves me, I linger over my enjoyment of it; I recall some passage that I don't know by heart; then I open the letter again and when I have admired, yet again, those four ink-blackened pages, so full of affectionate friendship, I feel as if I were receiving a fresh letter and I enjoy a fresh delight. These are my childish whims; they are dear to me at least, and I despise any man who'd be ashamed of them; I'm putting it badly: the hearts of such men would be unworthy to experience pure emotions and incapable of doing so. Is it really true that I have a friend whose letters alone are enough to give me moments of such sweetness? I have his heart itself, of which I'm sure they are only the dim reflection. There is such warmth in your letters that one feels all the more strongly that the full warmth of your nature is not revealed in them. Of all those to whom my heart has clung, and from whom, alas, I have become estranged, how few have written me letters like yours. It's really true: there is no one but you. One man would write just as he thought, but he had no thoughts and no feelings. Another friend would write elaborate letters, not to express his heart's impulses so much as to express them in a certain fashion and to ape Rousseau. There are others who have kind hearts and who are, I'm sure, true and staunch friends. But their writing emits a sort of heaviness and chill that depresses you as you read. Truly, the way people write is a touchstone. The most affected man involuntarily shows himself in his true colours, while another who may seem cold in ordinary life reveals springs of ardent feeling in his letters. The pity is that it takes so long to receive them. Many an evening one goes to bed like a man who has missed his supper, many a day one spends waiting for that confounded courier. You'll write an answer to me here, won't you, my dear fellow?

I am in my brother-in-law's native province. I have every sort of kind attention lavished on me. These people are good kind souls, and they spend endless time preparing food. Meals last four hours, because towards the close childhood memories are revived and stir up the

82

emotions of brothers and sisters who have grown old and wrinkled far apart from one another. And then political discussions have their turn. My brother-in-law aims at being elected deputy. I don't expect he will be nominated here this year; he might be in the Charente.

I shall only just have time to receive your answer before I leave. So I count on your punctuality. I am in the loveliest valley imaginable. The journey here from the Forest was a great delight to me. I travelled through part of the Limousin and that is really worth seeing. Endless huge mountains clothed with green pastures to the very top. Great rocks of red, black and grey granite hang over your head. The view changes at every step. You're continually looking from side to side. These magnificent landscapes escape you before you can take them in. The post-horse and the postilion, who do not appreciate fine scenery, drag you on relentlessly. Deep down at the foot of these tall, sheer mountain cliffs run tiny rivers, clear or foaming, winding between high banks thick with alders and poplars, or falling in water-falls which can be heard a long way off. No dwellings, or hardly any. A few dark, isolated chalets perched on the hillsides. You should see how the oxen and horses and sheep enjoy themselves there. They go where the grass attracts them; they wander freely up and down, and bathe at leisure in the streams. Oh, my delight was equalled only by my wish to linger. But one would have to spend whole months there to reap any fruit. A sketch can never be enough. The outlines of these lovely blue mountains are so fluid and so varied, so delicate, so elusive, that they would need to be studied closely. Here again, you'd miss your friends. You feel the need of those friends everywhere. All the spring of happiness are like springs of mineral water, partly hot and partly cold, cloudy and yet limpid. One side always seems bitterer because the other is more delectable. We shall soon see each other again. I think I am going to be left to myself again this winter. The idea of that picture[1] that I have to paint haunts me like a spectre. I should really have liked to be able to go back to my studio immediately. Oh, what a blockhead I am! I tried more than once to draw while I was ill, and what distressed me most of all was that everything I tried to do for my picture was quite worthless. I was far more concerned with all the foolish thoughts that passed through my head. It's not commonly realised what a variety of things can occupy one at a time. We are always inattentive; we are never masters of ourselves. We never have all our forces under our control. We fritter away our lives over a thousand trifles which lead to nothing. The mind loses its resilience; it yields, feebly, before the least difficulty. One is satisfied with having made an attempt: one is almost proud of having thought of doing so.

[1] *The Virgin of the Sacred Heart.*

A man who leaves his bed at eight or nine, weary after a bad night, and who goes straight from there to sink into a cushioned armchair by the fire, while other people go out shooting; who swallows his two doses of quinine while they eat their luncheon, and who watches his days slip by, slowly indeed yet under his eyes and within his grasp, who is all mind while his body can neither walk nor eat nor digest; who is in full possession of himself until fever, with its premonitory shivers, creeps to the very root of his nerves and sends him back to bed to philosophise, such a man unquestionably lives in an unfamiliar world; what plans, what undertakings he imagines, which daunt neither his mind nor his physical powers! He immerses himself doggedly in his task. Gazing blankly into the fire, he ponders his theme without remission, and even at night, when he lies in pain, his ideas escort him to beguile his weariness. That's what I was like during my fever. Food repelled and nauseated me. Night brought nothing but fatigue, I could not take two steps without a fit of dizziness. I could not write without feeling my head split. But when I dwelt on my daydreams my brain worked intensely and untiringly. I made plans of every sort, I tackled every kind of thing. The pity is that scarcely any of this is left, because I only set to it when I was beginning to grow used to my fever, which was by then starting to abate under the influence of quinine and other drugs.

And so my genius for composition vanished at the same time as my much abused fever. What a great disappointment for all those who might have read my work! It was a great pity, too. I find rhyming hard. I am a real barbarian. I hammered little words into my cramped, bunched-up lines.[1] It had almost become a duty and a pleasure to me. Alas, my dear friend, nothing is easy. How is one to make something that is complete, condensed and yet flowing? Painting and poetry, it's all the same, with the same frustrations. You have to go back to it often with fresh tools. You need a fearless eye which will span abysses without flinching. It's not enough for the springs of imagination to be active and fertile: you need a firm and subtle mind, concentrated and yet able to expand, to bear the weight of invention, to sustain it throughout and develop it without brushing off that evanescent bloom that colours thought while it is still thought, and which fades so rapidly when thought has assumed its visible and concrete form. How great really great men are! I picture those mighty geniuses in the throes of composition, working with steady wisdom on that high ground aglow with volcanic fires! The union of such gifts is the secret of true greatness. Half-men have one or the other of them. Some are richly endowed but weak-spirited; others are second-rate, wretched

[1] See letter to Pierret, 22 September 1819.

plodders. Let us strive then, since it is so hard to follow both these paths at once, to take a few steps along them together. Dear painter, dear bridegroom, dear father that you are, let us, above all, be good friends. *That* we shall be for a long time, I hope. Death, when it takes one of us away, will deprive the other of a friend, and that is something even rarer than the great men of whom we were speaking. Run over your acquaintance in your mind and see how many men of no more than forty have kept a single true friend. I can think of none; and up till now I have known only one, my good and honourable father, who died in his sixties[1] and still retained his boyish affection for two or three old friends. I was forgetting my mother, who left several whose eyes still fill with tears when they recall her blessed memory. Oh, I am not being blinded by my fondness for those beloved figures. Certain passages of your letter, revealing your filial devotion, touched me deeply. There is always the same cruel blend. The more one has loved, the bitterer are one's tears. But I shall not end my letter on such a note. I should like to say something more to you about the joy I look forward to sharing with you when I see you again. Perhaps when I've had your answer I shall not find time to reply myself. Shan't I talk to you, then, for three whole weeks? But how I shall talk to you then; how I shall gaze at you! What funny things we shall say to one another. "So it's you, poor boy!" "It's you, my good friend!" "You've been ill!" "You're a father!" And dear Félix too, with his kindly face. Now that I think of it, if you were to read him part of this letter, which is by no means necessary, don't let him see how long it is or how full the pages are. These good people distract my attention so, and I'm surrounded most of the time by so much noise that it is through a stroke of luck, for which I'm thankful, that I have found a moment's calm and quiet so that I've been able to pack my lines a little closer and let my streams somewhat overflow the banks through which I was wandering at random. I had moreover meant to tackle a certain point in your letter dealing with preferences among friends. But that is a very delicate matter; you can't touch it without going a little too deep. Conversation in writing is too precise and lacks the flexibility of conversation, protected by a deep-rooted and understanding friendship that grasps a man's feelings half-spoken, and reads them in his eyes. Do you remember a certain conversation we had together about something of this sort? I even recall the circumstances. It was on the Pont Royal, and I think it was at night. *Id se te fefellit*, we'll go on with our discussion by the fireside. It seems to me (and like you, I whisper it so softly that I don't even want to hear it myself) that in the secret depths of your heart you should . . . but I've already said too much to myself

[1] Charles Delacroix died in 1805.

and I am almost sorry to have said so much to you, so that I'm tempted to ask you to burn my letter. And yet, no; you probably, like myself, have some ark in which you conceal what the outside world must not see. Well, my friend, I tell you frankly: I'm very sorry that is so, and I wager that your heart would say the same thing in my place. But after all one is not responsible for one's heart's inclinations, any more than for its position between a pair of lungs for which, equally, one is not responsible.

Goodbye and goodnight: you've tangled up and confused all sorts of feelings in my head. You're a real monster, and yet I am very fond of you. Isn't this like a letter from a mistress to her lover, or *vice versa?* How crazy we are. . . .

↝ TO CHARLES SOULIER
[in Florence]¹

Souillac, 22 October 1820²

. . . Your words brought back to me that evening when I left you, the memory of which will always remain with me. After you had gone into a café I turned away abruptly and walked fast as though to escape from myself, and yet I felt a violent longing to see you again. I was right not to yield, but to bear my grief like a man, otherwise I should have had to watch the carriage vanish as it bore my friend away, gazing after you till the last possible moment. You see, departures are like deaths. When friends part, the hope of seeing one another again counts for nothing. You cling to that last moment when you still enjoy the sight of the one you love. There is one idea that always grieves me: I know that my friend exists and yet he does not exist for me. How precious are letters, at such a time: every line holds fast a treasure: not one word is devoid of interest. And you, who have been so deeply stirred by feelings of another sort, you must know the price of a scrap of paper scribbled over by a beloved hand, steeped as it were in the atmosphere of the person who wrote it and almost bringing you their very odour. Poor wretch, you have had a far harder separation to endure³ and if I know you, it must almost have equalled the pain of

¹ Soulier's employer, the Marquis de Maisonfort, had been appointed to the French Legation in Florence, and Soulier had gone with him.

² Letter begun at Souillac on 22 October, finished in Paris on 24 November. The first part includes a description of Eugène's illness.

³ Soulier had left his mistress behind in Paris. Delacroix later had an affair with her. She is the 'J' of Delacroix's *Journal*, perhaps Julie, wife of General de Coëtlosquet (*Journal*, 27 October 1822, and Huyghe, *Delacroix*, ch. I, n. 14, quoting Roger Leybold).

death itself, being followed by the silence of the grave. And during these two years what anxieties will beset you! But what a fool I am, what sort of comfort is this to offer a poor exile? Think rather of your return and of all the joys it promises. . . .

<p style="text-align:center;">24 *November* 1820</p>

I have glanced back at this letter I had begun, having just received your latest. Good heavens, what trivial stuff I was telling you, with cool detachment, while in Italy my very friendship was being called in question! Excuses can follow later: excuses are nothing; one can always find them or invent them. But friendship is something one cannot find in the depths of one's heart when it's not there, and one cannot find it there when it is insincere. No doubt I was partly to blame, but it was not entirely my fault and my friendship for you, good God, even if I had been the meanest of men or, rather, what most men are, would certainly not have had time to change into that sort of aversion towards you that your letter seems to fear. Alas, no, you're quite right, my friend, to reproach me for your lack of letters; but in your heart, even though you wrote thus, you did not mistrust my love, I'm sure. And I, wretch that I am, crazy insatiable fool that I am, was starting to reproach you too; when I received your first letter which did me so much good, I already felt that you had been too slow about it. What does a three months' delay matter? Oh, when I received that second letter, your writing, which on the first occasion had touched me with so pure, so keen a joy, made me tremble. I knew what it said before reading a word of it. My mind anticipated the full weight of every line before my eyes could scan it. You doubted me, my friend. Tell me, did you really doubt me? No, no, because you know me well and you know there is no guile in me. What impelled me to become your friend? What made me need to see you every day? Why was I constantly with you? Was there any sort of material interest in our attachment? Did we make any great profits together? God knows what these were! Did we have extraordinary things to tell one another, ever new and ever instructive? Had we, in short, anything to gain by loving one another? No, nothing at all. We almost always told each other the same things and I always enjoyed them with fresh pleasure. The pleasure we tasted would to most people seem very commonplace; but the memory of it will remain as deeply engraved in my heart as that of the keenest happiness. How sweet was the easy and careless confidence with which we opened our hearts to one another, among meadows and trees, during our delightful walks and over our simple meals! We did not roam together through entrancing valleys or fine

mountains: but everything was delicious. We were together, and all our feelings were shared. Tell me, do you believe my attention was feigned when I listened to you telling me all your life's adventures or speaking to me about your love affairs? Do you believe that I did not love you for your artless trust in one who was as trusting and as expansive as yourself? How I loved you when we planned pictures together, when we spoke of sunsets and picturesque scenes! Didn't you take me to see your mother and sister? Haven't I shared a meal with you in your home? I ate your bread as though it were some fraternal Eucharist, blessed by the presence of your good mother. Oh, your letter made me most unhappy. That *vous*, so distressingly substituted for the *tu* which had delighted me in the other letter, confirmed, from the very beginning, the fears I had only too keenly felt when I first cast my eyes on the address. One thing alone afforded me some comfort, and that is the delightful thought that I may have a letter from my friend every fortnight. Oh, this one of mine won't stay long on my table. It won't grow old in my pocket. It has already caused me too much distress, and it should, *long time* [sic], have crossed the mountains.

The Souillac which you see at the head of my letter is the home of my brother-in-law, where I have been spending a month. Only here was I able to start writing. Hardly recovered from my fever, still languishing and weak, like a poor wilting weed, I left the Forest to travel hither. And how I had to snatch my opportunities, during the first days of my stay here, to escape the crowds of over-obliging people who sought me out in all the corners to which I had retired to think about Florence and Paris, and who declared that an invalid ought to amuse himself, not study! The fools, not to see where my pleasure lay! I thought I was rid of that dreadful fever. Alas, I quickly relapsed. The second bout of fever was a violent one. However, time was pressing; we had to return to Paris. My nephew had to go back to school, and I myself was determined to go home. I thought the change of air might perhaps cure me. I left, therefore, with my sister and my brother-in-law. At Limoges it proved impossible to get seats in any mail coach or stage coach, and equally impossible by way of Bordeaux. Would you believe it? We had to return to the Forest and travel over sixty leagues. From the Forest we had no alternative but to resign ourselves to travelling with our own carriage and horses by short stages, until we could find seats in some conveyance. After many misadventures I eventually reached Paris, as feverish as I had been before. It's true that it now allows me a few days' respite. But when it returns, it's farewell to painting and everything else. I have to give it all up. You can picture my distress.

Must I tell the whole truth? My strongest excuse will seem the weakest to you. If only you could make me picture Florence otherwise than as one of those far-off regions which the imagination can scarcely reach: it seemed to me that it took an endless time for a letter to come to me and that I should never be able to write close enough and small enough and be sparing enough of the paper that has to travel such a great distance! Now you know my bad reasons, we've made peace. I haven't forgotten the little boy's[1] portrait which you commissioned me to do. Having only just arrived, and being still weak with fever, I am going to wait a little longer so that illness may not hinder me or lead to any awkwardness. I can't go and see your mother, keenly as I wish to, nor dear Pierret who often thinks of you. This unending fever means unending frustration on all sides. . . .

You lucky rascal to be seeing Italy! You're not laid up with the fever. You're not shivering by the side of the fire! You have noble-natured men to see, and signoras to console. But no Ronzi.[2] That surprises me. So there is no one like her in the world, that adorable woman? And at Easter we shall lose her! I shall lose her! You haven't yet told me how to get my letters to you free of charge. When are you going to let me make the acquaintance of M. Mauche?

I have done a little water-colour painting these holidays. I saw some magnificent mountains while crossing the Limousin. I saw some admirable scenery, but I was missing you all the while, and the pitiless postilions were concerned only with getting to the next stage, regardless of my ecstasies. How I shall write to you, how you'll write to me and tell me at great length about all you are doing! I am longing to see some of your painting. You are living among worthy people who cannot but be helpful to you. As for myself, I can only see through a mist the day when I shall go to Italy. . . .

ᥣ TO J.-B. PIERRET

Souillac, 29 October 1820

You're quite right. One does not write to a friend as if one were copying a minister's order. For me, at any rate, it is an important matter, but a delightful one. Next to the pleasure of hearing from a friend, writing to him is the best use of one's time; it would distress me deeply to have to write in haste to one I love. I find it difficult enough already to drag

[1] The son of Soulier's mistress.
[2] An Italian singer who first appeared in Paris in 1819 in *The Barber of Seville* and *Don Giovanni* and whose beauty made a great impression on Delacroix.

out of myself, one by one, the lines I set down on paper. By 'difficult' I mean that one's mind and heart, which are always racing ahead, since they have no legs and need none, one's mind and heart are constantly suggesting a hundred swift, affectionate themes, which to their lightning glance seem clear enough, but which are hard to disentangle, obscure or imperceptible to that other craftsman, style, which grasps them at second or third hand and which elaborates them slowly and painfully. When I think I've caught a glimpse of some idea within myself, I try to pursue it, and I cannot bring myself to say anything commonplace, inessential to my thought. Your instrument has served you well in the letter I have just received. I think I told you in my last letter something of what I feel about yours. I want to say it again. They are as swift and lively as thought itself, the best sort of letter. They reflect the mood you were in when you wrote and you put your whole world into them. When a person knows you and gets a letter from you, he doesn't open it as he might open anyone else's. It's true that in spite of one's intention to read it calmly so as to lose nothing of it, one has reached the end in no time; one's eyes have devoured it, swept it all up; one feels as if one couldn't have read it completely, and yet meanwhile, as if one's eyes had had nothing to do with it, as if one had felt all that you had thought, just as though an electric current had passed directly through one. Unfortunately I seem to remember having told you this a hundred times already; but I have to repeat it every time I read your letters.

The mail takes longer to come here than to the Forest, so that I've already been disappointed several times while waiting for your packet. It reached me at last through the kind offices of Piron. He's a good fellow and I'm very fond of him. I see, from the letter from our dear Félix which accompanies yours, that he is fond of Piron too. I'm very glad of that. This proves that there must be sympathy between us since our affection is reflected even on our friend's friend. Piron is somewhat touchy about friendship, but in his case that proves him a good friend. Félix, I suppose, will soon be going back to work; is he making his mark in his solicitor's office? It is hard on him, admit it: in spite of your difficulties, your lot is a happier one than his, and so is your future. The nature of his character is the only thing that can save him; as for yourself, I already consider you a painter, you're one of the profession.

A letter from Édouard,[1] in reply to one where I told him about my fever, speaks with high praise of Cogniet's[2] picture. It does indeed seem, as you say, that this is the best thing he has done; his latest work

[1] Édouard Bertin (1797-1871), landscape painter, a close friend of Delacroix's.
[2] Léon Cogniet (1794-1880) won the *Prix de Rome* in 1817.

showed little promise. I am very glad he has acquired some substance; but I'm afraid there's no solid rock there yet. He has made a failure of his Italian visit, or so I fear.

We tell each other whatever goes through our heads with such frankness that we shall end by praising ourselves to one another with equal candour. You speak of my 'treasures' as though you yourself were very poor. Is this a result of that so-called virtue, modesty? What is modesty, after all? Does it consist in failing to recognise one's own merits, in not feeling them? That at least is rare. Or in not impressing others with one's superiority, in not boasting of it? That is surely true modesty, if such a thing exists at all. I start from this point to examine myself in all sincerity of heart, and to try to discern what I really think of myself. How good it is when two friends have reached the point where they can disclose to one another those hidden depths where pride lurks. Alas, I have that in plenty and there is nothing to guide it. It sometimes gives me an exaggerated view of myself, but usually it arouses not so much self-esteem as endless disgust with the beaten tracks followed by the mass of mankind. I'm absurdly arrogant enough to sulk and grow indignant when I am wholly unappreciated, and the praises which invariably intoxicate and delight me make me see at the same time how far, how very far I am from any great goal. Why do you praise me and say such excessive things about me? Why are you the only person who, while going far beyond anything my strongest fits of vanity could have suggested to me, has yet restored me somewhat to my proper place? It's a strange thing; before knowing you I always had within me a feeling of pride that was self-consoling and self-sufficing. And now you make me laugh when you talk about my energy and all that rigmarole of treasures you so gratuitously ascribe to me. On the whole, we're all wretched creatures, and any right-minded man will blush for shame at exaggerated praise which flatters him, but which at the same time makes him more intensely aware of his deficiencies, his weakness, his inertia. But listen. One thing your affection for me has rightly revealed to you: you'll always have your share in whatever I produce. Your approval, all alone in one scale, will outweigh everyone else's in the other. Since you were the first to tell me that you felt there was something there in my work, it is right that you should be rewarded for the good you did me and the courage you gave me, by my efforts to please you. Rewarded! I'm speaking to your feelings, so let your mind pass the word without criticism. Such is the power of friendship! I venture to believe that the beauty of my works will pay my debt towards my friend. I began this paragraph of my letter quite coolly, almost for the sake of something to say. It is now so involved and progresses so awkwardly that I wanted to

throw it into the fire. But since it has brought me to this point, I'm grateful to it.

Here then you see the full extent of my ambition and my pride: I ask for your approval; and now I feel some strength in me. But also, please be less indulgent, I must urge you, be harsher than you often are. Criticise relentlessly the works for which I may display a fond father's excessive affection. And if I should disregard your frank opinion, leave me free to do so, whether I deserve such freedom or not, because I want to have my own opinion about my own work. But we feel too much in unison for that. I undertake the same promises towards yourself. I know by my own experience that one often makes a mistake when advising others, and any advice that I may give, however disinterested, is still my own personal advice, that of a man who has his own way of feeling and seeing and, in a word, of being, which cannot coincide at all points with anyone else's. So then I'm going to see you getting down to work at last! Félix tells me you've decided to go to art classes in the evenings this winter. He couldn't have told me anything that would please me more. This is where we'll really get to grips with things. I congratulate your wife on being your wife; I hope she no longer thinks of me as a monster. When one is happy, one forgives easily, as the tragedy says. Besides, she can't hold it against me that I showed my friendship by advising you to follow a path I thought to your advantage. Perhaps you may have told her I am less her enemy than she thought. I believe in your future happiness and can never pray for it enough. . . .

⮂ TO FÉLIX GUILLEMARDET

[*Souillac*] 30 *October* 1820

You are faithful and reliable friends. I am very grateful to you all for not forgetting me; and to yourself in particular. When you are on the point of returning for a long spell in a dusty office, it is no small sacrifice to give up a walk in fine weather to spend an hour or two writing letters. But I'm a fool, and I ought to judge from my own feelings what you must experience when writing to a friend. This is a source of great pleasure. Reading your friend's letter, and writing to him, are the pleasantest occupations in the world. I must admit that reading is even more delightful. Absence is such a distressing thing! How eagerly one fastens on to the paper that brings you your friend's thoughts. One reads his letter with a miser's enjoyment. Not a line can be spared, and when the whole thing has been read one feels an emptiness and a dissatisfaction as great as that caused by parting from

92

the friend himself. I can never envisage a visit to Italy without dreading what I should have to suffer during that long bereavement. I have missed you all so much during these last two or three months. With what eyes, then, shall I read your letters when I have to spend long years far from you, alone in a city of silence and tombs, what ardour I must bring to my study in order to alleviate that *ennui*. There will still be two of you together; you'll have New Year's Eve parties and friendly gatherings. How delightful it would be to go off with a whole party of friends, to bury oneself and find oblivion from the whole world in that land of poetry. *Ma!* . . . as the Italians say: *Ma*, forever *Ma* in this world's affairs. If I dared, I'd get married . . . *Ma!* . . . I should like to be a philosopher, able to stand up to the countless afflictions that distress and overwhelm me, and deserve only contempt from a lofty soul. . . . Once again, *Ma!* And yet this last point is just what one ought to start from: once one had achieved this, all the *Mas* that spring from the vexations of this life would lose their stings, would vanish in smoke at the first thrust of a secure and firmly-based philosophy. Do you agree that we shouldn't wear out our shoe-leather pointlessly on the pavement of the rue Saint-Jacques,[1] since we should gain little learning thereby? When we leave the place we go strolling in the sun and enjoying ourselves, like Academicians who have their attendance-tokens in their pocket and walk down the steps of the Institut with beaming faces and self-satisfied airs. More: not content with insulting the sanctity of the subject-matter by our lack of diligence in studying it, we make pitiless fun of those earnest swotters who take down every word, inscribing even *Gentlemen* in their note-books and who for two pins would add sugar-and-water, spectacles and an *Ave Maria* if there was one. What crimes! We've been committing them all year. And then when you have a fever you'll complain like a woman, and show innumerable kindred weaknesses. To have done with this subject, let's wait and see whether our strength remains inferior to our intentions.

I am very glad to see that you appreciate Piron. He's a good lad, sincerely devoted to his friends. If he's rather apt to take offence at the slightest remissness, it's because he is never remiss himself, and does everything possible to be useful to them. I have become very fond of him. The last year I spent at the Lycée I had practically no dealings with anyone else: we endured together the fury of Master Burnouf, we dozed together during endless sessions with that phlegmatic Dubos who had, I believe, the secret of halting Time's eternal hour-glass. During the interminable classes, the wearisome explanations, the tedious readings of these gentlemen's prose, we consoled ourselves

[1] Near the university.

with rhyming couplets, satirical songs and other such nonsense which had the advantage of amusing us. I always remember that time with pleasure, and the thought of Piron, which is associated with it, made me even fonder of him. He has considerable courage, too, he keeps on studying: he started Italian quite a while ago, and without any teacher save his grammar he has made noticeable progress. He has one great fault, that's a fear of making a fool of himself which would make him go to any length. This is an unfortunate failing.

I shall not ask you to answer this letter, because I shall be back in Paris soon after you receive it. I'm in two minds about this. I am longing impatiently for that moment: but how boring the coach journey will be: especially on that confounded road which is just an endless series of ups and downs: uphill, downhill and then you begin again. I think I'd more willingly push the coach myself than resign myself to being slowly conveyed through all these vicissitudes. However, I shall get there at last, please God, and we'll fall into one another's arms. . . .

♫ TO CHARLES SOULIER

26 *January* 1821

. . . I have at last recovered from my fever. I am livelier and less clumsy, and although the picture I have undertaken[1] takes up a great deal of my time, I shall certainly spare some to go and see your mother and talk about her lazy son. Who can explain this relentless silence? My letter surely cannot have been lost. Raisson sent it in the diplomatic bag, and such dispatches don't go astray. Oh, don't be angry with me. I am too fond of you and I miss you too much not to forget any wrongs you may have done me; do the same for your friend. Everything reminds me of the moments we spent together, and I keep looking round to see if you're there. I have right under my eyes the drawings you made by my side. I see your eyes in that portrait you never let me finish.[2] Even the sound of that tin can of a harpsichord reminds me of your showpiece in F major which you used to perform so well. But when I go outside, your image recurs to me at every step, if only because I compare my usual loneliness with your company, which had become a necessary habit to me. I never pass in front of M. Brant's shop in the rue du Bac without recalling the wretched dinner we ate there together, and the delightful evening that followed it. When I go to the theatre, particularly to the Italians, you can imagine how much I miss you. La Ronzi still flashes those fine eyes we admired so much together.

[1] *The Virgin of the Sacred Heart.*
[2] An unfinished full-length portrait.

You have dozens like her, and that's what makes you forget everything else. You are in a new country. Nothing there reminds you of old habits and old affections. You make love, you paint, and it all has the attraction of novelty. How happy you are to be living in lovely Italy! You have, I'm sure of it, acquired new ideas, learnt more things in the last six months than I have in six years in this obscure corner of a damp and humdrum land. I don't complain of receiving no letters. But surely I have a score of grounds for complaint? Weren't you going to send me some of your drawings, some water-colours to give me a foretaste of that lovely country? You promised to. Worse still, you now promise some to Perpignan, who is an uninitiate, a mere barbarian as far as painting is concerned, and yet these liberally promised gifts are withheld from a poor crazy fool to whom such things are meat and drink. Exciting, unfamiliar landscapes you have seen in plenty. You have worked. But have you written? In a word, you're a monster.

Honestly, though, you owe me two letters for one. You know that I never leave the rut of my familiar life, that if I had to bestir myself to seek some unfamiliar pleasure, I'd rather do without it than stretch myself a little too far out of my shell. I cannot honestly tell you that Paris has streets broad enough to take a regiment abreast. I cannot tell you that there's no mud there, that every house is a palace, every palace a temple, and all the women goddesses. If you'd never been here, I might have done so. I should treat you to all the supposed wonders which, when you were in England, the worthy *émigrés* described in such exaggerated terms. Moreover I am timid in love and the detailed description of my amorous adventures would have no interest for a man who makes love wherever he goes and even travels to the isle of Elba in search of beauties whose hearts he may comfort or break. You're a cruel Lovelace, my friend, nothing is sacred to you, and the gentle doves who flutter recklessly into your clutches are likely to leave their feathers there. Lovelace at least was a scribbler, he gave his friends the benefit of his pleasures and his adventures. So write, quickly and at length. I'm waiting till my next letter to *tutoyer* you, because I'm still rather angry with you.

Dear Pierret, with whom I so often talk about you, is just as puzzled by the whole thing. I hardly see anyone or anything except him, and my picture, over which I am wilting with boredom. What interesting news can I tell you? Yesterday I saw that crazy Raisson. I dined *tête-à-tête* with Philarète[1] at d'Agneau's. We queued up outside the doors of the Odéon, in the coldest weather imaginable, to see *Pourceaugnac*;[2]

[1] Philarète Chasles (1798-1873), writer and Academician, a schoolfellow of Eugène's with whom he later quarrelled.
[2] *Monsieur de Pourceaugnac*, by Molière.

and after waiting a very long time and hanging about, we went home to bed without having managed to get in. This morning I'm writing beside my fire, and poking it in a vain attempt to get warm. You're not cold, though; you can write to your friends without a running nose or frozen fingers. It's nice and warm in Florence. You have bright sunshine there, a blue sky, lush natural beauty and lovely women, oh, heavens! such heads as are never seen in our climes. Ices are cheap there, and you can eat your fill of tagliardini and macaroni. In a word, you enjoy every sort of happiness down in the south, including that happy *insouciance* that springs from the purity of the air and the generosity of the soil and the satisfaction of your desires. Oh, I shall go some day to taste the delights of idleness under an even purer sky than yours. I shall go at dusk to breathe the cool sea air of the Bay of Naples and I shall sleep by day in the shade of an orange grove. I shall go to Rome, to dwell among the dead and to forget everything that is not painting or friendship. Perhaps I shall realise all my brilliant dreams. Alas, I am very sad just now, the weather is so grey and the air so icy cold! Enjoy your Italy to the full.

Farewell, cruel friend, farewell, vindictive man; your looks were misleading, and I, though I am nothing much to look at, have a better nature than you. Nevertheless I embrace you tenderly.

<div style="text-align: right">Your devoted friend</div>

<div style="text-align: center">&cS; TO CHARLES SOULIER</div>

<div style="text-align: center">*Paris*, 21 *February* 1821</div>

. . . You're happy; you make me happy by telling me that. And yet you still complain; but heaven, which makes us wretched beggars from birth, does not intend us to find all our paths strewn with flowers nor all our food and drink ambrosia and nectar. You miss Paris, and I miss you and that Tuscany which I don't know. Paris is my aversion: its noise, its damp filth and the harsh cries of hawkers and beggars repel and irritate me. Since I love solitude, I see that I can never be happy in a place like this. But a lovely sky, expressive faces, a thousand delights, that Italy in a word with all its enchantments, that is what one longs for ardently when one lives in the north and when one cares neither for the so-called pleasures of high society nor the dissipations of low life. Take full advantage of the days you will spend in Florence, which will pass all too swiftly. They're not like the days one spends in Paris, and it's a crime to be bored in such a country. But alas, it's only too true that a man always carried with him that heart and that imagination that are the source of his joys, but even more of his

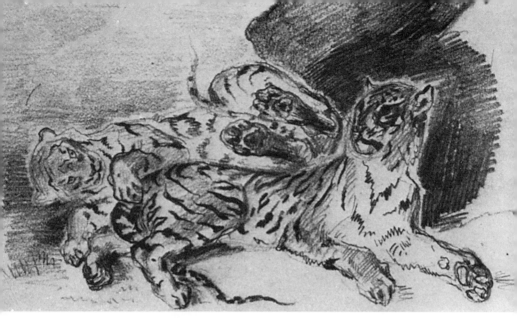

13*a* Young tiger playing with its mother

13*b* Lion

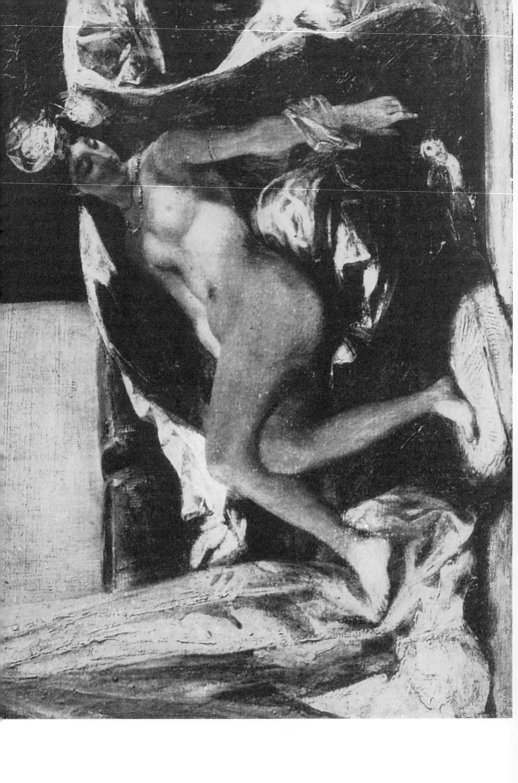

15a, b Studies for Liberty Leading the People, 1830

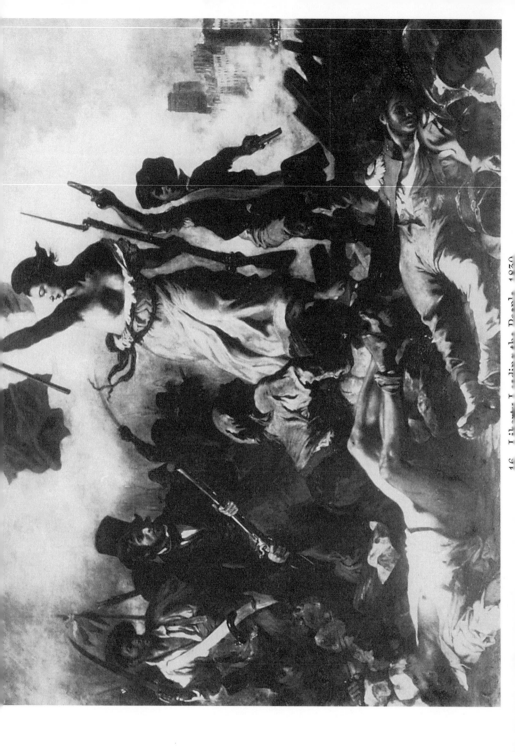

16. Liberty Leading the People, 1830.

miseries. Try as one will, one always sees within oneself a gulf, an abyss which is never filled. One is always longing for something that never comes. There's always a sense of emptiness, never an abundance, a full draught of happiness. At least you are working, and it's most important to store up your memories for the time when, back in the land of fogs, you will regret your past happiness. How glad I shall be, when you return, to look through all your countless albums and port-folios. Each page will remind you of something happy and will arouse in me the desire to go and see things for myself. When I think of seeing you again I'm wild with delight. I needed you so much and I've not ceased to miss you for one moment.

I often go to see Guillemardet, who now lives in the rue Louis-le-Grand, close, if you remember, to the Place Vendôme. Well, I always feel that I'm going to see my friend on the eighth floor.[1] What happy memories I have of those days! When I went to visit you, the way never seemed long, because I was thinking of the pleasure of spending my time with you; but when I had turned the corner and could look up at your little window, I began to tremble for fear I shouldn't find you in. I was always so disappointed when Oudard told me, "Monsieur, he's just gone out". And when, of an evening, I saw a light in the attic window, I felt like Leander seeing his torch shine through the mist. Yet you're not my mistress, dear friend: but love and friendship are closely akin for me.

I am miserable, I'm not in love with anyone. I cannot be happy, lacking that delicious torment. I have only vain dreams that disturb me and satisfy nothing at all. I was so happy when I was unhappily in love! There was something exciting even in my jealousy, and in my present state of indifference I am no better than a living corpse. In order to live truly, in my own way, that is to say through my feelings and passions, I am obliged to seek these joys from painting, to wrest them from my art by force. But this is not nature's way, and when I fall back on my own empty heart, weighed down by an *ennui* that I've beguiled and distracted by artificial means, I feel only too well that my flame needs sustenance and that I should paint very differently if I were kept constantly in suspense by the sweet excitement of love.

I've been working at my picture since the beginning of January. It's starting to take shape, but I feel uninspired, I'm groping my way. There has been no sudden flash of light to show me, right from the start, the path I'm to follow. I do something, then I undo it, then I begin again, and still I haven't found what I'm looking for. It is true that I had a fresh bout of the fever from which I had recovered, and so I was left short of time for my work. I hope, however, that when spring

[1] See letter to Soulier, 10 December 1818. n. 5.

comes I shall be quite myself again. But I remember that your last letter but one gave me distressing news of your own health. What does this mean, my dear fellow? I thought that the pure air of the country you're living in and the regular life you are leading would have put an end to those vapours, those frequent fits of malaise that so often affected you here. Take your health seriously, neglect no effort to get rid of any sort of weakness in yourself. Don't say it doesn't matter, because you must put an end to it. What you must not do is to live in a languid, half-alive or rather dead condition. To recover your health you need no drugs or remedies. The best thing would be to live as simply as possible. Eat little, drink little and go to bed early. That is the universal panacea. You'll be quite surprised to discover a doctor in the painter you left behind you. My science is neither lengthy nor complicated, and if you believe me you'll get well again very easily. Remember that you felt much better last year, when we often went to have dinner in the country and took some good walks. You used to go home tired out with healthy exercise, rather than wearied by some tedious entertainment or by playing billiards or sitting in cafés. Your digestion improved, you felt better and your spirits were brighter. Health, that tiresome thing, is so essential to one's work, it sheds a fresh and happy light over everything. So send me a few little things; and carry out the plan you mention of selling your drawings; you can be sure I shall spare no effort to get things going for you: you remember my acquaintance with our friend Lopez,[1] and his with the worthy Mme Perdoux.[2] You can thus count on the success of my efforts. I am so very anxious to see what you have done and how Italy has inspired you.

I am delighted to hear that you met Planat[3] in Florence. He used to be a very good fellow. At school he had a great passion for drawing and was very good at it. He must be doing well now. You don't tell me if he has really taken the plunge and become a painter for good, or if he still drags some shackles around like yourself. I shall have to visit that Tuscany of yours some day to rescue you all from your slavery, like a second Messiah, and fling you all into the arms of Painting, that kind indulgent mother who will forgive you for having, for a while, devoted part of your time to trivialities. For that matter, what are artists, whether good or bad? Good artists are truly wise men, who live in the innocent enjoyment of their souls and all their faculties; bad artists are fools who delight in playing with their baubles, and who are

[1] Landscape painter.
[2] Dealer in prints and drawings.
[3] Pierre Planat (1792-1866), painter of portraits and religious subjects. He is mentioned in the *Journal*, 1822-3.

not more to be pitied than those who sell their time and their consciences to serve other people's follies. . . .

30 *March* 1821

I received your drawings just over a week ago, dear friend. I took them to Mme Perdoux's straight away to try to dispose of them, and I didn't want to write to you before I could give you her answer. I shall not tell you at this point what I thought of your drawings, I shall talk about that later on. But here's the opinion of the lady, who gave them back to me yesterday saying that you were unknown, and that this would make it difficult to sell them, because it's important to realise that the ridiculous patrons who buy such things go by the artist's name and not by the quality of his work. In the second place, the drawings were thought to be insufficiently finished, and the sites insufficiently interesting. There was one other appalling disadvantage: two of these water-colours had been mounted on cardboard, and that alone, even in the case of a well known artist, would have been enough to keep them from ever leaving the shop. You must know that such drawings are almost all bought for albums, which are all the rage just now. A plain sheet of paper, which allows for a margin, is easier to paste into an album, and it was in view of this ultimate fate that the shape of your drawings was considered unsuitable. Now you have the key to the public's taste. Mine, fortunately, does not coincide with it. I recognised great progress in what you sent me. I was astonished at the ease with which you rendered the warm tone that is characteristic of your Italy. I don't know by what instinct you assigned to me the drawing I liked best in the whole collection. Why didn't you finish it, you wretch? It's the best thing you have done. I can't convey to you the pleasure it gives me every day. It would be quite enough, by itself, to send me off to Italy. God, what a country! What, do you have skies like that? Mountains like those? I'm not joking, that confounded picture quite went to my head and I was already making a whole crowd of wonderful plans to go and squander my little income in Tuscany by your side, my dear friend. But let's not talk of all that. I shall never have the strength of mind to take such a decision, and I shall rot for the rest of my life where heaven set me down in the first place. The sepia drawings are charming and the two others also, especially the mountain landscape where figures that look like bandits are standing. I did not care so much for the drawing you sent Perpignan. He likes it very much, though, and I did my utmost to convince him that it was the

best of all. I feel that those great black trees in the foreground don't look right. The background colour is good. I forgot to tell you that Mme Perdoux's art-loving customers like your figure studies very much. You must work at that side of things. You should sketch a great deal from nature and from prints. I saw a lot of drawings being sold at her place thanks entirely to the artists being well known, for I could see no other merit in them; they were insipid, undistinguished and badly coloured. Don't lose heart over all this. I shall find a way first of all to dispose of these. As for those you next send to be sold, take rather more care over your trees. Do them more delicately. See that the shape of your drawings is more suitable for albums, leave a margin round them and don't mount them. Choose subjects with more things in them; the mountain scene, for instance, was excellent in that respect. You should also try to keep your buildings more upright; this fault of yours gives your drawings a slovenly look that such people cannot stand.

That fellow Perpignan, it must be admitted, is a real barbarian and quite shameless. When he wanted to hang the walls of his apartment with drawings, he proposed to order half a dozen from you without more ado. I made him feel ashamed of this and we agreed that he would pay for them when he got them. And on that point, my dear fellow, you mustn't weaken! A man who has just made over fifty thousand francs by speculating and who spends as little as he does is surely in a position to support the arts.

Your second letter gave me great delight. Pierret looks forward eagerly to hearing from you; and I hope for another letter soon. I don't quite understand what you mean when you say that the French don't sufficiently appreciate their own country. Isn't Italy enough to console you for leaving France, or does your longing for those you have left behind you prevent you from enjoying the country in which you are living?

Please give me some details about your Tuscany. Are the people fine-looking, is it cheap to live there, could one easily find a studio and are rents very high? Is there any life class where one could draw from the nude, or any painters who have studios and take pupils? All these are rather vague questions; but after all who knows what may happen, and if all this Italian business were to work out, if my friend felt at all certain of staying for some time longer in Florence, if I for my part managed to get my affairs straight? Alas, though, I'm deceiving myself; a change of scene only means a change of suffering. Life is so monotonous, it so soon makes everything seem boring! My whole being yearns for Italy: I spend whole hours with my head in my hands, staring at your drawing. That sky, that landscape enchant me

and fill me with sweet melancholy. When I compare it all to gloomy Paris I feel amazed at still being here; and yet I fear I shall stay here a long time. Come though, I don't want to think of all that any longer. Think of next year's Salon. You've got to cover its walls with your water-colours and oil paintings. That's where you will really get yourself known. I'm eager to see what you've brought back from your journey to the isle of Elba. Tell me something about that region. What is the sea like there? Are the people there as stupid as they are in France? Are the peasants there mere beasts of burden? Do you hear street-cries of old clothes and rabbit-skins? You tell me nothing about your love affairs. Could you have become virtuous? Are Bonnard and Planat talented? A few details, please, you heartless creature. You've grown quite accustomed to the country in which you've been living for the past six months. But you must help me to get to know it a little.

You ask me in your letter, I think, whether the picture I'm working at is the *Sacred Heart*. You're quite right, it is. My brute of a fever has prevented me from finishing it. It's been dragging on for a long time, though.

I have heard no news of Adrien.[1] I don't know if it will be easy to get leave from school for him to sit to me. In any case I'm still at your disposal for that.

Spring will soon be here again. Everything must be bursting into flower and growing lovelier all around you! Alas, the season is drawing near of our last year's expeditions – Saint-Germain, Les Carrières, Asnières, Mme Dommage's – and all our adventures along the way! Bring me back those days. I am alone, depressed, bored, sick at heart. How happy we should be together under a bright sky, on that mad Italian sea, or in the countryside around Florence! But we should no sooner be there together than you'd be recalled, and we'd be parted again. That's when I should be really alone; no friends, no memories in that unfamiliar land. . . .

Farewell, farewell, keep well and try to dream of nothing but painting, or of money like Perpignan: but as for love or friendship, they're too heartbreaking. There's always some secret misery concealed there. My fondest embraces.

ॐ TO CHARLES SOULIER
[in Naples]
Paris, 50 *April* 1821

Where will you be when this letter, more fortunate than its writer, reaches you? In Rome, at the foot of the Coliseum or in Raphael's

[1] The son of Soulier's mistress.

Stanze? You're in Rome, and you don't write! At first, being uncertain whether they would forward anything I wrote to you in Florence, I had resigned myself to waiting. But there's something that torments me inwardly when I think of you. I have not been your boon companion for nothing. When I don't hear from you I have to talk to you, and I have to use the post since it is the only means left me. I was called on lately by a gentleman who did not give his name and who had news to give me, according to my porter, of the duke of Tuscany. But the porter's wife declared he had said Monsieur Soulier in Tuscany, and I was inclined to agree with the porter's wife. Alas, I was out when this fine gentleman called and I've waited for him in vain for the last three or four days. Seeing a man who has seen you would be almost like seeing you myself! No, indeed, nothing can represent an absent friend. Memories themselves are merely regrets. But at least I could ask the good man for some details. Perhaps he may have a letter for me, which he hadn't the sense to leave, nor even his address so that I could go and hunt him out. And so I keep fancying that I see the door open to let in this messenger of consolation, and I sit sighing in vain. I am sure that you're in Rome and that it seems quite natural to you now that you're there. You're wasting your time, I'm sure. You spend it drinking and wenching instead of seeing everything and taking advantage of everything and drinking in that air which must intoxicate the mind and fill it with ideas. But you can find wenches everywhere, and when you are back here, where they're 'no rarer than in Ferrara', you'll say like a booby, "Oh, I didn't look closely enough at this. I didn't see that. There was a most interesting view which I could have sketched in a quarter of an hour. I didn't bother to do so because I was convinced I should remember it." For that matter, this is the common fate of travellers. One gets so soon accustomed to a way of life! However delightful it may be, one soon takes it for granted. Oh, I am well aware of that. What could have been more delightful than our companionship on those joyous excursions into the country? I was very happy then; but I did not feel as intensely as I do today. And in love, above all, what regrets and what despair one feels for a quarter of an hour wasted, a happiness insufficiently appreciated! Relish those fleeting moments, then, enjoy them to the full. You'll go to Naples, no doubt, that loveliest and saddest region on earth. I advise you, as strongly as possible, not to neglect the slightest sketch you can find time to make. Your whole journey will live again in these notes. A drawing, however faint and indistinct, is better than the most accurate description. You may perhaps see a touch of selfishness in my suggestion, but I think it's not excessive, because, not to speak of my own pleasure, you will be storing up keen delight for yourself. Painting is life itself. It is nature

transmitted to the soul without an intermediary, without a veil, without rules or conventions. Music is vague. Poetry is vague. Sculpture requires a convention. But painting, particularly landscape painting, is the thing itself. Poets, musicians and sculptors, I'm not seeking to detract from your glory. Your various lots have their fine sides. Justice to everyone! *À propos* of painting, I have had no more news of the little fellow whose portrait I was to paint. I am ready, I am only waiting for my sitter. I remember I'd forgotten to thank you for the charming piece of music you sent me, it was quite delightful and most original. So you're bitten with it too?

30 *July*

. . . I am seized three or four times a month by a strong desire to emigrate to Italy. I've given up the thought of trying for the Academy prize.[1] Since I don't wish to go to Rome in order to eat well and live in a palace, I could subsist there on as little as I do here.

I should dearly love to paint a picture for the next Salon,[2] especially if it would help to make me known. As I am hard pressed with work at this moment, I see little chance of accomplishing this, for there's not much time left before the next exhibition. If only I could get hold of some of those fine heads that are so common in your part of the world! There's a great lack of them hereabouts.

It's some time now since I saw the gentleman I had waited for so long and expected so eagerly at the beginning of my letter, that's to say four or five months ago. It was M. Viéton, your little fellow's tutor, who had a letter to give me from you, introducing me in connection with the portrait. But it happens that the boy won't under any circumstances be given leave from school for this purpose. So I'm obliged, despite my good will, to wait till a little later.

Raisson, who is a pen-pusher, is inexcusable, he has not changed, he's as untruthful and self-satisfied as ever; he'll always be the biggest braggart I know. Oh, I was forgetting to tell you about your mother and sister. We took time off one fine day, Pierret and I, and went to Saint-Germain; unfortunately we got there so late that we could only stay a short time.

Planat is back. I don't know yet what he proposes to do here. He makes me more and more eager to see the country in which you're living.

This year we shall send you a landscape painter[3] to strengthen the

[1] *Prix de Rome.*
[2] The 1822 Salon, at which Delacroix exhibited *Dante and Virgil in the Inferno.*
[3] Remond, a second-rate landscape painter.

103

contingent in Rome and replace Michallon.[1] He's another facile painter, who shows brilliant promise: but hardly a Poussin. I went boozing yesterday with a couple of painters to the Ile Adam. After playing jokes on the landlord and washing down his fried fish with his Suresnes wine, we wandered off into the fields and covered ourselves with mud from the river banks. Afterwards, having inconsiderately tumbled over a haycock, scattering the hay so that at least ninety-nine hundredths of a bundle was irretrievably lost to the farmer, we had a set-to with a dozen haymakers who were coming home from work with their rakes and pitchforks on their backs. They called us various names and we laughed in their faces. Which shocked them so much that they went off without venturing to face up to us, but their voices grew more threatening and their insults coarser the further they went from us. You see, my dear fellow, that I'm having plenty of adventures, and like a faithful friend I make it my duty to tell you them in detail, in order to amuse you.

What! Not a word from Naples? You're really cruel. Don't be angry with me, write me immediately at such length that you won't get it all into your letter. Whenever shall I go there? Tell me whether, in view of the latest development in your affairs, you expect to stay there much longer. Tell me, too, what you have been painting. You ought to send us something. Have you been too busy to sketch Vesuvius and the *lazzaroni*? What splendid heads and legs and torsos there must be among the idlers lying in the sun or wrapped in their cloaks! From the heat we're beginning to feel here I can well imagine what you're enduring there; but the siesta and the sea breeze and the cool nights must alleviate the discomfort. Goodbye, crosspatch; goodbye, you sulky fellow. You've got to forgive my faults, I don't say that I forgive you yet, you're more guilty than I am. I embrace you.

E. Delacroix

ॐ TO ACHILLE PIRON

[Paris, postmark 1821]
Monday, 4 *June*

My dear friend, will you please arrange your affairs tomorrow so that we can go together to the Italians to see the first performance of *Othello*, del Signorissimo Rossini. As I shall have a chance to call on you at the Post Office tomorrow, I shall learn your answer. This is to give you warning in advance. If we could dine together too, so much the better. If M. Laboullaye cared to join us, it would be even more

[1] Michallon (1796-1822), Corot's first master.

delightful. I'm taking the liberty of addressing this letter to the rue Simon to be sure you receive it today.

Goodbye, with my love.

∾ TO CHARLES SOULIER

15 *September* 1821

... How changed I shall find you in every way when we see each other again. So many new things and new people will have made you make progress in every sort of way. One thing disturbs me: I heard that you had lost interest in painting, that your occupations prevented you from devoting yourself to it with any constancy and that you were afraid you might be obliged to give it up entirely. On the other hand you told me in that welcome letter that you were working at it steadily, at any rate as much as your daily tasks allowed you. Was that to gild the pill for me, and are you trying to beguile me into believing that I shall have you for a fellow-worker some day, and that I shall find a painter of real talent in so dear a friend, whereas in fact your resolution is failing? Can the love of painting have been kindled within you in this cold land I live in, only to abandon you in Italy and in Naples? I tell you that painting may some day prove your true foster-mother, and offer you the chance of a great fortune. Devote to it every moment that you can spare from your duties or from remembering your friends. We have no true painters nowadays in the style that you have taken up, and you would still be a highly original painter even among men of talent. Connoisseurs who have seen some of the water-colours you sent home say that they are perhaps somewhat lacking in simplicity, as if after making your sketches from nature you had re-painted the picture in your room. There may be some truth in this. But if you would only study you could do fine things. Why not send some home, to help us wait patiently for your return? It would at least be a little bit of yourself.

I have a few small favours to ask you on my own account. I am thinking of painting for the coming Salon a picture[1] whose subject I shall take from the recent wars between the Turks and the Greeks. I think that under the circumstances, and provided the work is well done, this would be a way to attract some attention. I should therefore like you to send me some drawings of the country round Naples, a few quick sketches of seascapes or picturesque mountain sites. I don't doubt but this would inspire me for the setting of my picture. Why not

[1] Probably the large unfinished picture, *Botzaris*, abandoned in favour of *Dante and Virgil in the Inferno*.

also send a few of the studies you have in your portfolio? You don't need them while you are out there, and it would oblige you to make some more of them. I see the time draw near when I shall be able to visit Italy myself. If the picture I'm proposing to paint is at all successful, I shall probably set off without delay, and please God I shall still find you there. You shall be my dear *cicerone*.

How I like those Italians! At the Louvois theatre[1] I revel in listening to their lovely music and gazing rapturously at their delicious actresses. We have a new Ronzi at this theatre; she has come most opportunely to replace that dear little madcap, whom I missed dreadfully.[2] She is Mme Pasta.[3] Her beauty, her noble bearing and her admirable acting have to be seen to be imagined. In any case I may be describing them to a man who could probably tell me more about them, since you may perhaps have seen her in Italy before she came here. Galli[4] has arrived. He made his début yesterday in *La Gazza* and scored a great success. I'm looking forward to seeing him at the second performance.

You'll notice that I am not writing as close as usual and, in fact, it's better to write rather oftener and rather less each time. Apart from my mania for procrastination, I had the further mania for only writing you very close-packed letters. But please do the same yourself. You must understand that I haven't a quarter of the things to tell you, that you can find to fill delightful letters with. Come on now, since you're giving up painting, monsieur, take up writing. Sharpen your pens, since you're grinding no more colours. Scribble away to us on the paper you've stopped covering with green and blue and black. I have a sort of plan to go and look at the sea again at the end of this month and breathe sea air for a week or so. That will take me away from my continual labours for a little.

Farewell.

> *Viva l'amicizia e la Pasta.*
> *L'amico in eterno.*

<div align="right">E. D.</div>

Tell me something about what the models are like in Naples, if you have any fine ones there, and if there is an art school where one can work, for I can see that's definitely the place to settle in. Tell me something about the climate and how it affects you. Does the heat prevent one from working? Full details, please, my dear boy.

[1] The Théâtre Italien in the rue Louvois.
[2] Mme Ronzi had left for London in 1821.
[3] Guiditta Pasta (1798-1865), one of the most famous prima donnas of her day.
[4] Galli (1783-1853), a famous Italian singer. The role of Fernando in *La Gazza Ladra* was written for him by Rossini.

106

15 *April* 1822

. . . I have just finished an arduous piece of work which has taken up every moment of my time for the last two and a half months. During this period I've completed a largish picture which will be shown at the Salon.[1] I am very anxious to be hung there this year, and so I'm trying my luck. If it attracts any attention, that will act as a further inducement to *spronar mi* to join you as soon as possible. Yes, my dear fellow; I can at last envisage with some certainty the prospect of a journey to Italy in the near future. This thought obsesses me constantly. I only ask one thing from heaven: the joy of having you there with me for a long time. You know how capricious fortune is. Perhaps, by some accursed stroke of ill luck, you may be recalled to France at the very moment when, free of hindrances at last, I shall be preparing to spend delightful moments with you in that beautiful country. I have seen Ludovic,[2] whose account, as you may well imagine, further excited me. I shall now be concerned only to set my affairs in order: I shall spend a few months with my relatives, with my brother in Tours, with my sister in Angoulême, and from there I shall go to join my beloved friend. Oh, I beseech you, be there: be my guide through that admirable city. Although your thoughts still turn regretfully towards France where you have left those you love so well, may friendship allow you, when at last I shall clasp you in my arms, to enjoy unalloyed pleasure for a moment. When I think that you may soon be returning to France, I should like to hurry time on for myself alone, to hasten its course and shorten my own life enough to allow me to spend more time beside you in so lovely a land. I have seen *la Cara*.[3] She took the trouble to come to my place; I was at the time immersed in the work I've just finished. She must have seen for herself that my moments were precious: I was working twelve or thirteen hours a day so as not to miss the moment when the work of painters who have not yet received grants is submitted to the jury. At the present moment I am like a man recovering from an illness; I am quite breathless, and need to recover my strength a little. At the first opportunity I shall gladly fulfil the promise I made you. What pleasure I anticipate in your company; but your own joy will be mixed with sorrow. Alas, there's no such thing as pure happiness.

Tell me, write me immediately if you expect to stay much longer

[1] *Dante and Virgil in the Inferno*. See plate 6.
[2] Ludovic Vitet (1802-73), art critic.
[3] Soulier's mistress, the 'J' of the *Journal*.

in Rome; for I suppose you are in Rome now, since another ambassador has been sent to Naples.

As for the sketches you mention, I have done a few for you, and I'm waiting for the opportunity you promise me to send them to you. You've still not sent me any of yours, you wretch. I have seen Perpignan's water-colours, which I was forgetting to mention. They are charming, except for a certain thinness in the foreground and the uncertain handling of the trees. But your backgrounds are excellent. Oh, we shall do some fine studies there! Give me some details about the sort of life I can lead, if I'm thrifty. Ludovic tells me it's not impossible to earn a little money there. Tell me about it all.

Farewell, farewell and a prompt reply! Friendship, friendship and Rome!

E. Delacroix

ℰ TO HENRIETTE DE VERNINAC

7 *May* 1822

My dear sister,

I think the best plan, definitely, is to let the apartment furnished. We have decided, on reflection, that the rent of a room where we could store the furniture, together with the cost of a removal which is just as likely to damage our things as ordinary wear and tear, was quite enough to make us give up the idea of letting it unfurnished. Consequently I have already begun the necessary arrangements. I shall manage to redecorate the drawing room by myself; I'll touch up the paint in a few places, it's time I made use of my rare talents! I shall hang up some engravings, which will further help to decorate it. You must tell me what I am to do about the white and coloured curtains you want to put up, where I am to find them, etc. . . . Tell me, too, if there are enough sheets for the principal bedrooms. What rent are we to ask for the apartment? What am I to do with the desk?

. . . I have a reason, moreover, for delaying my journey for several days. The principal painters of the school, who comprised the jury for the Salon, were extremely pleased with my picture,[1] and I shall have in the next few days to take a number of steps to try and sell it to the government and get another commission: this would follow almost inevitably, and it would be very important for me. Once I have the commission, I can do the work at leisure. Please write to me at once to tell me what you think of these arrangements. There are some new *coaches which go to Bordeaux very cheaply*. I am dreadfully

[1] *Dante and Virgil in the Inferno.*

worried about the money order for three thousand francs. Time is passing and I've heard nothing from you on the subject. I assume, however, that you'll have done something about it.

Goodbye, my dear sister, much love to yourself and my dear Charles.

E. Delacroix

I have sent all the chair covers to be cleaned. There are some new little handbills in English which are very useful for letting rooms to foreigners.

ℰ TO HENRIETTE DE VERNINAC

16 *May* 1822

I have had your letter of May 11, in which you give me details about letting the apartment. I had already written to you in answer to your previous letter, in which you seemed to be resigned to not letting it. This is the tiresome thing about being so far apart: since one's letters cross, one of us has always reached a decision about which at that very moment the other has changed his mind. I hope to be able to let it; but I think it would be better to shut up the drawing room rather than the boudoir; for one thing, because I realised it was decidedly too faded and that the paintwork would need too many repairs (for I had spoken in my letter of touching up the paint a little, on the woodwork of course, not of painting the engravings as you seem to have assumed); the red furniture would run considerable risks in a room that was let furnished; it's worn out after so many removals: a great many things are coming loose and need mending, not to mention the chairs which, as you know, are very fragile. Besides, the desk won't go into the boudoir, which you propose to shut up, and I shouldn't know where to put it. If we abandon the idea of letting the drawing room, the disadvantage of hanging the cashmere curtains there would disappear, and so on. I believe I could let the apartment under these conditions to a lady who is a friend of the Englishwomen who are lodging in the house.

The tax collector has finally sent a bailiff summoning me to pay last year's tax. I had always dodged the storm by paying deposits, hoping for an answer to the request I had made to the prefect (I'd secured the backing of somebody on his staff, but it has not proved strong enough so far to win my case). The total of the tax comes to seventy-nine francs plus the expenses these gentlemen have charged to me. I have paid several instalments and now I'm obliged to settle the whole account. I think I remember that you only sent me ten francs for the instalments I had paid, so you owe me another sixty-

109

nine francs. This leaves me in a terribly insecure position; and I don't know how I shall survive till the end of the month; so do try and send me this sum as soon as possible.

One very tiresome thing has happened to me. As my portress was nursing her baby, she took on a charwoman who, she assured me, was reliable. I now find a great deal of my linen is missing, and what vexes me particularly is that two of the linen shirts Charles had given me are gone. I'm afraid this will leave me uncomfortably short when I come to you. I hope to stock up a bit with linen and clothes when I get the money for my picture. The charwoman has been dismissed, but the theft has taken place nonetheless.

I wish my dear Charles would find out for me if there is at Angoulême any grocer selling paints wholesale, from whom I could, at a pinch, buy cheaper paints than the indispensable ones I shall bring from Paris. Since they presumably paint shops, etc. in your part of the world it's hardly likely that the painters send to Paris for all that they need. And for a number of things that I'm proposing to work at in the country I can make do with paints of inferior quality. Would he also find out if they keep poppy-seed oil and heavy oil for drying purposes? The best plan would be to come to some arrangement with a house painter in Angoulême. It would greatly help me to decide on what I shall have to spend here. In my last letter, which I hope has not gone astray, I sent you back the bill for three thousand francs. I have not yet solved the mystery of the two missing letters, in one of which you sent it to me.

Goodbye, my dear sister and my dear nephew, I embrace you tenderly and I long only for you. My nephew will have to be prepared to serve me as model sometimes; I expect I shall find him grown into a Hercules.

E. Delacroix

cℐ TO HENRIETTE DE VERNINAC

28 *June* 1822

[Postscript to a long business letter.]
I have had an idea. Wouldn't it be possible for the church at Angoulême to commission a painting from me? I don't believe that illustrious town has anything new of this kind and I would give it something first class. That would be some help. If the town could not afford this expense, perhaps as a last resort it could apply to the Ministry of the Interior for a painting by me, which might well be granted; for that was how the town of Nantes commissioned from my friend Géricault

the picture that he got me to do.[1] Isn't M. Chancel very much in with all the Church people? At any rate, we can discuss this.

However, I should like first to be sure of having a commission here; once I have that, the other would follow without any difficulty. We can always prepare the way. If you see M. Chancel before I arrive, suggest something of the matter to him if you think it can be done tactfully.

You see I'm taking my revenge by getting you to do my business.

But actually, why shouldn't the Forest property be sold in small lots? Its value would be increased threefold. It is in our creditor's interest.

♪ TO J.-B. PIERRET

Louroux, 18 *August* 1822

. . . I have been doing a few clumsy studies. I try to paint here and there among the hills and plains, but it's all of no account. I see dogs, trees, rocks and grass: I see so much of them that I shall maybe end by knowing them by heart. I take my gun and go shooting and I dig in the garden. I am writing to you at a couple of yards' distance from the most charming Lisette you can imagine:[2] our town beauties can't hold a candle to her! Those firm tanned arms have the purity of bronze; she carries herself like a huntress of classical antiquity. Tell our friend Félix that in spite of his dislike of blue-stockings I think he would succumb to Lisette. And moreover she is not the only one; all these peasant girls look superb to me. They have heads and figures worthy of Raphael and they're poles apart from the pallid insipidity of our Parisian women. But alas! in spite of a few stolen kisses, I make little progress with my Zerlina! *Saevus amor!* That reminds me, I saw in the newspapers that M. de Blacas[3] was coming back from Italy. Tell me if the Soulier ladies can give you any news of our poor friend.[4] The paper in which I read the article fell into my hands just as I was laughing at a story I was being told, and the sight of it affected me like a sharp, icy dagger thrust into a warmly throbbing heart. And capricious fate will certainly not miss such a fine opportunity of wounding mine and holding it in a vice. That's the sort of trick it plays. I

[1] *The Virgin of the Sacred Heart.*
[2] See *Journal*, opening entry.
[3] The Duc de Blacas, an *émigré* during the Revolution, returned to France in 1814 and was appointed Minister of the King's Household. He created the Egyptian section of the Louvre. He was sent as ambassador to Naples in 1816, then to Rome in 1817-22. Soulier was on his staff. Delacroix made a lithographic portrait of him.
[4] Soulier.

am already thinking of next winter with great and eager delight: are you? Have you and Félix taken advantage of these last days of fine weather? Have you been for walks? And his lovely maid? Heavens! I think she's called Lisette too; ah, what a charming pair of slender, graceful does worthy of drawing Diana's chariot: the differences between them are just what's needed to bring out each one's charms.

This letter, then, is for both of you, as we agreed. I shall presently write another to Félix to the same end. Answer immediately. You must tell me if anything more has happened as a result of the Salon.[1] The *Constitutionnel*[2] talks of nothing but politics, so that I don't know what may have been done. Above all, write me a huge enormous letter: a huge, huge one: the haste in which I've had to write this one will not, I hope, be an excuse for an equally short letter from yourself. I make bold to send your wife a kiss. That can't be dangerous at sixty leagues' distance. . . .

<div align="right">E. Delacroix</div>

৬ TO J.-B. PIERRET

<div align="center">[Louroux] 30 August 1822</div>

My dear friend,

I have received your letter, but not Guillemardet's yet, which is not surprising since they only send in to Tours from here once a week and his letter may have been lying there seven days. Be that as it may, yours gave me great pleasure. I am very sorry that your life does not seem to be as calm as mine: for you have every sort of reason to be happy. In spite of my inconstant nature I feel a sense of profound peace and well-being amidst this solitude. I sometimes feel regrets, or a longing for something new, for Italy, for instance, but I'm sure that when I have left these parts the happiness I am now enjoying will seem keener to me than anything that I could find in any of the other situations for which I can't help longing a little. You would appreciate its value for your own little family, for the sake of your children's health and their happiness, which would increase your own. Perhaps at the end of our lives we may both of us find such rest. I hope there may come a time when one has no more desires but can simply enjoy things. I have never before felt such thrills of excitement

[1] *Dante and Virgil in the Inferno.* The state bought it for 1,200 francs, half what Eugène had hoped for. (In a letter to the Comte de Forbin, Superintendent of Fine Arts, on 1 June, he had suggested 2,400 francs.)

[2] The *Constitutionnel* was a leading Liberal paper: politically it was later to support the Prince-President Louis Bonaparte, and to feature Sainte-Beuve's *Lundis*, which Delacroix read assiduously.

on reading good books: one good page gives me a sensation of delight that lasts several days. I hate writers who are not natural and who have merely style and ideas, without any genuine springs of feelings.

I have enough experience of business matters to see that you don't understand them: for while you tell me that my sister has sent you an account and some money, you don't say what she asks for, nor how much she has sent you, nor how much you got from Géricault, nor whether you have received the whole sum. In any case, I think I asked you to pay the rent before I left: if I did not do so, this is what I'd like you to be kind enough to do. One morning on your way to the office, call on Mme Cazenave, 11 rue de Bellechasse, and take her, first, five hundred francs which have been owing to her since 1 July, and also a hundred and twenty francs, I think, for last year's taxes. She will give you a receipt for both, or else she'll give you the printed form which serves as receipt for the tax. Tell me in detail, in your reply, what my sister specified.

I am undecided as to what I shall do when I return to Paris. I don't know if my desire for liberty won't make me try to live in my own fashion, apart from my sister: in any case, as I shall not see her till I'm in Paris, I shall take my decision then, according to the way my affairs with her have turned out. I have instructed a man here, whom I trust, to act on my behalf in claiming the share of my parents' estate to which I am entitled. A man with any warmth of heart is bound to suffer grievously in life when he has to take a course of action that may seem hard to those who are related to him by blood; but the main thing is to know and see things clearly and to be duped as little as possible. All this may sound like Hebrew. We shall have to talk about it.

Dear friend, if my small fortune materialises, we shall be able to enjoy some happy moments. I have hopes of salvaging something from the wreck: perhaps the ladies will discover that I don't always merely make promises. It is true that just lately the uncertainty of my future worried me and may well have added to the complications of my temper, which is as variable as a barometer.

Do tell me, if you know, who takes the part of the countess in *The Marriage of Figaro*, which is being performed at present, now that Mme Mainvielle[1] has left.

Farewell to you and Félix, both of you. I wish you good friendship and good health; my sympathy to your big-bellied wife, and my affectionate regards to her and to all the family. I am delighted to

[1] Mme Fodor-Mainvielle, a famous singer, rival to La Ronzi; she left Paris for Naples in 1822 and was replaced in *Figaro* by Mme Bonini.

hear what you tell me about Soulier. It makes me very happy. Farewell, your friend for life.

E. Delacroix

ᴥ TO FÉLIX GUILLEMARDET

[*Louroux*] 4 *September* 1822

. . . Your letter brings me one piece of news which excited me greatly: that my picture[1] was in the Luxembourg. I was far from counting on this. Thank you for letting me learn it from yourself. I'm afraid, though, that seen at close quarters it may be less admired. While I remember, would you kindly ask Pierret to request Mr Veny, who is responsible for inscribing aspirants for the competition for places in the Academy, to put me down for the final week's competition, too, for drawing in relief, and if he has not already replied, to let me know. . . . I appreciate more than ever the satisfaction of being at one's ease from morning till night. I spend my time, curiously enough, in relishing my present happiness, and despite certain anxious longings to see you again, dear friends, I get the keenest enjoyment from the peacefulness of days spent without any sort of incident in this quiet, homely landscape. I sometimes spend the evening sitting on a bench by the door of the little house, watching the moon rising up into the sky and flickering through the leaves of my brother's young trees. He planted them all himself and is therefore all the fonder of them. This winter he suffered a real disaster. Hail devastated the whole district in a horrible fashion, and his modest property did not escape. All the fruit was ruined; the vines, entirely stripped of an abundant crop of grapes, blossomed afresh after the hailstorms, which occurred in mid-June, and this blossom, which at another time would have meant such welcome promise, is yet another source of distress: it means that all next year's crop will waste away this year. . . . I expect to return shortly, and I am very anxious that we should arrange to have at least one day a week in future when we can all three meet. I see no prospect of getting a studio. If in your wanderings, no matter in what district, you should happen to see anything, any notice that looks promising, look at it for me. I shall very much enjoy seeing that Diorama with you. The papers describe it as being quite remarkable. They are not equally enthusiastic about M. Merville's play, at least to judge from the *Constitutionnel*, which doesn't rank it with Molière.

I hope, too, that we shall occasionally go together to admire the

[1] *Dante and Virgil in the Inferno*, which had been shown in the Salon of 1822.

114

magnificent Mme Pasta. I'm yearning to hear her. My heart is still full of the music of *Tancredi*,[1] which as you know I was lucky enough to see twice. I am very glad to see that they are reviving the *Nozze*.[2]

Goodbye, with all my love. Enjoy yourself. I hope to see you soon. Goodbye, keep well. . . .

✑ TO J.-B. PIERRET

[*end September* 1823]

My good friend, my brother arrived here this morning. Would you be good enough to have the camp bed taken to my place[3] immediately and tell the porter to put it in Fielding's studio with the mattress which my nephew[4] will have sent there during the day. I don't know if I shall see you tonight, on account of his arrival. . . .

He's plump and portly, and that cheers me up.

✑ TO FÉLIX GUILLEMARDET

[*Paris*] 1 *December* [1823]

I received your letter this evening, my dear Félix, and I shall try to answer it this same evening. You threaten to stay away another fortnight, which enables me to send you a letter but leaves my affection unsatisfied; these prolonged jaunts are becoming a nuisance. It's a long time since you took such extended holidays. You've no complaints to make about this, as far as I can see, except for a few evening parties which serve to remind you that you are mortal and that your pleasures are mingled with bitterness. In any case, they cannot all be so insipid, since that charming half of the human race which, as we all know, gives so much pleasure to the other half, provides an occasional change from politics and card-playing. Cut off as you are from your accustomed way of life, particularly in respect of that enchanting, seductive and delightful sex, I have no doubt that you will find opportunities to prove faithless to your fair Parisienne, whose identity you so wisely keep secret. There are certain beauties to be found in provincial society

[1] By Rossini.
[2] Mozart's *Marriage of Figaro*.
[3] Delacroix was now living with Thales Fielding, the English water-colour painter, at 20 rue Jacob.
[4] Charles de Verninac.

115

who lack neither elegance of form nor any other sort of attraction. It is not unusual to find, amidst the flocks of silly and pretentious women who abound there, a few unusual and distinctive characters in pretty little figures. All Parisian women, I mean those of the educated class, are accustomed to being, so to speak, on stage, which puts them all on a level in some respects. You have to be in the highest favour with them, and know them very thoroughly, to discover under this misleading exterior each one's original gifts, and I should not be surprised, to judge by the way you stress this point in your letter, if you had penetrated . . . deeply into this matter. And so, as you see, I have allotted it a respectable space in my own letter. It is a charming theme, unfortunately, but one must not dwell on it too often when one hopes to work at serious things. I am going to become a recluse. I have had in my studio, for several days now, a great brand-new virgin canvas, and it's going to take all the stuff I've got in me to cover it. Paris is scarcely worthy of your regrets, all its walls are oozing and weeping. The damp is encroaching into our very hearts; I defy it, as far as my feet are concerned, with a pair of hinged clogs. This is an excellent modern invention for those humble folk to whom fate has denied a carriage. I have even gone so far as to treat myself to an umbrella, which I left lying idle for a fortnight at the house of a man I'd been to call on. You flatter my artist's vanity with the success of my antique lamp,[1] I shall soon consider myself an Ancient too and I cannot believe that so many illustrious connoisseurs can have appreciated so highly the work of a mere modern Monsieur. It's a pity you did not see M. de Lamartine, the poet. He is a genius of the first water, I don't remember if you were still in Paris when his second volume of *Méditations*[2] appeared. I was delighted with it. But it's a sad pity, there is something lacking in the man which means that posterity will rank him below a whole host of people who are far from possessing his lofty imagination. I have also been reading some Las Cases.[3] What wonderful things there are in that. It's a precious book, interesting in every sort of way. There's everything in it, everything treated *à la* Racine, in the grand manner. We shall have lots to say about all this. I saw M. de Conflans[4] again some time ago, I had seen him during his illness. He must be better, since he's been singing and even performing *roulades*. We performed some heavenly ones together, not entirely to the delight of Mme de Conflans, for whom music is a real solace. I wish I had a quarter of her talent. . . .

[1] Reference obscure.
[2] Lamartine's *Nouvelles Méditations*, published 1823.
[3] Las Cases's famous *Mémorial de Ste Hélène* (conversations with Napoleon), published 1823. [4] Guillemardet's brother-in-law.

⤜ TO HENRI BEYLE [STENDHAL]

[*October* 1824]

I shall call on you between half-past eight and a quarter to nine, and we can go to the Jardin des Plantes[1] together, if I find you at home.

I have read the article in the *Revue de Paris*.[2] It seems to me extremely good and fair, *quite apart from the kind things* you say about myself, for which I thank you.

<div align="right">With all my sincerest regards.</div>

[1] Not to look at the zoo but to go to a party given by the director, Cuvier.

[2] Stendhal's article on the Salon, signed A, appeared in the *Revue de Paris et des Départements*, 9 October 1824. He was earning his living as a journalist, had published the *Vie de Rossini* and the first *Racine et Shakespeare*, but no novels as yet.

The Journeys to England and Morocco
1825 - 1832

ᴥ TO J.-B. PIERRET

London, Sunday, 27 *May* 1825

MM. Guillemardet and Pierret. This is for both of you.
My address is 15 Charles Street, Middlesex Hospital.[1]
My dear boy,

I have been in this great city for two or three days now and I have had no time to write to you because I was tired after my journey, which for that matter went very well. The mail coach is a very pleasant way of travelling, and I was in the hands of a good-natured fellow who was helpful to me in every sort of way. I reached Calais at half-past ten at night, left next morning, Thursday, at half-past ten, and got to Dover at half-past twelve or one o'clock, having been considerably tossed about during the crossing but not sick, which pleased me very much. I had rather counted on seasickness to cure my cold; a slight emetic of that sort taken against my will might have rid me of it, but I still have it, although not so badly. At Dover I had time to climb up on to the cliffs of which Copley Fielding painted a fine water-colour which you'll remember, and to see the castle that overlooks the sea. I was not too pleased by my first acquaintance with England. I had been extremely eager to reach this port; hardly had I landed than I felt some distaste for what I saw, and this impression is still with me. On reaching London, particularly, my constant feeling was that I should be very miserable if I had to stay there for ever. And yet I'm something of a cosmopolitan by nature. But I am sure that if certain things shocked me, it was due to my lack of familiarity with English ways. I instinctively compared everything I saw with France, and loved you all the more for it. I felt an actual hostility. In the coach from Dover to London I met an old Frenchman, a good sort of fellow, and we enjoyed ourselves abusing England in front of a fat *goddam* of an Englishman who, in fact, did not understand a word we said, firstly because he knew no French and secondly because of two bottles of port wine that he'd taken the precaution of bringing with him from Dover to cheer himself up on the journey. This made him wildly merry when he was not snoring.

The vastness of this city is inconceivable. The bridges over the river are out of sight of one another. What shocked me most was the absence of anything that we should call architecture. I may be prejudiced, but

[1] Delacroix left Paris on 24 May 1825 for a three months' stay. His interest in England was fostered by his admiration for Shakespeare and Byron, by his friendship with Soulier and Géricault and the English painters Bonington and the Fielding brothers, and by the discovery in 1823 of the art of Constable. See plates 11*a*, *b*, 12*a*.

121

I find it displeasing. And then they have a Waterloo Road which is a string of palaces like our Opéra one after the other, and at the end a building on top of which is a steeple like this, exactly [drawing of the steeple]. It's frightful.

But such fine shops! Such extreme luxury! The sun, again, is of a peculiar nature. It seems permanently under an eclipse. I have already seen a great deal in a short time. Yesterday I went with six young men, including the Fieldings, up the Thames to Richmond. We covered over six and a half leagues in two hours and a quarter going there and the same coming back, in a six-oared boat which in itself would have been worth the journey to see. Think of an Amati violin! The utmost delicacy in construction, grace, speed, in fact unimaginable. It's the most astonishing thing I've yet seen in this country. I can't tell you how admirable it was. I had the honour of holding the rudder. The banks of the Thames are charming. I recognised all the scenes which recur so constantly in Soulier's work.

I saw a play about Napoleon's invasion of Russia. It was very funny. The principal character was cleverly impersonated. He begins all his speeches to his brave soldiers by shouting: 'Gentlemen!' As for the poor soldiers themselves, they were most amusing! Their uniforms were full of very funny mistakes. It was at a theatre like Franconi's, where horses appear on the stage. They're very good at this sort of performance.

Fielding has found me a very comfortable lodging which costs me only forty francs a month, which is very cheap, isn't it? It's not true to say that *goddam* is the basis of the English language; its real basis is *one shilling, sir*. Every sentence ends with these words. I'm not exactly referring to the sort of conversation that goes on in the king's palace, but I've not yet been within earshot of that sort.

I have seen Mr West's[1] gallery, for one shilling, needless to say. There's a lot to say about this, as about everything else; we'll talk about it all. My love to both of you. I think I shall write to Édouard tonight, urging him to come here if possible. Remember me, please, to all those whom you love and whom I love for that reason.

<div align="right">Your friend,
E. Delacroix</div>

అ TO CHARLES SOULIER

London, 6 June 1825

Here I am at last in this country which is almost your own, and where I am very sorry not to have you with me. I could not possibly have

[1] Benjamin West (1738-1820), President of the Royal Academy after Reynolds.

received a kinder and more nobly courteous welcome than I did from the people to whom I had introductions. This city is superb, and very different from our own in many ways. But it comes to much the same thing in the end, and I now feel as if I had not left Paris. I was cruelly bored the first few days; I was on the point of leaving again without more ado. This was due to my doing nothing but look at things here, there and everywhere, with the sole result of wearing myself out. Since I have started to work, I am quite happy here. I am a great idler, to tell the truth, but not much of a sightseer, in the following sense: I am not at all interested in looking at a great many things in London which are no doubt very curious, but which are not in my field; and there are so many of that sort in Paris which I have never wanted to see, that I don't intend to start here. I shall even confess to you that all these endless picture galleries are terribly alike, and that when you know one of them you know all the rest.

At first sight, I did not care for their painting. Now I am growing used to it. I'm not surprised at the unfavourable impression it makes on visitors who do not already share our ideas on the subject. The imitation of old masters has its disadvantages, like everything else.

A society of influential persons has been formed, under government auspices, to encourage the painting of large-scale pictures. I am afraid this may prove disastrous for the English school. They have some admirable painters on a smaller scale. The desire to make a greater show will lead them astray. They will paint large pictures which will be beyond the means of private patrons. This society has bought a huge daub by Mr Hilton[1] for £25,000. It's a clumsy reminiscence of all the work of the great masters. On the other hand, there are some very fine *genre* paintings. I went to see Wilkie[2] in his studio, and I have only come to appreciate him since my visit. I had disliked his finished paintings, but in point of fact his sketches and rough drafts are beyond all praise. Like all painters, in all ages and in all countries, he regularly spoils his best work. But there is still pleasure to be got from this counter-proof of his fine things.

The horses, the carriages, the pavements, the parks, the Thames, the boats on the Thames, the banks of the Thames, Richmond and Greenwich, the ships, would all take volumes of letters to describe and we'll talk about it all at leisure. This country must have suited your talent exactly. Italy has rather unsettled you. I keep on seeing here those skies and river banks and all the effects that recur so constantly in your paintings.

[1] William Hilton the younger (1786-1839), historical painter.
[2] Sir David Wilkie (1785-1841), painter of historical and *genre* subjects and portraits, enjoyed great popularity at the time.

Fielding[1] is an excellent fellow. Copley[2] is a man one doesn't see much, and who's not my sort of person. Sunshine is not England's brightest feature. I have not yet got rid of a cold I brought over from France, because of the cold weather that keeps on returning. I don't know how things are going with you. If you go to Paris, please remember me *kindly* [*sic*] to your excellent friends in the rue Saint-Dominique.[3]

Your friend,
E. Delacroix
14 Charles Street, Middlesex Hospital

Tell Mme de Roncherolles[4] that Frenchwomen have no equals for grace.

❧ TO J.-B. PIERRET

[*postmark*] 18 *June* 1825

I have written to Soulier. Will you send him the enclosed note, and read it first yourself: it all forms part of my impressions of this country. You haven't written to me, and you probably expect that London friends will make me forget my friends in Paris. You want me to lose my affection for you, so that everything will concur to make me stay in these parts. Not at all! In spite of your neglect, I love our own country better, and far from trying to affect conformity with English ways, I choose to show myself wholly French. The English at home are quite unlike what they are abroad; but then this is true of all men. They are far more considerate, far more eager to learn your opinion of their country, and on the other hand I feel rather as they must do when they come to ours. I tend to praise France at their expense: which we never do in their presence when we are at home. Give me all kinds of news, and as for the wearisome tasks you've kindly undertaken to do for me, did you ask the portress to sprinkle some pepper in my Turkish clothes and saddles, and have wooden bars put on the horses' stable? Has my nephew found somewhere to live?

I saw in Wilkie's studio a sketch of 'John Knox preaching before Mary Queen of Scots'. I cannot tell you how fine it is, but I'm afraid he may spoil it; that's a fatal habit of his.

I saw here a play about Faust which is the most diabolical thing imaginable. The Mephistopheles is a masterpiece of character and

1 Thales Fielding, with whom Delacroix had shared an apartment and a studio in Paris.
2 Copley Fielding, Thales's brother.
3 The de Coëtlosquet family.
4 Wife of the Marquis de Roncherolles, Lieutenant-General and aide-de-camp to the Duc de Bourbon.

intelligence. It is an adaptation of Goethe's *Faust*;[1] the principal elements are retained. They have made it into an opera with a mixture of broad comedy and some extremely sinister effects. The scene in the church is played with priests singing and distant organ music. Theatrical effect can go no further. I have seen *Freischütz* in two different theatres, with some music that was omitted in Paris. There are some very remarkable things in the scene where they cast the bullets. The English understand theatrical effect better than we do, and their stage sets, although they are not so carefully carried out as ours, provide a more effective background to the actors. They have some divinely beautiful actresses, who are often more worth seeing than the play itself: they have charming voices and a grace of form which is not to be found in any other country.

Farewell, dear friend, remember me to all our friends, Leblond and the rest. If you see M. Rivière,[2] of whom as you know we are both very fond, give him all sorts of messages from me and tell him that I concur with his opinions of this country; I entirely agree that we are as good as these islanders and even better in many respects.

<div style="text-align:right">

Remember me to Mme Pierret.

E. D.

</div>

<div style="text-align:center">

&ed; TO J.-B. PIERRET

London, 27 June 1825

</div>

My dear friend,

I am taking advantage of M. Enfantin's[3] departure for Paris, after a month's stay in London, to send you some news from here. The longer I stop, the longer I want to stop. The weather has been very fine, which is unusual for London. Many people have pitied me for missing the coronation festivities,[4] but I hardly think my presence would have added any attraction to them. I have had a letter from you and one from Édouard,[5] who still declares that he is coming here shortly. I reckon he should be here at any moment. The English are extremely courteous to visiting foreigners and I have nothing but praise for them. The specimens of our nation to be found over here are not likely to give them a high opinion of the French character. A whole crowd of people who lead a very dubious sort of life have taken

[1] Possibly by Ignaz Walter, who wrote the first opera based on Goethe's *Faust* (Huyghe, *Delacroix*, p. 182, suggests Marlowe's play). The performance inspired Delacroix's lithographs on the theme, published in 1829. See plate 9b.

[2] *Maître des Requêtes* to the *conseil d'état*.

[3] Augustin Enfantin (1793-1827), painter.

[4] The coronation of Charles IX in Rheims and Paris, 6 June 1825.

[5] Édouard Bertin.

refuge here. All the bankrupts and forgers of Paris forgather in London hotels.

I have seen *Richard III* played by Kean,[1] who is a very great actor, with all deference to our friend Duponchel[2] who calls him the English Philippe.[3] I cannot agree with him. I do not care so much for Young,[4] whom I have seen in several plays, including a revival of *The Tempest*. They have altered the beginning of *Richard III*; the death of Clarence has been replaced by that of Henry VI. Richard, who is still only Gloster [*sic*], comes into his prison and stabs him with a sword. This scene was terrifyingly played by Kean, as well as a thousand others which I shall describe to you till you're sick of listening. I also saw his Othello. No words are strong enough to express one's admiration for the genius of Shakespeare, who created Othello and Iago. I am obliged, to my great regret, to miss a performance tomorrow in which Young is to play Iago to Kean's Othello. Although they usually act at different theatres they are to appear together in a benefit performance. I hope to see *Hamlet* too. Mr Elmore[5] has been extremely kind to me. I have begun working at his place lately.

How is Félix? I hope you will have had the good sense to send me a packet of letters by Édouard. I must have full compensation for having waited so long. I met Mayer,[6] who has been making a great deal of money painting portraits. He greatly regretted not having known that Duponchel was in London. He is the compass of fashion for me, as you can imagine: unfortunately one can't go far in this country without much cash.

There have been several hangings since I came here; but I have not felt tempted to go and watch. In any case, as they take place on Mondays and Fridays every week, if the fancy takes one to go it can easily be indulged. I don't know if I told you I was worried lest the moth should get into the Turkish clothes and carpets, etc. that are in my studio.

Farewell, my dear good friend. I embrace you tenderly and send kind remembrances to all those who are dear to you, first and foremost Mme Pierret.

E. Delacroix

On the back is a line for Henry.[7] I think he's living at 94 place Beauvau.

[1] Edmund Kean (1787-1833).
[2] Duponchel later became Director of the Opéra.
[3] Philippe (d. 1824), a famous actor of melodrama.
[4] Charles Mayne Young (1777-1856).
[5] A horse dealer.
[6] Auguste Mayer (1805-90), a Parisian friend and portrait painter.
[7] His cousin Henry Hugues.

London, 1 *August* 1825

My dear friend,

I am making use of a gentleman who is leaving for Paris to send you a few words. I received the letter from my nephew telling me about the apartment. I suppose that's where I shall have to go, or to write to him about anything: rue du Houssaye, No. 5. Tell him I'm delighted with the district and the advantages he describes; but that the distance from my studio is quite a problem, and that the lease is quite a problem too. But since the thing's decided, let's speak no more about it.

I am leaving tomorrow for a few days' trip, partly along the river Thames and partly on sea, in a yacht belonging to a friend of Mr Elmore's. I'm crazy about sailing and I may shortly go down to Cornwall with Eugène Isabey[1] who is here and who's a very good fellow. This would be a fortnight's voyage along the wildest coast of England, which would prove profitable enough in the long run to make up for any expenses I might incur at the time. Afterwards I propose to come back to London, where I shall no longer have a great deal to do, and then I shall soon be back among all the friends who have not been out of my thoughts for a single day since I left them and whose absence I feel the more keenly in this depressing country. There is decidedly a kind of constraint and gloom about everything here which is quite unlike things in France. The cleanliness of the houses and of some streets is made up for by the filthiness of others. The women are all slovenly, with dirty stockings and clumsy shoes. What strikes me most is a general shabbiness which makes one fancy oneself in a land of meaner and needier people than ours. I'm beginning to believe that they are, if possible, even stupider and more given to petty gossip than we are; and that's something I could never have imagined before coming here. I don't consider all this from the point of view of an economist or a mathematician. In those respects they have all sorts of fine qualities which I'll grant them. Besides, all these impressions are bound to be quite personal ones. I imagine the unconstraint of Italy would be more to my mind than England's tidiness. It must be admitted that the fine verdant countryside and the banks of the Thames, which form a continuous English garden, are a delight to the eye; but it's like a toy landscape. It's too far removed from nature. I don't know by what strange caprice of nature Shakespeare was born in this country. He is undoubtedly the father of all their arts and one is quite astonished to see what methodical disorder they introduce into these. I went to call

[1] Eugène Isabey (1803-66) was greatly influenced by English painting and by Delacroix.

on Lawrence[1] with someone who was so highly recommended to him that he received us with the greatest kindness. He is the flower of courtesy and a real painter of the aristocracy. I shall give you a full description of him later. I saw in his studio some very fine drawings by the old masters and some paintings of his own as well, sketches and even drawings which were admirable. Nobody has ever painted eyes, women's eyes particularly, so well as Lawrence, and those parted lips which are completely charming. He is inimitable.

I don't know if I told you that I had seen Kean as Shylock in *The Merchant of Venice*. It was wonderful and I shall tell you all about it. I bitterly regret having missed Young's Hamlet. The big theatres are closed now and in any case the weather is very warm.

I've taken up horse riding. Mr Elmore, who has shown me the utmost kindness, is my riding-master. I show great aptitude. I even looked like breaking my neck on two or three occasions. But it all helps to form one's character.

I'm continually taking up the cudgels for France against all sorts of Englishmen. This nation has something fierce and savage in its blood which comes out horribly in the rabble, who are hideous ruffians. Another thing, their government is excellent. Liberty, here, is not an empty word. Aristocratic pride and class distinctions are carried to a point that I find infinitely shocking; but these have certain good results. Farewell, my dear fellow, if I die on my storm-tossed travels, I shall not die an Englishman but a true Frenchman and your friend, and proud of it. Remember me affectionately to your wife and to all the friends to whom I'm not writing, because I should be merely repeating the same things. I cannot remember if I replied to Félix. But this letter is for him too. I had felt a passing wish to go through Brittany on my return journey and to visit his brother[2] there, but I don't think it will be possible. In the meantime, I embrace him as well as yourself. I'm much afraid I may not find him at home, because he'll be in his beloved Burgundy. If you can find the parcel of *gumwater* [*sic*] that Fielding once sent to me, you'd do me a great favour by giving a good part of it to M. Auguste,[3] who has none at all. Write your reply to the following address: *M. Eug. Delacroix at Mr A. Elmore, 3 John Street, Edgeware Road.*

As I propose to bring back for Leblond[4] various objects of interest that

[1] Sir Thomas Lawrence (1769-1830) had that very year painted in Paris the portraits of Charles X, the Dauphin, and the Duc de Richelieu.

[2] Louis Guillemardet.

[3] Jules-Robert Auguste (1789-1850), sculptor, painter and collector; he travelled widely, was a patron of artists and the friend of Delacroix, Géricault, Bonington and others, as well as of Balzac, Mérimée, etc.

[4] A mutual friend of Delacroix, Pierret, etc.

I may come upon, according to his instructions, to avoid having them unpacked and examined at Calais, I shall pack all such objects in a case and get it sealed on landing to be sent to the customs office in Paris, addressed to M. Leblond. Give him this message and ask him if there is any better way of doing things and what impressive title I must add to his name as official in the customs administration. This might save us any sort of difficulty. I heard of his escapades through Édouard, who however was unable to give me any definite news of Mme Berger, our common friend, who plays the part of Providence to people who aren't blessed with lawful spouses. Tell me how Henry is keeping; ask him to remember me to my uncle and aunt Riesener. Beg Félix to do likewise to all his family and to Mme Lamey and Uncle Pascot; tell me about Soulier. He is to convey my respectful regards to our friends in the rue Saint-Dominique.[1] Perhaps M. Louis Schwiter, to whom I make bold to be *kindly* [*sic*] remembered, would be good enough to let me know through you, when you give him news of his delicious Mlle Sophia, in which Princes Street the lady lives for whom I have a ring.[2] There are a dozen Princes Streets in London and London is a very large city. It's usual to add to the name of the street that of the nearest square or place of note, as for instance: Charles Street, Middlesex Hospital, etc. What they need here are some thorough lessons in good form. It must be admitted that some of the men here are unexceptionable but I've taken a dislike to their women. Except for Shakespeare's plays, I have seen nothing in any of their theatres which was not a more or less clumsy imitation of what we have in France. I have seen a *Barber of Seville* and a *Marriage of Figaro* which were ridiculous in their preciosity. Their music is atrocious. Even their blind musicians play their instruments – whether violin, clarinet or flageolet – with less feeling than ours do, if that's possible. In their theatres, they manage to introduce trumpets even into the most sentimental melodies. When John Bull, sitting up in the gods, fails to hear these, he thinks that it isn't music and that the orchestra has gone to sleep.

Has nothing been decided about those delightful productions of mine which M. Laffitte[3] seemed to want? The question of money is shortly going to become a matter of serious concern.

[1] The Coëtlosquets.
[2] Probably Mme Dalton, who became Delacroix's mistress. See plate 12*b*.
[3] Jacques Laffitte (1767-1844), a famous banker.

E.D.–K

London, 12 *August* [1825]

. . . I got back three days ago from a very pleasant trip into Essex, where I went by sea in a boat belonging to an English nobleman, who has a country house there in which I stayed several days. As the wind was contrary for sailing back to London we went for several expeditions in rough weather, which showed me the sea in a rather angry mood. But on the whole I don't find England very amusing. It would need a very powerful motive, such as business interests, to make me stop here. I merely glimpsed, during my stay, the possibility of working fruitfully some day in this land overflowing with gold. I shall be in Paris towards the end of the month. I found your letter when I came home yesterday, consumed with melancholy. It gave me infinite pleasure, and so did Leblond's; please thank him very much for me. Your letters are such a delight to me! You have all gone on living your usual lives, and one person the less never makes so noticeable a difference as when one is parted from everything at once. For all that, travel is a good thing. It gives one fresh emotions; it makes us form our own judgment of other countries and return to our own with delight. I can envisage the possibility of eventually settling in this country, but not without apprehension. One would need to earn a great many guineas to put up with the monotony of it, or to make enough real friends here for the time to seem short. Even so, one would always miss the other true friends one had left behind, whom one had loved first. Remember me to Mme Pierret, Mlle Annette[1] and M. Louis, not forgetting Baptiste, Claire and Juliette,[2] to whom I send kisses.

My dear Félix,[3]
Shall I have the pleasure of seeing you when I get home? I doubt it, if you're leaving for Burgundy. As usual I shall find it hard to accept the idea of returning to France and not finding you among the little band of friends I long for here. By the way, I remember you told me that you were learning English. I'm glad of that. I shall ask you for a few lessons when I get home, if you've already made as much progress as I imagine. I am so horribly lazy that I have not worked at my English at all and have not made all the progress I might reasonably have hoped for, after staying here three months or so. In fact, as always happens, I am leaving the country just when I'm on the verge of speaking the language with some fluency. All the Frenchmen here

[1] Pierret's sister.
[2] Pierret's children.
[3] Part of the same letter, addressed to Guillemardet.

say that it comes suddenly after a few months. But we'll work at it together, that comforts me.

The theatres are almost all closed. Everybody is in the country. You scarcely see a single carriage in the streets. Those people who stop in London (people of quality, I mean) take good care not to show themselves, or else live in the backs of their houses. It would be shocking in the extreme to be in town during this season. There's nothing left but the English opera, and music is one of those things the feeling for which cannot be acquired by means of industry and machinery.

Goodbye, my dear friend, remember me to your mother and all your family. The pleasure of seeing them again will be as great as the pleasure of embracing yourself.

E. Delacroix

[*End of letters from England*]

‹ᴐ TO CHARLES SOULIER[1]

[*Paris*] 31 *January* 1826

So you imagine I'm cross with you, monsieur peasant! Has Pierret not told you of my laziness, which is as intolerable to myself as to others? Would you believe it, since my return from England I have had two letters from my good brother which are full of the fondest affection? Added to which I was keenly anxious to tell him what pleasure I felt on hearing how, despite his badly messed-up thigh,[2] he had jumped into the water, in his village, to save a couple of idiots who were drowning,[3] and that in a frightful place where I shouldn't have cared to dip my toe. Well, I've been base enough not even to have given him a sign of life; so that he may think I've been swallowed up in the green waters of the Channel or killed in a duel by some English guardsman.

Far from being cross with you, I long for you continually. When we spend our evenings working I wish you were there to share our fireside and our tea. I have hardly been more than two or three times to see our friends in the rue Saint-Dominique. It must be admitted that the days are short. The fair lady doesn't rise until eleven, so a whole day is wasted paying a polite call; and then my evenings are taken up with

[1] Soulier was in the office of a mine owned by Général de Coëtlosquet at Beffes, in the Cher.

[2] General Charles Delacroix had been badly wounded in the thigh in 1812 at the battle of the Dwina.

[3] This incident is mentioned in the inscription Delacroix composed for his brother's tombstone in the Charterhouse cemetery at Bordeaux.

131

work and with the usual visits to Leblond, Auguste and others, so that I've no time left at all. . . .

I have been working rather more than when you knew me. I had Bonington[1] with me in my studio for some time. I was very sorry you weren't there. There's a tremendous deal to be gained from the company of that jolly fellow and I swear I'm all the better for it. . . .

E. Delacroix

I'm no enemy to the English, whatever you may think.

ও TO CHARLES SOULIER

13 *February* 1826

We have received a letter from you, dear fellow, which has given us great pleasure. You mention plans which are certainly worth considering and in fact perhaps not completely unrealisable. It looks as if you hadn't had the letter I wrote you some time ago. You were still considering me as a bear unworthy of seeing the light of day, and above all as a Cato. That's the affront that hurt me most deeply. I've a great longing to see you. Do you know that I left for *Old England* [*sic*] last May, almost a whole year ago, and then it was some time since I'd seen you, and in spite of that year time has slipped by since then. How swiftly our youth goes!

I have been working fairly hard lately. It's definitely the only way of keeping care at bay and achieving some calm. But the days are so short and it's so hard to drag oneself from the arms of Morpheus,[2] the great restorer, that work is bound to suffer. As for going into society, I've become harder to dislodge than ever. I need to be stimulated by some of your homilies. For, like your humble servant, you used to have a rare gift for giving others advice which you didn't follow yourself. While you're over there you could produce some deliciously naïve paintings and develop a truthful talent such as can only be found among those good Flemings, who painted what they saw around them. I have one great wish in the world, which is to be in Italy with you. In Italy! I can't think of going there without you: it's one of the dreams I've cherished most, and tell me, am I to die without realising it? If I had made my fortune, it would all be settled. Whatever anyone may say, we are made to dovetail into one another. Absent friends are too apt to assume that we're not thinking of them;

[1] Richard Parkes Bonington (1801-28) had been friends with Delacroix ever since his arrival in Paris in 1816. See letter to Thoré, 30 November 1861 for an account of their relations.

[2] A horrible and untranslatable pun: *l'orfèvre* (the goldsmith) for *Morphée*.

that they alone worry about those they have left behind. You're wrong, every time I think of the Place Vendôme, of the walks we took before you left for Italy, and of our life together afterwards, I feel convinced that the past is the only real pleasure we have. I'm writing to you in a fireless room, freezing cold and with my nose running. Leblond, with whom we were talking about you last night, gave a magic lantern show to Pierret's and Saint-Evre's children, and all the children, great and small, had great fun, except when they were asleep.

Goodbye, I'm dying of cold. Mind you write your answer by the fireside. That'll make you pack your lines closer. You ought to write to Leblond too, he'd be so pleased.

⟨ TO M. BÉNARD[1]
rue de Grammont No. 3

Thursday, 16 *February* [*postmark* 1826]

A thousand apologies, Monsieur, for the boldness of my request. I am taking the liberty of writing to ask you for the most remarkable facts and incidents you may remember from your reading about the present war in Greece: those, of course, which provide the most suitable subjects for painting. I have no books at my disposal, recent ones in particular, and the weakness of my eyes forbids me to do any reading for some time. If this should involve you in any sort of research, if your memory suggests nothing to you, please disregard this letter. Remembering the interest you take in that fair country, Greece, I have appealed to you. I should be honoured if I might call on you some morning for this purpose. I should be happy to meet you tomorrow, Friday, at M. Auguste's or at Dufrêne's.[2] For I am hard pressed to finish something I have undertaken,[3] which makes your help necessary to me. I don't know how to excuse myself for importuning you; but I had to appeal to a lover of Greece.

I beg you, monsieur, not to ascribe overmuch importance to my request, but to accept my deepest respects. I have the honour to be your humble and obedient servant,

E. Delacroix

PS What I want are individual incidents such as the self-sacrifice of Botzaris, etc., rather than general affairs or naval events.

[1] An architect.
[2] Dufrêne (1788-1862), painter and magistrate.
[3] Explained in the next letter to Soulier.

care of Mr Boivin, innkeeper
place d'Aumont, Tours

[*Paris*] 21 *April* 1826

Tell me, my dear Charles, why it is my horrid fate to live far away
from those I love best and yet never give them any sign of life? That
is how I've behaved towards you for I don't know how long. When I
got back from England one of the first things that made me ecstatically
happy was to learn through the newspapers of my brother's self-sacri-
ficing deed.[1] I leave you to imagine the joy this gave me. Everyone
congratulated me and I was proud as though I had been the hero my-
self. It seemed to me that I could never write quickly enough to tell
you all I felt about it. Well, whole months, half a year have gone by
without my fulfilling my obligation towards you. One of the things
that made me keep delaying was that I meant to send you a letter
from Fradelle which I had mislaid with a great many other things I
had brought back and which I am sure that I can now lay my hands on.
I'll send it to you as soon as possible. When I received the letters you
wrote me afterwards, I was even more delighted, and yet my keen
desire to ask you for news myself remained unfulfilled. Perhaps I'd
never have written to you, my dear brother, if I had not been forced to,
that's the worst of it. But since I've given such proof of my failings
and let so long a time elapse without writing to you, you must inevit-
ably know what sort of a scoundrel I am. I can only tell you that I
love people in a very odd way. Still, I do love them. You must have
received a letter from a business man at Ste-Menehould, about an
appeal against a lawsuit in which the verdict went against us. Accord-
ing to M. de Conflans it is practically impossible that we should not
win if we appeal, and in any case we should be gaining time, for we'd
have to pay the costs of the lawsuit immediately. After they had
bullied me to make me understand the affair I gave my consent, as did
my sister, who is urging me to write to you about it. You ought to
reply promptly to this person because the respite has nearly expired
and they would start worrying us about the adjudication. You see that
it takes this sort of thing to make me write. Moreover, I must tell you
that I get gloomier and more sullen every day. I sometimes lapse into
fits of depression of which nothing can cure me. Only a nice journey to
Louroux would take my mind off my distress. It's about time I began
keeping my promises. Write and tell me that you still love me as you
used to. In my heart of hearts I don't doubt it, but I should like you

[1] The rescue of two young men from drowning.

to tell me so. All my love to all your dear colony. I'm longing for the moment when I can forget myself among you all.

Goodbye dear brother, I shall shortly send you the letter from Fradelle which remained buried in the bottom of a box for over six months. He's a very worthy fellow too; I need not reproach myself with failing to let him know about your brave deed, for as soon as I read of it I wrote to him in England. Goodbye once more, I embrace you.

ℰ TO CHARLES SOULIER
at Maintenon

Paris, 21 *April* 1826

My dear friend,

I am overwhelmed with gloom and boredom. I am now reduced to the state in which I was so sorry to see you: I confess that I could only find life enjoyable at present with the help of some such stimulant as a journey, or the presence of all those I love. Although I cannot quite understand why you should sacrifice your future destiny to drawing arabesques for the General,[1] you're quite right to stick to it if it amuses you. Not to be bored is the essential rule; anyone who fails to keep it is going against the order of things. You mention a project of visiting Italy. That would be my dearest wish; and there's nobody with whom I would rather make such a journey. But, you wretch, you merely dream of it, and you think that your desire for it will make it possible. Aren't we going to realise this delightful plan? My whole life, that's to say the few moments of happiness I enjoy, centre round the thought of that journey. But it would be too wonderful, it won't happen.

We are to have an exhibition for the benefit of the Greeks. This will accustom the public to paying to see pictures. (What a pity my paper is so bad that you'll probably find it impossible to read this letter.) I am working very hard just now, I rise early, which is something most unusual. For you who are a countryman, it must be a mere trifle. Come back and be depressed along with us; it's fun being depressed together. If you should make a 'marriage of convenience', don't forget the question of cash. You can't conceive how it bores me to communicate by letter. I want to see you yourself, not just scribbled-over paper.

There's a fortune to be made with aquatints. I'm finishing a *Marino Faliero*, a fairly big picture which I imagine will be hung at the exhibition in aid of the Greeks that I've told you about.[2] We had hoped to form a Society of Painters on the model of the London ones.

[1] De Coëtlosquet.
[2] Delacroix's contributions to this exhibition, which opened in May 1826 at the Galerie Lebrun, were *Marino Faliero*, *Don Juan*, and *Death of a Turkish Officer in the Mountains*.

155

I got Fielding to send me the Laws *and Regulations. But I fear the Frenchmen will not have the constancy necessary to such a business,* because *an artist never will consent to lose a quarter of an hour a week for occupying himself of the common good of the society. If you were here, I would tell you how I am now unhappy by the treacherous abandon of a Desdemona,*[1] *which however I think I will not murder with* her pillows, *like Mr Kean so elegantly does in the Moor.* I am *completely of the same advice as Mr Fielding saying that living so lonely, you cant make any progress in the picture. On the contrary, I am convinced that you must forget, being not excited by the comparison of the work of another, with all your talent. You cant prize the difference, but it is sensible for us all. This is the language of the friendship.*

Adieu, dear fellow, I kiss your very tenderly, though that is not a very catholical way in English to testify the mere friendship. Pity my bad english writing, but love the writer.

Your Eugène

Pierret sends to you some tracings you ordered to him.[2]

ℰ⊃ TO J.-B. PIERRET

La Charité, Sunday
[*postmark* 18 *June* 1826]

. . .[3] I'm taking over from the previous writer: I have had a most pleasant journey and I'm writing you a line from the home of one of our mutual friends, whom I've known for twenty-four years. You see that neither you nor Soulier was the earliest, nor even Guillemardet whom I've known longer than any of you. I couldn't be happier; and I have only one regret, that when I see you again I shall be back in that villainous Paris, far from the nightingales, donkeys and ducks which are all far more intelligent than the Forty Immortals. (Business matters:) The picture-framer is to bring the frame for my painting of *The Giaour*[4] before the 15th. If he hasn't done so, go to his place: M. Crozet, rue Saint-Germain l'Auxerrois, No. 89, third floor. As soon as he has framed the picture in the studio, write to Bastiano[5] telling him to come and see you in the morning before his sitting, that's to say around six o'clock. Get him to fetch it from the studio and take it to the rue du Gros-Chenet, specifying that it is for the new exhibition. His address is: M. Vincentini, rue Perdue, No. 20, near the Place

1 Unknown.
2 All the words italicised are in English in the original.
3 Postscript to a letter from, presumably, the son of General Coëtlosquet.
4 *Combat of the Giaour and the Pasha.* See plate 10*b*.
5 Bastien, Delacroix's model and odd-job man.

Maubert. Write me a lot. I am very happy. That's unusual. Give your wife a kiss from me, for I left without kissing either her or yourself; treasure this letter, I wrote it in my cups. I kiss you as I love you.

ॐ TO JULES-ROBERT AUGUSTE[1]

[*Spring* 1827]

M. Champmartin[2] has just arrived and is proposing to go and see you on Saturday evening; he has come back with an enormous amount of information. As M. Prosper Mérimée has often expressed to me his wish to hear M. Champmartin talk on his return, since his impressions would then be quite fresh, dare I ask you to send him a note inviting him, since I did not tell him that your *soirées* were held regularly?

Please forgive the liberty I am taking, and accept the assurance of my most respectful regards.

ॐ TO HIPPOLYTE POTERLET[3]

Thursday, 9 *August* [1827]

My dear Poterlet,

I hear that you are just about to return and I have not yet had the pleasure of writing to you, although I have more than once intended to. But painters as a race, you know, are addicted to procrastination. I have several times seen Monsieur your father,[4] who has kept me more or less informed as to what you were doing over there. I have seen some fruits of your labour and I greatly admired what you have sent back. Four Rembrandts in particular, both large and small, seemed to me real masterpieces. The mistake you undoubtedly made was to send them too soon. They narrowly escaped damage, the dust having apparently crept in through the cracks in the packing case. I understand, too, that you have painted some portraits and a picture for the exhibition. The whole painting world is in a ferment for November 4th,[5] and everyone who wields a palette is doing his utmost to be ready in time. Models are hard pressed, and dealers in artists' materials greet this Bacchic frenzy, as you may well imagine, with the most cheerful of smiles.

[1] See above, p. 128, n. 3.
[2] Charles Henri Callande de Champmartin, painter and friend of Delacroix's, had just returned from a voyage to the east; he exhibited his drawings at the 1827 Salon.
[3] Hippolyte Poterlet (1802-35) specialised in painting copies of the old masters. Delacroix met him first in 1818 when working in the Louvre.
[4] J.-B. Poterlet worked, like Pierret, in the Ministry of the Interior.
[5] The opening of the 1827 Salon.

Mr Reynolds[1] will be delighted to have some of your sketches. He was charmed with those he saw in my studio, and I have no doubt that by means of exchanges or otherwise he will manage to secure some. As for the question of engraving a plate of the Rembrandt, this sort of business needs to be handled with a lucidity that is somewhat difficult to introduce into the conversation when one person speaks English no better than I do and the other doesn't understand a word of French. If you are anxious to pursue the matter, there are countless ways of tackling it seriously. In any case, he has to engrave innumerable horrors by Dubufe and company, which can only strengthen his desire to have fine things to work from.

M. Schwiter[2] and all our friends here send you messages. Come back plump and rosy. That's one of the necessary conditions for painting well. Health first and foremost.

<div align="right">Eug. Delacroix</div>

ᘓ TO MADAME HARO[3]
dealer in artists' materials

21 *August* 1827

M. Delacroix presents his compliments to Madame Haro and informs her that he hopes to be able to pay an instalment on his account within the next fortnight.[4] This is the only arrangement he can undertake and on which she can rely. He will settle matters with her at an earlier date if he is in a position to do so.

ᘓ TO CHARLES SOULIER
at Autun

28 *September* 1827

Dear boy,

I've had your brief letters and I've seen M. Jovet, who is an extremely pleasant man. It is very fortunate for you to have him with you in your backwater, to remind you from time to time that there is such a

1 Samuel Reynolds, painter and engraver.
2 Louis de Schwiter, amateur painter, one of Delacroix's friends. His portrait by Delacroix, now in the National Gallery, was refused at the 1827 Salon. See plate 25.
3 M. and Mme Haro were famous art dealers and experts; the business they founded was influential for over a century.
4 Delacroix was working at his *Sardanapalus* and had run up a considerable account at Haro's. This is the first of a great many letters which he wrote to the Haros, ordering materials or giving technical instructions.

thing as painting in the world. As he is staying in Paris for some little while and as I am *adesso* up to my eyes in work, he is kindly waiting for a few days more before going to see the Bonington. There are some reservations to be made about his painting, but he's such a good fellow that one can love him for his own sake.

I have not seen Pierret for five or six days and I understand from my big pupil that you have at last decided to send in some paintings. I reckon they must have arrived by now, but as it's half-past eleven at night I cannot hope to give you my opinion right away: and this will probably mean that I shall write to you again one of these days, if the good Lord spares me a little breath. I go to work very early. It seems that these gentlemen of the jury are proposing to be horribly severe, particularly towards innovators. So that in order to finish what I want to send in, excluding of course the great big picture,[1] which I shall definitely not have finished so soon, I am obliged to get up *very early* [*sic*].

I have a great deal to tell you. My brother came unexpectedly to spend a week or ten days in Paris. It was a mere trifle of five years since I had seen him. It was a great joy to me. He is as substantial as I am slender. I get compliments from everyone, including him, on dwindling away.

I have finished the painting of animals for the General,[2] and I've unearthed a rococo frame for it which I'm having regilded and which will do splendidly. The picture has already struck a number of connoisseurs and I think it will look rather funny in the Salon. By the way, I think it's since I saw you that I went to lunch with him one morning.

The English have opened their theatre.[3] They have worked miracles, for they draw such crowds to the Odéon that all the paving-stones in the neighbourhood rattle under the carriage wheels. In a word, they are all the rage. The most stubborn classicists have had to strike their flag. Our actors go to school to the English, and stare in astonishment. The consequences of this innovation are incalculable. There is a Miss Smithson[4] who has won all hearts in the parts Miss O'Neill used to play. Charles Kemble has toned down his acting, and is more successful than might have been expected.

Goodnight, I'm going to bed. Write a longer letter or not at all. You're so used to doing business that you only write just what is

[1] *The Death of Sardanapalus.* See plate 8.
[2] *Still Life with Lobster*, painted for General de Coëtlosquet.
[3] An English company gave a season of Shakespeare plays that was a notable contribution to the French Romantic movement.
[4] Harriet Smithson, whom Berlioz married. She inspired Delacroix's *Death of Ophelia.*

needed to say what you want to say. You should be more long-winded about it, and whatever you may say we are still friends, remember that.

∽ TO VICTOR HUGO

Wednesday, [] *September* 1827

Well, well! A general invasion:[1] Hamlet raises his hideous head, Othello whets his knife, that murderous weapon subversive of all dramatic law and order. Who knows what else? King Lear will tear out his eyes before a French audience. It would befit the dignity of the Academy to declare all such foreign importations incompatible with public morality. Farewell to good taste!

In any case, provide yourself with a stout cuirass to wear under your coat. Beware of Classical daggers, or rather sacrifice yourself courageously so that we barbarians can enjoy our pleasures. . . .

E. D.

∽ TO J.-B. PIERRET

Mantes,[2] *Tuesday* [*postmark* 16 *October* 1827]

Dear friend,

Suppose I were to give you some news of myself? Actually, I have been away some time and shall not be returning until Friday. This will break the monotony of the rue du Bac for you. Laziness was invented for my benefit. To do nothing, and then have dinner, and then repeat the performance, is a way of life that suits my temperament very well. What comforts me is that I have hardly anything to do in Paris. The longer I stay here, the more I want to stay. It's a pity that harsh necessity holds us in her clutches. Who shall I ask you for news of? But I fancy nobody has had time to get very ill or make a fortune in so short a time. Being poor is a confounded nuisance. When shall we have an estate of our own, and when shall we eat the rabbits that have browsed on our very own grass? If it weren't for the mud in rainy weather, it would really be delightful to be a landowner. One would have turkeys, and ducks, and a cook. Really, it would be worth getting married in order to have such things.

Have you any news of Soulier, and how's the lithography going?

[1] The English company at the Odéon.
[2] Where his friend Baron Rivet had an estate.

The less time I have the more plans I make. That Salon[1] ought to bring a little grist to my mill. An estate! An estate!

Give my love to Félix, whom you may not have seen at all. I feel as if I'd been away from your mudpit for two whole months. Oh, that brute of a freezing studio; a confounded bore! And yet it's not so. There are moments when I think of that damned painting of mine with some pleasure.

The dinner-bell is about to ring. One's got to keep up one's strength. I wish you a good dinner too, and many more to follow in that wonderful estate where we shall go shooting by torchlight.

Goodbye, and all my love. Give your wife a kiss from me.

Eug. Delacroix

❧ TO M. HARO

Monday, 29 *October* [*postmark* 1827]

M. Delacroix's compliments to Madame Haro; he asks her to prepare for him immediately 6 tubes of lead white, 6 of Naples yellow, 2 of yellow ochre, 2 of cobalt, 2 of peach black, all rather wetter than the paints prepared for other people. He will call without fail tomorrow, Tuesday morning at 7 o'clock to collect them. He begs Mme Haro to have everything ready by tonight.

The two portions of cobalt in a single tube, all the other separate.[2]

❧ TO M. MOTTE[3]

October 1827

Monsieur,

I am very sorry for the hitch over the portrait.[4] But it is extremely awkward for me to get it done. I simply have not the necessary time. I have my picture[5] to finish and two removals to make,[6] and I shall be fully occupied for some time to come. It seems to me that at a pinch the medallion could count as a portrait. If you are willing to wait, I am ready to do whatever you like, but it distresses me very much to

[1] The 1827 Salon, at which he was to exhibit twelve paintings, including *Sardanapalus.*

[2] On the page containing the address Delacroix indicates the colours he wants: the palette for *Sardanapalus.* This is typical of a large number of letters ordering materials, giving instructions, and so on.

[3] Printer and lithographer.

[4] The portrait of Goethe for the Faust lithographs.

[5] *Sardanapalus.*

[6] He was moving from the rue Jacob to 15 rue de Choiseul (flat and studio).

141

see any further delay in the publication of a work which has been waiting about for two years already. It might be possible to say in a footnote that we are merely including the medallion and one more plate. The subscribers will be none the worse off, I give you my word. For I am forced to admit my inadequacy in the matter of lithographical portraits, which always require a certain degree of finish.

Your devoted servant,
Eugène Delacroix

ↄ TO M. MOTTE

October 1827

Monsieur,

I shall be delighted to undertake another plate, but I am so hard pressed to finish my picture that I should like to know whether, if I let you have it about the 25th, that would be time enough. You could arrange matters so that you only had this one still to print. The two I have just finished have set me back considerably with my painting and just at present I have to count every moment. I must mention one other thing, I should like to have the money as soon as the plate is done, because, being urgently compelled to scrape together as much as possible to meet certain obligations by the end of the month, I should otherwise have spent the time I shall devote to this final plate in some equally productive work. You'll probably consider me an extortioner to hold a dagger to your throat like this. But frankly, I'm confessing my dire need to you, and I think you'll find my request quite natural.

Have you been good enough to set aside for me a few proofs of the last plate, with the pen and ink figures I had drawn in the margin? I am particularly anxious to have these. Will you tell M. Stapfer[1] how flattered I am by his good opinion and beg him to excuse me if I do not write? You will interpret my feelings to him.

Farewell, monsieur, with all my kind regards.

Eugène Delacroix

ↄ TO M. MOTTE

1 *November* 1827

Monsieur,

You would do me a great favour by giving me 200 or 150 francs. The gilders and other bloodsuckers have reduced me to such straits on

[1] Albert Stapfer (1802-92), translator of the *Faust* which Delacroix illustrated.

142

the eve of the Salon that I have recourse to you. A quick response would be twice as valuable just now.

All my friendly greetings and kind regards.

Your devoted

Eugène Delacroix

☙ TO LOUIS DE SCHWITER

21 *November* [1827]

My dear Louis,

I received your letter with great pleasure, and yet you will not be surprised at my slowness in answering it. You know me well enough to realise that anything else would have been too amazing a phenomenon. I must tell you that our friend Crozet[1] fell ill as a result of his immense labours in connection with the Salon, and that your order was held up thereby. But he did not tell me immediately. I was consequently unable to approach anyone else. If you leave on the 20th as you propose to, you will have to resign yourself to seeing your portraits unframed. It is more than likely indeed that my letter may not reach you. In any case I assume you have left instructions for the varnishing of your paintings. The Salon is, as it has been every year, a hotch-potch of detestable paintings amidst which a few have merit. You'll very quickly be disgusted with it. I am delighted you have made good use of your time. For my own part, I have spent some time at Mantes, and this somewhat delayed the completion of my picture,[2] which has nonetheless made notable progress. I must tell you by way of news that the portrait of young Lambton,[3] of which you have seen dark engravings in all the shops of Paris, has been at the Salon for the past week and has met with general admiration. They're also expecting an Englishwoman's[4] painting of a child's head which, incidentally, I've already had the pleasure of seeing, and which surpasses, or at least equals, anything you can imagine. I wish you, then, the joy of seeing these fine things, which apart from the pleasure they cannot fail to give you will help tremendously towards your progress. Poterlet, who is working by my side, sends you his greetings, and so do all the friends who have repeatedly asked for news of you.

[1] A picture framer in the rue Saint-Germain l'Auxerrois.
[2] *Sardanapalus*, not ready for the opening of the Salon in November, was first shown in February 1828.
[3] By Lawrence.
[4] Mrs Carpenter (1793-1872).

৶ TO DAVID D'ANGERS[1]

Friday, 23 November [1827]

My dear David,

I am taking the liberty of writing to you on behalf of M. Huet[2] who did not need my recommendation to enjoy your esteem. There is something so glaring about the injustice of which he is one of the victims that one cannot strive too earnestly to set the matter right as far as possible. You are good enough to excuse me for not having taken fuller advantage of all your kindness towards me, but this confounded picture still requires so much work that I tremble at the thought of all I still have to do.

Farewell. A thousand apologies, and sincerest good wishes from your wholly devoted

Eug. Delacroix.

৶ TO CHARLES SOULIER
at Autun

Paris, 6 February 1828

How kind of you, my dear boy, not to be cross with me. I really almost deserved it. That is why I was so happy to get your letter, although it's such a miniature, for in all conscience it's a disgrace to write such a short one. I heard from the La Maisonforts[3] that your stomach had been troubling you. I'd have thought, on the contrary, that your wandering life might have strengthened it, considering the less frequent opportunities of providing it with those good things that are our ruin in this damnable world, where everything pleasurable turns to bitterness.

I have actually finished my *second Massacre*.[4] But I have had to endure a number of tribulations at the hands of those very asinine gentlemen, the members of the jury. I shall have plenty to tell you on that head.

I'm continuing this letter two days later. They reopened the Salon this morning. My daub has been hung in the best possible position, so that success or failure is entirely my responsibility. I thought it looked horrible when I stood in front of it, and I hope the worthy public will not look at my masterpiece with my own eyes. It's unfortunate that I should happen to write to you on a day when I am so dissatisfied. But that will be your punishment for having written so little to me.

[1] Sculptor, member of the Institut since 1826, on the Salon jury.
[2] Paul Huet, landscape painter. All except one of his pictures were refused.
[3] The Duc de la Maisonfort was Soulier's former employer.
[4] *The Death of Sardanapalus*, the first being *The Massacre at Chios* (1824). See plate 7.

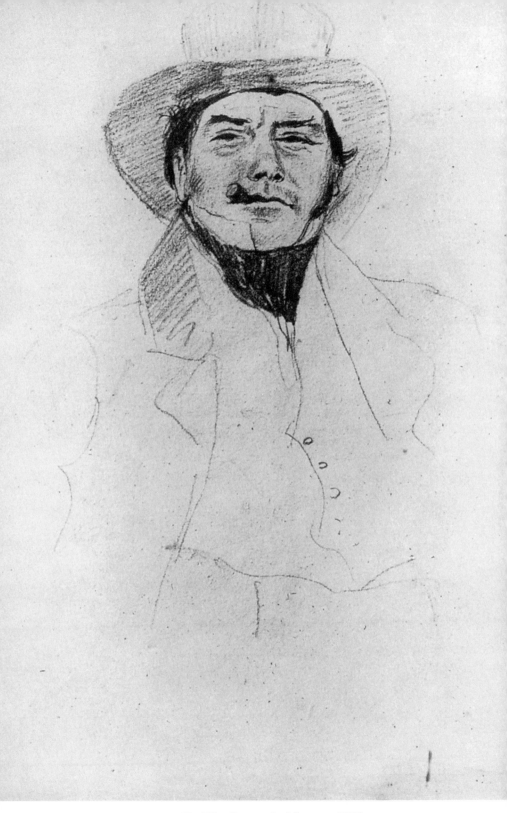

17 The Comte de Mornay, 1832

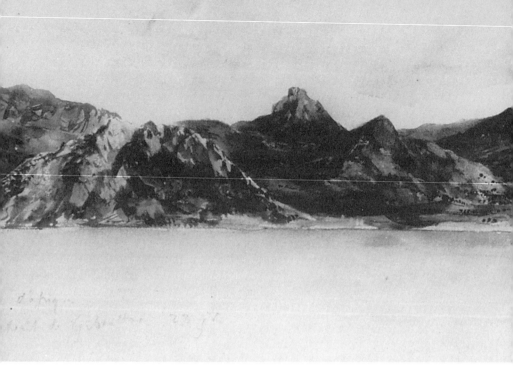

18*a* View of Gibraltar

18*b* Environs of Tangier

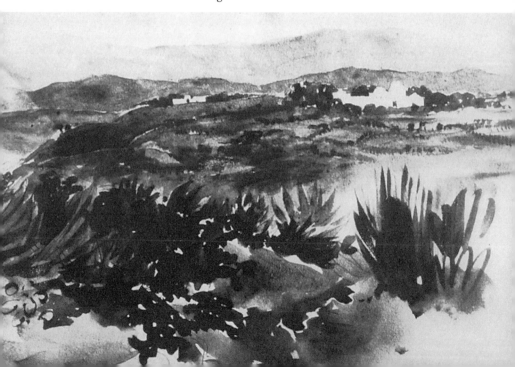

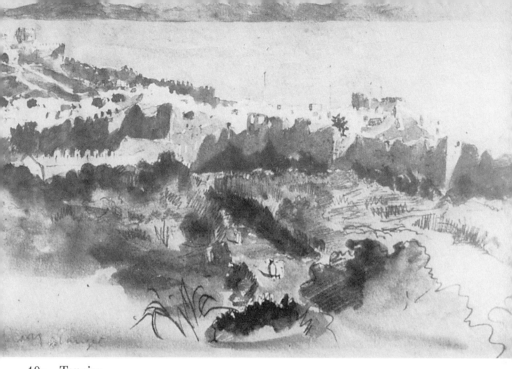

19*a* Tangier

19*b* Arab lying on mat

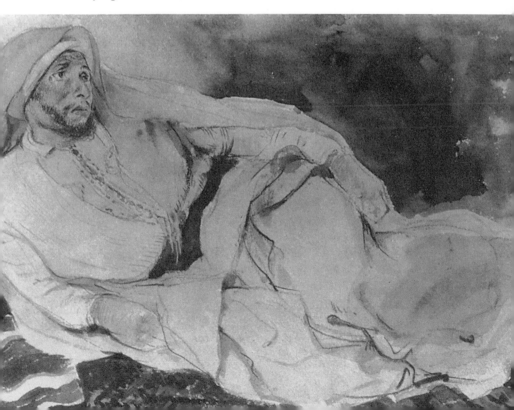

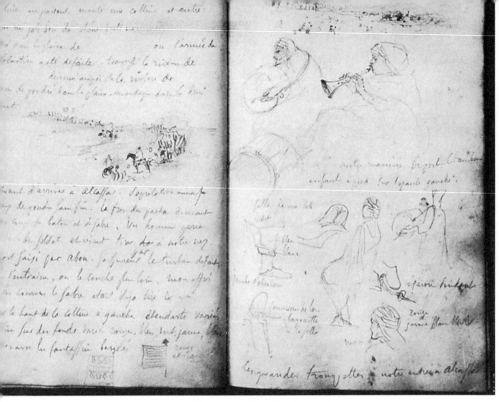

20*a* Page from Moroccan sketchbook. Arab musicians

20*b* Page from Moroccan sketchbook. Ruined gateway

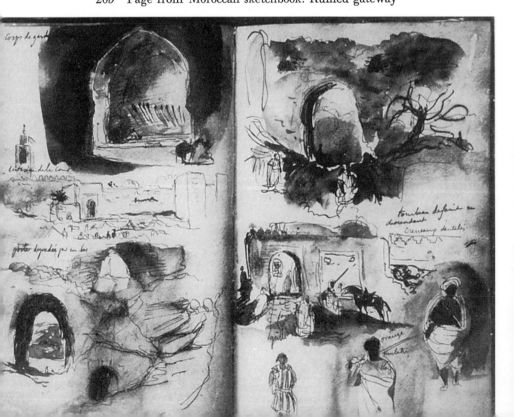

What a hateful profession, where one's happiness depends on matters of pure vanity! The result of six months' work is that I've spent a damned miserable day. Anyhow, I'm used to that sort of thing, so don't be too much alarmed for my sake. It may be, it probably is just like all the other times when the first sight of my damned painting hung beside that of others strangles me completely. It feels like a first night at the theatre where the whole audience hisses.

I have moved house. I am writing to you from 15 rue de Choiseul, a very *fashionable* [*sic*] quarter, far too much so for a poor devil like myself who's well on the way to the workhouse. Write to me there, and quickly, I beseech you. (Not to the workhouse yet, I've just noticed the ambiguity.) By the way, I'm no longer quite so thin. Apparently I was at death's door. But if my affairs go badly, farewell to my rosy cheeks! Goodbye to you; find me a good job in one of your mines. I look like a very worried man indeed tonight.

Goodbye, I embrace you.

E. Delacroix

ꝏ TO CHARLES SOULIER
at Montluçon

Paris, 11 *March* 1828

. . . I have not done very much as yet. I am sick of this whole Salon. They'll end by making me believe that I've had a real fiasco. And yet I'm not entirely convinced. Some say it's a total failure, that the *Death of Sardanapalus* means the death of the Romantics, since that's what they call us, others bluntly declare that I'm *inganno*, but that they'd rather be wrong with me than right with a thousand others who have good sense on their side, if you like, but who deserve damnation in the name of the soul and of the imagination. My own opinion is that they're all idiots, that this picture has both qualities and faults, and that if there are some things in it that I could wish better done, there are plenty of others that I hold myself fortunate to have done and that they might well wish to have equalled. The *Globe*, otherwise M. Vitet,[1] says that when an imprudent soldier fires on his friends as well as his foes he must be expelled from the ranks. He urges all those whom he calls the New School to give up any sort of alliance with such a perfidious independent as myself. The fact remains that those who steal from me and live on my substance abuse me more loudly than anyone else. It's all quite pitiful, and would not deserve a moment's

[1] Ludovic Vitet, art critic; his article appeared in *Le Globe*, 8 March.

145

attention except in so far as it directly jeopardises my wholly material interests, in other words, *cash* [*sic*].

You will have heard that my picture of *Marino Faliero* is at the British gallery,[1] and that the English papers have praised it enthusiastically. . . . Mme Mirbel[2] is extremely good to me and encourages me. Encourage me too, my dear good fellow, encourage yourself, let's encourage one another and let's try, before we give up the ghost, to enjoy a little peace and independence in this wretched world. A few books, a few bottles of good wine and a few other good things. The rest, as my old friend Sardanapalus remarked, is not worth a straw.

Farewell, farewell, write to me. I still love you and I long for us to be together and never part.

TO CHARLES SOULIER
at Nevers

Saturday, 26 *April* 1828

. . . You rascal, do you doubt my thinking of you? Let me tell you that since I knew you I have not formed a single true friendship. You were the last of all the friends I made at that age when, as some poet says, 'the soul is still new', comparing it to 'a pure lake that still reflects the sky'.

You must think I lead a gay social life if you suppose its attractions can compete with certain other bonds of affection. Nothing of the sort. The few evening parties to which I go out of habit, seeking entertainment and finding boredom, end by exhausting me completely. More often than not I'm monopolised by some ninny who talks a lot of nonsense to me about painting, thinking that his conversation will give me a high opinion of his capabilities. As for women, I get none that way. I'm too pale and too thin. The great concern of my existence, which holds in check and in abeyance the lofty and powerful faculties which, according to some good folk, nature has granted me, is just . . . to be able to pay my rent every three months and to keep on living in a shabby sort of way. I am tempted to apply to myself the parable of Jesus Christ, who says that his kingdom is not of this world. I have a rare genius which does not even enable me to live in peace like some petty clerk. A lively mind is the unlikeliest of faculties to help one make one's fortune; that is literally and unexaggeratedly true.

[1] Exhibited in London after the Salon, but not sold. Later returned to London to the Wallace Collection.
[2] A distinguished and fashionable miniature painter who helped Delacroix at the start of his career.

Imagination, when as a crowning misfortune that fatal gift accompanies all the rest, seals one's ruin, finally blights the unfortunate soul and shatters it completely. The love of glory, that deceitful passion, a will o' the wisp that always leads straight to the gulf of sorrow and vanity! I'm not speaking of love, which knows the sharpest pangs but which also gives us some really reviving moments. If I ever have children I shall pray heaven to make them stupid and give them good sense.

I must not expect any commissions or encouragement. My most favourable critics are at one in considering me an interesting madman, whom it would be rash to encourage in his errors and eccentricities. I had lately a little argument with that man Sosthène.[1] The gist of it was that I have no hope of anything from that quarter so long as I don't change my ways. By heaven's grace I kept my temper during the interview, in which that idiot, who is quite unbalanced and devoid of common sense, completely lost his. It's this very day at two o'clock that the distribution of honours and favours will take place at the museum. I shall break off in order to be able to tell you about it.

Sunday morning

I'll finish this scrap of a letter. I shall write you a longer one another time. I went to the meeting yesterday. As I expected, my picture has not been bought, and no commissions for the future. The joke was carried even further when they read the list of works previously carried out for the *conseil d'état*. There was no mention of my name nor of what I had done.[2] Which proves that I shall have to look round in other directions. For that matter, I haven't died of it, and there's life in the old dog yet.

Goodbye, my dear fellow, write me good and plenty. I embrace you and I love you dearly, be good enough never to doubt it.

Eugène

☙ TO VICTOR HUGO

Mantes, Saturday

My dear friend,

I am sending you almost the complete set of the costumes in question.[3] The tailor can now get to work. He will probably not make

[1] Sosthène de la Rochefoucauld, Superintendent of Fine Arts.

[2] *The Emperor Justinian drawing up his Laws*, destroyed during a fire at the Palais-Royal in 1848.

[3] Delacroix designed the costumes for *Amy Robsart* by Victor Hugo and Paul Foucher, which had a single performance at the Odéon in October 1828.

head or tail of them. But for that matter I shall come along myself to clear up any difficulties. There is only one thing I fear, namely, that we have set about it all too late. We may perhaps have difficulty in obtaining certain things. But I hope we shall have them for *Cromwell*,[1] or for some other piece of work which will be your true progeny. God grant it may be soon. I wish you in the meantime the patience of a saint for what you've still got to extract from these blockheads. The day before I left I happened to meet the man who's behaving like Flibbertigibbet. He seems to me well inclined enough, and as for certain doubts he still appeared to hold, I did my best to convert him.

Goodbye, my dear Victor. Give my respectful regards to Madame Hugo, and believe in my warm friendship and the enthusiasm with which I should help you, if I could, with something better than all these scribbles.

Your friend,
Eugène Delacroix

♪ TO FÉLIX GUILLEMARDET

[*Paris*] 4 *October* 1828

Many thanks for your letter, dear old fellow. We had had no news of you for a long time and were almost feeling anxious. Fortunately, if you'd been dead you'd have let us know immediately. I assume you're in robust health, since even though you have business worries you are breathing country air, which is enough to keep you well. Pierret began a letter to you which he'll finish Lord knows when, he felt sure that his would be the first to reach you, seeing how busy I am, but he's now turning out so lazy that I see I shall forestall him. The Turks are still being insolent enough to defend themselves, that's the latest news from here. . . . Bores abound, and great poets and great minds are still very scarce. In spite of the success of *Olga*, a semi-romantic piece by my good friend M. Ancelot, it is generally agreed that no successor has yet been found to Shakespeare the barbarian, that vulgar barn-stormer – *ce Gille de la foire* – as somebody called him, who was murdered again recently by those wretched English actors who are still trying to attract audiences, but with great difficulty, although Kemble is playing with them. I must tell you, in order to acquaint you with my good fortune, that the duc d'Orléans is pleased with my painting and that the Minister of the Interior has commissioned a picture from me, the subject of which is just the sort of thing I like to paint, the death of Charles the Bold. I plan to commandeer your

[1] *Cromwell* appeared in 1827.

archaeological knowledge on this subject. Go grape-gathering, you lucky mortal, enjoy the last remaining days of fine weather. I still intend to visit Touraine, but I have put it off from day to day and now I shall probably go there and freeze, but no matter. Having given your letter to Pierret almost as soon as I'd read it, I don't remember if you said you were coming back soon.

A small gap having occurred, it happens that during the interval Pierret has been less idle than I imagined and has written to you, contrary to my expectation. He lives so far away that it's quite a journey to see one another. Fortunately the omnibus service, which was in its infancy when you left, has expanded its scope prodigiously. There is now one that runs from the rue Bleue, next door to me as you know, along the rue de Richelieu and as far as the Carrousel, and another that takes you from there to Vaugirard. They'll soon be paying us poor folk to travel by omnibus. For all that, I'm just off to pay for my seat in the stage coach. They tell me I've been in better health lately, and that I'm getting fatter. Imagine what I shall be like when I come back with a whole month of Touraine in my *estomache*. . . .

↜ TO CHARLES SOULIER

October 1828

. . . The Minister of the Interior,[1] a very likable man in every way, has commissioned a picture from me for the museum of the town of Nancy, representing the death of Charles the Bold,[2] who was a most licentious character. When are you coming to Paris, you beloved rascal, to show me your dear old tallow-face that I'm so fond of and that reminds me of such happy moments in my wretched life? When you are in Paris, you spend all your time wandering about. I see no more of you than if you were at Autun, that city of pigs. Tell me when you're coming, since I cannot go out to see you. I spent part of yesterday evening with Leblond, another decent fellow who reminds me of the good old days. I smoked tobacco with him, as if he'd been yourself, for you are the only one who has hitherto corrupted my morals on that point, as on so many others. For you can boast of having smoothed for me the path to every sort of vice. You made me into a drunkard and a frequenter of low haunts, frowned on both by morality and good taste.

Goodbye, dear fellow, come and see me. I shall write to you from Touraine,[3] which seems to be retreating further and further from me;

[1] M. de Martignac.
[2] *The Battle of Nancy*, hung in the 1834 Salon.
[3] Where his brother Charles lived.

149

I've been putting off this *trip* [*sic*] for a mere six years. I ought to have gone a month ago, and I'm sure I shall not be there before winter. Goodbye, love me well, your devoted

<div align="right">

Eug. Delacroix
painter of historical scenes and baron-to-be.

</div>

Paris, 20 *October* 1828

There has been a gap of nearly two months since the beginning of this letter, on the back of this page. You can see from that the full extent of my indolence, which will be no surprise to you. I have had the letter in which you told me you were ill. Poor lad, I know from experience that fever is a horrid thing. I kept reproaching myself every day for not writing to you, knowing how a friend's letter is always welcome to a poor invalid. I think I shall send this off as it is, on just a single sheet, so as to be sure you get something from me promptly, and then perhaps write to you again later. That must not prevent you from answering me, since although I am in good health just now as a result of my visit to Touraine, I am always keenly delighted at hearing anything from you.

I'm about to move house once again. Heaven knows when I shall have done with my nomadic life! This time I shall have my living quarters and my studio in the same apartment, with the result, I hope, of saving time and improving my work.

You're in luck. I have just found a fresh piece of paper. You'll benefit to the extent of a page or two of my vile prose. Fate is a damned swine to arrange things, invariably, so that we have to live far away from one another. After that wretched Italy, I thought it would be over. Nothing of the sort. Although I have been back nearly a month I've not seen any of the Dominicans.[1] That's very wrong of me, I admit. For that matter, let me tell you that I've become quite seriously aware that what made me lose weight so terribly were those evening parties, which always ended by my going to bed at one in the morning. It's sheer stupidity, because one gains nothing from them except smart talk. My fair lady,[2] who's still fair enough for me, appreciates Monsieur's kind message. I advise Monsieur to give Monsieur's innards a good cleansing.

[1] The Coëtlosquets.
[2] Mme Dalton.

cs TO ANTOINE BARYE[1]

[16 *October* 1828]

The lion is dead.[2] Run, run. This weather should spur us on. I'll expect you there.

Kindest regards,

Eug. Delacroix

Saturday.

cs TO ANTOINE BARYE

1828

My dear Barye,

Would you kindly tell my maid the nearest place in this neighbourhood where one can get a cake of clay for a model that I need to make tomorrow morning?[3]

Kindest regards,

Eug. Delacroix

Friday evening.

cs TO J.-B. PIERRET
[*postmark Tours*,[4] 27 *October* 1828]

Hullo, my dear fellow, I spend all day idling, which doesn't prevent the time from passing fast. How are you keeping? Write and tell me. One thought has occurred to blight the pleasant prospect of finding a 1,000-franc note intact: namely, that in my reckoning I had forgotten that I owed Master Souty[5] a mere trifle of 300-odd francs and Master Jobin[6] a paltry 170 or 180. These wretched money matters will worry us perpetually. If you had happened to discover a mine since I left home, you'd let me know. Is Guillemardet back? He must be sleek and chubby. I haven't reached that point yet, but I am no thinner. I've been meaning to write to you for a week, and I keep trying to set aside in one corner of my brain the things I want to tell you. But now

[1] The animal sculptor.
[2] According to the museum archives, an African lion died on 16 October 1828, and no other between 1826 and 1828, when Barye was living in the passage Sainte-Marie. This enabled Joubin to date this letter.
[3] Delacroix was obviously trying his hand at sculpture, presumably a model of the dead lion.
[4] At his brother's.
[5] Dealer in artists' materials, rue du Louvre.
[6] Unknown.

151

the time has come to open the flood-gates I can remember nothing. The most urgent thing I should like you to do is to remind Osterwald[1] of the drawing Thales[2] has asked for. If you were not quite so fierce as I know you are, you would go to see M. Barry [*sic*], the sculptor, passage Sainte-Marie, care of Fauconnier the goldsmith, and tell him that by a deplorable oversight I packed the animal drawings he kindly lent me with my own papers, and that I have not sent them back to him lest they should go astray or get crumpled in the post. Give him my apologies and give yourself a good kiss from me, likewise your wife and all your progeny. I am trying to prod the chapter and all the curés into letting me paint pictures for their church. I have drawn up a magnificent prospectus and presented it to them. Write to me and give me news of yourself. I am writing to you absolutely on the spur of the moment; you who have a pen in your hand all day long, write me a good long letter. When one's alone, nothing is sweeter than letters. I'm getting infinitely rusty. I no longer have that mental activity which in the old days made up for my laziness. I don't find the same charm in things. Alas, that delightful prismatic glow is fading more and more. That rosy haze is vanishing damnably before my eyes, and I find little delight in what once stirred my imagination; even that is now growing cold and serves only to torment me over the most trivial issues. Why, the devil take us all, it's all silly nonsense, you, me, the devil and everybody else.

Write me a long letter before tomorrow, I embrace you.
Saturday.
Care of M. le Général Delacroix, maison Papion, rue Neuve, Tours.

୶ TO J.-B. PIERRET

[*postmark Tours, 5 November* 1828]

How good of you, dear friend, to have written to me so soon. I say so soon, because I know you, and in fact I was just going to write to you again to ask you to tell my caretaker to have my mattresses recombed as soon as possible: for not knowing exactly when I was coming back, which in any case will be quite soon, I should be very glad to find that operation done. You will please give him the necessary cash. Your letter made me very happy. I need that sort of encouragement in the black mood that overtakes me only too often, and you are about the only one who's capable of encouraging me. I'm sure you are aware that you are the only person with whom I am in complete sympathy

[1] Dealer in prints and engravings, 37 rue des Augustins.
[2] Fielding.

and I venture to say that I'm proud of it. The praises of others have never made more than an imperfect impression on me.

You are right. We change, that's all; but you know, one cannot observe one's own heart and imagination like a spectator at the theatre. It is only with a pair like ourselves, who have been one another's double ever since we first knew each other, that one half can observe and describe the other. I'm not telling you anything new, am I? That's the way we are together. Let us see to it then, dear friend, that if one of us dies, the other won't hobble far behind him in this dreary world. I tell you, not only could I never be comforted for the loss of you, but my life would be crippled and half-blind. So close a friendship must compensate for the loss of our youth and even for our humble hopes of fortune. For all that, give Félix a warm embrace from me if you see him again before I do. You know from your own feelings what mine are for him. We'll settle all these things on New Year's Eve.

The weather is still enchanting. The countryside is ablaze with rubies, emeralds and topaz, and with all the splendour of its farewell. Although my occupations summon me back, and although I'm doing nothing here, I dread going away to resume my weary yoke. You're living miles away from me, which will make communication difficult in winter weather. Don't be surprised at my shocking hand; I am writing on my knee to be near the fire. If your laziness doesn't prevent you, write me again. Nothing could give me greater pleasure. Try and get Rivet[1] to take one of my pictures, whichever suits him best.

Farewell. Kiss your wife and children for me. If it's not too late, write to Louis[2] asking him to bring me back as many views as he can of different aspects of the chapel and the place where Charles the Bold was killed.[3]

&ℓ; TO MADAME PIERRET

Friday morning [*November* 1828]

I lay at the feet of Madame Pierret the enclosed ticket for Franconi's[4] for today, Friday. She will see there, if she deigns to take advantage of it, the incomparable acrobat *Diavolo* and the *Siege of Saragossa*

[1] Dealer, rue Montmartre.
[2] Louis de Schwiter, whose father was *maréchal de camp* at Nancy.
[3] For the painting *The Battle of Nancy*, commissioned by the State in 1828, finished in 1831 and exhibited in 1834.
[4] Franconi's Circus, in the boulevard du Temple, was famous for its spectacular equestrian displays and battle scenes. Diavolo was a celebrated tight-rope walker. This is typical of a number of letters offering theatre tickets to Mme Pierret. See plate 4*b*.

with its accompaniment of fanfares and gunfire. Since I dare not take the liberty of embracing her even by letter, I embrace Master Pierret her husband.

ℰ꙰ TO CHARLES SOULIER

28 *January* 1829

My dear fellow, how is one to write in such villainous weather! Today, I stayed in bed until two in the afternoon so as to keep a little warmer. I am in the throes of a removal. I hope I shall be comfortable. Will you please write to me from now on at No. 15 quai Voltaire. You see I am moving closer to the neighbourhood of good society, and the result, please God, will be to make me become as unsociable as possible, go early to bed and snap my fingers at insolent and moneyed people, as my nature bids me. One has to try and put up with poverty, and chafe at it as little as possible. Just think, I have only one door to open, and indeed I can leave it open, and from my one room I go in my slippers into my very comfortable studio, which into the bargain has its own staircase, a nice clean one.[1] When you come to see me I can put you up on a camp bed.

All this will cost me a trifle more than I have been paying hitherto, but I shall save so much time that the money will be well and profitably spent. The greatest advantage for me will incontestably be having a home that I like, which is something I've been hunting for for a very long time. From my windows I can see the Louvre, a bit of the river and the Tuileries. It lies entirely with me to fancy myself king of it all.

This will all be very fine when I have the full enjoyment of it. At present, and until I am properly settled in, I'm living a wretched life, and have no other resource but to go and make myself a nuisance to all my acquaintance. Come and see it all. I shall do so much work, I hope, that it will make you want to send the mines to hell and devote yourself to art, even if it doesn't make you fat.[2] If I'm not *inganno*, it's a longish time since you wrote to me. Are you really cruel enough only to write to me on condition I write back? That would be very wrong of you. To prove to you that I'm becoming more and more of a bear, a wild and even a savage beast, I haven't seen and I never see a single soul from the rue Saint-Dominique. It's coming to the point that I don't know if I shall dare show the tip of my nose there again. I had dinner with dear Pierret, whose wife has been dress-making for the duchesses of Orléans. I have been picture-making for

[1] Pun on *propre* (clean, one's own).
[2] Pun on *l'art* (art), *lard* (*faire du lard*).

them[1] as you know, and they're as hard to please in one case as in the other.

I can't remember whether or not you like cold weather. If you do, you ought really to come to Paris to meet a particularly choice specimen. It's developing *rinforzando*, like a Rossini finale. Since the beginning of the year the Seine has a misleading look of wanting to be skated on,[2] like the slut she is. Weren't you fond of that sport in your younger days? I still am, but not in the respectable and moral sense. My fair one[3] spent part of the autumn stricken with rheumatism. The poor girl, no sooner recovered, has just hurt her finger horribly; nonetheless she sends you friendly messages and all sorts of delightful embraces through me. Write me as soon as possible. Did I tell you I had seen Piron again? O the vicissitudes of human life! The poor fellow had a very shabby coat and looked very poorly. It distressed me. But he has his . . . [*sic*] in his favour, which probably preserves him from the most painful blows of fate. I think I want to go to bed. The fire is dying down, and with it my creative ardour. There is a prodigious draught coming through my door, a real prince of draughts that catches me squarely in the back.

Goodbye, my dear old fellow, and write to me quickly. I embrace you.

ℰℐ TO CHARLES SOULIER

[*Paris*, 1829]

You vile wretch, why won't you reply to a man who loves you so much? For whom are you saving up your eloquence? Write to us who cannot see you and who want to so badly. I don't know what prevents me from going to surprise you some fine morning and waking you up in your bed with a *cold pig* [*sic*] of my own making. I do nothing but dream of the *cottage* [*sic*] that I'd like us to have to spend our lives in. Can't you picture the delicious indolence, the golden idleness we should enjoy there, and the good wine, and the gossip! Petticoat treacheries would have long since lost their power over us. The wine cellar and the library would satisfy all our needs. We'd laugh, and with good reason, at the foolish things we did for the sake of those monkeys in lace caps, those pretty ivory toys that lead us to perdition. How we should laugh at all their vapours, their airs and caprices. We'd be invulnerable, unassailable and yet lovable. They'd die of their longing

[1] *The Murder of the Bishop of Liège.*
[2] Pun on *patiner* (to skate, to fondle).
[3] Mme Dalton.

for us and we'd shrug our shoulders like the true sages we'd have become. We'd toss ourselves off, wouldn't we, rather than let those pretty little feet, those dainty, rascally little feet set foot in our home, those petticoated monsters. Perhaps you think that I've been teased, betrayed and done to death by one of those vixens. Not at all. My heart is calmer than it has ever been. Only this morning as I got up I said to myself, where are the good old days when I was unhappy? Do you ever consider conjugation, I mean marriage? Motte the printer's daughter, whose name is Céleste Motte, has just married Deveria[1] . . . *Celestial Motte!* I said on seeing the happy pair. Cannot I find a celestial Motte some day, to spend my life along with her? Don't you ever think of your little charity lass or of any other? I've been chatting to you for a whole hour. I must see you or hear from you. To punish you I shall only write this last page. What I should like above all is an income. A man with an income is a complete man. What can he lack, particularly when he's as philosophically minded as ourselves? Every month he sees a tidy little sum roll up, without being forced to earn it by paintings or writings that the devil may devour.

Goodbye, a thousand embraces and write to me.

Eug. Delacroix
quai Voltaire 15

↫ TO J.-B. PIERRET
rue Saint-Anne, No. 18, Paris

Valmont, 28 October [1829]

My dear chap,

It's rather late to start writing to you when the time for my return is already close at hand. I found my Valmont just as I had left it fifteen years ago and this induced great fits of melancholy during the first few days. I found nothing changed but myself, alas! and myself very much changed, and yet very little better off. I have not spent much time here, having constantly been out on excursions to visit friends or to the seaside. I saw some quite astonishing bits of scenery in the way of rocks, etc., and my Englishman, the decorator, had provided me with excellent information. I found everything that he had described and it was far better than he had said. . . .

What a lovely region this is, my boy! It's a pity that all the leaves are falling. And the sea: I always greet it again like a friend or rather

[1] The marriage of Achille Deveria, the romantic illustrator, to Motte's daughter in April 1829 enabled Dupont to date this letter.

156

like a mistress. When I'm here, I cannot tear myself away from it. All the seascapes ever painted are intolerably frigid.

I have several things to beg of you. First, to send me my passport which I forgot, as soon as possible, because I might be asked for it if I come back by way of Le Havre or Dieppe. You'll find it in the top drawer of my chest of drawers, in the pigeon-hole on the extreme right, in the middle of a jumble of papers and all sorts of things. This you must send me at once with no delay. Next, please try to get friend Goubaux[1] to hand over some money, so that one can pay one's rent when one gets home. Next, please remember my palette, which ought to be got ready now, at Rivet's, I suppose, and must be properly oiled. Please insist on his doing this, and having it ready for the 8th or 10th at latest. This is absolutely essential. I have heard from dear Soulier, who suggests that he would like to come and see me. I'm writing him a line to draw him a map of the way, in case he should manage it, and to tell him at the same time that I may perhaps go home soon enough to embrace him in Paris.

I am terrified when I think of the business affairs awaiting me. I've a million of them, and that's what makes me linger on idly here. I should like to spend a day or two at Rouen. Have you seen Rouen? I think you went there on your way to Dieppe. All this is superb, and one would need an endless series of lifetimes to do justice to it all. And anyhow we've all got our own jobs to do. There are some old women here who would do sublimely for a witches' sabbath. Great heavens! Thirty feet of goods to be produced![2] Which is scarcely relevant. All my love, and my most profound respects to Mme Pierret who is a friend of mine too, isn't she? and whom you will please kiss on the cheek for me.

Goodbye, goodbye.

Eugène

Care of M. Bataille, at Valmont (Seine-Inférieure)

Give the enclosed to Soulier at once.

⚛ TO FÉLIX GUILLEMARDET

Valmont, 2 November[3] 1829

. . . Although I found everything in the same place and looking just the same, on the other hand I was not recognised by a single one of

[1] Goubaux, an old friend, ran a boys' school, the Institution Saint-Victor, and commissioned Delacroix to paint portraits of prize-winning scholars at a hundred francs a head.

[2] *The Battle of Nancy.*

[3] Joubin published a fragment of this letter in the *Correspondance générale*, mistakenly (on Burty's authority) dating it October 1829 and addressing it to Piron.

the people who had seen me here in the old days. Some of those who were here then have changed very much for the worse, for they are dead; some were thin and have grown fat, and *vice versa*. Admit that it was sadly vexing. The garden alone has altered, because the trees have grown and since it was planted with exquisite taste it is really enchanting. Unfortunately I can only half enjoy it, because all the leaves are falling or have fallen. The days are short and we rarely have sunshine. The church is still the same and the good monks are still sleeping prostrate in their tombs, wrapped in the same leaden slumber. One remarkable thing that I had not remembered are two fine tombstones in the best style of the period immediately preceding the Renaissance, with superb statues of knights in tabards lying on them, emblazoned with coats of arms.[1] My cousin does not appreciate these as much as they seem to me to deserve. On the other hand he has a high opinion of things which are less to my taste.

You will have time to write and tell me something about yourself and all your occupations and interests. As for politics I know as much as you do, thanks to the *Constitutionnel*. Has Pierret told you about the journal *Le Temps* which is about to appear, and to which I had been asked to contribute?[2] I took an interest in it, which was quite natural for various reasons, but I also suggested some friends of mine: yourself and Pierret. I should very much like you two to encourage one another to try out this career. It would be a sure way to publicity for yourself, and by working at first through the anonymity of a newspaper you would gain that self-confidence the lack of which has so unfairly betrayed your excellent qualities. I am not paying you a foolish compliment. You know your real worth is unquestionable. And if only as an amusement, and not through ambition for fame, isn't there an enormous pleasure in speaking one's mind in public? It's almost a matter of conscience, when so many fools pride themselves on doing so. You have such special knowledge of so many things and you understand everything. Think it over. Make Pierret do the same, while I am urging him to lose no opportunity of persuading you. . . .

⨳ TO CHARLES SOULIER

Paris, January 1830

I must ask you a favour. I do not want our friends to know what has

[1] The tombs of Adrian and Nicolas d'Estouteville. In a letter to Pierret (19 November) Delacroix says he has been 'taking casts of certain small figures adorning the tombs in the church'.

[2] While at Valmont Delacroix wrote articles on aesthetic questions, which however appeared not in *Le Temps* but in the *Revue de Paris*.

happened between us.[1] When we meet in their company we shall try to behave as we did before and we must be supposed to visit one another as usual. As I believe your stay in Paris will be short, this will not be a great strain. In any case, such occasions may be infrequent, especially if people believe that you come to see me. You understand, the reason for this is a weakness that I want to conceal and which is stronger than my reason and my wounded pride. Would you have believed that though I have given you up I cannot yet give up another person who is bound to me by ties that I did not believe so strong? I can only depend on time for that.

In the letter you wrote me you express pity only for yourself. Surely you can gauge my feelings from your own. I am not blaming you for the upheaval you have caused, for some time, in my existence and for having embittered forever a feeling which was my sole happiness amid the dreary life I lead. I know too well, unfortunately, how opportunity and our weakness can carry us away. I can entirely understand how, yielding to a transient attraction, you treated as a pastime of no consequence something which almost entirely filled my heart and my imagination.

During your last visit to Paris, people wondered why you did not see me. Find some pretext for this.

Eug. Delacroix

Let me know that you have received this as soon as it reaches you.

⊘ TO CHARLES SOULIER

Paris, 10 *March* 1830

We are too pitiful and wretched creatures to go on living like this. I find this world too unbearable as it is not to feel the value of an old friendship. It is because I'm growing older. There are some people who love me and whom I cannot love because it is too late for that. Come back and see me.

Eugène

Please come in the afternoon if you can. If the portress makes any objections, come up all the same.[2]

[1] In a letter from Valmont (28 October 1829) Delacroix had written to Soulier, 'I am very glad you have been to embrace my good little friend in the rue Godot [Mme Dalton, his mistress since 1825] . . . Kiss her again before you leave, for my sake, and encourage her in her painting. . . .' Soulier obviously fulfilled his mission only too well. In this letter (above) Delacroix uses *vous* instead of his usual *tu*.

[2] He reverts to the familiar *tu* in this appealing note. Of subsequent relations between the two friends we have no trace until 28 May 1831, in a letter referring to Soulier's marriage (p. 171).

159

✒ TO ALEXANDRE DUMAS[1]

4 *April* [1830]

How disappointed I am, my dear friend! You took the trouble to call on me. I don't know if I was at home, but you ought to have assaulted the portress. In any case I gave her a good dressing-down. Just fancy, I was on a spree with Mérimée, Beyle and others and, moreover, had an engagement for that evening. You can imagine my disappointment at not being able to see you again, or to see your fine work.

I am busy choosing a subject out of your *Christina*[2] in order to serve you up a dish of my own making. You've made me experience some keen emotions of a sort one is no longer accustomed to find in the theatre. I can only hope to reproduce some part of them.

Farewell, ever yours,

Eug. Delacroix

✒ TO ALEXANDRE DUMAS

Friday [*April* 1830]

Dear friend,

Forgive my weakness and my stupidity; but after having turned a sheet of paper over and over and worried it for two hours, I became convinced that I could not possibly do the vignette in question; put me to the test, my dear friend, where the products of my industry are concerned; but such finicky work petrifies me and my hand seems fettered when I try to tackle it. So I am sending you back your manuscript intact, thankful at all events to have made my ridiculous attempts on a different piece of paper. I am writing to you nonetheless with one of your own pens. I didn't want to deprive myself of that pleasure which I so rarely get.

Once again, forgive me and believe me nonetheless your devoted friend where anything on a larger scale is concerned.

Farewell, farewell.

✒ TO CHARLES RIVET[3]

Paris, 16 *May* 1830

Fortunate friend, you who behold every day, perhaps with an indifferent eye, all the beautiful things of which I have been dreaming for

[1] Delacroix met Dumas in 1829. They remained good friends to the end; see letter on p. 355, and also affectionate references in the *Journal*.

[2] Dumas's play, *Stockholm, Fontainebleau et Rome*, which was first performed at the Odéon, 30 March 1830. Delacroix planned to do a vignette for a frontispiece to the play but gave up the project (see next letter).

[3] Baron Charles Rivet (1800-72), a friend of Delacroix's youth, a distinguished statesman and a man of culture.

21a Amin-Bias

21b Women of Algiers
 (sketch)

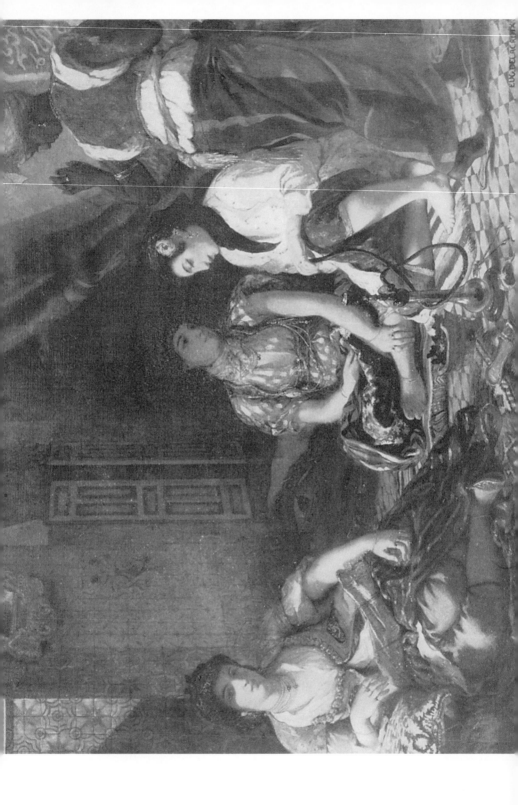

23a Encampment at Alcazar

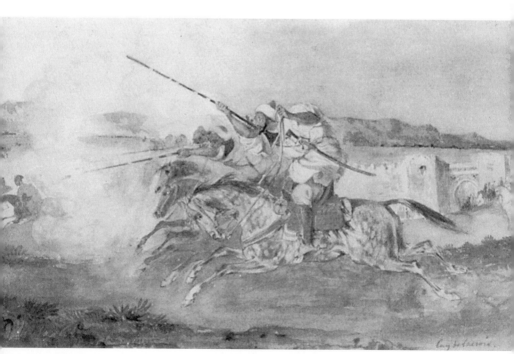

23b Fantasia before the gates of Meknes

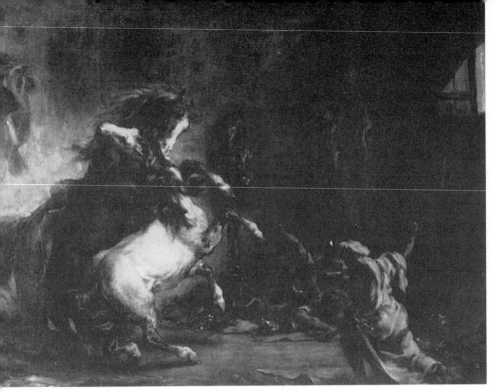

24*a* Arab horses fighting in a stable, 1860

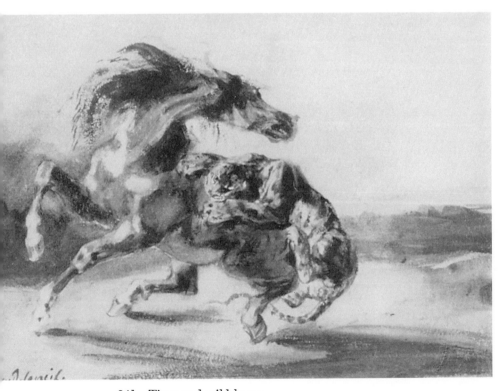

24*b* Tiger and wild horse

the past fifteen years, how cruel of you not to write more often to tell me something about it all! How long I waited for your letter. . . . Even if you are not deeply stirred, what does it matter? Write whatever you feel. If you don't paint, write.

I've had enough of the impressions of the gang of travellers and scribblers who have spoilt Italy for me ever since I first took an interest in that country. Your impressions will be fresh and unprejudiced.

Would you believe it, I was just going to write to you when your letter came. Yes, I myself was taking up my pen to tell you—what? That I wanted to hear from you, but you were well aware of that. I, so little of a scribbler that I'm cruelly keeping M. Véron[1] and the public languishing, although it seems the public can wait no longer and is beginning to fret. You fortunate man! While I write about Michelangelo you are gazing at his works. I shall lie to the aforesaid public as brazenly as all those who undertake to talk about themselves far more than the subject they are dealing with. Surely the barest descriptions, made in the sulkiest of moods but in front of the works of art themselves, would be, for readers endowed with sensibility, a thousand times superior to all my sham enthusiasm? You skim past Rome, you barely graze Naples; you run, you fly. Do for me, for the companion of your daydreams and your crazy ambitions, what schoolfellows do: go shares with me; keep me a small portion of the feast you're enjoying, while I savour it only in imagination! Egad! if you only come back in October, as you intend, you still have several months. So set down for me sometimes, when you go to bed at night, unless your lady friends have worn you out, a few lines – cheerful or ill-humoured – about those wonders past which you are rushing too fast. Poor fellow, to be wandering through the most beautiful country in the world in the company of Horace Vernet[2] who puffs smoke in your face and bores you to death with his frigid boastfulness! I'll go there myself, I'll go there alone, like a bear, like a tiger if need be. I shall show my claws to bores. I'll get bored with myself. But not with such fine opportunities as you tell me of. I shall live among all those illustrious dead.

I wager, you traitor, that without this scrap of a letter you wouldn't write me. You were waiting for me to answer you. What have I got to tell you? I lead the most monotonous of lives, as you know. Your letter has been the greatest event in the past month. Where you are,

[1] Dr Véron, later director of the Opéra, had just founded the *Revue de Paris* to which Delacroix contributed five articles; that on Michelangelo appeared in June-July 1830.

[2] Horace Vernet was director of the Rome School from 1829 to 1834.

Michelangelo and Raphael live on silently in true glory, while here everything goes on as usual. DE reigns triumphant in his small circle. A is the greatest painter of the age, for two or three years. B is better than Raphael. H[1] has superseded Dante, who can well dispense with living among H's admirers. How I wish I could admire myself a little, amidst all this! But would you believe it, I doubt my own infallibility more than ever, and yet I am not disheartened. I have just spent a month or two in deep dejection and gloom. Now that's all over; I am reborn with the spring greenery, and I'm in the mood for work. . . .

ری TO CHARLES DELACROIX

[*Paris*] 12 *October* 1830

I kept on waiting to write to you, like an ass, until I should have some good news to tell you about your request, my dear good brother. Your kind letter gave me very great pleasure. As to my spleen, that's passing off, thanks to hard work. I have undertaken a modern subject, *A Barricade*[2] . . . and if I have won no victories for my country at least I can paint for it. This has restored my good temper. But now for something else. Your friend Leboullaye gave me nothing but empty words. Impossible to make contact with General Genty St-Alphonse.[3] And now my fair one[4] has taken it into her head to make the thing succeed and as you know a woman can get through anywhere. She went to see Leboullaye this morning and he promised her to get things going. But this is how we must proceed. There's a certain Mr Santa Croce who has the position at the moment. But it seems that he's not very secure in the saddle and might come a cropper. This, and your own candidature for the place, depend entirely on Le Gal Corbineau, a former aide-de-camp of the emperor, who is in command of the Lille division. As I believe he is one of your old comrades-in-arms, Leboullaye feels sure he would do whatever he could for you immediately. So write to him as soon as you receive this and explain the position. Mme Dalton, for her part, will see General Genty St-Alphonse, to whom Leboullaye, stimulated by petticoat influence, has promised to introduce her himself, and as you can imagine she will put your case strongly to him. I hope that in this way things may go favourably. . . .

1 (Hugo.) Delacroix and Hugo had now quarrelled.
2 *Liberty Leading the People.* See plates 15*a*, *b*, 16.
3 General Delacroix was anxious to resume active service.
4 Mme Dalton. (The episode with Soulier had obviously been forgiven.) Her efforts on behalf of the General failed and he remained in retirement at Louroux.

ぷ TO M. ———

1 *November* 1830

I venture to trouble you yet again, Monsieur, about my affairs, with many apologies for my importunity: but you showed me such great kindness that I am taking advantage of it. Mr Nichols[1] had promised me a prompt reply: dare I ask you to intercede yourself with HRH Madame ———,[2] so as to secure a favourable one? Her Royal Highness having taken the praiseworthy decision to fulfil her obligations, surely, monsieur, there can be none more binding than that undertaken towards an artist who lives by his talent and who has devoted six or eight months of his time to a chosen subject,[3] which involved special researches outside the field of his usual labours, and for the sake of which he interrupted work undertaken for other patrons? The picture was not delivered, that is to say, taken to the château, purely out of deference to Her Royal Highness who, as you no doubt recall, monsieur, took particular pleasure in seeing the works she had commissioned while still in the artist's studio. I was deprived of the honour of a visit from her by the arrival of her father the king of Naples, to whom she devoted all her time. Next, the death of M. de Laurencel having temporarily interrupted my dealings with her about the work I had undertaken, the matter was still at the same point when the critical events of July took place.

Would you not agree, monsieur, that even admitting that the work was unfinished, an artist who has been asked to paint a picture on a particular subject is in a wholly different position from one who has been asked to sell one that is already completed and can consequently be more easily disposed of elsewhere; and in any case, surely the fact of having involved him in considerable expense and trouble and, above all, of having absorbed his time and talent, should imply indebtedness, as to any tradesman or contractor? One special circumstance, of which HRH is probably ignorant, is the following. When M. de Laurencel commissioned this work for HRH I asked a fee of four thousand francs. This was what I had just been paid by Monseigneur le duc d'Orléans for a painting of roughly the same dimensions,[4] but on being assured that Madame would be equally pleased with a smaller picture I reduced my fee to three thousand francs. When I was about to start work M. de Laurencel changed his mind, and although the price had

[1] A secretary of the Duchesse de Berry.
[2] The Duchesse de Berry, who had commissioned a large painting from Delacroix. The 1830 Revolution left him with the picture on his hands and trying vainly to get paid for it.
[3] *The Battle of Poitiers*.
[4] *Richelieu saying Mass*.

163

been settled, he assured me that Madame would be ill pleased if the picture was not large enough, and he reverted to the dimensions originally proposed. I agreed to this new arrangement without raising any objections.

Should I be making excessive demands on your time, monsieur, if I begged you to write me a line on what you think of the arguments I have taken the liberty of submitting to you, and to raise the matter with HRH at the earliest opportunity? The delay in this matter has been sufficiently prejudicial to me to arouse my keen desire that Mr Nichols and yourself, monsieur, should bring your influence to bear on Madame, since my own liabilities make it imperative for me to renounce nothing of what I consider as my unquestionable and legitimate rights.

Again, a thousand apologies, monsieur. I am really grieved that my relations with yourself should have begun with the discussion of these financial matters. Whatever the issue, for that matter, even if my persistence should involve me in arguments which I assure you I should greatly dislike, over the settlement of HRH's affairs, may I hope this will not prove an obstacle to the development of an acquaintance which your kindness and courtesy make infinitely precious to me?

I have the honour to be, Monsieur, your very humble and obedient servant,

Eug. Delacroix
Quai Voltaire, No. 15

৶ TO FRÉDÉRIC VILLOT[1]

[Autumn 1830]

Imagine my despair, my dear fellow, I have been rushing round these last few days after gaiters, collars, etc. But now that rascal of a tailor who had brought me a disgraceful coat, which he had had to remake, has played a shocking trick on me, knowing that I am on guard tomorrow – he hasn't finished it. If I don't have my things by tonight I shall come round and tell you, and M. Vieyra too; in any case I shall send my knapsack and leather equipment round to your place, so as to get ready there.

Have you remembered a cover for your cartridge-pouch? I don't know where to get one. Otherwise I have everything. . . .

I am sure that scoundrel of a tailor is quite capable of bringing me

[1] Frédéric Villot (1809-75), engraver, taught Delacroix lithography; their friendship, begun 1830, cooled later. This and the following letter refer to the uniform for the National Guard. See plate 3*b*.

back at the last minute the selfsame coat, having pretended to alter it; but in all conscience the skirt of it barely covers what decency requires us to conceal.

Wednesday morning [*postmark* 29 *December* 1830]

I should be greatly obliged if you could let me know as quickly as possible how the collar of our greatcoat should be made. The tailor wants to know if it should fasten with a hook in front or be turned down. Also I cannot remember what the trousers are like, if they have several red stripes or only one.

I apologise profusely; I'm a great nuisance. . . .

Would you also give me the address for the gaiters?

[*Paris, postmark* 15 *February* 1831]

It's not our fault, dear Félix, if we have not written to you. You were always on the point of coming home and in the hope of embracing you in two or three days we restrained our pens. You'll have heard about poor Pierret's misfortune. I really believe that we are sometimes dogged by ill luck. It strikes me that our poor friend has endured enough of it to deserve a breathing space. What's this illness of yours? I'll tell you, if it is only eye strain, I have repeatedly suffered from the same sort of thing, although less persistently, but I've always been told it was not dangerous. It just has to be borne patiently. I am most eager to hear you talk about Lamartine. This exceptional encounter must have made an interesting change for you. You'll probably have got more enjoyment from his company and his mind than many people who have seen far more of him than you. He will have been in *déshabillé* and with leisure for daydreaming. That's the best time to see men who are the public's darlings. They think they owe it to themselves most of the time to affect extreme formality, and in fact importunate admirers pester them so much that they have to be almost rude in order to breathe at ease from time to time. I am sure, too, that realising what he was fortunate enough to find in you made him appreciate the full flavour of your transitory relationship, far from civilised society (with all due apologies to Macon). As for friendship, there can be no question of that with people who combine with an immoderate concern with reputation the even stronger urge to attain position and power.

165

We are living in depressing times, my good friend. It needs great courage to serve Beauty as one's sole deity. Well, the more others desert it, the more I worship it. I shall end by believing that nothing is real in this world but our illusions. Moreover, although everything is going awry, we have no right to complain louder than all the other human beings who have gone before us. In every age people have said that things were going to the bad, that the world was drawing near its end and that everything was exhausted. Our descendants are still likely to consider us more fortunate than themselves.

Come back soon. I'd rather see you than write to you. Come and enjoy the delights of the National Guard in which, thanks to a brother-in-law, I have got myself involved, like an idiot. Come, above all, to embrace us, and let's join in reviling the human race, the present age, things, ourselves, women particularly, etc., etc.

Your friend. . . .

❧ TO THE EDITOR OF *L'Artiste*[1]

1 *March* 1831

Sir,

You have been kind enough to ask for my opinion on the question of competitions for paintings and sculpture. This is an important issue today, for what it means, in fact, is that all artists seeking commissions from the government would have to pass through this mill. The idea is not a new one, and it appears so obvious that it quite naturally occurs to the authorities when they shrink from the responsibility of making a choice, and to artists themselves, I mean to those whose share of commissions has been meagre. Such artists, who form the majority, have by their demands given great publicity to this matter of competitions.

They have become eager champions of this method, however remote the chance of success which it offers most of them. Vanity easily persuades every one of us that his deserts have been overlooked, and that in the full light of a public competition they will be revealed to the whole world; that if one fails to win the prize, one can still console oneself with the thought that the general public has discerned one's merits and, in its turn, condemned one's judges.

Moreover, arguing according to laws of general justice which are not unreasonable, you will be disposed to consider this device a very

[1] This letter was published in the fourth issue (1 March 1831) of *L'Artiste*, which made its appearance (1 February 1831) under the editorship of Ricourt. It was the leading Romantic review of art and literature.

liberal and fruitful one; for, you may say, nothing prevents men of talent from entering the lists; on the contrary, amidst the great crowd of claimants, real talent will always stand out.

At a first glance it seemed to me, as to yourself, convenient to have a means of testing talent as one tests metals, of picking them out immediately from amidst the crowd by means of the contrast automatically produced between good and bad art. If that means has really been found, Sir, what a problem we have solved! Posterity can never be sufficiently grateful to us for having contributed so much to its delight by ensuring that only works deserving of admiration shall come down to it; and at the same time we shall have spared the authorities much remorse.

But closer consideration will lead you to discover that this method, in theory simple and efficient, presents in practice innumerable difficulties. A quite recent experiment[1] has already disclosed unsuspected drawbacks, and these were such as to cause alarm as to the probable results of this method, if it were extensively employed. It was realised that besides the difficulty of persuading many people unfamiliar with this method to compete, there arose the greater difficulty of finding judges: dispassionate, unprejudiced judges, who were not liable to set their own friends above all the rest, and who were concerned only with justice and with the interests of art. The interests of art, Sir, are like the interests of one's country; everyone assumes them to lie in the direction of his own feelings and hopes; justice is each man's prerogative; his party flatters his inclinations and promises the triumph of his opinions. Especially since the great discovery of classicism and romanticism, the controversial factors seem increasingly irreconcilable. This issue, which has set friends at loggerheads and divided families, adds further complexity to the question of competitions.

It has moreover proved difficult to decide whether the aim of this method was primarily to employ artists of real talent, or merely to obtain works of art which should combine enough acceptable qualities not to seem out of place in the setting for which they were commissioned. This must cause great embarrassment to the judges, whom I assume to have been found and, of course, to be quite impartial. You will doubtless ask me to put this second problem more clearly. You believe that selecting a talent means preferring at the same time what

[1] The government had set competitors three subjects for paintings to be hung on the wall facing the hemicycle of the Chambre des Députés: Louis-Philippe's vow before the Chamber, August 1830; Boissy d'Anglas baring his head before the severed head of Féraud; and Mirabeau's protestation before the Marquis de Dreux-Brézé. Delacroix competed for the two latter, but was not chosen. Thirty-two sketches for the third had been exhibited at the École des Beaux-Arts since 3 February. Coutan won the prize for the first.

is the best and what is the most suitable; that talent triumphs over difficulties, and submits to them willingly; alas, no, Sir, talent does not submit. It delights in difficulties, but only in those it has itself chosen. Talent is like a mettlesome steed that will not offer its back to the casual rider, and refuses to fight save under the master that it loves. Not that talent lets itself be carried away by its own caprice, without due choice and restraint; not that it shuns the yoke of reason; proportion and reason are, in a word, the essence of all that talent produces when it is truly inspired; but it needs that inspiration, and it can no longer be held responsible for what it may produce when that is lacking.

Perhaps you do not see what prevents an artist from being inspired by a competition. The subject set may be of interest, may in fact be such as one would have chosen for oneself.

Note that what I am objecting to is not the necessity of interpreting some particular subject, but the necessity of submitting to the ruthless sifting of a public competition, of being lined up in front of an audience like a troop of gladiators, vying with one another for its impertinent approval and revelling in mutual slaughter in the arena. What an ordeal for the artist's cherished self-respect!

The artistic imagination, Sir, is not a shameless hussy who accepts contempt as readily as the tumultuous applause of a theatre, who exhibits herself before an audience in order to win its condescending favours. The more ardent and sincere it is, the shyer it proves. A mere trifle alarms and represses it. The artist, confined to his studio, works at first with inspiration and full of that sincere confidence which alone can produce masterpieces; but should he happen to glance outside and see the mountebanks' stage on which he must appear and the judges waiting for him, immediately his impulse dies down. He casts a saddened eye on his work. Too much contemptuous criticism awaits this innocent product of his enthusiasm; he lacks courage to follow it along the course that he foresees before it. Then he becomes his own judge and executioner. He alters and spoils his work, he wears himself out, trying to civilise and polish it so as to give no offence.

An absurd idea occurs to me. I imagine great Rubens stretched out on the iron bedstead of a competition. I imagine him cramping himself within the framework of a programme that stifles him, mutilating his gigantic figures, his splendid exaggerations, that whole luxuriant manner of his.

And I imagine Hoffmann, that divine dreamer, being told, 'Here is a subject just made to rouse you from your indolence. It is touching; it is even patriotic. Come now, warm to your task; only, here is a thread which you must follow without deviating in the slightest. We

168

have put exactly similar threads into the hands of some fifty aspirants like yourself, who are longing to prove their worth. If you see a few flowers by the wayside, you must by no means turn aside to pluck them; we don't expect your genius to offer us fantasies, nor to repeat all the echoes that the spectacle of nature awakens in your mind. See what a poor showing you would make at the end of the course, when you will all be lined up together to render a faithful account of your mission. It would never do to appear at this inspection like a straggler returning from battle with all his equipment in disarray, who has defeated the enemy but lost the scabbard of his sword!'

'That's a sad victory you're offering me, gentlemen,' the dreamer would reply. 'What you want is a man who walks with crutches; he is more likely to complete that tedious journey of yours without accident than I am, with my capricious leaps and bounds; every step of it is a struggle against my own nature; and what am I to expect at the end? Shall I even have achieved a work of art? For what is that sketch on the strength of which I, or my neighbour, must be selected from the crowd? A mere game, if I am not chosen; a production which is no such thing. Judges other than my own natural good sense are to decide whether my progeny is fit to survive. Out of these forty ideas, or ghosts of ideas, which stand there waiting to see the light, only one is to receive baptism, the other thirty-nine will be thrown out on to the rubbish heap and swept ignominiously away.'

You may perhaps tell this angry man that it is ungracious of him to deter others from a method which is not without its merits. But this is the position to which we are inevitably led – to this manifest contradiction between the object of the thing and its result, which is to disgust men of talent and to encourage mediocrity.

You will have no lack of probably docile competitors, ready to accept your conditions. What will most of them ask for? Merely the pleasure of appearing on your list, and catching the public's eye for a moment. For some of them, that is fame enough; as for artists who are devoted to their art, and who are sensitive, somewhat over-sensitive perhaps, you will see their number dwindle amid the motley crowd pressing into the lists. You will barely be able to pick out a few artists of moderate talent amongst the sturdy weeds that spring up all around them and smother them, in this no-man's-land that is open to all; no, a good work of art does not gain by being placed between inferior ones; the sight of bad art produces an intolerable nausea, which makes one disgusted with that which is beautiful, delicate and harmonious; it exudes a sort of tedium that tarnishes all around it. In a competition, natural charm appears insipid when set beside the contortions of a rhetorical talent; true audacity seems exaggeration,

beside some narrow and unimaginative production. Why, the most mediocre of painters may often hit upon some ingenious invention unknown to Raphael, who has only his style to commend him. Will you praise such a painter for having succeeded better than Raphael in the literal representation of his model? To which should the palm be given, to the work of prosaic accuracy or to that which shows a mastery of execution?

How many qualities there are by means of which a man of inferior capacity can gain the advantage over others whose talents are more natural and passionate; and even between rivals of equal strength, how hard it is to choose! One may be outstanding for the beauty and harmonious fitness of his composition; the other may have shown superior skill in rendering expressive details, and may have rendered the subject with greater energy, although lacking a more sustained general harmony. Do you prefer colour and a striking effect, or exquisite drawing, beauty and delicacy of particular features? In short, which will you choose of these qualities which are never found in conjunction, and a single one of which, carried to this degree of eminence, would be enough to distinguish an artist from amidst the crowd?

At the beginning of this article, I barely touched on the difficulty of finding enlightened and impartial judges; I did not discuss intrigues, nor the granting of favours; and, as you have doubtless noticed, I did not sufficiently stress the impossibility of securing equitable judgments. This matter is as distressing as it is rich in implications; I leave it to your wisdom, Sir, to your knowledge of men and of the weakness of human nature, to probe deeper into this depressing subject, and to shed light, if you have the courage to do so, on the manœuvres of the envious, and of the needy and greedy souls who rush into competitions like hungry beasts after their quarry. The matter is all the more painful because there seems no way out; and the administration has resorted to the scheme only in a sort of despair, without knowing whither it was going. What ought to be done, you may ask me? What method can be proposed? For you surely would not wish to substitute the arbitrary choice of the authorities for this misleading lottery. To this I know not what answer to give, except that things went better before the arts became the business of the administration. When Leo X wished to have his palace decorated he did not go and ask his Minister of the Interior to select the best painter for him; he simply chose Raphael, because he admired his talent, or perhaps just because he liked him as a man. You can be sure that he did not inflict on himself the depressing task of seeing in the efforts of thirty or forty competitors working under duress all the extravagant and ridiculous forms that a wretched idea

can take when elaborated in every direction by overstrained imaginations. He undoubtedly enjoyed the advantage of not taking a dislike to the object of his fancy before even seeing it brought to birth, or destroying beforehand all the pleasure that a work of art can give by depriving it of all freshness and novelty through this extraordinary ordeal, which is what happens to us in our competitions, since after fate, or caprice, has decided which artist is to prevail over his rivals, we feel tempted to excuse him from saying anything more on a theme which has been exhausted and has lost all charm.

Thus, to my deep regret, far from having established a starting-point, I have only enhanced your perplexities. I have scarcely touched on the most important aspects of the question. I have simply come to complain to you, and to lament with you, with all true friends of the arts, who are alarmed to see them lacking any firm guidance. You offer us your columns for the expression of our grievances; your paper is almost the only one as yet uninvaded by politics. Hold fast, Sir; resist that torrent; speak to us about music, painting and poetry, and you will find that you attract to yourself all those who give priority to the pleasures of the imagination.

<div align="right">Eugène Delacroix</div>

◷ TO FRÉDÉRIC VILLOT

[May 1831]

My dear friend,

Our company is due for inspection the day after tomorrow, Sunday. Shall you be there, or can I use your gun again? If you are coming, would you be kind enough to ask our adjutant to have mine sent back to me, not forgetting the sling? The day you kindly invited me to spend the evening with you I had gone to the ministry. This happens about three times a week and produces no results whatever.[1] I shall come round one of these days to borrow some volumes of Hoffmann[2] from you, to get started on our project. . . .

◷ TO CHARLES SOULIER

28 May 1831

You couldn't have told me anything that delighted me more.[3] So one of us, at least, has found a refuge against ill fortune. I felt my heart

[1] Referring to a petition sent to the minister in May 1831 for the reform of the Commission for purchasing works of art at the Salon.
[2] Delacroix was thinking of illustrating Hoffmann's *Tales*.
[3] Soulier's forthcoming marriage.

beat faster, I who shun emotions and whom they shun. The thought of your imminent happiness diverts me from the monotony of my own existence. You have chosen the right course, you've chosen peace, and that's the best thing in this world. There is no worse position than never knowing if one will have enough to eat in a week's time, and that is mine. Give me a desert, and amputate a wretched old lingering vestige of vanity, and I shall manage to get some happiness in this world. But reputation, fame, that success that one never achieves, is it all worth agonising all one's life to reach?

I'm longing to hear that you're married. Is it true that fate one day or another grows kinder and no longer casts a baleful eye on us? The events of this life surely owe us such compensations for all the illusions that, little by little, they take away!

My poor Raymond,[1] I'm going through a horrid attack of depression, I think you've been through it too. I haven't yet learnt to accept life's wounds and I have already lost the art of finding happiness in the small blessings it offers.

To become a countryman or an artisan, in a word not to depend for one's happiness on what lies outside oneself, that's the secret of such happiness as may be granted to us.

Goodbye, and I look forward to seeing you, and above all to congratulating you myself.

<div align="right">Your friend,
Eug. Delacroix</div>

∽ TO M. F. FEUILLET[2]
rue Castiglione, 3 or 5

June 1831

My dear friend,

I have just received your note. I read the story of Tam o' Shanter in Burns's actual ballad, written in the Scottish dialect, which is very hard to understand, and I had it explained to me as I read it by a native of the country. It must be in every collection of Burns's poems. Here, in any case, is the story.

Tam o' Shanter is a peasant who is fond of loitering at fairs and in taverns for two reasons. The first is that he is excessively fond of *usquebaugh*,[3] if I've got it right, and similar sorts of merrymaking;

[1] M. Alfred Dupont (*Lettres Intimes*) points out that all the originals of Delacroix's letters to Soulier are addressed to Charles, not Raymond.

[2] Feuillet de Conches, art critic for *L'Artiste*, and employed in the Ministry of Foreign Affairs.

[3] Whisky.

the second is that his wife is the most shrewish scold in the world. One evening then, when he goes home later than usual, he passes close to a half-ruined church, where the witches are holding their sabbath. He dares not breathe, naturally. However, at the sight of a strapping young witch who seems livelier than the rest he cannot resist calling out, *Bravo, Cutty Shirt*, or *Short*[1] (I don't vouch for the text). He gallops his fastest, or rather his mare's fastest, to reach the bridge which is to safeguard him: but just as he's about to reach it the Cutty Sark grasps the tail of his grey mare so hard that it stays in her hand. And that's ten times more than you need to know about the subject.

What I can't express often enough is how grateful I am for what you printed on Sunday about me,[2] and still more for your kind help, which was so speedy and therefore so welcome. I don't know what the result will be. I saw the Comte de F——[3] this morning. He offered me fine words. The only thing I am anxious about is whether he has definitely been able or willing to change anything, and whether when the matter is brought into the open to be settled, he won't perhaps tell me that his hand has been forced, and other nonsense of that sort. It's understood, isn't it, that we are not to mention the authority from which we have learnt the particulars?

I shall come and see you one of these days to talk about it. You see I don't stand on ceremony, and that I'm perhaps taking unfair advantage of you. I am working at Ricourt's *Tigers*[4] with enthusiasm, in return for the ready help he gave me.

Your sincerely devoted

Eug. Delacroix

꿍 TO HENRI DECAISNE[5]
painter, rue Saint-Lazare, 30

[*postmark*] 27 *June* 1831

My dear friend,

I have given considerable thought to our business. Your idea of getting our society of painters[6] to act seems to me a good one, quite apart from any action we might take individually or collectively. The

[1] 'Weel done, Cutty Sark!' See plate 10a.
[2] An anonymous article in *L'Artiste*, 20 June 1831, concerning awards to artists.
[3] Comte de Forbin, director of the Royal Museums.
[4] *Young tiger playing with its mother*, a lithograph which appeared in *L'Artiste*, based on the Salon picture.
[5] Henri Decaisne (1799-1852).
[6] The Société Libre de Peinture et de Sculpture, founded October 1830.

173

chief reason is that the other society[1] raised the issue first. It's incumbent on ours, which represents the opposite opinion, to bestir itself as much as possible so as to counteract such intolerable pretensions.

We must try to see one another as soon as possible, we must rack our brains beforehand so as to have an article all ready, or else commission some sensible person to write it. I have flung a few ideas on paper, but I have an unforeseen commitment which prevents me from paying proper attention to welding it all together. In any case, do as much as you can: try and examine my petition for yourself. You have a hundred thousand times more intelligence than is needed for that, and really all that's needed is good sense, for the most obvious good sense is in our favour. Suggest an evening, if you will: I'll come and talk to you about it.

What we must seek above all is to make it clear that there are two quite distinct parties where the arts are concerned; that the Institut represents one of these parties. The proof is that confusion reigned in the body that represented the feelings of artists seeking changes and reforms; it was impossible to reach agreement until two rival societies had been set up.

That the whole spirit of the Institut and of all those that follow its banner is directed towards damping down rising talents, etc.

That the demands made by the two societies are in direct opposition to one another; that, moreover, the society of those painters who call themselves classical, pure, what you will, simply want to be made the judges who will decide on the very existence of their colleagues.

There are a thousand more reasons to be alleged. I'll think of some which I will use either in an individual protest made in my own name, or in the name of some of our friends, such as yourself, Sigalon,[2] etc.

Since the task on which I am engaged prevents me from coming round presently to have a chat with you, as I had hoped, I am hurriedly suggesting these sketchy ideas which I am sure you will turn to good account.

If you have time, go and see Jal.[3] He may be useful to you on the *Constitutionnel*. Bertin[4] is hopeless. There's nothing to be expected from him. He almost told me that the thing was inevitable; still, we'll do our best.

<div align="right">

Your devoted

Eug. Delacroix

</div>

[1] The academic Société des Amis des Arts.
[2] Xavier Sigalon (1788-1837) had worked in Guérin's studio.
[3] Auguste Jal (1791-1873), influential art critic. Delacroix had been on friendly terms with him since 1820.
[4] Édouard Bertin, now Inspector of Fine Arts.

I am very anxious that you should not leave too much to be done by your society. You know that the way one sets forth one's arguments is almost equivalent to an argument. There are rules of taste to be observed in everything and since we are at the mercy of this minister[1] we should spoil everything if we upset his vanity. We must have Berrier[2] on our side, he's a level-headed man. Can you give me his number in the rue de Savoie?

Copy of an address sent in the name of the Société Libre des Beaux-Arts to M. d'Agoult, Minister of the Interior, drafted by Delacroix

[*July* 1851]

Monsieur le Ministre,

The members of the Société Libre de Peinture et de Sculpture beg leave to set before you certain observations in connection with the government's proposed acquisition of works of art from the exhibition at the Louvre. They have been induced to take this step by the rumour, now widely current, that the responsibility for making a choice of pictures and statues is to rest with a Commission. Since this measure might have the gravest consequences for everything that affects the life of artists, it is to be hoped that you will be good enough to take into consideration the following observations, which proceed not from one individual whose position and whose demands might be of a special character, but from a society large enough to represent a whole multitude of interests.

This measure, which would be quite unprecedented, is the more surprising in that the government has at no period included so large a number of persons who are well equipped and wholly competent to distinguish for themselves those talents that deserve encouragement. Aware of certain abuses practised under the preceding regime, the government had tried to correct these as far as possible, and in the question which the undersigned are venturing to discuss with you the same desire to observe the strictest justice can be recognised. The proposed measure is intended to obviate the slightest suspicion of partiality. But, as you will undoubtedly appreciate from the following observations, Monsieur le Ministre, it might on the contrary give rise to disadvantages which would run quite counter to the end in view.

The dissensions which have arisen within the French school of painting are now an undeniable fact. The public has witnessed the establishment of completely divergent systems, which have become a matter of serious concern to artists and lead them to follow opposite

[1] D'Argout, Minister of Commerce and Public Works.
[2] Berrier-Constant, of the Fine Arts department.

175

paths. It is generally conceded that these different ways of envisaging art can only prove beneficial to art itself, through the liberty they allow to individual talent and the variety they bring into artistic production. But their immediate result, if we consider only the mutual relations between artists, is inevitably to foster an extreme intolerance, evident in the attitude of artists to one another's works. It is remarkable that even among those people who are not professional artists but merely interested observers of the artistic scene there are few who would not be swayed by some private preference in the choice they might be called upon to make. Almost all of them, espousing some particular system, display a quite natural passion in their judgments and warmly uphold the objects of their predilection.

Several months ago, artists began to forgather in order to request various reforms and obtain certain improvements in the government departments that concerned them. Several meetings were held, at which it proved impossible to reach agreement even on the most essential points. Resolutions were passed one day by a majority and the next day a different majority, brought together by chance, took a quite contrary decision. After a number of avenues had been explored, two rival societies were eventually set up, which between them roughly represented the demands of the whole body of artists, and their respective efforts since their formation reveals how clear-cut is the division between them. They submitted exactly opposite requests to the Commission that had been nominated by the Minister of the Interior to review the regulations of the School of Fine Arts, and within that Commission itself it is well known that each of these opinions found representatives and supporters, and since its decisions were taken by majority vote it was a pure numerical chance that made one side or the other triumph.

The undersigned have the honour to draw your particular attention to this most harmful disadvantage of all, which results from the transitory influence of a majority whose decisions are nonetheless unalterable, and invariably oppressive towards the opposite side.

In any Commission, however it is made up, private passions, protected by the secrecy of the ballot, and the chance that decides the favourable or unfavourable attitude of an assembly, are liable to obstruct men of talent and permanently discourage artists in the pursuit of their long and difficult career. In several branches of their art, only the encouragement of the government can sustain them. To leave the responsibility of deciding on their deserts to the passionate bias of rival artists or to the prejudice and half-hearted attention of laymen would be to jeopardise their whole existence. Even men of the loftiest talent and character would not prove impartial judges. Con-

viction in the arts is another religion, which has its own fanatics, a religion which is more unshakable and more deeply felt in eminent men. But however much it deserves respect as a matter of personal opinion and private conscience, it must not be allowed to extend its influence over spheres which affect material interests.

The undersigned appeal to the government to provide the necessary encouragement, thinking that this method would give least opportunity to preferences dictated by loyalty to a coterie. The authorities are bound to consult public opinion, which recognises clearly enough those men who are worthy of note. Their action consists in holding a kind of balance between rival claims, with all the caution imposed by such a mission, and experience has already proved on several occasions that government influence could in no case present as many drawbacks as the system of juries and commissions.

The members of this Society of painters and sculptors hope, Monsieur le Ministre, that you will be good enough to take into consideration this request, which concerns them to such a high degree and which is in every way deserving of your attention.

 ॐ TO J.-B. PIERRET

Valmont, 30 September [postmark 1831]

Here I am in Valmont, that abode of peace, where the whole world can be forgotten. The charm it has for me, old friend, lies in that complete absence of those keen and spasmodic emotions which make my life in Paris a continual ordeal, and a tight-rope walk without a balancing-pole. Money matters, affairs of personal vanity, rivalries, social duties, love itself, all these things together don't take up as much room in my heart and mind here as a single one of them does when I am in the midst of that hotbed of ceaseless agitation where you live and breathe. I have never been so keenly aware of the uselessness of foolish passions in helping one to lead a happy life. Perhaps I should find this condition as intolerable as the other if it were more prolonged. The irritability of human nature inclines me to think so. In Paris, we're chiefly obsessed by the rage for keeping up appearances. I think now that if I could find someone who would provide me with the necessaries of life, like a capon to be fattened, provided I had all the work I wanted and enough control over my own liberty, I'd accept the bargain on the spot.

I have too much freedom to value it fully. Here, I have less and yet more. Less, in that I'm living with an absolute despot who rules me physically, makes me dine at a certain time, sends me to some particular place for my amusement, etc. More, in that my mind, freed from the

177

need to worry about a thousand problems that my nature finds intolerable, wanders at will, enjoys its own tranquillity, and creates palaces and enchantments without ever being summoned back to earth by the voice of trivial necessity.

I haven't the same passion for work as two years ago. But I'm enjoying myself, that's the main thing. At Rouen I've found a subject for a picture which is inspiring me quite fruitfully.[1] We'll discuss that this winter.

Goodbye. Keep on loving me in spite of everything. We shall never find another bond like that which unites us for life; meanwhile we must foster that bond. The older I grow, the more I feel the need for old friendships. New ones are ill-planted trees, uprooted by the first gust of wind. Write to Guillemardet, who is our third leg; bid him cherish it for a long time to come, lest we should end up our days limping.

Will you get Vivet[2] to pack the picture as economically as possible, after he has varnished and framed it? Send it to the following address: Monsieur Bataille, care of M. Villard, innkeeper, place du Vieux Marché, Rouen. You'll have to pay the cost of carriage.

When you write to me it's as before, M. Delacroix, care of M. Bataille, at Valmont, Seine-Inférieure.

Remember me affectionately to your wife.

I should like Vivet to send me at the same time *two small cakes of green bice*, French colour. If it's not asking too much of your kindness, I'd like you to put into the box my clogs . . . which are on the shelf in my little wardrobe. It is damp here and I need them for getting about.

[*Arrangements for the journey to Morocco
follow in Paris, c. December* 1831]

❧ TO HIPPOLYTE ROYER-COLLARD
Head of the Department of Arts and Sciences

Wednesday morning [6 *December* 1831]

I was out all day, dear sir, so that I do not know what time your letter came, and whether I could have answered it yesterday, which I should have done without fail, for it gives me great pleasure to reply. I don't propose to thank you now for all the trouble you have taken about my business;[3] I am grateful to you for something that makes me infinitely

[1] *Interior of a Dominican convent in Madrid.*
[2] Dealer in artist's materials.
[3] He was hoping before leaving for Morocco to receive an advance payment for *The Battle of Nancy*, commissioned 1828 and not yet begun.

happier, the chance you have given me to be of some use to you. You understand my feelings, I think, as I do yours. The extreme distaste you feel, as I should myself, for anything savouring of subservience towards you on account of your position is so natural that to receive a gift must be as embarrassing as it is to offer one. There is moreover something absurdly conceited about a man who thinks he can express his gratitude for anything by offering as a rarity some small object of his own making. This is not ridiculous modesty: I mean, as you must realise, that some wretched sketch might well seem infinitely precious to me, but that to offer it as a gift of some value makes me see it in a quite different light.

I shall therefore gladly undertake any commissions you may give me[1] and since your kind letter commits you to friendly relations with me in the future, you mustn't consider the scraps of paper I shall bring back[2] as things of commercial value but simply as reminders of a country that you're fond of.

I am busy making something that may, at a pinch, pass for the beginning of a sketch.[3] It will be in order before I leave. I gather that it will do if Bertin sees it within a couple of days. In any case I shall not draw the advance in question until then, and so nothing can go wrong from that angle.

Please accept my renewed thanks, and the assurance of my sincere devotion.

Eug. Delacroix

I shall arrange to see you again and talk about these Moroccan leather goods.

❧ TO J.-B. PIERRET
rue Sainte-Anne, 18

Toulon, 8 January 1832

. . . We have had a great many misadventures on this confounded journey. Filthy cold and frost when we left. Snow near Lyons and almost as far as Avignon, more than I'd seen in Paris for a long time, and at our journey's end, between Marseilles and Toulon, a storm of wind and rain that went right through us. This was what delayed us so much. Fortunately, I hope we shan't be too late starting off. It'll probably be the day after tomorrow. I think you have been to Toulon. The countryside is exceedingly fine. This is the real south; I recognise it. Such lovely views, such fine mountains!

[1] Leather goods to be brought back from Morocco.
[2] Sketches he plans to do in Morocco. For illustrations to the Moroccan journey see plates 17-24.
[3] *The Battle of Nancy.*

179

I couldn't help feeling rather sad when we entered Marseilles. Time and its scythe have wreaked havoc all round me and on those I loved, since I left this town. I was happy to find my father's memory still alive.[1]

By the way, I saw Fontainebleau on the way through. There have been some terrible strokes of vandalism. It is incredible that unreason should have gone so far as to tear down the admirable fragments of painting that still remain there to make room for the scaffolding and the brush of M. Alaux, 'the Roman'.[2] I am convinced I shall find nothing as barbarous in Barbary. But the devil's will be done. . . .

Farewell, my dear good friends: it's bad enough to feel oneself already 202 leagues away from you all, and there's to be an even greater distance between us. However, I am in excellent health. This excitement suits me. My travelling companion is perfect. I embrace you all, not forgetting Mme Guillemardet and Mme Pierret.

<div align="right">Eugène</div>

ೞ TO J.-B. PIERRET

Off Tangier, 24 January 1832

At last we're off Tangier! After thirteen excessively long days and a crossing that was alternately amusing and exhausting, and after several days of seasickness, which I had not expected, we were maddeningly becalmed and then met with gales which were quite alarming, to judge by the expression of the *Perle's* skipper. On the other hand we saw some lovely coasts, Minorca, Majorca, Malaga, the coasts of the kingdom of Granada, Gibraltar and Algeciras. We put in at the latter port. I had hoped to land at Gibraltar, which is quite close by, and visit Algeciras on the same occasion; but the inflexible quarantine laws forbade this.[3] However, I touched Andalusian soil with the people who were being sent to lay in stores. I saw grave Spaniards, dressed à la Figaro, gather round us at a distance – within range of a pistol-shot – for fear of contagion, and flinging to us turnips, greenstuffs, chickens, etc., and moreover picking up the money we put down on the sandy beach without bothering to disinfect it in vinegar. I felt the keenest delight at finding myself on leaving France transported, without touching land elsewhere, straight into this picturesque

[1] Delacroix's father was one time Préfet of the Bouches-du Rhône, 1800-3.
[2] Louis-Philippe's favourite painter, who ruined under pretext of restoring them the paintings by Niccolo dell'Abbate in the Palace of Fontainebleau.
[3] An epidemic of cholera was raging in France.

country, at seeing their houses, and the cloaks which all wear, down to the meanest wretches and even beggars' children. All Goya was alive around me. It was for a short time only. Leaving Algeciras yesterday morning we expected to be in Tangier by yesterday evening. But the wind, which had been slack at first, got up to such a force towards evening that we were obliged to sail clear of the straits and make for the ocean, against our will. We spent a very unpleasant night; but our luck changed towards morning and we were able to retrace our steps, and this morning at nine o'clock we dropped anchor off Tangier. I greatly enjoyed the sight of this African town. It was quite another matter when, after the usual signals, the consul came on board in a boat rowed by a score of black, green and yellow marabouts, who started climbing over the whole ship like cats and mingling with us. I could not take my eyes off these peculiar visitors. My dear good friend, you can imagine my delight on seeing for the first time, in their own land, these people whom I've come such a long way to see; for it's been a very long way, my dear fellow, and more than once, within the wooden walls of my floating prison and during my tedious nights of lurching and tossing on the rough sea, I have thought of my peaceful nest and the faces I have loved since I first knew how to love. I'd do the journey all over again if I had to, but absence brings much unhappiness.

Tomorrow we are to make our grand entry. We shall be received by the consuls of the other powers, by the Pasha, etc. . . .

ॐ TO J.-B. PIERRET

Tangier, 25 January [1832]

I've just arrived in Tangier. I have rushed through the town. I am quite bewildered by all that I've seen. I can't let the mail boat go — it's leaving shortly for Gibraltar — without telling you something of my amazement at all the things I've seen. We landed in the midst of the strangest crowd of people. The Pasha of the city received us, surrounded by his soldiers. One would need to have twenty arms and forty-eight hours a day to give any tolerable impression of it all. The Jewesses are quite lovely. I'm afraid it will be difficult to do more than paint them: they are real pearls of Eden. We were given a superb reception, by local standards. They treated us to the most peculiar military music. At the moment I'm like a man in a dream, seeing things he's afraid will vanish from him.

181

❧ TO FÉLIX FEUILLET
rue Castiglione, No. 3 or 5, Paris

Tangier, 25 January [1832]

My dear friend,

Here I am, after a very long and wearisome crossing, in a country that is quite new to me and abundantly picturesque. One would need a long stay here to convey adequately even a fraction of the strange and remarkable things to be seen here. This country differs noticeably from other countries of the Levant. You behold in me an unfortunate being who appeals to you as to a saviour. It has occurred to me that with your usual kindness, of which you have given me so many proofs, you would be willing to forward me by way of the Foreign Service the letters that my friends might give you for me. Since you are in a position to know exactly when mail is being sent to M. de Mornay, you would then be kind enough to include mine at the same time. Pierret is acting as headquarters; letters would be brought to him and he would be responsible for conveying them to you. My indebtedness to you would be complete if you could let him know when despatches are due to be sent.

You remember no doubt that you promised to use your influence in the ministry to prevent our being left to moulder here. It would be a great help if M. de Mornay were left free to decide when the time was ripe to return. You realise that at such a distance it takes an age to send and receive communications. Our ministry is essentially dilatory. M. de Mornay, for his part, through a sort of discretion which you will appreciate, can hardly make this request just now. I'm the one, therefore, whom you will oblige by interceding for us. Despite all my admiration for what I see here, far surpassing all my expectations, I cannot stay too long away from my own affairs.

Amidst all these fine Moroccan figures, I hope to find something worth showing you. Perhaps there may even be some which might make you forget the disappointment of not having anything of the sort in your collection, and for which you will find a corner somewhere.

❧ TO J.-B. PIERRET AND FÉLIX GUILLEMARDET

Tangier, 8 February [1832]

My dear friends,

I'm writing to both of you. You can neither of you take offence, since you know that I feel the same towards each of you and that what I say to one, I say to the other. There was a chance of posting lately which I

heard of too late to take advantage of it. One must do as one can. I am really in a most curious country. My health is good here, I am only a little anxious about my eyes. Although the sun isn't very strong yet, the glare and the reflected light from the houses, which are all painted white, tire my eyes excessively. I am gradually insinuating myself into the customs of the country, so as to be able to draw many of these Moorish figures quite freely. They have very strong prejudices against the noble art of painting, but a few coins slipped here and there settle their scruples. I go for rides in the surrounding country, which I find infinitely delightful, and I enjoy moments of delicious idleness in a garden by the city gates, under a profusion of orange trees in full bloom and covered with fruit. Amid these lush natural surroundings I experience feelings like those I had in childhood. Perhaps some vague memory of the southern sunshine which I saw in my earliest youth[1] is astir within me. Anything I may accomplish will be insignificant in comparison with what might be done here. Sometimes I feel quite baffled, and I'm sure I shall bring back only a faint shadow of it all.

I don't remember whether in my last letter I told you about our reception by the Pasha, three days after the one he held for us in the harbour; I should only weary you with it in any case. And I don't think I have written to you since an excursion we made in the neighbourhood of the town with the English consul,[2] who has a mania for riding the most unmanageable horses in the country, and that's saying something, for the gentlest are all absolute devils. Two of these horses fell out with one another, and I witnessed the fiercest battle you can imagine:[3] all the furies invented by Gros and Rubens are tame in comparison. After biting one another in every conceivable way, climbing on top of each other and prancing on their hind legs like men – having first, needless to say, got rid of their riders – they then plunged into a stream and went on fighting there with unheard-of ferocity. It was the deuce of a business getting them out of it.

The emperor is preparing the most magnificent reception for us. He intends to give us a high opinion of his power. We're beginning to be afraid that he may take a fancy to hold his reception at Marrakesh, which would involve a journey on horseback of four hundred leagues there and back. It's true that it is an extremely interesting journey and one which few Christians can boast of having made.

Most likely he will receive us at Meknes, one of the capitals of his empire. The best way of writing to me is as follows: frank the letter as far as the frontier and address it to M. Thibaudeau, French consular

[1] At Marseilles, 1803-5.　　　　　　　　[2] Mr Hay.
[3] Delacroix painted scenes of this sort several times. See plate 24a.

agent, at Gibraltar, to be delivered to M. Delacroix at Tangier. Or rather, send your letters to Piron, who will forward them post free. I'm writing to him to this effect; I think this is a safer way than through Feuillet, since the Ministry of Foreign Affairs is sometimes rather remiss.

Will Pierret please write to Bastien[1] asking him to shake my clothes frequently for fear of moths?

℘ TO THÉODORE GUDIN[2]
painter, rue de la Ville-l'évêque
near the rue de la Pépinière, Paris

Tangier, 23 February [1832]

My dear Gudin,

Amidst all the curious and unfamiliar things that surround me I have not forgotten my promise to you, which I am happy to fulfil. You wanted me to send you a reminder of Africa; and you, who have caught its character so well, will, I hope, be glad to learn of all the enjoyment I am finding here amidst a people so different in many respects from other Mahometan peoples. I was above all surprised by the extreme simplicity of their dress, and at the same time by the variety of ways in which they arrange the articles that compose it. The season is too early as yet for me to judge of the full beauty of the country. We have been here about a month, and we are all leaving for Meknes, where the emperor is at present, and where he is going to receive us with all sorts of Moorish courtesies, rifle shots, horse races, etc., etc. You can imagine how wonderful I shall find it all: you are, of all people, the man best qualified to appreciate the striking character of such spectacles. I am really sorry, now, for those artists, endowed with any degree of imagination, who are fated never to get a glimpse of the marvellous grace and beauty of these unspoilt, sublime children of nature. I have left in Paris a number of friends of whom I am sincerely fond, I left them with regret, and yet I shall be sad when the time comes to leave, probably forever, this land of fine orange trees, covered with flowers and fruit, of fine sunshine, fine eyes and all the other beauties with which you are familiar.

Farewell, my dear Gudin, I hope that on my return you will allow me to show you some of the sketches I shall bring back to remind me of this place. They all seem horribly imperfect when one is face to face

[1] Delacroix's model and servant.
[2] Baron Théodore Gudin was a landscape painter, a close friend of the Orléans family.

with nature, but at a great distance and in our prosaic country they may perhaps look rather better.

> Your greatly and sincerely devoted
> Eug. Delacroix

᎒ TO M. DUPONCHEL
Director of the Opéra

Tangier, 23 February [1832]

My dear friend,

You are the person to whom, next to God, I am indebted for the delightful journey I am now making. This alone would entitle you, even if you had not a thousand other claims to my grateful remembrance, to be kept informed as to what I have been doing in this part of the world.

You ought to hang yourself for not having come too. You dislike, quite rightly, whatever smacks of the *bourgeois*. Here you would be excellently placed to meet at every turn the exact opposite of that. The people of this country are quite exceptional; they differ in many respects from other Mahometan nations. Their dress is quite uniform and very simple, and yet the various ways of arranging it confer on it a kind of beauty and nobility that leave one speechless.

I plan to bring back enough sketches to give some idea of these gentlemen's appearance. Moreover, I shall bring back actual specimens of most of their articles of dress. I'll gladly ruin myself for this purpose, and for the sake of the pleasure you will get from seeing them.

And then it's hopeless to try and give an idea of the delightful details of the painting on their buildings and the charming proportions of their architecture. That's where a man like yourself would have been invaluable on our expedition.

I fancy that by studying engravings of Granada, with the help of the indications I shall bring back, you will be able to reconstruct the sort of thing one sees here.

The Jewish women are also very handsome and their dress is most picturesque. I have witnessed a number of their ceremonies; there are subjects for pictures at every street corner. I must admit that we have no boulevards here, no opera house, nor anything resembling these. The rue Vivienne of the place is a huddle of huts like those of the lunatics at Bicêtre, in which crouch and squat solemn Moors, hooded like Carthusian monks, surrounded by the rancid lard and six-months-old butter that they sell to people. All this scarcely smells of ambergris or frankincense, but I didn't come here to gratify my

senses, and the pure love of beauty makes one overlook many discomforts.

My good friend, I must beg you to convey to Mlle Mars[1] my heartfelt gratitude for her share in making my journey possible. And I take this opportunity of thanking you for introducing me to our excellent ambassador. He is all you told me and far more. I grow fonder of him every day. One couldn't wish for a better travelling companion, in every way.

If you should see Armand or Édouard[2] remember me to them. I am much indebted to them, too, for all the trouble they took to get me hitched on to Mornay. By the way, we're hoping, while in quarantine, to stage a ballet which will make the fortune of Véron[3] and all subsequent directors. I shan't tell you its title, for fear someone may open my letter and rob us of the glory.

Goodbye, my dear friend – so old a friend already; remember me sometimes.

ɔ TO FRÉDÉRIC VILLOT
rue de la Ferme des Mathurins, No. 26

Tangier, 29 February [1832]

Thank you very much, my dear friend, for your kind thought in writing to me. Your letter was in the first packet that reached me from Europe, and it's a great joy to get letters: if you have ever been far from those you love, you must know how sweet it is. Pierret will no doubt have given you news of my journey, of the sea, the country, etc. This place is made for painters. Economists and Saint-Simonians might find much to criticise as regards human rights and equality before the law, but beauty abounds here; not the over-praised beauty of fashionable paintings. The heroes of David and Co. with their rose-pink limbs would cut a sorry figure beside these children of the sun, who moreover wear the dress of classical antiquity with a nobler air, I dare assert. If you ever have a few months to spare, come to Barbary and there you will see those natural qualities that are always disguised in our countries, and you'll feel moreover the rare and precious influence of the sun, which gives intense life to everything. I shall doubtless bring back some sketches, but they will convey very little of the impression that all this makes on one.

The day after tomorrow we are leaving for Meknes, where the

[1] Mornay was the lover of Mlle Mars.
[2] The Bertin brothers.
[3] See letter to Charles Rivet, 16 May 1830, p. 161, n. 1.

emperor is; he'll welcome us with every sort of Moorish courtesy, horse racing, rifle firing, etc. The weather is kind to us, we were afraid of rain but apparently the worst of that is over.

When I see these unfamiliar sights I feel as if I'd already spent a year amongst it all and had not seen my friends for centuries. Remember me to those friends of yours who are mine too. . . .

♪ TO J.-B. PIERRET

Tangier, 29 *February* 1832

You don't deserve an answer. Yesterday I received the first news I've had from France, and you send me four casual lines, saying that you've nothing of interest to tell me. I'm not asking you for news, I'm no more avid for news here than in Paris, where my habit is to live, as I'm doing here, purely according to my heart's dictates. But don't you know the pleasure of receiving from somebody one loves a whole string of lines that merely express affection? I swear to you, my dear good friend, that in this land where life is so pleasant the only thing one feels the lack of is the love of those one has left behind in France; these ties of kinship and affection are the only things that bind me to that country which is no more my own than this one, where I feel happy, although deprived of the delight the heart finds in love (if I except a slight sentimental affair I'm having with a very pretty and proper little English girl).[1] My friend, what a joy to be far from the field of ambitions and intrigues!

I gladly spend part of my time working, and another quite considerable part just letting myself live; but the thought of my reputation, of that Salon which I was supposed to be missing, never occurs to me. I'm even sure that the considerable sum of curious information that I shall bring back from here will be of little use to me. Away from the land where I discovered them, such particulars will be like trees torn from their native soil; my mind will have forgotten its impressions, and I shall disdain to give a cold and imperfect rendering of the living and striking sublimity that lies all about one here, and staggers one with its reality. Imagine, my friend, what it is to see lying in the sun, walking about the streets, cobbling shoes, figures like Roman consuls, like Cato or Brutus, not even lacking that disdainful look which those rulers of the world must have worn; these people possess only a single blanket, in which they walk about, sleep or are buried, and they look as satisfied as Cicero must have been in his curule chair. I tell you, you'll never be able to believe what I shall bring back, because it will

[1] The daughter of Mr Hay, the British consul.

be far removed from the natural truth and nobility of these men. There's nothing finer in classical art. Yesterday a peasant came by, got up like this [a sketch]. And this was what a wretched Moor looked like, begging for a handful of coppers a couple of days ago. All of them in white, like Roman senators or Greeks at the Panathenaean festival.

Goodbye, I'm sealing my letter. My love to Félix and all our friends. These Muslims are great procrastinators. We're not leaving for Meknes until Monday, the day after tomorrow.

Give your wife a kiss from me, and when you write, be good enough to fill the pages, say anything that comes into your head without bothering to give me the news of the day. I'm not interested in it.

Goodbye, my dear good fellow.

<div align="right">Eugène</div>

Drop the enclosed letter into the post.[1]

↜ TO J.-B. PIERRET

Meknes, 16 March 1832

Yesterday we reached this town, the goal of our journey. We had taken ten days to cover fifty leagues. That seems nothing much. But it's nonetheless a tiring business when you jog along in the hot sun on uncomfortable saddles. How are you, my dear friends? Everything is tremendously African now. Our entry here was of the utmost beauty, and the sort of pleasure one may well hope to experience only once in one's life. All that happened to us that day was only the complement to what the journey had led us to expect. At every moment we were met by fresh armed tribes, who fired an extravagant amount of gunpowder in honour of our arrival. Each provincial governor passed us on to the next, whose guards came to augment our already sizable escort. From time to time we heard a few belated bullets whistling past in the midst of the rejoicings. We had, among other adventures, a river crossing, without bridges or boats, needless to say, which might be compared to the crossing of the Rhine,[2] such was the quantity of rifle fire that greeted us. But all this was as nothing beside our reception in the capital. To begin with we were made to take the longest way in, so as to travel all round the city and appreciate its importance. The emperor had given orders for everyone to keep holiday and give us a festive welcome, under pain of the severest penalties, so that the crowds and the chaos were extreme. We knew that when the Austrians were welcomed here six months ago twelve men and fourteen horses

[1] For Mme Dalton. [2] By Napoleon.

were accidentally killed. Our small company thus had great difficulty in keeping together, and finding its bearings, amidst the thousands of rifle shots being fired in our faces. We were led in by a band of musicians and over twenty flags carried by men on horseback. The band was mounted, too; each horseman carried a kind of bagpipe hung round his neck, with a drum which he beat with two sticks, a large and a small one, alternately and on either side. This made an extremely deafening din, mingled with the volleys of the cavalry and infantry and the enthusiasts who darted forth all round us to fire into our faces. We found it all infuriating and yet comical, and I look back on it now with less ill-temper. This triumphal entry, which resembled the ordeal of some wretched victims being led to the gallows, lasted from early morning until four in the afternoon. *Nota bene* that we had taken a light snack by way of breakfast at seven that morning in our tents. In the midst of my fury I noticed some very curious buildings in this town, in the Moorish style of course, but more impressive than those at Tangier.

20 *March*

We have been held prisoner for the past five or six days in a house in the city, pending the time for our audience. As we are continually in one another's presence we are less inclined to gaiety and the hours seem very long, although the house we are in is a very curious specimen of Moorish architecture, which is that of all the palaces in Granada, of which you have seen engravings. But I am learning by experience that one's sensations are dulled in course of time, and the picturesque stares you in the face so much all around that one ends by becoming insensitive to it. The day before yesterday we were brought a packet of letters by a messenger who had travelled on foot from Tangier, since we have no means of communication in this country where there are no roads or bridges or boats on the rivers. My heart beat faster at the thought that there might be something for me: but you're all unkind to me, and yet I swear to you that a word from one or other of you would have delighted me more than the whole of Africa.

I imagine we shall have to stay here another ten days or so. I shall write to you from Tangier to tell you when I am likely to return. All my love to you and yours. I still love you, despite your silence.

23 *March*

Yesterday we were received in audience by the emperor. He granted us a favour which he never grants to anybody, that of visiting his private

189

apartments and his gardens. It is all exceedingly curious. He receives his visitors on horseback, with all his guard around him on foot. He suddenly appears through a doorway and comes towards you, with a parasol behind him.[1] He's a rather handsome man. He looks very like our own king, only with a beard and somewhat younger. He is between forty-five and fifty. He was followed by his state coach, a sort of wheelbarrow drawn by a mule. So I've reached the goal of my journey. Our main concern now is not to moulder away too long in Africa. I'm afraid we may be held up some time in Tangier. All my fellow travellers have been getting letters. I'm the only one who has had none from anybody. I'm not really surprised at not receiving any through the Ministry of Foreign Affairs, as they have not written yet, but I reckon you must long before this have received the letter in which I begged you to write to me through Piron; since, despite my hopes, it's still extremely uncertain when I shall return, write to me up till the last moment, and in case Piron should not have received the letter in which I gave him the requisite address, please be kind enough to give him your letters, telling him to address them to M. Thibaudier, French consular agent at Gibraltar, to be sent to M. Delacroix at Tangier. The slightest details are precious to an exile; when I say news, I don't mean political or literary news but your own, the simplest things, how Félix is, and Pierret's wife and children, whatever you like, words and lines in your handwriting which, received here in Africa, would be very precious to me. Please remember me to all our friends. Although I'm on excellent terms with my two fellow-travellers I miss being able to talk about any of you with them. Well, pray Heaven not to drag out my exile too long, and in any case, write.

Farewell, farewell.

Eugène

Félix, give news of me to Henry.[2] This letter is for him as well. Tell him to remember me to M. and Mme Destandis.

Pierret, please, when you go to my studio, loosen the spring of the easel on which *The Battle of Nancy* is standing, so as to lessen the strain on it, and let the weight of the picture bear on its base: it's a bit late, but no matter. All my love to our friends. Write, please, write. Post this letter to Mme Dalton. Let her know about it when you have a chance.

[1] The scene in the painting *The Sultan of Morocco amidst his guards*, exhibited in the 1845 Salon.
[2] Henry Hugues.

190

Meknes, 2 April

Dear friends,

I'm still here; you see that we weren't far wrong when we reckoned that three months at least would be spent on the journey. Fortunately our business is settled and we shall set off the day after tomorrow to return to Tangier, where I suppose we shall presently take ship. The prospect of being in quarantine is not attractive; but once one has touched land, above all the land where all one's memories dwell, it's not so harsh an ordeal as that which I have been undergoing during the past three weeks, imprisoned here. I told you in my last letter that we had been granted an audience with the emperor. From that moment we were supposed to have permission to walk freely about the town; but I was the only member of our party to take advantage of this privilege, since these people have such a loathing for the dress and appearance of Christians that one must always be escorted by soldiers, which did not prevent two or three quarrels which might have proved extremely unpleasant, in view of our position as envoys. Every time I go out I am escorted by a huge gang of curious onlookers, who lavish insults on me – dog, infidel, *caracco*, etc., and jostle one another to get near me and make contemptuous grimaces in my face. You cannot imagine how one itches to lose one's temper, and only my keen desire to see things induces me to submit to such infamous treatment. I have spent most of my time here in utter boredom, because it was impossible to draw anything from nature openly, even the meanest hovel; if you so much as go on to the terrace you run the risk of being stoned or shot at. The Moors are fantastically jealous, and it is on these terraces that their women usually take the air or visit one another.

The other day we were presented with some horses for the king (I've just been sent one), a lioness, a tiger, ostriches, antelopes, a gazelle and a kind of stag which is a savage beast; it took a dislike to one of the poor ostriches and ran it through with its horns, from which the ostrich died this morning. Such are the events that bring variety to our existence. Otherwise, no news. . . .

I've not told you about all the strange things I see. They end by seeming quite natural to a Parisian staying in a Moorish palace adorned with porcelain and mosaics. Here is something typical of the country: yesterday the prime minister, who is negotiating with Mornay, sent to ask us for a sheet of paper in order to give us the emperor's answer. The day before yesterday Mornay had been sent a saddle of velvet and gold, of inestimable value.

Meknes, 2 April 1832

Dear Armand,

Let me send you some news from the land of lions and leather. You kindly took so much trouble arranging for me to come here that I owe you some account of my experiences, both pleasant and unpleasant. We have been in the Moroccan capital (one of three) for about a fortnight and we are surrounded with honours and closely watched. The custom is that envoys to the emperor remain shut up in the house assigned to them until they are granted an audience. After that date they are free to go about, but you shall see what sort of freedom this is. You are allotted a certain number of soldiers, whom of course you have to pay yourself, with whom you may walk about the town if the fancy takes you. There you are surrounded by an execrable crowd, who execrate the dress and appearance of Christians and who fling in your face all sorts of insults which, luckily, you don't understand. It takes all the curiosity I've got to run the gauntlet of this mob. The picturesque is here in abundance. At every step one sees ready-made pictures, which would bring fame and fortune to twenty generations of painters. You'd think yourself in Rome or in Athens, minus the Attic atmosphere; the cloaks and togas and a thousand details are quite typical of antiquity. A rascal who'll mend the vamp of your shoe for a few coppers has the dress and bearing of Brutus or Cato of Utica. I could go on forever telling you about our reception, our audience with the emperor, his parasol and his state coach, taken out of the stables especially for our benefit; it's a kind of two-wheeled sedan, drawn by a mule. We were granted an honour that nobody before us had enjoyed, that of visiting the palace, the garden and the private apartments of His Majesty. The day we entered Meknes there was pandemonium, and more rifle shots than they fire in their battles; we were almost smothered under all this bustling zeal, since the emperor had ordered all the inhabitants, on pain of the severest punishment, to shut up their shops and make merry for our benefit; as from this morning, the deal seems to have been concluded, and not without trouble. So the rainbow of liberty, as you call it, gleams as brightly here as in our own fair country, and in all seriousness I think Mornay is well satisfied, and rightly so, with the success of his mission. He had to overcome considerable obstacles due to the Moors' stupid adherence to custom. He tackled the problem better, perhaps, than a professional might have done, and in a short time achieved a result which I think

[1] Editor of *Le Journal des Débats*.

goes beyond what might have been hoped for under present circumstances.

Now, my dear Armand, you must set about getting us away from here, now that we've nothing more to do, with the same kind energy that you put into sending me out here. Ministries think nothing of a fortnight's delay in answering one's letters and recalling one home: but it means an age to those in exile, who have business to attend to. Please convey my respectful regards to Monsieur and Madame Bertin. Édouard, to whom this letter is addressed as well as yourself, will please accept his share of the warm affection and the gratitude I have so long felt for you both.

<div style="text-align: right">
Your devoted
Eug. Delacroix
</div>

✒ TO AUGUSTE JAL[1]

Tangier, 4 June [1832]

I was very happy to get news of you, my dear friend, your kind letter reached me on my return from Spain, where I had been for a brief visit. We are at last about to sail for poor France, and I was anxious not to leave Africa without sending you a word of thanks.

Your newspapers, your cholera, your politics, all these things unfortunately detract from the pleasure of going home. If you knew how peacefully men live here under the scimitar of tyrants; above all, how little they are concerned about all the vanities that fret our minds! Fame, here, is a meaningless word; everything inclines one to delightful indolence; nothing suggests that this is not the most desirable state in the world. Beauty lies everywhere about one. It drives one to despair, and painting, or rather the frantic desire to paint, seems the greatest of follies. You have seen Algiers, and you can imagine what the natives of these regions are like. Here there is something even simpler and more primitive; there is less of the Turkish alloy; I have Romans and Greeks on my doorstep: it makes me laugh heartily at David's Greeks, apart, of course, from his sublime skill as a painter. I know now what they were really like; their marbles tell the exact truth, but one has to know how to interpret them, and they are mere hieroglyphs to our wretched modern artists. If painting schools persist in setting Priam's family and the Atrides as subjects to the nurslings of the Muses, I am convinced, and you will agree with me, that they would gain far more from being shipped off as cabin boys on the first

[1] Auguste Jal witnessed the capture of Algiers in 1830 as correspondent for Le Constitutionnel.

boat bound for the Barbary coast than from spending any more time wearing out the classic soil of Rome. Rome is no longer to be found in Rome.

By the way, you may perhaps have died in this dreadful epidemic of cholera: God forbid it should be so, my dear friend; I hope for kinder things of fate. Please remember me to Pierret and all our friends. So far I have lost no one in the holocaust. I shall be infinitely obliged if you will remember me to Mme Mirbel should you see her. A thousand thanks for your kind letter; one treasures them in this country; and pray believe in my sincere devotion. All my respectful regards to Mme Jal.

I have just written to Pierret. Tell him I am grateful for his letter. He should write to me henceforward at Toulon, *poste restante*, and tell our friends to do the same.

<div align="right">Eug. Delacroix</div>

TO J.-B. PIERRET

Tangier, 5 June

I have had no word from you or Félix, or indeed from almost anybody, since your horrible outbreak of cholera. I write to you without knowing whether you are still alive. The newspaper reports were quite terrifying, and I know that on these occasions they understate the truth.

I have just got back from Spain where I spent a few weeks:[1] I saw Cadiz, Seville, etc. In this short time I have lived twenty times more intensely than in several months in Paris. I am very glad to have been able to form some idea of this country. At our age, if one lets slip a fine opportunity such as this, it never recurs. In Spain I found once again all that I had left behind me among the Moors. Only the religion is different here; the fanaticism is the same. I saw the Spanish beauties, who are quite equal to their reputation. The mantilla is the most graceful thing in the world. Monks of every colour, Andalusian costumes, etc. Churches, and a whole civilisation, just as they were three hundred years ago. You don't deserve a whole letter, and in fact I am somewhat pressed for time. I've had one single letter from you: doesn't it look as if you were the one who's been travelling, distracted by a thousand unfamiliar sights, and I the one who sits at a desk with a pen in his hand?

I came back here three days ago and am awaiting orders to return home. We shall pass by Oran before touching our fair homeland. In what sort of state shall I find it? When the thought of homecoming

[1] He spent a fortnight there, 16-31 May 1832.

194

occurs to me, I put it out of my mind: who shall I find dead, or a hopeless invalid? What new revolutions are you preparing for us, with your ragpickers and your Carlists, and your street corner Robespierres? – *O tempora!* Is this the price we pay for civilisation, and the happiness of wearing a round hat instead of a burnous?

The climate of Tangier is delicious; it's not nearly as hot here as in Spain, particularly inland in Andalusia. My health is still good, but what about yours? Write to me here, I may have left in a couple of days,[1] but it's all still uncertain. Love to Félix. All sorts of messages to his family and your own, if Mme Pierret still remembers me. Give me some news of Henry. Send your letter by way of Piron. Once again, it's the only way. The Ministry of Foreign Affairs sends mail only once in every three months.

<div style="text-align: right">Eugène</div>

ॐ TO J.-B. PIERRET

Toulon, 5 July [in quarantine]

I only reached here this morning, my dear fellow. I hoped to find a word from you or some of the others. We left Tangier over a month ago: but we had to call at Oran and then at Algiers, whence we have come here. I am not sorry to have had the opportunity of comparing these places with my Morocco, and in all conscience, although the time spent on my journey far exceeded what I had reckoned, it has proved interesting to see so many different things. The contrary winds were most exhausting. We are now beginning a real purgatory: the dreary quarantine. My recreation consists of a few minutes' walk in a bare paddock, where there's not a tree growing higher than my knee, and that's not much protection against the sun of these regions. We have a pleasant view over three cemeteries, convenient for burying the people who die of boredom, I imagine, as much as of the plague, and the principal object that adorns the entrance is a stone slab on which autopsies are performed. Isn't it hard to be in France and yet to be treated as a prisoner and an African, and not to be able to fly at once to where one's friends are? So do write me a word. I don't yet know how long I shall be in quarantine; probably twenty-five days. We shan't know till the day after tomorrow. And so I'm going to see you again! Well, well, so you fight,[2] you conspire, ridiculous madmen that you

[1] The party left Tangier, 10 June, called at Oran, 18 June, stopped at Algiers, 25-28 June, and landed at Toulon, 5 July, where they were held in quarantine.

[2] There had been rioting on 5 and 6 June at the funeral of the republican General Lamarque, who died of cholera.

are. You should go to Barbary to learn patience and philosophy.
Farewell, my dearest friends. . . .

ᕗ TO FÉLIX FEUILLET

Toulon, 7 July 1832 [*in quarantine*]

I have not thanked you, my dear Feuillet, for your inexhaustible
kindness, to which I owe so many welcome consignments of mail in the
course of our various travels. May I send you my grateful thanks in a
letter written on the soil of France, which has indeed proved most
inhospitable towards its unfortunate sons who long so eagerly to recover
their birthright. Our native land grants us, for two whole dreary
weeks, nothing but a wretched paddock in which a donkey couldn't
graze: a great many fleas, and that lazaretto dirt which is the foulest
of all, for it comprises the filth of the inhabitants of the four quarters
of the globe, including their names scribbled on all the walls. Alas!
what shall I find in that Paris which was our distant lodestar on our
travels? Barricades again, or perhaps only ruins, those ultimate barri-
cades, a throne worthy of our modern reformers. What has become of
art, poor art, amidst these disorders? The arts are now, and will
probably be for a long time to come, the worst of professions for those
who practise them, and a feeble pastime for the rest, a feeble compen-
sation for the miseries of the age into which heaven has caused us to be
born. . . .

[*End of Moroccan journey*]

ᕗ TO FRÉDÉRIC VILLOT
[at Champrosay]

30 August [*postmark* 1832]

I'm replying to your kind letter, my dear friend . . . I'm working
fairly hard; I've got down to it again quite eagerly. I suppose you are
busy too. Paris bores me profoundly; men and things appear to me in
a very special light ever since my journey; very few people seem to me
to have good sense; the plays at the Vaudeville are neither amusing
nor very moral, and the Opera, particularly the ballet, doesn't seem
to me to reproduce nature very closely. If it weren't for the pirouettes,
I'd prefer the dancing of the Jewish girls at Tangier. . . .

The drawings[1] are waiting for you, as you might expect, to be

[1] The Moroccan sketches, which he worked at while in quarantine, 'in a little room
that had to be cleansed of the grime of a century', according to an earlier letter to
Villot, 7 July.

properly mounted; you and Pierret are the only people capable of tackling this.

I am being relentless towards the art-loving public and refusing to open my studio.

Farewell, all my sincerest affection, and all my respects to Mme Villot.

௸ TO HONORÉ DE BALZAC[1]

[end of 1832]

Allow me, by way of thanks, to express to you some of the ideas which were suggested to me by yours in *Lambert*, and which I wrote down as I sat by my lonely fireside, reading it, not quickly, which I can never do, especially with books I like, that's to say those in which the author's ideas continually stimulate my own.

Whether Lambert is your brain-child or actually existed, you have in any case created him: for to create, for a poet, means to show others what they might see in nature as he does, and what they do in fact recognise there when, like a mirror, he reflects things, setting them within a frame, for the benefit of the unenlightened common reader, whose vacant gaze, vaguely impressed by everything, concentrates on nothing.

I have known such men as Lambert, or of a like character. I have myself been a sort of Lambert, with less depth; but as for the delicious hours that the child spends amid his poetic imaginings, the way he isolates himself in the middle of his classroom, with his nose deep in his book and pretending to follow the teacher's explanation, while his soul wanders off and builds palaces, I have experienced it all like yourself, like your Lambert, and I might venture to say like all children. At that age everything is new, and one dares to think in one's own way. Later on, originality is dulled by book learning. A book by a great man is a compromise between himself and his reader. It is a neutral ground on which he condescends to meet the reader on equal terms, summing up his reveries in clear language, midway between his creative imagination and the understanding of the common reader. In order to formulate ideas, even for the benefit of unenlightened

[1] Draft of a letter to Balzac. *Louis Lambert* appeared in *Nouveaux Contes Philosophiques*, October 1832. The previous year Balzac had sent Delacroix his *Romans et Contes Philosophiques* with an affectionate letter ('Mon cher et excellent Eugène'). In his *Journal*, 10 February 1852, Delacroix remembers his first meeting with Balzac at Nodier's or Mme O'Reilly's *salon*. Their relations never became close; Balzac was a fervent admirer of Delacroix's, but the latter in his *Journal* is highly critical of Balzac as a person.

minds, he has to cut them down and plane them and force them through a constricted opening that shapes them as they emerge into the light of day. Like glass which grows cold as it issues from the furnace, and which, instead of the glowing substance that was bubbling in the hungry abyss, becomes a mere utensil, a flask destined to serve the meanest purpose, so the idea, bare and cold but precise and resonant, is no longer molten lava or flashing lightning, it is a useful vessel which contains instruction or amusement for everyone: amusement for idle readers, for silly women, and for all that frigid public that watches the birth of works in order to adapt them to its own use, or to pour scorn on the creator and his progeny, an unquestionably superior pleasure.

So, then, a book ought to be written about *the book* and about the common illusion that it is a faithful echo of what has taken place in the author's mind.

Your passage on the word makes one sorry that it only takes up one page. As you say, there is a whole science contained therein, as in so many other things, and you must have abandoned it with regret.

Don't you think it amazing how many favourable circumstances are required to develop genius and make it bear fruit?

I had a friend like Lambert; we used to found republics, but I was less of an enthusiast than he. I think such precocious development seldom leads to real greatness. In this world, what's needed is a practical genius that can descend to the level of average minds. . . .

Maturity
1833 - 1853

꧁ TO M. CAVÉ
Head of the Department of Literature,
Science and Art at the
Ministry of the Interior and Commerce

30 *May* 1833

Monsieur,

Would you be kind enough to request the minister's permission, as soon as possible, for the ceiling that I am to paint[1] to be treated against damp by M. Darcet's process: all the moisture previously absorbed must still be in the plaster, for it has reappeared after five successive coats of paint. The same stains will inevitably soon show on the final coat and on the gilding. The church of Notre Dame de Lorette, which is being painted at the present moment, has been treated in this manner, which is indispensable only in the ceiling of the room I am painting. The architect will give you an estimate of what it is likely to cost.

I have the honour to be, monsieur, your most obedient humble servant,

Eug. Delacroix
Quai Voltaire, No. 15

꧁ TO LOUIS DE SCHWITER
[in London]

3 *July* [1833]

My dear Schwiter,

I have just received your letter, which puts me in a somewhat difficult position. Triqueti[2] left at least two days ago, so that I don't know how to send you the sum I am able to spare you. I can really only let you have 300 francs, and believe me I'm greatly and sincerely distressed at not being able to send more. If, however, your commitments were heavier and it were absolutely necessary for you to have 500 francs, as I may have led you to expect by my promise, I could do it. But I must confess I should find it a strain.

I was sorry to see from your letter to Pierret that you are not pleased with the way your pictures have been hung.[3] It appears too that John Bull isn't easily caught, I mean as regards painting, and where his money is concerned. As for patronage by favour, you'll find that all over the world. Moreover I must confess that I've stolen one

[1] The Salon du Roi in the Chambre des Députés.
[2] Henri de Triqueti, sculptor, worked and died in England.
[3] Schwiter showed two portraits at the Royal Academy.

such commission from you. Mornay,[1] who is here, insists on having his portrait painted; he wanted to have you to do it, and in your absence he's accepted me. You see that Fortune often sits waiting for us while we go chasing after her. You may perhaps find her on your doorstep, or by the wayside.

Please remember me kindly to the Elmores,[2] Rochard[3] and the Fieldings.[4] Do you know that when I read in your letter about the exhibitions of Lawrence and Reynolds[5] I nearly rushed off? But I'm past the age of such escapades.

Goodbye, send me a prompt reply and believe me, dear Schwiter, your very sincere friend

Eug. Delacroix

⌐ TO MME DE FORGET[6]

25 February 1834
[*postmark Beaumont-sur-Oise*][7]

Good morning, my dear cousin,

What do you think of me for writing to you? And yet nothing is more sincere than my sudden longing to do so, for which I hope you won't be vexed with me, since being at such a distance from the people I most often think of, it's quite natural that memory should often bring them back to me. I might have thought of you, as I often do, without telling you so. I imagine you'll understand how I was the less able to resist my desire, being deprived of the possibility of seeing you. In the country one's heart grows fonder. Many desires which, amid the noise and bustle of Paris, are vague and timid, become more imperious in seclusion. I am like a poor insignificant monk writing to you from the depths of his cell. As soon as I get back into the civilised world I shall resume my customary self-control and my real or apparent calm. I have just read Mérimée's *La Double Méprise*,

[1] The Comte de Mornay, with whom Delacroix went to Morocco.
[2] Elmore, the horse dealer, befriended Delacroix on his visit to England.
[3] François Rochard, miniaturist, worked in England.
[4] Copley, Newton and Thales Fielding.
[5] Fifty paintings by Reynolds and forty-three by Lawrence were being shown at the British Institution.
[6] Joséphine de Forget, *née* de Lavalette, a distant cousin. She was shortly to become his mistress, thereafter the closest of his women friends and the *consolatrice* of his later years. At this time she was living apart from her husband, who died the same year. She met Delacroix in November 1833, probably through their mutual friend Cuvillier-Fleury (whose mistress she had been). This is the second letter to Mme de Forget, the first being more formal in tone. All other letters 1834-44 were destroyed by her executors. See plate 27.
[7] He was staying with his cousins the Rieseners.

which I didn't care for. I say the thing's impossible, morally as well as physically, and that even though it takes place in a post-chaise, love cannot really happen quite so fast, can it? That's my firm opinion. Besides, his gentleman is a specimen of cold-blooded impassivity that is very hard to imagine, while his lady represents a degree of flightiness, to call it no worse, that I consider very rare.

You may ask me why on earth I'm writing to tell you all this? Simply because the fancy took me to. You're at liberty to forget it all a minute later. My eccentricity will scarcely come as a surprise to you.

Goodbye, my dear cousin, and above all take care of your health; I wish you could have some of the fine sunshine I'm enjoying.

Your devoted cousin

❦ TO MME DE FORGET

[1834?]

Kind, kind darling, a thousand thousand thanks for your charming letter and your heartfelt expressions: how can one not love life when one is loved? I should be most ungrateful towards fate, which has granted me so kind a response from you. I am feeling much better, despite the sadness that always follows happy moments, and the hope of spending a happy evening on Tuesday will keep me in this frame of mind. Yesterday evening, which I spent with my ex-friend,[1] was very unlike the one before. We felt constrained the whole time and ill at ease in one another's presence. This is a real and irremediable sadness, whereas that which follows moments of joy lifts gradually at the thought of future meetings. You must have felt very sad yesterday morning. I thought of that, my dearest one. You can tell me more about it.

Goodbye, my kind comforter. All my renewed love and affectionate thanks.

❦ TO CHARLES SOULIER
[at Combreux]

Paris, 20 July 1834

It's a long time, my dear friend, since I sent you any first-hand news of myself. What I have to tell you of my own affairs is very distressing and I think you are still fond enough of me to share my grief.

I have learnt of the untimely death of my poor Charles,[2] my good

[1] Joubin thinks this refers to Cuvillier-Fleury.
[2] His sister's son who was in the consular service.

nephew, the only surviving member of my unfortunate family, who should have been my last remaining friend according to the laws of nature, since his age allowed me to hope that he would outlive me. He was returning from Valparaiso, in charge of important missions which should have furthered his advancement. I was eagerly expecting him. At Vera Cruz he caught yellow fever, and succumbed in quarantine at New York on 22 May this year. You can imagine what I suffered.

You yourself had some acquaintance with this excellent fellow, on whom I founded such high hopes for that time of life when, too often, our attachments gradually diminish; you can thus appreciate the extent of my loss, and I needed to tell you about it. . . .

ᶜᴖ TO J.-B. PIERRET[1]

Paris, 29 *July* [*postmark* 1834]

My dear friend,

I went to see your wife the evening before last and there I read your long, welcome letter, sent from I don't know where. I'm glad to see that so far your journey has not gone badly. I had been longing to see a few lines in your handwriting. Inwardly, I had always disliked the thought of this journey of yours whereby innocence is brought into contact with vileness, and idealism with hideous passions, in all their naked crudity. For to tell the truth I am convinced that with a few exceptions we live with the souls of convicted criminals rather than with the souls of angels, or even of simple human beings. You, so pure amidst all that hell, and moreover enduring a loneliness that must seem doubly wretched! I thought you would be pleased and somewhat heartened to receive, midway through your journey, a few lines from one whose heart is all yours and who needs you so much. I have no news to give you; I am chained to my galley as usual, the wretched prey of every sort of emotion, now borne sky-high, now sinking lower than the wretches under your charge. When a man's dreams and fancies make him unhappy, to what depth of misery can he not descend! But you know my way of life, and my life means my nerves, my spleen, my constitution, or rather a sort of fever.–I'm working hard, I hope to realise some of my plans. I have seen Buloz, and spoken to him about you: as he does not know what kind of man I'm proposing to give him, he could not thank me as he would have done had he known you. Now consider carefully the career which you must now undertake, which necessity and duty press on you as well as your own

[1] Pierret had been appointed inspector of a gang of convicts being taken to the galleys at Brest.

inclination. Don't answer me if you haven't time. Keep an open mind. I realise that it needs great courage.

Farewell, my dear friend. I have had a letter from Soulier which gave me great pleasure; he wants us to visit him. It's difficult, for I am overwhelmed with work, and you are busy too.

Farewell again, I embrace you,

Eugène

෴ TO FRÉDÉRIC VILLOT

Valmont,
Tuesday, 23 September [1834]

I think I told you, my dear friend, that you'd hear from me. I have become so lazy here that the pleasure of talking to you a little doesn't stop me from considering it a most wearisome matter to cut a pen and look for paper in order to do so. All I do here is vegetate, so to speak. A few rare excursions into the country round and to the seaside complete my existence, which is wholly adapted to a provincial way of life. I assure you that you live too near Paris[1] really to enjoy country life. You're too well aware how easily you can make a trip to Paris and even go and see the latest opera there. Here, where there aren't even any roads, that particular temptation has no power. When I say I do nothing, that doesn't actually mean that I have done nothing at all. I was forced to stop in Rouen for a day and a half, while waiting for a carriage to bring me here. At the museum there I did a water-colour sketch after a magnificent Veronese[2] which you will enjoy seeing. If ever some small business matter should require you to visit Rouen, let this picture be a further inducement: it's worth the journey on its own account. It seems to me somewhat in the style of the *Esther* and *Susannah* in the Louvre. What I have made of it is horribly imperfect. The picture is very finished, and carefully painted throughout. It has not been retouched or cleaned, indeed, but I prefer its venerable grime and I've implored the director not to touch it.

By the way, I say I've done nothing; that's not quite true. I have perhaps done rather more than I imagine, for I've tried my hand at fresco.[3] My cousin had a small piece of wall prepared for me with suitable colours and in a few hours I did a piece of work in a medium

[1] The Villots had an estate at Champrosay near Fontainebleau, where Delacroix later (1844) bought a cottage.
[2] *St Barnabas healing the Sick.*
[3] Three frescoes painted by Delacroix in the abbey at Valmont, representing Leda, Anacreon and Bacchus, are still preserved there.

which is quite new to me, but which I think I could manage to master if the occasion arose. It's more convenient than tempera: the difficulty lies chiefly in defining one's forms and giving them the proper roundness; but I think that the change that takes place in the colours is not as great as with tempera. For that matter, it takes a very long time to dry, and though it has been done four or five days I'm not yet sure whether the colours have recovered their full brightness. I must confess I should be tremendously exhilarated if I could attempt something in this medium seriously, on a larger scale. I believe the process is far simpler than it's made out to be. In any case one would merely have to make a trip to Italy to visit some old plasterer to complete one's education.

Looking at this picture has revived a secret longing to go and see the fine things in Venice. When will that be? . . .

&ʃ TO FRÉDÉRIC VILLOT

Valmont, Wednesday [*October* 1834]

Your kind letter has just reached me this morning, my dear friend. It gave me the truest pleasure, first because of my affection for you and secondly because I found in it an echo of my own thoughts, I mean my thoughts about art, which stirred up within me all that was seething there for want of an outlet. For if I should venture to introduce such topics as poetry or painting to the people amongst whom I am living they would never return my service. Gracious providence, how unfairly you have distributed men's lives and minds! I have sometimes deplored the straitened circumstances which deprive me of certain material advantages, but I am now more keenly conscious than ever before of what spiritual starvation means. Divine Dante! The fragment of verse you so kindly sent me moved me almost to tears. That lofty poet, a stranger in his unenlightened century, a lonely wanderer, must have seen many of his finest flights of imagination fall back unrecognised! I am deeply grateful to you for sending me these lines. I had not read them in the original, but in Deschamps' translation, which is very fine, particularly of this passage.

I am writing with an ulterior motive: to get an answer from you. Only *don't delay too long*, for I should doubtless have gone away before now but for my cousin's indisposition, since I don't want to abandon him just now when everyone else has left him – and my own, for I've been very unwell the last few days.

I have made a second attempt at fresco painting, in which I showed more patience and succeeded better. You're quite right, I don't take

naturally to coloured cartoons, and that is a drawback. But the advantages would be as follows: the need to do everything straight away puts the mind into a state of excitement very different from leisurely oil painting. My greatest failing has always been to spoil by retouching what my first impulse has created. As you know, the greater the difficulty the keener are one's efforts. Any recalcitrant material stimulates one to overcome it: an easy conquest arouses less enthusiasm. In this connection I recall certain Spanish painters whose work has this quality of immediacy, particularly Zurbaran, with whom I don't think you are familiar. The general harmony of their work suffers thereby, I think. But there's a certain intensity about it which is lacking in your beloved Venetians. Only, when one is as lazy as I am, I should never have the courage to leave unaltered something that detracted from the general harmony, if I had the ability to correct it. This, then, is one of the advantages of fresco. Besides, a certain discordance between the different parts is, at a pinch, permissible in fresco, and I maintain that only thus can one develop the full *ideal*, if you see what I mean, of which great painting is capable, or rather, I'd admit that the two styles are two separate arts of equal beauty but having totally opposite requirements. I'll expound all this more fully to you, for this slight experiment has made me think deeply about the matter and led me, regretfully, to recognise that it is impertinent to attempt oil-painting without a close study of nature, which is unnecessary and indeed inappropriate in fresco painting. Understand this if you can.[1]

Don't worry about your health, which I've always thought better than you have. The power that controls our destinies laughs to scorn our vain pretensions to health and strength. What could be more unexpected than the fate of the unfortunate friend[2] whom I have lost and whom I still mourn; no one could have been more naturally robust, and he should by rights have followed me to the tomb! Perhaps, as you say, you are going through a critical period; but I think you went through it, actually, six months ago. Nature has made great efforts, in your case, and although slow they seem to me decisive. *Addio e comportati*. I take my leave of you, thanking you once again for your letter and assuring you of my sincere affection.

Eug. Delacroix

I wholeheartedly approve of your love of antiquity, which is the source of everything.

[1] Delacroix was about to start work on the Salon du Roi and had obviously considered painting it in fresco.
[2] His nephew Charles de Verninac.

ᴥ TO FRÉDÉRIC VILLOT

Paris, 18 *October* 1834

I owe you I don't know how many replies, my dear friend. Let's begin with what's most urgent: you were good enough to think of reserving me a seat at the Bouffes[1]: that's a real act of kindness these days; it's all the rage, and everybody's asking for tickets. This is my position: the same offer had also been made to me by some kind friends, and for the same day, which is unfortunately most inconvenient for me. I had to refuse, to my great fury: but you are kindly offering me a seat every fortnight, and under these circumstances, although keenly regretting that I cannot be there every week, I accept most gratefully. That's the first point.

The other is your second letter, as delightful as the first. Once again, many thanks. I found it on my return here a week ago. Painting, that lovely and capricious mistress, was waiting for me with open arms and no sooner had I embraced her than I felt all the sharp prickles with which she wounds her most devoted lovers as well as all the rest. I am most eager to see you again. We can work together sometimes in the evenings this winter, if you like. We shall have Pierret, who is living close by, and endless battles about Veronese, that rascal Rubens, Raphael, Zurbaran, etc. Fresco and encaustic painting will be discussed ruthlessly and will have to account for their drawbacks as well as for their advantages. Forgive me for not answering your kind letter at length, as I'd have liked to. If I had received it in the country things might have been different. But here life is hectic and time has six pairs of wings. Somewhere or other I've seen a new engraving after Correggio which I'm mad about: there's another odd fellow whom I'm very fond of.

Farewell, meanwhile. All my sincerest thanks to your ladies for their kind thought in offering me the seat.

ᴥ TO J.-B. PIERRET

[*postmark Franconville*
Thursday, 27 *February* 1835]

Thank you very much, dear kind friend, above all for your letter and also for having kindly taken the trouble to enquire about that print[2] and to have got hold of it and sent it on to me. I like it very much and so does Riesener. I found the black rather startling, as you did: but

[1] The Italian theatre.
[2] Probably a lithograph from the *Götz von Berlichingen* series.

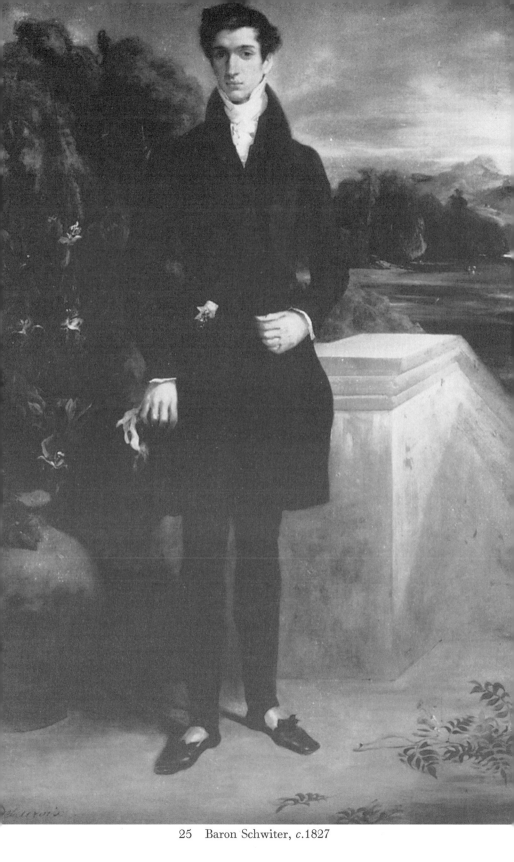

25 Baron Schwiter, *c.*1827

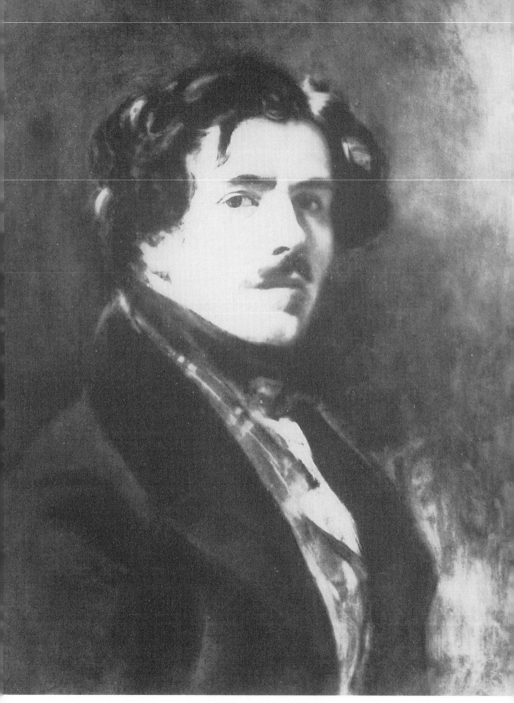

26 Self-portrait, 1835-7

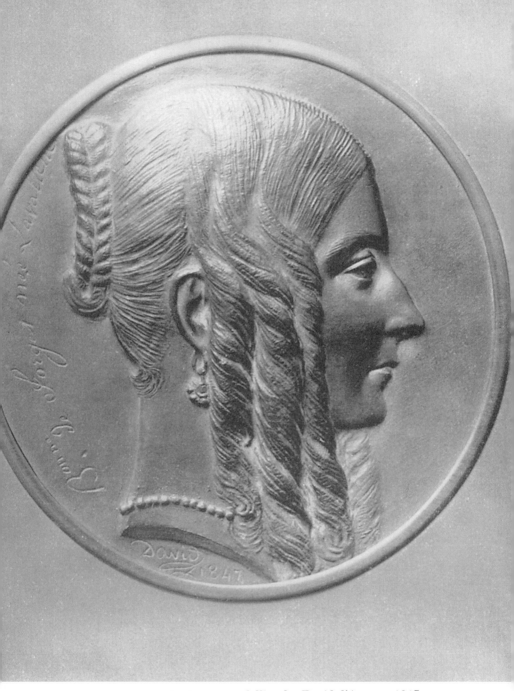

27 Joséphine de Forget, medallion by David d'Angers, 1847

Chair. Chopin

231 Clara der Rose...

I would rather spread it a little further than take any away; for if they go on tinkering at it the whole thing will look like a piece of lattice-work. The worst fault is that the hatchings that form the background, near to the arm, are too coarse and stand out too prominently. If they were like the black part which is behind the man's figure, against his legs, it would be far better. I think we shall have time to discuss it, since your gentleman is willing to delay the appearance of the article: on the whole I think it will be best to leave the thing as it is. . . .

❦ TO ADOLPHE NOURRIT[1]

10 *March* 1835

Dear Sir,

Belatedly, I send you my sincerest congratulations. I saw *La Juive*[2] for the first time yesterday; and I must tell you how wholeheartedly I admired the lively interest you shed over this play, which is certainly in need of it, smothered as it is by all that rubbish that's so alien to art.[3]

What has become of us, that we need so many extraneous reinforcements for music, which is the most powerful of all the arts, for poetry, which should appeal to us in its own right, for declamation and gesture, and for song, which enhances all the rest?

And yet you have discovered the secret of appealing to an audience which will soon have grown insensitive to anything short of actual bear-fights, or even fights between men, as always happens in times when the pleasures of the mind have become insipid.

Farewell, dear Jew, every inch a Jew from beard to toe, and above all a Jew in your heart, and without any trace of caricature. A thousand thanks for last night, and I look forward to thanking you personally; believe me, meanwhile, your very sincere friend.

❦ TO GEORGE SAND[4]

[26 *April* 1835]

I have just come home,[5] dear madame, and I thank you for your kind invitation. I shall call on you presently, at six o'clock, shall I? Are you

[1] Adolphe Nourrit was for some ten years the principal tenor at the Opéra.
[2] By Halévy, first produced at the Opéra, 23 February 1835.
[3] The spectacular settings were a sensation at the time.
[4] Delacroix first met George Sand in November 1834, when he painted her portrait for Buloz, editor of *La Revue des Deux Mondes*. See plate 29.
[5] From the Rieseners' country house at Frépillon.

going away, then? But perhaps you'll stay, for a fortnight ago you were going to stay.

You narrowly escaped a tremendous epistle from me, when I'd finished reading *André*[1] the other day, which would have begun, 'Wonderful woman! . . .' But we are not old enough friends yet for me to dare behave as absurdly with you as my present mood often leads me to. Perhaps one day I shall be more enterprising, so as to tell you all that I think of *André* and a great many other things besides.

Goodbye, dear madame, until we meet presently,

Eug. Delacroix

And yet I cannot resist adding another line about that pretty serpent.[2] The first few days I was completely crazy about it.

❧ TO GEORGE SAND
[*April* 1835]

Dear Madame,

Would you be good enough to write me a line saying whether Buloz sent you the page of *André* which contains the passage you are kindly going to copy out for me? If you have not got it, I must procure the book myself. You will even have to be self-sacrificing enough to tell me when I can send round for the thing. I've found it difficult lately to call on you at times when you've been at home. Don't be too much surprised at my importunity. The reason is a simple one; I am egged on by a woman who keeps pestering me about you.[3] If I pester you somewhat on her behalf you must blame the terrible tenacity of the sex to which, charming as it is, you no longer wish to belong.[4] Try not to become a man either, they are horrid creatures.

Forgive me once more, and accept the drawbacks of celebrity.

Eug. Delacroix

Friday morning.

❧ TO THÉOPHILE THORÉ[5]
18 *January* 1836

Monsieur,

In accordance with the letter you did me the honour of writing me on 20 December last year, I am sending you a list of some of the works

[1] By George Sand, published in *La Revue des Deux Mondes*, March-April 1835.
[2] A paperweight which had belonged to the actress Marie Dorval and which George Sand gave to Delacroix.
[3] Probably Mme de Forget.
[4] George Sand had cut her hair and wore men's clothes.
[5] Théophile Thoré-Burger (1807-69), democratic journalist (exiled after the *coup d'état* of 1851), an enlightened and progressive art critic and one of Delacroix's most courageous admirers.

which I have exhibited in public, together with the date of their appearance. This, I think, completes the information I can give you about myself, there being nothing particular in my biography that can be of interest to the public.

At the exhibition of 1822 *Dante and Virgil crossing the stream that surrounds the wall of the infernal city of Dis.*

1824 *The Massacre at Chios. Greek families in distress awaiting the death of slavery.* At the same exhibition a small painting representing *Tasso at St Anne's Hospital, Ferrara,* where he was shut up with madmen.

1827 *The Emperor Justinian drawing up his Laws,* intended to form part of the decoration of the rooms of the *conseil d'état.*
Christ in the Garden of Olives.
Greece on the ruins of Missolonghi.
Death of the Doge Faliero.
Dr Faustus in his Study, as Mephistopheles appears to him.
Sardanapalus, besieged in his palace by his rebellious subjects, has all his women put to death and burns himself alive with all his treasures.

1828 For the gallery of the Palais-Royal, *Cardinal Richelieu saying Mass, surrounded by his guards.*

1829 *The Boar of the Ardennes, having taken by assault the castle of the Bishop of Liège, summons the latter before him during an orgy* (this picture forms part of the collection of Mgr le duc d'Orléans, Prince Royal).
The Combat between the Giaour and the Pasha (Lord Byron).
In 1828 appeared a set of lithographs based on Goethe's play, *Faust,* printed in a *de luxe* edition with a new translation. Goethe, in the literary and artistic journal which he edited, mentions this edition with particular praise.

1830 *The Battle of Poitiers and capture of King John of France* (commissioned by Mme la duchesse de Berry).
The 28 July: Liberty Leading the People, an allegorical picture about the events of July 1830, exhibited at the Salon of 1831.
Two Tigers, lifesize studies.
Boissy d'Anglas at the Convention of 2nd Prairial (sketch).

1832 I undertook an interesting journey through the empire of Morocco and through our own African possessions, from which I brought back some unusual studies. During this journey I made a set of some twenty finished drawings of the dress and customs of the country, which are the property of M. le comte de Mornay, at present French ambassador in Sweden. A number of drawings

and water-colours, the further fruits of this journey, are in the possession of various private owners, including M. le comte Demidoff.

[1833] At the Salon of 1833 *The Emperor Charles V at the Convent of St Just.*

1834 *Full length portrait of Rabelais,* intended for the library of Chinon, his native town.

The Battle of Nancy: death of Duke Charles of Burgundy, intended for the museum of Nancy.

Women of Algiers in their home.

Melmoth, subject taken from an English novel (Mgr le duc d'Orléans).

1835 *The Natchez.* Two young savages, fleeing from their persecutors, travel down the Mississippi. The young woman, seized with labour pains, has just given birth on the shore (taken from Chateaubriand's *Atala*).

Christ on Calvary.

The Prisoner of Chillon (Lord Byron). (Mgr le duc d'Orléans.)

In 1833 I was commissioned by the Minister of the Interior, M. *Thiers,* to decorate the Salon du Roi in the Chambre des Députés. This very considerable task is almost completed. Nothing remains to be painted save the *grisaille* in the lower part. The rest is so far advanced that it was possible to receive the king in the Salon at the opening session of the Chamber.[1]

I have not included in this note a large number of smaller paintings, lithographs and drawings, as well as several pictures which are not quite finished.

Allow me, Monsieur, to thank you for the interest you have shown in asking for these details, and to assure you of my sincerest regards.

Eug. Delacroix
Rue des Marais, No. 17
(Faubourg Saint-Germain)

꿍 TO THE MINISTER OF THE INTERIOR

27 *December* 1836

Monsieur le Ministre,

The decoration of the Salon du Roi in the Chambre des Députés, as originally envisaged, was very much less complicated than it has now become, owing to the need to make the fullest use of the available

[1] On 29 December 1835.

space. In the original plan, the only portions to be painted were the coffers in the ceiling and the pillars between the windows. The whole of the long frieze of figures which now fills the space above the arcades is a later addition. Now, owing to the size and number of these figures, the work has been more than doubled and a considerable expense of time involved. The original arrangement included, below the mouldings that support the ceiling, a relatively narrow band which could only be filled with purely decorative accessories. It seemed to us that this arrangement looked awkward and clumsy, especially in conjunction with the extremely meagre effect produced by the four isolated figures in the ceiling. We considered taking down the whole ceiling and replacing it by another in which the paintings would be less cramped and more suitable to the intended purpose of the Salon.

I then suggested that instead of pulling down and then rebuilding the ceiling it would be sufficient to do away with the band that lay above the door and window apertures. This measure, planned in consultation with the architect and approved by M. Thiers, then Minister of Public Works, was carried out. The government was thus spared the expense which the reconstruction of the ceiling would have involved, as well as any regrets about the waste of money on the original ceiling. But in this new plan, what had originally been, from the painter's point of view, only an unimportant accessory, became the principal feature of the entire work, since this frieze comprised no fewer than sixty or seventy relatively elaborate figures.

I admit that I found some compensation for an expense of time that went far beyond what I had envisaged or indeed what the minister had asked for in the satisfaction of making the whole decoration more complete. I must beg you, however, Monsieur le Ministre, to be good enough to consider whether I am not entitled to an indemnity proportionate to the scale which the work has now acquired. I also take the liberty of pointing out that the decoration which accompanies the figures has been carried out by professional artists,[1] at a considerable cost, which I have had to meet myself. These expenses also include all the gilding that forms part of the decoration.

I should moreover like to stress the fact that the very moderate fee of 35,000 francs which had been agreed on when the work was of a more limited scope is extremely inadequate in view of the time which has had to be spent on the execution of the later plan, and particularly in regard to the fees which have subsequently been paid to various artists for similar work. I may mention, among others, the Hemicycle in the École des Beaux-Arts,[2] the individual paintings in the church

[1] e.g. Ciceri. [2] Paul Delaroche.

213

of the Madeleine,[1] for each of which 25,000 francs was paid, and several more.

I have the honour to remain, M. le Ministre, your most respectful and obedient servant,

Eug. Delacroix
Rue des Marais Saint-Germain, No. 17

ॐ TO THE PRESIDENT OF THE FINE ARTS SECTION OF THE INSTITUT[2]

Paris, 4 February 1837

Monsieur le Président,

I venture to submit for the approval of the Fine Arts section my candidature for the seat left vacant by the death of M. Gérard. While stating the claims that might perhaps justify my aspiring to this honour, I am all too well aware of their insignificance, particularly on this occasion when the loss of so eminent a master as M. Gérard has caused a void in the French school of painting that will not be filled for many years to come.

Here, however, are the names of some of the works which I venture to recall to the indulgent memory of the Academy:

> *Dante and Virgil; The Massacre at Chios; Christ in the Garden of Olives; Marino Faliero;* 28 *July* 1830; *Women of Algiers; St Sebastian;* the paintings in the Throne Room at the Chambre des Députés, etc.

I have the honour to be, Monsieur le Président, your most respectful, humble and obedient servant,

Eug. Delacroix

ॐ TO THÉOPHILE THORÉ

2 *March* [1837]

My dear Sir,

I am equally gratified and embarrassed by the article you have written about me in *Le Siècle.* I think I am inclined to agree with the worthy Buloz.[3] My vanity and my prudish modesty are at odds with

[1] Schnetz, Bouchot, Abel de Pujol, Couder, Cogiet, Signol, for paintings in the side chapel; Ziegler for the decoration of the apse.

[2] The first of Delacroix's eight attempts to be elected to the Institut.

[3] Buloz, editor of *La Revue des Deux Mondes,* thought Thoré's articles in *Le Siècle* (24-5 February) too enthusiastic; hence his unwillingness to take on Thoré as regular art critic on his journal.

one another and in my heart of hearts I should like to be of your opinion.

Believe me, however, the truest thing you say refers to that uneasy ardour that constantly impels me towards that region that I shall never reach; at the start of any work, one's imagination catches fire and promises something very different from what it can actually achieve. So that when one has finished one can only cast a regretful glance at that shapeless blend of good and bad which is called an artist's production. And thus that vague longing that impels one to push on when one has been through one province, that reluctance to go over the same ground twice, is perhaps a weakness rather than a virtue.

You mention another article in which you discuss my Palais-Bourbon paintings. Would you be kind enough to tell me where I can find it?[1]

Looking forward to seeing you again and telling you in person how much pleasure you have given me,

Eug. Delacroix

TO FRANÇOIS BULOZ

Monday, 2 March 1837

My dear Sir,

I have just learnt, on my return from the country, that you are undecided on the choice of a critic to write the reports on the Salon for the *Revue des Deux Mondes*; this distresses me greatly, I assure you. For I had been delighted that my friend[2] should be connected with my favourite journal. I am convinced, moreover, that his serious turn of mind makes him fitter than many others for this task. However, I shall not remind you of any other claims than the promise you had given him. This, indeed, would have been the most natural answer to make to any applications you subsequently received.

I am in an awkward position, since I may appear an interested party in this matter.[3] I hope you will do me the justice of believing that my only concern is to be helpful to a man whom I consider talented and, moreover, to be helpful to your journal itself.

Your sincerely devoted
Eug. Delacroix

[1] In *La Loi*, 24 February. [2] Thoré.
[3] Thoré's article in *Le Siècle* praised Delacroix.

215

It is not with the intention of influencing your judgment that I mention by the way that I have made some headway in a small article I am doing for you.[1]

ꝯ TO FRANÇOIS BULOZ

[end of April 1837]

Yes, my dear sir, I'll let you have the article on Poussin;[2] but since you want me to speak frankly I must tell you that, whether on account of the multiplicity of my occupations or the fact that I have entirely lost the habit of writing, I never found any task harder to get going and even more to get finished. Be kind enough therefore to have patience a little longer. I need plenty myself, I assure you, to carry the thing through, and in the end I may only give you something of less than ordinary merit.

Your sincerely devoted
Eug. Delacroix

Will you be good enough to thank M. Barbier[3] for me, when you see him, for his kind remarks about my work in his *Salon*?

ꝯ TO MME PIERRET
rue Neuve du Luxembourg, No. 1

[postmark 19 May 1837]

Please forgive me for always bothering you about my affairs, madame, but I must beg your help about those everlasting shirts. I have absolutely none at all. Mine were in a very bad state, in any case, and now I don't know what to do. As soon as your health permits, will you be kind enough to get them finished according to the pattern, only with collars added, the cuffs made as usual and the front pleats *without spaces between them*: this will prove more economical in use. I won't disguise the fact that white ones would be far more useful to me than coloured ones, and it would be very kind if at the same time you could see about my sheets.

Once again, please forgive me for giving you so much trouble: I shouldn't keep on doing so if the thing were not already started.

[1] An article on Poussin which was eventually published in *Le Moniteur* (1853).
[2] Although Delacroix failed to complete the article on Poussin he sent Buloz one on Michelangelo which appeared in the *Revue des Deux Mondes*, 1 August 1837.
[3] Auguste Barbier of the Académie Française.

Goodbye, madame, all my sincerest affectionate good wishes to yourself and Pierret. Eug. Delacroix
Friday, 19th

ᴄ§ TO FÉLIX FEUILLET
Ministry of Foreign Affairs
or rue de la Ferme, No. 17

Wednesday, 7 June 1837

My dear friend,

Since you lay down the law in ceremonial matters[1] I am sending my tailor to call on you so that you can let him see the sort of coat you wear for court balls. I want to have one made for myself as *cheap* [*sic*] as possible, and I'd like him, after seeing yours, to think up something not too unsuitable. I've unfortunately been invited to a rout at Versailles;[2] so I've got to make myself smart.

Goodbye, my dear friend; forgive my importunity and believe me, ever your devoted

Eug. Delacroix

Tell him whether boots are worn with trousers.

ᴄ§ TO CHARLES RIVET[3]

15 *February* 1838

. . . I have to thank you, not only for the success which I owe entirely to you,[4] I'm convinced, but even more for your kind and constant friendship. I know how I could make up for all my shortcomings towards a man like yourself: by simply getting into a coach and turning up, in my travelling boots, at your fireside. But that's the sort of happiness I am allowed to dream of and, by some adverse fate, never to enjoy. Not to mention the thousand hindrances to which we unfortunate artists are always subject, I am pursuing two or three intrigues[5] not one of which will succeed, no doubt, in order to be asked to paint a few feet of wall, with no greater profit to myself, probably, than what I have already done, but so as to satisfy that urge to do something big which becomes overpowering when one has once experienced it.

[1] Feuillet was in charge of protocol at the ministry.
[2] On 10 June, to inaugurate the Galerie des Batailles.
[3] Baron Rivet was then Préfet of the Rhône.
[4] Delacroix's painting, *The Natchez*, shown at the 1835 Salon, was bought by Rivet and offered as a prize in a charity lottery. It was won by a certain M. Paturle.
[5] He was planning to stand again for the Institut.

You'd not have thought I'd reach such a point, would you, my friend? That's what has happened, though, and God will ordain things as he chooses.

Meanwhile, the months slip by without my seeing you, or seeing our beloved Venice, or Rome, or so many other fine things. I had intended to surprise you this year by visiting that Italy which seems to withdraw further from me each year, owing to those perpetual hindrances which shackle us so-called 'independent' people. . . .

How I wish my wretched picture, if it gave you the slightest pleasure, had fallen to your share! J'm the more sorry, particularly for Mme Rivet, since I am really afraid I may not readily meet with so conciliating a subject, if I may use such a term. My leanings to the tragic always dominate me, and the Graces seldom smile on me. . . .

⁊ TO M. DE MARESTE[1]

24 February 1838

Dear friend,

I believe you know Caraffa[2] and see him sometimes; will you ask him to support my candidature for the Institut? I imagine he's too new there himself to be already committed. Tell him I'm highly virtuous and have all the requisite qualities. You know that it is customary, before paying official visits, to seek the support of members through mutual friends: of course you're not to do anything about it if you don't know him well enough. In that case, who does know him?

I'm behaving towards you like a pig. Make all my excuses to Mme Alberthe, who knows that I'm nonetheless just as fond of her and of yourself.

A thousand kind remembrances.

By the way, it's Thévenin,[3] a member of our Academy, who has died, and it's his place that is to be filled.

⁊ TO MME CLÉMENT BOULANGER[4]

Spring 1838 [?]

Would you be kind enough, fair lady, to write and tell me as quickly as possible whether I can get hold of the Negro who posed for you in

[1] Baron Adolphe de Mareste was a well known figure in fashionable society and in the Romantic movement, friend of Stendhal, Mérimée, Musset, etc.

[2] An Italian composer, elected to the Academy in 1837.

[3] Charles Thévenin (1764-1838), Keeper of the Print Room at the Bibliothèque Royale.

[4] Élise Boulanger, an attractive young woman married to a painter, who herself painted, taught and later wrote about painting; Delacroix met her in 1833 at a masked ball and fell in love with her; their intermittent affair was followed by enduring friendship. She later married François Cavé, Director of Fine Arts under Louis-Philippe.

a blue coat, and what is his address?[1] Mme Vieillard[2] told me she had seen you, at Charenton, I believe, but as she couldn't tell me if you were returning soon, I've decided to write. Besides, I'm in a hurry for a word from you about this request. . . .

All my affectionate regards, and all my friendly greetings to Clément,

Eug. Delacroix
Rue des Marais Saint-Germain, No. 17

⌐ᴣ TO FRÉDÉRIC MERCEY[3]

Saturday, 19 *May* 1838

My dear Sir,

I am belatedly writing to thank you for the very kind and friendly things you say about my pictures in the *Revue*.[4] Buloz had given me your address; I had lost it, and have now found it again. Allow me to say that you are too indulgent to me. I should like to be quite sure that your private opinion coincides with your generous public expression of it. I should then be doubly grateful to you. Your Salon, moreover, has been much appreciated, and to quote only the experts, Musset was delighted with what you say about Dubufe, as were several others that I could mention.

My letter has a further purpose.

One of my friends, Cl. Boulanger, has made a request, which has received considerable support in the Ministry of the Interior, to accompany Marshal Soult on his official visit to London in order to depict the principal scenes of the coronation,[5] and if you should be consulted on this matter, would you be kind enough not to express any adverse opinion and even, if need be, put in a word in his favour, if you should find an opportunity within the next few days? I believe, as a matter of fact, that he is particularly well suited to this sort of painting.

Goodbye, my dear sir; please accept my sincere and friendly thanks.

Eug. Delacroix

I had already asked Mme de Rubempré to remember me to you.

[1] For the portrait of Youssouf (Robaut 661).
[2] Her husband, Narcisse Vieillard, was a close friend of Delacroix's.
[3] Frédéric Mercey, painter and writer, was under Cavé at the Department of Fine Arts.
[4] *La Revue des Deux Mondes,* 1 May 1838.
[5] Of Queen Victoria, 28 June 1838.

ꝗ TO GEORGE SAND

Valmont, 5 September (1838)

Dear woman,

It's only during the last two or three days that I have been able to settle down. Since leaving Paris I've been tossed hither and thither and my annoyance has quite outweighed my pleasure, except for the sea which I always behold with fresh delight, as Louis-Philippe does his beloved deputies. I have seen many intolerable provincial faces, many hotel dinner tables and would-be wits, many inns and very few English-style privies (excuse my vulgarity, but it's an extremely important detail), in short, I've endured a multiplicity of vexations. I even got to the point – having to spend a whole day in Dieppe, an atrociously boring town where I know nobody – of shutting myself up in the town library, where I read Lebeau's *History of the Decline of the Roman Empire* to distract myself from my own catastrophes. Even so, I was not allowed to rest my head in that sort of barn, where some hundred books chase one another and play puss-in-the-corner with the rats. I was only suffered to stay there an hour or so because it was the curator's dinner time.

I am in the most delightful spot here, but I feel the lack of too many things. It has one great advantage, however, namely that it makes painting seem easy to me since I am deprived of the means of doing any. Things are different in Paris, where I have no excuse not to work.

This place was once a wealthy monks' abbey; it has a superb ruined church and enchanting gardens and waters.[1] It all makes one rather sad. One finds oneself here desperately defenceless against a host of emotions which the surrounding hubbub helps one to keep at bay in Paris. There are even ghosts in the garden, in which everybody believes; but the true ghosts are only too real to me, although they are in my imagination. They are beloved petticoated ghosts, which I keep expecting to see at the corner of shady walks and along rushing streams, worthy of Ariosto's glades. No place was ever more apt to wound one with those stings that do not kill, but grieve the heart. Does happiness exist only at the moment one enjoys it? Isn't it too cruel, then, to pay for it a million times over with regretful longings? One even comes to doubt whether it really existed. Only the hope of recovering it can comfort one for having lost it. My dear, enjoy those precious drops of honey. You are so worthy of being loved! You are neither a *précieuse* nor a coquette. You judge the foolish tactics of my sex and of your own in that war they call love, at their true worth. I could even wish you, perhaps in spite of yourself, a little dose of

[1] See plate 38.

220

oblivion after the season of enchantment is over. I should like to find it here, I had almost hoped to do so: but for that I should need another sort of distraction than those I find here. A thousand apologies for my atrocious handwriting. I can no longer hold a pen. I'm seized with a fit of nervous irritation as soon as I pick one up. This is literally true. I embrace you. All my love to Chopin and to any kind friends you may be seeing, above all Mme Marliani. I embraced your dear good son at Rouen. He'll have told you of our exclamations when we met. I re-embrace him here.

Farewell.

Chez M. Bataille at Valmont
(Seine-Inférieure)

ↄ TO FRÉDÉRIC VILLOT

Valmont, 13 September [1838]

My dear friend,

I am writing you a few words so as to win from you a really long reply, if you have the slightest delicacy of feeling. I am living here remote from the centre of civilisation, and in profound isolation; you can guess that a good long letter from you, in which you would talk a great deal about yourself and a great deal about painting, would give me considerable pleasure. I revisited the museum at Rouen; I discovered there a second Veronese,[1] almost as fine as the one of which I'd made a sketch four years ago; but what I admired with fresh enthusiasm were three small pictures by Raphael[2] in his earliest manner, which are incomparable. None of his small pictures in the Paris museum is equal to these. Incidentally, they seem quite unaware at Rouen what treasures they possess. They boast about a great copy of the Dresden Madonna[3] and never mention the three charming bits of work that lie neglected here. I shall only retain a faint impression of the Rubens.[4]

Did you learn through the newspapers that the ministry had commissioned me to paint the library of the Chamber, amongst a number of commissions to other artists for this building?[5] I learnt the news through the same channel, and it has since been fully confirmed. I'm delighted to tell you this news, if you had not heard it already, for I'm sure you will be pleased for my sake. You know the place; so

[1] An altar-piece from Veronese's studio.
[2] Actually by Perugino: *Adoration of the Magi, Baptism of Christ,* and *Resurrection,* fragments of an altar-piece painted for the church of S. Piero in Perugia.
[3] A copy made in 1654 for the abbey of St Amand in Rouen.
[4] *The Adoration of the Shepherds,* painted shortly before 1620.
[5] Delacroix had in 1837 designed a general plan for the decoration of the Chamber; he was allotted the library.

be kind enough in your leisure moments to consider what is the best use to be made of it: five cupolas and two hemicycles at each end. The subjects I had thought of have drawbacks, and if a better idea occurs to me I shall use it, which I think is quite likely. As you know, they are pendentives.[1]

What is needed there is a fertile idea which is neither too realistic nor too allegorical, in short, something for all tastes. I'm doing very little here. I am like those army generals who fall sound asleep on the eve of battle. Sometimes I feel my feet itching to go away. I have also got to cope with a certain Fall of Constantinople for Versailles; all of which means that this is less than ever the time to lose the use of one's arms. Rather, I shall need to fix somebody else's arms on to my own. I must try to organise myself accordingly.[2]

Give me some news of whatever interests you; have you some work in hand? I assume you are at Champrosay and I'm addressing this letter there. I used to think there were some things of which one never tired and that the sea was one of the chief of these. I'm now convinced of the contrary and I admit that one can have enough of it. So that when, thanks to balloons and railways, we can see it after a three hours' journey from Paris, it will no longer be a pleasure, any more than looking at the trees in the Tuileries. Thus everything has to be bought; an easily won pleasure ceases to be a pleasure, and easy works of art are like easy pleasures: they make little impression on those who look at them and also on those who have made them.

ᓚ TO ADOLPHE THIERS

Paris, 27 October 1838

Monsieur,

The newspapers may perhaps have told you that I have quite recently been commissioned to decorate the library of the Chamber. They informed me myself of my good fortune at a time when I was away from Paris, having quite forgotten this scheme because of what seemed to me an obstinate determination on the part of the authorities to disregard it, whereas everything seemed to favour a decision on the question. You may remember that you had allowed me to hope that in the event of the necessary funds being available you would agree to entrust this new task to me. But when some two years ago the plan was in fact judged feasible, I no longer found the same encouragement and the hand you had so generously held out to me was no longer there

[1] Here a sketch of the pendentives.
[2] He organised a studio in the rue Neuve-Guillemin to train pupils to help him.

to assist my fortunes.[1] After a number of vicissitudes which I shall not describe to you because I am ignorant of them myself, certain considerations which, in my opinion, were quite trivial swayed the balance in my favour and my first thought was to turn towards yourself, monsieur, as being the person to whom I owe my first, my only thanks. Having returned to Paris a few days ago, it was only here that I was able to find out how I could reach you with this letter, which I am writing with great pleasure, fulfilling a very happy obligation.

You offered me, out of pure friendliness, one of those decisive opportunities which open up to an artist an entirely new career, and which are bound to increase his stature, unless they lay bare his impotence. A mind like your own is familiar, moreover, with that delight and excitement of the struggle which double a man's strength and raise him above his usual self. You will therefore understand better than anyone else could how grateful I am to you. Your rare talents have enabled you to attain that glorious goal of which all generous hearts dream, and even your leisure hours are devoted to lofty ideas.[2]

I do not wish to trespass longer on the precious minutes of your valuably busy life; but I venture to believe that you will be glad to receive this heartfelt expression of the respectful and unalterable attachment I shall always feel for you.

ᴇꜱ TO FRÉDÉRIC VILLOT

Sunday morning
[*postmark* 20 *January* 1839]

My dear friend,

I've found in Diderot a reference to the subject of *the Death of Commodus, torn to pieces by wild animals.* Please give me details; he gives none. Don't appear in my presence without a full account of this subject. Wouldn't it be a fine thing to do, for a man who keeps company with bears and panthers?

I can imagine the picture already.

Yours, my dear friend,

Eug. Delacroix

[1] Adolphe Thiers had ceased being Minister of the Interior since April 1837.
[2] *Histoire du Consulat et de l'Empire.*

ᴄᴊ TO FRÉDÉRIC CHOPIN[1]

Saturday [March 1839?]

Dear Chopin,

I'm sending you two little books which M. Clericetti[2] gave me for you and which you'd be kind to accept, thinking of the pleasure you will give the poor fellow.

I don't know whether those quartets and quintets for which you were good enough to reserve me a place are being performed tomorrow; but I shall unfortunately not be able to enjoy them. My fever has gone, but I have been unwell again as a result of going out and my doctor is afraid of the slightest chill bringing on my attacks again: without his orders I'd have gone to greet you affectionately and ask for news of the inhabitants of Nohant.

Goodbye, dear fellow, with my sincerest affection,

Eug. Delacroix

ᴄᴊ TO JULES JANIN[3]

10 March [1839]

My dear Janin,

I have been unwell and housebound for nearly a fortnight, otherwise I should have gone to thank you for the kind things you have written about me in L'Artiste. Although I have not yet been admitted to the ranks of respectable painters, who docilely follow the teachings of L'Écluze,[4] etc. I am nonetheless highly flattered at having attention paid to me. To take up space is, it must be admitted, the ambition of us all, and to take up so much in your pages, my dear Janin, is an even more flattering thing.

Once more, please accept my sincere thanks and good wishes.

ᴄᴊ TO M. CUVILLIER-FLEURY

16 March 1839

Will you forgive me for making this request in writing, instead of going to discuss it with you in person? My health has been very poor

[1] See plates 28a, b.

[2] Author of a poem in Italian, 'Francia, Italia, Polonia', with prose translation in French, published 1837.

[3] Jules Janin (1804-74), an old friend and a Romantic writer, had protested in L'Artiste (II, 213) against Delacroix's exclusion from the Salon and later (p. 230) discussed Delacroix's painting. Delacroix had recently failed to win election to the Institut.

[4] Etienne Delécluze (1781-1863), art critic of the traditional school who remained permanently hostile to Delacroix.

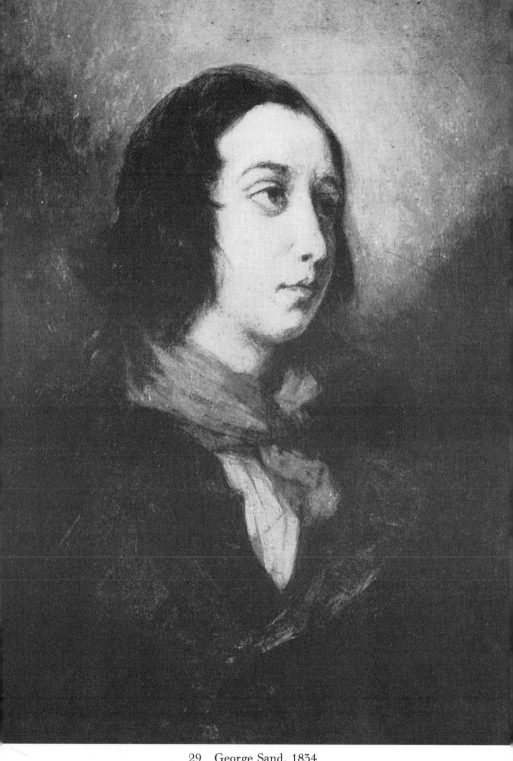

29 George Sand, 1834

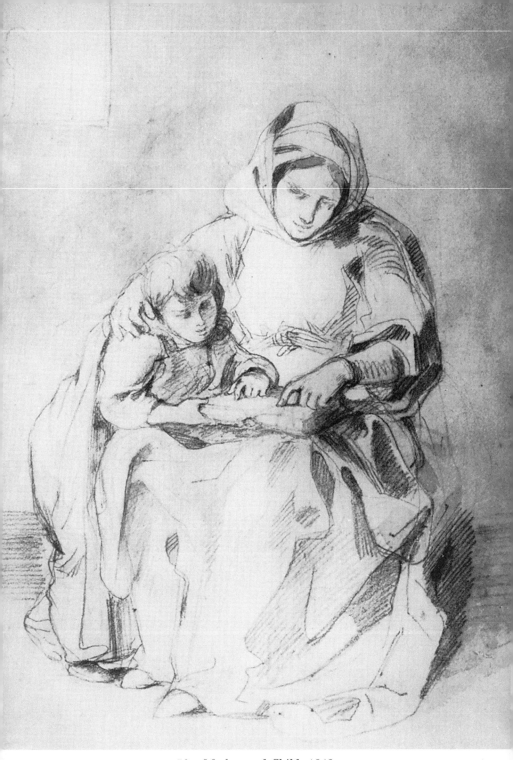

30 Mother and Child, 1842

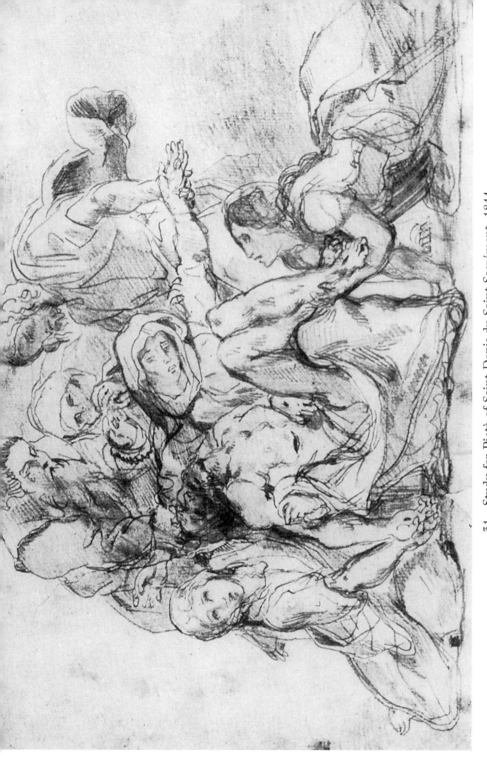

31 Study for Pietà of Saint-Denis du Saint-Sacrément, 1844

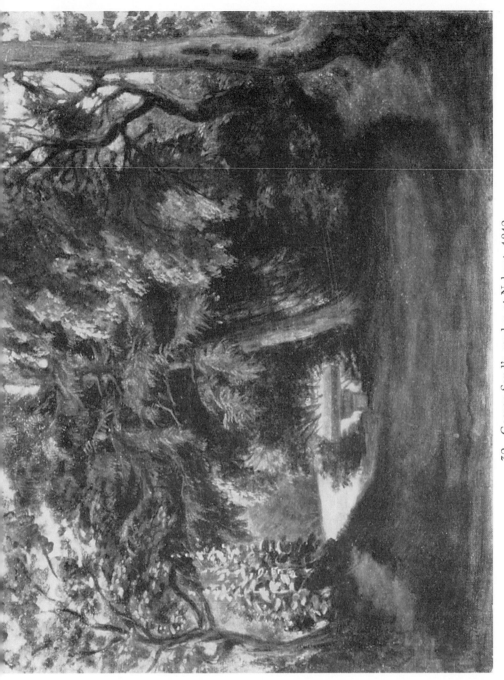

32 George Sand's garden at Nohant, 1842

ever since the beginning of winter; but for the past month or so I have been kept at home, and most of the time in bed, by an inflammation of the throat, which has just flared up again with renewed intensity because I was rash enough to go out a few days ago. So I hope you will forgive me for explaining the business here.

Would it be very difficult to obtain a berth on a state ship for a lady, a professional artist and a fine landscape painter,[1] who is anxious to visit friends in Algiers and at the same time to pursue her artistic studies there? I thought you might perhaps be able to guide me with your advice and kind encouragement in this matter, provided it does not involve putting you to any inconvenience; for I should be greatly distressed to give you the slightest trouble.

Forgive me once more, monsieur, and in any case please believe me, your most respectful and sincerely devoted

<div style="text-align: right">Eug. Delacroix
Rue des Marais Saint-Germain, No. 17</div>

ᴥ TO CHARLES DELACROIX

Paris [postmark 31 August 1839]

My dear good brother,

Here I am back in Paris at last, and I must confess I did not write to you immediately because I kept hoping to be able to tell you that I was coming to see you. A thousand reasons, unfortunately, most unpleasant ones, keep me here. To begin with the need to make some money, the ministry had advanced me a paltry sum (for it was impossible to obtain any money *ad hoc* before I left) for a painting that had been ordered some time ago, and now I have to fill the gaps. It's essential that I should try to reproduce the things that struck me during my journey, while my memory of them is still fresh, and the imminence of the Salon hardly allows me to hope I can get more than one or two things done. . . .

I gather, my dear Charles, from your letters to Henry that you are very hard up and my greatest regret is that I am still as impoverished and unable to send you the wherewithal to supply your needs provisionally. Some lives are really dogged by ill luck. I have a greater reputation than many artists and yet I am far from earning what this would reasonably lead me to expect.

Goodbye, good brother, my love to your wife,

<div style="text-align: right">Your brother and friend,
Eug. Delacroix</div>

[1] This refers to Mme Dalton, and marks the end of their relationship.

The Hague, 21 *September* 1839[1]

. . . I did not experience the effect I had been dreading. I'd been afraid of feeling utterly discouraged: on the contrary, to speak only of Rubens, who is all these people's God, I realised here what I had not understood elsewhere, that he is as uneven as everybody else. Hitherto I only knew one style of his; it's easy to see from the paintings in this country that he made every sort of attempt and experienced every sort of uncertainty: sometimes imitating Michaelangelo, whom indeed he frequently recalls, sometimes Veronese and Titian, and almost always in these various phases he is affected and awkward. When he tries hard he is cold and uninspired; when he breaks free of his models he is the great Rubens. I'll tell you about it in detail. I saw Antwerp thoroughly. I have not seen Ghent. Perhaps I may go there to see one or two magnificent works of his. I'm just back from Amsterdam and I hope in four or five days at most to be back in Paris. There are some very fine things in Amsterdam too. You'll have some idea of them from Poterlet's sketches. I came here last night. I'm writing to you in the morning before having seen anything, but I shall not stay more than a day.

And what about your own feelings and dreams? You must tell me how it's all going. For my part, I really feel I have been dreaming. To have so many varied pleasures and emotions of every sort all at once is really a dream, such as one has only once in one's life. I am sending you a letter which I beg you to send *immediately* to Soulier, asking him to send it on *immediately* to its address.[2]

๛ TO G E O R G E S A N D

[*postmark* 20 *February* 1840]

Dear friend,

Since seeing you I have experienced a very great grief. I have lost one of my dearest friends,[3] and one who was related to me! It is one of the greatest sorrows I could possibly experience and one which will seem to me as irreparable as on the first day, every time I shall think of it until the end of my life. You know, it's one of those sorrows which eventually allow one to indulge in all the diversions and foolish

1 Delacroix made this trip to the Low Countries in the company of Mme Clément Boulanger and was naturally anxious to hide the fact from Mme de Forget.

2 A letter to Mme de Forget, pretending that he was staying with Soulier at Saint-Mammes.

3 Félix Guillemardet.

vanities with which we beguile our misery, but which lie in the depths of our hearts as a source of bitterness for the rest of our days. I thought you would share in what I'm feeling, and it is a comfort to me to turn towards those I love for reassurance as to what I still have left me.

Farewell, good and illustrious one. Keep a corner for me in your kind heart.

∽ TO GEORGE SAND

Tuesday morning
[postmark 17 March 1840]

Dear kind friend,

I shall not be able to come and see you tonight: it's the last night of my Italian players and *I Puritani*;[1] but I shall be most disappointed. Do you think I visit you for the sake of Mr So-and-so, whom you promise me? Great men! It rains great men; and is it even for the sake of your genius that I go and keep company with you? Don't believe it. It's yourself, your eyes, your little beloved person that I love. . . .

∽ TO FRÉDÉRIC VILLOT

Valmont, 16 *September* 1840

You don't write to me, my dear friend; I deserve much comforting, for I am greatly disappointed here by the appalling weather which has reigned unceasingly. Hurricanes succeed one another without respite and the rain has only left off for a single day. You can imagine how depressing this is, when one is in the midst of charming country which is still as green as in May and where one might have taken such delightful walks. The sea is turbulent: I had the pleasure of seeing it in a very fine state of fury, but I was completely soaked going there and back. To crown my misfortunes, I can neither write nor draw without my sight becoming immediately blurred. Reading tires me less; so you see that you've got to write to me. Tell me at length, at great length, about yourself, your health, about painting, about whatever occurs to you. At Rouen I once again admired the fine pictures there. Veronese's *Sick Man*[2] is miraculous. The little Raphaels,[3]

[1] Bellini's opera was performed for the first time at the Théâtre Italien on 4 January 1835.

[2] *St Barnabas healing the Sick*, painted *c.* 1566 for the church of San Giorgio in Braida in Verona.

[3] See above, p. 221, n. 2.

227

which may be by Perugino, are to my mind far more precious than anything of the sort in the Paris museum. There is a newly acquired Ribera[1] which is miraculous and three or four others which are very fine and most unusual. Some day you must go and see it all. You're going to have a railway built for you on purpose which will take you to Rouen in four or five hours.

I found the boat trip rather tiresome, in spite of all the injunctions I'd been given; since no one is responsible for the luggage, there's a free-for-all pillage on arrival; there's a general stampede over trunks, travelling bags and umbrellas. If you escape with your limbs intact you consider yourself fortunate. Are you working, are you feeling better? Tell me about it all. I am writing to Pierret too, begging him to write to me; encourage him to do so, and meanwhile I'm encouraging him to press you to write.

What a murmur of trees and storm and wind! It's too beautiful, and here I am confined to the chimney-corner and deprived of all the delights of the countryside.

I see that the Corbeil railway is going to bring you to Paris in the twinkling of an eye. If I buy a cottage in your neighbourhood, that will be an added incentive.

ℐ TO GEORGE SAND

Valmont, 17 September [1840]

Dear friend,

Are you surprised to find me writing to you? Surely not! I feel remorse at having left without embracing you, and you'll find at the end of this letter a crowd of affectionate little rings which I've covered with kisses, like the late Lafarge,[2] hoping that you'll do likewise so as to pay me back. Seriously, this is what happened: I went to see you during the day. Ungrateful creature that you are, after telling me that I should find you at home you had gone out, and that evening I had to do a whole mass of packing and to go out for all sorts of things which I hadn't thought of until the last minute. So kiss my little rings, please, remembering me.

[Here the rings.]

This is not intended to extort a bit of an answer from you. You must have a horror of pens and paper and you have told me that this horror

[1] *The Good Samaritan.*
[2] A reference to the trial of Mme Lafarge, convicted of poisoning her husband.

was increasing. I can easily believe that. So don't put yourself to any trouble. And don't be too grateful to me, either, for overcoming my laziness in order to write to you. I am often bored here, although I have only been here a short while, and I was seized with a furious longing to talk to you. Nevertheless how you would love this place, where I am depressed in spite of its beauty and perhaps on account of its beauty! Nature's melancholy and beauty are far more disturbing than the melancholy of Paris, where what is trivial and mean and ridiculous forces you to laugh at life rather than deplore the necessity of living. These lovely woods and waters cast me into an emotional state that prepares me for something that never comes: it all stirs one up fruitlessly. One's imagination is enchanted and yet not satisfied. And then I hanker after that vortex in which the mind has no time to see the emptiness, the great black depths we have within ourselves. The sight of natural grandeur leaves one far more wretched. Only you have described this aright: and I think this is the dominant impression that you too feel in front of Nature, that cruel, that adorable mistress. In our youth, this melancholy is followed by a boundless hopefulness that comforts one up to a point. Later on, one feels only the burden of it all. Does Nature promise us that we shall love and possess one another elsewhere, without that disquiet and anxiety that accompany our happiest moments? The woods and springs tell me so. This anxiety is due to an element which we must shed before we can attain unalloyed enjoyment of all the delight to which our souls aspire.

My dear friend, I was interrupted at my finest point, and like Petit-Jean[1] I don't know where I'd got to with my soul, which craves of yours some indulgence for its reveries. Meantime, while waiting for that immortality of happiness with which I was deluding myself just now, grant me and keep for me all that share in your affection that you can spare in this transient life. You won't find me ungrateful, I assure you. Forgive my eloquence, then, and believe more firmly than ever in the pleasure I take in remembering the moments when I see you.

Farewell, dear kind creature. Don't think too much about Nature. Think about me, about all those who love you.

ᴥ TO J.-B. PIERRET

Valmont, 19 September [postmark 1840]

. . . I've looked, and looked again, at fine pictures in Rouen, where I nonetheless spent a very dreary day waiting for carriages to bring me

[1] A character in Racine's comedy *Les Plaideurs*.

here. We are decidedly barbarians. In England there would have been twenty carriages for every one here. You know that I soon tire of antiquities, in spite of my respect for them. I went through museums and collections. In the Natural History Museum, amidst all the stuffed serpents and the most eminent jawbones in creation, I saw in a cupboard the result of the science of phrenology, which no doubt you rate at its true worth. The heads of three or four idiots were shown there beside those of Napoleon, Lacenaire, Horace Vernet, two thieves who were murderers, three thieves who were not murderers, one murderer from virtuous motives, and a score of other examples confirming all the fine discoveries which have not corrected a single scoundrel and have proved nothing but the excessive development of the bump of silliness in learned men. Really, has man received the gift of reflection and comparison only to devote himself to the pursuit of the crudest absurdities? Have we come together in society only to give proof of a ferocity before which savages would shrink, under pretext of a love of justice? Corpses analysed with the patience of ravens dismembering carrion: the law thrusting its nose deep into corruption, and learned men, who are ubiquitous and whom I find increasingly detestable, freely displaying over these mangled bodies the contradictions of their limited learning. What are our special absurdities, yours and mine, for we must have our share? Are we as stupid and ferocious as these monsters? All these reflections occur to me in connection with the Lafarge affair,[1] of which you may not have read, and wisely so. Tell me about yourself and your family. Remember me to your ladies, and kiss them from me if they'll allow it.

ɘʂ TO FRÉDÉRIC VILLOT

Valmont
Saturday, 26 [*September* 1840]

My dear friend,

I can't resist answering your very kind letter, first for the pleasure of talking to you and in the hope that you'll write to me again, giving yourself free rein and not sparing my eyesight: I can always find enough for that purpose; and secondly to scold you for the unhappiness that pervades it and to which you seem to have given way completely. This really distressed me, and I should like in my answer not only to

[1] The trial of Mme Lafarge, then taking place in the Corrèze, aroused great public interest and involved clashes of opinion between famous lawyers and scientists, notably over the presence of arsenic in Lafarge's remains.

tell you that I am grieved by what grieves you, which would be only for conscience' sake and would do you little good, but also to find reasons which might comfort you effectively. No, you are not that profoundly unhappy man that you describe: no man can be irremediably and overwhelmingly unhappy if he has your intelligence and your heart. These two faculties may bring one much suffering, but they enable one the better to rise superior to vulgarity and to the thousand needs of human existence. The life of the mind is such a great talisman against utter discouragement! We grow too easily accustomed to countless advantages to which we do not have sufficient recourse when depression overtakes us. I am living here in a region where there is no opportunity for exchanging a single idea in a whole year; really, one might quickly grow to resemble the depressing surroundings amidst which one lives: whereas in Paris you have the few people who understand you, your books, your painting, a visit to the museum. Think of poor Guillemardet, think of what it would be like for you now to have to live buried in the provinces, without all these resources against real sorrows. Against these I shall not foolishly attempt to arm you: or rather, I should like to arm you against them, since one cannot escape them or cease living in their presence. The thing, then, is to set against them as many as one can of those moments in which one's imagination is fired by noble dreams. I can understand, too, how one of your keenest sorrows, particularly in view of the remedy I'm proposing, is the forced interruption of your work by your state of health. You will thus have to deprive yourself of that most powerful source of encouragement, success. But is that not really a complete illusion, whose deceptive joys are a hundred leagues removed from the pleasure one feels when one's at work? Therein lies true joy, and it is in your own hands, in a thousand forms which the variety of your studies and knowledge brings within your reach. What is the stage on which ephemeral reputations are displayed and discussed? Consider how profoundly ignorant the whole world, save for a small minority, is of the very existence of the most outstanding men; consider, within the tiny group of those who can judge and appreciate, the endless controversies about those men whose value is least contestable, and then see what is left of your fine dream of glory.

The further I advance in life, the more convinced I am of the necessity of that principle of wisdom which befits our nature: enjoy what lies in your own hands. All the follies of the Utopian believers in perfectibility come from having always wanted to act with instruments which they have dreamed of but which do not exist. Moreover, this sovereign rule has guided the production of great men in all ages. Why? Because reason is the foundation of all greatness. Whether you yourself

231

produce, my dear friend, or merely seek to employ your life with a view to happiness, that's to say, to forgetfulness of the troubles which life necessarily and inevitably engenders, don't look outside yourself to find the elements you will need. I have heard that scientists define life as resistance to chemical affinities. I like that, although it's scientific; I fancy I see the human mechanism surrounded by hostile agents that cripple its life, while an inner principle strives ceaselessly to preserve it by warding off the inroads of external nature. The same must be true of the pursuit of happiness. Some men avert the sense of their miseries by seeking physical pleasure; others have to fight against these miseries before they can devote themselves to the pursuit of beauty, to contemplation or a passion for greatness. You are not more incomplete than the greatest of men. The finest works, the noblest hearts have the same original flaw that you describe. If you could change your constitution you would only exchange your miseries for others. Perhaps a constitution that was less imperfect in some respects would offer you none of the compensations that are within your grasp. Would you choose to be one of those blockheads who spend all day drinking, or go hunting from morning till night? Could you spend your days in a bank, or among the speculators in the Stock Exchange? Would you sacrifice a single lofty pleasure for all the ignoble delights of those wingless animals? Love yourself and respect yourself as you deserve and as you see your friends do. I should be particularly distressed to see you yield to such an extent to sterile sorrow, to the *ennui* that we all bear within ourselves. Do not bury it too deep: seek distractions, but do not let it undermine you secretly without giving outward vent to it. I wager that your letter, sad though it is, has brought you some relief. It made me really sad; but while revealing to me, as you have done, how unhappy you are feeling, it left me the hope of sometimes rescuing you from your depression. Talk frequently about your unhappiness to Pierret, he's the worthiest man I know. He too bears a heavy burden: his apparent calm conceals many troubles. He might have aspired, like yourself, to fame, through intellectual achievement; other causes, poverty, perhaps a certain natural laziness brought about, in his case, the same result as in yours. Merely to see him ought to comfort you. We shall talk about all these subjects later.

Farewell, send me a long reply. I shall probably leave here on Thursday, which is October 1st, and I shall be in Paris by Saturday or Sunday. Believe me, I do appreciate your friendship, my dear boy. I need it badly; but on that account I need you to be happy.

<div align="right">E. D.</div>

♫ TO FRÉDÉRIC CHOPIN

[1 *January* 1841]

Dear good Chopin,

Forgive me if you did not receive the prints last night; I was let down, and this annoyed me very much. I had counted on sending them to you to the rue Tronchet, but I'm sending them this morning to the rue Pigalle.

Accept all my good wishes, not the sort that everybody sends: the wishes of a heart that loves you *dearly, dearly, dearly.*

I hope to see you this evening; but just now I'm on the point of going mad.

Goodbye, my good friend.

I'm not satisfied with the engravings. They don't look well, but they will be useful. I should have liked to have time to visit a number of shops. My best wishes to Mme Sand, until I can go and present them to her myself.

♫ TO GEORGE SAND

[*Spring* 1841]

Dear friend,

My headache flared up again last night and made me too lazy to go out. Would you do a kind deed and send me, right away, the *address of the glove dealer?*

One of these mornings you shall have back your *Compagnon*[1] which I have kept too long, but one of the volumes came apart and I had it rebound.

Although I have said nothing to you about it, that doesn't mean I don't think highly of it. My dear friend, I was overcome with admiration for the first volume, which is *your masterpiece,* and disappointed by the second. Forgive my foolish taste, which is quite incompetent in this instance, at least, I sincerely hope so. Nothing could be loftier than the whole of the part that I like, and I was deeply stirred and moved to tears by it. So much for that, and you mustn't give a damn for all I say about it. . . .

[1] George Sand's novel, *Le Compagnon du Tour de France,* published by Perrotin in 1841. It was to have appeared in the *Revue des Deux Mondes* the previous year, but its socialist tendencies alarmed the editor, Buloz, who sent back the MS. The rift between George Sand and Buloz lasted for many years.

ᴄᔕ TO PAUL HUET

Sunday [postmark 5 April 1841]

My dear Huet,

Thank you very much for your beautiful etching.[1] I had not got it, and I am delighted with it.

With my sincerest regards.

ᴄᔕ TO DE GISORS[2]

Friday, 25 June [1841]

My dear De Gisors,

I have been very unwell lately and unable to start work on the pendentives.[3] Morover, having seen Riesener's paintings[4] in their setting, it struck me that the blue arabesque on a gold background did not look right beside the painting. Having also seen, and studied on the spot, the sketch of the cupola, I wanted to ask you if it would not be possible to do away with the dark red stucco that frames the doorway and reaches right up to the painting.[5] I had not noticed this detail before, but it seems to me difficult to harmonise with the colours above it, and it is bound to affect the pendentives too.

I am going to spend a few days in the country.[6] If by chance the committee which is dealing with the sketches should meet while I am away, that's to say before Tuesday or Wednesday, I should be very grateful if you would kindly show them my project in my absence. I have discussed it with you enough for you to be able to present it to them.

The dealer[7] who used the sketch to fix his canvas will tell you where it is. . . .

ᴄᔕ TO GEOFFROY SAINT-HILAIRE[8]

22 August 1841

Dear Sir,

I am very anxious to obtain permission to make studies of the animals in the menagerie of the Royal Garden,[9] and for this purpose

[1] *Les sources de Royat* (1838).
[2] The architect in charge of the decoration of the Chambre des Pairs.
[3] Four hexagonal pendentives representing Theology, Eloquence, Poetry and Philosophy, in the library of the Chambre des Pairs.
[4] In the coffers of the ceiling.
[5] Nothing was done about this.
[6] With his brother Charles at Vichy.
[7] Haro.
[8] Isidore Geoffroy Saint-Hilaire (1805-61), naturalist and member of the Institut, was then professor at the museum.
[9] Delacroix made many sketches of animals in the Jardin des Plantes during the years 1841-3.

to be allowed inside the building where they are kept, at their feeding time. I should be most grateful if you would kindly grant me this favour as soon as possible.

I have the honour to be, dear sir, your respectful and obedient servant,

<div align="right">
Eugène Delacroix

painter

Rue des Marais Saint-Germain, No. 17
</div>

ℰ TO GEORGE SAND

Trouville, 11 September [1841]

The date of this letter will clearly tell you, my dear friend, how grieved I am not to be able to visit you as I had hoped to do until the last moment. But the doctors intervened, grabbed me by the hair and packed me off to this region, where I cannot say that I'm wilting away, since I'm constantly in the water, which I had dreaded greatly at one time but now find great fun. I miss you nonetheless: all the pleasant attractions you offered to tempt me are nothing beside the pleasure of seeing you all the time, so to speak, as I'd have done if I had been in Berry. Believe me, my dear friend, my promise to visit you was not mere empty talk; in spite of my brother's stay in Paris, I had managed to arrange things: but I must admit that at least I have not been cheated in the purpose for which I came here. My eyes, in particular, have benefited remarkably from sea-bathing. I was moreover suffering from what my *Physician* calls an *atonic condition*, which means, as you will easily understand, a lack of tone, not of *bon ton*, mind you; a dandy of my calibre always has plenty of that, and 'it is for this that Hippolytus is renowned throughout Greece'.[1] If only you had been somewhere on my way for my return journey: but you are exactly at the Antipodes from the place I am staying in. Into the bargain, the government has kindly deigned to enquire into my progress;[2] it demands of me, through the agency of its Minister of the Interior, when I shall have finished. I haven't answered, because I don't know any more than the government. That's the way to get out of a difficulty without compromising oneself. See now: I had put off answering you from day to day, because I found it so hard to express my own distress and my self-reproach. I had brought your kind letter here to reply to it from here and consider more fully what I should say to you: that letter is here and I have not re-read it. I shall read it

[1] *C'est par là qu'Hippolyte est connu dans la Grèce* (Racine, *Phédre*, IV, 2).

[2] The decoration of the library of the Chambre des Pairs.

again after having written, when my own letter has gone and the damage is done. What, are you going to stay away all winter?[1] My dear friend, you don't mean it! You cannot, you must not. If you're short of money, I'll beg some of my government, I'll promise it whatever it likes and I'll lend you a million or two rupees. I say nothing about all the friends you promised in your letter I should find at Nohant: I'm thinking only of what I miss by not seeing you; but don't make me even sadder by announcing this endless retirement, for in all conscience, when you have spent the winter there, it will be too late to come back to Paris in the spring.

Embrace my Chopin: between ourselves, I miss him too, but nobody else. I despise all the rest, except perhaps Pauline[2] and Duteil.[3] I embrace Duteil too and I shall drink a glass of cider to his good health. But come back, my dear friend. If you saw me in my bathing outfit you'd have a good laugh. But I'm not the only one: there are some young women who, I declare, look very pretty emerging from the liquid plain; it sometimes brings back my brilliant youth to me, like a night-light flickering feebly in the early morning sunshine; but I assure you that the sight of all those little bare feet and all that they suggest leaves me marvelling at the power that imagination can still impart to our wretched machine. Don't be annoyed with me for being unhappy, dear friend; I should dearly love to see you here bathing by my side, even though you'd think me very ugly, and I shall be that all my life, as well as your most devoted friend,

<div align="right">Eug. Delacroix</div>

ꝯ TO J.-B. PIERRET

Saint-Leu-Taverny
Saturday [postmark 5 March 1842]

Dear friend,

I am keeping my promise. I stood the journey well: I cannot hope for any great change yet, since I have only been here a day and a half. I realise now that if I had submitted earlier to the regimen of silence which I can follow more easily here, I should have been cured long ago; for as regards my voice I am in worse shape than ever. But how enchanting the country is! My boy, you only have to come in March to a village as shabby and bare as they all are round about Paris to have all your theories about beauty, the ideal, choice, etc., turned

[1] George Sand returned to Paris in November to help launch *La Revue Indépendante*.
[2] The celebrated singer, Pauline Viardot, daughter of Garcia.
[3] A friend and neighbour of George Sand's.

topsy-turvy. The meanest lane with its leafless sticks of trees, set against a flat, drab sky-line, speaks as much to the imagination as all the most famous beauty spots. This tiny cotyledon piercing through the soil, this violet shedding its first scent enchant one. I love it all quite as much as those Italian pines that look like plumes and those buildings standing in a landscape like bowls arranged for dessert. Long live cottages, long live whatever appeals to one's soul.

He's a lucky man who owns a plot of land; but even if that plot of land were ten thousand acres wide, I shouldn't want it without memories to bind me to it and remind me at every step of those I have loved. I'd give the most splendid villa for some tiny patch where I had spent my youth. But I must give up such thoughts.

Such are my day dreams here. Perhaps I may work a little. But only to make me enjoy my walks the more. Let us love one another, my poor dear old friend; let's be living memories to one another; since the trees don't want us, let each of our wrinkles serve at least to remind us of some vanished joy and at the same time of the sorrows that make up the whole fabric of our frail existence.

Send me back a brief answer. Embrace all your family: despise all false joys. I have shown you that a feeling was worth more than a treasure. But you know that already.

Farewell, I embrace you with all my heart.

<div style="text-align:right">

Eug. Delacroix
Chez M. Riesener at Frépillon,
near Saint-Leu-Taverny

</div>

◢ TO J.-B. PIERRET

Saint-Leu-Taverny
Saturday [postmark 12 March 1842]

. . . I'm having myself daguerrotyped:[1] I shall have copies made, in any case. I have also been busying myself arranging drawings in the format of the *Magasin pittoresque*[2] for the woodcuts I want to make. All in all, the thought of Paris terrifies me; I picture you living there amid filth and rags and corruption. Shall we never be able to leave that seat of meanness and depression and aimless agitation?

[1] The daguerrotypes are reproduced in *Delacroix raconté par lui-même*, ed. Moreau-Nélaton, pl. 237, 238.
[2] These woodcuts appeared in the *Magasin pittoresque* for 1843.

ᢏ TO M. LASSALLE-BORDES[1]

Saint-Leu-Taverny
Monday [*postmark* 28 *March* 1842]

. . . I am very glad that you expect to have finished your sketch soon.[2] I hope we can go on to the chapel[3] without delay. I should be very glad, too, if we could also get started on the drawing for the hemicycle of the Chambre des Pairs. My own design is ready, and as soon as I get home I will draw it on the model[4] so that within the next fortnight something, at least, can be done on the spot. I should like Léger[5] to do this work, perhaps with an assistant, and meanwhile you could keep an eye on things from time to time. We should thus take possession of the place, and moreover we could have the scaffolding taken down when we begin work on the cupola. We'll discuss the matter.

Thank you very much for what you have been doing for the studio. I will visit the young gentlemen regularly; but in order not to risk any setbacks to my health, I think I shall resort at first to writing in pencil my comments on each one's work on a sheet of paper previously prepared by him. I was not sufficiently warned by the doctor how important it was to speak very little. I was really cured a month ago, and then I overstrained my voice, thinking I had quite recovered it.

Goodbye, my dear Lassalle. Look after your own health, and believe in my sincere friendship.

ᢏ TO GEORGE SAND

10 *April* [1842]

Good-day, my dear friend; I am weary of not seeing you, and yet I must keep up my seclusion. So don't come, if you had thought of doing so. Until the warm weather comes I shall probably be shaky. I have recovered five or six times and my rashness in talking too much and too soon has made me relapse. Before wiping your most serene pen, scribble me a scrap of friendly remembrance which will help me to be patient. My style shows the effect of my banishment from good society. I have been living for the past six weeks[6] among turkeys and dogs and feeling the better for it. But all that's not the same thing as

[1] One of Delacroix's chief collaborators on the murals. This represents a series of letters to Lassalle-Bordes and other collaborators about work in hand.
[2] For *Orpheus*, in the library.
[3] The chapel of St Denis du Saint-Sacrément. See plate 31.
[4] A wooden model of the hemicycle which he had had made.
[5] Léger-Chérelles, one of his pupils.
[6] At Frépillon, with the Rieseners.

friendship. Alas, my dear friend, cling fast to those people whom you love and who love you. This is a need that we feel the more the older we grow. I have suffered several more painful bereavements lately. When all those we used to love and go grazing with are under ground, what's left above ground to make us cling to life? For me there will be nothing, and I shall no doubt pack my bags before waiting for that time.

Give me news of my Chopin. All my friendly regards to Mme Marliani, and tell her about my disability.

My most sincere affection.

cᴊ TO CHARLES SOULIER
at Saint-Mammès

20 *May* [1842]

Dear friend,

I am sending you a brief friendly greeting through Mme Pierret. When you wrote to me, I was not in Paris, I had gone to spend six weeks or so at my aunt's to try and recover a little. Pierret will have told you that I have been very busy all this winter. And when, think-ing of our dear Félix,[1] whose loss we shall never cease to mourn, you spoke to me of the uncertainty of human life, I was meanwhile aware through my own weakness of how little one can count on anything in this world. Besides, it's all so sad, these manifold bereavements follow so fast on one another that one becomes, as it were, inured to that misfortune which I consider the greatest of all, the loss of friends of one's own age. When I got back from the country I learnt of the death of two people who were not nearly so dear to me as Félix, but of whom, nonetheless, I was fond and who were, each in his way, irreplaceable. Last year, I lost my old cousin in Normandy[2] whom I really loved and still miss very much; a short while before that, Henry[3]; but I won't take the gloomy catalogue any further back. I try to deaden my grief; I think of those who are left me; I think of you; but where are you? You exist, but I don't see you. As indeed you said in your letter, we love each other and we live so far apart that we might as well not exist. Take care of yourself however, let's struggle against this inexorable fate. You have in your own home compensa-tions for the absence of your friends. Here too you find grief and anxiety, as well as heartfelt joys. This is the inexorable law. You tell

[1] Guillemardet, who died in 1840.
[2] His cousin Bataille, at Valmont.
[3] Henry Hugues.

me your son is better and that you are satisfied about your wife's health. I'll come and see you; when? I don't know yet, but I look forward eagerly to seeing you and talking to you again.

Goodbye, my dear friend, kiss all your family for me, and may I soon have the pleasure of kissing you myself.

<div align="right">Eug. Delacroix</div>

ᴥ TO GEORGE SAND

<div align="center">Monday morning [postmark 30 May 1842]</div>

My dear friend,

I have just received your far too kind letter. How good you all are ' to a wretched creature who will never deserve so much kind consideration; and what can I say to you in return for it all, particularly now that my throat is so bad? Anyhow, I am quite overwhelmed by your kindness and I'm writing you a line to tell you so, but not as much as I feel. Tell my dear little Chopin that the only kind of entertainment I love is to stroll along garden walks talking about music, and listening to it in the evening, on a sofa, when God takes possession of his divine fingers. And my dear, this is the literal truth: I am neither a huntsman nor a walker nor a good neighbour: I loathe above all things noise and bustle and having a fuss made of me. All I dream of is to be with you all, seeing you and hearing you, vegetating by your side. And what about *Consuelo!*[1] I haven't told you how much I like it. It's in your purest vein: up till now I have only had what you have lent me and I'm very impatient for the rest. But, my dear genius, take good care of that charming child of your finest inspiration. I have not yet followed her to Germany: think of the pleasure that lies before me. I am leaving by stage coach on Wednesday; I preferred this for all sorts of reasons. The bustle of the mail coach upset my nerves in anticipation: and then in spite of the boredom of spending so long in the coach, I like being able to get out of it sometimes to breathe, and so forth. I was anxious, too, not to give you the trouble of coming to meet me. I should have managed quite well with the directions you gave me. I should have gone to bed on arrival and been with you by dawn. So don't stir, my friend: I shall be all the rosier for it and you won't be jolted about. Well, well, I'd like to shove time by the shoulders! What's that you're saying about July? Good heavens, and what will M. le Grand Référendaire[2] say, in his Luxembourg palace, if the

[1] George Sand's novel, the first two volumes of which had just appeared.
[2] The Grand Référendaire of the Chambre des Pairs (today's equivalent would be the secretary-general of the Senate) was the Duc Decazes.

'painter' isn't soon at his post?[1] How much longer is that 'painter' going to clutter up our polished floors, say their lordships. We'll talk about all this as we stroll under the limes and the other trees that I can see in my mind's eye. I'm already imagining a Nohant for myself that will of course bear not the slightest relation to what I shall find; as for you yourself and all the good friends who are there, I can picture you all just as you are and can't wait to see you in reality. Once again, dear friend, don't make any preparations for me, don't alter a thing. The countryside, peace and solitude are identical things in my mind. Quietness by your side to calm my damned nerves, a corner of your hermitage to forget the strains of Paris, that's my ideal.

Farewell once more. All my affectionate remembrances to Chopin, to Maurice and to Solange, who shall have a kiss for her trouble.

Looking forward to seeing you soon, my dear friend, with my love.

 ᴔ TO J.-B. PIERRET
rue Tronchet, No. 13, Paris

[postmark Nohant, 7 June 1842]

Dear friend,

I came here a few days ago and stood the journey very well, apart from the discomfort inseparable from all journeys and above all the awful heat and *ditto* dust. Now, no sooner am I settled in than I realise that my plans for doing nothing will not hold, and that I should be horribly bored unless I undertook something. I'm going to amuse myself with the son of the house[2] painting a little picture for the local church. Moreover, I feel in the mood for doing Charton's wood engravings.[3] You realise that I'm appealing to you to get all this carried out; I'll explain the matter right away. The end of my letter shall be devoted to the romantic part of my journey. The first thing is to put into some box or other the *two wood engravings* that are still at my place; plus the three drawings which still have to be done; plus one or two sheets of *vegetable paper* which you must fold in four, and which I need for tracing. I have some at home, in one of the big portfolios which are underneath *Sardanapalus*; the three drawings must be lying about on the big table with the green tablecloth. If they're not there, they'll probably turn up in a mass of drawings and engravings that I had taken to my aunt's place and among which are the drawings for *Hamlet* and *Berlichingen*. This bundle of drawings

[1] At the library of the Chambre des Pairs, Palais du Luxembourg.
[2] Maurice Sand. The picture in question is *The Education of the Virgin*.
[3] For the *Magasin pittoresque*, of which Édouard Charton was editor.

must be all together in the studio cupboard. As for the paints I need for the picture let Jenny[1] know which they are and take them from among those that are still in the studio. If there are some missing, she must go and get them from Haro's. Here is the list: 8 *lead white*, 6 *Naples yellow*, 4 *yellow ochre*, 2 *Venetian red*, 1 *Vandyke red*, 2 *green bice*, 6 *madder lake*, 2 *Vandyke brown*, 4 *peach black*, 1 *ivory black*, 2 *Prussian blue*, 6 *Laque Robert No. 8*. Jenny can perhaps find in the attic some box which will hold all this. I should even prefer the box to be considerably bigger than necessary, and filled up with hay or paper, because I had so little room to pack my things when I came that I should find it convenient to have a new receptacle for my return journey. Jenny should go and take it all to the stage coach at Notre-Dame-des-Victoires without delay, paying carriage to the following address which must be written on it: M. Delacroix, *at Nohant, near La Châtre, via Châteauroux, Indre*. So it should be put on the Châteauroux coach.

I fancy this letter so far looks like an attorney's letter and not at all like a friend's. So I'll stop, and pick up the thread of the beginning again. The place is very pleasant, and the hosts could not be kinder or more considerate. When you're not all together for luncheon or dinner, playing billiards or going for walks, you're in your own room reading, or guzzling on your sofa. From time to time you hear through the window which opens on to the gardens[2] wafts of Chopin's music, as he works in his own room; this blends with the song of nightingales and the scent of roses; you see that I'm not greatly to be pitied so far, and yet I need work to give savour to it all. This life is too easy. I must earn it by a little brain work; and just as a huntsman eats with a keener appetite after he has fought his way through briars, so one must exert oneself in pursuit of ideas in order to appreciate the delight of doing nothing. In spite of all the occupations I shall give myself, I shall not take root here beyond the time I have roughly fixed for myself: I even think that without my doctor's orders I should never have spent all these fine days far from Homer's *Elysium*, which is beckoning me from the Luxembourg.[3] The work in store for me grows even greater in prospect, and I'm earnestly praying for the recovery of all the strength I shall need.

Tell me about yourself and your family. I pity you for not being able to travel from time to time; it is necessary for mental as for bodily health; it takes you out of your usual rut, and makes life seem longer

1 The first mention in these letters of Jenny Leguillou, who had been his housekeeper since about 1835 and remained with him until his death. See plate 41.
2 See plate 32.
3 The subject of the cupola of the library.

by giving it variety. So try and arrange to come and spend the end of July at Soulier's. There's nothing to prevent you, since the ministry will be on vacation. There's the question of money, you told me. It's hard indeed that you cannot surmount this cruel restriction: with a little less of the philosophy that you have, and a little more of that which you ought to have, which consists in not letting oneself be caught out unprepared by fate, you would not be obliged to worry about this, or many other things.

Farewell, dear fellow, I embrace you even while I preach at you. I ask your forgiveness in advance for all I'm asking you to do, and for so long a letter into the bargain. Rob the government to answer me at greater length.

৩ TO FRÉDÉRIC VILLOT
Nohant, 14 *June* 1842

. . . Although I am in the pleasantest possible situation in every respect, both mentally and physically, for my health is much improved, I cannot help thinking about work. It's an odd thing: work tires one, and yet the kind of activity it gives the mind is necessary to the body itself. In vain have I developed a passion for billiards, in which I take daily lessons, in vain do I enjoy good talks on all my favourite subjects, and music which I grasp in fleeting snatches – I feel the need to create something. I have undertaken a picture of St Anne[1] for the parish church, and I have already started on it. . . .

You know what a wretched craftsman I am; you wouldn't believe what trouble and pain I had to fix myself up a canvas. I had to nail it and unfasten it five or six times and in the end I've been forced to paint on it without priming it. The sketch will have to serve as a primer; and yet I am very glad to have undertaken it. . . .

৩ TO J.-B. PIERRET
Nohant, 22 *June* 1842

It was very good of you, dear friend, to take so much trouble sending me all the little things I had asked for. I received everything in excellent condition, and your last kind letter besides. . . . I lead a cloistered and wholly unchanging life here, with no incident to vary its tenor. We were expecting Balzac, who has not come, and I'm not sorry about that: he is a chatterbox who would have interrupted the nonchalant harmony that soothes and delights me here. Meanwhile, a little

[1] *The Education of the Virgin.* It was refused at the 1845 Salon.

painting, billiards and walking are more than enough to fill my days. I have endless tête-à-têtes with Chopin, of whom I am very fond, and who is a man of rare distinction: the truest artist I have ever met. He is one of the very few people one can admire and respect. Mme Sand is afflicted with frequent headaches and eye-aches, which she strives to master as much as possible, and with great strength of character, so as not to weary us with her sufferings. The greatest event of my stay here has been a peasants' ball on the lawn of the château, with the most famous bagpipe player of the neighbourhood. There is something remarkably gentle and good-natured about the people of these parts; they are seldom ugly, although one is not frequently struck by their beauty. But there is none of that sort of feverishness that is characteristic of people who live near Paris. The women all look like those gentle figures one sees only in paintings by old masters. They are so many St Annes.

I shall bring you back sketches of the picture I am painting.[1] I don't know how it will turn out. I have had all sorts of trouble stretching the canvas and getting it ready. You know how bad I am at sticking things together; luckily the son of the house is better at it than I am and has helped me a bit. I need not tell you that I shall not alter my plans for returning home. I shall be greeting you at the beginning of July, as I had hoped: too many relentless laws will drive me back, and possibly too, the pleasure of meeting once again that family of heroes who are all asking me to provide them with arms, legs, heads, etc.[2] Not to mention M. le Grand Référendaire.

Goodbye, my dear good fellow, may you and all yours keep well. We shall meet again soon; with a spirit of resignation one can find life good everywhere, and even death itself not evil. I embrace you once again and love you.

Eug. Delacroix

◢ TO GEORGE SAND
Paris

Tuesday [end of June 1842]

What a change, my dear friend: how horrible Paris is: you've no conception of the heat and dust we breathe here, and it's so depressing! That's far worse than all the rest. Since I came here a fit of depression has seized me which I cannot shake off and which will overcome me again whenever I think of Nohant; and you're not going to tell me

[1] *The Education of the Virgin.* See plate 30.
[2] On the cupola of the Luxembourg library. See plate 44.

that it's a result of the natural inconstancy of man, who is never satisfied with his present state and embellishes the past in his imagination. You will remember how I dreaded being back amongst my troubles; they are very real, and everything increases them: the unbearable heat of my studio, the discomfort of a wearisome journey amid somewhat comical circumstances, which made of it a bourgeois Odyssey about which I shall tell you later, but above all the remembrance of that delightful Berry where I met with so much affection and kindness. In spite of the discomfort of the heat I am going to immerse myself in work, if I die of it. That's the only way to kill the enemy that takes possession of me. I can still see you all before my eyes; I follow you at every moment of the day: I see you at table, in the garden: I see myself in that dear little study, so cool and secluded, where I thought, at such a distance, about all that afflicts me here. But I shall never have done with telling you my regrets. . . . You will come back, but I shall only see you now and then: there won't be that daily delight; and my tête-à-têtes with Chopin, where shall I find them? I'm writing to you, but I cannot see you, and I had grown used to seeing you. Talk to me at length about yourself and those dear friends. I met someone yesterday who had found great relief for nervous headaches by a mixture of ether and cold water. Don't use ether by itself: and water alone is not enough either; but both together. This is the prescription of a very well-known doctor.

I have been unable to write this wretched letter to you without being interrupted, and the whole thread of my ideas is broken: to start the tale of my regrets all over again would be tedious and would express them inadequately. Take care of yourself then, take care of Chopin. Perhaps he'll work now that I don't interrupt him so often; I am sure he neglected his work on several occasions to keep me company. Tell him I took his message to his gentleman in the Place Vendôme and that everything has been done correctly. . . .

ℰ TO GUSTAVE PLANCHE[1]

9 *August* 1842

. . . You ask me for news of Mlle Rachel, and I thought at first you were joking when you spoke of her admirers as being blind. I remember we failed to agree about her. For my part, I persist in my feeling, and success has nothing to do with it. I still find her quite exceptional; I have never seen, and shall probably never see, anything like her,

[1] Gustave Planche (1808-57), writer and art critic in *L'Artiste*, *La Revue des Deux Mondes*, *Le Journal des Débats*, *La Chronique*, was travelling in Italy.

and nor will you, believe me. My work at the Chambre des Députés[1] has been very much held up. For one thing I made the mistake of letting much time elapse before beginning on it, for a variety of reasons. Then, just as I was getting started, I had to attend to the work in the Chambre des Pairs. Then illness held me up for a long time. Now I have resumed both tasks, and am not too much dissatisfied; but there's a lot to be done. For the Luxembourg, I have found a subject which is somewhat out of the common run of Apollos, Muses, etc. It's for a library: it's the moment when Dante, *le Dante* as our fathers used to say and not just *Dante* as scholars who want to be different say today, is presented by Virgil to Homer and to some other great poets in a kind of Elysium imagined by the poet, where they enjoy what he calls a *serious happiness*. In short, all the great men you can think of are to be seen there, walking around or sitting down as they please. You shall see it: the subject attracts me greatly, but the place itself is extremely tiring.

Goodbye, my dear friend. I very much hope to meet you again in Italy.[2] Nothing has changed here: the greatest fools and the worst scoundrels make the laws and have the best of it everywhere; one has to get oneself forgotten if one can, or get oneself forgiven, which is harder. . . .

ℰ TO M. LASSALLE-BORDES
[postmark 31 October 1842]

My dear Lassalle,

Perhaps I am a little late in writing to you, and you may have made your arrangements to stay at home a little longer. Since you left I have been constantly working, or resting in the country. Consequently my job has made good headway, and if you could come back soon we might work on our sketch;[3] and I think I can cope both with that and with what I still have to do for the Chambre des Députés. See if this can fit in with your plans, especially considering you have your own picture to finish.

I hope your stay in the country has refreshed you after the exhaustion of working on the cupola, which you did with such self-sacrifice and I may say with success. After you left I was obliged to have it covered with sheets because Riesener brought a great many people to see his

[1] In the library, Palais Bourbon. See plate 43.
[2] Delacroix was again toying with the idea of a journey to Italy, this time, for his throat's sake, to avoid winter in Paris.
[3] For the hemicycle of the library at the Chambre des Pairs, Palais du Luxembourg.

paintings[1] and I was anxious not to have my sketches seen in the state they were in. Haro arranged it for me quite skilfully, so that curious visitors may have felt some disappointment–I did a great many charcoal studies on the spot to work out the composition of the hemicycle,[2] and I think I have decided on it. In any case, send me a brief answer telling me your plans. The studio is going fairly well and there are quite a few people. I fancy Gaultron is carrying out your functions[3] competently enough for you not to find it all too chaotic.

✑ TO GEORGE SAND
The World, The Universe

[*Autumn* 1842]

You are all loves, Jean[4] too and Pistolet[5] too. I embrace them all. I hold them all in my heart, and all the rest too. I have the devil of a cold. My head's topsy-turvy. Today I heard Rossini's *Stabat*.[6] It's a cut above Pistolet, and above Jean too. It isn't quite Mozart, either; but such as it is, it stands quite a few cubits higher than my friend Halévy.

Receive the blessing of the most heavily-becolded of enthusiastic men, and much affection, to little Chopin, too.

If the pipe[7] is as good as it is long, it will be the Phoenix of pipes; I'm going to try to learn to smoke it.

✑ TO FRÉDÉRIC MERCEY
chef de bureau in the Fine Arts Department
Ministry of the Interior
rue de Grenelle

Sunday, 15 *January* [1843]

My dear Sir,
 I am scheming to enlist your support, if possible, for two of my friends who are soliciting M. Cavé: M. *Riesener*,[8] the painter and

[1] Riesener had painted seven compartments of the library ceiling.
[2] 'Alexander, after the battle of Arbelles, encloses Homer's poems in a golden casket.'
[3] Lassalle-Bordes was *massier* or supervisor at Delacroix's studio, as well as his assistant on the murals.
[4] One of the Nohant servants.
[5] George Sand's dog.
[6] *Stabat Mater*, first performed October 1841.
[7] George Sand had sent Delacroix a *chibouk*, a long Turkish pipe.
[8] Léon Riesener, his cousin. See plate 3a.

M. *Préault*,[1] the sculptor. I dare not tell you how highly I think of
the former, because he is my relative as well as my friend: but I hope
that if you knew some of his work you would share my opinion. The
second, quite apart from his talent, deserves consideration because of
his unusual situation. For the past ten years, Messieurs the members
of the Institut have stubbornly rejected all his work for the Salon; so
that if he has not blown out his brains in the meantime, it's because,
much as he might want to put an end to this sad state of affairs, he
will not give them that satisfaction; at least that's what I should feel
myself.

Forgive my indiscretion. You may say that I would do well to seek
protection for myself. Alas, I am only too well aware of that, particu-
larly as far as these gentlemen are concerned. It would not be hard to
find an opportunity: but in any case, please subordinate my recom-
mendations to your personal inclination, and I still remain none the
less your devoted

Eug. Delacroix

❦ TO CHARLES DELACROIX

[*Paris*] 23 *January* 1843

My dear kind brother,

. . . Up till now I have stood up to the winter, which in truth has not
been very severe, and I have been able to resume the work which my
health forced me to interrupt for so long last year. If the cold weather
comes, at least we shall not have to endure it for very long, since the
season is far advanced I need all my health to catch up on arrears of
work, which are really considerable and might well prove too much
for my strength.

I sincerely hope that your precious health has not been impaired
as it was the year that you came to Paris. I know that you take reason-
able care of yourself and I'm very glad of it.

I told you about the bronze portraits of our dear father and mother.
There were all sorts of setbacks, to begin with, in the casting of them,
which is a delicate operation, and secondly in the trivial matter of
making the frames, which had to be begun all over again, since, being
circular, they had been made all wrong. I hope I shall soon be able to
make up for this delay. I think you will be pleased with their likeness.
It is quite as good as sculpture, maybe, and I am delighted to have

[1] Augustin Préault (1810-79), one of the most original sculptors of the Romantic
school, a constant admirer of Delacroix's and the *bête-noire* of the Institut.

preserved them thus, for I had only a plaster cast of them both which was liable to accidents.

Goodbye, my dear good brother, let me know as soon as possible how you are. I don't yet suggest coming to see you because I cannot foresee any opportunity, but I promise you I shall seize it eagerly if I can do so without interrupting my whole set-up, for I'm not working alone and they make all sorts of foolish mistakes when I am not there. It would be a great delight to me to be able to embrace you once more.

In the meantime, all my good wishes and all my love.

Eug. Delacroix

Remember me affectionately to Mlle Annette.

TO J.-B. PIERRET

[postmark Saint-Leu-Taverny,
2 April 1843]

I am sending you a few words, my dear fellow, from the depths of my retreat, which is far from unpleasant, I can assure you, as nature revives all around me and revives me with her. The trees are turning green: the recent rain has brought them on, and hastened all this rebirth. Although the sun seldom visits us and the showers are frequent, I enjoy myself here as usual. Only I have not yet succeeded in starting any sort of work, and I am somewhat dissatisfied with myself. This feeling always tends to spoil everything else for me. It seems to me that one should have fulfilled one's task in order to enjoy with a clear conscience the good things that nature offers one. A great argument in favour of work! I wonder how an idle man can enjoy true pleasures. These must all be bought by enduring some discomfort or even suffering. I read, but that is not work: in spite of the attraction reading has for me I am not fully satisfied when I have spent my time thus. Only a really good cigar can make me somewhat forget how wrong I am to indulge in laziness; for it is pure laziness and nothing else. I cannot begin. I know that when the first half hour had passed I should find the greatest pleasure in working, and in spite of this I cannot surmount that moment of disinclination. A cigar is decidedly a means of relaxation and an agent of corruption. As long as I hold it, and I make it last as long as I can, I walk up and down the avenues, without even needing thoughts to occupy me. I need only to keep my eyes, my nose and my ears open. When the cigar is done, the illusion vanishes and I reproach myself. Old age is coming: every hour should bear its fruit. I say this to myself in every possible tone of voice and above all I must be in an excellent position to say it to others.

249

Give me news of yourself and all those around you. Riesener's little daughter is no bigger than a rat. You know what compassion I feel for any human creature entering on that career of pain of which we have already had our share. I felt even greater pity for this one, in view of her smallness and the feeble resistance she seems likely to offer to the blows of fate. But this will not prevent men from going on making them to the end of time, just as we ourselves were made.

In this connection, I hope your daughter will soon, in her turn, be able to show her mettle. The sooner the better. A thousand kind regards to Mme Pierret and your young ladies and a thousand thousand fond messages to yourself.

Eug. Delacroix

Have you thought about our Easter party? I shall be in Paris next week.

ᘓ TO J.-B. PIERRET

[*postmark* 17 *June* 1843]

Dear friend,

I shall have my proofs of *Hamlet*[1] some time on Monday. Write and tell me if you are not too preoccupied with your sister's illness at this juncture to pursue your approaches to Gihaut.[2] I should like to get the thing going without delay before I leave for Vichy, which will be about Friday or Saturday next week. I have already mentioned it to a few journalists, as well as to Batissier.[3]

A line, and all my love,

Eug. Delacroix

ᘓ TO THÉOPHILE GAUTIER[4]

6 *August* 1843

My dear Gautier,

I am sending you a work of mine which is just being published.[5] Most of these plates were made some time ago and having suffered

[1] A series of thirteen lithographs on *Hamlet*.
[2] Publisher of prints and engravings, who eventually published these lithographs.
[3] An art critic who had praised Delacroix enthusiastically in *L'Artiste*.
[4] Théophile Gautier (1811-72) began by studying painting, but being hampered by short sight soon turned to literature. He published poetry and novels but was chiefly active as dramatic and art critic on a number of papers, particularly *La Presse* and *Le Moniteur*. His best poems, *Émaux et Camées*, appeared in 1852. He was always an enthusiastic champion of Delacroix and a number of letters express thanks for his support.
[5] *Hamlet*.

from imperfect printing they are likely to meet with great disfavour from most of the public, which prefers a finished reproduction to a striving for expressiveness. In any case, you would be very kind to ensure me a simple reference in *La Presse* and if you can in some other paper: I shall be most grateful to you.

With all my sincere and friendly regards.

 ℘ TO GEORGE SAND

Saint-Eugène, 15 November 1843

My dear kind good friend,

It's very lucky for you that I did not answer you immediately, you would have had a whole volume of ridiculous endearments and I could not find a sheet of paper big enough to write them on. I am always afraid of being rather foolish in my first impulses of affection and of saying too much or too little, particularly with you whom I love in a wholly original manner. Nothing makes one talk more nonsense than passions of this sort, and so I congratulate myself on having suppressed my tirades. Actually your letter gave me very great pleasure. It found me living a sort of life as peculiar as my friendship for yourself. My heavy cold has gone, but I still get tired when I talk. So I abstain, and see nobody. By day I go out to take exercise when it's fine, or to work. In the evenings I stay at home, and people respect my taciturnity. Solitude is by no means so irksome to me as that cold shower of banalities that greets you in every drawing room and makes you curse, when you leave the place, the time you wasted there. Since my imagination peoples my solitude I can choose my company. You are often with me, dear, I conjure you up before me together with that small handful of beings whom I still love, for alas, I have more friends in the grave than out of it. This happens to those who stay too long in this world.

You had the kind thought, or else it was by chance (but there's not such a thing as chance according to your school of thought), you had the kind thought of sending me the two first volumes of *La Comtesse de Rudolstadt*,[1] and I'm delighted with it. It's clear, it's pure, it's interesting, but how French it is! This is the sort of French that's only spoken underground nowadays, if the great dead can still converse together; the French of Jean-Jacques, of

[1] Sequel to *Consuelo*; the first two volumes, sent to Delacroix, were published late in 1843, the remaining three in 1844.

Voltaire (your enemy) and of all the rest whose like we no longer have, save for yourself. You are the guardian of that sacred flame. One has only to look at the best of living writers to see the difference.

Talking of Cagliostro,[1] I have been thinking great thoughts, by my fireside, about a previous existence. When at night, weary and yawning, I fling myself into the arms of that last friend and refuge, my bed, I fall asleep and then I enter on my previous existence. I suppose that then the body is at rest and the soul goes wandering. Would you believe it, my bitch of a soul is, three times out of five, with you, and, soul though it is, behaves in the most improper fashion. Doesn't this suggest either that the theory is devoid of common sense, or that in former days I paid you more assiduous court than I do in this last, perishable transformation into a painter which I'm at present undergoing? Perhaps I was a sultan and you were called Zuleika or Zetusbe,[2] or perhaps Gromufila! See what solitude engenders, for one thing tediously longwinded letters that tire your eyes, and for another the craziest dreams.

You plant and sow fortunate flowers! I should be even more fortunate if I could look at them by your side, as I so long to do. You are base enough to tell me that if I were not so busy you'd have asked me to spend some of the last remaining days of autumn with you. Autumn or spring, you really deserve to be taken at your word and I should do so, by Hercules (who's not my patron) if . . . Interpret that as you will. Come to that, I don't care a straw about it, so at this point I'll embrace you and bid you farewell . . . Why no, I must talk to you about *Fanchette*.[3] A kind action, and vigorous prose. Your heart and your verve are inexhaustible; and I also have to thank you for lengthening that delicious cap.[4] You think of everything and your kindness extends to everything. . . . And your thought, too! I admire and love it. You remember the saying: great thoughts come from the heart. That's how I understand it, and my heart thanks you and sends you back all the friendship and affection with which it is, and always will be, filled for you, my dear friend, whom once more I embrace.

<div style="text-align: right">Eug. Delacroix</div>

All my fond regards to Papet.[5] I am following his regimen as far as possible, and respectful regards to Mlle Solange.

[1] Cagliostro appears in the novel.
[2] Characters in poems by Byron.
[3] A pamphlet of George Sand's on behalf of Fanchette, an idiot girl in an asylum.
[4] An embroidered cap given to Delacroix.
[5] Dr Papet.

◢ TO LOUIS DE PLANET[1]

21 *December* 1843

My dear de Planet,

I have been thinking that Malivernay[2] is too dark, and has a beard. I don't want to put a beard on the figure behind Cicero.[3] I would therefore rather have a model like Lambert. Try to get him, or Poche if he is posing. I'll explain to you why I prefer them.

In any case, begin by painting the Cicero, I should like to see the picture before you paint the bending figure, so that its head is correctly placed in relation to Cicero's hand. In the study you will make of this nude figure, be careful to direct the hand as in the sketch.

◢ TO J.-B. PIERRET

Wednesday morning,
27 *December* 1843

I have been thinking that I might very well introduce Niel[4] to the princess.[5] Although I never go there, I took some trouble for her over the Hôtel Lambert,[6] and my present indisposition dates from that time. So if he mentions it to you again, tell him that I'll do so as soon as I am fit to speak and come and go.

Come over on Sunday night, you shall read me some Diderot and we'll pass through the straits of the New Year together. Dear friend, you must forgive my vagaries. I am a prey to a state of nerves that makes me like an hysterical woman. Solitude, and my still precarious health and perhaps, as I believe, a particular crisis in my temperament, make me want and not want, and turn the simplest matters into something monstrous.

I shall expect you then. Alas, our third interlocutor will be absent. He is even more mute than I. Poor Félix!

Ever yours, dear friend.

Eug. Delacroix

[1] Planet was one of Delacroix's assistants, working on the pendentives in the library of the Chambre des Députés.
[2] Malivernay, Lambert and Poche were studio models.
[3] *Cicero accusing Verres* is the fourth pendentive in the third cupola, *Legislation*, in the library.
[4] A pupil in Delacroix's studio.
[5] Marcelline Czartoriska.
[6] Delacroix had encouraged the princess to buy the Hôtel Lambert and had undertaken to restore Lesueur's paintings there.

৶ TO LOUIS DE PLANET
January 1844

My dear Planet,

Make your tracing from the sketch[1] which is not yet painted. The difference from the other one consists in my having shortened the lower half of the woman's figure. It is important that there should be a space at the bottom, so that the foot may clearly be seen to be in the water. You could even allow a little more at the bottom than the sketch shows, for the edge of the paper cut short the end of the drawing. Tell my housekeeper[2] at what time she can come to collect the two sketches. When you have the canvas, you can always work from your tracing, and I'll send you back the sketches without delay. Grisaille will be useful, for greater delicacy.

Very sincerely yours,

Eug. Delacroix

৶ TO THÉOPHILE GAUTIER
[postmark 14 June 1844]

My dear Gautier,

On the point of leaving for the country[3] I have received a letter from Riesener in which he tells me that M. de Girardin[4] would like me to write something for him. I am very grateful to him and to yourself. But may I, please, come and talk to you about it in a week's time. I am so behindhand with my painting that I feel somewhat apprehensive at the thought of undertaking fresh commitments, for which I feel far less aptitude. Please forgive my delay. I will see you as soon as I get back. Would you be kind enough to convey this message to him?

Very sincerely yours,

Eug. Delacroix

৶ TO MME DE FORGET[5]
Champrosay,
Monday, 1 July 1844

My kind dearest,

Here I am settled in at last and I think it's all going to turn out not too badly: with time, I shall make something tolerable out of it. It's

1 The sketch of *Numa and Egeria*, the first pendentive of the third cupola.
2 Jenny Leguillou.
3 For Champrosay.
4 Émile de Girardin (1802-81) was then editor of *La Presse*.
5 The correspondence with Mme de Forget begins again after a gap of ten years (letters written between 1834 and 1844 having been destroyed by Mme de Forget's executor). In June 1844 Delacroix settled for the first time at Champrosay, where he had previously stayed with the Villots. See plate 37*a*.

much better than I had imagined: besides, some small repairs have been done and my bits of furniture don't look too bad. The flowers arrived in perfect health and were replanted the very evening of my arrival. As for the jardinière, it is blooming, and this is what I shall do when I go away: I shall have the flowers taken out of the earth in which they are standing and planted in the garden, where they can be more easily watered in my absence. All in all, it should be possible to relax here. The view is superb. I am not too hot, as I had feared: although the place gets a great deal of sun, the walls are so thick that the temperature inside remains unchanged. When it has all taken shape a little more, you shall come and give me your final advice, my dearest, and you'll see that one can be happy in a humble retreat. . . .

ॐ TO MME DE FORGET

Champrosay,
Monday, 15 *July* 1844

My good darling,
 I want to send you a brief message of affection before I go home. I have not changed my plans and I shall sleep in Paris on Tuesday night. I left you the other day in such a sullen mood that it must have made you unhappy. So forgive me, dearest friend. I have realised my own stupidity and above all how absurd it was to spoil all the pleasure we were having together for such a trivial motive, and for an accident so easy to put right. There are moments when I completely fail to see things as they really are. Last night, for instance, I awoke with the most unpleasant sensation in the world. I thought everything was ruined, I considered myself the most hopeless of blockheads and was on the point of throwing myself into the river. Fortunately reason returned with daylight. In the same way, yesterday and the day before I realised how stupid I had been. You're so kind that I take unfair advantage of it. Scold me, and treat me as I deserve. . . .

ॐ TO HIPPOLYTE GAULTRON[1]

Saturday
[*postmark* 5 *September* 1844]

. . . When you are softening a drawing, you may use the utmost freedom; when you have drawn your outline and even filled it in with

[1] A pupil of Delacroix's, and a connection by marriage.

charcoal, rub it with flannel, then draw over again and add more charcoal until you have shaded it to your satisfaction: then with a scraper you must take away some of the black, taking care not to scrape down to the grain of the stone. This rubbing spreads and blurs what was too strongly marked in your first draft, and the effect of vagueness thus produced, although nothing is effaced, will enable you to draw your idea once again, correcting it. When you have scraped away and made light patches you can put on more black and soften it in the same way until you have conveyed your idea. Take a chance on it, you'll find out all these magic secrets for yourself.

Would you do me the favour, when you're out some time, of calling at that Bonne-Nouvelle shop[1] where you bought the little *Tasso*[2] and where I have foolishly left my *Marino Faliero*[3] and a painting of Arabs too long. I should like to withdraw them, and that before starting on a new month (for you pay by the month). These people are rascals – excuse the expression – who, I'm convinced of it, asked a higher price than I had fixed, so that they had the chance either of pocketing the difference themselves or of keeping the said paintings on show longer; this is just to warn you, so that you'll look closely into their conditions. You understand, if I am nearly at the end of one month I don't want to begin another. I could without delay have taken them to my new lodging.[4] If the term is nearly up would you be kind enough to write and let me know, with a brief note of what I owe them. I'll arrange for the pictures to be received at my lodging the day they bring them back.

Goodbye, dear fellow, your affectionate friend.

Eug. Delacroix

ॐ TO M. LASSALLE-BORDES

[*postmark* 12 *September* 1844]

My dear Lassalle,

Your letter reached me during a brief rest which I was taking in the country.[5] The delay in your return will not affect my work. I am

[1] The Galerie des Beaux-Arts, 22 boulevard Bonne-Nouvelle, where artists displayed their canvases for sale.
[2] *Tasso in the madhouse*, first shown in the 1824 Salon. Delacroix had never succeeded in selling it.
[3] *Marino Faliero*, shown in the 1827 Salon, was sold for 1,800 francs, and later bought back by Delacroix for 3,000 francs.
[4] 54, rue Notre Dame-de-Lorette, to which he moved on 15 October.
[5] At Champrosay.

leaving you to bring into line certain portions of the landscape;[1] and you'll be back well in time for that. I have taken on Valmore[2] to help me with the smaller details. I give him some paintings to copy while I work, and it's all going well, thanks to my health which continues very good. I hope therefore in spite of the large number of sunless days to complete my cupola. My greatest worry now is my removal, which is going to interrupt the work. I got permission yesterday to have the main planks of the scaffolding taken down from the two hemicycles of the Chambre des Députés. The Orpheus is, as I feared, too much up in the air; but with a few details in the foreground I can use it as it is, and I was glad to see that the blisters had not spread, so that by getting them repaired promptly and leaving them untouched for a while I shall see whether I cannot finish the picture as it is, which I very much hope to do. The landscape in this painting claims your attention, and when you have any spare time I'd be glad if you could help me with it. The other painting[3] looks very well, and we'll change nothing in that.

The studio has dwindled to two students who between them pay the model until the end of the month. There was a fortnight's vacation and I was forced to pay the model for a whole week or even more, without anyone to make use of him; but I hope things will resume their normal course once I am back.

Goodbye, my dear Lassalle, everything will go all right.

My housekeeper thanks you for your kind message. She is ill at the moment; but I expect she will be about again in a few days.

&ℓ TO GEORGE SAND
at Nohant, near La Châtre (Indre)

20 *September* [*postmark* 1844]

You're not at all kind. You had promised to write to me a little. Mme Marliani left here some time ago and I have had no news of you. Oh, Aurore, Aurore, what a way to behave, and then you accuse me of inconstancy! Must I say *donne! donne! eterni dei!* Alas, I am fagged out, crushed with work, and I need comforting. But perhaps you are on your way back now. Have you Mme Viardot[4] with you, and have you got her to do a study of Françoise?[5] Not a sketch, mind you, but a

[1] In the cupola of the Senate.
[2] One of Delacroix's pupils, son of Marcelline Desbordes-Valmore.
[3] *Attila.*
[4] Pauline Viardot was a frequent visitor to Nohant.
[5] Françoise Meillant was a Berrichon peasant, a children's nurse, who sat for St Anne in *The Education of the Virgin.*

proper study such as she did of Maurice. She'll think me very demanding; in which case she can send me packing.

I assure you that if people don't show a little kindness towards one another, life is worth precious little. For nearly three weeks I've been living like a bear; I haven't more than a couple of acquaintances in Paris; everyone else has run away, has gone bathing or hunting. I sometimes go to bed at eight o'clock, really worn out by work: but still I'm making headway and I hope that with God's help I shall prove equal to the task which I had set myself, and which frightened me so when I was at Nohant. This work prevents me from getting depressed and from thinking, as I have a right to, that you have deserted me completely. But everything deserts one. Oh, dear friend, try not to grow old, for the most horrible thing isn't being an old person, horrible as that is, but being bereft of every kind of feeling. You abandon some, others abandon you, until you yourself abandon this vain and stupid world, Amen!

Embrace Chopin for me, and Solange and Maurice too. Don't forget to bring me back the *St Anne*. If I like it when I look at it again, I shall perhaps ask you if I may send it to the Salon.[1] I wanted to send nothing, as I did last year, but I have found a few oddments here which I might well send in, and then yours would form the reserve, unless we change our minds.

May it sometimes convey to you all the thoughts I had about you while painting it and then I shall not need to remind you of them here. . . .

❧ TO GEORGE SAND

21 *November* 1844

My kind, kind, kind friend,

Your kind letter[2] made me extremely happy, and the hope of embracing you shortly delights me. What, so you are depressed and have been unwell yourself? Dear friend, take as much care of yourself after your illness as you did during it. The complaint from which I suffered two years ago began with a sort of mucous fever which led to this perpetual irritation of the bronchial tubes, of which I still feel the effects. So I bless Papet in anticipation for the help he must be to all of you, just as I blessed him for the horoscope he cast for me. Apart from this inflammation or irritation, this soreness that recurs whenever I give full vent to my eloquence, my health has been perfect and

[1] It was refused at the 1845 Salon.
[2] She had written for his fête-day, 'la Saint-Eugène'.

I feel better than I did at twenty-five, and I work harder. Only that indifference, which he had forecast for me into the bargain, has not yet come. Alas, that state of mental health is unknown to me: I am continually wounded by a thousand pinpricks at which most men would laugh. The slightest trifles make me happy, while on the other hand I have mountains of worries. Indifferent! I knew I could never be that when I saw your dear handwriting. I felt I was embracing you yourself, with the tenderness that I shall always feel for everything that is you. Friendship is always described as peaceful; there is no such thing as peaceful friendship, any more than peaceful love; it is a passion like love, it is as fiery and often as shortlived. You know that we have not quite the same theories on that subject. Lasting friendships are very rare, my dear friend, and when I think of my affection for yourself, I feel that I have often believed I had such feelings towards others and that they were not the real thing. Man, you see, and this I maintain, is a vile and horrible creature. The horrid self, that's to say vanity, self-interest, all those monsters which prevent us from being good, I mean from loving ourselves through other people, are always there close beside us: when your friend takes your arm, they cling to it too; often an outspoken word may alarm or repel this horrid part of our nature. I assure you, my dear friend, that I have experienced this painfully, and to my misfortune, since I, of all men, need to be able to unburden my heart. I am very happy now at the thought that I am going to be your neighbour.[1] But you shall see what I've had to endure for that purpose, and I'm not yet at the end of my troubles. The work that was being done for me was begun too late, so that when the time came for my removal nothing was ready, the plaster was still damp and the workmen were all over the place. I was forced to rent a second apartment close to the first, so that I'm not really anywhere: I go to my studio which is not at my home and I don't know when I shall be able to settle down definitely. Fate is mean enough to play yet another such trick on me. This new district is liable to turn the head of an ardent young man like myself. The first sight that met my virtuous eyes on arrival was a magnificent *lorette* of the top flight, all dressed in black velvet and satin, who as she got out of her carriage, with goddess-like unconcern, showed me her leg right up to her navel. I won't mention other encounters to which I have already been exposed and which may perhaps cause me to waver in the path of righteousness. . . .

I haven't the heart to scold you for overworking. I know as you do

[1] She was living in the Square d'Orléans, 5 rue Saint-Lazare; he had just moved to the rue Notre Dame-de-Lorette nearby (a notorious haunt of prostitutes, known as *lorettes*).

that it's only by such means that one can avoid *ennui*. I am launching out again even now, and this very day I am starting on an enormous task[1] which will keep me overwhelmed with work until the Salon and yet will enable me to live. I am a tortoise, and never feel so comfortable as when I'm carrying a house on my back.

Farewell my dear, I embrace you and all the children and friends whom I shall see again with you, and last but most of all yourself.

ℰ TO M. DE GISORS

[*postmark* 15 *December* 1844]

My dear de Gisors,

I am more disappointed than anyone else at not having been able to finish the cupola.[2] But through forcing myself to work at it too long in darkness, I got my eyes into a very bad state for six weeks and have not yet fully recovered the use of them. Broad daylight is essential to me; actually, it won't be for very long; but at this time of year, and in view of the distance from the Luxembourg at which I am now living, not to mention the cold, it would be an impossibility. Please let M. le duc Decazes[3] know how sorry I am about this.

Would you be good enough to see that as much space as possible is left between the paintings and the cloths that are put to cover them? In their present state, the lack of light would affect them, particularly the skies. I should be most grateful if you could see to this.

Please accept my sincere apologies and kind regards.

<div align="right">Eug. Delacroix</div>

ℰ TO FRÉDÉRIC CHOPIN

[*end of* 1844-45]

Dear friend,

I forgot to ask you as a favour yesterday to be so kind as to write a line yourself to Mr *Brown*, the bootmaker, asking him to come to see me some morning about 9 o'clock (54, rue Notre Dame-de-Lorette). He will perhaps condescend, on your recommendation, to make me some boots. I have written to him in vain and I've decided to ask you to do me this kindness before you leave.

How sad to spend our lives without seeing one another! I am truly

[1] Paintings for the 1845 Salon.
[2] At the Chambre des Pairs.
[3] The Grand Référendaire.

fond of you and respect you as one of those who do most honour to our wretched race.

Yours, from the bottom of my heart, my dear friend,

<div align="right">Eug. Delacroix</div>

♫ TO THÉOPHILE THORÉ
at the offices of the Alliance des Arts
rue-Montmartre, Paris

[*postmark* 14 *April* 1845]

My dear Sir,

Having been out of Paris recently[1] I did not see your latest article about me when it appeared.[2] Please accept my belated but very sincere thanks for it. Are there really some languages in the arts so hard to understand that most people never succeed in penetrating their meaning? Is it absolutely necessary to be this or that kind of person on pain of being nothing at all? I've come to realise over the past twenty years or more that such are the alternatives between which I'm torn. I did not think I was so indecipherable and must be doubly grateful to those who are not discouraged by my enigmas. After so many attempts, I now confine myself to hoping that the cold indifference of the majority will not also spread to the small number of men of taste of whom you speak, by whom in the long run, reputations are often established. . . .

♫ TO CHARLES BAUDELAIRE[3]

24 [*April* 1845?]

My dear Sir,

I am extremely sorry that I cannot be at home today: I have to go out on unavoidable errands, and shall therefore be unable to receive you and M. Malassis today. If you would be so kind as to postpone your visit until next week I shall be delighted to look at the drawings you mention.

Please excuse me, and accept my kindest regards.

<div align="right">Eug. Delacroix</div>

[1] He had been staying with the Rieseners at Frépillon.
[2] An article in *Le Constitutionnel* about Delacroix's paintings in the 1845 Salon.
[3] No address; the letter was taken by hand. Delacroix's acquaintance with Baudelaire dates from the 1845 Salon. It is not known what drawings are referred to here.

Eaux-Bonnes,[1] 24 *July* 1845

My dear friend,

I have been tossed hither and thither excessively during the past fortnight and have never been settled enough to give my address. I came here a few days ago, intending to stay here indeed: but I felt so unwell and so tired after my journey that I did not know whether I should have time to take the waters; in which case I'd have gone away again so as not to waste my time. The doctor in charge of the waters professes to be able to cure me in the brief spell I can spare here; may God hear and above all grant his prayer. The waters here, as at all spas, benefit the staff; plenty of dazzling cravats worn first thing in the morning, dresses of Pyrenean oddity and boring fools such as one meets nowhere else. Balls and routs are held, amidst this throng of consumptives ready to breathe their last.

I have already been driven from the best hotel in the place by the din of pianos playing dance music for the ladies till eleven o'clock at night. We are all on top of one another. It's an absolute craze.

The natives, men and women, are far superior to the visitors: their dress, the women's particularly, is charming. The country is magnificent. This is mountain scenery in all its majesty. At every step, round every bend in the path you see really enchanting landscapes: if, into the bargain, you have the feet of a mountain goat with which to scramble up, you can enjoy this region to the full.

I'm keeping the most interesting item to the last. I mean the Goyas.[2] I had armed myself in Paris with information and letters from Dauzats to different people in this connection. I have lost on the journey a portfolio in which there were some drawings, these letters, and your information. This last is what I most regret losing, and it would be very kind of you to send me another copy here without delay. But in spite of that I hope to have unearthed the thing, and after several fruitless excursions where I failed to find the people I could have approached, chance favoured me and I discovered the printer who told me he still had some copies; but it would take him some time to look for them and I was leaving the same night. When I pass through Bordeaux on my way back to Paris I shall see him and, if I can, plunder his portfolios. . . .

[1] Delacroix's doctors had sent him to take the waters at Eaux-Bonnes in the Pyrenees. See plate 36*b*.
[2] The *Tauromachia,* lithographs printed at Bordeaux.

Eaux-Bonnes, 5 August [1845]

My dear friend,
I was very happy to receive your letter. In the purgatory where I'm now living, it provides real sustenance. All the natural beauty that surrounds me means nothing to me. I admire it occasionally but I can make no use of it. For one thing the gigantic scale of it all disconcerts me. There is never any paper large enough to convey the idea of these masses and the details are so numerous that no amount of patience can get the better of them. In the second place, and this is the greatest obstacle, the need to look after one's health means that one cannot devote oneself to any work that is at all demanding. . . . I shall go home without having seen the finest parts of the Pyrenees. Such a journey would take several days and just now I'm counting the minutes. Any time that I'm not devoting to my health I'm saving for the work I still have to finish in Paris, and Heaven knows if I shall have time enough for that.

Champrosay will be a real luxury article for me this year again. Take advantage of it yourself, at any rate, since I cannot enjoy it, and make whatever use you like of my palace. You're lucky to be able to paint: I am hungry for palettes and paint brushes; but it would be impossible for me here. Roqueplan[1] and Huet[2] are here. . . .

I am very pleased with what you tell me about the engravings you have been asked for. Here at last is an honest publisher. This should make me known in Paris and the departments, and it's not the worst of ways. I am very sorry that copper-plate tires my eyes so. I might have tried some etchings; but in any case I should hardly have had time.

Paris [*September* 1845]

Chopin, my dear friend, is kindly bringing you this scrap of a letter. Why did I never write to you from the Pyrenees, where I was champing my bit for over a month? You'll find it hard to believe that the most extreme boredom had paralysed my most basic faculties, that I neither wrote nor read and that my sole occupation was being bored, and that amid magnificent scenery; but just consider: I expected solitude and instead of that I found myself in a wasps' nest, amidst a throng of

[1] Camille Roqueplan (1805-55) a minor Romantic painter.
[2] Paul Huet (1803-69), an old friend and a leading Romantic landscape painter.

people who, for having once seen you in the street, considered themselves your inseparable friends. Often, wandering along a secluded path, two thousand feet above sea level, I would fancy myself safe from tactless companions. Not at all, the person or persons I met would fasten on to me, and there was no way of escape unless one had wings; I have never more ardently wished to be an eagle, I assure you. You have a glance and a bearing which you know how to make redoubtable to bores; I am defenceless against that sort of person. I passed near Poitiers, not without a pang, I was thirty leagues from your home, but you know how pressed I was for time. I could only spare my kind brother seven or eight days[1] and since I couldn't allow myself another week I never went to see the finest parts of the Pyrenees, which were within a stone's throw. . . .

I am living the life of a savage and seeing nobody; so you must not put off coming too long. Talking of savages, you'll have missed the Odjiberias, who were worth looking at, after our other friends the Redskins,[2] but Maurice will give you a full account of them. . . .

ᴄᔍ TO MME DE FORGET

1 *January* 1846

Dear friend,

Forgive my delay in sending you news of myself. I reached here[3] too late. My journey took far longer than I expected, because of the rain and the bad roads; otherwise I might yet have seen my poor brother alive. You can imagine what scenes have surrounded me for the past two days; I have fortunately found some of his friends here who are helping me with all necessary duties or rather who are doing almost everything. I shall not tell you what my feelings were as I saw that fine face bereft of life, and embraced him frantically. It already seems to me like a dream. Tomorrow comes the cruel and wearisome ceremony: to be stared at by curious and for the most part indifferent spectators, when one's grief is so well-founded! My dearest, you feel this as I do. If only you had been beside me for just a few moments. My health stood up to it, in spite of extreme exhaustion. Today my stomach is badly upset and I must try and rest for tomorrow. I shall have to defend myself, and with much difficulty, against the over-officious zeal of visitors. People are far more formalist in the

[1] At Bordeaux.
[2] Delacroix had been greatly interested in the Iowan Indians brought to Paris by Captain Catlin and made several drawings of them. See plate 34*b*.
[3] Bordeaux.

provinces than they are in Paris, and they'll slay me to do me honour. My dearest, answer me without delay. I now feel a great longing to have news of you, and I shall need it more and more. I cannot write to you at great length. I embrace you, my only faithful friend, with all the fondness of my soul.

. . . I am only writing to you, so far; my friends will realise that as things are with me just now, a little delay is excusable.[1] All my love once more.

୶ TO HIPPOLYTE GAULTRON
Bordeaux, 3 January [1846]

Dear friend,

I came here too late; my poor dear one was no more, and I should have found him alive if the journey had not taken some six or seven hours too long. My dear friend, you loved your mother dearly, and my brother was both brother and father to me. You can understand then what I have been going through. I have at least had the consolation of being able to see that every possible honour was paid to his memory. I was deeply touched by the respectful zeal shown by all the military men, young or old. If I had not been there everything would have been planned by the scheming creatures who kept his friends away. The seals were affixed, but too late as usual. So since we do not know what we shall find, you'll have to be good enough to send me some money. I must beg you for two thousand francs. Please be kind enough to let me know how I can draw it.

My brother left a will in which he makes me his heir, except that he leaves his housekeeper an annuity of three hundred francs. We don't yet know how much he has left. If I assume the title of beneficiary legatee, it naturally follows that I shall only pay this annuity if there is sufficient capital. On the other hand I am in great perplexity, for according to the Civil Code, I understand, the beneficiary legatee cannot withdraw articles of property by mutual agreement; a public sale is required, and a whole host of objects very dear to my heart will be put up for auction. It would be very kind of you to reply as soon as possible, giving me your opinion or that of some competent authority, and above all saying what you think you would do in my place.

I cannot bear writing in this situation. Any letter causes me painful emotions and I have all sorts to write. So please do me the favour, my dear friend, of informing Bornot[2] from me, begging him to excuse me for not doing so directly. Please also tell Larrey and M. Eynaud for me,

[1] Another letter, to Pierret on 3 January, tells of his bereavement and asks Pierret to write to Soulier, Villot, etc.
[2] Gaultron's half-brother, who owned Valmont.

and any other friends of ours you may see, until I send them printed letters. . . .

I embrace you, dear friend, alas, very sadly,

Eug. Delacroix

ᴥ TO GEORGE SAND
Bordeaux, 25 January [1846]

My kind, kind friend,

My heart melts as I read your letter,[1] and it made me very happy after a time of such great sorrow. What thanks I owe you! This is what

[1] Letter from George Sand to which this is an answer:

21 *January* 1846

Well, my dear, good friend, aren't you coming back from that dreadful journey? Oh, how we have suffered for you and with you, on account of that harsh necessity and its cruel consequence; so much cold and exhaustion, so many physical sufferings mingled with such anxious longing to reach your journey's end, and then to reach it too late, we hear? We have been talking about you constantly, and with anguish. We have not had a single thought or occupation, either as a family or as individuals, in which we have not remembered you with grief and affection. I am writing to ask Jenny whether she has news of you and if she expects you back soon, and for your address to write to you. My dear, my old friend, come back! We shall not comfort you, but we shall love you so much that you won't feel yourself abandoned. One loves one's friends well when all is peaceful and happy, but my own feeling is that one loves them even more in misfortune, and that any cruel blows you endure bind me closer to you than ever, if that's possible. Come back, at least, for the sake of the fame that awaits you when your cupola is unveiled. I know that fame can scarcely touch a heart that is wounded in its affections, but you who are a serious artist must not turn away from the triumph of truth in your work. I have put aside two newspaper articles for you. These do justice to you, if not with great intelligence, at least with sincere enthusiasm. M. Ingres has been exhibiting his whole bag of tricks, for the benefit of needy artists, by the side of paintings by David which show him up considerably and tiny canvases by Géricault and Prudhon, no bigger than your hand, which show him up completely. The public is no longer fooled, and his few friends go into raptures amid an unappreciative crowd. You must put an end to that charlatan and deal him the *coup de grâce*. When I think that, when my artistic appreciation was in its infancy, I admired that first odalisque with her greenish contours and her back like a white leech's, and Berlioz's brass-band symphonies, I thank Heaven's daylight for having opened my eyes and ears, for one has to be a paralytic to fall into such errors. Come and see the reaction which is going to take place among a public which has been slower to get rid of its infatuations and perhaps less candid about abjuring them. The artists who have caught a glimpse of your great work say that it's as fine as the great masters, and I am sure they are telling the truth.

But what are you doing all this while, surrounded by such cruel memories? I am afraid you may be unwell and ill cared for, and that you may not have by your side friends who love you as we do. We shall see you soon, shan't we? All our arms are eager to embrace you and our hands to clasp yours.

George

I did not know that Jenny had followed you. Hitherto I had got news of you from M. Gaultron who had informed Maurice, and it was not until this evening that I learnt your address and was told that you would soon be coming home. It can never be too soon for us. I am glad that good creature is with you and that you are not deprived of your familiar comforts. This reassures me a little. Give her many friendly messages from me, I love her because she is devoted to you.

I have denied myself hitherto by not writing to you, but dear friend, I found it almost impossible to write and the fonder I was of people the less I wanted to write to them. I felt that when you heard of my grief you would not be surprised at my silence. Grief is not talkative, my kind friend, and for such deep-seated sorrow, such anguish of body and soul, paper is but a frigid intermediary, and to tell you what? That I was unhappy you already knew, dear friend. Yes, I came too late, I found my brother, my hero, cold and insensible. When I clasped those honoured remains in my frantic embrace, I met with no response. My poor friend! have you ever taken part in such a scene: what a dreadful moment, what countless painful details, and what a throng surrounded him, and it was high time indeed for me to come and see that our dear one was honoured as he deserved. I brought him to the very place where our father was buried forty years ago. What a strange fate. My father's tomb was never finished and under the Restoration I suppose it was deliberately removed. Be that as it may, there is no trace of his remains. I sought therefore to provide a joint memorial to these two fine men[1] and among all the ignoble details that inevitably followed on my poor brother's death, my mind was taken up with these other duties and I have conceived something which I think is simple and suitable and which will be carried out before the end of the summer. In any case I am leaving tomorrow and in three or four days I shall clasp you in my arms, with what joy! for you must inevitably inherit a great portion of the love I bore to my heroic brother. How kind you all are! Let me thank you.

I have not thought half a dozen times about painting here, except in churches, which I love visiting and in which I have discovered a few pictures. You talk to me of fame, my dear friend! alas, I have just buried a man whom nobody knows and yet who deserves the purest fame. All the young soldiers who gathered round him respectfully did not know him; they were not of his generation. Not one of his comrades was there. When, beside his open grave, somebody asked whether anyone was to make an oration, I told them: Gentlemen, we need no oration, your rifle shots provide the most fitting speech for such a man.

Dear friend, let us love one another then, with or without fame. It's not your fame that I love; it's yourself, the contents of your beloved petticoats. So I'm about to leave this place of mourning which is dear to me nevertheless, for my earliest childhood was spent here and I leave the last of my kindred here. I shall see you, and a very few others, with joy. Give my love to your dear children and my good Chopin. I

[1] In the cemetery of the Chartreuse at Bordeaux.

have often thought of him, and I send him affectionate greetings and to you, too, a thousand thousand times over.

Jenny thanks you very much for your kind message; what a good idea of mine it was to bring her and how lonely I should have been without her! She has been a great help to me too, for I have been very unwell and still am.

⳩ TO THÉOPHILE THORÉ

Monday, 16 March 1846

My dear friend,

You must remember that when you saw the picture in question[1] I was no longer in possession of it: that since then I have made every sort of effort to get the obstinate owner to release me from my promise, and that I told you to my great sorrow that he refused to give way. I should infinitely have preferred on the contrary, to see it in your hands. You have written a perfect article on Ingres.[2] You have struck a very true note, and nobody until now had pointed out that basic vice, that absence of heart, of soul, of mind, in short of all that touches *mortalia corda*, that essential flaw which leads to the production of works that are merely clever and that satisfy nothing but idle curiosity; which is, indeed, what he does deliberately, spontaneity being even more lacking than anything else.

Please accept my kind regards, and believe how truly sorry I am about the picture.

Eug. Delacroix

⳩ TO FRÉDÉRIC VILLOT

Champrosay, 10 *July* [*postmark* 1846]

A thousand thanks for your kind letter, my dear friend; I had heard the news[3] which took me by surprise in Paris, where I went for a day and a half and where I was given the minister's letter. They had been dangling this honour before me for a long time; I had not sought it, but I am not Roman enough to disdain it when it comes to me. As

[1] '*Rebecca abducted by the Templar Boisguillebert*, which belongs to M. Bouruet' (note in Thoré's hand), now in the Metropolitan Museum, New York.
[2] In *Le Constitutionnel*: republished in Thoré's *Salon de 1846*.
[3] He had been made an Officer of the Légion d'Honneur on 3 July.

for the Institut, that would surprise me much more. That will come when I've lost my teeth, if it ever does.

I am very lazy. I'm only progressing at a snail's pace with my Prudhon article;[1] I brought yours with me from Paris and am relying on this and on Charles Blanc.

I don't yet know when I shall return; perhaps unexpectedly; I'll let you know, or come and see you immediately. . . .

\circlearrowleft TO GEORGE SAND

[10 *August* 1846]

My dear, dear friend,

I did not want to answer you before being able to tell you when I could come to embrace you and to thank you for remembering me. Nobody would think, to see me, that I was so heavy to get moving, and yet that's the truth. For one thing the worries and hindrances I really have, and for another those I create for myself, thanks to my faculty for making mountains out of everything. But at last the mountain has begun to stir and before the 15th I shall see Nohant again, Nohant which lives in my heart and mind as one of the few places where everything delights me, soothes me and comforts me. Fortunate Nohant, which claims you for its own for half the year! What I tell you is very true, my dear friend, and although I don't write it to you every week I think it almost every day. If only, when I have endured the ultimate betrayals of my cruel mistress painting, those inevitable betrayals which await the ageing artist in his last years and which will poison them if he is foolish enough to lay too much store by the opinion of the common herd, I could retire to vegetate quietly beside your trees, until the time comes for me to be buried in some corner there! Don't imagine, my dear friend, that I am turning gloomy when I describe all this future, which I assure you I should find a most delightful prospect. I shall see you before the 15th; so you see the time is drawing very near. I am not at all proud of being an Officer, which honour surprised me without turning my head; in any case you are and always will be my commanding officer. Of whom shall I give you news? Of nobody, since I see nobody. We're stifling in Paris: with your love of heat, you should not have left at such a splendid moment. For the past two months we have been unable to breathe, and highly-strung people such as myself find it extremely trying. I have so much to tell you that I don't know what to say. I think it is the excitement I look forward to of spending a few

[1] It appeared in *La Revue des Deux Mondes* on 1 November 1846.

moments by your side that makes me long to express it to you; and now here is something I wanted to tell you and should have done long before, and that is, to overwhelm you with my admiration for 'Germain' the shrewd countryman, and the adorable 'Marie'.[1] This is one of your masterpieces, dear friend, and an exquisite piece of work; simple and beautiful! how very beautiful it is. I shall never stop talking about it if I once start. That was a good idea of yours, to dedicate it to Chopin.

My love to you and to him and to all those about you. . . .

ᶜᵍ TO J.-B. PIERRET
Nohant, 19 *August* 1846

. . . It's the same story in all the situations of life. The only fixed point is what's unreliable. One must take uncertainty as one's basis. Consequently, owing to the brevity of the moments in which we can enjoy rest or a certain degree of happiness, we live in constant apprehension of what lies in store and of the burden we shall soon have to assume once more. Herein lies the great superiority of animals over men, which somewhat adjusts the balance in their favour. Nature, in her distribution of the blessings and ills inseparable from their condition and our own, has granted them the gift of enjoying the favourable moment to the full, and at the same time conceals from them the threatening aspect of mortal life. This perfectly explains the philosophical aspect of drunkenness, apart from the pleasure caused, while flowing down your gullet, by the beneficent liquid which will shortly afterwards allay all cares and remove the thorns that fill the pillow of the virtuous as well as the guilty man. I am growing melodramatic unawares, and I believe it's due to the clouds gathering on the horizon and bringing us more rain. . . .

ᶜᵍ TO FRÉDÉRIC VILLOT
Nohant, 19 *August* 1846

. . . I am appallingly lazy: I do nothing, I scarcely even read, and yet the days flow by only too fast, for after all, I shall soon have to give up this peaceful life and go back into that furnace where ideas, good and evil, are taking shape; for in Berry they have very few ideas, and they're none the worse off for that. Chopin played me some

[1] Characters in George Sand's *La Mare au Diable*, which had just been published.

Beethoven divinely well; that's as good as any aesthetic theory. What have you been doing and thinking? Tell me about it. Tell Mme Villot, or repeat to her, that I'm at her disposal for the great Saint-Rémi.[1] Tell her, moreover, that I'll do her a superb painting if she will help me in a plot I'm hatching to get something out of M. Rambuteau,[2] and I thought that Mme Villot, who knows Mme Rambuteau, might be more successful than anybody, provided she has kept up the acquaintance. I'll explain to her what it's about. Broadly speaking, to secure for an interesting but unfortunate fellow a humble post which depends on the said prefect. If she can at the same time secure for me a job as concierge, with a few perquisites, I shall apply for it at the same time, having noticed that it is the pleasantest possible profession and that I am becoming admirably fitted for it by the idle life I am leading here. Indeed, the concierge (*vulgo* porter) has nothing else to do but raise his arm slightly to pull a cord, which is far less tiring than wielding a brush on canvas. He can even carry out his task without stirring from his armchair. He knows your secrets before you do yourself, and as regards letters, visits, newspapers, and even firewood and wine, you generally only get his leavings. Your fate is in his hands; lucky the man who is in his porter's good graces, thanks to paying him well. . . .

༄ TO GEORGE SAND

12 *September* 1846

. . . Isn't it a great pity that the nearer I come to that age when, so they tell us, the only happiness to be enjoyed lies in the quietness that results from being unable to move, I can find some well-being only in emotion; for that's synonymous with agitation and disturbance, which are attributes of youth. It seems to me, too, and this is one of my complaints against the great Demiurge, that such capacity for enjoyment as he has granted me is like the faculty of digestion, it needs food. You quite rightly want all men to have their share in the common bread with which earth rewards their labours; I myself should like a few flowers into the bargain, to satisfy another side of myself which is very exacting. . . .

. . . Chopin will no doubt have heard from M. Franchomme,[3] who was intending to write to him. I delivered into his own hands the

[1] A drawing for an altar-cloth Mme Villot was embroidering for the church at Champrosay.
[2] Prefect of the Seine.
[3] A cellist and organiser of concerts in Paris.

precious charge I was carrying,[1] on whose account, far more than for my own purse, I had travelled in dread of highway robbers. As for the elusive Prince Palatine of the rue de Rohan,[2] I was deprived of the satisfaction of embracing him as I'd hoped to do, for he had either gone out, although it was early in the morning, or else he was so entangled in wreaths of roses that he could not be seen. I handed over the packet addressed to him, with every sort of precautionary advice, to his barber (Chopin told me I could trust this *fidus Achates*). I need not tell Chopin, that beloved great man, that I have found here nothing to equal the pleasure he so kindly gave me. That was the sort of spiritual sustenance which is so rare in the present age and indeed in all ages. I therefore send him my fondest love and remembrance. . . .[3]

I took your advice. I stopped some hours at Blois, I saw the château and a great many interesting old things. I needed that: I was heavy-hearted and nothing in Paris held any promise of compensation. . . .

ℰ TO M. ROCHÉ

Paris, 6 *March* 1847

. . . At the beginning of the autumn I had a fresh bout of a very tiresome throat complaint, from which I used to suffer but had thought myself partly cured. Moreover I was obliged to finish the paintings in the Chambre des Pairs. This work which, at the point it had reached, would have been a trifling task in other circumstances, proved so trying – for I had to paint a vault – that I was obliged to break off for a complete rest after each session. It would have been impossible for me to have completed anything for the Salon. Fortunately the works I could show there had been finished a long time before and were already in the possession of friends or collectors.

I should have liked, too, in the circumstances, to have sent you something more considerable. I was only able to start again when my work at the Luxembourg was finished. I don't know if you will care for the subject. Since at the last Salon I had shown a *Lion*[4] which met with general approval, I thought to send you a sort of companion picture.[5] I am now working on my little *Christ in the Garden of Olives*

[1] Musical compositions of Chopin's.
[2] Prince Alexander Czartoriski, husband of Princess Marcelline.
[3] Unknown to Delacroix, relations were becoming strained between George Sand and Chopin; the latter was to leave Nohant in November, never to return.
[4] *Lion holding a serpent*, a water-colour. See Thoré, *Le Salon de 1846* (p. 365).
[5] *Royal tiger lying down.*

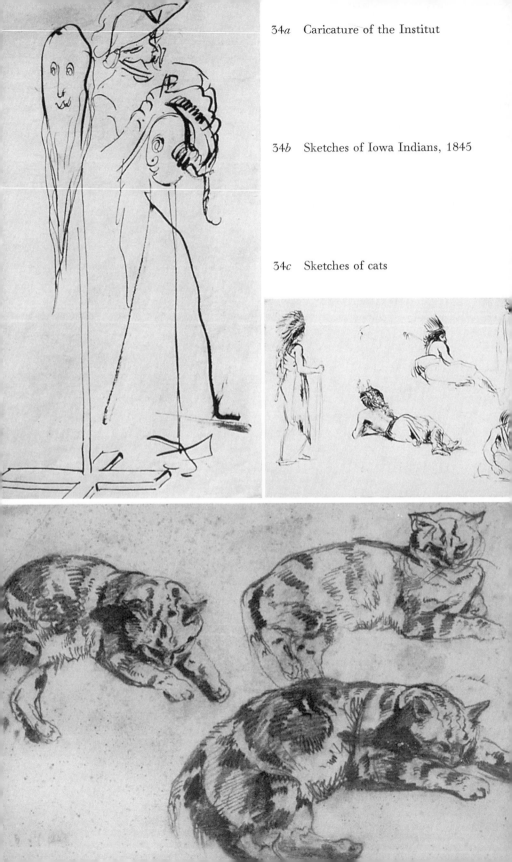

34a Caricature of the Institut

34b Sketches of Iowa Indians, 1845

34c Sketches of cats

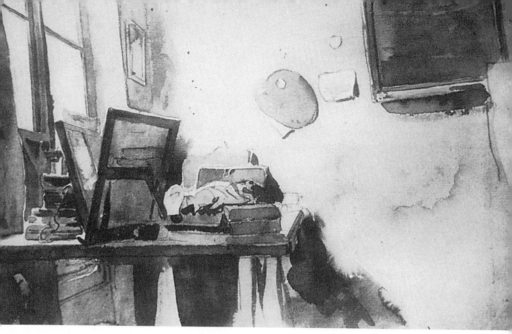

35*a* Interior of Eugène Delacroix's studio

35*b* Eugène Delacroix's studio in the rue Furstenberg

36*a* View of Paris

36*b* Landscape in the Pyrenees, 1845

which I am doing in pastel, and which I should like Mme Roché to accept in grateful thanks for her kindness to me, in which case I will beg her to find a corner for it in her oratory. But since my picture is quite dry now I was anxious not to delay sending it, and I hope you will accept it in the meanwhile. . . .

ও TO M. DESSAUER[1]

Tuesday, 23 [*March* 1847]

Dear friend,

They're doing the *Matrimonio* tonight. Go to it, on your head if needs be, leave friends and mistresses, cats male and female. You'll never see anything like it.

Goodbye, dear friend. All my love to the greatest cat-lover of them all, next to myself.[2]

Eug. Delacroix

ও TO MME DE FORGET

Champrosay,
Friday noon [26 *March* 1847]

Your letter gave me great pleasure, my dear; it reached me just as I was in the middle of reading *La Cousine Bette,* which you so kindly gave me and which I had brought here with me. It refreshed me (your letter) amidst that atrocious welter of shameful and degrading passions, the picture of which is unfortunately true enough as regards many people, and I am very grateful to you for the sweet sense of relief I experienced. Amidst all the misfortunes of which we complain and which prevent us from being completely happy, owing to the tribulations that pervade this life, we find one compensation, at least, in the happiness of belonging to one another, through the purity of our feelings. My wretched health is, alas, one of those obstacles that are only too real. Take care of your own then, lest we should have two invalids instead of one.

Would you believe that I have only just begun to recover the use of my voice, and that I owe this, I'm convinced, to the assiduous silence I maintain and to the mildness of the weather, which has made me stop here a day or two longer. I shall leave on Sunday during the day,

[1] An excellent musician, born in Prague, and a prominent figure in literary and artistic circles.
[2] See plate 34c.

in time to be back for a dinner that Bornot[1] arranged a long time ago with Gaultron and to which I committed myself some ten or twelve days ago. But on Monday, if you like, I'll come to dinner with you, and I'll be there earlier than usual so as to be with you a little, tête-à-tête. I hope I shall see only satisfactory evidence of your good behaviour in following the doctor's orders and subduing that melancholy which does you no good. I hope too that Hortense's[2] company will provide you with some distraction. The time is drawing near when we can go out and look at the country. We shall have some good expeditions, which will bring us respite from our troubles.

Goodbye, my dearest, I embrace you a thousand times and I long for the time when I shall see you again.

❧ TO THÉOPHILE THORÉ

Thursday, 8 April 1847

My dear friend,

I only learnt the day before yesterday that your article had appeared[3] and I only read it yesterday: I need not tell you that it made me very happy and that you are very kind to me in it. Please accept my sincerest thanks. The distinction you make between the qualities appropriate to painting and to poetry is a very just one and can never be pressed home too strongly into the mind of the public. People always judge us by literary standards, and are foolish enough to expect from us literary ideas. I should be very glad if it were as true as you say that I have only a *painter's ideas*; I ask nothing more.

With my devoted friendship.

❧ TO J.-P.-M. DIÉTERLE[4]

1 May [1847]

My dear Diéterle,

I am taking the liberty of introducing to you the painter M. Delestre,[5] who has been my pupil and who has already had consider-

[1] Delacroix's cousin, owner of Valmont. Gaultron was his son-in-law. See *Journal*, 28 March, for an account of this dinner.
[2] Mme de Querelles.
[3] In *Le Constitutionnel*, 4 April.
[4] J.-P.-M. Diéterle (1811-89), painter, leading theatrical designer, also chief artist at the Sèvres porcelain factory.
[5] A.-M. Delestre (1823-58) worked in Delacroix's studio. See *Journal*, 2 May 1847, for a critical comment on this painter. (Delacroix invariably went to great trouble to secure introductions, encouragement and help for struggling artists.)

able experience of decorative painting. He would be glad if you could employ him occasionally, and if this is possible, you would greatly oblige me by doing so. He could be particularly useful to you for figure drawing, and I think you will have reason to be satisfied with him.

I am still anxious to go to see you and I keep postponing, in spite of my wish to do so: you know that I consider decoration as the best possible school for a painter. Many people who have a high reputation, and who shine at the Salon, would be hard put to it to produce the least of your effects.

<div align="right">Eug. Delacroix</div>

ℐ TO GEORGE SAND

12 *May* 1847

Dear friend,

I send you all my heartfelt wishes and my thanks for such a kind and trustful letter.[1] This is an important matter, indeed, and a very serious one; but after all the essential thing is that the dear child is following her inclination and that it is impossible that she should not find some happiness: I say some happiness, for as you say yourself in your letter happiness itself, that's to say a stable and enduring condition, is not among this world's goods, any more than the permanence of youth and of all that makes life so sweet in its beginning; marriage being an even graver matter than anything else, a great deal is gained if one can enter it through the golden gate. So pure and spontaneous a feeling is less likely to go wrong than the calculations and complexities with which an old cynic would inevitably have conducted such an affair; for my prudence is merely timidity and I have often envied the resoluteness of so many people whom I have seen leaping into the arms of fate without a second thought, and being none the worse off for that. I should not, however, consider myself entirely worthy of the frank friendship you have shown me if I did not at this point introduce an old fogey's warning on the question of material interests, which is a highly important one in life; in a word, that you should submit the precise material arrangements to some of the sincere friends you have by you, who, being knowledgeable in business matters, will suggest a

[1] George Sand had written to him about her daughter Solange's marriage to the sculptor Clésinger. He received this letter on 7 May (see *Journal*). Solange's sudden infatuation with Clésinger had made her break off a previous engagement, and a shot-gun wedding took place on 20 May. George Sand was not too happy about her son-in-law.

settlement which could in no way offend an honest man but which will effectively ensure your daughter's independence, *as far as this can be done beforehand*. If I were young and lucky enough to deserve to become your son, after having been your friend, I should welcome any proposal of this sort, you may be sure, and I have no doubt that the man you have chosen for this honour will do so too.

Poor dear friend, my heart was in a tumult when I tried to answer your letter, and in my usual confounded way I put off till the morrow, so as to write to you with a clear head and a firm heart; but in the end, without having quite secured either of these, I shall repeat what I said at the beginning, namely that my keenest good wishes are for this child, whom I love as I love yourself and whom I'd like to see as happy as anyone in this world.

As for myself, who can no longer hope for anything from a chaste spouse, if I ever took one, except to be given tisane for my cold and to have a hand to close my eyes, I shall feel myself living a new life through dear Sol and her little Solangeaux, about whose advent I feel quite confident, for you have often told me you counted on being surrounded by a flock of grandchildren.

Yes, I shall see you at Nohant, dear friend: when? God in Heaven knows. I have just had a low fever which kept me for two whole months not quite bedridden but unable to touch my tools. I am going to spend four or five days at Champrosay to get myself quite fit again and I shall have arrears of work to get going again. You'll be planting some fine cabbages on the gable-end[1] and I shall find them still green when I arrive. Mme Marliani will have told you about Chopin's health.[2] He had a very violent attack of asthma: but he has recovered now; and whereas this wonderful civilisation of ours would seem to have invented towns in order to bring men together, I only learnt a week after it happened, and quite by chance, that my dear friend and close neighbour had been in such danger. The warmer weather will put everything right. . . .

<p style="text-align:center">∳ TO GEORGE SAND</p>

<p style="text-align:center">Champrosay, 2 August [1847]</p>

My delay in writing this letter, dear friend, which you must not mistake for indifference to your distress,[3] is due to my foolish desire

[1] A marriage custom in the Berry.

[2] Chopin had now broken with George Sand. She was deeply distressed by the news of his illness.

[3] George Sand had quarrelled with her daughter and son-in-law, who had left Nohant. She had written to Delacroix on 29 July (see *Journal*).

to tell you definitely whether or not I can come to see you. It is due, too, to the disorganised life I have been leading for the past fortnight, trying to work here while enjoying the countryside, and also returning to Paris from time to time for a few sessions of work at the Palais Bourbon. The sole result of all this has been to make me waste my time and tire myself out into the bargain, so that I have neither benefited from the country nor done any worthwhile work.

What sad happenings, and how can I say anything more about them to you? I feel even more how wrong I was not to reply to you immediately: for now my letter must recall painful subjects to your mind. Life is so truly horrible most of the time that one must consider oneself fortunate when it seems merely empty and useless. It is when such frightful lacerations interrupt it that one is tempted to wonder who is devouring us and our sad hearts. Let us vegetate rather, let us shun friendship and love, since both bring an almost inevitable succession of torments: death ends the one, leaving us for the remainder of our days with painful yearning; passions and folly shatter the other, and the remembrance of it is the cruellest of all.

Perhaps by now you have recovered a certain calm. I very much hope so, dear friend. A little work, and the peacefulness of your retreat, will have their effect on your mind. Perhaps, forgive me for saying so, all is not shattered. Time changes everything, and the irrevocable is too terrible for our weak spirits.

Dear friend, I shall not be able to come to see you, and I am reluctant to tell you so: for you need more than ever the mental relief to be found in sincere affection. I am in a dilemma from which I can only extricate myself by considerable exertions. I haven't a penny: this is a situation common to too many people to make my own case interesting; but chance has brought me a commission for a copy of one of my pictures[1] to be made before the end of September, which will be tolerably well paid. It has to be done within this period, and I have only just time to get down to it. I had tried to see what I could do in the country and the result was unfortunate. There are also a number of small duties and commitments that keep me here, to my real regret, I assure you, dear friend. A fortnight ago, when I received your letter, I still hoped I might go and enjoy your pure air and try to relieve your troubles for a few moments. I drop all mine as soon as I see your church spire, but they are trivial beside those which I should have liked to help you forget a little. . . .

[1] *The Corps de garde*, asked for by M. de Cailleux, a former director of the Louvre (see *Journal*, 20 July 1847).

20 November [1847]

. . . I have had a sad bereavement. I have lost my good aunt[1] whom I loved like a mother. She was a woman of noble character and one in whom spiritual qualities took precedence over everything, which is rare; one must needs have admired her, even if one had not loved her; you can imagine then what a gap this leaves in my already lonely life. Live, then, dear friend, cherish that precious spark which makes you not only live but love and be loved. I know now by experience that we really live through other people; when one of the beings who are necessary to our existence disappears he takes away with him a whole world of feelings which no other relationship can revive: what are old men, then, and what have they to regret when they leave this world?

Your fury against men of letters[2] seems to equal mine: they are a vile crew. They call themselves priests of a temple of which they are not worthy to be the doorkeepers and, make no mistake about it, everything in our age is in keeping: turgidity assiduously accompanying emptiness. Last night I saw the opera of the famous Verdi[3] about whom that young German musician I met at your house waxed so enthusiastic; Verdi or Merdi is all the rage today; it's a rehash of Rossini's leavings, minus the ideas; nothing but noise. They'll want your opinion, they'll discuss it in front of you: you'll have to go, willy-nilly, but you'll go without me, I promise you. I kept thinking of your poor Madame Viardot whose inevitable fate, if she wants to subsist, is to sing these scoundrels' music for evermore. Where is Chopin, where is Mozart, where are the priests of the living God, where are you?

You have seen my painting at its best, dear friend, as far as ideas are concerned, in the article in question,[4] which has the great merit, for me, of having been written by a man I don't know, and did not know existed. He was fired with enthusiasm for my merits and to some extent for his own ideas, for I believe he found the fine things he writes in his own head rather than really seeing them in my painting. Indeed, if it were not about myself that he says all this (excuse my

[1] Mme Riesener.
[2] The Société des gens de lettres was suing George Sand in connection with the publication of her *Mare au Diable*. The lawsuit went on for two years and George Sand lost it.
[3] *Jerusalem*, first performed at the Opéra on this date.
[4] An article by Louis de Ronchaud on 'La Peinture monumentale en France', dealing with Delacroix's decorative paintings in the Chamber and Senate, appeared in *La Revue Indépendante*, 10 and 25 November 1847.

modesty) I should say that it's so much the worse for painting if it makes a man see so much. For the beauty of this craft of ours lies chiefly in things which speech is not skilful at expressing. You understand me moreover, and one sentence in your letter says clearly enough how well aware you are of the limits necessary to each of the arts, limits which your colleagues – doorkeepers and cobblers – step over with admirable ease. Dear friend, come home soon: don't catch too many colds in your travels before you return. If you still find it boring here, well, we'll grumble together; I was going to say something silly, an Irishman's remark, namely that it's delightful to share one's boredom with somebody amusing.

All my love, you never bore me, I want you and I expect you. Kiss all your household for me. Prepare poor Chopin[1] for the harsh music he's going to find here, farewell, farewell.

◦§ TO THÉOPHILE GAUTIER
Tuesday, 21 December [1847]

My dear Gautier,

It would be very kind of you to spare a few minutes to come to see my work at the Chambre des Députés. I shall be on duty there tomorrow Wednesday, Thursday and Friday, to show it to a few friends, before giving out tickets. The light is unfortunately very bad; but I shall be there to explain the thing to you.

With my most sincerely devoted friendship,

Eug. Delacroix

From 11 to 1. Ask for the library, and say that I am expecting you.[2]

◦§ TO GEORGE SAND
[March 1848]

Dear friend, dear friend,

How much has happened in a few days! I have taken longer to reply to the best and most affectionate of letters than it has taken here to overthrow a government.[3] If I haven't written to you for a week, there's nothing surprising about that: but before then, and in spite of the

[1] Delacroix still did not know of the break between George Sand and Chopin.
[2] Similar notes are extant to the painters Diaz and Couture, the sculptors David d'Angers and Préault, and to Villot.
[3] The 1848 Revolution, 22-7 February, when the Republic was declared.

pleasure I felt at your dear token of remembrance, I put off writing for reasons that are difficult to tell: I was overwhelmed by the task of finishing some pictures[1] in which there was really too much to do and I was obliged to do it under the shadow of two grievous events in my own petty existence[2] which held me back and saddened me all the time I was spending on a thankless task, for it's always depressing to finish a job. You must have endured cruel distress[3] and if you missed some of your friends a little, I am one of those who have felt your grief most keenly. Can such wounds heal? I fear that in your case, my poor friend, they may bleed for a long while to come. Your daughter seems not to be made of the same clay as other human beings. This is doubtless what prevented your reconciliation, when you met again: pride at such a time, and towards a mother, that's what I cannot conceive of. As for Maurice,[4] he is radiant. He has just left here, in a state of near intoxication: I had not thought him capable of such a degree of enthusiasm; he has moreover stored his memory with subjects for pictures which will probably last him his whole life; for if he could conceive such a passion for the figures of soldiers whom he never saw, the real actors he has been watching now will open up a whole new career for him. There, now they're interrupting me again!

My dear friend, I'm resuming my letter two days after beginning it. I am overcome with exhaustion and I have done nothing. I have had an almost continuous procession of visitors coming and going and meanwhile very few moments to myself. To come back to yourself, kind friend. You'll have been excessively surprised, no doubt, at the events which have dominated everything and gone beyond all possible reckoning. We have truly lived through fifty years in a few days. Youths have become men and I am afraid many men will swiftly become quite decrepit. Such is the will of Providence, which none the less admits no change in the order of the seasons and will not allow the smallest bud to open before the appointed hour. I have been very moody and depressed for some time lately; this has very much affected my temper; and that's why these events may perhaps have impressed me less powerfully. Things are now settling down, and appear to be contained within reasonable limits. I hope the provinces will follow suit. The Muses, my dear friend, are friends of peace, whatever people may say; mental excitement makes one's brush shake and deflects one's touch.

[1] Delacroix exhibited six paintings at the 1848 Salon, among them: *The Entombment, The Death of Valentine, The Death of Lara, Arab Comedians and Buffoons.*
[2] Reference unknown.
[3] Her quarrel with Solange and Clésinger.
[4] Her son.

Farewell, dear friend, I embrace you most tenderly. A word when you have time, and when you have recovered from all this. Farewell, dear.

<div align="right">Eug. Delacroix</div>

ॐ TO J.-B. PIERRET

Friday morning, 5 [*March* 1848]

Dear friend,

Would you be kind enough to take to the ministry for me this morning a letter I am writing to M. Garraud[1] about my *Barricades* painting.[2] See that it is delivered to him.

I am still very unwell and very depressed. All my love.

<div align="right">Eug. Delacroix</div>

ॐ TO M. MOUILLERON

Wednesday, 28 *March* 1848

Dear Sir,

I am very anxious to have a proof of *Liberty*[3] without delay: be kind enough to let me know immediately when and at what time I can send someone to collect it. I have had news of you from M. Leroux[4] – I know you have been working – that's the best thing one can do.

With kindest regards from your devoted friend,

<div align="right">Eug. Delacroix</div>

ॐ TO CHARLES SOULIER

8 *May* 1848

Dear friend,

I have not written to you and yet I have not forgotten you. Your letter, when I received it, brought a little balm to my heart. We had just been witnessing a terrible upheaval, and for nearly a month I felt as if a whole house had fallen on my head. I have resigned myself

[1] M. Garraud was appointed provisional Director of Fine Arts after the February Revolution and remained in this post during March 1848.

[2] As a result of Delacroix's request the painting of *Liberty leading the People*, painted after the 1830 Revolution and acquired by the nation after being shown at the 1831 Salon, was officially claimed for public exhibition.

[3] Mouilleron's lithograph.

[4] Eugène Leroux (1811-63), lithographer.

now. I have buried the man I was with his hopes and his dreams for the future, and now I can come and go with a certain semblance of calm over the tomb in which I have shut all that away, as if I were a different person. I believe that everyone, according to his temperament, has undergone the same metamorphosis sooner or later. One gets used to forgathering to watch a strange but somewhat costly spectacle. We shall all swarm, like the wretches we are, around the altar of the fatherland: but principles above all. There is talk of a celebration[1] in which we shall see the ox Apis, and triumphal chariots bearing, and followed by, four or five hundred maidens. It took another revolution to bring about such wonders.

Do you feel secure about your own position? That's what I want to know. I hope you have fewer unpleasant excitements in the country than we do in our Babylon. Apart from a few pangs, you must find occasional relief in the unchanging spectacle of fields and trees. As for us, we cannot for a single moment lose sight of the present and the future. The newspapers, which are cried in the streets all day long, the frightened talk you hear all around, and the unending functions remind one constantly of the situation.

How old are we, and how old it's going to make us! I have seen some enthusiasts, and they were young. Nothing shows better than revolution the absolute necessity for the old to make way for new aspirants to life. I myself am cold as marble, and perhaps I shall in the end become as devoid of feeling.

I had almost ruined my eyes recently reading the papers: it was a thirst I could not slake. I have now resolved not to read a single one. Events will do without my opinion, since they do without my cooperation, and I was not consulted about what has happened.

Farewell, dear friend, let's huddle into our cloaks if we've got them. Let's keep an old bottle to drink to friendship; it'll all lead to something. Meanwhile, I wish both of you peace of mind and patience. . . .

ி TO GEORGE SAND

Sunday, 28 May 1848

Dear friend,

A thousand heartfelt thanks for your kind letter: I'm beginning at the beginning. As soon as I received your letter I looked to see what I could send you and among the sketches of Turks, horses, etc. I found a *Cleopatra*[2] gazing at the 'pretty worm of Nilus' that Shakespeare

[1] The Fête de la Concorde, 21 May.
[2] *Cleopatra and the peasant*, a sketch for the 1839 Salon picture.

makes a mocking peasant bring her. There was less to be done to this sketch than to the others, although I cannot conceal from you that it would have needed a little more work to satisfy me; but this would have taken too long and I reckon that if it goes off today (I'm writing after handing it in at the stage coach) you can't fail to get it at least by the 31st, unless your driver is very slow. I earnestly hope this poor sketch won't displease you too much, and you must forgive it for the sake of my greatly respected master, who inspired it.

You did well to leave:[1] you might have been accused of setting up barricades. You say quite rightly that in such times as these the mind ceases to reason and that rifle shots and bayonet thrusts become the only valid arguments. I hope at least we may enjoy a little rest for a while. Your friend Rousseau, who for that matter had never seen any fire except the kitchen range, extols somewhere, in a fit of warlike enthusiasm, a Polish Palatine's remark about his turbulent republic: *Malo periculosam libertatem quam quietum servitium.* The Latin phrase means: I choose freedom with danger rather than peaceful servitude. I have unfortunately reached the opposite conclusion, considering chiefly that this freedom, won by dint of battles, is not real freedom, which consists in coming and going in peace, thinking, above all eating at one's own time, and many other advantages which political agitators do not respect. Forgive my reactionary reflections, my dear friend, and love me despite my incorrigible misanthropy. Let me for instance thank you for so assiduously sending me copies of your works, which will stand in the front row of my little bookcase and which will be my constant consolation, apart from the pleasure of thinking that it all issued from yourself, whom I love and shall always love. I embrace you then, and Maurice and Solange,[2] and send my devoted regards to all your friends.

Eug. Delacroix

৶ TO AUGUSTE PRÉAULT

[*postmark Champrosay,*
8 *August* 1848]

My dear friend,
I am writing to you from the depths of the forest, otherwise I should have gone to see you. I want to talk to you about our friend

[1] She had left for Nohant on 6 March.
[2] Solange, who had recently lost a week-old baby, was apparently reconciled with her mother.

Villot and his arrangement of the Louvre.[1] I believe the system he has followed of gathering together the works of various masters, and above all of bringing closer to the eye, in a deliberately planned arrangement, many masterpieces which were unknown because they were hung too far away, will produce an admirable exhibition. I am appealing to you to speak for Villot to your friends and see that he gets proper support. The Institut has already begun to hiss its disapproval of this rearrangement, in which we shall no longer see Gérards and Girodets side by side with Correggios, etc., and there is a cabal against our friend.

Speak a word, then, to our friends of the press, as you so well know how to do. We are fighting here for our homeland, for I assume that your own homeland means Rubens, Titian, etc. And Villot, through a chance for which we might well have had to wait for twenty other revolutions, happens to be right for the post he fills and able to show off our treasures to advantage.

I don't know if you have been working; for my part, in spite of my rural retreat, I am doing very little but I breathe the fresh air and sleep a great deal.

Affectionately yours,

Eug. Delacroix

Villot will probably open the museum on the 15th, which is quite soon. So speak to Gautier if you can.

∽ TO MME DE FORGET

Château de Groussay,[2]
Tuesday, 15 August 1848

My kind darling,

I am writing to you from a delightful spot inhabited by people who are happy enough, considering that they have twenty servants. That sort of happiness would not make me happy; it complicates life too much and such a multitude of auxiliaries hinders instead of helping me; but when one is used to it and especially when one's in one's own home, there may be advantages.

Mme de Mornay is quite the most excellent creature in the world, I really believe (next to somebody I won't name), and if a man can find happiness through the warmth and goodness of the being who shares his life, Mornay will undoubtedly be happy. There couldn't be a more unaffected and kindhearted woman. Moreover, the luxury

[1] Villot had been appointed Curator of Paintings in the Louvre on 24 March. There had been considerable opposition to his rearrangement of the pictures. The gallery was opened on 27 August.
[2] He was staying with the Comte de Mornay, whom he had accompanied to Morocco.

of it all is unbelievable, rare furniture, pictures, hangings, gilding, carriages, etc. Both husband and wife treat me with the kindest consideration; indeed they make too much fuss of me: I should like to be alone rather more; the result is that I feel rather tired and I long for tranquillity and the simple roast meat and *bœuf à la mode* of my own home. If I can manage to be released, I shall leave shortly and descend on you like a bomb, so let my rivals take warning.

Write to me nonetheless, my dear, as soon as you have received this, to give me news of yourself. Don't covet delightful gardens or flowe·s or country cottages. There are plenty of all these here, such as one seldom sees elsewhere, and the great question is whether this is enough to banish the god of *boredom*, that cruel foe whose presence makes all happiness impossible. I declare myself decidedly a bourgeois, a grocer, worse still if possible; but simplicity in the running of one's life is preferable to pomp with a score of servants. . . .

 TO MME DE FORGET

Champrosay,
Tuesday, 29 *August* 1848

My dearest,

I received your dear little letter yesterday and I'm answering you at once to give you better news of my health. Yesterday it was excessively hot, and I looked forward to fine days for the studies I want to make for my flower paintings. This morning on the contrary there's a very thick mist which looks like turning to rain, and that will alter my working plans.

You try to cheer me up about politics, dearest. Since hitherto chance, rather than any sort of plan, has made things turn out tolerably well, I cherish the hope that Providence will keep on acting thus. And yet when one sees what an abyss is yawning beside us and what fierce passions are still confronting us, a certain anxiety is justified. This Louis Blanc business[1] is utterly stupid: if these people had to be brought to trial, it should have been before the Assembly; obviously if they are brought before an assize court, very few jurymen will be found inclined to risk martyrdom by condemning them; the probable consequence will be an acquittal, which will raise these gentlemen's stature considerably. Under the circumstances it would have been better to leave them alone, pretending to believe them innocent. That's the humble political opinion of a painter; it's a great pity I am not asked

[1] The trial of Louis Blanc and Caussidière, begun 25 August, on a charge of insurrection during a popular demonstration in favour of Poland on 15 May.

for my advice from time to time; I'm beginning to think myself well fitted to govern, since I see that my forecasts are often realised, simply because I argue from the most basic commonsense; I conclude, by the same logic, that we are very ill governed, since our rulers invariably do the opposite of what the most ordinary prudence would seem to advise. Why then, cannot I govern myself, and why am I always either up in the air or down in the depths?

You are my Republic and I give you my vote: I shall come at the beginning of next week to tell you I love you and that this, at least, does not vary amid all my tergiversations.

Farewell, my kind darling, all my fondest love: you haven't told me about your health.

ɔ͠ TO J.-B. PIERRET

Champrosay, Friday
[postmark 29 September 1848]

Dear friend,

I've just had your letter and hasten to urge you to come (I think this coming Sunday will be possible). I have undertaken a considerable task[1] and the loss of a single day would set me back badly. The flowers are dying and at the first touch of frost I shall be left without a model. Take the train that leaves the station *at three o'clock precisely*; thus I shall have time to do a morning's work and we shall have till nine o'clock at night to talk. You shall take pot luck with me and we'll talk about ourselves and our poor shipwrecked friend.[2]

His position, which I can guess at, distresses me extremely; he's my old companion, but for that very reason I know him well. Lend him money! I'd as soon lend to Acheron or the Ocean. You'll see, my dear fellow, that I've been slaving for the past month to try and pick up a thousand francs or so to stop the holes the Republic has made in my slender fortune. *Primo vivere.*

All my love, and I look forward eagerly to seeing you on Sunday.

Eug. Delacroix

ɔ͠ TO CONSTANT DUTILLEUX[3]

6 *February* 1849

Dear Sir,

You must excuse my delay in replying to your letter, and attribute it to the thousand preoccupations or rather the negligence habitual to artists, which makes them invariably postpone all business, however

[1] The flower paintings, shown at the 1849 Salon.
[2] Soulier, who was in financial difficulties.
[3] Constant Dutilleux (1817-65), painter, a faithful friend and admirer of Delacroix.

important. As soon as I received your letter I went to see the two flower paintings;[1] and I entirely agree with what you say of them. They show great talent; the brushwork is particularly remarkable; their only fault seems to be that which is common to almost all works of this sort, painted by specialists: the study of details, highly elaborated, somewhat detracts from the effect of the whole. Since the artist, in carrying out his work, proceeded not so much by broad local divisions of lines and colours as by an extremely careful rendering of the various parts, those objects which in the picture serve, as it were, as background to each of these too lovingly emphasised details, eventually fade out, and the consequent dispersal of interest rather spoils the general effect. All this does not really detract from the value of these pictures, whose masterly execution precludes comparison with most other productions in this genre.

You kindly enquire after the flower paintings which I am at present finishing. As it happens, I have been working in exactly the opposite way to the two works in question, and I have subordinated details to the whole as far as possible. I tried to get away from the convention which seems to condemn anyone who paints flowers to reproduce the same vase with the same columns of fantastic draperies to serve as background or provide contrast. I have tried to paint bits of nature as we see them in gardens,[2] only assembling within the same frame and in a fairly probable manner the greatest possible variety of flowers. I am worried now as to whether I shall have time to finish, for I have not been able to get back to them and there is a great deal to be done. If they are finished in time, and to my liking, I shall probably send them to the Salon. There are five of them, neither more nor less.[3]

I have indeed made a few attempts at etchings at various times; they are all scattered. However I will collect as many as I can and send them to you through M. Souty,[4] as soon as I have recovered all or some of them; but I warn you beforehand that they are insignificant.

Farewell, dear sir, I am most grateful for your kind remembrance of me. Your flattering approbation encourages me greatly; and so does your undiminished friendship for me. As I grow older I become aware that sincere and disinterested affection is very rare. Artists above all find it hard to know what to believe of the opinions expressed to them or the feelings of those that surround them.

Once more, my thanks and my sincerely devoted friendship.

Eug. Delacroix

[1] Flower paintings by old masters.
[2] e.g. plate 33.
[3] Only two were shown in the 1849 Salon.
[4] Father-in-law to Francis Petit, founder of the Galérie Petit, who became Delacroix's friend.

❦ TO MME DE FORGET

Sunday morning [20 *May* 1849][1]

When I think now how ill-humoured I was last night and how foolishly and flippantly I spoke of things that vexed you and might distress you, I cannot forgive myself. You are perhaps the only person in the world who loves me sincerely, and I hurt your feelings. Poor, or rather horrible, human nature! I lay sleepless part of the night, going over all my chatter in my head: alas, the state of depression in which I have been for some time lately makes me reflect bitterly, and almost with derision, on all the miseries of life: but on whom should I inflict these jeremiads? On the cold insensitive creatures who abound in this world, not on fond and unselfish souls. Scarcely had I taken one step down the staircase last night on leaving you when I wanted to go back and kiss you, if I'd been able to. I am still in a state of agitation due to all that has been happening to me for the past six weeks: I must gradually get back into my ordinary way of life, above all to my occupations, which leave an unaccustomed void in my wretched mind. And then I shall surely be my real self, endlessly grateful for your affection and careful to avoid distressing you.

Let me send you, my dear and only friend, all the embraces I could not give you last night. I hate myself and I love you more than I can ever tell you.

Goodbye, my dear darling.

❦ TO LÉON RIESENER

Champrosay, 9 *June* 1849

Dear friend,

I have just received your letter, for which many thanks. I had seen my pictures[2] briefly the day I went back to the Salon for the hanging, and they made a bad impression on me; it would be most kind of you, in my absence, for I am very unwell and should find it hard to go myself, it would, I say, be most kind of you to treat them as if they were your own and do me the favour of removing the two weakest, unless you see any possibility of hanging them where they would look better. However I don't insist on this. I even think that all things considered it would be better to withdraw them completely. I had not

[1] The date is uncertain, but there may be a connection, which the handwriting bears out, between this letter and the entry in the *Journal*, 18 May 1849, 'Friday evening, a little quarrel with J.F. . . .'.
[2] His flower paintings.

37*a* View near Champrosay

37*b* Garden at twilight

39*a* Sea at Dieppe. Water-colour, *c*.1855

39*b* Augerville, 1846

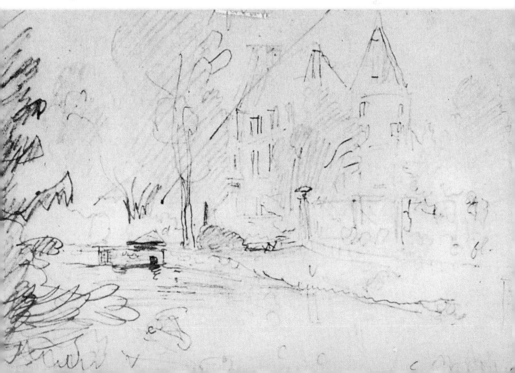

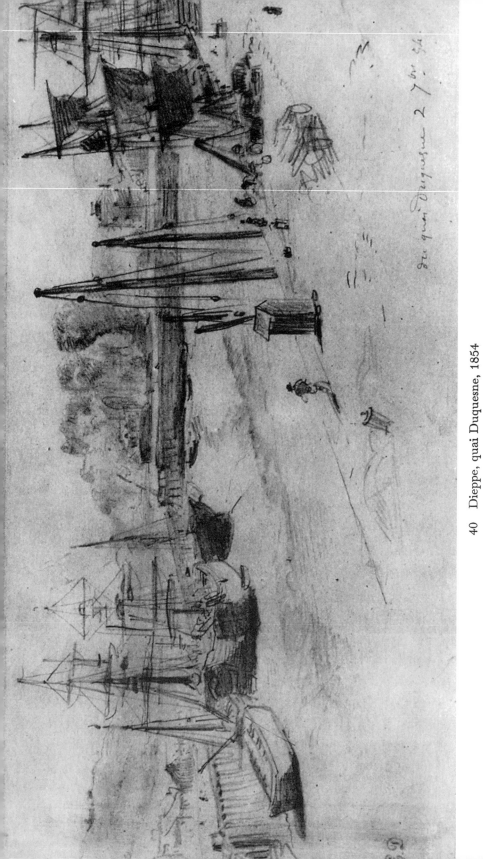

40 Dieppe, quai Duquesne, 1854

intended to touch them up, and they will stay as they are. The curious thing is that in my studio they looked as brilliant as the others.

<div align="right">Eug. Delacroix</div>

৶ TO LÉON PEISSE

Champrosay, 17 July 1849

. . . I dare not say that all your comments here[1] are extremely sound, since they are to my own advantage. What you say about colour and colourists has scarcely ever been said before. Criticism is like many other things, it lingers over what has already been said and never comes out of its rut. As for that famous Beauty which some see in the serpentine line, others in the straight line, they all persist in never seeing it except in lines. I am at my window, and I see the loveliest landscape; the idea of a line never occurs to my mind: the lark sings, the river reflects a thousand diamonds, the foliage rustles; what lines can produce these delightful sensations?

They refuse to see proportion and harmony except in lines: the rest, to their mind, is chaos, and the compass is sole judge.

Forgive my critical outburst against my critics. Note that I humbly shelter behind the great names you mention, while setting them even higher than is usually done. Yes, Rubens can draw. Yes, Correggio can draw. Such men have no quarrel with the ideal. Without an ideal no painter can exist, no drawing, no colour. And what is worse than having no ideal is having that second-hand ideal which these critics go to learn at school, which might well give one a loathing for all models.

Since there are several volumes to be written on this subject, I'll stop, to revert to the pleasure you gave me. . . .

<div align="right">Eug. Delacroix</div>

৶ TO LÉON RIESENER

29 August 1849

Dear friend,

In reply to your note, you could help me by speaking to Vieillard[2] about Vernet.[3] I have happened to learn that Vernet has a particular

[1] In an article in *Le Constitutionnel*, 8 July, devoted to the 1849 Salon.
[2] Narcisse Vieillard, former tutor to the eldest son of Queen Hortense and as such, *persona grata* with Louis Bonaparte. The project here discussed was a plan to get Delacroix made director of the Gobelins factory; Mme de Forget and Cavé and his wife had promoted it.
[3] Horace Vernet was highly influential at the Elysée Palace.

dislike for me which inclines him to prefer everyone else to me: he said this to Rivet the other day, without knowing that Rivet was my friend. Perhaps Vieillard could persuade the President[1] to ask Vernet to support me, simply as a personal favour to himself. I shall meanwhile approach people who may have some influence in this matter; the more the better. I'm neglecting nothing: since I've started work on this campaign I'd go to China if needs be to win support. I don't think Schnetz[2] as reliable as Vieillard may believe, tell him so.

Contrary to my expectation, things aren't going too badly; so let us forge ahead and take advantage of everything! I found Couder[3] a very good fellow. As soon as I'm a little freer I shall come and see you. All my love.

<div align="right">Eug. Delacroix</div>

ꙅ TO MME DE FORGET

<div align="center">Champrosay, Monday [September 1849]</div>

Dear friend,

I am writing hastily to beg you to ask Vieillard to abandon any approaches he may have thought of making. I have thought the matter over and over again, and I definitely do not feel I have the makings of a director. I haven't slept ever since this foolish idea occurred to me, and when I spoke to you about it the other evening I had almost abandoned it. I have thus reverted to my original feelings. Please drop the whole matter completely.

I have a horrible cold. The daisies are fading, and it maddens me to see what a fleeting existence all these lovely flowers have.

Your *Gros-jean comme devant.*[4]

<div align="right">Eug. Delacroix</div>

ꙅ TO CHARLES SOULIER

<div align="center">Paris, 23 March 1850</div>

Dear friend,

I was very sorry not to have been at home when your dear boy called and left your letter. I am very glad to have news of you, although your letter was sad on account of your son's departure. Life

[1] Louis Bonaparte.

[2] Jean-Victor Schnetz, member of the Institut and Director of the Rome School, 1841-6, influential in official circles.

[3] Alexandre Couder, painter of historic subjects, *genre* pictures and portraits, member of the Institut.

A proverbial expression, meaning a nobody; used by Rabelais, and La Fontaine (Fables, VII, x).

is just a series of shocks, and they are nearly always sorrows. The times we live in provide a fuller measure of these than life normally entails. The present causes grief, the future anxiety; only the past remains, and to take refuge in memory is a great consolation. Where is our carefree life now? I never cross the Place Vendôme[1] without looking up at the little window which is still the same; but how many things, or rather how many men have changed, not to speak of all that has vanished! A month or two ago I was shown the painting of animals[2] that I did at Beffes, some four-and-twenty years ago! The poor marquis having died in his turn, the picture was for sale. We all end up at the second-hand dealer's; that's the universal burial ground. Work is my surest refuge, not only against *ennui* but against sorrow, and I know that you too appreciate this authentic solace. Look after yourself, for we must still care for our bodies first of all. Your son Paul is delightful. This is the younger generation that must take our place. These gloomy thoughts of ours don't enter into their young heads, and so much the better. Are you coming here soon? Pierret was unable to tell me.

Goodbye, with all my love.

Eug. Delacroix

ও TO MME DE FORGET

Champrosay, 30 *April* 1850

. . . On the whole my health is not bad. Nevertheless my voice is still very weak; that's the danger-point. But I don't talk to a living soul. Sometimes, especially when I wake up in the night, I'm terrified by the amount of work I have to do; but on the other hand it is *attractive* work, as the Fourierists would say, and I like to fancy that the attraction will make it seem less arduous. Thank you a thousand times for taking the trouble to copy out passages of Voltaire for me. I have found here some extracts which I'd made at various times.[3] You wouldn't believe what pleasure this gives me. Being afraid of tiring my eyes I am delighted to have in a few lines the quintessence of several pages, for since I only extract what interests me I have more matter to think over than my eyes have to read. This is all gain: for one sometimes wearies oneself very foolishly over nonsense, which is a waste of time and effort.

[1] Where Soulier lived in his youth.

[2] *Still Life with Lobster*, painted in 1826 at Beffes for the General Marquis de Coëtlosquet.

[3] In a small notebook which has been preserved and published by André Joubin as supplement to the *Journal*.

You are feeling better, my dear: take care of yourself all the same and don't treat such indispositions lightly. Our bodies have their laws, to which we must submit; revolt only turns against oneself. You keep me company unawares on my walks. I send you in my thoughts all the violets I find in the woods; they are charming and one would like to pick them all. Unfortunately they have no scent; which is further proof of the value of education, which develops or should develop one's good instincts. Is this always the case? That's a weighty question. I'd sooner embrace you than discuss it at length; so I embrace you a thousand times. In a week's time I shall be doing so in real earnest. . . .[1]

৶ TO DR LAUGIER
Surgeon-in-chief at La Pitié
rue des Capucines, No. 13

Saturday, 22 *June* [*postmark* 1850]

Monsieur le Docteur,

I should be most grateful if you could call tomorrow or as soon as your commitments will allow you for two small consultations, one for Jenny who, apart from her habitual ailments which have become almost intolerable, has an inflamed eye which needs treatment. I should also like to consult you on my own behalf; I have been extremely tired these last few days and as I am about to embark on a considerable task[2] I should like to revive my plan for taking the waters; if I could do so in the region of Aix-la-Chapelle or Ems, it would fit in with a number of considerations, one of which is all-important. This is that since I want to take Jenny, the railway journey would be far less tiring for her than travelling south by coach, which I am convinced she would never stand. I think I remember hearing that the waters of Aix-la-Chapelle would do her good. I could settle her there and go on to Ems, if, as I believe, the waters there are good for chest complaints. If you would be so extremely kind as to look into the properties of these waters, you could then give us your opinion of them.[3]

Believe me, monsieur le Docteur, your most sincerely devoted and respectful

Eug. Delacroix

[1] But he was still at Champrosay on 19 May, writing to her, 'I don't want to go back without having finished three small pictures I had brought' (identified by Joubin as *Woman combing her hair, Michelangelo in his studio, The Lion Hunter.* See *Journal* for this date.)

[2] The ceiling of the Galerie d'Apollon in the Louvre.

[3] Delacroix took a cure at Ems in July and visited Belgium on the way there and back. This letter is typical of his affectionate solicitude for his devoted housekeeper Jenny Leguillou.

TO MME DE FORGET

Ems, 13 July 1850[1]

What a long time it has taken, my dear, for me to be settled down here and able to write to you. I got here the day before yesterday, but with such a headache and after such difficulties that it was quite impossible to write. For one thing, there was nowhere to stay: there are eight hundred more people here than usual. I was offered the most appalling holes. So I spent a whole day rushing about in the sun, when I was already very weary after a journey which is not as easy as might be imagined. The impossibility of making oneself understood adds greatly to the inconvenience: furthermore, the difference in coinage drives one to despair: this changes every twenty leagues or so and one is constantly having to learn it all afresh. My exertions, as I've told you, gave me a headache yesterday which lasted all day. However, I went to the post where I found nothing from you, which makes me think you have had difficulty in finding somewhere to stay. I am in any case not settled here definitely. I only have somewhere to lay my head provisionally, and on what a bed, good heavens! Those of Carpentras must be princely compared with what one finds here in the best hotels. I slept at Cologne in one of the latter, on a regular camp bed. One of the most intolerable things is that endless transferring of one's luggage from Belgian carriages into Prussian ones, from these to the boat and from the boat into another carriage. The Customs, passports, all kinds of the most varied torments. So, as usual, I had to consider myself the unluckiest man in the world, and to crown my misfortunes I could not unpack my things either to read or write. If I'd been able from time to time to solace myself with my dear little book of extracts from Voltaire[2] I might perhaps have borne my miseries with patience, when I considered those of that great man. Such comparisons are a great help. Those that a traveller makes between the inconveniences that meet him at every step of the way and those that he finds at home must add greatly to the pleasure of his return. The sight of some of these German figures makes me think of those I left behind in Paris. It's obvious that this brand of elegance does not come from the rue de la Rochefoucauld, nor even from the Parisian suburbs; and this is no compliment to my fair compatriots. To tell you the whole story, I made a brief stay in Brussels, which I turned to good account. As you can well imagine, I was greatly excited by the splendid paintings by Rubens, and the effect on my imagination yielded only to the worry over the Customs, the driving rain which went on almost without respite

[1] See *Journal.*
[2] Made by Mme de Forget.

for five or six days and is still falling, and in short to all the discomfort of a journey which had been described to me in such glowing colours. So give me, in your turn, an account of all your miseries, for if one cannot spend a day of one's life without enduring one or more of these, travelling increases a millionfold one's chances of being miserable.

The doctor thinks the waters will do me good. He is an old German whom I like very much and who invites one to call on him very often, which involves no extra cost since the fee one pays at the end of one's stay is a sort of fixed price. This morning I drank my first glass of water, together with some goat's milk whey. That is my diet until further orders. The place looks to me horribly boring: I have no books except my *Homme de Cour*[1] and my Voltaire. I shall try to fill the hours with as many walks as I can.

Goodbye, my dear kind friend, how glad I shall be to forget, in your company, all these faces belonging to another world. Really, that confounded France of ours deserves the envy felt for her by Germans of all descriptions, Englishmen, Russians, Americans and the rest. We'll talk a great deal about all this. Meanwhile, all my love. This is the first quarter of an hour that I haven't spent either yawning or fuming. Farewell again, my darling.

ᴄ᠊ TO CHARLES SOULIER
Ems [15 *July* 1850]

. . . I have endured a few moments of boredom, but they were really very short. Think of all that is conveyed by the words: no business matters! No visits to be paid or received! No bores! My bad moments were spent on the promenades where everybody walks, because there I met all those painted faces and dressed-up figures, *bourgeois* or aristocratic, so many puppets. There, boredom overtook me; but as soon as I was out in the country, amidst peasants and oxen and, in short, things that were natural, I regained possession of myself, I enjoyed life. So much for my opinion of what is called society. This is yet another resemblance you can find between myself and your beloved Rousseau. All I need now is his Armenian dress, and you know how I long for that. . . .

ᴄ᠊ TO MME CAVÉ
Paris, 4 *September* 1850

Dear lady,

I have just received your letter from Sainte-Adresse, and I am answering it with the greatest pleasure. You are very kind to lay so

[1] By Balthazar Gracian.

much store by my article[1] which I only wrote as a matter of conscience: it did not, moreover, cost me much effort of imagination, for I thought the best way to praise the book was to quote freely from it. I had hoped it might appear on September 1st and I had made every effort to that end, for the proofs had been corrected and sent off; but that idiot Buloz did not understand that there was any need for urgency, far more, indeed, than for most of his long-winded screeds. Since you want to do a second edition, it's essential that we should go over the book together to remove a few blemishes. Your work is so interesting that it deserves a classic form, although your own is piquant enough. This is what my sincere affection for you, joined to my high opinion of your delightful treatise, emboldens me to tell you. You are quite right to ensure the necessary confirmation for your book's success by applying your method as far as possible: your pupils, guided largely by your advice, will achieve wonders and what you tell me does not surprise me. Notice that what you have done as regards drawing ought to be done for everything else; whatever we learn, we learn in spite of methods and masters; entire generations are driven to despair by the absurdity of education in every field. Lively minds, endowed with natural lucidity, are struck by this from their childhood; they struggle through as best they can, by instinct, but the common run of apprentices are satisfied with knowing that they have been to school.

You're lucky indeed to be in the fresh air and by the sea. I was unfortunately unable to go as far as Holland, but I revisited Belgium[2] in somewhat greater detail and in less of a rush; I really looked at the paintings, and gained greatly from this. I am still in love with Belgium; it's agreed that I shall have to go there to get married; I am greatly attracted by this country's air of all-pervading calm.

৩ TO CONSTANT DUTILLEUX

Paris, 5 October 1850

Dear Sir,

I should have no excuse for not having replied to your excellent letter, which I received so long ago, if my whole summer had not been taken up with comings and goings. I was away from Paris when your letter came there,[3] and since my return I have been so busy with a piece of work which they are clamouring for[4] that I have postponed

[1] An article on Mme Cavé's book, *Le Dessin sans Maître*, which he had written while at Ems and which appeared in the *Revue des Deux-Mondes*, 15 September 1850.
[2] He had visited it first in her company, when she was Élise Boulanger.
[3] At Ems.
[4] The ceiling of the Galerie d'Apollon in the Louvre. See plates 45, 46.

writing from day to day, with the deepest regret, I assure you, for it's impossible to be more deeply touched than I am by all that you tell me. The interest you are kind enough to take in all that concerns me – your friendship, in a word, of which this is a certain sign – is something so rarely met with that your letter – which I am re-reading at this moment – gives me a real thrill of happiness. As we grow older, every sort of tie is weakened to a painful extent: and people who for one reason or another are in the public eye are more liable than others to see cold indifference replace the affectionate feelings we meet with in youth from our companions and friends. You can easily appreciate, therefore, the pleasure that any sincere feeling brings to one so placed.

It is very kind of you to attach any importance to the small figure you mention. It was painted just over a year ago, and even repainted, for I did not like it when I began it, and when I eventually put it aside I still did not like it. I had no particular purpose in painting it. I often do these small pictures when I have nothing more important on hand. I have little encouragement to do so, moreover, for it strikes me that patrons of art, who are sparing of their good opinion, conclude from the fact that I am supposed to be good at large-scale works that I must be bad at small ones. I don't know if this is really so: for my own part, I paint either sort with equal pleasure and I believe that one can pack as much interest within a narrow frame as in an entire monument.

I have not yet been able to begin at Saint-Sulpice, although my compositions are already planned. The work I have been commissioned to do, as I told you, is a ceiling to be included in the restoration of the Galerie d'Apollon at the Louvre. It is on a considerable scale, and will be placed in the finest position in the world, beside some of Lebrun's noble compositions. You see that I shall have to tread carefully and firmly. I have begun to make some headway in this work. It has naturally held up the other, particularly as winter would have driven me from Saint-Sulpice. This latter task I like very much: I have to paint two large subjects facing one another in the chapel, as well as a ceiling and a number of ornaments. One of the subjects is *Heliodorus being driven from the Temple*, and the other *Jacob wrestling with the Angel*, and finally the ceiling, *St Michael the Archangel vanquishing the Demon*. As you see, in these various subjects I tread very close to certain impressive great masters. But religious subjects, among all the various attractions they offer, have the advantage of leaving one's imagination free rein, so that each artist can express his individual feeling in them.

If, as I should like to, I were to visit Belgium within the next year or eighteen months, I should certainly go and call on you and thank

you. Perhaps I shall see you in Paris in the meantime. The Salon may possibly attract you hither.

Goodbye, my dear sir.

Eug. Delacroix

৵ TO M. HARO

Champrosay, Saturday, 16 *November*
[postmark 1850]

Dear Monsieur,

You give up too easily where your own interests are concerned,[1] and yet you display a persistence about my own stupid business[2] for which I can never thank you enough. But I implore you: let those cads of librarians settle down where they like; when they've been given the best rooms they'll give the others to their porters. Who can stop them? Haven't they been guilty of a kind of fraud by rushing through, or faking, the decision in their favour? I'm quite reconciled to it myself; think of your own position, which requires all sorts of help, owing to your being new to the game. I had a very poor reception, and was annoyed with myself for having left without insisting further. At the time I was so sick of the whole business that I thought only of my own boredom and my longing to come here to finish two or three little paintings. Indeed, you are dealing with people who are stupid rather than malevolent; but stubbornness is almost always more difficult to convince than ill-will. I shall be in Paris at the end of this coming week. We shall see what advantage we can gain from your recommendations, which are weighty.[3]

Please thank M. Sacaley for his interest; I liked him as much as he liked me. I had a word from M. Mocquard[4] informing me of the disappointing result. I am obliged to him, too. I repeat, I'm sorry that Mme de Forget went and stirred it all up again. It's amazing to see what efforts are needed for the fulfilment of so modest and equitable a request. You speak very wisely in your letter about the spirit of resignation that makes you turn to work again. I have always thought it one's best protection, and this has saved me in all my difficulties.

As soon as I get back I will look out some lithographs for M. Lacrosse. Remind me of this in Paris, for I have no memory and I should be very sorry to fail you.

[1] Haro was applying for the post of restorer of paintings at the Institut and the École des Beaux-Arts.
[2] Delacroix had applied for Ampère's room at the Institut; it was allotted to Tarin, librarian of the Bibliothèque Mazarine.
[3] Including one from Ingres.
[4] The Prince-President's *chef de cabinet.*

297

Don't forget the cylinders for the picture. As the workmen aren't easy to get going, it would be as well to start the thing early.

Believe me, dear sir, your ever grateful and affectionate

<div align="right">Eug. Delacroix</div>

<div align="center">❧ TO ROBERT-FLEURY[1]</div>

<div align="center">*Paris*, 15 *January* 1851</div>

My dear Fleury,

You will not, I hope, find it extraordinary that I should tell you in a letter what I might have felt some reluctance or embarrassment at saying to you. I am sure I need not remind you of the friendly feelings I have so long entertained towards you; anything I could do to prove these I have always done eagerly. And you have behaved in the same way towards myself. Nevertheless, I have felt you were somewhat more reserved towards me just lately; which is why I am writing instead of speaking to you. Nobody would be happier than I to be shown that I am mistaken.

Your election made me very happy; I felt as much involved in it as in my own, if I may say so; and when I learnt the result I expressed my feelings to you in a letter that came from my heart, since I was unable to congratulate you personally. The thought that a friend's election might forward my own never occurred to my mind. I only remembered gladly, believing it to be the expression of your feelings, that in the early days of our acquaintance, when I met you in the street, you gave me the assurance that if you should succeed before I did I might count on your loyal support, as you well know you could have counted on mine.

I felt bitterly grieved, I must confess, when after your election I did not receive one word, one gesture from you in answer to those which the occasion and your success had drawn from me. I have seen you since, at our meeting at the Louvre about the restoration of pictures, and lately on the jury; and you seemed to me, it pains me to tell you, if not exactly cold, at least different from what you were when I was happy to depend on you.

Don't be surprised at the frankness of my approach, my dear Fleury. I could not help showing my distress to my other friends, who are also yours. Am I mistaken? Am I too sensitive? But perhaps a touch of coldness which, coming from anyone else, would not have affected me, hurt me more when it came from you.

[1] The painter Robert-Fleury was elected to succeed Granet in the Institut, 19 January 1850. Delacroix had been a rival candidate, standing for the Institut for the fifth time. He got no votes.

I am not asking a favour, my dear Fleury; I am asking for your friendship, which was really precious to me, and only when I have regained it, as I think I deserve to, shall I hope for that support from you which I need now for my candidature;[1] I am asking not only for your support but for that of your friends; I believe my rivals are redoubtable, and what I ask you for is not votes but the enthusiasm with which one furthers a friend's cause. This I have always sought to display wherever your interests have been at stake; judge, then, what I should have done had I been in your position and you in mine.

One friendly word from you, my dear Fleury, before we meet; you will fill a painful gap in our feelings for one another, and at the age we have both reached, it is not easy to renounce any affectionate relationships and above all it is impossible to replace them.

Your truly devoted

Eug. Delacroix

ও TO LOUIS DE SCHWITER

Thursday, 27 *February* 1851

. . . I have handed in my resignation as member of the jury:[2] I met with nothing but annoyance there. I cannot recommend you to any of my colleagues who are still on it, since I have had reason to complain of their attitude towards you, and even if they should be disposed to give you fair treatment, their decisions are disregarded. I have only set foot once in the Salon since we had been supposed to preside over its arrangement, and I found everything quite different from what we had decided. So I don't know what to advise you to do. It is hard to withdraw the things you refer to; but perhaps it's better than having them so abominably placed.

ও TO THÉOPHILE GAUTIER

10 *March* [1851]

My dear Gautier

A thousand thanks for your kind article:[3] you are absolutely right about those horrors: fortunately I am endeavouring to justify your judgment even further if I can, by working hard at more important things.[4] This is a task which I find excessively interesting but so

[1] Robert-Fleury replied in affectionate terms, promising support.
[2] For the 1850-1 Salon.
[3] Gautier's article on the 1851 Salon appeared in *La Presse*, 8 March.
[4] The ceiling of the Galerie d'Apollon at the Louvre.

tiring that I cannot go and thank you myself. I am busy the whole day because the job has to be finished on time and by the evening I am like a man who has walked twenty leagues. 24 feet by 24: I shan't tell you any more about it until I ask you to come and see it. That will be in a couple of months, I hope.

Many thanks once more, and may I send you a thousand fresh expressions of my old and affectionate gratitude.

<div align="right">Eug. Delacroix</div>

๑ TO CONSTANT DUTILLEUX

Paris, 10 *April* 1851

Dear Monsieur,

The *Female Nude* is no longer in my possession,[1] and I am very sorry, since it might have gone where, in all probability, it would often have been seen by yourself. One of the greatest pleasures an artist can hope for is to know that his works are in the hands of those that love them.

I am writing this in the thick of the work my ceiling gives me; it is even more arduous than I had at first imagined. The necessity of doing it in sections[2] keeps one's mind continually in check, because of what one cannot see, and in spite of the care I took to set down my ideas clearly in a sketch, the need to enlarge the scale involves inevitable differences which demand constant scheming. But the delight of working on something like this makes up for the trouble and fatigue, and as I am keeping fairly well I hope it won't drag on too long. I have covered the greater part of it, and the top is finished, except perhaps for some slight retouching which I may want to do when I see the whole thing.

I very much enjoyed seeing you again and this is the case whenever we meet; why must we live so much apart? As one gets older, genuine friendships are so rare, and artists above all are more isolated than other men. Almost all faces wear a mask and this naturally affects one's feelings. With you I feel at ease, and it makes me happy to tell you so. . . .

<div align="right">Eug. Delacroix</div>

[1] It had been bought by Vacquerie.
[2] The painting for the Apollo ceiling was folded in two in his studio.

1 *May* [1851]

Dear Monsieur,

I did not reply to you immediately because I was unable until yesterday to get together the lithographs of *Hamlet*.[1] I thought I had no complete set left; but I had still kept a certain number of surplus proofs, for some reason. Besides, I was not able to carry out this search as I should have liked: my studio is encumbered by a 24-foot canvas which obliged me to relegate all my portfolios to the attic, and the one in which I discovered these drawings had been long forgotten. To whom should I gladly give these sketches, if not to those that enjoy them? I had only had a few printed, and I had done wisely, for they had no success and by no means recouped me for the expense of printing. I should have sent them to you, if you had not told me that you wanted a talk with me: so I shall be very late in expressing all I wanted to say about what you wrote on me.[2] I read no papers; so unfortunately I hardly ever see anything of this sort, and I readily admit that I regret this very much. It would be most kind of you to tell me how I could get hold of some of your articles. I never thanked you for what you said in your Lenain essay:[3] I ought to have done so two years ago.

Please accept, dear Monsieur, the expression of my sincere devotion.

Eug. Delacroix

ᵉ TO MME DE FORGET

Sunday, 13 [*July* 1851]

My dear,

I was very glad to get your welcome letter; I think your stay will be good for the gastric complaint which has been troubling you for some time: it's an old enemy of yours, from which you used to suffer a great deal, and you must be very careful about it. I myself am so accustomed to these petty sufferings that they've become second nature. Often, even the precautions I take make no difference; at other times, even after infringing my regime, I get off fairly lightly.

[1] The *Hamlet* lithographs had appeared in 1843.
[2] An article in *Le Corsaire-Satan* on the 1846 Salon.
[3] The *Essay on the life and work of the Lenain brothers* appeared in 1850: Champfleury writes on p. 57 of 'the tormented painters', Rembrandt, Theotocopuli (El Greco), Tintoretto, and 'Delacroix, the only contemporary who can be classed with the old masters'.

I am still leading the same life; I'm making headway, thank God, and perhaps I shall not take quite as long as I had thought.[1] You are in the sort of place one dreams of finishing one's days in: there is something of everything at Fontainebleau, and moreover things that are probably found in combination nowhere else. In the first place, the forest and the château. It seems to me that a man who was tired of the vanities of the world, if he retired there, would find many opportunities for enjoyment. I have sometimes thought of doing so: one isn't far enough from Paris to grow completely rusty: one would have plenty of resources for one's health and for one's mind. You ought to buy a little place there, which you could reach in an hour to rest from time to time; a stay in a place like that will do you good. I should certainly like to go and surprise you there if I were not what I am, namely very busy, anxious to finish at all costs, and consequently worn out by midday. Give all my kind regards to the Menneval ladies, I thank them in anticipation for the pleasure you are going to enjoy in their company. Indeed, there's great pleasure to be got from a peaceful life amid the society and conversation of people one likes, particularly in the country, and when one is sure of its lasting for some little time.

Goodbye, my dear, I look forward to seeing you again, whether I drop in on you some day or whether some circumstance happens to bring you back to Paris. Until that happy moment comes, all my love.

E. Delacroix

I'm getting very rusty about politics, I shall have to resort to asking you for news. You were my only contact with the world of the newspapers and the events of the day.

ᦉ TO MME DE FORGET[2]

Tuesday morning
[*postmark* 12 *August* 1851]

. . . You are right when you say I'm fortunate to practise an art in which I find such true enjoyment and interest; but what a price one has to pay to acquire a talent, too often dubious and mediocre, which solaces one at certain moments, and what unhappinesses go with it, of which not a fraction is ever told! Note that you are one of the small number of those for whom we honeybees wear ourselves out! It is in order to please you that we grow sallow and suffer from stomach-ache:

[1] Still on the ceiling for the Galerie d'Apollon.
[2] Mme de Forget was still at Fontainebleau. Delacroix copied out this letter to her in his *Journal*.

you have nothing to do but admire us or, which is far pleasanter, criticise us; and this under conditions which make digestion infinitely easier, since you take rest and exercise whenever you like. You come and go, you rest; but even a haberdasher works like a slave for thirty years of his life only in the hope of resting some day: so you start from the point towards which we slaves strain with all the force of our muscles or our minds. You are safe from journalists and from the envious. If you have an enemy, you can ask him to dinner, and even take the opportunity to make him entertain you.

Come then, my dearest, cheer up a little concerning your own affairs and consider what so many wretches suffer who, far from giving dinner parties, enjoying luxuries and the pleasures that money can buy, lack even the essentials of life; and above all, go and look at the sea. There, for sure, one can never be bored; that's a spectacle of which one can never tire. . . .

ᴄ�𒑷 TO MME DE FORGET

Dieppe, 3 September [postmark 1851]

. . . I find the countryside still so beautiful that I pity you for having finished all your excursions for this year. You know my passion for the sea, and I'm indulging it to the full. I go every morning along the cliffs that overlook the bathing beach, and towards the end of the day I go on to the jetty, if the tide is in, to see the ships come in and out. The smart visitors rather spoil the place for me, I must even admit that it was the sight of these pinched waists and these male and female dolls that made me want to go into some spot unfrequented by such creatures; but I've grown resigned to them. I console myself with the seamen's honest faces and the smell of tar and of the sea. At the rate I'm going I shall soon have to order myself an Armenian outfit like my enemy Jean-Jacques. I shall enjoy telling you my traveller's impressions of this place, which reminds me of that delightful time when we stayed at Tréport. . . .[1]

ᴄᒑ TO GEORGE SAND

Dieppe, 4 September 1851

. . . It's this terrible *Art* which is the cause of all our sufferings, not to mention all the envious and spiteful rascals who look askance at our

[1] In August 1838.

303

wretched works before they're done. Fortunately we do them partly for our own sakes, very little for the sake of posterity, which I haven't the honour of knowing, but chiefly to help us forget our troubles a little. It is difficult to imagine, unless one has experienced it, the sort of labour this great thing[1] has required of me, both because of its exceptional size and because of the state of puzzlement in which I was continually kept by seeing only one section of it at a time. Hence a certain state of languor, a disturbance of the circulation, a peculiar sort of depression about which for a moment I felt anxious. . . .

꙯ TO GEORGE SAND

Dieppe, 9 September 1851

. . . My real trouble, which was a slackening of certain ligaments, made worse by standing for long hours on my ladder, needed this astringent treatment, which may have to be repeated later. One has to submit to such piecemeal demolition of one's frail machine. The truth is that one can accept this more easily the more detached one becomes from things; as long as I go on enjoying my work I shall not greatly regret the rest.

I don't know how long it will take me to retouch my picture *in situ*, after the canvas has been fixed to the ceiling.[2] That space of time, plus a few days for it to be looked at by Pythons of all grades, will take me up to the middle of October, and I'll arrange things so as to idemnify myself for all that I have missed so far. The weather is superb here, in September; I shall be most unlucky if, in your more favoured regions, I don't still find a few fine days in October.

Goodbye, my dear friend, I thought of you a great deal yesterday; I went to see the ruins of the Château d'Arques: there couldn't be a more impressive sight. By the way, you ought to read what the chronicles tell about the famous Ango, a sixteenth-century shipbuilder who gave François I a most kingly reception here and who waged war with his ships on the king of Portugal: you might perhaps be tempted to relate some scene out of his life, as you so well know how to do. He died sad and poor: that completes his story, from a novelist's point of view. I had never heard tell of him.

At which point I send you all my love, looking forward with much delight to seeing you soon.

Eug. Delacroix

[1] The ceiling for the Galerie d'Apollon.
[2] The ceiling was finally shown to the public on 16 October.

10 *October* [1851]

I dared not write to you, dear friend, because I am in the thick of my retouching and it's the 10th already. The work will take me several more days, apart from the time needed for it to dry off a little before being varnished, for it must be displayed to best advantage: and then I shall have to show it to a certain number of friends and bigwigs who must be given priority. All this, although it will take up time, doesn't deprive me of the hope of visiting you at Nohant first: within the next few days I shall write to you again and I shall probably be able to say for certain what I can do. What I am finishing at the moment is a big thing for me just now; people are waiting for it to know definitely whether I'm a painter or a dauber. As you see, the public, and especially those who provide its opinions, are sometimes very recalcitrant: next year it will be exactly thirty years since I first came before them and exhibited my first picture.[1] The fixing of the canvas was wonderfully successful: in itself a masterpiece. As for the picture which, after working on it for six months, I only saw the day part of the scaffolding was taken down, none of my reckoning had misled me; only trivial details needed retouching. People are amazed to see the picture looking just as if it had been made for the place: since it did not make itself, they would be less amazed if they knew what precautions I had taken. You know what trouble the smallest details often give one.

All my love again, and renewed thanks. I am wonderfully well: the sea has worked miracles. Love to Maurice and to your guests. I look forward to seeing you soon, in any case, my dear, but I hope it'll be at Nohant.

Eug. Delacroix

⌀ TO GEORGE SAND

20 [*October* 1851]

Dear friend,

I have finished the Apollo and I'm showing it to friends and enemies: but I cannot leave the field of battle: as the thing is being more successful than I had expected, I must take advantage of it, and that immediately, in pursuit of a further commission, which would be another important place to decorate.[2] So I shall not be able to visit you

[1] *Dante and Virgil in the Inferno*, shown at the 1822 Salon.
[2] The Salon de la Paix at the Hôtel de Ville.

at Nohant! Is it ever possible to enjoy unalloyed satisfaction? What increases my regret is that the weather has been magnificent and may go on being so, and that I'm exhausted with keeping my nose to the grindstone for the past six months or more. I'm particularly anxious, my dear, that you should realise how much I shall miss the pleasure of seeing you in circumstances so different from here in Paris, where we only get passing glimpses of one another. See what an odd race we artists are: for more than a year now I have toiled over this picture or its preparation far harder than any galley-slave, for my mind was chained to it as well as my body: all so that thirty Parisians might talk about it for a couple of days: and now all I want is to climb back up my ladder, after cursing it a hundred times.

You are very kind, or else your publisher is: I have just received your latest instalment,[1] and send all my thanks. I embrace you and beg you to forgive me.

<div align="right">Eug. Delacroix</div>

↪ TO J.-B. PIERRET

Wednesday morning
[*postmark* 12 *May* 1852]

My dear friend,

I got back last night[2] and found an invitation to a grand banquet at the Hôtel de Ville[3] for *Friday*. Now (you see I have a good memory) I remember we were to dine together that day. The fates have conspired against our meeting. Would you put it off until Sunday or any other day of the week you like. Can I remind you of some small things I asked you for, *half-a-dozen* cakes of common soap (I rather like the pale yellow sort, like Windsor soap) plus another half-dozen cakes of finer quality soap, *Jasmine* and *Patchouli*. Plus one litre of *ordinary eau de Cologne*. What a lot of requests! Please forgive me, and write me a line about it. I've had a week of fine weather, which I enjoyed tremendously but which somewhat put me off work. One should never desert one's task.[4] That is why time, and nature, and indeed whatever labours slowly and unceasingly, achieve such good results. We who work intermittently never spin the same thread to the end. Before I left I was producing the work of M. Delacroix, as he was a fortnight ago: now I'm about to start the work of the Delacroix I shall be

1 George Sand's *Works*, illustrated by Johannot, was appearing in instalments.
2 From Champrosay.
3 In honour of the president of the Republic.
4 The end of this letter is reproduced in the *Journal*, 12 May 1852.

tomorrow. I shall have to pick up the stitches, and the knitting may be slacker or tighter.

Looking forward to a good chat with you,[1] I send you my love.

<div align="right">Eug. Delacroix</div>

ও TO M. VARCOLLIER[2]
Champrosay, 7 July 1852

. . . In the evenings I visit some of my neighbours, or else I go for walks to enjoy the coolness. In the mornings I work as regularly as in Paris, and although my paint is dry before the end of the session, I stick to it! I keep boredom at bay and I have no time for gloomy thoughts. Such is the life I am leading, and I should be very happy to prolong it, just now particularly; the prospect of working in my Paris studio is a real bugbear, and yet I can't run away from it. *Dimicandum*, that's the brave device which I have made my own, from necessity and indeed from inclination too. I add to it another: *Renovare animos.* To keep on passing from serious matters to pleasurable ones, from the town to the country, from society to solitude, until at last one passes from being *something* to being *nothing*! But then, whatever Hamlet may think, in that sleep of death no dreams will come to convey the illusion of movement, and incomparable Nature wisely provides another sort of renewal as she flings us all into one great whole, heads, arms, bellies, minds, feelings, base natures and noble spirits, to produce therefrom, unendingly, a fresh series of living forms, and bring fresh youth to the great eternal spectacle. Let us die, but let us live first. Many men worry about life after death, and do not dream. Here and now, how many men dream, in your opinion, not to mention sleep and sickness! How much of our life is spent in pastimes degrading to the mind, in smoking or watching tedious entertainments that take up room in one's life without occupying it in a manner worthy of man! Many men who have never tried to live say that they have no more time left, and fall back on to the pillow where they loll without enjoyment. One must keep constant watch over oneself, for laziness entices one at every moment; one must fight therefore, or die a squalid death.

Goodbye, my dear friend, that's quite enough in this weather. I felt a promising inspiration, and I broke off short—probably from laziness. God preserve you from that mental rust. But your mind is not one of those that go to sleep, and even when maddened by the sufferings that keep it awake you are like Voltaire's brahmin, who would not be like an animal. . . .

[1] An untranslatable pun: *en attendant que nous tricotions ensemble des mâchoires.* . . .
[2] Head of the Fine Arts section at the Préfecture.

ej TO GEORGE SAND

2 *September* [1852]

Dear friend,

A thousand thanks, a thousand heartfelt congratulations, for the delightful evening and the little masterpiece I enjoyed last night.[1] You still think from time to time of a horrid ungrateful creature who never gives you any token of his existence and who never asks you whether you exist, and you show him that, as far as your mind is concerned, you are very much alive. Thank you once again; you'll be pleased with the way it's acted, and with the response of the 'decent folk' who filled the house. There wasn't a single 'newshound' to be seen hanging about the lobbies or sneering in the stalls or elsewhere. Their resentment against you proves, at any rate, that you are unlike them. Impotence and insolence, terms which should be irreconcilable – that's the stigma with which I hope some future code, in some third heaven still to come, will brand them at each fresh tirade. People of this sort really believe that they make you, that you are their work, that it is their kind recommendation which, holding you in leading-strings, has gradually opened for you the doors of the temple into which they never enter, and they have no intention of giving up control except to abandon you to your own resources when they produce fresh candidates for glory, to whom of course they will sacrifice you, or so they fancy. So you had warned nobody; the thing was a bombshell. The good captain,[2] who was present, told me he was as surprised as I was. I saw Solange, who told me to my astonishment that you weren't here and were not coming just yet. So you'd put Maurice in charge of producing the play? If he sees a great deal of these delightful actresses he'll probably end by running off with one of them. As for my own affairs, I've done an enormous amount of work these past five or six months:[3] I've not had time to stir, for I have been set an irrevocably fixed date, which drives me wild and at the same time makes me live happy. I've been advised to go back to the seaside for a fortnight, for I'm growing old and I need bracing up, and I probably shan't go. Every evening I am like a man who has gone ten leagues on foot and next morning I wake up eager to rush back to look at yesterday's productions: I find the poor things still damp from my kisses; more often than not I feel I've bungled them, sometimes I'm satisfied; and so I carry on, painting and correcting and then repainting, and when

[1] George Sand's comedy, *Le Démon du Foyer*, first performed at the Gymnase theatre on 1 September. It contains a sharp attack on journalists and critics, which they repaid in kind.
[2] Captain d'Arpentigny, a friend of George Sand.
[3] On the Salon de la Paix at the Hôtel de Ville.

I get to the end, if I ever do, I shall want to begin again; for in this world, when one's got no more princesses to elope with, one has to work or else die of boredom.

Goodbye, my dear, with all my fondest love to you who have always been for me goodness itself, indulgence and devotedness. I'm trying to repay you as far as in me lies, and I hope to do so until the end of my life.

Goodbye once again, and rejoice in your success.

Eug. Delacroix

ᴖ TO MME DE FORGET[1]

Dieppe, 13 September [postmark 1852]

My dear,

I am staying on here rather longer than I had intended.[2] So I'm sending you some news from the seaside to amuse you. I should have returned home earlier but for the persistent bad weather, which hardly let up during the first few days. I've been promised moreover one of the highest tides of the year for tomorrow, Tuesday, I couldn't resist that, particularly as, now I am used to it, I enormously enjoy this lazy life, whereas the first few days I nearly ran away from boredom. You don't like Dieppe, you'll probably explain my eulogies of my stay here by the need for rest which had become imperative for me. I find, for my part, that there is variety enough here; one can choose between society and solitude, although to tell the truth the latter privilege is the rarer. The first few days my boredom was largely due to my terror of meeting boring people; so that I got bored for fear of boredom. In fact this taught me a little lesson, which is truer than it seems. I learnt that neither constant solitude nor constant distraction will do for the man who wants to spend his life as pleasantly as possible. The two must be intermingled so as to succeed one another, and so that one is always longing for that state in which one is not. So one must always be wanting something, or hoping for it. When one can hope for the thing one longs for, one has all the sum of happiness to which we – machines endowed with thought – are entitled. To obtain what one has longed for is already a step down towards anxiety and uneasiness and, further down still, towards depression and even pain. There's no way out of it.

The sea still delights me: I stay for three or four hours at a time on

[1] Addressed to her at the Hôtel de la Sous-Préfecture, Compiègne, where she was stay-ing with her son Émilien, *sous-préfet* of Compiègne.

[2] He stayed at Dieppe from 6-14 September. See *Journal.*

the jetty or on the shore at the foot of the cliff. I cannot drag myself away from it. If I could live like this for some time, provided I also had something interesting to do, I should keep very well. For the past few days I have been eating luncheon; I've been speaking less ill of mankind and the times we live in; I wake up quite cheerful, a notable symptom, and not dreading the burden of the day that lies before me: in short I'm close to becoming like anybody else. To be like everyone else – that's the true condition for happiness. Sea air and mental distraction are working this miracle on me: what you need is just the contrary: you're dying of boredom through what comprises most people's happiness – having nothing to do. You need the opposite remedy to mine: and I'm speaking in dead earnest; one's got to be driven, to be chained to some task; unless one's a drunkard or a mindless brute, one is bound to be bored if one has not found the secret of making distraction desirable. . . .

ᴔ TO GEORGE SAND

7 December [1852]

My dear friend,

Your kind letter reached me when I was still suffering from an indisposition due as much to disappointment as to extreme fatigue. The hall in which they have put up my paintings[1] is the darkest spot you can imagine: I had to carry out such extensive alterations on the spot that I got quite ill from vexation at lack of time and excessive effort. Yes, my dear, I'll send you something, and something that you had already liked when you saw it in its early stages. It's a small surprise I had prepared for Maurice and yourself. You must allow me to send a New Year's gift to the boy, whom I love as much as I love yourself. The subject is one of which you already have a pastel or a watercolour: *Lélia in the cave.*

I have lived all this year in a state of constant overwork: this is the second year it's been going on, and see what time does to one; ten years ago I should not only have raced through this task but have finished it in time. In youth one is always self confident: later on one must reckon with rheumatism, or rather with capricious fortune, who deserts one, favouring the young rather than the bold, whatever the proverb may say. Fortune is like public opinion, friendly only towards beginners.

Congratulate Maurice for me on his engravings in the latest instalment of the *Meunier d'Angibault.*[2] He will very quickly acquire

[1] The Salon de la Paix at the Hôtel de Ville.
[2] In vol. IV of the illustrated edn.

the skill that publishers require and yet retain a charming natural inventiveness which the worthy Johannot[1] lacked. I'll arrange to have my little present sent at the right time. Let me kiss you in anticipation, my dear friend, whom I remember so fondly and with such pride and joy amid the loneliness in which I spend my life. The sight of a letter from you is a ray of happiness and this has always been so: never the least trace of bitterness has spoiled that pure feeling; you accept me with all my quirks, which are the result of my wretched health and nerves, and you recognise through it all the deep feeling that binds me to you. . . .

♪ TO PIERRE ANDRIEU[2]

6 *January* 1853

. . . I am up to my neck in small pictures. Having gone some time without working I have been seized with a furious urge to paint, which I'm venting on small canvases:[3] this keeps me occupied and at the same time relaxes me after my major tasks. I still feel rather resentful against large-scale painting, to which I owe my last disappointment:[4] so I don't expect to settle down again quite yet to such work. On the one hand I should like to do something for the Salon;[5] on the other I shall not be able to work at the Hôtel de Ville until the celebrations are over;[6] which will bring us to the end of March. What vexes me exceedingly is that whereas you are free now, the time for your return to Belgium may coincide with my resumption of those major tasks in which you are so indispensable to me. I shall try to arouse the goodwill of M. Romieu;[7] if between now and the end of the month he could arrange for you to make a copy, it seems to me that by leaving at the beginning of February you would still have some tolerably fine days and at least two months of work. Unfortunately I anticipate much difficulty in securing this favour; but I'll do my best. If you have something else to do in Belgium on your own account I

[1] Tony Johannot, who had contributed illustrations to the *Complete Works*, had died the previous August.
[2] Delacroix's pupil in 1844 and since 1850 his devoted collaborator.
[3] Delacroix painted a large number of small pictures this year.
[4] The repainting *in situ* of the pictures he had done in his studio for the Salon de la Paix.
[5] The 1853 Salon showed three small paintings: *St Stephen*, *The Pilgrims of Emmaus*, *African Pirates*.
[6] In honour of the Emperor's marriage, 29-30 January.
[7] Romieu was then director of Fine Arts. Delacroix saw him on 7 February; see *Journal*.

311

think it would be to your advantage to leave in February or even before. At the moment I am at work by half-past eight at latest, and I work until three even on dark days. In a month's time you can easily go on until after four, and I believe the museum at Antwerp does not stay open later than that. You'd have made good use of your time and it would leave you a certain latitude for the summer. Between now and then you could go to Tours to the General's.[1]

Give careful thought to these various ways of getting round the difficulty. Many thanks for all the kind things you say about my Bordeaux show.[2] I am very glad you liked my pictures. It's my misfortune to lose all feeling for them once they are out of my studio, so that I am very happy when they meet with approval, particularly when the people who approve are, like yourself, not given to empty compliments.

Remember me kindly to your uncle,[3] and make him my apologies for not having written. I am working really very hard just now and find it difficult to do anything other than my painting.

P.S. Jenny thanks you kindly for your message and sends her respects.

ꜱ TO MME LA BARONNE DE MAUPOINT
(*née* IRÈNE CERVONI)[4]

28 *March* 1853

I am the first to suffer from my shocking laziness about writing, since it deprives me of hearing from you often and of reviving, in conversation with you, the delight of childhood memories. I am the more to blame, and my own enemy, in this matter, since living isolated as I do my mind dwells far more on the past than on what I see around me. I have no sympathy with the present age, the ideas that thrill my contemporaries leave me absolutely cold, my memories and all my predilections are for the past, and all my study is directed towards the masterpieces of bygone ages; it's lucky, at any rate, that with such leanings I have never contemplated marriage. I should certainly have appeared, to a young and charming woman, infinitely more bearish and misanthropic than I seem to those who only meet me casually.

[1] General de Courtigis.
[2] He had sent five paintings to the exhibition of the Société des Amis de l'Art in Bordeaux, 15 November 1852: they included *The Prisoner of Chillon, Hamlet and the Gravedigger, A Jewess with a Moorish woman, Arab horseman crossing a stream.*
[3] The curé of Villeneuve-lès-Bouloc.
[4] The orphan daughter of General Cervoni had been adopted and educated by Delacroix's mother.

P.S. I am reading with great delight a very old book which I hadn't read, or had forgotten, Lesage's *Bachelier de Salamanque*. Read it, or re-read it, you'll see how far behind it leaves all our men of genius.

E. D.

cℑ TO MME DE FORGET

Champrosay, Wednesday morning
[*postmark* 11 *May* 1853]

My dear,

I am established here in the midst of fresh young greenery, but the weather seems unable to stay definitely fine. Yesterday it was magnificent, but this morning it's unsettled, and the day before it was grey and even wet. I enjoy being in the country nonetheless. Of course country life may lead to depression and even to boredom, which is perhaps worse; but that's when one has no occupation, even a tiring one, to make one's moments of relaxation seem more delightful. I pity those people who go into the country with the sole purpose of amusing themselves all day long. This makes it quite clear to me why so many people would rather be bored in Paris than in the country: in Paris one is involuntarily distracted, even if one's not entertained.

Here I am provided with an excellent reason, and a wearisome one, for finding the country entertaining: this is the terrible article whose scattered pages I see on my table.[1] I'm sweating blood to stitch it all together and I think it's because I'm obliged to do it that I find the job so tedious. I'm following your advice: I won't touch a paintbrush until I've got it into tolerable shape; perhaps that's the only way to get through it.

... I don't see a soul here: I don't shave, I'm getting quite close to the state of pure nature. By the way, I've been eating a little luncheon since I've been here; perhaps I shall modify my regimen, and I shall be very proud of that. I felt humiliated at not being like everyone else. That's the best course to take in this world when one doesn't want to be persecuted.

Goodbye, my dear one,

E.

cℑ TO MME DE FORGET

Champrosay, Monday [*postmark* 16 *May* 1853]

... I am sticking to my plan of not painting, but the article,[2] although it's progressing, is only progressing very slowly: I always need great

[1] The article on Poussin which appeared in *Le Moniteur Universel* on 26, 29 and 30 June 1853. Reprinted in *Œuvres littéraires*, ed. Élie Faure, II, 57.
[2] The Poussin article.

strength of mind to get down to it. I'm not bored, that's the chief thing: I lounge about, I look out of the window at my view, which has a wonderfully calming effect on one's eyes and one's mind, so peaceful and pleasant is the countryside. I watch the trains passing, I watch the boats going up and down the river and if I haven't such a lively scene before my eyes as in my other house,[1] which looked on to the street where people of every sort kept coming and going, I find this quiet outlook more conducive to rest and contemplation. . . .

<p style="text-align:center"> ♭ TO CHARLES SOULIER
at Saint-Mammès</p>

<p style="text-align:center">19 May [1853]</p>

Poor dear friend, how I've neglected you, and yet you harbour no resentment! Your kind letter, while reminding me how badly I've behaved to you, delighted me nonetheless. You know how slackness leads one to postpone doing what one ought, and don't imagine that any important business of mine made me forget you, after your kind letter early this year. I don't attend to my own business, and as little as possible to other people's. The longer I live the more unbearable I find both of these, and the more absent-minded I become. My thoughts have often sped towards you; electric wires would be very convenient for this, if it were possible to fasten one mind to another mind we could give each other pleasant little shocks without being obliged to dip our fingers in the ink. I think of you particularly every time I see that unfortunate Pierret, whom I should like at all costs to see living in the country, considering the state he's in. Although he has got his pension and is so ill, he still clings to those Paris streets along which he has walked for the past fifty years, he needs his bit of gossip every evening and his newspapers which somebody has to read to him, since he can no longer read them himself. I imagined that if he had rented a cheap little place near you he would have had, into the bargain, fresh air and sunshine, birdsong, a little of that nature which is so sweet to those whose strength is failing, and to crown it all the company of a friend like yourself. But the unreasonableness and the singular obstinacy which prevented him from getting well when there was still time, by giving up his work, still prevent him from adopting so simple a means of making life easy and pleasant. Another inexplicable whim was that which made him send for his son back, just as he was reaping the reward of his exile, without being assured of a job, which he certainly hasn't got and which could hardly be as good as the one he had.

1 He had just moved to another house at Champrosay, which he was later to buy.

You thank me for replying to your poor sister with a few words of consolation. Her letter moved me and awakened memories of those days of our youth, of which she herself speaks, when we used to go to St-Germain together. She writes of you with the greatest affection, and I gather from you that she is in very straitened circumstances, of which her own letter did not complain. How could I have failed to answer her with alacrity?

I am working, as you say, and this is my sole pleasure. I get as much satisfaction now from living alone as I used to do from a busy social life. I still fret and fume as much as ever, but I am more easily comforted now and besides, the need to fret about something every day seems to me as much a natural law as living in the water is for a fish, so that I am prepared beforehand for the annoyance which is coming after the one I've just got rid of, or for enduring them both at once. The great annoyance, which is the most difficult to remedy, is bad health. Thank heaven, and thanks to a little self-restraint, mine is better than it used to be, without being entirely satisfactory. On the days when I don't work I am greatly to be pitied, as well as on those when I am dissatisfied with my work. . . .

ᴄ⁀ TO CHARLES SOULIER
at Saint-Mammès

Wednesday morning, 14 *September* 1853

I have this minute received your very nice letter, my dear fellow, and I'm writing at once to tell you how much pleasure it gave me. Come, by all means; let's see one another again. You're right: one should snatch at every passing happiness that life still offers at our age. I think of myself as a sheep shut up in its fold, allowed to graze on some meagre provender here and there until a mighty hand carries it off and puts an end to it. So I enjoy these little windfalls, until the time comes when we have to leave it all. Sometimes I wonder if it's really possible to enjoy something whose imminent end one foresees; but after all that's the rule, and as you say we must consider ourselves luckier than Cottrau[1] and poor Ronzi.[2] She must have found some consolation, or some preparation, for the end in the fact that her beauty had predeceased her. In that respect nature does not take us by surprise; she gives us unmistakable signs that we're no longer good for anything, before dealing us the knockout blow which we probably don't feel.

[1] Félix Cottrau (1799-1852) a painter and an old friend, had died in December 1852. The *Journal* has an unflattering reference to him.
[2] Mme Ronzi, an Italian prima donna whose beauty had much impressed Delacroix and Soulier in their youth. See letter of 24 November 1820.

I have played truant lately and spent a whole month in the country, although I had a great deal to do; now I shan't budge. So you'll find me at my post, and we'll drink a bottle together to the success of your young warrior. I congratulate you on having fixed up both your boys; they've each got a good job, and it's so important to start off on the right foot. The rest follows naturally. Not having the honour of being a father I cannot have a complete idea of the feelings involved in this situation. Yet I think I can imagine the satisfaction to be derived from the thought of providing one's children with a good situation. One must be constantly haunted by the thought that ne'er-do-wells who have made a wrong start in the world, and yet who are your progeny, are going to get into all sorts of trouble through their own fault or that of their bad beginnings.

You must lecture Pierret on the folly of sticking to his post too long. I am not satisfied with his reason; if he retired now and went to live in some quiet place, I'm convinced he would enjoy a long life; but the smell of his documents has gone to his head and will play some nasty trick on him.

As for yourself, I am sure that your life in the country, apart from the inevitable moments of boredom, must have saved you, particularly in your recent illness, and that the open air and rural surroundings will keep you going for a long while yet. . . .

<div align="right">Eugène Delacroix</div>

༄ TO GEORGE SAND

<div align="center">Thursday evening [24 November 1853]</div>

Dear friend,

I shall be happy to go and hear your *Mauprat*,[1] but all by myself, like a bear, being exhausted in the evening after my day's work, and delighted to collect my thoughts in peace, watching something I like. If then you'd have the kindness to send me a ticket I should be very glad. You are well, since you're working; we'll go on working until our last gasp; what else is there to do in this world, except get drunk, when the time comes when reality falls short of our dreams?

My fondest love, dear friend, until I see you again. Maurice has done a pretty thing in *La Dernière Aldini*:[2] a little woman walking down a garden path that I seem to recognise as the covered walk at Nohant.

<div align="right">Eug. Delacroix</div>

[1] First performed 28 November. See critical comment in *Journal*.
[2] In vol. VI of George Sand's *Complete Works*.

<div align="center">316</div>

↵ TO FRANÇOIS BULOZ[1]

25 *November* [1853]

My dear Sir,

Please forgive me, as being a man overwhelmed with commitments but sincerely anxious to do what would please you. Since I shall find it impossible, for some considerable time, to undertake literary work of any length or continuity, I could from time to time let you have disconnected pieces of criticism, such as you may have seen recently in two numbers of *L'Illustration*.[2] They had been inserted without my knowledge, although they are in fact by me. The thing might be called *Critical Letters and Reflections*. Not being a professional writer, I cannot sit at my desk long enough to produce a lengthy study, and besides I consider that everything people write, *without exception*, is too long. I shall at least have the advantage of not being a long-winded bore. I think that I show far more liveliness and spirit in short sallies, where I am careful to speak only of the things I believe I know about.

I am unwell at the present monent, and being nonetheless obliged to work during the day, I go to bed very early in the evening; but in about a month's time I hope to be somewhat freer, and I shall be very glad to go and see you from time to time on Saturday evening. I had forgotten which day you were at home. . . . When that time comes, I shall take Planche[3] along with me to look at my work,[4] and we'll talk about it for as long as necessary. He wrote a good article on Cousin for you.[5]

Eug. Delacroix

[1] Editor of *La Revue des Deux Mondes*.
[2] Two articles, .29 October and 5 November 1853, extracts from Silvestre's *Histoire des artistes vivants*, consisting, in turn, of extracts from Delacroix's *Journal*, copied by Silvestre and printed in *L'Illustration* without Delacroix's knowledge.
[3] Gustave Planche was the official art critic of *La Revue des Deux Mondes*.
[4] At the Hôtel de Ville.
[5] *La Revue des Deux Mondes*, 15 November.

PART IV

The Last Years
1854 - 1863

Paris, 7 March 1854

Dear Sir,

I am doubly indebted to you, for introducing me to the process of photographic etching[1] and also for procuring me the acquaintance of M. Cuvelier. The kindness with which he supervised my very imperfect attempt made me very happy. Moreover he will have told you that my eyes were in such a pitiable state, due to the strain of painting the ceilings,[2] that I found even a few moments' concentration extremely tiring. I only needed to rest them, or so I hope, and thanks moreover to the ointment he has kindly sent me, my cure, with God's help will be complete. I much admired, too, the fine photographic proofs he showed me; he was so very kind as to let me keep some and promise me others, of those that interested me most. How sorry I am that this admirable invention should have come so late, as far as I am concerned! The possibility of making studies from such results would have had an influence on my work which I can only guess at from the use I can still make of them, even in the limited time I can devote to detailed study; photography provides a palpable demonstration of nature's true pattern, of which otherwise we have only the most imperfect ideas.

I have only just finished my work at the Hôtel de Ville, because of the retouching I was obliged to do to the paintings, through having failed to reckon with their effect in artificial light. You will tell me on your next journey what you think of it all: your opinion, dear Sir, is one of those I value most. I expect this summer to get down seriously at last to my work at Saint-Sulpice, which had constantly to be postponed on account of urgent commitments such as the Louvre ceiling and this latest job at the Hôtel de Ville. In any case, whatever I happen to be doing in the way of painting gives me such pleasure that it comforts me for all the ills, great and small, that life incessantly offers. Living alone, and deprived of great joys, but also free from the sometimes excessive griefs which one suffers through members of one's family, I have plenty of time to give to that art which will delight me as long as I live. I should like to have many such judges as yourself, even if they should condemn me; unfortunately everything Gothic is in such favour nowadays that the painting we love is in great danger of being completely neglected. . . .

[1] *Cliché-verre* or glass prints, a process whereby the emulsion side of a photographic plate is scratched with a metal point, the resultant negative image then being printed as positive on photographic paper.
[2] At the Salon de la Paix.

ε⅃ TO THÉOPHILE SILVESTRE

[*April* 1854]

My dear Sir,

Please accept my sincere thanks for the first instalment of your study of myself,[1] which you have been kind enough to send me; you know that with my unsociable nature I was scared of so many details. Allow me just to say that, in spite of your very kind intentions, I am afraid you may have seen more in me than is really there: am I in fact the man you describe? In that case, I have not yet attained the *nosce teipsum* of the Ancients. What do you really think of Masson's reproduction,[2] and of the impossibility of finding draughtsmen in a period when the production of these seems to be the public's main concern? Photography at least has its unquestionable advantages, side by side with its drawbacks.

ε⅃ TO MME DE FORGET[3]

Champrosay, 15 *April* [1854]

My dear,

The weather, as I write, is extraordinarily fine, so fine as to distress everyone – the earth itself, in the first place. I must say I cannot remember ever seeing anything like it at this time of year; the good farmers are in despair; the grass in the forest is as dry as in the August dog-days, and they're anxious about their crops. I myself derive nothing but enjoyment from the cause of this anxiety; but I would gladly sacrifice the pleasure I get from this brilliant sunshine for the sake of other, more positive advantages. To consider only the point of view of one's pleasures, the leaves don't grow, which spoils the landscape and deprives us of the shade we badly need in this intense heat.

I am working at my painting[4] and not, for the moment, inspired by literature.

I must tell you, for your edification and to increase my own claim to respect, that before I left I received my Academician's diploma from

[1] Silvestre's *Histoire des artistes vivants français et étrangers* appeared in instalments, in two editions, folio with photographs, and quarto with wood engravings; an octavo edition of the study of Delacroix, without illustrations, appeared in April 1854, and is here referred to. The studies of various artists were collected in one volume and published in 1856.
[2] Portrait of Delacroix engraved from a photograph and included in Silvestre's study.
[3] This letter is copied in the *Journal*.
[4] At the following paintings: *Lion stalkers, Clorinda, Hamlet having killed Polonius*.

Amsterdam, adorned with the arms of the Netherlands and with all the requisite paraphs; only I cannot understand a single word of the letter that confers on me this high honour from a foreign land. I shall have to go to Holland some day to have it read to me. In the meantime I walk about with a certain self-satisfaction, convinced now that I have not entirely wasted my labours in this world. . . .

ℰ TO GUSTAVE PLANCHE
9 *May* [1854]
Dear Sir,

It was only on my return from the country two days ago that I read your kind article[1] about my work in the Hôtel de Ville. This made me very happy, and I must hasten to express my thanks. I do not know whether my illustrious fellow-worker on the ceiling[2] will be as pleased with your appreciation as I am myself. I entirely agree with you that cameos are unsuitable to be turned into paintings, and that there is a right place for everything. I also think you were quite right to point out the absurdity of showing nothing, at the Hôtel de Ville, which bears any relation to the Hôtel de Ville. Mars, the Muses, Napoleon in the clouds, have in fact nothing in common with what goes on in a municipality, and a considerable part of the decoration might have been devoted to the latter theme.

I am, dear sir, your most grateful and respectful

Eug. Delacroix

ℰ TO MME DE FORGET
Thursday morning [15 *June* 1854]
My dear,

I accept your invitation with the greatest pleasure.[3] I have had a great deal of sorrow since I last saw you. I have lost my poor dear friend Pierret,[4] whose death had indeed been expected but happened suddenly. You can imagine all that this brought about with it. Another old friend of mine[5] died at the same time. I shall be very happy to spend a few moments with you to take my mind off my sorrows. Take good care of yourself, my dear, and keep as well as you can for the sake of those that love you.

Goodbye, my dear, until Friday.

[1] In *La Revue des Deux Mondes*, 15 April.
[2] Ingres.
[3] See *Journal* for a reference to his dinner with her, 16 June.
[4] Pierret died on 8 June.
[5] Horace Raisson, a friend of his youth, died the same day as Pierret.

323

৬ TO LÉON PEISSE

31 *July* 1854

Dear Sir,

I have just returned from a journey[1] which prevented me from replying any sooner to the letter you so kindly wrote me. I am grateful to you for your considerate offer to correct any mistakes there may be in M. Silvestre's study.[2] I am almost embarrassed at the flattering way in which he speaks about me in countless respects. He may perhaps have over-stressed, and this is my opinion, certain characteristics that smack a little of fanciful painting; but on the whole I have too much to be pleased with to find much fault with the point of view he has adopted, which after all is his own; as regards factual accuracy, he makes one mistake in describing me as living in extreme poverty after having spent my early years in easy circumstances. I was never reduced to such straits, and I have never taught in schools or elsewhere.

I can only specify, among the pictures I intend to show in the forthcoming exhibition,[3] a large *Lion hunt*; I have not decided on the others, if indeed I am in a position to show any.

The picture of *St Stephen*[4] is in my possession; the *Pirates*[4] in that of M. Moreau, a stockbroker; the *Pilgrims of Emmaus*[4] belongs to Mme Herbelin.

I remain, dear Sir, your most sincerely grateful and respectful

Eug. Delacroix

৬ TO MME DE FORGET

Dieppe, 25 *August* 1854

My dear,

I am very late in writing to you; I was bandied about from one lodging to another before finally settling down. Here I am at last on the Quai Duquesne, with a seascape all around me:[5] I can see the port and the hills towards Arques: it's a delightful view, and its variety provides me with constant entertainment when I stay indoors: as usual I don't see a soul and I avoid going where I might meet boring people. I came across two or three when I first came here; we promised, we even swore to see each other again, but since I never set

[1] He had actually been back (from Augerville) two months.
[2] The study which later formed part of the *Histoire des artistes vivants.*
[3] The 1855 exhibition.
[4] Shown at the 1853 Salon.
[5] See plates 39*a*, 40.

foot in the establishment which is everybody's meeting-place there is every likelihood that I shan't run into them. I resorted to my usual standby for avoiding boredom in idle moments: I borrowed one of Dumas's novels[1] which makes me sometimes forget to go and look at the sea. It has been superb, ever since yesterday: the wind is getting up and we shall have some splendid waves. I pity you for having finished your holidays already, whereas mine have only just begun: but you are fonder of Paris than I am. Out of Paris, I feel more of a man; in Paris I am merely a *gentleman*. There you find only ladies and gentlemen, in other words, mere dolls. Here I see sailors, farm workers, soldiers, fishmongers. The lady visitors are all elaborately dressed in the latest fashion, contrasting with the fishermen of Pollet in their heavy boots and the short-skirted Normandy peasant women, who are not without a certain charm, in spite of their headdresses which are like cotton nightcaps.

I enjoy excellent cooking: they have in my lodging an oven something like yours and I've developed a passion for everything that comes out of that oven: as for the fish and oysters, the crabs and lobsters, they are incomparable. You get only rubbish in Paris by comparison. As you see, I'm wallowing in material delights; I find everything, even down to the cider, excellent. I sometimes get bored at having no continuous occupation: the little drawings I do now and then are not enough to keep my mind busy: then I pick up my novel again, or else go down to the jetty to watch the boats coming in and out.

Such is the life I shall go on leading for a little while longer; I shall no doubt make a few trips into the neighbourhood, but my headquarters will still be on the Quai Duquesne: that's where you would be very kind to send me news of your dear self, and from where I hope to write to you again before I leave. One's got to exorcise the phantoms that haunt this wretched life which, for some reason or another, has been thrust on us, and which turns so easily to bitterness unless one faces its boredom and its troubles with steely resolution; one must shake up one's body and mind, which consume one another in torpid stagnation. One should change over completely from work to rest and *vice versa*: then they appear equally pleasant and salutary. The poor wretch who is overburdened with arduous tasks and who works without respite is no doubt horribly unfortunate: but the man who is obliged to amuse himself all the time gets neither happiness nor even tranquillity from his pleasures; he is conscious of combating that boredom that has hold of him by the hair: the spectre always stands close to the amusement and peers over its shoulder.

Don't imagine, my dear, that because I do my stint of work I

[1] *Le Vicomte de Bragelonne.* See *Journal.*

am safe from that terrible foe: it's my conviction that a man with a certain type of mind would need inconceivable energy never to be bored: the pleasure I take in holding forth to you on this familiar topic is proof that whenever I've the strength I eagerly seize any opportunity to occupy my mind, even by talking about that enemy whom I'm trying to exorcise. I have almost always, all my life, found time too long: I attribute this partly to the pleasure I almost always find in my labours. The so-called pleasures that succeed them fail to provide sufficient contrast with the fatigue induced by work, which most men, as far as I can see, find far more painful. I can easily understand the delight that rest provides to all those men we see around us, burdened with tedious tasks: and I don't mean only poor folk toiling to earn their daily bread: I mean lawyers and office workers, swamped with their musty papers and constantly involved in other people's business; it's true that most of such people are not overburdened with imagination: they even find their mechanical tasks as good a way as another to fill up their time. The stupider they are, the less they suffer.

I conclude by comforting myself with the axiom that it's having too lively a mind that makes me bored, which is not the case at present since I'm writing to you; on the contrary I've just spent a pleasant half-hour talking to you, my dear, and telling you all this nonsense which, in its turn, may enable you to spend five minutes with some enjoyment by reminding you of my genuine affection for you.

ꙮ TO MME DE FORGET

Augerville-la-Rivière,[1]
nr Malesherbes (Loiret), 27 October 1854

My dear,

I have been here since Monday, and this is the first day the weather seems to have relented and granted us a little sunshine. . . . The company here is invariably pleasant, but we are not so large a party as last time I came. M. Batta,[2] who was one of its chief ornaments, and the princess[3] are missing; this deprives us of some excellent music. Batta was here when I arrived, but he was obliged to leave suddenly . . . M. Berryer makes up for it all by his excessive kindness to me. When the evenings were devoted to music, which he loves, our attention, like his, was concentrated on this sole occupation; now that we are

[1] See plate 39b.
[2] Alexandre Batta, a well-known cellist of Dutch origin, was a frequent visitor at Augerville.
[3] Princess Czartoriska, a friend of Chopin's.

deprived of it he treats us to an inexhaustible flow of fascinating recollections, told in the most amusing manner, and I think I am the gainer by the exchange. If the weather were to improve I should ask nothing better than to go on living thus for a long time; but one must be sensible. . . .[1]

E. D.

ᣔ TO FRÉDÉRIC DE MERCEY[2]

26 *March* 1855

Dear Sir,

I should be very glad if you could appoint a time, as early as possible, when you can find it convenient to come to the exhibition.[3] I will come there myself in order to arrange with you for my pictures to be suitably hung. I had been encouraged to hope for room in the halls which are entirely devoted to MM. Ingres and Vernet. I am far from disputing the privileges due to age and talent. But I am myself neither young nor unknown. It is not right that I should have brought large pictures from the depths of the provinces at great expense and trouble only to show them here in an unfavourable light. Moreover I am anxious that all those patrons who have kindly put their pictures at my disposal, in spite of the length of the exhibition and the risk incurred by showing them here, should see them honourably hung.

I should be much obliged, dear Sir, if you will grant me the appointment I have taken the liberty of asking for. With my sincere respects,

Eug. Delacroix

ᣔ TO PAUL HUET

21 *April* 1855

My dear friend,

I think you will be pleased to hear what pleasure I got from your pictures at the exhibition. Your big *Floods at Saint-Cloud*[4] is a masterpiece, and crushingly shows up the fashionable cult for superficial effects. Your *River*[5] is equally striking, and all three of your pictures are so hung as to enhance one another. I hope you will be pleased with what everyone will tell you about them; for my opinion concurs with that I have heard expressed by all who have seen them.

[1] The visit is described in the *Journal*, 23 October-7 November 1859.
[2] De Mercey was now head of the Fine Arts Section in the ministry.
[3] The Exposition Universelle, at which he showed thirty-five paintings.
[4] Bought by the State in 1857, now in the Louvre.
[5] The *Sunset at Saint-Port*, now in the Louvre.

Let me assure you, dear friend, how delighted I am at your well-deserved success, and remind you of my old and sincere friendship.

Eug. Delacroix

✒ TO CHARLES RIVET

Thursday morning [May 1855]

My dear friend,

Your letter made me very happy last night, and this morning I hasten to thank you for it. We artists toil and exhaust ourselves for the sake of enjoying pleasures such as that three or four times in our lives. When a disinterested voice like yours speaks to us such welcome words of praise, particularly when one is no longer at the start of one's career when everyone offers encouragement, one forgets for a moment the uncertainties, the doubts, the difficulties of one's profession, that art which is so long that one never acquires it. As for the opinion of the vast majority of the people who will see my paintings, I don't take much note of it, provided men like yourself show me some sympathy. Indeed, it is no bad sign not to please many people these days; inflation, sentimentality, poor painting and bad taste are what the public likes, and without taste, I mean without proportion, there can in my opinion be no beauty.

Goodbye, my good friend. I'm depriving you of a whole page of aesthetics . . . I'd rather send you my heartfelt thanks, and shall repeat them when I see you.

Sincerely yours,

Eug. Delacroix

✒ TO MME CAVÉ

[June 1855]

Dear Madame Cavé,

I found your kind and charming letter when I got back to Paris, and if I were not setting forth again almost immediately I should have gone to see you and to thank you instead of writing to you. Nobody but yourself would have yielded to an impulse like that which made you seize your pen to convey your impressions to me. I had read yesterday the article[1] in which M. Pétroz advises me to conform to modern ideas: I have not the honour of knowing them, any more than

[1] In *La Presse*, 5 June 1855.

328

I bothered to find out what Classicism was in David's time or Romanticism in Hugo's, twenty-five years ago. He does me the honour of telling me at the beginning of his article, which incidentally is very friendly, that I belong to no clique, that I have followed none of the trends with which I have seen the public infatuated at various periods. I shall do as you advise me, if indeed I do much more painting; I shall take advice only from my own instinct, which was once considered a sort of madness and which today finds many partisans.

I am very sorry to have left without seeing Mme Ristori[1] in *Myrrha*: I had seen her in *Francesca da Rimini*, in which she was very good: but I gather she is much better in the later play. Truth is so close to the parody of truth that it is not surprising that they are often mistaken for one another: which caused the ruin and confusion of the so-called Romantic school, or rather, as you also say, the word school means nothing; truth in the arts concerns only the person who writes or paints or composes, in any *genre* whatsoever: the truth I may discover and bring out in nature is not the same that will strike any other painter, be he my pupil or not: consequently the sense of beauty and truth cannot be transmitted, and the expression *to create a school* is nonsense; but it is convenient for the second-rate to concoct their own petty fame out of the leavings of men who have ideas and really deserve fame. Schools and coteries are nothing but associations of mediocrities, guaranteeing one another a semblance of renown which is indeed short-lived but which makes life pass pleasantly.

Goodbye, dear Madame; your kind friendship and your remembrance of me made me very happy: I am rather weary and depressed and it set me going again. I am writing to you in haste, with a thousand thanks and fresh assurances of my old and very sincere friendship.

<div align="right">Eug. Delacroix</div>

ᴄ͚ TO CHARLES BAUDELAIRE[2]

Champrosay, near Draveil, 10 *June* 1855

Dear Sir,

I have only just received your article, which is full of such high praise. You are too kind to tell me that you consider it an understatement: I am happy to see what you felt about my exhibition. I'll

[1] A famous Italian tragic actress. See reference in *Journal* in July 1855 when he saw her in *Myrrha*.

[2] Charles Baudelaire (1821-67), whose art criticism was as brilliant and original as his poetry, was one of Delacroix's most perceptive and enthusiastic admirers. The article here referred to was published in *Le Pays*, 26 May 1855 (and reprinted, with a later article, in *Curiosités esthétiques*). See also above, p. 261.

confess to you that I was not dissatisfied with it myself, and my own work pleased me more than usual when I saw these pictures all together; may the worthy public have eyes, may it above all have your eyes, which I am sure judge more favourably than I do myself. I am very sorry not to have seen your other articles, the one before and those that follow the article on myself. I am in the country; and even in Paris it is impossible to know beforehand when they are appearing in a paper to which one is not a subscriber. Put them aside for me if you remember and you can give them to me some day.

Your sincerely devoted

E. Delacroix

❧ TO MME DE FORGET

Augerville, 17 *July* 1855

. . . The master of the house[1] is as kind as ever and the company as pleasant, although we are a very small party this time, which does not seem to detract from the charm of the place. Mme Jaubert, who is here, is a great asset because she's a very good talker and moreover can read any sort of music at sight, a precious advantage for our evening's entertainment. As we dine late, we can't go for walks after dinner, and in the absence of virtuosi such as Batta, etc., we plunge boldly into score-reading. We must sound very odd stumbling through *Don Giovanni*, *La Gazza Ladra*, etc. Berryer loves music and enjoys as much as I do these operatic recollections, and he knows them nearly all by heart. . . .

❧ TO THÉOPHILE GAUTIER

22 *July* [1855]

My dear Gautier,

I have just read, on my return to Paris, your extremely kind and generous article on my exhibition.[2] My heartfelt thanks go far beyond what I can express. It must indeed be a satisfaction to you to see that all those extravagances of which you were once almost the sole champion have now come to seem quite natural. But this fresh confirmation has had a great effect on people's minds. Last night I met a woman whom I had not seen for ten years and who

[1] Berryer.

[2] In *Le Moniteur Universel*, 19 July 1855. A second article appeared on 25 July. Both were reprinted in *Les Beaux-Arts en Europe*, 1856.

assured me that, on hearing part of your article read aloud, she had thought I must be dead, assuming that such praise was given only to those who were dead and buried. Thank heaven, I am alive, but if it's true to say that mental strife and activity keep one alive, it must also be admitted that praises encourage and sustain one. You may well believe that yours have had that effect; the least drop of such balm would serve to sweeten many cups of wormwood which are hard to swallow. As I have always, fortunately, been hard on myself, your ever generous opinion further helped me to take my own side against my enemies.

Goodbye, my dear Gautier, believe me your sincerely grateful

Eug. Delacroix

↲ TO CHARLES SOULIER
at Saint-Mammès

9 *August* 1855

My dear friend,

It is at least two months since you wrote to me and I'm ashamed of not answering until today. A score of times I have meant to write to you and I have always been interrupted. I have only been back in Paris a few days and I am rather unwell as a result of starting work again in the church.[1] When your letter reached Paris I was not there; I spent all my time either at Champrosay, or else at the home of a friend and relative[2] who lives between Corbeil and Orléans. Your letter was forwarded to me there; I was unsettled the whole time and kept putting off writing. You tell me you could come to Paris towards the beginning of September, I shall be delighted, since I shall not go away before about the tenth of the month: it would be kind of you to arrange your business so as to come not later than that; we can spend some happy moments together, such as come all too rarely nowadays, though we need them more than ever in the loneliness which age creates around each one of us. My greatest standby is work; if that failed me I should have to shut myself up in a Trappist monastery and my only occupation would be to dig my own grave. *Ennui*, emptiness, is the constant enemy that circumvents the ageing man in every sort of way, and meanwhile he is inevitably deprived of the pleasantest way of spending his time: his senses no longer enable him to enjoy simple pleasures: his legs have ceased to bear him, his eyes to see. He must be sparing of these innocent

[1] The Chapelle des Saints-Anges at St Sulpice.
[2] Berryer.

331

enjoyments: even conversation is denied him, for with whom can one speak of things that really interest one, when one is surrounded only by people whose age and whose prejudices are different from one's own? And yet one wants to go on living, and one pities those that disappear. Our weak spirits quail before the thought of ceasing to be, of ceasing to feel either good or evil. . . .

<div align="center">

 TO MME DE FORGET
at Pau

16 *August* 1855

</div>

. . . You ask me where happiness is to be found in this world: after trying a number of ways I am convinced it lies only in being content with oneself. Passions cannot give one this contentment, we are always longing for what's impossible and are unsatisfied with what we get. I suppose people who are genuinely virtuous must enjoy a generous share of that contentment which I hold the chief condition of happiness: not being myself virtuous enough to be pleased with myself from that point of view, I make up for it by the real satisfaction I find in work. This gives one a real sense of well-being and increases one's indifference towards those pleasures which are pleasures in name only and which are all that society people can enjoy. That's my humble philosophy, my dear, and it's unfailing effective, particularly when I am feeling well. This should not prevent one from snatching at small distractions from time to time: an occasional slight love affair, the sight of a fine landscape, travels in general leave one with delightful memories: one recalls all these emotions at a distance, or when one is deprived of similar experiences; a little happiness stored up for the future, whatever that may bring.

So then I am working, apart from interruptions due to the celebrations that are taking place, or am about to do so.[1] I don't even mind these disturbances. They relax my mind, although they are fatiguing. It's a different sort of fatigue from that of painting: I hear full dress *Te Deums*, I attend banquets, I get as much amusement from fools as from intelligent men; mingled in this crowd, all men are alike, impelled by one common feeling, the urge to push oneself forward over one's neighbour's body. It's an interesting sight for a philosopher who has not yet discarded all vanities.

That's enough, I should hope; I am writing to you under the impression of the official visits I paid yesterday. We are expecting the

[1] For the Universal Exhibition.

queen of England,[1] who'll give me something else to think about. By the way, I am having a pair of knee-breeches made for myself;[2] that's the biggest event of the week. . . .

❧ TO MME AUGUSTE LAMEY[3]

15 October 1855

. . . You are mother, aunt and sister to me, and what makes me very happy is that I myself remind you of those you have loved. Moreover you have one great consolation, in the companionship of one on whose affection and support you can rely. So give one another all the help you can. When man has lost affection he has lost everything. . . .

❧ TO THÉOPHILE SILVESTRE

3 December 1855

How could I fail to be pleased, my dear Sir, you treat me as I should like to be treated by posterity, for which you know I profess the greatest respect. I received your packet[4] the day before yesterday in the evening, and I only read it yesterday, that's to say the part that concerns myself. So you would only have had my letter today: I meant to send it to your publisher's.

The alterations you have made are most successful: your work has gained in unity: it already had considerable verve, and has lost none of that. I therefore offer you all my sincerest, and indeed embarrassed, thanks.

I have not yet read the biography of Ingres, or rather re-read it, for I've not got beyond the earlier version you sent me, on which I did not comment this autumn because I went away very hurriedly.[5] I had already expressed my opinion on what you happened to tell me about it. I had begged you to take out any personal remarks, which even when favourable, are in themselves a departure from former custom when one is speaking of living persons. With that frankness which you like and which I myself sometimes use, I shall tell you

[1] Queen Victoria went to Paris on 8 August.
[2] For the ball at the Hôtel de Ville on 23 August.
[3] His cousin, with whom he had recently been staying in Strasbourg and at Baden.
[4] The study of Delacroix which was later incorporated in the *Artistes vivants*.
[5] To visit relatives at Croze and at Strasbourg.

that I should be sorry if you had not made certain alterations in this respect, for your sake, for my own and for everybody's.

Let me reiterate my most grateful thanks: accept them, like my criticism, as the sincere expression of my feelings.

E. Delacroix

cʃ TO THÉOPHILE GAUTIER

Tuesday, 26 February [1856]

My dear Gautier,

Your funeral oration on Heine[1] is a true masterpiece, and I cannot resist congratulating you on it. The impression of it haunts me, and it shall form part of my collection of memorable excerpts. For surely your art, which has so many advantages that fragile paintings lack, is under certain conditions even more ephemeral; what will become of four charming pages, inserted in a newspaper between the catalogue of eighty-six departments' virtuous deeds and the report of the day before yesterday's vaudeville?

They should have told us, they should have told a few of those who admire genuine great talent. I did not even know poor Heine had died; I should have liked to feel, standing beside the bier that carried away so much fire and wit, the things you so truly felt there. I send you this brief tribute, less moreover because of what I owe you than because of the sweet, sad pleasure I found in reading your words. . . .

cʃ TO AUGUSTE LAMEY

27 February 1856

My dear cousin,

I am writing to ask for news of you, in spite of or rather because of your great sorrow.[2] I think I have never regretted the distance that divides us quite so much: I believe you would have been happy to have me beside you, and I should have been happy to share your grief. This kind, loving friend gave me so many proofs of her affection that this last token of her remembrance of me, which indeed touched me deeply, can add nothing to my feeling for her memory. It gives me a sad sort of pleasure to speak to you about her and I hope you are not one of those who hurriedly put aside whatever can remind them

[1] Gautier's article appeared in *Le Moniteur*, 25 February 1856. It was reprinted in *Portraits et souvenirs littéraires*, 1875.
[2] The death of Mme Lamey.

of a beloved person: at least, that's the feeling I have always had myself when I have experienced such griefs as this. Please, overcome your reluctance and scribble a few lines to tell me about yourself.

ℰ TO MME DE FORGET

Champrosay, 25 October [1856]

My dear,

I have just got back from Berryer's, where I have been staying for nearly a fortnight; I only had your letter when I came here, and I thank you very much for your kind messages. I have been constantly on the go since I last saw you; I spent all the first part of the month in Champagne, in the land of our forbears, with my cousin Delacroix[1] whom you probably remember and who has more than once talked about you. I had long been wanting to make this little journey: I thought there were only two Delacroix left, himself and me: I can now rest assured that our name is in no danger of dying out, although neither of us has any children: everyone in my father's native region is my cousin: and I am very glad I took this trip, and shall probably go back, particularly as this region is on the way to Strasbourg, where I have other ties.

On returning from this journey I spent only a couple of days in Paris. It was during this interval that I was able to attend the funeral of poor Chassériau,[2] whose death surprised everyone, and with good reason: I would willingly have exchanged my lot in life for his.

ℰ TO THÉOPHILE SILVESTRE

1 *November* 1856

My dear Sir,

I have just got back from the country, and I have been reading your latest article[3] with great pleasure: I am grateful to you for your very true remarks on prejudice concerning drawing and colour. You imply that I gave lessons when I first started painting: I have always loathed teaching and have never done it: I have always been methodical enough not to *suffer* when I was in straitened circum-

[1] Commandant Philogène Delacroix, who lived at Ante in the Argonne. Mme de Forget's mother's family came from that part of the world.

[2] Chassériau died 9 October 1856. Delacroix had a genuine admiration for him. See *Journal*.

[3] The study of Delacroix published in a quarto volume with wood engravings: reprinted in 1856 by Blanchard, without illustrations (octavo).

stances; I never thought myself to be pitied, and then as now I have always considered myself one of the most fortunate men I know. I have never been much concerned about the contrariness of fate and of my critics. I suffered far more from the occasional sick headaches which time has now cured. I feel that all the pinpricks of fortune enhance the value of the tranquillity I enjoy. They have even proved advantageous to my studies, by preventing me from plunging into premature dissipation or seeking the pleasures of society before I was ready to enjoy them properly.

You have the historian's habit of reducing your characters to consistency, and so you ascribe to me a tragic childhood: on the contrary, my childhood was extremely happy, given my parents' situation and thanks to my own character. During the *nine years* I spent at school I was not miserable; I acquired there a love for the fine things of classical antiquity which I now set above all else. The trifling misadventures I told you of, which I suffered at a certain period in my life, are such as occur to all men and, thank heaven, have left me neither halt nor blind.

That is all I had to say to you, at somewhat too great a length perhaps, about your article, for your own edification if not for the public's. Once again, my very sincere thanks for all the kind things you say of me. I have never asked for such kindness from any one, not even from yourself, but I appreciate it deeply when I meet with it.

Your most devoted

Eug. Delacroix

I am reopening this letter to tell you that in spite of their imperfections I am very pleased with the prints of the *Massacre at Chios* and the *Liberty*: they are quite striking. If you could let me have one or two extra of each I should be most grateful. The *Algerian Women* is not so successful, owing to the difficulty of reproducing reflected light.

ॐ TO CHARLES SOULIER

6 *December* 1856

I'm a monster, I'm a brute; I'm re-reading the dear kind letter you sent me over a month ago, and I wonder how I had the heart, or rather the heartlessness, not to answer it. All that I can tell you, my dear friend, is that the wish to write to you was not lacking, but my unforgivable carelessness kept making me postpone my letter. So forgive me, and let me send you my belated but sincere thanks. I shall not say by way of excuse that I've been too busy: I have never

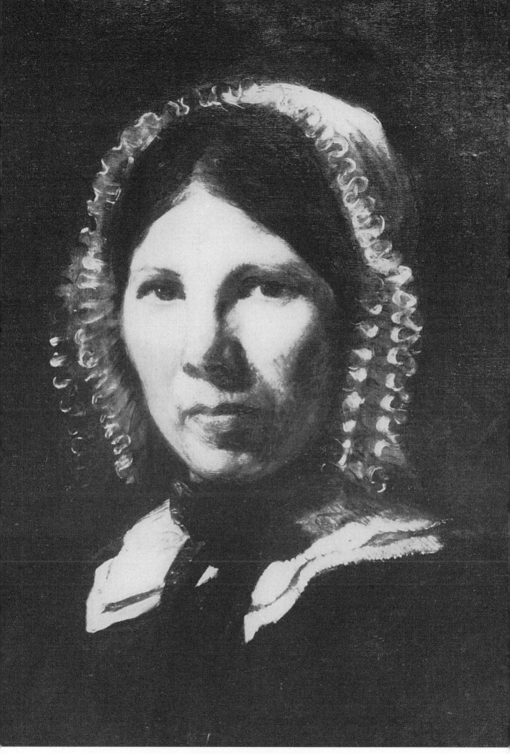

41 Jenny Leguillou, 1840

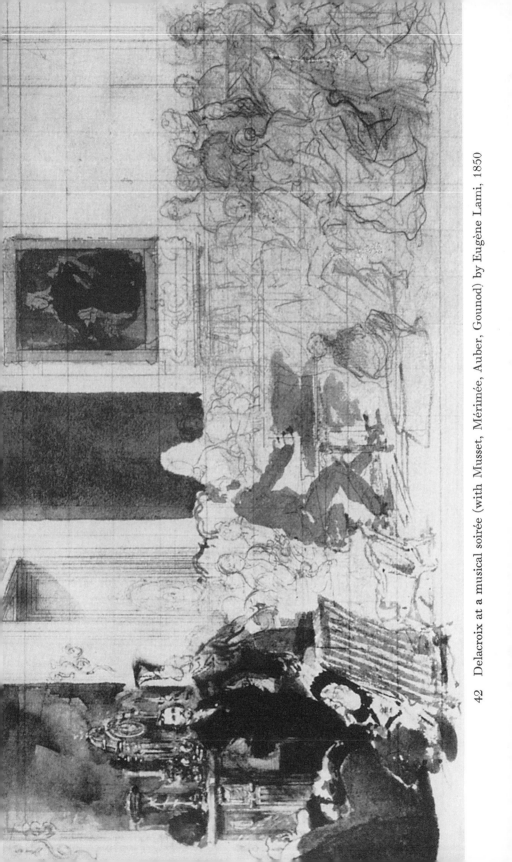

42 Delacroix at a musical soirée (with Musset, Mérimée, Auber, Gounod) by Eugène Lami, 1850

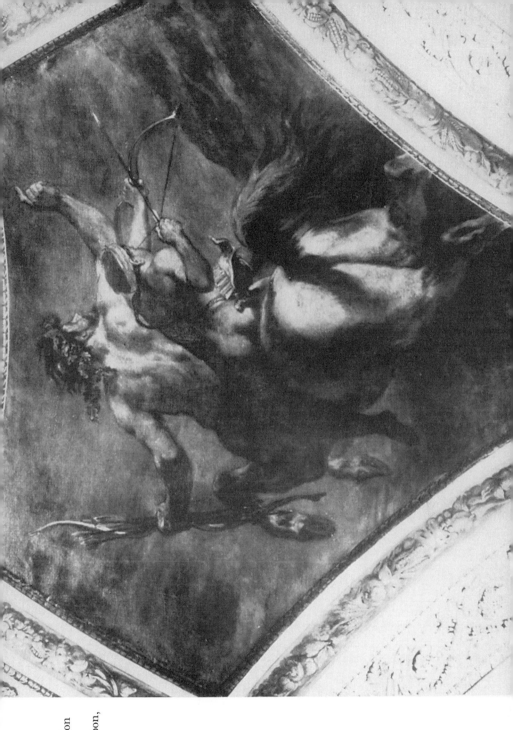

43 The Education
of Achilles:
Palais Bourbon,
1838-47

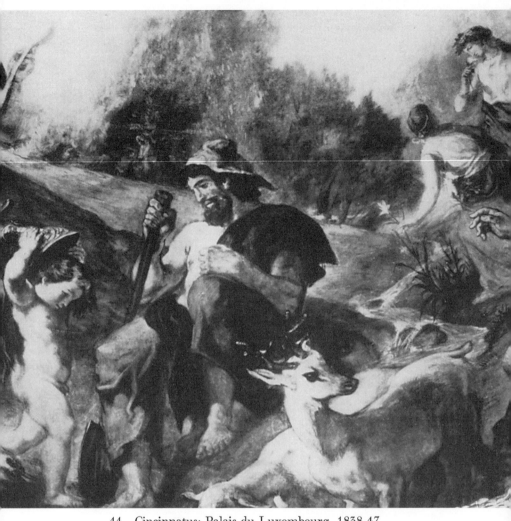

44 Cincinnatus: Palais du Luxembourg, 1838-47

known how to fill up my days, as I see so many people do who won't take time to eat or breathe amidst the tedious tasks they undertake with a sort of frenzied zeal. Although I only do things that amuse me they have not the art of occupying every moment of my time, and boredom often insinuates itself into the intervals; yet I am far less subject to this complaint now that grim age is approaching than when I was young, at a time when, so they say, everything is rose-coloured: that was when I cursed this life, which at that age should surely be filled with such delightful occupations. How many fruitless or tedious hours I spent waiting for a single moment! what disappointment, what regret followed that moment! Now, as far as is possible in this ever-turning world, I enjoy that boon which is called tranquillity, and which is known neither to public prosecutors, who want to become attorney-generals, nor to military commanders who want to become high-ranking officers, etc. Actually, I have applied for a seat in the Academy; but that's a wish I have cherished for so long that I'm beginning to become *blasé* about hope or fear in this connection. Despite a certain unyielding hostility, I gather that I stand a better chance this time, please God.

When shall we drink a health to our memories? When are you coming here? As I have almost given up reading, especially at night, I have moments of apparent idleness which are by no means that boredom I spoke of earlier: I close my eyes or I gaze into the fire. Then I reopen the book of memory, many chapters of which are already closed, and I rediscover delightful moments, the best of which are those we spent together. I never pass through the Place Vendôme without looking up at that attic where we were so merry. How many years have passed since then; how many losses we have suffered! Things are well ordered, in that the old are less violently stirred by their feelings than the young. They have so much to regret, so much to dread from loneliness, sickness and a thousand other ills that they could not face it all if they felt keenly. Perhaps real feelings are not affected by age. I still feel young in heart about some things, above all memories like these. I embrace you with all the affection I still have in me, since there's no room for a longer letter. . . .

<div align="right">Eug. Delacroix</div>

TO M. INGRES

<div align="center">1 January 1857</div>

Monsieur,

I had hoped to find it possible to call on you personally before the session of the Academy, as convention and custom demand, in order

to solicit the honour of your vote.[1] I have been unable to do so, and I beg you to believe that my failure to fulfil this duty is due solely to an obstinate indisposition which has kept me at home for the past fortnight and which might gravely endanger my health if I risked exposure to the cold before I had recovered from it.

Believe me, Monsieur, your most sincere and respectful admirer,

Eug. Delacroix

❧ TO CONSTANT DUTILLEUX[2]

13 *January* 1857

My dear Sir,

I am writing immediately to thank you very warmly for your kind and heartful letter. No congratulations could give me greater pleasure than yours. Everything was done quite fairly, which enhances my success in the public eye. You say quite rightly that this success, twenty years earlier, would have given me far greater pleasure; I should then have had a chance to prove myself more useful than I can be today, in such a position. I should have had time to become a professor at the École des Beaux-Arts, where I might have been able to exert some influence. Be that as it may, I do not share the opinion of some people—friendly or otherwise—who more than once indicated to me that I should be wiser to abstain. To skulk in one's tent betrays more vanity than genuine self-respect: in any case, I was being quite consistent with my own past, since once my decision had been taken I never failed to stand for election time after time.

That's too much by way of apologia. My only concern now must be to thank you once again, and send you my love.

Your most devoted

Eug. Delacroix

❧ TO CHARLES SOULIER

13 *January* 1857

Dear friend,

I don't want to do like last time and serve you up a long-delayed answer, like a warmed-up dish. Your letter made me as happy as

[1] Needless to say, Ingres did not vote for Delacroix, who nevertheless was at last successful in securing election to the Institut, after twenty years and six failures.

[2] One of many replies to congratulatory letters from friends, relatives and fellow artists.

they always do, that mixture of wit and true sensibility with which you write them is one of the rarest qualities, particularly when it seems to have cost no effort. Your image of the green grove guarded by satyrs[1] (who cannot, I fancy, be very dangerous to the nymphs of the neighbourhood) is very apt. I might, again, compare myself to those faithful knights-errant who, in order to free their Dulcinea or achieve some other highly important aim, buried themselves for years in the mazes of some enchanted forest, amidst the most fantastic anemones. So I've got there at last. Twenty years ago it would have given me far greater pleasure and I might have hoped to wield some influence there. But today, as the numbness of old age creeps on imperceptibly, the overwhelming and stimulating ardour of my early years is very much abated. I no longer think of anything but the pleasure of working. I prefer this to notoriety and ephemeral success. You complain of your eyes and I complain of mine too. I have not yet reached the point of focussing on the middle of someone's cheek, as Horace Vernet was telling me is now the case with him. But I need plenty of support from spectacles when I'm working on my wall-paintings; your philosophy is the one I try to apply myself to all the inevitable ills of age and fate. The supreme tonic is resignation. I accustom myself to saying, when anything goes wrong, what the philosopher Martin tells himself in *Candide*. As I'm sure of being badly off everywhere, I put up with the ills of my present situation....

☞ TO THÉOPHILE GAUTIER

21 *January* 1857

Dear Gautier,

I have only just read your splendid and infinitely too generous article in *L'Artiste*[2] about my introduction *in docto corpore*. I should have gone to see you and thank you as best I could, only for the past month I have not set foot outside and I have finally been ordered to spend a few days confined to my room, not uttering a word. That is why I am resorting to my pen to express my feelings. I dare not praise your style on this occasion as I have so often done when you wrote about other men; I would rather praise you from the heart, leaving the intellect out of it, for your kind and friendly remembrance of me.

Your sincerely devoted

Eug. Delacroix

[1] An allusion to the Institut.
[2] 'Eugène Delacroix à l'Institut', in *L'Artiste*, 18 January 1857.

ᴄᴊ TO ALEXIS PÉRIGNON[1]

21 *January* 1857

. . . This election is none the worse for being long delayed: the difficulty I had in winning it increases its value for me; only, there is one essential point threatens to make it fruitless. When they made me an Academician they did not make me professor at the École [des Beaux-Arts], for that is just where the danger would lie in the eyes of our learned colleagues. Around a green table, where everyone speaks his opinion informally, words do not carry great weight, particularly when they are addressed to people whose minds are already made up, after a fashion; it is from a teacher's desk, by correcting the mistakes of the young, that one can teach something, and unfortunately teaching posts are filled by election by the Academicians. This is the situation which detracts vastly from the value of my new post: you can easily understand this moreover. By a recent measure, the jury of the Salon will once more be among the functions of the Institut: I like to think that I may be of some use there, for I shall find hardly anyone to share my views, and it will be most necessary not to be ill. Well, the new coat I put on will not, I hope, change the man I am; instinct has always been my whole science, and the learning of others has only served to bewilder me. . . .

ᴄᴊ TO GUSTAVE FLAUBERT

[*January* 1857]

M. Eugène Delacroix, having belatedly learned M. Flaubert's address, wishes to express his grateful thanks for the present of M. Flaubert's fine book.[2]

ᴄᴊ TO M. CHAMPFLEURY

19 *March* 1857

Monsieur,

I am writing promptly in answer to the letter you were kind enough to write me, enclosing M. Bracquemond's engraving after a

[1] Alexis Pérignon (1806-82), a painter, had just become director of the École des Beaux-Arts and Museum of Dijon. He became a great friend of Delacroix's and was one of his executors.

[2] Probably *Madame Bovary*, which appeared in January 1857.

painting of mine,[1] and I shall speak entirely frankly, as you asked me to do.

The work undoubtedly conveys lively feeling; the horse's head in particular is most expressive, and the whole thing shows great promise; but the lack of experience in draughtsmanship and in conveying the relief of the different planes is too generally evident; the figure of the man – which unfortunately was the most important one – is a complete failure: the head, hands, turban and dress are quite inadequate, so that one cannot imagine M. Bracquemond achieving any success with a work in which figures play an important part.

You may think I am being over-severe, Monsieur, and there is no one to whom I would rather have given satisfaction on this occasion, but you will understand more readily than another man that I have more to lose than anyone else by an imperfect interpretation. I absolutely must have someone who can draw properly, not like a Rome prize-winner but with a knowledge of the human form and a manual skill capable of interpreting unerringly where the picture gives only the slightest indications.

I am well aware that such knowledge can only be the fruit of long studies, which most painters themselves do not undertake: as for engravers, some of them can only make a close but timid copy of the original, for lack of sufficient acquaintance with nature; others, for the same reason, disguise their inadequacy as best they can with the tricks of their trade.

Let me assure you once again, Monsieur, how sorry I am to have to say these things; I am forced to be sincere because this matter is of the utmost importance to me.

I have in fact been very unwell, and for three months have not held a paint brush; even today, although convalescent, I have to take great care and to lead a cloistered life for some time yet.

Please accept, dear Sir, every assurance of my sincere admiration for your talent and my great respect,

Eug. Delacroix

৶ TO MME DE FORGET

Plombières,[2] *28 August* [1857]

. . . I am very sorry not to be able to go into the country when I return to Paris but I have simply got to finish seeing to this Faubourg

[1] *Arab horse, tethered.*
[2] He had been taking the waters at Plombières since 10 August.

Saint-Germain house.[1] Its greatest drawback, from my point of view, in spite of what you say about it, is that it takes me further from you, for I think it has great advantages of every kind. When it has been cleaned up it will be as good a home as any. Nobody will see me in my garden, for there are covered walks running all round it. I shall be only a stone's throw from places to walk in, and the aspect is a good one. . . .

⑤ TO CHARLES SOULIER

15 *January* 1858

My dear friend,

How grieved I am to hear that you are still unwell! I have been prevented from answering you by my own poor health, and still more by the difficulties that beset me in connection with my removal. This is no easy matter, particularly when one isn't well. I'm perpetually afflicted with a cold, or on the verge of one, and yet I have to keep going. After having my new home repaired from top to bottom I still find myself, now that I'm living in it, overrun by workmen who do over again what has already been done; so that bricklayers and plumbers come hacking away at paintwork that's as smooth and bright as a looking-glass, in order to put right what's amiss: for there's everlastingly something amiss; imperfection is the law of our nature, and I come across considerable drawbacks everywhere, not to speak of the price, which was too high for my purse; and now I'm incurring considerable expenses for the sake of economy. I thought I could not endure the annoyance I foresaw, and now I'm experiencing annoyances of another sort. On the whole, though, apart from the inconvenience, if it is one, of leaving the fashionable district, the conditions I find here are attractive to an unsociable man: big rooms, which I've always adored, a lower rent, even taking into account the preliminary expenses, and a tiny garden in which I can take a little moderate exercise, in the intervals of my work, without going out into the street. In any case I no longer had any choice in the matter, and I was quite relieved, all things considered, not to find myself homeless.

You shall see the whole place when I'm lucky enough to have you to myself. You sound too depressed, my dear fellow. Heaven will grant you a longer life than you expect. Quiet lives last longer than others; dashing adventurers who fancy themselves eternally young reach the end of their journey prematurely: the journey

[1] No. 6 rue de Furstenberg, now the Delacroix Museum.

342

itself is an unpleasant one, if you like, but it's like the question of one's lodging: we know the inn where fate allows us to live and breathe a while, but who knows what awaits us at the next stage? The end of the story is a riddle that I'm not anxious to solve, despite the drawbacks of one's present existence.

You can find comfort in the satisfaction your children give you. I'm very glad of that, my dear fellow. Take courage, we'll have a drink together once again, as in the good old days. Those days, as you truly say, were very mixed: we did not know we were happy, we had the most precious treasures within our reach and yet we kept longing for tomorrow to come. Now, the best thing we can do is to think about the past; I find great joy in doing that, and some of my very happiest memories are of the times we spent together.

My most affectionate regards to Mme Soulier. . . .

Eug. Delacroix

Rue de Furstenberg, 6. It's quite close to our beloved rue Jacob, where we spent such happy moments. That was what poor Leblond was saying to me the other day. He was so anxious to have news of you.

⌁ TO CHARLES BAUDELAIRE
17 *February* 1858

My dear Sir,

I am most grateful to you for your high opinion of the articles[1] of which you speak. I do not feel the same affection for them, and in any case, if I were to publish them, they would need considerable recasting. I must tell you that I recently refused M. Silvestre the same request, although he was very pressing and I had every sort of reason to try to please him: I am thus absolutely compelled to give you the same answer, although it distresses me greatly to have to disoblige you.

I am writing this in haste before going out. A thousand thanks for your good opinion: I am already greatly in your debt for the *Fleurs du Mal*:[2] I have already said something to you about that, but it deserves far deeper consideration.

⌁ TO AUGUSTE LAMEY
30 *March* 1858

. . . I like my hermitage more and more: although I have been unwell again since I wrote to you, I have already been able to enjoy

[1] Delacroix's scattered magazine articles on art and artists.

[2] Published April 1857. Six poems were condemned as obscene in August the same year.

my little garden. . . . In any case you will find me, I hope, comfortably settled in: I am working, I am striving to finish the pictures that my sickness obliged me to interrupt. Almost all those you saw on my easel two years ago are still there: you see how behindhand I am; perhaps you may even find some which won't have got off the ground. . . .

⌘ TO THÉOPHILE GAUTIER

8 *May* 1858

My dear Gautier,

I have already thanked your friend M. Feydeau for the excessive praise he kindly lavishes on me in *L'Artiste*;[1] I am now thanking you, as editor of that journal, to which you have given a new lease of life. My heartiest thanks go to you both together: my indebtedness to yourself began a long time ago.

Your articles on Balzac[2] are very good and must have won you well-deserved praise. They are a tribute to the friend as well as to the writer. That was indeed the Balzac I knew: but why was he allowed to die without being told all these things? You and M. Feydeau have treated me better, since I am still here to thank you. . . .

⌘ TO CHARLES SOULIER

Champrosay, 19 *May* 1858

My dear friend,

Your kind letter was forwarded to me here and you can guess how sorry I was. I have been here some ten or twelve days, and as I was clever enough to catch a cold in the delightful weather you refer to, I am staying on now that I'm better in order to catch the few rays of sunshine which have made a tentative appearance during the last two days. Please tell your good son how sorry I am to have missed his visit, and far less, I assure you, because of the interest I should have taken in any details he might have given me about Africa than because of the pleasure of seeing this full-grown man, issued from yourself. Alas! we must indeed be on the verge of our return into nothingness, now that we see our progeny grown to such stature and such strength! Let's put up a fight, however, there may still

[1] In an article published 2 May 1858.
[2] Six articles in *L'Artiste*, 21 March 1858 onwards, subsequently collected and published in book form.

be a few good moments for us in the twilight part of life, witness the pleasure we found in our meeting.

I feel that if I lived in the country I might perhaps recover some sort of health. Although for a long time now I have been living in Paris somewhat like a countryman, as far as urban pleasures and entertainments are concerned, one misses there the kindly natural influence which here, in the country, affects one's mind through its action on one's body; here you feel yourself in the midst of friendly things, things really made for you. I feel the benefit of all this: a brief walk delights me, and except for this cold I feel very much better. Don't forget that, contrary to the ideas of our youth, Racine was *the romantic* of his day. The success of his plays, which was strongly contested at the time, is due to their truth to nature. He has been criticised for depicting the courtiers of Versailles in the guise of Greeks; what else could he have done? That was what he had in front of him; but he created men, and above all, women. They have just been acting *Phèdre* in Italian; nothing could be more comic, or could further enhance the greatness of our *Jean*. This redundant over-fluent language forms a perfect contrast with the elegant sobriety of his divine style. The actress played her part with extravagant gestures, waving her arms: a street-corner Venus. This does not deny the eternal youth of Old William's [*sic*] characters; but we must make amends for our unfairness, especially when we experience such keen pleasure into the bargain.

So embrace your Bajazet for me. Perhaps I shall not always be debarred from seeing him in all his glory. So far I have only loved him as his father's son. Remember me affectionately to Mme Soulier; and to yourself all my love,

E. Delacroix

ᶜ�5 TO MME DE FORGET

Plombières, 23 July[1] 1858

My dear,

I have not written before because I had no very satisfactory news to give you. I had to interrupt my baths almost as soon as I arrived on account of a fresh cold, and I foresaw the possibility of having come here merely to go for walks. Fortunately things have gradually improved; I have started bathing again, and recreation does even more to strengthen me. Man was not made to spend long hours in a

[1] He went to Plombières for a cure on 10 July. See *Journal*.

studio or in his study. Living in the public square, as one does at these watering places, suits me perfectly from a physical point of view. One spends as little time at home as possible; one meets the whole world, and the day passes quickly enough, thanks incidentally to Dumas's novels, which are my usual standby in such circumstances.

The Emperor's visit does not affect the life we lead here. He receives nobody, very wisely, since he is more exposed to indiscreet approaches here than anywhere else. You meet countless people who have come to try their luck, not for the sake of their health, but each carrying a petition in his pocket with which to besiege the head of state. I have met him two or three times: on one occasion he came up to me and politely enquired after my health; our relations went no further, in fact I avoid him; I should hate to be associated with the petitioners who conspire against the few moments of rest he has undoubtedly earned. . . .

ℰ TO CONSTANT DUTILLEUX

8 *August* 1858

. . . You ask for my opinion on the restoration of the Rubens paintings.[1] On the whole I think it has been well done, remarkably so indeed compared to the usual methods of cleaning pictures. What has happened is this: the complete removal of the varnish, particularly on the lighter colours, has revealed a freshness of tone which might have been expected. Novices in painting, who imagine that they only have to paint in thick oils and to produce, with the help of bitumen, what they call warm tones in their pictures, must have been disappointed. People will realise now that it's possible to paint very warmly and yet to reproduce the true tones of nature. The only drawback of this process is doubtless due to the way the pictures were painted. Rubens probably produced his shadows by means of scumble. This was done with a coating of transparent colour which has since turned blackish. The yellow tint of the varnish, accumulated during the years, which affected the lighter tones as well, spread a sort of unity between the light and dark tones. Today the proportion is disturbed. I mean the shadows look darker and the light tones gleam so brightly – as the painter intended – that the pictures have a somewhat metallic and monotonous appearance, due to the uniformly dark effect of the parts in shadow. This moreover is the effect almost invariably produced by cleaning. I wish pictures need never be varnished. Our descendants

[1] The restoration of Rubens's *Life of Marie de Medicis* in the Louvre by Villot incurred great criticism; he was obliged to give up his post as curator.

would certainly have a more accurate idea of our paintings; but how can anyone resist the desire to give his contemporaries the best possible opinion of himself and his works? . . .

ↈ TO M. ANTOINE BERRYER

4 *October* 1858

. . . Having just returned[1] and wanting to start work again, I have succeeded, by laboriously trying out various alternatives, in making myself strong enough to endure fatigue. I am extremely tired, but it's the most delightful tiredness in the world. I began in a state of languor which drove me to despair for several days, now I am struggling with the toughest part of the task;[2] I have made a violent effort which, I think, will save the work, which has got somewhat bogged down.

What rogues these journalists are, who, I cannot think on what authority, announce that a piece of work which, even under the most favourable conditions, could not be completed in less than a year, was shortly going to be shown to the public! This caused me not a little bother. Last year they said that I was dead, which aroused a certain excitement among a good many people in Champagne and elsewhere who probably counted on being my heirs. They will say one of these days that you have eloped with the sultan's favourite wife, and your friends will wonder why they haven't been asked to the wedding. Such is that shining light they call the press, that *victory* of 1789, to use the language of the day, whose serial stories hardly make up to me for the inaccuracy of its news.

ↈ TO PAUL HUET

13 *October* 1858

My dear friend,

There is some confusion in your remembrance of my methods for dulling paint. I simply use wax and turpentine blended together, either in the cold state or in a double boiler; but, and this is the essential point, I have this mixture on my palette while painting and I take up some at every brush stroke to mix with the ordinary colours. You get no effect, or rather a very unpleasant effect, when you apply this nostrum on a finished picture.

Haro has a sort of wax which he applies to paintings to dull them

[1] From Champrosay. [2] At St Sulpice.

after completion; but this process dulls them very irregularly, so that your picture no longer produces even a fainter version of its original effect. You will realise that if, while painting, you dull the colours yourself at the same time, you can take into account which colours suffer most from being dulled, and strengthen them correspondingly. If the operation is performed after the picture is finished, the result is most unsatisfactory, as I know from experience.

If I were you I should varnish my pictures; they are well worth being looked at in good light; otherwise you will have an ambiguous result which will be advantageous neither to yourself nor to the owners of your pictures.

I hope your stay in the country is doing you good: it is my own favourite remedy. At the moment I am very busy with my Saint-Sulpice chapel, which is making headway and not tiring me as much as I'd have expected. . . .

ᴄᴽ TO ANTOINE BERRYER

2 *November* 1858

My dear cousin,

Your tempting picture of friends drinking together round your hospitable table scarcely makes me look forward to what awaits me.[1] But I hope the poisonous atmosphere of a court will not seduce me from my staunch affections. The *collar that fetters me* has not, as yet, left any deep impression on me, for my sole ambition today, which no man can satisfy, is to enjoy good health: but as Bridoison says, *la a a a forme!*[2] We must keep up appearances!

My compliments to that unnamed beauty whom I somehow suspect to be Mme de la Grange,[3] and whom I am particularly sorry to miss. What, you've persuaded her to come now, at this time of year, while I am serving my apprenticeship as courtier? And Batta too! Give him my love, and tell him and all your guests how sorry I am to miss them.

ᴄᴽ TO CHARLES SOULIER

14 [? *December* 1858]

How could I not have written sooner in answer to your very kind letter, my dear fellow? There were a hundred good reasons for doing

[1] Delacroix had been invited by the Emperor to visit him at Compiègne, and therefore had to decline Berryer's invitation.
[2] *Le Mariage de Figaro*, act III, sc. xiv.
[3] Marquise Conrad de la Grange.

so at once. It made me very glad because it showed me your friendship, and very sad because you seem to be feeling particularly keenly just now the burden of that yoke that has oppressed us all since our father Adam's transgression. The emptiness of life, the futility of our wishes and regrets weigh quite as heavily on me, alas, as on yourself. You speak of your isolation, but none could be greater than mine. I no longer have even the common distractions of society to deaden the pain. As I am constantly unwell, I have entirely given them up, and I very often spend the evening by my fireside. Illusions fade one by one; a single one is left me, or rather it's not an illusion but a genuine pleasure, the only one unmixed with the bitterness of regret: my work. But in fact that is my only passion; may it long survive all the rest! I keep on working in spite of the inconstancy of my health, indeed perhaps because of it: for since this is sufficient pretext to excuse me from all foolish social obligations, I devote to painting all the time that I once spent so wildly and so uselessly. My dear friend, you could not have written all these things, inspired by your unhappiness, to anyone better fitted to understand them. Work itself is only a diversion, numbing the pain for a moment, and any diversion, as Pascal says in other words, is merely a means invented by man to conceal from himself the depth of his misfortune, the horror of his profound wretchedness. It is when the soul faces that cruel nothingness that all resources are powerless to bring one consolation: when you wake up at night, for instance. During sleeplessness or sickness, at certain moments of solitude, when the end of it all is clearly envisaged in all its nakedness, the man endowed with imagination needs a certain courage not to forestall the nightmare and embrace the skeleton. What a difference a few years bring to our ideas! I feel now that all books speak nothing but platitudes. What they say about love and friendship repeat half a dozen banal ideas that were expressed a thousand years ago. Not one of them, to my mind, has ever painted the disenchantment, or rather the despair, of maturity and old age. I wager that you have never seen in any book what you feel about that, in the way you feel it. Nothing but rhetoric and empty phrases!

I'm sending you no consolation, because I'm damnably depressed myself. I keep reverting to Candide's conclusion:[1] *That's all very fine, but one must cultivate one's garden*, and to that other axiom of this truest of all books: *Man spends his life convulsed with anxiety or lethargic with boredom.* These are the two terms of the problem.

If only, amidst all this boredom and all this agitation, we could occasionally see one another. But is once in a while really seeing one

[1] Voltaire had always been one of his favourite authors.

another? Remember those dinners at Mère Tautin's,[1] how we walked there through the snow and ate in company with thieves and turnpike men! And how we'd spend two hours coming and going, often barely exchanging a couple of words, but each feeling he had a friend within reach. The moments when I take refuge in these delicious recollections set their true price on memories of love and its follies. What's left of love? Dust and ashes, less than that. But the pure emotions of one's youthful friendship yield a whole world of delicious sensations, in which I often take refuge. I shall see you for sure, I'll arrange things so as to spend a few days with you; we must meet again. Send me news of yourself meanwhile, and make use of my method: work, draw, dig. Keep me informed of any chance of your coming to Paris, so that we can have a drink together and recapitulate our imprecations against life. All my unchanging love.

⌇ TO THÉOPHILE SILVESTRE[2]

Paris, 31 December 1858

My dear Sir,

Your letter from London has just reached me, and I find it hard to fulfil its demands, both because of the matter to be treated and because of my own condition: for three days now – and this is exceptional, since I have been in excellent health for the past six months – I have been laid low by an indisposition. If only you had asked me for this information for a somewhat later date, I could have chosen my time. However, what you ask of me is something I take great pleasure in doing. The memory of that period of my life when I visited England and of certain friends I knew then are very dear to me. Most of these friends are no more. Of the English artists who did me the honour to welcome me – all with the greatest kindness, for I was practically unknown in those days – I don't think a single one is left. Wilkie, Lawrence, the Fieldings, great landscape painters and water-colourists, particularly Copley, and Etty, who I believe died quite recently, all showed me the greatest consideration. I have not mentioned Bonington, who also died in his prime; he was my friend and companion, with whom – as well as with Poterlet, whose premature death (he was a Frenchman) was a great loss to painting – I spent my life in London,

1 An inn on the outskirts of Paris where Delacroix, Soulier and their friends often forgathered. See *Journal,* 27 January 1824.
2 Delacroix had formerly considered writing an article on the English school – see *Journal,* 17 August 1853. See his letters from London (1825) for references to Lawrence, Wilkie, the Fieldings, etc. For Poterlet, see letter 9 August 1827; for Bonington, letter to Thoré, 30 November 1861.

amidst all the delights that an ardent young man can enjoy in that country, surrounded by countless masterpieces and witnessing that amazing civilization. I have no desire to see London again: I should not find any of these memories, and above all I should not be the same man myself, I could not enjoy the things to be seen there today. Even the English school has changed. I might perhaps find myself obliged to take up the cudgels for Reynolds, for that enchanting Gainsborough whom you so rightly love. Not that I am opposed to what is happening today in English painting. I have even been struck by the tremendous conscientiousness these people display, even in the things of the imagination: it almost seems as if, in their tendency to overstress details, they are more faithful to their own genius than when they imitated Italian painters principally, and Flemish colourists. But what does the outer skin matter? They are still Englishmen, under this apparent transformation. Thus, instead of making pastiches pure and simple of Italian primitives, as has been the fashion in this country, they introduce into their imitations of these old schools an infinitely personal feeling, they infuse them with the interest that springs from a painter's passion, which is generally lacking in our own frigid imitations of the techniques and the style of schools that have had their day.

I'm writing to you without a pause, and flinging at you whatever comes into my head. My impressions of those days might perhaps be somewhat modified today. Perhaps I might find in Lawrence a certain exaggeration for the sake of effect, somewhat too redolent of the school of Reynolds. But his prodigious delicacy of line, the life he imparts to his women, who seem to be speaking to you, make him as portrait painter superior even to Van Dyck, whose admirable figures seem static. The gleam in the eyes, the parted lips are admirably conveyed by Lawrence. He welcomed me most graciously: he was an essentially gracious man, except when his paintings were being criticised. Two or three years after my visit to England I sent several pictures there, among others *Greece on the ruins of Missolonghi* and *Marino Faliero*.[1] This latter painting attracted considerable attention from Lawrence. I was told he had expressed the intention of acquiring it. He died about that time. I had an eight-page letter from him about a short article I had written in *La Revue de Paris* about his portrait of the Pope.[2] I was rash enough to show it, before having read it properly myself, to an ardent autograph-collector from whom I was never able to retrieve it.

[1] These two pictures were sent in 1828 but not sold.
[2] 'Portrait du Pape Pie VII de Sir Thomas Lawrence', in *La Revue de Paris*, June 1829.

Wilkie, too, was as kind to me as his reserved character would allow. One of my most striking memories is of his sketch of John Knox preaching. He subsequently made a picture from it[1] which I have been told is inferior to the sketch. I had ventured to tell him when we met, with typically French impetuosity, that 'Apollo himself, if he took up the brush, could only spoil it by finishing it'. I saw him again a few years later, in Paris. He came to see me and to show me a few drawings he had just brought back from an extensive journey in Spain. He seemed to me entirely overwhelmed by the pictures he had seen there: I marvelled that a man of such genuine genius, on the verge of old age, could be influenced to such an extent by works so very unlike his own. When he died, soon after, his mental state, I am told, was highly unbalanced.

Constable, an admirable man, is one of England's glories. I have already told you about him and about the impression he had made on me when I was painting the *Massacre at Chios*. He and Turner were real reformers. They broke out of the rut of traditional landscape painting. Our school, which today abounds in men of talent in this field, profited greatly by their example. Géricault came back in a daze from seeing one of the great landscapes Constable sent us.

I was not in England at the same time as Charlet and Géricault; I need not tell you what we must think of these two men. You know my great admiration for them both. Charlet[2] is one of the greatest men our country has had; but we shall never set up a statue here to a man who did nothing more than play about with a stump of a pencil, drawing little figures. Poussin[3] had to wait two hundred and fifty years for that famous fund to raise a statue to him, which I believe still does not exist, owing to the inadequacy of the subscription. If he had merely burned a couple of villages he would not have waited so long.

I hope and pray you will bring over here some of the fine works you mention.[4] Our school badly needs an infusion of fresh blood. It is old, and it seems to me that the English school is young, that they seek to be natural, while we seek only to imitate other paintings. Don't expose me to being stoned by publicly quoting these feelings which, unfortunately, are my true ones.

The little picture[5] for which I am sorry I made you wait so

[1] Now in the Tate Gallery.
[2] See Delacroix's article on Charlet in *La Revue des Deux Mondes*, 1 July 1862.
[3] See his articles on Poussin in *Le Moniteur Universel*, 26, 29, 30 June 1853.
[4] Silvestre did not succeed in organising an exhibition of British painting in Paris.
[5] Unidentified.

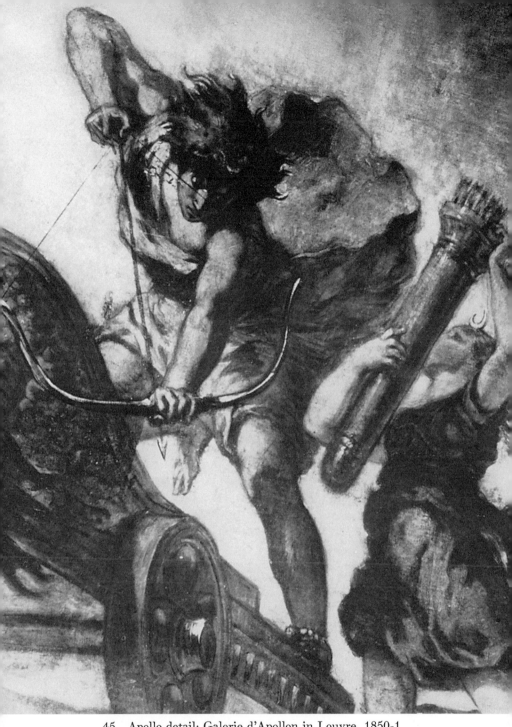

45 Apollo detail: Galerie d'Apollon in Louvre, 1850-1

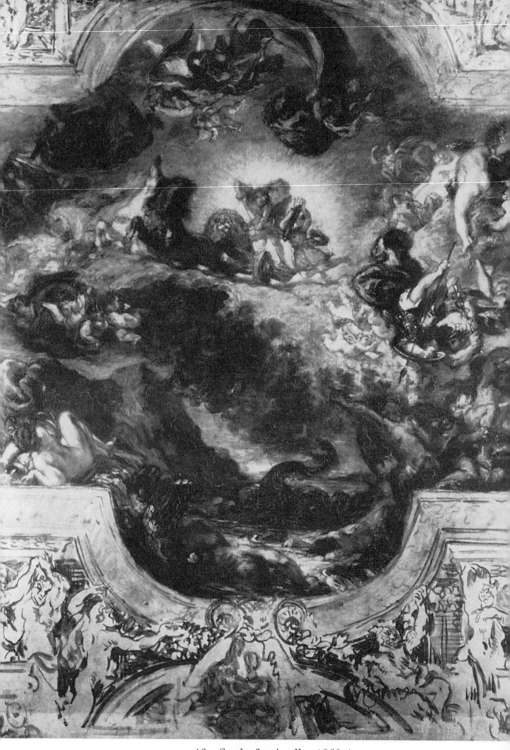

46 Study for Apollo, 1850-1

47 Christ on the Lake of Genesareth, 1853

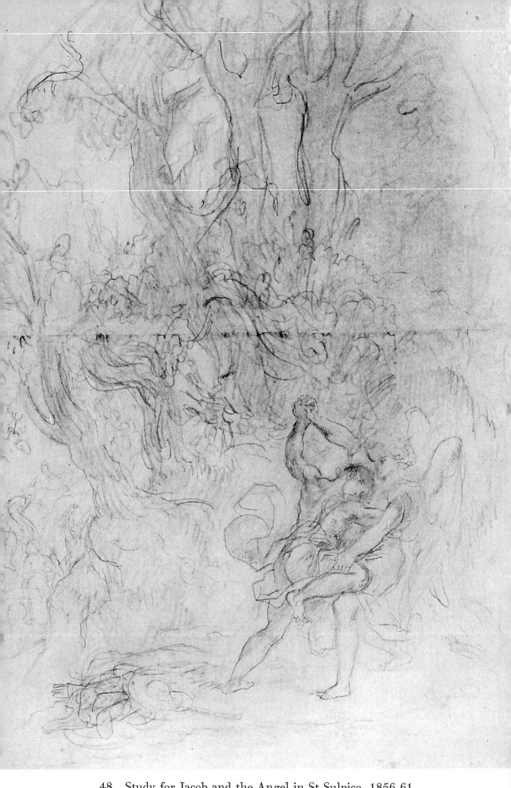

48 Study for Jacob and the Angel in St Sulpice, 1856-61

long was finished a short while ago, and I will hand it over to some trustworthy intermediary, unless you prefer to wait until your return. How right you were to launch me on a subject I am fond of. Here are four pages from an invalid whom these recollections have somewhat refreshed. I shall be very glad if all this can be of use to you. You know how grateful I am to you and how happy to oblige you.

Your devoted
Eug. Delacroix

❧ TO CONSTANT DUTILLEUX

2 *April* 1859

My dear Monsieur,

As you were kind enough to forewarn me, M. Daverdoing[1] came yesterday to tell me that I could send the picture.[2] I was unable to get it packed yesterday, since that was the day they were collecting my pictures for the Salon: but the measurements of the case having been taken, the operation of packing the picture was accomplished this morning and it will be taken today to the dispatching office of the railway. I am sending it by slow goods service, of course. M. Daverdoing assures me they take great care of parcels. It is addressed to the Secretary of the Museum Commission.

So that great matter is now dealt with: I hasten to send you my warmest thanks: you were the heart and soul of all the negotiations. I hope all the other people who have shown so much goodwill in this affair will like the painting and consider it worthy to hang in the museum of your city.

I performed a real *tour de force* in finishing my pictures for the Salon. I have no less than *eight*. You will appreciate that I'm not the sort of man to have improvised anything under the circumstances: they had all reached the point when all difficulties seemed to have been overcome. And yet I encountered some which I had not expected: putting the finishing touch is a most difficult matter. The danger consists in reaching the point where remorse no longer serves any useful purpose, and I am much addicted to remorse.

You encouraged me to hope you might come here at the time of the exhibition. I should be very glad of this, so that I could greet you cordially and tell you once again how grateful I am.

[1] Daverdoing (1813-95), a painter from Arras.
[2] *The Stoning of St Stephen* (shown at the Salon of 1853), commissioned by the town of Arras where Dutilleux lived.

18 *April* 1859

Dear Sir,

Your letter is so gracious and friendly towards me that I ought to be hurrying to embrace you instead of thanking you by yet another letter. And will this tell you all the pleasure you gave me? Judge for yourself: I had no news of the Salon; I had sent all those paintings, over which I had laboured up to the last minute, in a terribly damp state, in which they still are, and two or three members of the public had already told me they were invisible. Since you have seen them, and seen them as you did, I am amply rewarded, and can dispense with the favour of those who absolutely insist on varnish.

I repeat, the good opinion of so talented a colleague as yourself, whose modesty blinds him to his own merits, is the richest of rewards. You ask me if I have a secret: my secret is the same as that of those people, and they are all too few, whose greatest subtlety consists in always telling the truth. We have had dinned into our ears that there are certain artifices without which painting cannot attain its full value. By closely observing nature, who produces her effects effortlessly, one comes to realise that one should study to follow her step by step, instead of trying to make additions or corrections. There is one man who produces an effect of brightness without violent contrasts, who conveys the open air, which we were always told was impossible, and that is Paolo Veronese. In my view, he is probably the only painter to have grasped the whole secret of nature. Without actually imitating his manner, one can follow a good many paths along which he has lit real torches.

The younger generation think of nothing but technical dexterity. There is perhaps no greater obstacle to any sort of true progress than this universal mania, to which we have sacrificed everything. It is this that keeps a painter from cutting out whatever is not absolutely necessary to a picture, which leads him to prefer fragments to the whole, and which prevents him from going on working until he is truly satisfied.

A thousand thanks, dear monsieur, I venture to say dear friend, since only a friend, and one with great nobility of soul, would have written to a colleague as you did to me: and before long, whether you come to see me or I to see you, I shall say all this to you far better. My heartfelt thanks, and in the meantime my sincerest and most cordial remembrances,

Eug. Delacroix

If you come, don't fail to give your name.[1]

[1] Jenny only let in special visitors, in order to spare Delacroix's voice.

∽ TO ALEXANDRE DUMAS

28 *April* 1859

My dear friend,

It was only yesterday that I saw the article which you devoted to me in the *feuilleton* of *L'Indépendance*.[1]

The difficulty of getting hold of the paper once the day on which it has appeared is past deprived me for several days of the pleasure of reading it and that of thanking you for it with all my heart.

My friend, you have remembered your old comrade; you already treat him as if he had won his own small portion of immortality, or rather you confer immortality upon me by your praises, which are full of that ardour that you put into everything.

You deplore, with good reason, the present trend in art. Our aims were high, once; fortunate indeed was the man who could attain them! I fear that the stature of today's champions puts the mere thought of that beyond their reach. Their petty, restricted truth is not that of the masters. They grovel on the ground, looking for truth with a microscope. No more broad brush strokes, no more powerful displays of passion on the stage!

But why are you off to Kamschatka?[2] They tell me, however, that you bring back treasures from there.

Most affectionately and gratefully yours, my dear friend,

Eug. Delacroix

∽ TO PAUL HUET

Wednesday [*May* 1859]

My dear friend,

I learned when I got home that you had taken the trouble to call on me. Forgive me: for the past few days I've been obliged to be almost constantly absent from home, and I unfortunately neglected to answer your kind, warm-hearted letter. I blame myself for this all the more that it dealt with business matters. I am very grateful to you for giving me some encouragement about the effect of those wretched paintings, which I was beginning to regret having exhibited;[3] actually, I ought to be used to this effect, which is that of all my exhibitions. Whether from the contrast between my pictures and the

[1] *L'Indépendance Belge.* Dumas's articles were published in book form as *L'Art et les artistes contemporains au Salon de 1859.*
[2] Dumas was always spreading rumours of his imaginary forthcoming journeys.
[3] At the Salon.

rest, or for some other cause such as the absence of varnish, I always notice a sort of reluctance to approve of them even among my friends and people who are used to my painting: all the more among those who only go by other people's opinion, or who prefer above all else the gleaming varnish and glaring colours of many freshly-painted pictures.

I'm afraid the price I am asking for my paintings may scare off your art collector:[1] it is rather more than I usually ask, but that's because I am anxious to get at least as good a price as dealers get from art lovers for things that I consider rather successful, and that have given me a good deal of trouble; I cannot let them go for under four thousand francs each. Please believe how sorry I am if this price is more than your friend can afford; perhaps I may be able to satisfy him by finding something among my relatively less important works which I could let him have at the price I usually ask from dealers.

What a lot of words about a matter of self-interest. What delighted me in your letter was to read in it your fondness for me, which flatters me, and honours me even more.

I have not yet ventured to go to the Salon for fear of looking at myself there: so that I cannot speak about your fine panels.[2] The impression they made on me lingered in my mind long after I saw them in your home last summer. I am sure they will be appreciated at their true value, which is very high.

Kindest regards, until the pleasure of our next meeting,

Eug. Delacroix

ℰ TO CHARLES BAUDELAIRE

27 June 1859

Dear Sir,

How can I thank you adequately for this fresh proof of your friendship? You come to my rescue at a time when I am being abused and vilified by a considerable number of serious and would-be serious critics.[3] These gentlemen want everything on the grand scale, and I simply sent in the works I had just finished without taking a measure to find out whether their dimensions were those prescribed for survival

[1] Ernest Legouvé.
[2] Eight panels painted by Huet for M. Lallemand, at the Château de Vaufreland.
[3] Delacroix was so upset by the attacks of such critics as Delaborde, Maxime du Camp, etc., that he refused to exhibit any more in the Salon. He was somewhat comforted by the enthusiastic appreciation of Baudelaire, Dumas, Gautier and Paul de Saint-Victor.

to posterity, which I have no doubt these gentlemen would have helped me to attain. Since I've had the good fortune to please you, I can forget their censure. You treat me as only the *great dead* are treated; you make me blush, and you make me very happy: that's the way we are made.

Goodbye, dear Sir; you should publish something oftener; you put something of yourself into whatever you write, and those who love your talent complain only that they see too little of it.

With cordial greetings,

Eug. Delacroix

ॐ TO JENNY LEGUILLOU

Strasbourg, 30 August 1859

Dear Jenny,

I was very glad to get news of you: my own news is satisfactory; I am keeping very well, and I am already planning my journey to Champagne. I shall leave here next Saturday, 3 September: I shall be at my cousin's by the evening, I hope, and I shall have spent over a fortnight at M. Lamey's, so that everyone will be satisfied. I shall only be completely happy when I see you again, and above all if you're not too dissatisfied with your state of health. Remember, you are half of myself. I already have trouble enough keeping well: imagine what I feel like when you are ill. So you're contributing to my health when you take good care of your own.

I shall write to you from Champagne and as I shall not make so long a stay there as here, I shall probably be able to tell you to expect me home shortly. I shall try to keep well in Paris for the sake of my work, for one must consider one's duty, and your presence will encourage me to do so.

Goodbye, my good friend, with all best wishes and my sincerest affection,

E. Delacroix

Thank Jean and Julie for their messages. Tell them the best way to please me is to be nice to you.

My good cousin keeps well, and we get on excellently together. He often speaks to me of you, with all the esteem that you deserve. Mind you go out often.

❧ TO ALEXANDRE COLIN[1]

Champrosay, 11 *October* [1859]

My dear Colin,

When you wrote to me I was in the depths of Champagne, far from any railways, and moreover your letter was never forwarded to me there; I should have found it very difficult to be present at the adjudication even if I had known your son was one of the competitors. I am extremely sorry about all these injustices: they have always existed and they always will; that's why I have long disliked competitions. They prove a snare to a host of young men, who go on competing until they are thirty; during that time, and in order to win the prize that is so seldom awarded to a man of merit, they let slip the opportunity of giving some idea of their true strength. Even those prizewinners who come back, at thirty-five, from their stay in Rome hardly ever display a talent formed after great models, and they certainly lose any sort of independence. The way the exhibits from Rome are judged by the Institut is on a level with the way the competitions are judged. To hell with schools, my good friend; Velazquez, Titian, Rubens, these are the good masters who reward you for looking at them, and the spark that's in them will make a way for itself more surely than at the school in Rome.

Forgive my outburst, dear friend, but it expresses my very sincere conviction. I am nonetheless sorry for the injustice done your son.

Yours very sincerely,

Eug. Delacroix

❧ TO GEORGE SAND

10 *December* 1859

. . . Mme Viardot has just been singing *Orphée*;[2] the best thing you can do at this moment is to take the coach from Châteauroux and come to Paris to see her in this masterpiece, to which she has really given fresh life. 'Nothing is beautiful but the true'[3] as you well know, like all great artists; you'll never see it so clearly confirmed. You would also find reassurance in this further proof that this truth and this beauty are secure from time and fashion and that they will always find hearts and minds to understand them. . . .

[1] Alexandre Colin (1798-1875) had been a fellow-student of Delacroix's at Guérin's studio. He remained a lifelong friend.
[2] Berlioz had got Mme Viardot to sing the title role in the enormously successful revival of Gluck's *Orfeo*.
[3] '*Rien n'est beau que le vrai, le vrai seul est aimable*', Boileau, *Art Poétique*.

❧ TO CHARLES BAUDELAIRE

13 *December* 1859

Dear Sir,

Forgive me for not replying to your letter, which I had mislaid and which contained your address. I am so behindhand in my work, for all sorts of reasons, that I cannot tell when I can see about the drawing or sketch which you mention and which I wish, nonetheless, were already in your hands or in those of your friends.[1]

I have indeed found a charming little book of yours on Théophile Gautier:[2] it has the drawbacks of several of your published works; the print is so small that I find it difficult to read. I gathered from it however that you appreciate our critic as he should be appreciated and as I do myself. I must also tell you that since then I have happened on a book which you praise highly but which I had never read, although it appeared so long ago, *Mlle de Maupin*.[3] I was delighted with it: I discovered an aspect of Gautier which I did not know, and my admiration was increased by the fact that he was so young when he wrote it. . . .

❧ TO M. LE COMTE DE NIEUWERKERKE
Director-General of the Museum

15 *February* 1860

Monsieur le directeur-général,

You were good enough, at my request, to give orders for restoration work to be begun on my picture of *Dante and Virgil*, which was in danger of deterioration. As I imagine that this work must be progressing, I am taking the further liberty of asking for what I should consider a very special favour, since it departs from the usual custom; I should attach very great importance to being allowed to retouch my picture myself, and by retouching I mean only the reparation of the cracks left after backing, which are unfortunately very numerous. If my request, unusual though it be, does not seem too bold and if you are good enough to enable me to do this retouching, I shall be most grateful to you for this further kindness.

Believe me, Monsieur le directeur-général, your most respectful

Eugène Delacroix
Rue de Furstenberg, 6

[In the margin a pencilled note by M. de Nieuwerkerke: 'Consult M. Villot'.]

[1] Malassis, a friend of Baudelaire's, was anxious to acquire some drawings of Delacroix's.

[2] *Théophile Gautier*, prefaced by a letter from Hugo, Paris, 1859.

[3] *Mlle de Maupin* had appeared in 1835 when Gautier was twenty-four.

3 *March* [1860]

My dear friend,
I was very sorry, when I came back from my walk,[1] to find I had missed you. I should have thanked you delightedly for your lovely tulips, which are my favourite flowers. This was my second outing; both have done me a great deal of good. The mildness of the weather yesterday enabled me to sit for three-quarters of an hour in the Luxembourg garden. Nothing could have been more rural; I was surrounded by delightful children (you know how fond I am of them) and their simple nurses, throwing balls at my legs and making a great din with their innocent shouts. I was there with all the cripples of the neighbourhood, who crawl into the sun, like myself, to try and recover from their ailments. Joking apart, the treatment is an excellent one, and I shall only abstain from going out if the weather should be too harsh.

A thousand thanks once more, and all my love, dear friend.

ↄ TO LOUIS DE SCHWITER
[in Venice]

30 *April* 1860

. . . Your letter is very tempting,[2] but it finds me at the moment so tied up that to leave is out of the question. My work at Saint-Sulpice is at its most interesting stage, and it is extremely important that I should complete it as soon as possible. I'm none the less infinitely grateful for your kind insistence, but there comes a time in one's life when, though one seems to have all that is needed to be free, one is shackled by inexorable necessities; time, too, is very short, and one's commitments more numerous. When I have fifty thousand francs to spare I shall buy a palace; it will be just like my little country place at Champrosay, where I never have time to set foot, and which is brimful of attractions. I admire and envy you for having arranged your life so as to take a month or more for a holiday when you choose. I shall die without having budged, telling myself I am free to do so, which is also true. What I dread most of all at this moment is finding it impossible, when I get back, to resume that arduous work which started off my present excited train of thought,

[1] See *Journal*, 3 March 1860. He had been ill for several months.
[2] Schwiter had asked Delacroix to join him in Italy.

but which after charming diversions would seem irksome. Take advantage of it all while you're still there. And make some sketches, at least, to enhance my regrets when you return. . . .

ꝯ TO THÉOPHILE GAUTIER

11 *May* 1860

I must thank you once again for your very kind article[1] and inform you that your poetic instinct was, as usual, right in guessing the subject of the picture[2] to which people have given the idiotic but legendary title of *L'Amende Honorable*. They had only to open the catalogue of the Salon at which it was exhibited. The subject is taken from *Melmoth*,[3] which you no doubt admire as much as I do, and the sublime story of the Spaniard who was confined in a monastery. He was dragged over broken glass and sharp points in the presence of the bishop, then whipped and flung into a foul dungeon together with his mistress. There follows the scene where, before they both die of hunger, the lover eats a piece of his beloved mistress's flesh: the story doesn't say what piece. I thought I had better not choose that scene.

Goodbye, my dear Gautier, I have been ill this winter and have had, for so long, to do without our delightful meetings at Riesener's and Mme Cavé's. I hoped we could renew them in my own home, but I was stopped short, and am still not very well. . . .

ꝯ TO CHARLES SOULIER

Champrosay, 27 *May* 1860

. . . Now, as to your request: I used to know Lieutenant-General Barbier in the Ministry of War, who is probably very influential. I could have had some pull through him: but I have fallen out completely with Villot,[4] his brother-in-law, and I no longer see either of them. We picture friendship as a peaceful deity, whose gentle ties replace those of love when our staider years bring us, or are supposed to bring us, a preference for calm relationships; nothing

[1] In *Le Moniteur Universel*, 5 May, describing an exhibition of modern painting at the Galerie Francis Petit.
[2] *Melmoth, or the Interior of a Dominican monastery in Madrid*, painted in 1832 and exhibited at the 1834 Salon; now in the Philadelphia Museum.
[3] A horror novel by Maturin.
[4] Joubin suggests that Delacroix's feelings for Mme Villot had something to do with this estrangement.

could be further from the truth. Friendship, drab and colourless though it be, has its storms, and unfortunately reconciliations are more difficult because of the absence of physical attraction, which neither man nor beast can resist. . . .

✑ TO M. HARO

Champrosay, 10 *September* 1860

My dear Sir,

Your letter made me very happy; you tell me that my little keepsake[1] pleases you; that was what I wanted above all; not having even any paints here, in order to rest more thoroughly, I had nothing at hand but pastels; I am not sure whether during its transport a little dark dust may not have fallen here and there where it shouldn't have done; so don't seal up the frame with paper at the back, in case I want to touch it up. Mount it with a white border, but not too dazzling and above all not too broad, for that's the way to kill the effect of a painting or drawing. We are so used to enormous frames today that we are not conscious of this drawback. I am fairly well and I'm going to try to start work again, but only coming in to Paris for my session[2] and then returning here. I am still uncertain whether the fatigue of these journeys will not cancel out the benefit of country life.

With my sincere and devoted remembrance,

E. Delacroix

Jenny thanks you very much for your kind message, which she much appreciates.

✑ TO AUGUSTE LAMEY

Champrosay, 2 *October* 1860

. . . Three weeks ago I had the following inspiration, which so far has suited me very well. Every morning I'm woken at half-past five to catch the first train; I am at my work by half-past eight, and I come back here during the day, trying not to keep on too long at my work in spite of the tremendous excitement I feel about it. I can go back to Champrosay at three o'clock. I dine early and go to bed early too. Such is the odd way of life which makes me expend an excessive

[1] To thank Haro for selling his picture. This pastel, *Woman at her toilet*, must have been 'touched up' by Delacroix, for it is signed and dated 1862.
[2] At St Sulpice.

amount of energy, perhaps, but which, while not leaving me a single moment of idleness or boredom, allows me to hope that I may get through my task. I am encouraged by the twofold pleasure I shall have, first from being done with it, God willing, and secondly from reaping the reward of all the trouble I took earlier, of all my successive alterations, now that I see the work going ahead on its own, so to speak, all or nearly all the difficulties having been overcome; it's like a ripe fruit, which can be plucked with ease.

Shall I be able to persevere in this way of life for any length of time? I must admit that it needs a certain strength of mind, in spite of the hope of reward. I need to take infinite precautions against cold, against my tendency to eat large meals: my stomach still has the deplorable habit of only tolerating one meal a day: whence my excessive appetite, against which I try to protect myself. Your good wishes encourage me and will help me in my undertaking.

All my respectful compliments to Mme Fix, whom I beg you to thank, when you see her, for her kind remembrance of me.

What do you think of all these happenings?[1] What strange conditions are forever being brought about by chance and human passions, to the ruin of those who are involved in them, and for the entertainment of the gullible, among whom I include myself through the eagerness with which I devour these impertinent and mendacious newspapers that take advantage of our thirst for news!

I am already thinking of visiting you next spring or summer for a rest; as you say, there's still the terrible winter between us. Let us renew our prayers to the unknown Deity who is responsible for our joys and pains. May he grant my sincerest wishes for your happiness.

I embrace you affectionately,

E. Delacroix

༄ TO GEORGE SAND

[*Champrosay*] 25 *November* 1860

My dear friend,

Your dear letter overwhelmed me with joy, but they were quite right to try to prevent you from writing it:[2] for Heaven's sake, avoid all temptation to write or do any sort of work; I have repeatedly paid dearly, after numerous illnesses, which have become a habit with me, for the pleasure of starting work again too soon, and each time I

[1] The occupation of Naples by Garibaldi.
[2] George Sand had just been very ill at Nohant, with typhoid fever. She must have written to Delacroix for his fête, St Eugene's day.

behave just as foolishly. This winter I stayed by my fireside for four months, and then relapsed once again, after attempting to work, into a state of languor which I only shook off by means of a regimen which still works wonders with me and has restored my strength, and which consists of never keeping still, of being continually in trains or perched on my ladders. At the present moment I am well, but you are not yet in a state to go chasing about the country, nor, above all, to take up your heavenly pen: turn a deaf ear to the promptings of that delightful imagination which inspired your 'Ville Noire',[1] your agreeable philosophising marquis[2] and his charming friend, and so many other delightful characters which you bring to life to console us for having to live among real people.

You must know, my dearest friend, that those few extra years which bring resilience to certain mental processes slow down considerably those that control our motion and digestion. I am firmly convinced that the mind grows towards perfection (I mean a good mind, naturally sound and above all well-balanced). If one really has such a mind, it does not grow weaker with age; but – cruel law of implacable nature! – there's soon nothing left of one's body, nor any circulation in that body. I remember the ancient saying of Themistocles, quoted by good old Poussin at the end of his life: 'Man declines and departs just when he is beginning to do good work'.

However, you're out of the wood; what a joy, as you so truly say, to see all one's loved ones around one, and to come back to the light of day which reveals such lovely things! Let us keep well, my dear friend: there are very horrid things in this world, but after all what shall we find beyond it? Night, dreadful night. There won't even be, according to my sad presentiment, that gloomy limbo in which Achilles, now nothing but ghost, wandered not merely regretting that he was no longer a hero, but wishing that he was the meanest peasant's slave, able to feel cold and heat under that sun which, thank heaven, we still enjoy (when it's not raining). . . .

❧ TO AUGUSTE LAMEY[3]

Paris, 25 November 1860

My dear kind cousin, my worthy friend,

Thank you a thousand times for your letter; I have repeatedly blamed myself for not having written to you to keep you informed

[1] 'La Ville Noire' appeared in *La Revue des Deux Mondes*, 1 and 15 April and 1 May 1860.
[2] *Le Marquis de Villemer.*
[3] Part of this letter is copied in the *Journal*, 26 November.

about the success of the work in which you take so kind an interest. When I say success, I mean progress, for I have not yet reached the point of showing it, I have worked at it unceasingly and if my health does not fail me I hope to have finished by the beginning of January; I don't go as fast as you think, and yet I don't spare myself. For that matter I think it's good for my health, although fatiguing; anyhow, it has so great an attraction for me that I run to it as a healthy young man runs to see his mistress.

I am already thinking about our reunion in the summer months. My thoughts fly through winter's fogs and frost; I spend less time crouching over my fire; I have to go out to my work, and I go out again in the evening; all this gives me strength. We have a sort of wheel within us which sets everything going, as in a mill. It's absolutely essential to keep it turning, for otherwise it rusts and our whole machine stops, body and soul. Your excellent regimen maintains you in this good condition. But I need exercise and work.

You ask me for news of our good Guillemardet.[1] His own health is poor and precarious and he has recently suffered a bereavement. He has lost his niece Mme Coquille, who has just died after an illness that lasted over fifteen years, and at an age when she might have looked forward to longer life. There are really some people who seem doomed to special sufferings, which does not safeguard them against the griefs and pains that afflict all mankind. Poor Félix, whom you knew, was smitten before he was thirty by an implacable disease that destroyed him slowly, and cut him off from the land of the living before the appointed time.

Let us keep well, my dear and worthy friend; let us still be seeing one another in thirty years' time, now in Strasbourg and now in Paris. I was reading recently the story of old Parr, who died in the reign of Charles II at the age of a hundred and forty. His health was perfect; the king insisted on seeing him; at court, he got an attack of indigestion which caused his death; when his body was opened not one single organ was found to be .diseased or enfeebled.

That's the sort of example we should set ourselves. You see we have plenty of time to make plans. With which comforting reflection I embrace you fondly, assuring you of my affectionate respect,

Eug. Delacroix[2]

[1] Louis Guillemardet.
[2] Delacroix only wrote once more, a month later, to Auguste Lamey, who died in January 1861.

৩ TO THE MINISTER OF STATE[1]
[1860]

Monsieur le Ministre,

The picture painted by myself, representing a *Crucifixion*, was bought by the Ministry of the Interior at the Salon of 1835 and assigned to the municipality of Vannes, which presented it to the church of Saint-Paterne. I am informed that this work, which was placed a long time ago in a dark damp chapel in this church, is threatened with complete destruction if this situation continues any longer. I am venturing to approach Your Excellency to ask whether it would not be advisable to have the picture sent back to Paris, and subsequently disposed of as Your Excellency thinks best. You may perhaps consider that the town of Vannes, which possesses no museum, is scarcely entitled to claim it in order to replace it in the church, which failed to ensure the preservation of an object which had been entrusted to it. It has moreover been suggested to me that the unfavourable place allotted to my picture may be accounted for by the figure of Mary Magdalene, which the clergy considered inadequately draped. This may appear to Your Excellency a further reason why this picture, which I had painted without any thought of its being placed in a church, should find a new home after undergoing adequate restoration.

I shall be deeply grateful for anything Your Excellency can do under the circumstances to save a work to which I attach some value, and I pin my hopes to the kind interest which Your Excellency takes in everything that concerns the arts.[2] . . .

৩ TO COUNT GRZYMALA[3]
7 *January* 1861

Dear friend,

A thousand thanks for your kind remembrance of me. If I live like a hermit, it's because I have now reached an age when even the heart's needs have to be restrained when they compete with the demands of one's work. I don't mean that the latter take, or will always take, first place with me. I should be greatly to be pitied. But after years of languor which prevented me from fulfilling my duties as an artist, I have recovered a measure of health which allows me to resume a

1 [*Sic.*] Draft of a letter found among Delacroix's papers by Piron, his executor.
2 Delacroix's plea remained unanswered. In 1865 however, as the picture was in a very bad condition, it was sent to Paris and repaired by Andrieu. It is now in the museum at Vannes.
3 A friend of Chopin's and of George Sand's; he bought several paintings by Delacroix.

considerable piece of work, too often interrupted but now nearing completion.[1] For the past four months I have been off at dawn, hurrying to my exhausting task, and returning only at nightfall. The hope of finishing it soon, unless my uncertain health and the bad weather present fresh obstacles, sustains me and makes me beg you to excuse and forgive my unsociable confinement. When I have finished I will let you know, and shall see you again as gladly as ever and with all the emotion that your kind letter revived in me. With whom else can I talk about the incomparable genius whom heaven begrudged the earth, and of whom I often dream, now that I can no longer see him in this world nor hear his heavenly strains?

If you sometimes see the charming Princess Marcelline,[2] whose humble admirer I am, please convey to her the respects of one who has never ceased to remember her kindness or to admire her talent, another link with that angel whom we have lost and who, now, delights the heavenly spheres.

All my heartfelt affection,

Eug. Delacroix[3]

꿍 TO GEORGE SAND

12 *January* 1861

Dear friend,

I was told by someone, I've forgotten by whom, that you were quite well again and were going to spend the winter somewhere or other to complete your recovery. Whatever you do is right, although I'm not convinced that staying in inns is the best way to restore one's health; one's own comfortable bed, in the place where one has taken root, is as precious as one's mother's milk. Thanks be to heaven. I am quite well myself, and so far I have avoided the ordeal, which I had dreaded after two winters spent by my own fireside, of exposure to the discomforts of travel and the danger of catching a chill. For the past four months I have followed a way of life which has given me back the health I thought lost; I rise early, I hurry to work at some distance from my home, I come back as late as I can and next morning I begin all over again. This constant occupation, and the ardour I put into working like a carthorse, make me feel as if I were back at that

[1] The chapel at St Sulpice.
[2] Princess Czartoryska, whom Delacroix had once greatly admired and whom he used to meet at Berryer's. .
[3] The end of this letter is copied in the *Journal* at the same date.

367

delightful time of life when one was constantly on the go, particularly in pursuit of the fickle beauties who enchanted one. Nothing now enchants me except painting; and now, into the bargain, it has given me the health of a man of thirty; I think of nothing else, I scheme for nothing else, I am entirely devoted to it, in other words I bury myself in work as I believe Newton (who died a virgin) did in his famous discovery of the law of gravity.

My thoughts gravitate towards you, my dear, kind, faithful friend. I said I made no schemes, and yet I might perhaps not have written to you had I not met Bertin,[1] who implored me to ask you whether you were going to fulfil your promise to send him a novel. He is very anxious for something and begged me to tell you so. I know that I shall incur the wrath of our friend Buloz if he should discover my request.[2] He made a scene about this last summer, and he apparently assumes that I owe allegiance to his firm. I put him in his place, and he calmed down. Tell me personally, if you like, whether you think of doing something for the *Débats*, which is eager for it, as I can well imagine, and which is now more popular than ever. I have only room left to tell you that I shall always love you.

c♪ TO LOUIS GUILLEMARDET

22 *May* 1861

Dear friend,

A thousand thanks for your present. I find the sketches extremely interesting and they are a most intriguing example of Goya's work.[3] How could the museum[4] have been so foolish as to let slip the chance of securing the whole collection? They're always doing such things. It is really a pity that the collection is broken up, and in any case it could hardly have gone in its entirety to one individual.

It was very kind of you, too, to visit me in my country home and at such an awkward time. I'm sending you this hurried note before returning to my slave-labours. I hope with God's help to have finished the job soon.

All my love and renewed thanks.

[1] Édouard Bertin.
[2] George Sand had quarrelled with Buloz and broken off her long connection with *La Revue des Deux Mondes*.
[3] Probably from the collection of Guillemardet's father, who had been ambassador in Spain and whose portrait by Goya hangs in the Louvre.
[4] The Louvre.

29 *June* 1861

M. Delacroix requests the honour of your presence in the Chapelle des Saints-Anges at Saint-Sulpice, to view the paintings he has just completed there.

They can be seen, on presentation of this letter, from Wednesday, 21 July to Saturday, 3 August, inclusive, from 1 to 5 p.m.

First chapel on the right, as you enter by the main portal. *Ceiling.* The Archangel St Michael vanquishing the demon. *Right hand picture.* Heliodorus driven from the temple. Having entered with his guard to rob it of its treasures, he is suddenly overthrown by a mysterious rider: at the same time two heavenly messengers swoop down and beat him fiercely with rods until he is driven from the holy precincts. *Left hand picture.* Jacob wrestling with the angel. Jacob is seen bringing flocks and other gifts with which he hopes to allay the wrath of his brother Esau. A stranger appears, who stops him and closes with him in a stubborn wrestling-match that ends only when Jacob, touched in the sinew of his thigh by his adversary, is rendered powerless. This struggle is interpreted by sacred writers as a symbol of the ordeals which God sometimes imposes on His elect.[2]

ↈ TO PAUL HUET

Thursday morning [*August* 1861]

My dear friend,

The pleasure your letter gives me surpasses all the rewards to which an artist can aspire. I hope to see you soon; meanwhile, all my grateful thanks. Men of talent are unfortunately not always endowed with lofty feelings. What do petty rivalries matter: I have never worried much about them: the approval of a man like yourself, so nobly expressed, wipes out the impression of a thousand pinpricks. . . .

ↈ TO THÉOPHILE GAUTIER

4 *August* 1861

My dear Gautier,

A thousand thanks for your article,[3] so full of poetry and praise, and for the alacrity with which you wrote it. You have so often spoilt

[1] Sent to a number of critics and public figures, as well as to friends – Gautier, Thoré, Saint-Victor, Haussmann, Thiers, etc.

[2] See plate 48. [3] In *Le Moniteur Universel*, 3 August.

me that I've come to believe all that you so kindly write about me; I forget too readily that your imagination improves on my inventions, and your style adds polish to them.

All my sincerest thanks and friendly regards.[1]

Eug. Delacroix

ℰ TO LÉON RIESENER

Champrosay, 1 *September* 1861

. . . Neither the minister nor the préfet came, nor Nieuwerkerke, nor anybody from the court or from high society, in spite of my invitations. As for the 'Institut people', only a few of them came; but on the other hand, a great many artists. Actually many people were out of Paris. On the whole I'm pleased; I was assured by everybody that I was not yet dead.

ℰ TO CHARLES BAUDELAIRE

Champrosay, 8 *October* 1861

My dear Sir,

Having recently returned from a visit which kept me away from Paris for some time, I have only just read your very kind article[2] on my Saint-Sulpice paintings, which, like everything you write, shows such originality of mind. I am sincerely grateful to you, both for your words of praise and for the reflections which accompany and confirm these, on those mysterious effects of line and colour to which, alas, too few adepts are sensitive. This factor, which is like music or pure pattern, is non-existent for many people, who look at a picture as Englishmen look at a foreign country when they travel: that's to say, they have their noses in their guidebooks, conscientiously acquiring information about the country's production of wheat and other commodities, etc. In the same way, respectable critics want to understand in order to prove something. Anything that does not wholly come under their rules cannot satisfy them. They feel themselves cheated by a picture which proves nothing and merely gives pleasure.

You wrote to me some two months ago about the process I use for

[1] Further letters are extant written during August 1861 to a number of friends and critics who expressed appreciation of the St Sulpice paintings, e.g. George Sand, Louis de Schwiter, Berryer, Dauzats, Thoré, etc.

[2] Published in *La Revue fantaisiste*, 15 September 1851, and reprinted in *L'Art romantique*; the discussion of line and colour referred to forms part of another article published in the same book.

370

wall-painting, but I did not know where to send my reply. I venture today to send you my grateful thanks at the offices of the *Revue*.

⸿ TO THÉOPHILE THORÉ[1]

Champrosay, near Draveil
(Seine-et-Oise), 30 November 1861

My dear friend,

The letter in which you ask me for details about Bonington has been belatedly forwarded to me in the country: I am very glad to send you such scanty information as I possess.

I knew him well, and I was very fond of him. Despite his imperturbable British sang-froid, he lacked none of the qualities that make life enjoyable. When I met him for the first time I was very young myself and I was making studies in the Louvre gallery: it was about 1816 or 1817. I beheld a tall youth in a short jacket, silently painting studies in water-colour, usually after Flemish landscapes. He was already astonishingly skilful in this *genre*, which at the time was an English novelty. Shortly afterwards, at Schroth's newly opened gallery (the first of its kind, I fancy) where drawings and small pictures were for sale, I saw some water-colours which were delightful both in colour and composition. They already showed all the charm which is his special quality. To my mind, some other modern artists show qualities of strength, or of accuracy in representation, which are superior to Bonington's, but nobody in this modern school, or possibly even before him, has had that lightness of touch which, particularly in water-colour, makes his pictures as it were like diamonds that delight the eye, quite independently of their subject or of any representational qualities.

He was at that time (about 1820) working in Gros's studio, where I believe he did not stay long; Gros himself, who already admired his talent, advised him to devote himself entirely to its development. At this period he had done no oil paintings, and the first he painted were seascapes: these early ones are recognisable by their heavy impasto. He later gave up this excess, particularly when he began painting figure compositions in which costume played an important part: this was towards 1824 or 1825.

We met again in England in 1825, and we worked together making studies at Dr Meyrick's: this was a famous English antiquarian who had the finest collection of armour there has ever been. We became

[1] Thoré published this letter in his study of Bonington in *Histoire des peintres de toutes les Écoles.*

371

close friends during this journey, and when we were back in Paris we worked together for some time at my studio.

I could never weary of admiring his marvellous understanding of effects, and the facility of his execution; not that he was easily satisfied. On the contrary, he frequently repainted things that were completely finished and seemed wonderful to us; but his skill was such that his brush immediately produced fresh effects as delightful as the first. He turned to good account all sorts of details he had discovered in the works of the masters, and fitted them very skilfully into his own compositions. These include figures taken almost whole from paintings that were familiar to everybody, and it did not worry him in the least. This habit by no means detracts from the merit of his works; these details taken, as it were, from life and which he made his own (chiefly as regards the dress of his figures) enhanced their air of truthfulness and never smacked of pastiche.

Towards the end of his all-too-short life he seemed to be afflicted with depression, particularly because of his ambition to paint something on a large scale. He made no attempt, however, as far as I know, to increase the size of his pictures; however, those that contain the largest figures date from this period, notably the *Henri III*[1] which was exhibited here last year in the Boulevard, and which is one of his last paintings.

His name was Richard Parkes Bonington. We all loved him. I used to say to him sometimes, 'You are king in your own realm and Raphael could not have done what you do. Don't worry about other people's qualities or the proportions of their pictures, since your own are masterpieces.'

Some time before this he had done some views of Paris which I don't remember and which I think were for publishers: I only mention them because of the means he had thought up to do his studies from nature without being disturbed by passers-by: he installed himself in a hired carriage and worked there as long as he wanted.

He died in 1828. How many delightful works in so short a career! I learned all of a sudden that he had been afflicted with a chest complaint which was taking a dangerous course. He was a big strong fellow to look at, and we were shocked as well as grieved to learn of his death. He had gone back to England to die. His birthplace was Nottingham. He was only twenty-five or [twenty-] six when he died.

In 1837 a certain Mr Brown of Bordeaux sold a magnificent collection of Bonington's water-colours; I doubt whether we shall ever see the like of it. There were specimens from every period of his talent, but particularly the latest, which was the best. These pictures

[1] *Henri III and the English Ambassador*, now in the Wallace Collection.

372

fetched huge prices; in his life-time he sold all his works, but he never saw them reach these enormous prices which, for my part, I think quite justified and the due of so rare and exquisite a talent.

My dear friend, you have given me an opportunity of remembering happy moments and honouring the memory of a man whom I loved and admired. I am all the more delighted because an attempt has been made to depreciate him, and because he is in my eyes much superior to most of those who have been put forward in preference to him. You must keep the balance between my predilections and this criticism. If you like, you may ascribe to my memories of long ago and my friendship for Bonington anything that may seem biased in these notes.

With affectionate regards from an old and most grateful companion,

Eug. Delacroix

❧ TO THÉOPHILE THORÉ

16 *December* 1861

My dear friend,

I received your *Treasures of Art*[1] and thank you very much for it. I shall read it with great pleasure, and go through it carefully. I am very glad that my notes on Bonington were of use to you. I forgot to tell you that about two years before his death he had made a journey to Venice which had some influence on his way of painting: he never went further afield in Italy, as far as I know. He had then become passionately interested in the use of tempera and had used this to sketch out several pictures. Once more, affectionate greetings from an old and grateful friend,

Eug. Delacroix

❧ TO MME CAVÉ

1 *January* 1862

Dear Madame Cavé,

How can I thank you for your kind and *luxurious* gift? I think I shall scold you, but the splendid dressing gown fits me as if it had been made for me and it is in such exquisite taste that I haven't the courage to tell myself I am not worthy to wear it: I should need to have grown a little handsomer and more than a little younger. No matter, it's a charming thing and an original thought. Jenny cannot thank you

[1] Incorporating the notes on Bonington provided by Delacroix on 30 November.

enough; the colour and shape are exactly right for her and I am happy for the poor creature's sake, for I love her as much as all my relations put together.

I dread long drives in this cold weather, the persistence of which infuriates me and makes me ill. I can only take brief walks round about my den. I should have liked to know how our suit is prospering[1] and whether the minister will deign to turn his attention to it, after it has been predigested for him.

All my love and very sincere best wishes for the New Year. Remember me affectionately to Albert;[2] I hope soon for the pleasure of seeing you both.

<div align="right">Eug. Delacroix</div>

☙ TO PHILIPPE BURTY[3]

1 *March* 1862

. . . I only read the second part of *Faust* long after my engravings were made, and then very superficially. It seemed to me an ill-digested book, not very interesting from a literary point of view, but eminently calculated to inspire a painter through the mixture of characters and styles it comprises. If the work had been more popular I might perhaps have undertaken it. You ask me what gave me the idea for my *Faust* engravings. I remember seeing Retzsch's[4] engravings in about 1821, and being rather struck by them: but it was chiefly the performance of a dramatic opera on *Faust* which I saw in London in 1825 which stimulated me to do something on the subject. The actor, Terry by name, who made some impression in the English theatre of his day and who even came to Paris, where he played *King Lear* among other parts, was an accomplished Mephistopheles; his stoutness did not detract from his agility and his Satanic character.

You know that Motte was my publisher; he had the unfortunate idea of publishing these lithographs with a text which prejudiced their sale, while the peculiar character of the illustrations themselves invited caricature and confirmed my reputation as one of the leaders of the *school of ugliness.* Gérard, however, although an Academician, complimented me on some of the drawings, particularly that of the Tavern. I cannot remember what I got for this: something like a

[1] Mme Cavé, with Delacroix's enthusiastic support, was trying to get her method of teaching drawing approved by the minister.

[2] Her son.

[3] Burty was planning a catalogue of Delacroix's engravings and lithographs which, however, never appeared.

[4] Auguste Retzsch, historical painter, illustrator of Goethe and Shakespeare.

hundred francs, plus an engraving of Lawrence's *Portrait of Pius VII.* All my speculations have been of this type. *Hamlet* even more: I had it printed at my own expense and published it myself. The whole thing cost me five or six hundred francs, and I did not recoup half my expenses. The *Medals*[1] (some proofs of which I have recovered for you) were displayed at some dealer's, but nobody wanted them.

I don't know whether Bonington did the etching you speak of; you remind me that I did a rather clumsy lithograph[2] after one of his drawings, representing an old man sitting at a table and reading, if I remember rightly, a letter brought him by a young man in high boots, leaning against the table. I must have one single proof of this; there may be another one in circulation, which may have given people the idea of attributing it to Bonington. But my drawing is very far from having the delicacy of touch that he brought to his lithographs, and indeed to every product of his admirable talent. I gather that the younger generation of today has no high opinion of him. He shares this disgrace with the illustrious Charlet[3] who, to our young contemporaries, is old-fashioned in his technique and belongs to the days of the Empire. . . .

♂ TO ANTOINE BERRYER

13 *April* 1862

. . . The speech is going well: but I'm counting on my peroration, which I cannot bear to interrupt.[4] Talma used to say that when he was on stage he'd have stopped there if his house had been on fire. What a disappointment! All that greenery and those delightful talks! Nothing can equal that first sigh of nature as she shakes off the bonds of winter. I watch the poor little trees in my garden[5] growing green under my eyes, and they delight my heart. But what's that beside Augerville with you? I have worked as I used to at thirty, and in complete peace . . . I shall not add a gloomy note to this letter, which I began full of thoughts of spring and its delights, by telling you at length my impressions of Vitet's article.[6] Who the deuce forced him to write it,

[1] Five plates of lithographs of Greek medals published in *L'Artiste* and a sixth (Robaut 150).
[2] *The Message.*
[3] N.-T. Charlet, painter and lithographer, much admired by Delacroix.
[4] An article he was writing on Charlet, which appeared on 1 July 1862 in *La Revue des Deux Mondes.*
[5] In the rue de Furstenberg.
[6] Vitet had criticised Delacroix's St Sulpice murals in an article in *La Revue des Deux Mondes*, 1 April, ironically contrasting him with Raphael.

and he admits he did so unwillingly! He isn't in the position of journalists paid by the line and obliged to crush friends and foes alike to fill their columns. Couldn't he have praised Raphael as much as he liked, but left me in peace? How unkindly he persists in the comparison, and how hypocritical his praises sound, amidst this ill-disguised animosity! His greatest compliment is that I am young. I wish to God he could take away my surplus years by means of his wretched criticism! He still thinks I am in 1825; that was how Delécluze treated me in those days. At this point in my life and my career it's a more serious matter. . . .

๑ TO ERNEST CHESNEAU

Champrosay, 7 June 1862

Dear Sir,

I have had forwarded to me here the volume containing the whole of your studies on modern painters,[1] and I hasten to reiterate my warmest thanks: I discover that I am further beholden to you for the flattering manner in which you mention me in those of the studies which I had not yet read. All your judgments may perhaps not meet with approval, but they all deserve interest through their sincerity and the subtlety of your observations. May I venture, dear sir, to express my surprise that in so conscientious a work (and one in which for my own part I find nothing to blame save an excessively generous partiality where I am concerned) I find no reference, among the painters of this century whom you consider most remarkable, to one admirable man who ranks very high in my esteem and whose name you do not even mention: I mean Prudhon,[2] perhaps the most original of all the men with whom you deal, and one whom posterity will undoubtedly set high above a good many of those you have discussed. I can only ascribe this omission to a deliberate bias, for which you no doubt have grounds but which I am sorry you have not taken the trouble to explain to the art-lover reader, to whom you promise a sort of history of painting in our time. I should also have liked (being hard to please, despite your spoiling of me!) a bigger place for Charlet. He is not a mere caricaturist, he is a huge man; he painted with his pencil; nowadays, on the contrary, the painter's brush rarely succeeds, despite all the resources of his palette, in imparting any passion to the

[1] Chesneau had previously sent Delacroix – and been thanked for – the article on himself first published in *Revue européenne*, 1 December 1861, and later incorporated in *La peinture française au 19e siècle*.
[2] Delacroix had published an article on Prudhon in *La Revue des Deux Mondes*, 1 November 1846.

pictures of a generation that is averse to seeking great effects in its painting and thus suppresses its principal difficulties.

I must beg you to excuse these observations, dear Sir; they will at least prove to you the keen interest I have taken in reading your really original studies, and if I venture to ask for a kind of supplement to them you must see in this wish only another way of expressing my gratitude.

TO THE DUCHESSE COLONNA DE CASTIGLIONE

Champrosay, 13 *June* 1862

Madame la Duchesse,

How can I thank you for so kind a letter, and for the praises inspired by your partiality for my work, which I so much appreciate? . . .

You realise, of course, Madame la Duchesse, that when I praise your taste I am not thinking of the kindness with which you temper my self-censure but of the lofty disgust which you feel for all that is horrible. Alas, we are surrounded by the horrible: it takes the form of insipidity, as well as of exaggerated energy. Can you make anything of today's literature, of all those stories which are exactly like one another, or of all those paintings which display nothing but impotent pretentiousness and the repetition of the same pastiches?

I had indeed seen that famous picture,[1] Madame la Duchesse; but I was not in the least surprised by it, I mean by the kind of badness to be found in it, which is not so very different from the badness for which the painter had a predilection in the old days. It is a pity he was persuaded to display this depressing production at an age when there is little hope of making amends. . . .

E. D.

TO ANTOINE BERRYER[2]

1 *August* 1862

. . . A few fine days, an uninterrupted spell in September, will allow me to forget, in your company, the dreadful pandemonium of our glorious achievements, our industry, our progress in every sphere, which will leave nothing for our descendants to do but which I detest and which vex me to an extent which you must well appreciate, to judge by the delightful way in which you describe them. What a joy, on the other hand, to find that you share my sympathies and anti-

[1] Ingres's *Jesus in the midst of the doctors.*
[2] Answer to a letter from Berryer inviting him to Augerville.

pathies! Hugo and Racine: these are, to my mind, the types that sum up the genius of our incomparable epoch and that which our good forbears were simple-minded enough to set highest of all. I'll say no more on these topics, which lead me straight into invective against the human race. It still contains, fortunately, a few examples of dignity, a few objects worthy of veneration. You, whom all admire and whom I love tenderly into the bargain, you are one of those models who encourage and console one. I need that; I am depressed and bored; life is what you know it to be. The years that accumulate are far from enhancing its value. Gout, bad eyesight and the rest make it very tedious. Boredom, in a word, quite apart from pain, these are the monsters against which we should fight; but one needs energy, as well, to be able to enjoy oneself. . . .

⹂ TO LOUIS DE SCHWITER

Champrosay, 8 *August* 1862

My dear Schwiter,

I am obliged by my health on the one hand, and on the other by considerations I shall tell you about, to postpone any project of a journey to Italy. I have had a severe attack of the complaint I told you about (bladder trouble, etc.) which makes travelling difficult. The heat may have been partly responsible; but in any case it's a tiresome affliction and I should be afraid of its becoming a serious one. In the second place, your lovely Italy seems to be launching out on fresh adventures.[1] It would be unpleasant, when travelling for pleasure, to find oneself involved in some affray or merely frustrated in one's plans by circumstances or by the mere fact of being a Frenchman, particularly in Rome, which is my main objective. All this may come to nothing in spite of rather ominous appearances. You stay in that country so often that I hope not to miss the opportunity, to which I was so much looking forward, of making the journey in your company; I still cherish the hope of doing so, and I shall try to choose a time when we need fear neither the excessive heat of the climate nor the eccentricities of patriots.

Such, my dear Schwiter, is the result of my reflections on our project, which I am far from having abandoned and which I shall find particularly agreeable in your company. Let me assure you in the meantime of my faithful and devoted friendship,

Eug. Delacroix

[1] Renewed activities of Garibaldi in Lombardy and Calabria.

ぷ TO SAINTE-BEUVE

Champrosay, 12 *August* 1862

Dear Sir,

How grateful I am to you for your kind references to myself in your excellent article on good old Delécluze,[1] to whom you do too much honour by this tribute from your exquisite pen! I am all by myself in the country, and had had the *Constitutionnel* sent on to me, thinking that it was just an ordinary newspaper; and now every Monday I am given food for the mind and a source of exquisite pleasure. Keep it up, my dear old companion-in-arms; go on vigorously proving (and for my part I shall be delighted) that one can be a Romantic and yet have good sense and a noble mind.

I clasp your hand with true gratitude,

Eug. Delacroix

ぷ TO THE DUCHESSE COLONNA DE CASTIGLIONE

Ante (Marne), 23 *September* 1862

. . . The diversions I am enjoying here make a new man of me: I scarcely think about painting. On the other hand I get great pleasure from everything I see, I am really in the country here. Champrosay is a comic-opera village: it's full of smart people, or peasants who look as if they had been dressing up for the stage; nature herself seems to wear paint; I am shocked by all these tidy little gardens and cottages fixed up by Parisians. And when I am there I feel more attracted by my studio than by any pleasures the place can offer. Here, in the heart of Champagne, I see men and women and cattle; I am touched by it all, and feel sensations unknown to those who dwell in towns, be they artists or petty *bourgeois.* . . .

E. D.

ぷ TO M. BEULE
Secrétaire perpétuel
of the Académie des Beaux-Arts

Ante, near Givry-en-Argonne, 28 *September* 1862

My dear colleague,

Allow me to express my regret and vexation at finding myself unable to attend the sessions which the Academy of Fine Arts has been

[1] Article in *Le Constitutionnel*, 11 and 18 August, 'Souvenirs de soixante années'. Reprinted in *Nouveaux Lundis*, III, 11.

devoting to an examination of the Campana Collection (Musée Napoléon III),[1] in order to pass an opinion on the proposed eliminations. Having been under the misapprehension that this question would not be examined before the middle of November, I had, to my deep regret, taken no steps to ensure that I was duly notified, being at some distance from Paris, and I beg the Academy to accept my apologies for my involuntary absence, which I cannot sufficiently regret. I do not even know, at the present moment, whether the Academy has completed its task, and it is solely in the hope that it may perhaps not be too late for it to consider the reflections submitted herewith, which I should have been glad to expound before it, that I venture to send you this imperfect résumé of my own observations, begging you to communicate them to the Academy.

I need not point out the distress which all artists must have felt on learning of the proposed alterations to the Musée Napoléon III. This collection, famous throughout Europe, had aroused in all of us, from its first appearance, both admiration and at the same time the most respectful and sincere gratitude to the Emperor, who had deigned to take it under his special protection by giving it his name, after having so generously bequeathed it to France.

It seemed to me, in particular, that a considerable part of the interest offered by this assemblage of admirable objects arose from the fact of their being thus assembled, and that the idea of diminishing the collection under pretext of removing exhibits of secondary importance was completely contrary to the manifest intention of its founder and to the purpose of a true museum. Such a collection is not like that of an enthusiastic and exclusive amateur, who chooses to admit only select specimens, the sole merit of which often lies in their rarity. A collection from which students are to benefit must consist not only of fine objects but also of those which, while of a lower order of merit, enable one to trace and appreciate the tentative process through which art attained its perfection.

Nothing could be more instructive. This interesting collection of Italian paintings from the Campana Museum, which I mention in this connection, has been, to my mind, judged superficially and, for the most part, condemned, by people who did not sufficiently realise its relative importance and the light it throws on the origins and progress of the Italian schools. Such enlightenment, hitherto unobtainable in Paris, results from the juxtaposition of the pictures and the com-

[1] The Campana Collection had been bought in Rome by Napoleon III in 1861. It consisted of 646 Italian paintings, chiefly fourteenth- and fifteenth-century, and antiquities, chiefly Greek and Etruscan ceramics. Despite the protests of Delacroix and others the collection was broken up and distributed among seventy-seven provincial museums.

parisons that arise naturally therefrom. To break up the group and distribute the pictures among various collections would mean destroying an assemblage which was invaluable from this point of view, without notably enriching the collections to which these pictures would go and where they would pass unnoticed.

I venture to say as much about the magnificent gallery of ceramics, in which one can never tire of admiring the beauty and variety of the genius of classical antiquity. This variety springs, I feel, in a wholly admirable way from the frequent use of the same motifs, repeated with almost imperceptible nuances, the study of which reveals in the most interesting fashion the fondness of classical artists for certain subjects and, at the same time, their avoidance of mechanical reproduction, since the artist never fails to vary the type with differences which, though apparently slight, are characteristic.

I am well aware that the incredible objection has been put forward that so numerous a collection of exhibits would require too large a space. A strange objection indeed, which consists in regretting the richness of the collection! It is easier to find room for a display of pictures and statues than it is to discover and acquire so large a number, and of such high interest. This was what the Marquis Campana had succeeded in doing in that vast museum which bore his name, and which rash mutilations threaten to scatter, thus depriving it of the name of its recent and august patron.

The painted vases, the majolicas and the stoneware in relievo seem to me to give rise to the same observations, and if I might add a personal wish to my hopes that so precious an assemblage will be preserved in all its harmony, I should like to see it include the admirable plaster casts which M. Ravaisson,[1] with such enlightened zeal, had displayed in the same exhibition. I have no doubt that if the museum should be preserved it would shortly be enriched by gifts from a large number of art lovers, eager to add to its wealth and to fill its lacunae. It has come to my knowledge that certain intended gifts of this sort have been discouraged and held in abeyance, since the public were warned of the possibility of imminent dismemberment.

I shall not trespass longer on the Academy's attention by enlarging on the ideas which I have ventured to suggest above, and which have no doubt occurred to its members on their visits to the Musée Napoléon III. The high intelligence, the taste and experience of so many men distinguished in every branch of art make me confident of the impression they will have derived from it and the desire they will feel to safeguard so exceptional a treasure for France. This fine collection has

[1] Then Curator of Antiquities in the Louvre.

already received a precious tribute of admiration: the illustrious M. Ingres felt almost in duty bound to recommend it to the enlightened protection of the Academy; I follow him although with inferior eloquence, at least in manifesting my keen sympathy and my earnest desire for the preservation of the Musée Napoléon III.

Kindly accept, Monsieur le secretaire perpétuel, my dear colleague, the expression of my respectful regards,

<div align="right">

Eug. Delacroix
Member of the Institut

</div>

♪ TO M. MOREAU, Sr

17 *January* 1863

Dear Sir,

Please accept my sincere apologies for my delay in replying to your kind letter dated 3 January. I was suddenly interrupted in the midst of all my activities by an indisposition which rendered me incapable of doing anything whatsoever. I am better now, and hasten to thank you for your kind remarks on the very inadequate article I wrote on Charlet.[1] I owe you some explanation for my reluctance to write anything about Decamps;[2] I mentioned certain motives which you understood. I feel moreover that his death has occurred so recently that any assessment of his work would be incomplete and would moreover lack the interest of judgment passed at a later date.

May I add that this great artist was fortunate enough to enjoy, in his life-time, the uncontested favour both of the public and of his fellow artists: not a single voice was raised against the successes of every sort which he deserved and won. Charlet was not so lucky. Admiration for his work was confined to a narrower circle, and it was precisely because of the kind of work he did, which public opinion considered of an inferior category, that it seemed to me important to bring out the greatness he imparted to it. For that matter, since I had the pleasure of seeing you, the figure of Decamps has gone up in my esteem. After seeing the unfinished sketches which comprised the latest sale of his works, I was genuinely excited about some of these compositions, and my feelings were shared by all who saw them. I must also tell you that this article, which had been commissioned a long time ago, gave me a great deal of trouble to compose; writing is a special craft which, like all others, demands much practice. I only

[1] *La Revue des Deux Mondes*, 1 July 1862.
[2] Delacroix's early enthusiasm for Decamps had diminished. Decamps died in 1860.

got the fatigue of it without the pleasure, and that I cannot say about painting, which is still my favourite pastime and to which I return without any yearning for literary glory.

<div align="right">Eug. Delacroix</div>

↪ TO A.-A. WACQUEZ[1]

February 1863

Dear Sir,

Yesterday was the first time I was able to visit the exhibition in the Boulevard des Italiens. I was, and still am, unwell. I was very sorry not to have been able to tell you my impression of your picture. It seemed to me to have a great deal of truth, and the details are most carefully studied. Possibly a certain slackness in the rendering of the background detracts somewhat from the vividness of the whole thing. Actually, I think this may be explained by the fact that your animals, which incidentally are very well drawn, are modelled in very strong relief. The slight faults that I venture to criticise, among others that of introducing rather too much detail into the foreground, seem to me to be due not to any poverty of effects, for you are abundantly rich in that respect, but to a cause which I feel is bound to lead artists of every sort of talent into this error. I have already ventured to advise landscape artists against living continuously in the country. The presence of nature takes away any initiative, and it seems to me almost impossible, when confronted with her unvarying perfection, not to consider oneself inferior whenever some particular inspiration requires one to make certain sacrifices. I much prefer the system of simply making studies after nature, and then, when one is at a distance from the object of one's imitation, memory preserves only its most outstanding features.

Please forgive me for suggesting these ideas, which are inspired by a sincere desire to be helpful to you.

↪ TO PAULINE VIARDOT

19 *March* 1863

To my great distress, madame, I shall be unable to go to see you or to dine with you as you so kindly invited me to. We could have talked about your dress for *Armide*. I had been fairly well, but have been smitten with a heavy cold which forces me to stay at home. I venture to suggest a few reflections on the subject of your letter.

[1] A.-A. Wacquez, painter and engraver, pupil of Delacroix.

Armide's costume must be purely fanciful; here, even more than in *Orpheus*, you can choose whatever suits you best. Here you're in the realm of pure fairy-tale: a mixture of nymph and fine lady. I am sure you have such good taste that you are certain to hit the right thing, just as you did in *Orphée* where you were admirable.

I am very grieved at being fettered thus; I have missed all sorts of good opportunities this winter.

Assuring you of my keen and undying admiration,

Eug. Delacroix

Please remember me affectionately to M. Viardot. Mme Sand, whom I have been seeing, was most delighted with your performance.

ᏒᎧ TO P. ANDRIEU
21 *May* 1863

My dear Andrieu,

Many thanks for your kind remembrance of me; I am particularly glad to hear that you have had no disappointment with your compositions. Only that which has been well prepared can be finished well. You will reap the reward of all your preliminary efforts. . . .

I have seen the duchess[1] two or three times, with considerable pleasure: I think she misses you a great deal, and she wants to do some painting. I gather that she has had a great success with her busts, on which the Empress has complimented her highly: I think she must be pleased.

Don't fail to accept any commissions you may be given, particularly if you should have thought of refusing them in view of the work we might be going to do together. The bad patch I have just been through makes me disinclined for the moment to launch out into large-scale undertakings, in spite of my passion for them; passion must give way before reason, I have reached an age when one must get used to sacrifices.

Haro told me about your disappointment at the exhibition: artists are being treated abominably, and this state of things is bound to go on so long as the jury is made up as at present.

Keep me informed, meanwhile, about what you are doing. This work will increase your self-confidence: that's the most necessary factor for success in all things.

[1] The Duchesse Colonna de Castiglione.

↲ TO LOUIS GUILLEMARDET

3 *June* 1863

Dear friend,

I was so exhausted and overwrought by having to make all my arrangements that I was unable to go to see you before leaving; I was particularly sorry since I knew that you had a slight misadventure. Three days ago I had to come back to Paris to see the doctor: this three-months-old cold was beginning to take a nasty turn. I was patched up, more or less, and given permission to go back tomorrow, under orders to observe absolute rest and silence. I cannot do this anywhere better that at Champrosay; at any rate, instead of seeing only the chimneys of Paris, I have the loveliest of landscapes under my window. You see, rest, silence, and particularly silence. It's because I have been involved in so many conversations that, with the help of my cold, I have got to the point of not being able to utter one word without coughing.

I hope, my dear friend, that you will also keep up the same beneficent regimen and that we shall soon meet again, with all our anxieties behind us.

With all my love,

Eug. Delacroix

↲ TO M. HARO

Champrosay, *Friday*, *July* 1863

My dear Monsieur Haro,

I am much better, but my progress is very slow; seclusion is proving very helpful, and it's my chief remedy. I would have written to you earlier but my weakness makes any activity burdensome. Very many thanks for the kind things you say about me: Jenny thanks you warmly, as well as myself. I will take advantage of your kind offer for anything I might need; but since I use no remedies, but only follow a regimen, I hope I shall get on all right. This is only a short note, dear Monsieur Haro. I am sincerely grateful to you. Jenny joins me in thanking you.

Your devoted

Eug. Delacroix

↲ TO MME DE FORGET

[*July* 1863]

I need not tell you, my dear, how delighted I was with your flowers: but the day you came I was really very ill: writing is torture, I can

only give you my heartfelt thanks. During the past two or three days there has been a noticeable improvement.

Ever yours, my dear,

E. D.

Thank you for the books.

ঌ TO GEORGE SAND

21 *July* 1863

Dear friend, you are surprised at my not answering your letter: I can't bear writing. I have been very ill, I still am. A cold that dragged on all winter brought on unpleasant consequences. I'm perceptibly better, however. How kind of you to have remembered me amidst your family rejoicings. You must indeed be delighted. Long life to Marc,[1] may he be as good as you all are.

I shan't write much: think of it, for two months now I have not left my room, and I'm weaker than I'd have thought possible.

All my love,

E. Delacroix

ঌ TO LÉON RIESENER

Paris, 6 *August* 1863

Dear friend,

Don't be surprised to see an unfamiliar handwriting – my greatest affliction just now is my weakness, for all my other symptoms have disappeared. My convalescence will be very slow on that account; however, I welcome visits from my friends and above all my appetite is good.

If anything serious should happen you would be immediately informed.

All my love,

Eug. Delacroix

ঌ TO P. ANDRIEU

Paris, 6 *August* 1863

My dear Andrieu,

Instead of painting, I have been almost continuously in bed for the last two months. You see we were far out in our calculations. I am

[1] Maurice Sand's newborn son.

much better now, only my convalescence is going to take a long time. Goodbye, and good courage. I see you're full of the right spirit. Very sincerely yours,

Eug. Delacroix

[Note added by Jenny: Monsieur Andrieu, Monsieur is very ill.]

ℰ TO ANTOINE BERRYER[1]

6 *August* 1863

My dear cousin,

I am so weak that I cannot write; on the other hand all my other symptoms have disappeared; I hope now that I shall only need patience. I shan't say any more and I send you all my love.

Eugène Delacroix

JENNY LEGUILLOU TO MME BABUT

Paris, 20 *August* 1863

Madame,

Thank you for the kind letter you wrote me. I am deeply grieved to have to tell you of the dreadful blow that has fallen me; I wanted to write to you at once, but I was ill with grief and weariness; but I had addressed a formal note to you. My poor dear master had been ill for three months; his illness began with a cold as usual and then his poor chest was affected; all the time I looked after him without leaving him for a single moment; he retained his calm and tranquil mind until his last hour, recognising me, clasping my hand without being able to speak, and he breathed his last like a child.

I am, dear Madame, your respectful humble servant,

Jenny Leguillou

[1] Written by Jenny and signed by Delacroix.

Appendix

Select bibliography
Index of correspondents
General index

SELECT BIBLIOGRAPHY

The two principal French texts consulted for the translation:

Correspondance générale d'Eugène Delacroix, ed. André Joubin, 5 vols (Plon, 1935-8)

Eugène Delacroix, *Lettres intimes, correspondance inédite*, ed. Alfred Dupont (Gallimard, 1954).

Other French works cited:

Lettres inédites, ed. J.-J. Guiffrey (Rillet & Dumoulin, 1877)

Lettres d'Eugène Delacroix, ed. Philippe Burty, 2nd edn, revised and enlarged, 2 vols (Charpentier, 1880)

— (another edn), ed. Charles de Lacombe and Antoine Berryer (1885)

— (another edn), ed. Alfred Robaut and Constant Dutilleux (n.d.)

Eugène Delacroix raconté par lui-même, ed. Etienne Moreau-Nélaton, 2 vols (1916)

Delacroix, peintre, graveur, écrivain, ed. Raymond Escholier, 3 vols (Floury, 1926-9)

Eugène Delacroix, sa vie et ses œuvres, ed. Achille Piron (1865)

— (another edn), *Œuvres litteraires*, ed. Elie Faure, 2 vols (Bibliothèque Dionysienne, 1923)

Delacroix's verse, ed. André Joubin, *Gazette des Beaux-Arts* (1927)

A study of Delacroix, in Théophile Silvestre, *Histoire des artistes vivants français et étrangers* (1856)

English works cited:

René Huyghe, *Delacroix*, trans. Jonathan Griffin (Thames & Hudson, 1963)

John Russell, *Portfolio and Art News Annual*, No. 6 (1962)

Arts Council, in association with the Edinburgh Festival Society, *Delacroix*, catalogue of the exhibition, London and Edinburgh (1964)

Editions of Delacroix's *Journal*:

[French] *Journal d'Eugène Delacroix*, ed. André Joubin, 3 vols, latest edn, preface J.-L. Vaudoyer (Plon, 1960)

[English] *The Journal of Eugène Delacroix*, a selection, ed. H. Wellington, trans. Lucy Norton (Phaidon Press, 1951) (*cited*)

[English] *The Journal of Eugène Delacroix* (another selection), trans. Walter Pach, latest edn, Evergreen Books (New York, Grove Press, 1961)

Other principal works:

[French] Alfred Robaut, *L'Œuvre complet d'Eugène Delacroix, peintures, dessins, gravures, lithographies*, commentary by Ernest Chesneau (1885)

[French] Maurice Sérullaz, *Mémorial de l'Exposition Eugène Delacroix organisée au Musée du Louvre à l'occasion du centenaire de la mort de l'artiste* (1963)

[French] —, *Delacroix: Water-colours of Morocco* (Paris and London, 1952)

[French] —, *Les peintures murales de Delacroix* (1963)

[French] —, 'Les premières decorations murales de Delacroix', *Arts de France*, III (1963)

[English] Jack J. Spector, *The Murals of Eugène Delacroix at Saint-Sulpice* (New York, 1969)

French periodicals cited:

Le Constitutionnel, 1822, 1829, 1832 *passim*, 1845 *passim*, 1846 *passim*, 4 April 1847, 8 July, 1849, 11, 18 August 1862

Journal des Débats, 1832 *passim*, 1842 *passim*

La Chronique, 1842 *passim*

La Loi, 24 February 1837

La Minerve française, 1818

La Presse, 1843 *passim*, 1844 *passim*, 8 March 1851, 5 June 1855

La Revue de Paris et des Départements, 9 October 1824

L'Artiste, 1 March 1831, 1831 *passim*, 20 June 1831, 1839 (II, 213), 1842 *passim*, 1843 *passim*, 18 January 1857, 2 May 1858, 21 March 1858 and ff., 1862 *passim*

Le Corsaire-Satan, 1851 *passim*

Le Globe, 8 March 1828

Le Moniteur Universel, 1833, 1843 *passim*, 26, 29, 30 June 1853, 19 July 1855, 25 February 1856, 5 May 1860, 3 August 1861

Le Pays, 26 May 1855

Le Siècle, 24-5 February 1837

Le Temps, 1829

L'Illustration, 29 October 1843, 5 November 1853

L'Indépendance Belge, 1859 *passim*

Magasin pittoresque, 1843, 1842 *passim*

Nouveaux Lundis, III., 11

Revue de Paris, 1829 *passim*, June-July 1830
Revue des Deux Mondes, 1835 *passim*, March-April 1835, 1837 *passim*, 1 August 1837, 1 May 1838, 1840 *passim*, 1842 *passim*, 1 November 1846, 15 September 1850, 1853 *passim*, 15 November 1853, 15 April 1854, 1, 15 April 1860, 1 May 1860, 1861 *passim*, 1 April 1862, 1 July 1862.
Revue européenne, 1 December 1861
Revue fantaisiste, 15 September 1851
Revue Indépendante, 1841 *passim*, 10, 25 November 1847

INDEX OF CORRESPONDENTS

Andrieu, Pierre, 311-12, 384, 386-7

Angers, David d', 144

Artiste, L', editor of, 166-71

Auguste, Jules-Robert, 157

Balzac, Honoré de, 197-8

Barye, Antoine, 151

Baudelaire, Charles, 261, 329-30, 343, 356-7, 359, 370

Bénard, M. (architect), 133

Berryer, Antoine, 347, 348, 375-6, 377-8, 387

Bertin, Armand, 192-3

Beule, M., 379-82

Beyle, Henri (Stendhal), 117

Boulanger, Élise (later Mme Cavé), 218-19

Buloz, François, 215-16, 317

Burty, Philippe, 374-5

Castiglione, Duchesse Colonna de, 377, 379

Cavé, François, 201

Cavé, Élise Boulanger, Mme, 294-295 328-9, 373-4

Champfleury, M., 301, 340-1

Chesneau, Ernest, 376-7

Chopin, Frédéric, 224, 233, 260

Colin, Alexandre, 358

Cuvillier-Fleury, M., 224-5

Decaisne, Henri, 173-7

De Gisors, M. (architect), 234, 260

Delacroix, General Charles, 78, 134-5, 162,* 225,* 248-9*

De Mareste, Baron Adolphe, 218

Dessauer, M. (musician), 273

Diéterle, J.-P.-M., 274-5

Dumas, Alexandre, 160, 355

Duponchel, M. (director of Opéra), 185-6

Dutilleux, Constant, 286-7, 295-7, 300, 321, 338, 346, 353

Feuillet de Conches, Félix, 172-3, 182, 196, 217

Fine Arts Section of Institut, President of, 214

Flaubert, Gustave, 340

Fleury, Robert, 298-9

Forget, Joséphine de, 202-3, 254-255, 264-5, 273-4, 284-6, 287, 290, 291-2, 293-4, 301-3, 309-310, 313-14, 322-3, 324-7, 330, 332, 335, 341-2, 345-6, 359, 385

Gaultron, Hippolyte, 255-6, 265

Gautier, Théophile, 250-1, 254, 279, 299-300, 330-1, 334, 339, 344, 361, 369

Grzymala, Count, 366-7

Gudin, Baron Théodore, 184

Guillemardet, Félix, 31,* 38-9,* 44-6,* 56-60,* 60-2,* 65-6,* 79,* 79-82,* 92-4,* 114-15,*

* From Eugène Delacroix, *Lettres intimes*, ed. Alfred Dupont (Gallimard, 1954).

395

Guillemardet, Félix—(cont.)
115-16,* 130-1, 148-9,* 157-
158,* 165-6,* 182-4
Guillemardet, Louis, 368, 385

Haro, M. (art dealer), 141, 297-8,
362, 385
Haro, Mme, 138
Huet, Paul, 234, 327, 347-8,
355-6, 369
Hugo, Victor, 140, 147-8

Ingres, J.-A.-D., 337-8

Jal, Auguste, 193-4
Janin, Jules, 224

Lamey, Auguste, 334, 343-4,
362-3, 364-5
Lamey, Mme, 333
Lassalle-Bordes, M., 238, 246-7,
256-7
Laugier, Dr, 292
Leguillou, Jenny, 357
Louvet, Félix, 31-2

Maupoint, Mme la Baronne de,
312
Mercey, Frédéric, 219, 247-8, 327
Moreau, M., 382
Motte, M. (printer), 141-3
Mouilleron, M., 281

Nieuwerkerke, Comte de, 359
Nourrit, Adolphe, 209

Peisse, Léon, 289, 324
Pérignon, Alexis, 340, 354

Pierret, J.-B., 35-7, 39-44, 46-8,
49-50, 53-6, 62-5, 75-8, 82-6,
89-92, 111-14, 115, 121-2,
124-31, 136, 140-1, 151-3,
156-7, 177-8, 179-81, 182-4,
187-91, 194-6, 204-5, 208-9,
226, 229-30, 236-7, 241-4,
249-50, 253, 270, 281, 286, 306
Pierret, Mme, 153, 216
Piron, Achille, 32-4,* 34,* 46,*
51-3,* 104
Planche, Gustave, 245-6, 323
Planet, Louis de, 253, 254
Poterlet, Hippolyte, 137-8
Préault, Auguste, 283-4

Riesener, Léon, 288, 289-90, 370,
386
Rivet, Baron Charles, 160-2, 217-
218, 328
Roché, M., 272-3
Royer-Collard, Hippolyte, 178-9

Saint-Hilaire, Geoffroy, 234-5
Sainte-Beuve, Charles, 379
Sand, George, 209-10, 220-1,
226-7, 228-9, 233, 235-6, 238-
239, 240-1, 244-5, 247, 251-2,
257-60, 263-4, 266-68, 269-70,
271-2, 275-81, 282-3, 303-6,
308-9, 310-11, 316, 358, 363-4,
367-8, 386
Schwiter, Louis de, 143, 201-2,
299, 360, 378
Silvestre, Théophile, 322, 333,
335-6, 350-3
Soulier, Charles, 48-9, 74-5, 86-9,
94-104, 105-8, 122-4, 131-3,
135-6, 138-40, 144-7, 149-50,
154, 155-6,* 158-9,* 159,*
* From Eugène Delacroix, *Lettres intimes*, ed. Alfred Dupont (Gallimard, 1954).

171-2, 203-4, 239-40, 281-2, 290-1, 294, 314-16, 331-2, 336-7, 338-9,* 342-3, 344-5, 348-50, 361-2
Stendhal (Henri Beyle), 117

Thiers, Adolphe, 212-14 (as Minister of Interior), 222-3
Thoré-Burger, Théophile, 210-12, 214-15, 261, 268, 274, 371-3

Varcollier, M., 307
Verninac, Henriette de, 66-74, 108-11
Viardot, Pauline, 383-4
Villot, Frédéric, 164-5, 171,186-7, 196-7, 205-8, 221-2,223, 227-8, 230-2, 243, 262-3, 268-9, 270-1

Wacquez, A.-A., 383

* From Eugène Delacroix, *Lettres intimes*, ed. Alfred Dupont (Gallimard, 1954).

GENERAL INDEX

Abbate, Niccolo dell', 180*n*
Adoration of the Magi (Perugino), 221*n*
Adoration of the Shepherds (Rubens), 221*n*
Adrien (son of Soulier's mistress), 89, 101, 103
Agnese (Paer), 52
Aix-la-Chapelle, 292
Ajaccio Cathedral, 6
Alauz, M. ('the Roman'), 180
Algeciras, 180, 181
Algiers, 15, 16, 193, 195
Amsterdam, 226, 323
Amy Robsart (Hugo), Delacroix designs costumes for, 8, 147
Ancelot, Jacques, 148
André (Sand), 210
Andrieu, Pierre, 19, 366*n*
Angers, David d', 279*n*
Angoulême, 39, 107, 110
Ante, 335*n*, 379
Antwerp, 226
Aphrodite of Melos, 14
Apotheosis of Homer (Ingres), 21
Arago, Étienne, 14
Argout, Comte d', 175*n*
Armide (Gluck), 383
Arnold, Matthew, 22
Arpentigny, Captain d', 308*n*
Arques, Château d', 304
Art et les artistes contemporains au Salon de 1859, L' (Dumas), 355*n*
Art poétique (Boileau), 358*n*

Art romantique, L' (Baudelaire), 370*n*
Artiste, L', 166, 172*n*, 173*n*, 224, 250*n*, 339, 344, 375*n*
Atala (Chateaubriand), 212
Augerville-la-Rivière, 324*n*, 326-327, 330, 377*n* and *Pl.* 39*b*
Auguste, Jules-Robert, 7, 8, 10, 128, 132, 137

Bachelier de Salamanque, Le (Lesage), 313
Balzac, Honoré de, 1, 17, 23, 49*n*., 344; 'a chatterbox', 243
Baour-Lormian, M., 35, 48, 55
Baptism of Christ (Perugino), 221*n*
Barber of Seville (Rossini), 129
Barbier, Auguste, 216
Barbier, Lieutenant-General, 361
Baroilhet (singer), 16
Barye, Antoine, 152
Bastien (model and servant), 136, 184
Bataille, Augustin, 31*n*, 239*n*
Batissier (art critic), 250
Batta, Alexandre, 326, 330, 348
Baudelaire, Charles, 2, 10, 28
Beaumont-sur-Oise, 202
Beerbohm, Max, 11
Beffes, 291
Belgium, 5, 292*n*, 293-4, 295
Bellini, Vincenzo, 227*n*
Berlioz, Hector, 8, 139*n*, 266*n*, 358*n*

Berrier-Constant (of Fine Arts department), 175
Berry, Duchesse de, 163-4, 211
Berryer, Antoine, 326, 330n, 331n, 335
Bertin, Armand, 186
Bertin, Édouard, 90, 122, 125, 126, 129, 174, 179, 186, 193, 368
Blacas, Duc de, 111
Blanc, Charles, 269
Blanc, Louis, 285
Blois, 272
Boileau, Nicolas, 358n
Boilheau, M. (family lawyer), 68
Boissy d'Anglas, F.-A. de, 167n
Bologna, 79
Bonaparte, Louis, 289n
Bonaparte visiting the Victims of the Plague at Jaffa (Gros), 7
Bonington, Richard Parkes, 10, 11, 28, 121n, 132, 139, 350; Delacroix's notes on, 371-3, 375
Bonini, Mme (singer), 113n
Bordeaux, 264-8, 312; brother buried in, 131n, 267
Bornot (cousin and owner of Valmont), 265, 274
Boulanger, Clément, 219
Boulanger, Élise (later Mme Cavé), affair with, 218n, 226n
Bracquemond, F.-J.-A., 340-1
Brancas, Mme de, 70, 72
Braque, Georges, 21
Buissonneau, M., 51-2
Buloz, François, 23, 204, 209n, 210, 214, 233n, 368
Burns, Robert, 172
Byron, Lord, 10, 56, 211, 212, 252n

Cagliostro, Count, 252
Cailleux, M. de (Louvre director), 277n

Campana Collection, 380-2
Candide (Voltaire), 339, 349
Caraffa, Michele Enrico, 218
Carlos de Austria, Don, 59
Caroline (maid and mistress), 49n
Carpenter, Margaret Sarah, 143n
Carpentras, 293
Castiglione, Duchesse Colonna de, 384n
Catlin, Captain George, 264n
Cavé, Albert, 374
Cavé, François, 218n, 247, 289n
Cazenave, Mme, 70, 72, 113
Chambre des Députés library, 18, 246, 253, 254, 257, 279, 299
Chambre des Pairs library, 221, 222, 234, 235n, 238, 241n, 242n, 244n, 246, 260n, 272
Champmartin, Charles-Henri-Callande de, 137
Champrosay, 25, 28, 222, 256n, 263, 271n, 276-7, 283, 285-6, 288-90, 291, 297, 306n, 313-314, 322, 329, 335, 344-5, 358, 360, 361-4, 370-3, 376-9; Delacroix buys cottage at, 205n, 254-5; mode of life at, 307, 314, 315, 362-3; move to another house at, 314n; 'a comic-opera village', 379; last visit to, 385
Charles IX, 125n
Charlet, Nicolas-Toussaint, 352, 375, 376, 382
Charton, Édouard, 241
Chasles, Philarète, 95
Chassériau, Théodore, 21, 335
Chateaubriand, Vicomte de, 60, 212
Châtellerault, 78
Chaussier, M. (family doctor), 67
Chenavard, Paul-Joseph, 21, 27

Chénier, André, 55
Chios, 8
Chopin, Frédéric, 23, 27, 221, 236, 239, 240, 242, 245, 247, 263, 267, 270, 271-2 and *Pl.* 28*a*, *b*; 'truest artist I have ever met', 244; breach with Sand, 272*n*, 276*n*, 279*n*; illness, 276
Christina (Dumas's *Stockholm, Fontainebleau et Rome*), 160
Clericetti, M., 224
Clésinger, Jean-Baptiste, 275*n*, 280*n*
Coëtlosquet, General de, 86*n*, 129*n*, 131*n*, 135*n*, 139*n*, 291*n*
Coëtlosquet, Julie de (possibly 'J', mistress of Soulier), 86*n*, 107*n*, 129*n*
Cogniet, Léon, 90
Cologne, 293
Compagnon du Tour de France, Le (Sand), 233
Compiègne, 348*n*
Comte, Auguste, 20
Comtesse de Rudolstadt, La (Sand), 251
Conflans, M. de, 116, 134
Conflans, Mme de, 116
Conservateur, Le, 48
Conspiracy of the Spaniards against Venice (Saint-Réal), 59
Constable, John, 9, 121*n*, 352
Constitutionnel, Le, 6, 112, 114, 158, 174, 261*n*, 268*n*, 274*n*, 289*n*, 379
Consuelo (Sand), 240, 251*n*
Coquille, Mme (niece of Guillemardet), 365
Corneille, Pierre, 32
Corot, Jean-Baptiste-Camille, 26, 104n
Correggio, 208, 289

Corsaire-Satan, Le, 301*n*
Cottrau, Félix, 315
Couder, Alexandre, 290
Cour des Comptes, 21
Courtigis, General de, 312*n*
Cousin, Victor, 48, 317
Cousine Bette, La (Balzac), 273
Couture, Thomas, 279*n*
Cromwell (Hugo), 148
Crozet (picture framer), 143
Cuvelier, M., and photographic etching, 321
Cuvillier-Fleury, Alfred-Auguste, 24, 202*n*, 203*n*
Czartoryski, Prince Alexander, 272*n*
Czartoryska, Marcelline, 23, 253*n*, 326*n*, 367

Dalton, Mme (D's mistress), 129*n*, 150*n*, 155*n*, 162, 188*n*, 190 and *Pl.* 12*b*; episode with Soulier, 159*n*, 162*n*; end of relationship with Delacroix, 225*n*
Dante, 52, 65-6, 204, 246
David, Jacques-Louis, 73, 193, 266*n*
Decamps, Alexandre-Gabriel, 382
Decazes, Duc, 240*n*, 260
Delaborde, Vicomte, 356*n*
Delacroix, Charles (father), 3, 6-7, 13, 85, 180; bronze portrait of, 258; his tomb, 267
Delacroix, General Charles (brother), 3, 6, 115, 139, 149*n*; estrangement from sister, 73; Delacroix's visits to, 73, 74, 78*n*, 107, 114, 150, 152, 234*n*; rescue of drowning men, 131, 134; death, 265-7
Delacroix, Eugène; family background and early life, 3-7;

Delacroix, Eugène—(cont.)
possibly natural son of Talley-
rand, 3, 6-7; first public show-
ing of major picture, 5, 105,
107, 112, 114n, 305; interest in
East, 7-8, 9, 105, 133, 148;
visit to England, 9-11, 121-31;
visit to Morocco, 15-17, 179-96;
public decorative schemes, 18-
21, 25, 201, 207n, 212-14,
221-3, 234, 238, 246, 253-
254, 257, 260, 272, 279, 296,
300, 302, 304-6, 310; evolu-
tion of correspondence, 21-5;
campaign to enter Institut, 25,
214, 217n, 218, 224n, 269, 297,
298-9; holidays at Valmont,
31-2, 157-8, 177-8, 205-7, 220-
222, 227-32; early love affairs,
33, 35-7, 43, 49; attempts to
write and read English, 36, 74-
75, 130, 136; holidays in Forest
of Boixe, 38-46, 49-53, 56-66,
74-9; writes verse, 54, 84; his
mother's death, 62-4; respon-
sibility for nephew and house,
66n, 108-9; daily routine, 69,
362-3, 367; money problems,
71, 72, 73, 109-10, 113, 138,
142, 151, 201, 277; visits to
brother, 73, 74, 78n, 107, 114,
150, 152, 234n; bouts of fever,
78, 84, 88-9, 94, 97, 258, 276;
interest in theatre and music,
104, 106, 113, 115, 122, 124-5,
126, 128, 139-40, 148, 153,
208, 209, 247, 308, 316, 329,
345, 358, 374; visits England,
121-31; unsuccessful lawsuit,
134; moves house, 145, 150,
154; improved health, 145,
149, 150, 151, 258, 315; quar-
rel with Soulier, 158-9; tries to
sell picture commissioned by
Duchesse de Berry, 163-4; joins
National Guard, 164-5, 166,
171; depression, 172, 281, 349;
visits Morocco, 179-96; first
meeting with George Sand,
209n; campaign for election to
Institut, 214, 217n, 218, 224n,
269, 297, 298-9; 'atonic con-
dition', 235-6, 238-9; laryngitis,
236, 238, 240, 272, 273, 291;
visits Nohant, 241-4, 269-71;
settles for first time at Cham-
prosay, 254-5; eye trouble, 260,
292, 339; takes waters at
Eaux-Bonnes, 262-3; brother's
death, 264-7; Officer of Légion
d'Honneur, 268n; takes waters
at Ems, 293-4; resigns from
1850-1 Salon jury, 299; buys
house at Champrosay, 314n;
elected to Institut, 338-40;
buys house at rue de Fursten-
burg, 342n; perpetual cold, 342,
344, 345; refuses to exhibit at
Salon because of critical attacks,
356n; deteriorating health, 378,
382, 383, 385-7; death, 387

OPINIONS ON:

antiquities, 230; artists, 54-5,
98; boredom, 135, 285, 294,
309, 310, 313, 325-6, 331, 349,
378; competitions, 166-71, 358;
contentment, 332; death and
bereavement, 54-5, 62-4, 85,
226, 239, 267, 307; decorative
painting, 275; drunkenness,
270; English school of painting,
123, 351-2; fresco-painting, 207;
friendship, 4, 39, 40-44, 46-7,
82, 85, 87-8, 91-3, 101, 153,
159, 178, 259, 287, 300, 361-2;

happiness, 39, 42-3, 54-5, 172, 220, 231-2, 270, 271, 332; imagination, 147, 168; Institut, 174, 340; journalists, 308, 347; languages, knowledge of, 52, 57-8, 130; letter-writing, 82, 86, 89-90, 92; line and colour, 289, 370; London, 121-2, 123; modesty, 91; Morocco, 182-96; Nature, 229, 354, 383; 'noble savage' cult, 58-9; old age, 258, 315, 331-2, 339, 349-50, 364; painting, 102-3, 108, 278-279, 289 and *passim*; Paris, 96, 116, 196, 244; photographic etching, 321, 322; retouching, 207, 359; revolution, 282, 283; Salon, 143, 144-5, 299, 340; schools and coteries, 329; shooting, 51, 53-4; talent, 168; technical dexterity, 354; travel, 130, 242; uncertainty of life, 270; womanhood, 12-13; work, 243, 245, 249, 291, 325-6, 332, 349

WORKS:

Abduction of Rebecca, 268n, 398

Adrien, 89, 103, 398

African Pirates, 311n, 324, 398

Amadis de Gaule delivering a young girl from the Château de Galpan, 26, 398

Animals in the Jardin des Plantes, 234, 398

Apollo ceiling, Louvre, 18, 19-20, 292n, 295n, 296, 299-300, 302n, 304, 305-6; *Pl.* 45, 46

Arab Comedians and Buffoons, 280n, 398

Arab horse tethered, 341n, 398

Arab horsemen crossing a stream, 312n, 398

Baron Schwiter, 11, 398; *Pl.* 25

Barricade – see *Liberty leading the People*

Battle of Nancy, 14, 149n, 153n, 157n, 178n, 179n, 190, 212, 398

Battle of Poitiers, 163n, 211, 398

Battle of Taillebourg, 2, 398

Boissy d'Anglas at the Convention, 13, 211

Botzaris, 105n

Chambre des Députés library, 18, 246, 253, 254, 257, 279; *Pl.* 43

Chambre des Pairs library, 221, 222, 234, 235n, 238, 241n, 242n, 244n, 246, 260n, 272; *Pl.* 44

Christ in the Garden of Olives, 211, 214, 272

Christ on Calvary, 212

Christ on the Cross, 26

Christ on the Lake of Genesareth, 11; *Pl.* 47

Cleopatra and the Peasant, 282

Cliffs at Etretat, 26

Clorinda, 322n

Combat of the Giaour and the Pasha, 136, 211; *Pl.* 10b

Corps de Garde, 277n

Cromwell at Windsor Castle, 11

Crucifixion, 366

daguerrotypes, 237

Dante and Virgil in the Inferno, 7, 105n, 114n, 214 and *Pl.* 6; his first to be exhibited, 5, 305; completion of, 107; sale of, 6, 108, 112n; restoration work on, 359

Death of Cato, 17

Delacroix, Eugène—*(cont.)*
Death of the Doge Faliero, 211
Death of Lara, 280*n*
Death of Ophelia, 139*n*
Death of Sardanapalus, 2, 11, 17, 211, 241 and *Pl.* 8; women in, 12; work on, 138*n*, 139*n*, 141n, 143*n*, 144; hostile criticism of, 145
Death of a Turkish Officer in the Mountains, 135*n*
Death of Valentine, 280*n*
Dr Faustus in his Study, 211
Don Juan, 135*n*
drawings of machines, 49*n*, 70
Education of the Virgin, 27, 241*n*, 243*n*, 244*n*, 258; model for St Anne in, 257*n*
Emperor Charles V at the Convent of St Just, 212
Emperor Justinian drawing up his Laws, 18, 147*n*, 211
Entombment, 280*n*
Fall of Constantinople, 2, 222
Faust lithographs, 141*n*, 142*n*, 211, 374
Female Nude, 300
Flowers, 285, 286, 287, 288
George Sand, 23; *Pl.* 29
Götz von Berlichingen series, 208*n*, 241
Greece Expiring on the Ruins of Missolonghi, 12, 13, 211, 351
Greek medals, lithographs, 375
Hamlet lithographs, 241, 250, 301, 375
Hamlet and the Gravedigger, 312*n*
Hamlet having killed Polonius, 322*n*
Horses, scenes of fierce battles, 183*n*

Interior of a Dominican convent in Madrid, 178*n*
Jewess with a Moorish woman, 312*n*
Justice of Trajan, 2
Lelia in the Cave, 310
Liberty leading the People, 12-14, 16, 162*n*, 211, 281, 336 and *Pl.* 15*a*, *b*, 16; woman as symbol of humanity in, 13; alleged self-portrait in, 14
Lion holding a serpent, 272
Lion Hunt, 27, 324
Lion Hunter, 292*n*
Lion Stalkers, 322*n*
Marino Faliero, 11, 135, 146, 214, 256, 351
Massacre at Chios, 8, 9, 12, 144*n*, 211, 214, 336 and *Pl.* 7; women in, 12; Constable's influence, 352
Melmoth, 212, 361*n*
Message, 375*n*
Michelangelo in his studio, 292*n*
Milton and his Daughters, 11
Moroccan sketches, 184, 185, 186, 188, 196*n*, 211; *Pl.* 20*a*, *b*
Murder of the Bishop of Liège, 13, 16, 155*n*, 211
Natchez, 212, 217*n*
New Year's Eve album, 41*n*, 47*n*
Odalisque, 26
Pietà, 18; *Pl.* 31
Pilgrims of Emmaus, 311*n*, 324
Prisoner of Chillon, 212, 312*n*
Rabelais, 212
Return of Christopher Columbus, 27
Richelieu saying Mass, 163*n*, 211

Royal tiger lying down, 272n
St Anne–see Education of the Virgin, 205n
St Sebastian, 214
St Stephen, 311n, 324
Saint-Sulpice chapel murals, 18, 19, 296, 331, 347, 348, 360, 362n, 367n and Pl. 48; public viewing of, 369-70; criticism of, 370, 375n
Salon de la Paix ceiling, Hôtel de Ville, 18, 305n, 308n, 310n, 311, 321, 323
Salon du Roi ceiling, Palais-Bourbon, 18, 19, 201, 207n, 212-13, 214; payment, 213
Still Life with Lobster, 139n, 291n
Sultan of Morocco amidst his guards, 190n
Tales of Hoffman illustrations, 171n
Tasso in the Madhouse, 256; Pl. 9a
Tasso at St Anne's Hospital, Ferrara, 211
28 of July 1830, 211, 214
Two Tigers, 211
Valmont abbey frescoes (Leda, Anacreon and Bacchus), 205-206
Virgin of the Sacred Heart, 6, 73n, 79n, 83n, 94n, 101n, 111n
Woman at her toilet, 362n
Woman combing her hair, 292n
Woman with a Parrot, 11; Pl. 14
Woman with White Stockings, 11
Women of Algiers, 26, 212, 214, 336; Pl. 21b, 22
woodcuts, 237, 241

Young tiger playing with its mother, 173n; Pl. 13a

WRITINGS
'Charlet', 375n, 382
'Michelangelo', 161n, 216n
'Portrait du Pape Pie VII de Sir Thomas Lawrence', 351n
'Poussin', 216, 313n, 352n
'Prudhon', 269, 376n

Delacroix, Commandant Philogène (cousin), 335
Delacroix, Victoire (mother), 3, 6, 312n; death, 62-4, 68, 85; bronze portrait of, 248
Delaroche, Paul, 213n
Delécluze, Etienne, 224, 376, 379
Delestre, A.-M., 274-5
Démon du Foyer, Le (Sand), 308
Dernière Aldini, La (Sand), 316
Desbordes-Valmore, Marcelline, 257n
Deschamps, Antony, 206
Dessin sans Maître, Le (Cavé), 295n
Deveria, Achille, 156
Diavolo (tight-rope walker), 153
Diaz de la Pena, Narcisse, 279n
Diderot, Denis, 223
Dieppe, 75, 79, 220, 303-4, 309-310, 324-6; Pl. 39a, 40
Dorval, Marie, 210n
Double Méprise, La (Mérimée), 202-3
Dover, 121
Du Camp, Maxime, 356n
Dufrêne (painter and magistrate), 133
Dumas, Alexandre, 325, 346
Duponchel (director of the Opéra), 15, 126
Duteil (friend of Sand), 236

Eaux-Bonnes, 262-3
École des Beaux-Arts, 21, 46, 167*n*, 213, 338, 340
Elba, 95, 101
Elmore, Mr (horse-dealer), 126, 127, 128, 202
Émaux et Camées (Gautier), 250*n*
Ems, 292, 293-4, 295*n*
Enfantin, Augustin, 125
England, 2, 5, 9-11, 121-31; mixed feelings towards, 10, 127-8; theatre and opera, 10, 122, 124-5, 126, 128, 129, 131; school of painting, 10, 11, 125, 128, 350-2, 371; public hangings, 126; 'depressing country' and 'not very amusing', 127, 130; slovenly women, 127, 129
Essay on the life and work of the Lenain brothers (Champfleury), 301
Essex, 130
Estouteville, Adrian and Nicolas d', 158*n*
Etty, William, 10, 11, 350
Exposition Universelle (1855), 327*n*, 330

Fanchette (Sand), 252
Faust (Goethe), opera from, 125, 374
Ferdinand II of Two Sicilies, 163
Fête de la Concorde (1848), 282*n*
Feydeau, M., 344
Fielding, Copley, 48*n*, 121, 122, 202, 350; 'not my sort of person', 124
Fielding, Thales, 115, 121*n*, 122, 124, 128, 136, 152, 202
Fix, Mme, 363
Flaubert, Gustave, 28
Fleurs du Mal (Baudelaire), 343

Floods at Saint-Cloud (Huet), 327
Florence, 79, 89, 96, 98
Fodor-Mainvielle, Mme (singer), 113
Fontainebleau, 180, 302
Forbin, Comte de, 6, 112*n*, 173
Forget, Émilien de, 309*n*
Forget, Joséphine de, 21, 210*n*, 289*n*, 297 and *Pl.* 27; character, 23-4, 25; relations with Delacroix, 24-5, 202*n*, 226*n*, 255, 274, 288; 'little quarrel' with, 288*n*
Foucher, Paul, 147*n*
Fourierists, 291
Francesca da Rimini (Pellico), 329
Franchomme, Auguste, 271
Franconi's Circus, 153
Franconville, 208
Freischütz, Der (Weber), 125
Frépillon, 209*n*, 238*n*, 261*n*

Gainsborough, Thomas, 351
Galerie d'Apollon ceiling, 18, 19-20, 292*n*, 295*n*, 296, 299-300, 302*n*, 304, 305-6 and *Pl.* 45, 46; Henry James on, 19, 20
Galerie des Beaux-Arts, 256*n*
Galli, Filippo, 106
Garibaldi, Giuseppe, 363*n*, 378*n*
Garraud, M. (director of Fine Arts), 281
Gaultron, Hippolyte, 247, 266*n*, 274
Gautier, Théodore, 356*n*, 359
Gazza Ladra, La (Rossini), 106
Gérard, Baron, 6, 8, 214, 374
Géricault, Théodore, 4, 5, 6, 7, 16, 65*n*, 73*n*, 110, 113, 121*n*, 266*n*, 352
Gerusalemme Liberata (Tasso), 48*n*, 55

Gibraltar, 180; *Pl.* 18*a*
Gihaut (publisher), 250
Girardin, Émile de, 254
Gluck, Christoph Willibald, 358*n*
Gobelins factory, plan to make Delacroix director of, 289-90
Goethe, 125, 141*n*, 211
Good Samaritan (Ribera), 228*n*
Goubaux (schoolmaster), 157
Goya, Francisco José de, 262, 368
Gracian, Balthazar, 294*n*
Granet, François Marius, 298*n*
Grange, Marquise Conrad de la, 348
Greek War of Independence, 7-8, 105, 133, 148
Grimod de la Reynière, A.-B.-L., 81
Gros, Baron Antoine-Jean, 7, 183, 371
Groussay, Château de, 284-5
Guérin, Baron Pierre-Narcisse, 49; Delacroix's studies with, 49*n*, 69, 70
Guillemardet, Félix, 4, 50*n*, 69, 75, 85, 90, 92, 97, 111, 112, 128, 151, 230 and *Pl.* 2*a*; Delacroix on their friendship, 45, 92-3, 153; death, 226, 239, 253, 365
Guillemardet, Louis, 4, 128*n*, 365
Gymnase theatre, Paris, 308*n*

Hague, The, 226
Halévy, Elias, 209*n*, 247
Hamlet, 126, 128
Haro, M. (art dealer), 28, 234*n*, 247
Hay, Mr (British consul, Tangier), 183, 187*n*
Hay, Miss, 187
Heine, Heinrich, 23, 334

Henri III and the English Ambassador (Bonington), 372
Herbelin, Mme, 324
Hérin (painter), 65
Hersent, Louis, 65
Hilton, William the younger, 123
Histoire des artistes vivants (Silvestre), 317*n*, 322*n*, 324*n*, 333*n*
Histoire du Consulat et de l'Empire (Thiers), 223*n*
Hoffman, Ernst Theodor Wilhelm, 168-9, 171
Holland, 5, 226
Homme de Cour (Gracian), 294
Horace, 4, 57; 'soul's finest doctor', 45
Huet, Paul, 28, 144, 263
Hugo, Victor, 8, 147*n*, 162*n*, 359*n*, 378
Hugues, Henry (cousin), 126, 129, 190, 195, 239

Illustration, L', 317
Indépendance Belge, L', 355*n*
Inferno (Dante), Ugolino episode, 58, 65*n*
Ingres, J.-A.-D., 21, 266*n*, 268, 297*n*, 333, 377*n*, 382
Institut de France, 174, 370; Delacroix's efforts to become member, 25, 214, 217*n*, 218, 224*n*, 269, 297, 298-9; his election to, 338-40
Iowan Indians, 264*n*; *Pl.* 34*b*
Isabey, Eugène, 127
Isabey, Jean-Baptiste, 15
Italien, Théâtre, 104, 106, 227*n*
Italy: Delacroix's unfulfilled wish to visit, 5, 39, 47, 89, 96, 99, 100-101, 103, 106, 107, 112, 132, 206, 218, 246, 360, 378

407

'J' (Soulier's mistress), 86n, 107n
Jal, Auguste, 174
James, Henry, 19, 20
Jardin des Plantes, 117, 234n
Jaubert, Mme, 330
Jean (Sand servant), 247
Jenny – see Leguillou, Jenny
Jerusalem (Verdi), 278n
Jesus in the midst of the doctors
 (Ingres), 377n
Johannot, Tony, 306n, 311
John Knox preaching before Mary
 Queen of Scots (Wilkie), 124,
 352
Joubin, André, 54n, 78n, 151n,
 156n, 157n, 291n, 292n, 361n
Jovet, M., 138-9
Juive, La (Halévy), 209

Kean, Edmund, 10; his Richard
 III and Othello, 126, 136; his
 Shylock, 128
Kemble, Charles, 139, 148

La Boixe (family property), 38-46,
 49-53, 56-66, 74-9, 88, 111;
 shooting at, 38, 40, 45, 51, 53;
 dinner-parties, 45, 60; peas-
 antry, 58; Delacroix's fever at,
 74-5, 78
La Charité, 136
Lafarge, Mme (poisoner), 228, 230
Laffitte, Jacques, 129
Lamarque, General, 195n
Lamartine, A. M. L. de, 116, 165
Lambert (model), 253
Lambert, Hôtel, 253
Lamey, Auguste, 357
Lamey, Mme, 68, 69, 71, 129;
 death, 334
Las Cases, Comte de, 116

Laure (model), 11
Laurencel, M. de, 163
Lavalette, Comte de, 24
Lawrence, Sir Thomas, 10, 11,
 128, 143n, 202, 350, 351, 375
Leblond (friend), 125, 128-9, 130,
 132, 133, 149, 343
Léger-Cherelles (pupil of Lassalle-
 Bordes), 238
Légion d'Honneur, Delacroix an
 Officer of, 268n
Legouvé, Ernest, 356n
Leguillou, Jenny (housekeeper),
 242, 254n, 257, 266n, 268, 312,
 354n, 362, 373, 385 and Pl.
 41; Delacroix's affection and
 care for, 292, 374; on his death,
 387
Leo X, Pope, 170
Leroux, Eugène, 281
Lesage, Alain René, 313
Life of Marie de Medicis (Rub-
 ens), 346n
Limousin region, 80, 85, 89
Loi, La, 215n
London, 10, 121-31, 350-2, 374
Lopez (landscape painter), 98
Louis Lambert (Balzac), 2, 17,
 197-8
Louis Napoleon (later Napoleon
 III, q.v.), 290
Louis-Philippe, 14, 18, 167n,
 220; as Duc d'Orléans, 148,
 163
Louroux (brother's home), 73n,
 74, 111-15, 134, 162n
Louvre: Apollo ceiling, 18, 19-20,
 292n, 295n, 296, 299-300,
 302n, 304, 305-6 and Pl. 45,
 46; Villot's rearrangement of,
 284; his resignation from, 346n
Lovelace, Richard, 95
Lycée Impérial, 93

Madame Bovary (Flaubert), 340*n*
Madeleine, church of La, 214
Mlle de Maupin (Gautier), 359
Magasin pittoresque, 237, 241
Maisonfort, Marquis de la, 48*n*,
 86*n*, 144
Malivernay (model), 253
Mansle, 38*n*, 41, 49, 62, 74, 75
Mantes, 140-1
Marliani, Mme, 221, 239, 257,
 276
Marquis de Villemer, Le (Sand),
 364*n*
Marriage of Cana (Veronese), 49*n*
Marriage of Figaro (Mozart), 113,
 115*n*, 348*n*; 'ridiculous' English
 production, 129
Mars, Mlle, 15, 183
Marseilles, 180, 183*n*
Martignac, M. de (Minister of
 Interior), 149
Matrimonio segreto, Il (Cima-
 rosa), 273
Maturin, Charles, 361*n*
Mauprat (Sand), 316
Mayer, Auguste, 126
Meillant, Françoise, 257
Meknes, 183, 184, 186, 188-93;
 Pl. 23*b*
Melmoth (Maturin), 361
Mémorial de Ste Hélène (Las
 Cases), 116*n*
Merchant of Venice, Kean in, 128
Mare au Diable, La (Sand), 270*n*,
 278*n*
Mérimée, Prosper, 11, 12, 14, 27,
 137, 160, 202
Meunier d'Angibault, Le (Sand),
 310
Meyrick, Sir Samuel Rush, 371
Michelangelo, 5, 226
Michallon (Corot's first master),
 104

Mickiewicz, Adam, 23
Minerve française, La, 48
Mirabeau, Comte de, 167*n*
Mirbel, Mme (miniature-painter),
 146, 194
Mocquard, J.-F.-C., 297
Molière, 21, 95*n*
Moniteur Universel, Le, 216*n*,
 250*n*, 313*n*, 330*n*, 334*n*, 352*n*,
 361*n*, 369*n*
Monsieur de Pourceaugnac (Moli-
 ère), 95
Montbazon, 57
Moreau, M. (stockbroker), 324
Mornay, Comte de, 15, 16, 186*n*,
 202, 211, 284-5 and *Pl.* 17;
 in Morocco, 182, 191, 192
Mornay, Mme de, 284-5
Morny, Duc de, 6
Morocco, 2, 5, 15-16, 178-96, 211;
 effect on Delacroix's technique,
 16; Jewish women of, 181, 185;
 reception by emperor, 183,
 184, 187, 188-90, 191, 192;
 grace and beauty of people, 184,
 185, 186, 193
Motte, M. (publisher), 156, 374
Mozart, 115*n*, 247, 278
Musée Napoléon III, 380-2
Musset, Alfred de, 12, 23, 219
Myrrha (play), 329

Nancy, 149
Nantes, 110
Naples, 102, 104, 105, 106, 108,
 363*n*
Napoleon, 122, 188*n*, 230
Napoleon III, 346, 348*n*, 380*n*;
 marriage, 311*n*
National Guard, 14, 164-5, 166,
 171
Newton, Sir Isaac, 368

Niel (pupil), 253
Nieuwerkerke, Comte de, 370
Nohant, Sand's house at, 5, 23,
 241-4, 258, 269-71, 272n, 276,
 283n, 306, 316, 363n; *Pl.* 32
Notre Dame de Lorette, church
 of, 201
Nouveaux lundis (Sainte-Beuve),
 279n
Nouvelle Héloïse, La (Rousseau),
 44n
Nouvelles Méditations (Lamar-
 tine), 116

Odéon theatre, 8, 95, 147n, 160n;
 English company at, 139, 140,
 148
Odjiberia Indians, 264
Olga (Ancelot), 148
Oran, 194, 195
Orientales (Hugo), 8
Orléans, Louis-Philippe, Duc d'
 (later King), 148, 163
Orpheus (Gluck), 358, 384
Ostervald, M. (print-dealer), 152
Othello, Kean in, 126, 136
Othello (Rossini), 104
Otway, Thomas, 59

Paer, Ferdinand, 52n
Palais-Bourbon: library, 18, 20;
 Salon du Roi, 18, 19, 201,
 207n, 212-13, 214
Papet, Dr, 252, 258
Paris, *passim*; Quai Voltaire (No.
 15), 154; Rue de Choiseul
 (No. 15), 141n, 145; Rue de
 Furstenberg (No. 6), 342-4,
 375n; Rue Jacob (No. 20), 115,
 141n, 343; Rue Notre-Dame-
 de-Lorette (No. 54), 256n,

259n, 260; Rue de l'Université
 (No. 114), 66, 69-70, 71, 72,
 108-9. *See also specific buildings*
Parr, Thomas ('Old Parr'), 365
Pascal, Blaise, 349
Pascot, Uncle, 70, 72, 129
Pasta, Guiditta, 106, 115
Pays, Le, 329n
'Peinture monumentale en
 France' (De Ronchaud), 278n
Perdoux, Mme (print-dealer), 98,
 99, 100
Perugino, Pietro, 221n, 227n,
 228
Petit, Francis, 287n
Petroz, M. (critic), 328
Phèdre (Racine), 235n, 345
Philippe (actor), 126
Pierret, J.-B., 4, 39, 69, 95, 100,
 133, 148, 149, 154, 158, 197,
 228, 265n and *Pl.* 4a; regular
 New Year's Eve celebration,
 41, 47, 75-6; Delacroix on their
 friendship, 40-44, 46-7, 82, 85-
 86, 91, 152-3; problem of marri-
 age to mistress, 55, 58, 61, 64,
 76-7, 79n; Delacroix's anxiety
 over, 58, 61, 62-5, 80, 165;
 his many troubles, 61, 232, 314,
 316; father's death, 62-5; mar-
 riage, 79n, 80; death, 323
Piron, Achille, 90, 155, 184, 190,
 195; Delacroix on their friend-
 ship, 93-4
Plaideurs, Les (Racine), 229n
Planat, Pierre, 98, 103
Planche, Gustave, 317
Plombières, 341-2, 345-6
Poche (model), 253
Pope Pius VII (Lawrence), 351,
 375
Poterlet, Hippolyte, 143, 350
Poterlet, J.-B., 137

Poussin, Nicolas, 216, 313n, 352, 364; 'noble unselfconsciousness', 42
Préault, Augustin, 248, 279n
Presse, La, 250n, 251, 254n, 299n, 328n
Prix de Rome, 5, 358; Delacroix's attempts at, 39n, 47n, 103
Prudhon, Pierre-Paul, 266n, 269, 376
Puritani, I (Bellini), 227
Pyrenees, 262n, 263; *Pl.* 36b

Querelles, Mme de, 274n

Rachel, Mlle, 245
Racine, Jean, 229n, 235n, 345, 378
Radeau de la Méduse (Géricault), 5, 65n
Raisson, Horace, 48n, 49, 94, 95, 103, 323n
Rambuteau, M., 271
Raphael, 47n, 79, 170, 208, 221, 227; 'noble unselfconsciousness', 43; Delacroix ironically contrasted with, 375n, 376
Ravaisson, M., 381
Redon, Odilon, 19
Remond (landscape painter), 103n
Resurrection (Perugino), 221n
Retzsch, Auguste, 374
Revolution of 1830, 18, 163n
Revolution of 1848, 279-80, 281-282, 283
Revue de Paris, 117; Delacroix writes for, 158n, 161n, 351
Revue des Deux Mondes, 209n, 210n, 215, 216n, 219, 233n, 269n, 295n, 317n, 323n, 352n, 364n, 368n, 375n, 376n

Revue européenne, 376n
Revue fantaisiste, 370n
Revue Indépendante, 278n
Reynolds, Sir Joshua, 202, 351
Reynolds, Samuel, 138
Ribera, José, 228
Richard III, 60, 75; Kean in, 126
Richelieu, Cardinal, 43
Richmond, 122, 123
Ricourt (editor of *L'Artiste*), 166n, 173
Riesener, Henri, 73, 129, 208, 234, 246
Riesener, Mme, 278
Riesener, Léon, 247-8; *Pl.* 3a
Ristori, Mme, 329
River (Huet's *Sunset at Saint-Port*), 327
Rivet, Baron, 140n, 290
Rivet (dealer), 153, 157
Rivière, M., 125
Rochard, François, 202
Rochefoucauld, Sosthène de la, 147
Romans et Contes Philosophiques (Balzac), 197n
Romantic movement, 8, 145, 329
Rome, 47, 96, 102, 108
Romieu, M. (director of Fine Arts), 311
Ronchaud, Louis de, 278n
Roncherolles, Mme de, 124
Ronzi, Mme (Italian singer), 89, 94, 106, 113n, 315
Roqueplan, Camille, 263
Rossini, G. A., 104, 106n, 115n, 247
Rouen, 31-2, 157, 178, 220, 227-8, 229
Rousseau, Jean-Jacques, 44, 283; and 'noble savage' cult, 59; Armenian outfit, 294, 303
Rubempré, Alberthe de, 1

Rubens, Peter Paul, 168, 183, 208, 221, 289, 294; 'as uneven as everybody else', 226; restoration of paintings, 346

Sacaley, M., 297
St Barnabas healing the sick (Veronese), 227n
Saint-Denis du Saint-Sacrament, chapel of, 18, 238n
Saint-Leu-Taverny, 236-8, 249-250
Saint-Pierre, Bernardin de, 59
Saint-Réal, Abbé de, 59, 60
Saint-Sulpice, Chapelle des Anges, 18, 19, 296, 331, 347, 348, 360, 362n, 367n, 369-70, 375n; Pl. 48
Saint-Victor, Paul de, 356n
Sainte-Beuve, C.-A., 112n
Salon exhibitions, 5, 340; (1822) 101, 103n, 105, 107, 108, 112, 114n, 305n; (1824) 9, 117n, 256n; (1827) 137n, 141, 143, 256n; (1828) 144-5; (1831) 211, 281n; (1833) 212; (1834) 361n; (1835) 217n, 366; (1845) 243n, 261n; (1846) 272n; (1848) 280n; (1849) 286n, 288; (1850-1851) 299; (1853) 311, 324n; (1859) 353-4, 355n, 356
Salon de la Paix, Hôtel de Ville, 18, 305n, 308n, 310n, 311, 321, 323
Salon du Roi, Palais-Bourbon, 18, 19, 201, 207n, 212-13, 214
Salter, Elizabeth (housemaid to Delacroix's sister), Pl. 1a; youthful affair with, 35-7, 43; draft of letter to, 36n and Pl. 1b
Sand, George, 21, 384 and Pl. 29; 'unclouded friendship', 22-3,

259; first meeting, 209n; rift with Buloz, 233n, 368n; Delacroix's visits to, 241-4, 269-70; breach with Chopin, 272n, 276n, 279n; quarrel with daughter and son-in-law, 275-6, 277, 280n; lawsuit with Société des gens de lettres, 278n; reconciliation with daughter, 283n; illness, 363-4
Sand, Marc, 386
Sand, Maurice, 241, 244, 258, 264, 266n, 280, 283, 308, 310, 316, 386n
Sand, Solange, 241, 258, 275n, 276, 280n, 283, 308
Schiller, Friedrich von, 59
Schnetz, Jean-Victor, 25, 290
Schwiter, Louis de, 129, 138, 153
Shakespeare, 10, 75, 127, 148, 283
Sharpe, Sutton, 12
Siècle, Le, 214, 215n
Sigalon, Xavier, 174
Silvestre, Théophile, 26, 317n, 324, 343; his study of Delacroix, 324, 333, 335-6
Smithson, Harriet, 8, 139
Société des Amis des Arts, 174n, 312n
Société Française de la Photographie, 21
Société des gens de lettres, 278n
Société Libre de Peinture et de Sculpture, 14, 173-4; address to Minister of Interior, 175-7
Souillac, 79-84
Soulier, Charles, 4, 5, 69, 70n, 78, 79, 111n, 114, 121n, 122, 157, 205, 226; first meeting with Delacroix, 48n; in Florence, 79, 86, 96, 98, 100; Delacroix on their friendship,

86-8, 94, 97, 337; his drawings, 94, 95, 99-100; in Rome, 101-2, 108; in Naples, 103, 105-6; illnesses, 150, 342; breach and reconciliation with Delacroix, 159; marriage, 159n, 171-2; financial difficulties, 286n
Soulier, Paul, 290, 291, 344
Soult, Marshal, 219
Sources de Royat, Les (Huet), 234n
Spain, 194
Stabat Mater (Rossini), 247
Stapfer, Albert, 142
Stendhal (H. Beyle), 10, 11, 12, 14, 27, 117n, 160
Stockholm, Fontainebleau et Rome (Dumas), 160n
Strasbourg, 333n, 357
Sunset at Saint-Port (Huet), 327n

Talleyrand, C.-M. de, 3; possible father of Delacroix, 6-7
Talma, François, 34, 375
'Tam o' Shanter' (Burns), 172-3
Tancredi (Rossini), 115
Tangier, 15, 180-8, 193-5, 196; *Pl.* 18b, 19a
Tarin (librarian, Bibliothèque Mazarine), 297n
Tasso, 48n, 55-6
'Tasso's Lamentation' (Byron), 56n
Tauromachia (Goya), 262n
Tautin's, Mère (inn), 350
Tempest, The, 126
Temps, Le, 158
Terry, Daniel, 374
Thames, River, 122, 123, 127
Themistocles, 364
Thévenin, Charles, 218
Thiers, Adolphe, 6, 14; as Minister of Interior, 18, 212, 213

Thoré-Burger, Théophile, 215n
Titian, 226
Toulon, 16, 179, 195-6
Touraine, 149-50
Tours, 66, 67, 73, 74, 107, 151-3
Treasures of Art (Thoré), 373
Tréport, 303
Triquet, Henri de, 201
Trouville, 235-6
Turner, J. M. W., 10, 352

Vacquerie, Auguste, 300n
Valmont, Abbaye de, 3, 15, 18, 31, 156-8, 177-8, 205-7, 220-2, 228-32; *Pl.* 38
Valmore (pupil), 257
Vannes, 366
Venice Preserved (Otway), 59
Verdi, Giuseppe, 278
Vernet, Horace, 161, 230, 289-90, 339
Verninac, Charles de (nephew), 64n, 73, 109, 110, 115n; Delacroix's care for health and schooling, 66n, 67, 69, 70, 72, 88; death, 203-4, 207
Verninac, Henriette de (sister), 3, 35, 37, 42, 63, 88, 107; quarrel with brother Charles, 73n; financial matters, 108-11, 113
Verninac, Raymond de (brother-in-law), 38n, 79n, 83, 88
Véron, Dr, 161, 186
Veronese, Paolo, 49n, 221, 226, 227, 354
Versailles, 217, 222
Viardot, Pauline, 236, 257, 278, 358
Vichy, 234n, 250
Vicomte de Bragelonne, Le (Dumas), 325n

413

Victoria, Queen, 219n, 333n
Viel-Castel, Horace de, 12
Vieillard, Narcisse, 219n, 289-290
Vieillard, Mme, 219
View of the Stour near Dedham (Constable), 9
'Ville Noire, La' (Sand), 364
Villemessant, Julie de, 'childish love affair' with, 33
Villot, Frédéric, 21, 22, 279n and *Pl.* 3b; unhappiness, 231-2; as Curator of Paintings in Louvre, 284, 346n; estrangement from Delacroix, 361
Villot, Mme, 271, 361n
Virgil, 4, 57, 59, 246

Vitet, Ludovic, 107, 108, 145, 375-6
Vivet (dealer in artist's materials), 178
Vivonne, 67
Voltaire, 291, 293, 294, 307, 349n

Walter, Ignaz, 125n
West, Benjamin, 122
Wilkie, Sir David, 10, 123, 124, 350, 352

Young, Charles Mayne, 126, 128

Zurbaran, Francisco, 207, 208